UNDERSTANDING TRAVEL BEHAVIOUR
IN AN ERA OF CHANGE

UNDERSTANDING TRAVEL BEHAVIOUR IN AN ERA OF CHANGE

Edited by

PETER STOPHER

Louisiana State University, Baton Rouge

and

MARTIN LEE-GOSSELIN

Université Laval, Quebec

Pergamon

U.K.	Elsevier Science Ltd, The Boulevard, Langford Lane, Kidlington, Oxford OX5 1GB, U.K.
U.S.A.	Elsevier Science Inc., 660 White Plains Road, Tarrytown, New York 10591-5153, U.S.A.
JAPAN	Elsevier Science Japan, Higashi Azabu 1-chome Building 4F, 1-9-15, Higashi Azabu, Minato-ku, Tokyo 106, Japan

Copyright © 1997 Elsevier Science Ltd

First edition 1997

Library of Congress Cataloging in Publication Data

Understanding travel behaviour in an era of change/edited by
Peter Stopher and Martin Lee-Gosselin.
p. cm
Includes indexes.
ISBN 0-08-042390-6 (hc)
1. Choice of transportation. 2. Urban transportation.
I. Stopher, Peter R. II. Lee-Gosselin, Martin.
HE336.C5U52 1996
388—dc20 96-11486
 CIP

British Library Cataloguing in Publication Data

A catalogue record for this book is available from the British Library.

ISBN 0-08-042390-6

Printed and bound in Great Britain by Biddles Ltd, Guildford

CONTENTS

ACKNOWLEDGMENTS

After the Quebec conference, the IATBR Board opted for a fully translated and edited book with keynote chapters, rather than a conference Proceedings. Also, in order to keep the volume affordable, the appointed editors agreed to provide a fully formatted and integrated, machine-readable manuscript to the publishers. We quickly discovered that this required us to reconcile not only differences in language, but also an unexpectedly large number of incompatibilities between micro-computing systems.

The objectives of the IATBR Board have been satisfied after a long and complex collaboration to which many people have contributed in several countries. The editors would like to thank each of the authors for their generous cooperation and patience as they resolved problems with us.

The manuscript was assembled at Louisiana State University with the meticulous assistance of Margaret Stephens, who corrected and verified chapters after each stage of the multiple review process, and who had more than her fair share of wrestling with uncooperative computers. Ram Sajja, who has now left LSU to work as a consultant in Houston, undertook the thankless task of standardizing the formatting of tables, figures and equations, in some cases their recomposition. We would also like to acknowledge the help of a number of our graduate students in the transportation engineering specialty of civil engineering at LSU, or in planning at Université Laval, who checked edits and translations.

Throughout this undertaking, we have greatly appreciated the advice and encouragement from the editors at Elsevier Science Ltd, Oxford, especially David Sharp and Chris Pringle.

Finally, the struggle to balance family and professional needs would have become impossible without the generous understanding of our spouses, and the material support of our employers, the Department of Civil Engineering, Louisiana State University, and the Département d'aménagement, Université Laval.

INTRODUCTION

In preparing a book on travel behaviour research for the mid-1990s, the editorial board appointed by the International Association for Travel Behaviour Research (IATBR) was conscious that such research has an unusually pivotal role to play in informing the current, world-wide debate over the degree to which the growth in personal travel, notably by private motor vehicle, should be encouraged or controlled. At stake are complex public interests concerning air quality, energy, lifestyle, economic development and the built environment.

The papers were selected for their relevance to the current unprecedented questioning, by both specialists and public interest groups, of our assumptions about the nature and consequences of personal travel. Many of these papers were presented in an earlier form at the 1991 Quebec International Conference on Travel Behaviour, which was the sixth of a unique series of interdisciplinary conferences organised around the world over the past 20 years. The first such conference took place in South Berwick, Maine in 1973, and was followed by conferences in Asheville, North Carolina; Tanunda, South Australia; and Eibsee, Germany during the 1970s. The previous conference in the series was held in October 1987 at Aix-en-Provence, France and the following conference near Santiago, Chile in June 1994. In recent years, some of the methodological debates have also engendered smaller, specialist meetings among the international community of travel-behaviour researchers on such topics as dynamic and/or activity-based approaches, survey methods, and choice modelling. This amount of international exchange is necessary because of the unusual degree of cooperation required between the social and engineering sciences, and — as the title of the book suggests — because travel behaviour is inherently linked to the societal and economic transformations now going on in all regions of the world.

Organisation of the Book

The book is organised into four sections, corresponding to the predominant domains of travel-behaviour research in the mid-1990s: understanding shifts in traveller activity and perception; using the Stated-Preference (SP) approach to measure future contexts; the incorporation of the dynamics of behaviour in travel analysis; and, the improvement of the practice of behavioural travel models. Each section offers a balance of methodological and substantive findings, although methodological considerations predominate in the "SP" and "dynamics" sections. At the start of each section is a recent keynote paper written to complement the material presented in the papers of that section. Thus, in addition to the revision of the individual chapters,

there is a considerable amount of new material beyond that presented in Quebec in 1991.

In addition to the pertinence of this book to the questioning of assumptions about travel, two further objectives figured strongly in the selection and the organisation of all the material. First, we wished to reinforce the view that travel behaviour cannot be reduced to a limited set of attributes of trips, such as mode choice. This view gained wide acceptance in the mid to late 1980s, but more recently a particular effort has been made to encourage contributions beyond the "mainstream" of travel-demand modelling. It will be seen that some of these papers draw on research that either enriches the variable set or extends the temporal and spatial boundaries of the behaviours studied. Second, such a broader scope requires new linkages between alternative conceptual frameworks and methodological traditions: we have attempted to make some of these linkages more visible. In light of both these objectives, the reader should not be surprised to find some of the contributors to this book drawing on such diverse fields of research as time-use, longitudinal analyses of vehicle duty-cycles, brand loyalty or the perception of hazard in road environments.

A Brief Guide to the Book

There are many ways to use a collection of papers. It is hoped that the assignment of the papers to the four sections will reduce the search time for those in search of thematically-related material. However, there are other common threads which serve to introduce the various contributions. We offer here the editors' personal views of some of the links between the content of the book and key trends that characterise travel-behaviour research in the mid-1990s. It does not, of course, pretend to do more than suggest a number of starting points, and these are not necessarily what the authors or the editors would consider to be the most important aspects of the chapters.

The first of these trends is the increasing interest in *the analysis of travel behaviour over extended periods of time.* In the recent past, key insights obtained from panel data have provoked interest in longer horizons for travel analysis. An example here is the evolution of modal preferences during the development of new public transport supply in Hiroshima, as described in the chapter by Fujiwara and Sugie. They provide valuable results from an investigation of sources of bias in the temporal variability of SP panel data. However, panel data are not the only source for understanding longer-term dynamic processes, and several other papers illustrate the variety of evidence considered.

Two kinds of demographics — those of the structure of households and of motor vehicle ownership — underlie the chapters of Séguin and Bussière and Madre and Pirotte. Séguin and Bussière review the period 1974-1987 for the Montreal region, paying particular attention to gender roles given the rapid growth in the participation of women in paid employment, and offering a taxonomy of households as a basis for comparing mobility patterns. Madre and Pirotte also employ trends from the 1970s and 1980s, and go further, using linked demographic (vehicle) and econometric (fuel consumption) models to predict household car ownership and use for France over a twenty-year period. Their work takes into account the different stages of motorisation of households in different regions.

A finding of considerable significance for behavioural theory is reported by Raux and Ondan in their study of households in greater Lyon who relocated their residences to suburban areas, in most cases without first acquiring much understanding of the level of accessibility and living conditions to be found there. This understanding was acquired over the longer term only *after* moving home, yet it is often assumed to drive residential-location choices. Similar extended searches for information may be a factor in other novel situations such as telecommuting, for which Mokhtarian offers some of the first data to become available on the subject. She finds examples of both reduced and increased travel effects, but only weak relationships between the opportunity to telecommute and residence relocation, which latter she attributes in part to the recentness of the phenomenon. She recommends monitoring these issues over the long term.

A second trend is *the growing incorporation of an activity framework into travel analysis.* In the 1970s, "activity-based" methods were primarily seen as the domain of innovative qualitative research aimed at explaining travel behaviour but with little direct application to the business of modelling demand. However, as Eric Pas pointed out in his keynote paper to the 1988 Oxford Conference on Dynamic and Activity-Based Approaches, the appreciation of travel in an activity framework perhaps represented the only "revolutionary" shift in understanding travel since the beginning of its analysis. Today, a variety of activity frameworks pervade quantitative and qualitative approaches, and as Peter Jones reminds us in his concluding comments at the same conference, an understanding of activity patterns is an essential complement to, and not a substitute for, work on dynamic processes.

This trend is exemplified by several chapters, two of which are the Raux and Ondan and Mokhtarian papers already mentioned. Pas and Harvey's chapter makes the very useful link to the findings and methodological tradition of time-use research, with a particular emphasis on the common ground of activity participation and scheduling.

The importance of this link was recognised in 1995 by the Eindhoven Conference on activity scheduling and the analysis of travel patterns, which was the first meeting to be sponsored jointly by the International Association for Time-Use Research and the IATBR.

In their keynote chapter on Stated-Preference applications, Jones and Polak provide a useful critique of the experimental approach used in SP Surveys, including the complexity of potential biases. An important extension with its own risks and advantages is the use of adaptive SP designs that draw on activity patterns and scheduling. The influence of activity frameworks also extends into some of the leading work on trip chaining and scheduling, such as the work on commuters reported by Mahmassani, Hatcher, and Caplice. Although not broadly based on household activity patterns, their work gives fresh emphasis to the importance of multiple-activity tours as commuters manage their travel needs from day-to-day in the face of road-network conditions. The complexity of travel/activity patterns is often understated by travel surveys, especially when cars are used. New light on the extent of automobile trip-chaining can be obtained by comparing results from diary surveys and automatic recording devices: an example of such work is given in the chapter by André.

A third trend, closely related to the interface between the activity and dynamic frameworks, is *a broader appreciation of the roles of perception, learning processes, and decision rules* in travel choice. Several chapters offer excellent examples from very different disciplinary perspectives. Ortúzar, Ivelic, and Candia show the payoff from a four-stage data-collection process from which the state of the public-transport system in Santiago, Chile was diagnosed from the users' perceptions of level-of-service (LOS). Importantly, notions of perceived LOS were induced from both experts and user groups rather than being specified *a priori* by the researchers. A related theme is pursued in the Hensher and Battelino paper with their use of SP methods to estimate a model of preferences for competing traffic-management devices.

Turning to a more psychological track, Gärling and Sandberg's chapter reminds us that many observed decisions are difficult to explain in the light of expressed intentions and attitudes. They did not find, as expected, a clear "commons dilemma" response to reducing car commuting, retrofitting a catalytic converter, or buying an up-to-date car in the interests of air quality; and they call for more research on social dilemmas. The book also includes some research into cognitive processes, which is perhaps most familiar to travel researchers as applied to path selection and destination choice. Work such as that presented in the chapter by Fleury and Dubois offers important additional insights about the relationship between user behaviour and the

mental categorisation of successive segments of the road environment. In their case, the objective was to provide improved environmental clues to car drivers as they make decisions in real time, such as the selection of a safe speed.

The work of Fleury and Dubois also bears on the cumulative learning of travellers and the choices they make on successive occasions, a theme that is echoed from a different perspective by Mahmassani in his keynote chapter on dynamic processes. Mahmassani is one of a number of authors who explores decision rules beyond the utility-maximisation paradigm. He describes work which views "the behaviour of the individual trip maker engaged in daily commuting as a boundedly-rational search for an acceptable outcome" and pays particular attention to indifference bands around disruptions in activity schedules, such as the early or late arrival at work.

Four other chapters on choice modelling also make innovative use of empirical data, and offer additional illustrations of an increased sensitivity to underlying decision processes. Kitamura and Supernak analyse observed activity engagement/disengagement decisions among visitors to an activity site with multiple opportunities (a zoo). They propose a formal approach based on equalised marginal utilities which they see as the basis for a wide range of activity-duration models. Hivert places the notion of relevant choice sets into a knowledge-based system, initially applied to observed mode choices. It is interesting to note that the rules in his system permit the characterisation of interrelationships within households.

DeJong presents an example of a joint discrete/continuous approach where household car-ownership level (0, 1, or 2 cars) and the amount of kilometrage a household chooses is modelled simultaneously. Unlike in most transport models, car kilometres is one of the arguments to the utility function. This follows micro-economic theory which suggests that a *threshold* level of use should follow a decision to own because of the disutility of fixed costs. Also on car ownership, Chandrasekharan, McCarthy, and Wright discuss the relationship between the nature of consumers' search activities and brand loyalty. Their approach includes the simultaneous analysis of preferences for vehicle attributes and of consumers' visits to dealers within and across submarkets. Their inferences about the strategic decision of automobile purchase make for an interesting comparison with those of Raux and Ondan on the arguably more important strategic decision of residence location (albeit on a different continent).

The embracing of a diversity of theoretical underpinnings is also evident in the trend towards *the use of multi-method approaches, and in particular, efforts to reconcile observational and experimental methodologies.* This trend is already implicit in some of the points raised above from the Pas and Harvey, André, and Madre and Pirotte

chapters. However, it is central to several other chapters. In Jones and Polak's keynote chapter on SP, there is both the general question of adaptive experimental designs, mentioned above, and the use of joint Revealed Preference (RP) and SP approaches. A particular example of a joint RP/SP approach is given in the Bradley and Daly chapter. Using two case studies concerning the relative attractiveness of rail services, they explore the extent to which the strengths and weaknesses of both RP and SP data can be offset within a logit choice-model framework.

A related idea is the combination of simulation experiments with RP data, as described in the Mahmassani, Hatcher, and Caplice chapter on switching behaviours of commuters faced with congestion and personal constraints. As with adaptive SP designs and some of the work on activity scheduling, such experiments are benefitting greatly from developments in interactive micro-computing. At the same time, of course, low-cost computational power has improved at an astounding rate. This has opened up new multi-method strategies, and has breathed new life into promising older approaches, such as microsimulation, which had been constrained by the complexity of calculations or the size of data sets that could be handled by the machines of their day. In this regard, the chapter by Hautzinger provides a very useful overview of alternative statistical designs for travel surveys, and of the limitations of estimation procedures using current software.

In his keynote paper, Stopher attempts to summarize a number of recent areas of the application of travel-behaviour methods. He deals, in turn, with developments in data and survey methodology, exogenous inputs to behavioural models and their impacts on the models, extensions beyond mode choice, transferability in applications, and issues relating to non-traditional areas of application. In the area of survey methodology, Stopher deals with survey methods, respondent recruitment, expansion and weighting, and data errors and bias. In the area of exogenous inputs, he examines the potential to improve forecasts of such variables as auto ownership, residential location, and job location. He also comments on choice-set formation and captivity, noting that far too few practical models use explicit input of either. In considering extensions beyond mode choice, Stopher notes that current efforts to develop a new paradigm of travel forecasting may render such extensions to be of only passing interest. He also raises some concerns about transferability as it is practised.

Some other chapters provide other examples of multi-method approaches. For example, Hivert's paper includes an experiment to compare his knowledge-based simulator to a conventional logit approach, and then to a chained combination of both approaches. Finally, Mahmassani's keynote paper on the dynamics of commuting behaviour includes a formidable catalogue of complementary methodologies, with

particular reference to the evolution of Intelligent Transport Systems/Advanced Transport Telematics.

It seems appropriate to conclude this brief "reader's guide" with an invitation to read two chapters that address what we hope is a trend towards *sound applications of travel analysis to solve policy dilemmas,* such as those arising from the emerging contexts laid out in Lee-Gosselin and Pas's keynote chapter.

We have already mentioned Hensher and Battelino's paper on anticipating community preferences for alternative traffic management schemes, but it is interesting to note their strong recommendation that their SP-based model be used to set guidelines for community acceptance of devices only if it is estimated from the responses of residents of communities already exposed to the range of alternatives. This may be a suitable caution to those who may expect too much of SP models in novel situations.

The closing chapter of the book, by Algers, Daly, and Widlert, lays out an ambitious integration of model structures and software developed for regional planners in Stockholm. The model suite is believed to represent the most comprehensive incorporation of behavioural interactions that is currently feasible for a large urban area, including within-household allocations of cars, choices about who shops for the household, and various permutations of intermediate and final destinations.

This final chapter is a fitting closure for a book that reflects what we perceive to be a growing awareness by the international travel-behaviour research community that much of our progress has been built on the integration of an uncommonly broad base of knowledge.

Martin Lee-Gosselin
Peter Stopher

PART I

UNDERSTANDING SHIFTS IN TRAVELLER ACTIVITY AND PERCEPTION

1

THE IMPLICATIONS OF EMERGING CONTEXTS FOR TRAVEL-BEHAVIOUR RESEARCH

Martin E. H. Lee-Gosselin and Eric I. Pas

ABSTRACT

This chapter examines major international trends that will have a determining impact on the future of travel-behaviour research, namely the emerging environmental, socioeconomic/demographic, and technological contexts. The implications of these contexts at both individual and societal levels are discussed with particular reference to the findings presented at the 1991 Quebec conference, including the other papers in this book. The future of travel-behaviour research is expected to be radically different from what has taken place in the previous three decades, partly because these emerging contexts compel researchers to adopt new paradigms for behavioural research, and partly because of major developments in the tools available.

INTRODUCTION

In this chapter, we address some of the most important recent changes in the contexts for travel-behaviour research from both the individual and societal perspectives, and we explore the implications of these changes. We cover below some changes in the political and legal contexts that have accompanied, in particular, late 20th. century developments in three domains: environmental protection, socioeconomic and demographic shifts, and technological advances. However, as we approach the middle of the last decade of the century, we must also recognize the world context: the volatility of the current period in history. Most importantly, one of the precepts of the modern world, a strong Soviet Union, has dissolved before our eyes, and even fervent opponents of centralized socialism find the idea unnerving. Political unions are forming in Western Europe, while dissolving into civil war in the former Yugoslavia,

and showing strain in Canada and elsewhere. Paradoxes can also be found in the world-market structure. Huge proposed free-trade areas, such as that created by the North American Free Trade Agreement (Mexico, USA, Canada) or the European Community plus the European Free Trade Area, promise the internationalisation of economic policy among some of the same countries and regions that wish to loosen existing political ties.

Meanwhile, notwithstanding the worst economic recession since the 1930s, few see travel demand as likely to decline. The traveller in North America and Europe could be forgiven for feeling that suburban gridlock, and other symptoms of increasing dependence on private cars, are immutable trends. A much-feared conflict in the Persian Gulf has come and gone with few apparent consequences for the price of oil. Even during the Gulf War, few car owners could have failed to notice that the price of crude oil actually declined to below pre-conflict levels after the initial few days. Thus, this war produced no more inconvenience than retail fuel-price fluctuations of a magnitude similar to those produced by market forces and taxation policy in the 1980s. In the most densely-populated areas of Europe, road congestion is a matter of active popular debate and, while public investment in competing public modes has enjoyed some increased support, car ownership and use mostly continues to grow at a rapid rate. In North America, only in the largest metropolitan centres is the effective universality of private motor vehicles seriously questioned.

At the same time, in a period in which market mechanisms have enjoyed wider political support than regulation in most parts of the world, the resistance to increased investments in road capacity and other automobile infrastructure – to the detriment of other modes – has matured into the appeal for the wider accounting of externalities, particularly as concerns congestion and air pollution. Another aspect of the emerging world context is the balance of development. This discussion paper, like most on travel-behaviour, deals primarily with the industrialized world. It is here that most of the motorized travel demand is found. As an indicator, in 1988 about 64 percent of the world's transportation energy was consumed in the OECD countries, 14 percent in the former East Bloc states, and only 22 percent in all of the rest of the world[1]. In the coming decades, however, population growth in the industrializing countries and global environmental degradation could combine to place incremental pressures on the world economic order of sufficient proportion to lower the wealth of individuals in the industrialized nations. This in turn would have a major impact on the total demand for travel. The linear extrapolation of the growth that leads to congestion, pollution, and other consequences cannot be taken for granted, while the resource requirements for third-world economic development cannot be ignored.

What challenges do travel-behaviour researchers face as they attempt to respond to these mixed signals? As a starting point, we recall briefly the historical background to travel-behaviour analysis, following which we discuss in turn the emerging environmental, socioeconomic/demographic, and technological contexts and the implications of these contexts for travel-behaviour research. We conclude with some thoughts on the future of travel-behaviour research.

BACKGROUND

The basic structure and underlying premises of what came to be known as the four-step travel-forecasting model system was developed during the early, large-scale transportation-planning studies conducted in the 1950s in such United States cities as Detroit and Chicago; while similar studies, using similar tools, were subsequently conducted in many industrialized countries in the 1960s and 1970s. It is not surprising therefore, that most travel-behaviour research conducted in the 1960s and early 1970s was essentially oriented to improving the traditional models of trip generation, trip distribution, modal split, and traffic assignment.

The four-step travel-forecasting model was developed in an era when the primary concern was with regional planning of highway systems. Thus, the role of the model was essentially to forecast the future demand for highway travel, in order to determine the expansion of the highway system needed to cater to the expected increase in demand. Of course, in this context, the models did not need to be particularly precise, because highway lanes represent lumpy investments. In any case, car ownership and use was increasing at a very rapid rate and therefore any errors in the forecasts were soon obscured by congestion (and subsequently by smog!). In this context it is also important to recall that when the four-step, trip-based travel-forecasting process was developed, not only were the problems being addressed very different from today's problems (in fact they were much simpler), but computing capability was very rudimentary by today's standards. The developers of the traditional travel-forecasting process were very constrained by the limited computing capabilities available at the time.

During the 1960s, however, questions about investment in dedicated rights-of-way transit began to emerge in the United States as a major policy concern. By the end of the decade, more sophisticated modal-split models began emerging in the research environment, subsequently to be known as mode-choice models when random-utility choice models (primarily logit) were introduced. However, the dominant philosophical approach was still one of increasing the supply of transportation to meet projected demand for travel. Increasing concern about energy and the environment (and to

some extent equity) prompted a new transportation-planning philosophy to emerge in the United States in the mid 1970s. Transportation planners began for the first time to consider managing the demand for travel, using what were referred to as Transportation-System Management (TSM) actions, rather than simply increasing the supply to accommodate the projected demand.

In the United Kingdom, transportation planning has followed a somewhat different track. In the case of interurban travel, a similar early preoccupation with capacity expansion has continued to the current day, with major government proposals for further expansions to the road network, including, for example, the widening of London's orbital motorway to 14 lanes at key locations. In urban areas of Britain, increasing emphasis was given to improving traffic flow through efficient traffic management. Efficiency has been pursued through physical improvements, such as one-way schemes and roundabouts, and through operational technologies such as coordinated/responsive traffic-signal control systems (e.g., SCOOT). As we discuss further below, demand management in Europe in the period 1960-1980 was mostly confined to the treatment of urban environmental problems.

By the mid-1970s, discrete-choice models were beginning to emerge internationally as practical alternatives to aggregate modal-split models. At the same time, travel-behaviour researchers began pioneering the use of psychometric-type scaling techniques to understand travelers' perceptions better and to quantify such variables as comfort, convenience, and reliability[2]. This research fits quite well within the traditional framework and it gave planners a better perspective on mode-choice behaviour. However, as Goodwin[3] has noted, a substantial amount of research done in the past 20 years, no matter how impressive, seemed not to count, essentially because it did not fit easily into the established framework. In effect, *"...the existing technical framework became the tail that wagged the dog, and in the end has tended to stifle exactly that research which was necessary to solve new problems."*

One of the examples that Goodwin[4] uses to illustrate his point is the line of research, generally known as the activity-based approach to travel analysis. A number of studies in this stream of work, initiated in Sweden, Britain, the U.S.A., and several other countries, showed the importance of patterns in activity programmes in space and time across individuals. In the mid 1970s, major advances in activity-based techniques were achieved under the leadership of the Transport Studies Unit at Oxford University, and a landmark collection of findings is to be found in Jones et al.[5] A specific challenge to the assumptions underlying the four-step modelling framework was the finding that choice of trip time was more central to household decision-making on a daily basis than was mode-choice. In fact, these studies showed that mode-

choice decisions were often determined by scheduling considerations (rather than being a function of modal characteristics). However, such research has generally not received the attention it probably deserves, primarily because it does not fit comfortably within the established framework – in fact, it is based on a view of travel-behaviour that actually contradicts the foundations of that framework. Pas[6] has noted that the activity-based approach represents the only paradigm shift in the history of the field of travel-demand modelling, not only by providing a new framework for the analysis of travel demand, but also through the emphasis on understanding travel-behaviour as opposed to the prior focus on forecasting.

Specifically, the activity-based approach highlights the importance of a number of interdependencies that are ignored in the traditional trip-based framework, including interdependencies between trips and between travellers from the same household. Further, the activity-based approach explicitly recognizes the importance of scheduling in travel-behaviour and the fact that travel demand is derived from the need or desire of individuals to participate in out-of-home activities. As noted in the Pas and Harvey[7] paper included in this volume, time is recognized in the activity-based approach as being a broader concept than simply travel time by alternative modes or routes, or to alternative destinations (which is the role played by time in the traditional conceptualization of travel-behaviour). As a result, the activity-based approach addresses explicitly the temporal constraints under which daily travel is undertaken.

A natural development, from the focus on activities, schedules, and constraints in the activity-based approach, is the recent and continuing interest in the dynamics of travel, both in terms of day-to-day variations as well as in terms of analysing and modelling longer-term changes in travel and related behaviour (see Mahmassani's resource paper in this volume for a review of these streams of research). Examination of the dynamics of travel-behaviour has encouraged researchers to begin questioning a fundamental assumption of travel analyses, namely equilibrium.

In understanding the evolution of travel, it may be possible to distinguish periods of adjustment from periods during which – to quote Mahmassani's[8] summary of the Dynamic Modelling Workshop from the 1988 Oxford Conference – *"...the ratio of fluctuations is somewhat narrower than it would be during an adjustment period."* Equilibrium remains a key concept, but it can be viewed as a transitory state on an evolutionary path. The historical preoccupation with system equilibrium as an end-state may limit the creativity of modellers. As Allsop[9] puts it, *"...we need to shift attention from states of equilibrium to processes of equilibration, and often to the early stages in these processes, because before they reach their later stages they will have been superseded by fresh processes."*

A distinction must also be drawn between equilibrium in an individual's behaviour and equilibrium in a system or network. Indeed, the evolution of individual and household travel-behaviour and the evolution of transportation networks are two very different classes of dynamic phenomena that are poorly understood and that, to date, have been the subject of unconnected model systems.

THE EMERGING ENVIRONMENTAL CONTEXT

Of fundamental importance is whether long-term and non-localized payoffs are valued together with improvements to short-term and local environmental conditions. The air-pollution issue has become locally acute in certain cases, notably the megacities of developing countries. Without measures to curb vehicle emissions, megacities such as Mexico City, Tehran, and Bangkok are expected to be exposed to *"...unhealthy and dangerous levels of automotive air pollution by the turn of the century[10]."* In the industrialized countries, serious air-quality problems have led to some ongoing traffic-reduction measures, such as those in Athens, Greece, and occasional emergency traffic restraint in other major cities such as Milan, Italy and Lyon, France. One of the most comprehensive responses to local conditions may be found in the Los Angeles Basin of California, which has been the subject of major new developments in car-use reduction interventions by state and regional authorities (notably Regulation XV), as well as the mandatory introduction of low-emission vehicles through percentage sales quotas, beginning in 1998. The regional market is large enough for this development to have created renewed automobile-manufacturer interest in alternative fuels, including electricity, natural gas, propane, methanol, ethanol, and reformulated gasoline.

With respect to long-term and long-distance environmental degradation, the current predominance of market mechanisms in most national economies is not accompanied by consistent policies to build "long view" environmental externalities into price signals. However, the European Commission[11] has documented the broader implications of the inefficient pricing of transport, and worldwide awareness of externalities is arguably rising. This is illustrated by the widespread discussion of greenhouse-gas and ozone-depletion impact scenarios, and "public interest" litigation over transportation and the environment. But for now, much of the policy context in the industrialized countries amounts to across-the-board vehicle and fuel technology standards (with some notable regional differences in severity), and intervention to control traffic and manage travel-demand in "non-attainment" metropolitan areas, against the background of nationally-defined air-quality standards.

The policy (and legal) environment within which travel-demand analysis and modelling are undertaken has recently changed dramatically in the United States. The Clean Air Act Amendments (CAAA) of 1990 and the Intermodal Surface Transportation Efficiency Act (ISTEA) of 1991 have profound implications for travel-demand analysis and modelling, and hence for travel-behaviour research. The requirements set out in these two pieces of legislation highlight the well-known and clearly-documented deficiencies of the traditional travel-forecasting models, and the latter have become major stumbling blocks in conducting analyses either explicitly required by the new legislation or implicitly required in the new policy-making and funding environment created by these two pieces of legislation. The Clean Air Act Amendment of 1990 lists a total of 16 Transportation Control Measures (TCMs) to be considered in improving regional air quality[12]. Most of these control measures deal explicitly with changing the demand for travel and, as such, are really in the class of Travel-Demand Measures (TDMs). Such measures include public-transit improvements and the provision of high-occupancy vehicle lanes, as well as employer-based trip-reduction plans, trip-reduction ordinances, restricted areas and flexible work hours.

The existing travel-forecasting model system might do a reasonably good job in the context of those measures that entail changes to the transportation system itself (primarily in terms of travel time by alternative modes of travel), and where the primary response is likely to be a mode shift between single-occupant automobile and either shared-ride automobile or public transit. On the other hand, many of the other measures are poorly modelled by existing approaches, for a variety of reasons, including the fact that non-motorized modes of travel receive scant attention in the models (at least in the United States of America). Also, the time of day at which travel is undertaken is not explicitly modelled using the traditional forecasting methods: the existing model system is constructed around the notion of unconnected trips within origin-destination matrices, so that the time-dependence of sets of personal and household activities is beyond analysis. Yet it is the linkages between trips that must be understood, if we are to attempt the estimation of demand under alternative TDMs.

In the United States, the future of travel-demand analysis and modelling is likely to be very much influenced by the entry of the environmental lobby into the debate over travel modelling. In fact, the landmark lawsuit brought by the Sierra Club Legal Defense Fund and Citizens for a Better Environment against the Metropolitan Transportation Commission (MTC) in the San Francisco Bay Area and the State of California, is likely to have a greater impact on the field of travel-behaviour than any other single factor. This lawsuit has already impacted the field through creating enough uncertainty to motivate the release of new research funds. It will also have

an effect on the direction of the new research in that the questions that arose during the lawsuit served to emphasize once again some of the shortcomings in our existing understanding and modelling of travel-behaviour and related processes and phenomena. The major issue in this lawsuit was the effect of added highway capacity (and thus reduced travel time, at least in the short term) on travel and related behaviour, and hence on air quality.

In the United States, the Department of Transportation has been the Federal government agency concerned with travel behaviour and modelling in the past; however, the Environmental Protection Agency is now taking a much more active role in this area and is currently sponsoring a number of research efforts in the area of travel and related behaviours. In particular, the EPA is concerned with analyzing the effectiveness of TCMs and with modelling vehicle ownership and use. Perhaps this will broaden the constituency for travel-behaviour research. At the same time, it would be wrong to imply that the recent US legislation has been exclusively motivated by concern for air quality. The ISTEA, in particular, is also a response to concerns over congestion and the competitiveness of the economy.

In Europe, air pollution from stationary sources received major attention in the post-war period. However, air-quality legislation in the transport sector, such as European Community vehicle-emissions standards, is a relative latecomer in an environmental-policy context preoccupied, since the 1950s, with the impact of growing and congested motor traffic on the built environment – notably noise, loss of neighbourhood, and visual intrusion. United Kingdom examples include the report of the Buchanan committee[13] and the work of the Standing Advisory Committee on Trunk Road Assessment[14]. Even today, it is fair to say that the European debate over investment in the infrastructure for private versus public modes as a means of reducing congestion has a higher profile than the debate on air quality. Although somewhat tempered by the recent recession, the congestion issue is frequently very visible, especially in Britain, France, and The Netherlands. A comprehensive review of the debate will be found in Mogridge[15]. In Europe much more so than in North America, a wide range of pricing options is included in the discussion of alternative policies[16].

In both continents, the existence of complex relationships between land use and transportation has long been recognized and is fairly widely accepted. However, the nature of these relationships is not at all well understood. In particular, there is the "chicken-and-egg" problem of whether the predominant relationship is one where land use affects transportation or vice versa. For example, the United Kingdom Department of Transport uses an inter-urban highway-appraisal methodology that assumes

that new roads may cause drivers to change routes but not to undertake additional trips, relocate activities, or revise their interest in adjacent land. Very little research has been undertaken in the recent past of the land-use/transportation interface. In fact, land use is still treated for the most part as an exogeneous input in conducting a travel forecast. However, it is becoming clear that the land-use/transportation interface, and people's willingness to adopt alternative land-use patterns, needs to be addressed because revised land use is one approach being advocated to accomplishing the end of improving environmental conditions.

There is a policy dilemma that is in an acute form in North America: controls over land use and road infrastructure are increasingly being decentralized at a time that some degree of region-wide control of car traffic is seen as necessary through taxation, parking surcharges, etc. These controls tend to be higher in central districts and, thus, increase incentives for peripheral, low-density development, unless applied on a metropolitan-region basis. For example, a tax on shopping-centre parking to aid transit in Montreal recently failed politically for this reason. Many, but not all, planners regard sprawl as undesirable in terms of land conversion, transport-energy use and air pollution[17].

A major trend internationally is the polynucleation of metropolitan regions. In some Canadian situations, this is seen as the only means of providing economies in services through modest redensification and a lowered dependence on the main CBD. However, polynucleation may mean that sub-state regional-planning mechanisms (e.g., Regional Municipalities in Central Canada, MPOs in the U.S.A.) must operate at a wider scale than they were set up to handle. In England and France, a relatively strong central control of land use has not been used to deny the development of many car-dependent retail centres on the edges of urban areas, nor the substantial expansion of parking facilities in the centres of medium and small conurbations, even while car-restraint policies of types mostly unknown in North America are broached in the same conurbations.

However, many urban areas are beginning to grapple with strategic issues, including questions about regional growth and its connection to transportation. One of the unresolved questions that arose in the MTC lawsuit, mentioned earlier, concerns the potential impact of added highway capacity on regional growth and development and thus on air quality[18]. The traditional traffic/transportation planners' argument is that expanding highway capacity improves air quality (through improved traffic flow), but this logic was challenged in this lawsuit. In fact, nine possible effects of an expansion of the highway system were recognized in the court case, ranging from changes in route, mode and destination, to the impacts of transportation improvements on

regional growth. In Canada, a recent study of alternative urban structure for Greater Toronto examined the potential for (a) continued peripheral development, (b) redensification of central areas or (c) compact polynucleic development. Significantly, an accompanying Ontario Ministry of Transportion study concluded that: *"...road capacity could not be increased sufficiently to avoid a lowering of levels of service, compared to 1986 levels. This was true, in varying degrees, for all three urban structure concepts. This result underlines the importance of land use planning in reducing commuting and supporting public transit. It also implies a more ambitious program of transit improvement than might have originally been thought necessary[19]."*

Portland, Oregon is another region where the environmental context has gone beyond an initial preoccupation with air quality. The group known as 1000 Friends of Oregon is sponsoring the development of an enhanced land-use/transportation model for the region in a study named LUTRAQ (for land use/transportation and air quality). Two major weaknesses were identified with the current Portland Metro Forecasting System (as reported in the first project report, which concerns modelling practices). These are (a) the lack of a formal feedback mechanism from the transportation system to the land-use forecasting process, and (b) an insensitivity to the effects that variations in urban design can have on travel decisions. Problem (a) was addressed by installing a transportation-sensitive land-use model as part of the Metro Forecasting System. Problem (b) was addressed by making enhancements to the models of auto ownership, destination choice, and mode choice, by including variables that represent development density and characteristics of the pedestrian environment. These changes have also resulted in an improvement to the model's capabilities for predicting short trips as well as walk and transit trips. They found that the model improvements were particularly effective in improving the ability to estimate the effects of development density and pedestrian environment on the choice of walk and bicycle versus vehicle (either automobile or transit) for home-based trips. However, these preliminary model improvements may not have gone far enough to include the effects of (micro-scale) urban design on travel-behaviour, which appears to be necessary if we are satisfactorily to evaluate the transit-oriented (TOD) and pedestrian-oriented (POD) development proposals commonly discussed in the USA today. Certainly, not much is known about the relationship between neighbourhood or urban form and travel behaviour (number of trips, mode choice), although considerable interest in this subject is now emerging[20].

It should also be noted that some of the socio-demographic and technological changes discussed below considerably complicate the relationship between land use and transportation. For example, if one thinks of the recent and continuing changes in household structure (see next section), coupled with the increased participation of

women in the labour force, it is easy to agree with Banister et al[21] who note that *"...the classic link argued in location theory between home and workplace has been broken as many people now move (residence location) for reasons not directly connected with work."* Further, work is no longer the primary journey purpose in many countries and even the pattern of work journeys is no longer fixed by time of day or day of week, as *"...it seems that destinations may vary as individuals may visit the head office once a week, a regional office on other days and even work from home for one day. Regular patterns may be established, but not on a daily basis[22]."*

As is illustrated by the above examples, the environmental context has developed primarily at the societal level, in the arena of public policy on transport investment and regulation. Although the extent to which environmental consciousness influences individual choice in transport is not fully understood, the Garling and Sandberg "commons dilemma" paper in this volume reveals that current-day travellers may not be wholly hedonistic. A number of European phenomena support this hypothesis, such as a "green" auto-club in Switzerland, and the rapid recent growth in car-sharing associations. But the willingness of individuals to moderate their participation in motor traffic probably has more to do with congestion than with environmental quality.

The Implications for Travel-Behaviour Research

The research challenge is to understand how different mixes of regulation and personal values and morals lead to travel-behaviour changes. A theme that is common to the environmental, socio-economic and demographic, and technological contexts is the degree to which households and individuals might be willing and able to consider entirely new packages of activity and travel choices, in some cases commensurate with ideals of lower consumption and pollution. In the past, such packages have manifested themselves as new towns or neighbourhoods, but other time-space-connectivity notions may emerge, especially if regulation or infrastructure investment inhibits formerly comfortable travel-behaviour. There is renewed interest in urban form, which has been the subject of recent specialized conferences in the U.S.A. and Australia[23], and in the policy implications of the energy-intensiveness and pollution balance sheet, which has obvious parallels in travel-behaviour research.

While a detailed consideration of potential behavioural responses to major shifts in pricing is beyond the scope of this chapter, it is important to recognize that marginal social and environmental cost pricing may become widespread, putting an end to an era of cheap motorized travel. Part of such a trend could be to shift standing costs such as annual vehicle-license fees and insurance to variable-pricing mechanisms such

as fuel tax, reversing the oft-observed incentive for motorists to reduce per-kilometre costs by maximizing the use of their vehicles. Although the price inelasticity of demand for gasoline (at least in the short term) is an entrenched notion, travel-behaviour research has only begun to address the coping reponses that might emerge following a radical and stable (i.e., non-emergency) shift in the pricing of private vehicle use. In this area, it would be prudent to draw on the experience of less industrialized countries with intermediate levels of motorization.

Travellers will be affected by the emerging environmental context in other ways, too. For example, some low-polluting vehicles will have unfamiliar characteristics, such as limited range and refuelling outlets, and new research on the implications for daily trip patterns is underway at the University of California Davis, in France, and elsewhere. As Garling and Sandberg[24] point out, we have much work to do on our understanding of the stability of stated intentions under a wide variety of future conditions. Yet, the use of techniques in which we expose respondents to hypothetical situations will be essential in our efforts to understand the implications for travel and related behaviour of substantially different policies. When one considers the changing socio-demographic and technological environments discussed below, the need becomes even clearer to develop such techniques further. Some of the methodological developments in such techniques are discussed further in the chapter by Jones and Polak[25] on stated-preference techniques.

SOCIOECONOMIC AND DEMOGRAPHIC SHIFTS

In the wealthier countries, the period following the Second World War has been one of generally rising per-capita income and diminishing rates of population increase. These trends have not, however, been linear, as illustrated by periodic economic recessions and the "bulges" in population pyramids associated with the "baby boomers" and their children. The combination of economic and demographic trends has been associated with important shifts in life style, notably smaller families and the predominant involvement of women in the work force. In many respects, it is difficult to determine the direction of causes and effects.

Here we must again emphasize that the combination of public policy and individual choice result not just in patterns of trip-making but also in strategic decisions that constrain the future of personal travel – land-use and transport infrastructure decisions, work and residence location, vehicle purchases and so forth. However, what is uniquely important in this "era of change"? Below, we look at: growth in population versus growth in personal income and the demand for "discretionary"

activities; the aging of the population; inter-generational tension; and changing household structures.

Growth in Population Versus Growth in Personal Income

In the more industrialized countries, the growth in personal travel has substantially outstripped the growth of population. As an example, it is instructive to compare Greater Toronto over the period 1961-1986. In this 25-year period, population increased by 77 percent, and employment by 142 percent, but trips increased 157 percent. Income and economic activity are no doubt implicated: other evidence is provided by sanitary sewage (a weak correlate of economic activity), which was up 84 percent, and solid waste (a much stronger correlate) which matched trip-making at 159 percent.

It has been widely observed that increased disposable income tends to increase the demand for travel. In broad terms, mobility growth is staying slightly ahead of Gross Domestic Product (GDP) growth, but it is worth remembering that in the 1950s and 1960s, mobility growth was two to three times that of GDP, depending on the country[26]. In part, higher income is associated with larger activity spaces and so with longer trip lengths. Of critical importance for the future is that increased income also allows increased consumption of goods and services, and travel is necessary for the resultant shopping, delivery, or participation. A key element of this is the growth in demand for discretionary activities, especially leisure[27]. However, an often-overlooked element of the picture is that the proportion of total car use that serves social and recreational activities is rather comparable across income groups and countries, despite large differences in total kilometres driven[28]. It is by no means true that lower-income car users give disproportionate priority to "essential" work-related travel. Nor is the automobile inaccessible to lower-income travellers: single-occupant automobile was the mode used for the work trip by 60 percent of workers from US households classified as below the poverty line in 1989, according to the American Housing Survey[29]. It should also be borne in mind that the cost of driving, especially fuel, has declined over the past three decades in real terms and relative to average wage rates.

The Aging of the Population

Average life-expectancy has risen substantially since the beginning of this century, with increases of 20 years or more in developed countries. Coupled with the "baby boom" of the post -World War II years, the proportion of the population that is elderly

will increase. For example, in Greater Toronto, over 65s made up 10 percent of the population in 1986, and this group is very likely to comprise 18 percent of the population in 2026. The impact of this change in population distribution on travel-behaviour is likely to be substantial. However, it is important to distinguish two different phenomena among the over 65s: the growth in the very elderly population and the economic vitality of the retired.

The very elderly – those over about 80 years old – have become known as the "4th. age" in the French literature, distinguishing them from the term "3rd. age," formerly used to refer to all "senior citizens." Although chronological age alone is an inadequate predictor of functional ability, this group is of unique concern because of the cost of providing adequate support services, including specialized transport, especially in view of changes in extended-family relationships. To the extent that the 4th. agers follow the broad trend towards living in suburban areas, the problem for transport planners may be acute.

The growing economic vitality of the 3rd. agers is closely associated with the evolution of retirement-income protection at a time that their numbers have been increasing. While by no means all 3rd. agers are financially secure, we are currently in a period of expansion of those who have both income and the time to use it, although many concerns are expressed about the future ability of the diminishing proportion of the population that is actively employed to support programmes such as Social Security. An additional factor, for the next few decades, is the advantage enjoyed by those old enough to have bought a house at a time when it took only one middle class income to support a mortgage – roughly before 1980. Such people have higher disposable income because their housing costs are low, and in many cases they have "cashed out" part of their equity to retire early or obtain investment income. Banister et al.[30] report an increasing trend in Britain toward early retirement, at the same time that the proportion of those in the oldest age groups is increasing.

Accompanying economic vitality is the declining use of transit: the over 65s showed the biggest drop in transit use of all adult age groups between the 1983 and 1990 U.S. Nationwide Personal Transportation Surveys[31]. The counterpart is the increasing involvement of 3rd.-agers (and even 4th.-agers) in the driver population. This has changed much in recent years. It was true once that most elderly drivers, especially women, had not been driving all their adult lives. However, as time progresses, a higher and higher percentage of the older driving population will have obtained their licenses in their younger adult life. For example, estimates from four waves of the NPTS show that the total US driving population has risen linearly with time for men (approximately 59 million in 1969 to about 80 million in 1990); women drivers,

however, numbered 45 million in 1969, but increased sharply to 58 million in 1977 and rose more steadily since to outnumber men drivers at about 82 million in 1990. In a discussion paper, Axhausen[32] discussed published driver-license statistics from several countries and cited figures published by the Federal Highway Administration (FHWA) showing very high levels of license-holding for US men under 70, rising to close to saturation within five years of licensing age. Women take about 20 years from minimum licensing age before levelling off at close to 90 percent of those eligible. Importantly, younger cohorts are closing the male-female gap in the rate of license acquisition, and are reaching a higher plateau of license penetration than earlier cohorts. There is some concern about over-counting in the FHWA statistics, notably for drivers who are in the records of more than one state, but it is clear that the percentage of the elderly who are licensed is rising. License penetration among older cohorts is lower in Europe. In Britain, for example, the increase in license diffusion with time among the over 50s is roughly linear over the past two decades, but it should be noted that at the end of the 1970s a substantial majority of women over 50 and men over 65 were not licensed.

It is reasonable to expect that older drivers who have grown up with the automobile will make life-style choices that prolong their dependence on the car. In this connection, Banister et al. [33]note that the elderly of this decade will be the first generation that have experienced mass car ownership. This presents new challenges for medical screening, driver licensing, control and counselling, and accident countermeasures, and these matters are now the subject of substantial specialized research activity. A key issue is the need to regulate a group that may or may not exercise good judgement about avoiding driving conditions beyond their capacity.

For the majority of older drivers who have few restrictions, imposed from within or without, we can expect to observe increased activity, and the evidence of this is beginning to be documented[34]. One interesting observation from their study is that the average amount of travel among women drivers over 70 seems to have increased for recent cohorts in the U.S.A., but decreased in Britain. It is speculated that in the U.S.A., we are seeing the near saturation of motorization working its way through to the older female age groups. In Britain, with its tougher license-entry requirements, earlier female cohorts were typically licensed late in life to meet a particular need to drive. It is possible that such women were more active, on the average, than later cohorts of over 70s that included more women who renewed licences held for many years, whether or not they depended on a car for mobility.

Inter-Generational Tensions

We have already touched on the problem of financing services for the elderly in a "top-heavy" population. Other examples of inter-generational tensions may emerge. One possibility is an increasing segregation of the better-off older people in sun-belt retirement areas, such as parts of Florida and Arizona, or the migration of retirees into the rural or "cottage" hinterlands of major metropolitan areas. A cynical view could be that this is a longer-distance version of the phenomenon of "white flight" of earlier decades – a reaction to the "city jungle" where younger groups struggle with economic deprivation. At the least, the better-off older groups will likely travel regionally and inter-regionally more than their current counterparts in the coming decades, and this may be in contrast to a flattening of travel growth by the younger majority of the population. Politically, the "grey vote" will increase in importance and could contribute to inter-generational tensions.

Changing Household Structures and Lifestyles

We know, from census information, that in most industrialized countries a majority of women have entered the workforce, a trend that is still on-going. For example, Banister[35] et al. report that 90 percent of the growth of the labour force in Great Britain over the period 1988-2000 is expected to be women. At the same time, household sizes have declined, in part because of lower birthrates, and also because of a rise in single-parent households. Pisarski[36] cites the decline in average US household size from 3.16 in 1969, to 2.83 in 1977, 2.69 in 1983, and down to 2.56 in 1990. Marriages and childbearing are taking place later in life and, more recently, economic pressures on the young (unemployment, housing costs) have led to the "prolonged-nest" phenomenon, with adult children staying in the parental home well into their twenties or even later. A slower rate of household formation also may mean both shifts in the travel patterns of the parental households (more multi-car households in which "everyone does their own thing" rather than shared activities), and a truncating of life-cycle stage explanations of the travel patterns of new households.

These phenomena are not solely demographic. They represent for many a choice of a lifestyle "package," be it traditional or non-traditional. This choice is closely related to residence location decisions. Raux and Andan[37] remind us that residence location is much less rational with respect to transport than most models assume. Their study finds that the move of a sample of central city residents out to the Lyon suburbs was

usually followed, not preceded, by a test of the transport and activity-accessibility implications.

Most of these households purchased an ideal without having a concrete notion of the change in activity space that it would represent – in some cases not even, it seems, as concerns the journey to work. The rural/urban ideal has a long history, for example Garden Cities[38] or Arcadia[39] . These are metaphors for escape from the dangers of the city, a notion that we have already noted has contemporary manifestations. The idea of a compact living space, fundamental to the Garden Cities idea has rarely been achieved, in part because of the difficulty, well known in the British new towns, of balancing the development of housing, community amenties, and local employment. Low-density suburbia offers households little of what Howard sought but remains nevertheless desirable, and the data from activity-based studies alert the travel-behaviour researcher to a broad notion of personal security and control in the selection of a residence location and a life-style.

The Implications for Travel-Behaviour Research

The travel-behaviour research agenda here is primarily about the strategic individual/household activity-space choices of different population groups, notably residence and work locations; and about the role of government intervention in those choices. Lifestyle and household classifications are increasingly incorporated into travel-behaviour research[40]. It can be argued that our categorisations of lifestyle or even households have been rudimentary, but that two types of research directions are emerging. First, is the improved segmentation of the travelling public, notably using elaborations of life-cycle stage, to take into account shifts in sociodemographics, values, and alternative living styles (e.g., retirement colonies), or using multivariate "bottom-up" analyses of trip and trip-chain characteristics[41]. Second, there is an evolution underway of activity-based methods to deal with activity space shifts, such as those shifts reported by Kitamura and Mokhtarian[42]. Some recent work[43] integrates the life-cycle/household structure and trip-chaining ideas of the activity-based approach into fairly traditional travel-demand model structures. However, other work envisages substantially new directions that exploit recent advances in computing capacity and software. For example, improved spatial data from geographic-information systems and tools such as microsimulation offer the potential for incorporating a much richer set of behavioural relationships[44].

It would be tempting to focus future research efforts, in the higher-income countries, on extrapolations of the broad trend of increasing person-kilometres of travel by an

increasingly wealthy, car-dependent population. As Pisarski[45] puts it in the introduction to his NPTS report[46]: *"...there is a sense from these data that we are seeing the final democratization of travel, as young and old, low income populations, and women make immense strides in personal transportation."* There is much evidence of this, but it must be remembered that current results, including those in this book, depend on the interpretation of data in the relatively prosperous period of 1985-1990. Three cautions should be made. First, the rate of change in travel activity may diminish as a result of shifts in major determinants of change, such as the eventual saturation of the rising involvement of women in the workforce, or the slowdown in the formation of new households. Second, few data are yet available on the aftermath of the world recession of the early 1990s during which there may have been important structural changes. Finally, indices of income are often highly aggregate, such as GDP per capita, and these hide important distributional effects. These effects may be of increasing significance under current market policies: for example, under the U.S.A.–Canada-Mexico North American Free Trade Agreement (NAFTA), total GDP may increase in the U.S.A. and Canada, but the benefits may accrue disproportionately to the higher-paid managerial and professional groups at the expense of lower wage earners.

TECHNOLOGICAL DEVELOPMENTS

Current and emerging technological developments present both challenges and opportunities for travel-behaviour research. However, it must be considered as to what extent new technology brings about a transportation-policy and decision-making context that is truly different from that of the 1980s and earlier. The key element is flexibility. Technology is emerging to support the current market notions of "customer-driven" and "user pays," especially for individual and urban modes.

For the inter-regional modes, it can be argued that not much has changed. High-speed technologies such as super trains and airline systems present much the same dilemmas of capital investment and public policy as the transcontinental railways of the 19th.Century: subsidy, competition, and regional-development priorities. This much is evident from the recent Royal Commission on National Passenger Transportation in Canada. However, even here new technologies may eventually make these modes more flexible and customer-driven, such as in the MIT proposal for large numbers of low-capacity trains at short headways on a high-speed network, responding dynamically to reservations between many suburban nodes in a broad corridor.

For the individual and urban modes, it is helpful to reflect on the history of the impact of transport technology on travel-behaviour. In broad terms, travellers, on the average, have seemingly used increased speed to expand their activity spaces while managing their time, so that travel maintains a reasonably constant proportion of the day. This translates into patterns of location and travel that can be studied over long periods. Thus, various relationships between the population density of central areas and the mean radius of cities show discontinuites associated with the introduction of new transport technology. London, for example, showed such discontinuities around 1850 and 1902, times of rapid expansion of rail and underground rail, respectively. Interestingly, the London data show no such discontinuity associated with the introduction of the private automobile, which assumed major importance during the period 1949-1964 with the quadrupling of car ownership[47]. Mogridge argues, in effect, that the automobile, unlike previous new technologies, was unable to achieve a travel-speed advantage in a congested transport system. However, significant spatial effects of the automobile may eventually occur in London, when cars are fully automated, as is now actively pursued with the various branches of Road Transport Informatics (RTI): Intelligent Vehicle and Highway Systems (IVHS), Automatic Traveler Information Systems (ATIS), Automatic Traffic Management Systems (ATMS), and Automatic Vehicle Identification (AVI).

A very significant amount of effort has been invested in Japan, Europe, and the U.S.A. to promote an RTI industry, but the policies behind this may have more to do with economic development strategies than with the maintenance of personal mobility. These technologies are but one manifestation of a whole range of new technologies that may profoundly affect production and consumption, and hence have considerable travel impacts. In the near term, the key for travel behaviour is the extent to which new technologies are likely to be diffused, especially those systems, such as navigation or most alternative fuels, that need to pass a critical threshold of coverage to become useful. In addition, the possibilities for new forms of pricing using informatics will raise the visibility of the debate on what "user pays" means in practice: deciding what to charge implies a consensus on marginal social costs!

In another area of technology affecting travel-behaviour, namely, telecommunications as a substitute for travel, the diffusion of technology is again being largely decided in a context other than that of transportation planning – that of human-resources management and organizational development. This relates not only to the availability of a pool of appropriately-skilled employees, but also to the demand for more flexible working conditions, such as shared appointments, part-time posts at senior levels, and contracting-out.

There is much ambiguity about the extent to which new technologies are leading or following the development of travel choices. We can argue that ameliorative technologies in the IVHS/ATIS family become most important when they affect the decision to travel (e.g., predictability of travel time, or of parking availability at the destination). Similarly, telecommunications technologies become most important when they make new day-to-day activity patterns possible: it should not be a surprise if the accumulation of mundane functions handled by modem, fax, or telephone are much more important to travel patterns than the high-profile telecommunications innovations of the 1970s and 1980s, such as broad-band video teleconferencing for long-distance business meetings. However, travel researchers are beginning to recognize that there are potentially complex relationships between telecommunications and travel, and that improved telecommunications might lead to increases in travel in some cases[48].

The Implications for Travel-Behaviour Research

Travel-behaviour research will continue to focus on the changes in the opportunity set that result from new technology, but there are also interesting issues associated with understanding how people perceive and respond to the attributes of the technology (including, for example, maglev trains, telecommunications, and in-vehicle information systems). As noted above, a major new issue is that in-vehicle information systems require us to understand how people make route choices, both before leaving home, as well as dynamically while the trip is in progress. Much of the work undertaken by travel-behaviour researchers in the past focused on choice of frequency, destination, and mode of travel. However, little work has been done on route choice. For the most part, network assignment algorithms are based on the user-optimizing criterion formulated over 40 years ago by Wardrop[49]. There have, of course, been developments in how the network loadings are determined and the deterministic approach has been extended to the stochastic user-equilibrium approach. However, only recently have researchers started to address some of the issues associated with analysing and modelling driver's reactions to advanced traveller information systems (ATIS). Recent studies include laboratory simulations of commuter decisions,[50,51,52,53] and discrete-choice models of the responses to congestion incidents by downtown car commuters surveyed in the Chicago area[54].

It can be argued that RTI is already compelling travel-behaviour researchers to re-examine the nature of information used by travellers, as well as the credibility, perceived value, acquisition, and exploitation of that information. These are

fundamental issues that must be addressed if the technology is to be applied effectively, but the expected benefits to the field go beyond RTI.

Among research activities on RTI systems, there are a number of trends that affect travel-behaviour explicitly. For example, the European DRIVE and PROMETHEUS programmes have tried not just to evaluate the potential impact of new technologies piecemeal, but also to develop broad research paradigms appropriate to a transport system modified by the technologies (e.g., the DRIVE I projects EURONETT and EUROTOPP). This is a welcome trend involving some innovative uses of SP, field trials, and interactive survey methods, a trend that has also emerged in some of the alternative fuel work, such as the projects on user response to limited-range electric vehicles at the University of California at Davis, the University of California at Irvine, and INRETS, France in collaboration with the Laboratoire d'Economie des Transports, Universite de Lyon II.

In the telecommmunications area, the Mokhtarian chapter[55] and the 1991 special issue of Transportation on the subject show that travel-behaviour researchers are mostly at the phenomenological stage – observing telework operations – and that there is a need to tap into the human-resources/organizational-development research around the emergence of "flexiplace." Some examples are Collins[56], Hamilton[57], and Newman[58].

In all technological areas, there is speculation about the rate and nature of diffusion. Some of the scenarios may be wrong, because technology does not always get adopted for the expected purpose (e.g., the first Apple computers were not expected to be widely used for word processing). We should ask whether researchers are doing enough to find out how user creativity is showing up.

There are clearly new challenges for travel-behaviour research due to technological developments, as discussed above. At the same time, however, technological improvements in research methods and computing technology offer opportunities for advances in the state of the practice and the state of the art of travel-demand modelling. As noted above, recent and continuing advances in computer technology (both hardware and software) present us with enormous opportunities for analysing and modelling travel-behaviour. Post-1990 improvements in computing capacity and speed open up the possibility of very detailed Geographic Information Systems (GIS), microsimulation of unprecedented complexity, and the treatment of very large quantities of monitoring data from RTI systems.

The wide range of devices and services that fall largely under the umbrella of RTI technology will provide a wealth of new data about the behaviour of travelers in a

variety of contexts, as well as information about the performance of the transportation system, although the majority of such efforts will provide little information on why people do certain things. Beyond data produced as a by-product of RTI, new technology is transforming survey and research data-collection and retrieval methods. Recent reductions in costs open up opportunities that make the current period truly different from the 1980s and earlier. For example, it now costs only a few hundred dollars for a Canadian on-board automatic trip logger using smart cards to programme data collection and store data: as a result, it is now feasible to instrument representative samples of vehicles[59]. In the area of interactive surveys, the last few years have seen increasing use of portable microcomputers in stated-preference surveys. Again, improvements in capabilities with reductions in cost, have made this possible. This not only makes it possible to conduct the surveys in convenient locations (e.g., train stations and places of work), but allows the scenarios presented to be customized for each respondent. Further, the use of emerging multi-media technology will allow the analyst to provide the respondent with more realistic descriptions of the alternatives to be evaluated and of the contexts within which they are to be evaluated[60].

Technology is also having an impact on the transportation-planning process by facilitating the growing sophistication of interest groups outside the traditional transportation-analysis community, such as environmental groups. The increasing availability of relatively low-cost, powerful workstations provides an opportunity for such groups to conduct analyses of their own of a type that only a few years ago would have been the exclusive preserve of major agencies. This development will no doubt put additional pressures on the travel-behaviour community to improve our understanding, and thus modelling, of traveller behaviour. At a minimum, this circumstance will force travel modellers to do a much better job of explaining their models and the underlying behavioural assumptions. In some cases, an environmental group could work cooperatively with the local planning agency, and the result would be an improved modelling and analysis capability for the region. This is already happening in Portland, Oregon, through the 1000 Friends of Oregon LUTRAQ project mentioned in the section above on the environmental context.

CONCLUSIONS : THE FUTURE OF TRAVEL-BEHAVIOUR RESEARCH

We conclude that, after a considerable period of relative stability, the current and emerging contexts represent a major change of direction with very important implications for the future of travel-behaviour research. However, as this chapter shows, travel-behaviour researchers have already moved in directions that will enable a relatively rapid response to the changed circumstances.

One way to look at the future of this field of research is to examine the potential for different parts of the world to provide what amounts to a variety of "natural" experimental settings on a large scale. It is clear that many of the tendencies discussed above in the environmental, socioeconomic/demographic, and technological contexts show similar evolutions between countries, at least in the higher-income countries. However, is it possible that different combinations of states of the three contexts offer valuable bases for comparison? To the extent that individual contexts evolve at different rates in different countries, this is inevitable. The answer is also "yes" in respect to at least three other themes on which we have touched in this dicussion.

First, the inertia of existing urban forms will provide important regional differences in the starting-point for responses to the emerging contexts. Second, the unequal ability of different countries to invest heavily in RTI means that private transport and transport networks will see varying degrees of partial automation and, most likely, varying degrees of sophistication in the marginal pricing of facilities. Third, the importance of litigation as an instrument of public-policy debate will be much higher in some countries than in others.

We have outgrown the simplistic notion that the accurate modelling of human behaviour awaits only sufficient data and computing power directed to discovering underlying principles analogous to physical laws. Nevertheless, the field will change radically as unprecedented computing flexibility and capacity become widely available and are applied to more comprehensive, and even hybrid, analytical approaches. For example, a new modelling approach appears to be emerging in the form of the coupling of microsimulation of activity-travel patterns in space and time with dynamic network assignment[61]. Clearly, the notion that we need to be able to determine equilibrium flows on a network in order to establish the appropriate expansion of that network is no longer the dominant rationale underlying travel-behaviour research.

The future of travel-behaviour research is likely to be both stimulated and frustrated by the pressures coming from a wider constituency of "clients," questioning both the interpretation of results and the underlying methodology. Fundamental assumptions, phenomenological relationships, and professional wisdom will all be increasingly subjected to critical scrutiny. As a result, we will need to be able to defend and explain our procedures to those not familiar with our field. While this will certainly tax our ingenuity, it will also, no doubt, ensure that we do a better job.

The interpretation of results may be increasingly politicized, and possibly over–generalized. More than ever before, the role of researchers should include bringing

together balanced inferences from a wide variety of existing situations in both the high- and the low-income regions of the world. A new forum for examining and discussing our best predictions of the global consequences of strategic choices at the societal level may be appropriate as an extension of the series of international travel-behaviour conferences.

Meanwhile, in the methodological realm, it remains to be seen how quickly we can reconcile our traditions that, until recently, have tended to isolate our understanding of the determinants of evolving matrices of trips from our appreciation of evolving patterns of human activity and travel.

ACKNOWLEDGMENTS

The authors gratefully acknowledge the thoughtful review of an earlier version of this paper by John Polak and the suggestions of Peter Stopher. Martin Lee-Gosselin has been supported in this work by the sponsors of the Automobile Mobility Data Compendium at Université Laval: Energy, Mines and Resources Canada, Transport Canada, the Ontario Ministry of Transportation and Shell Canada Limited. Eric Pas wishes to acknowledge support from the Southeastern Transportation Center, which is funded by the University Transportation Centers Program of the US Department of Transportation. The views expressed are the responsibility of the authors alone.

REFERENCES

1. Schipper, L. and S. Meyers, with R. B. Howarth and R. Steiner, "Energy Use and Human Activity: Global Developments and Prospects," Conference on Transportation and Global Climate Change, Asilomar, California, 1991.

2. Neveu, A. J., F. S. Koppelman, and P. R. Stopher, "Perceptions of Comfort, Convenience, and Reliability for the Work Trip," *Transportation Research Record*, 1979, 723, 59-63.

3. Goodwin, P. B., "The Right Tools for the Right Job: A Research Agenda, in Longer Term Issues In Transport," (Eds.: Rickard, J. H. and Larkinson, J.), Avebury: Aldershot, 1991, 3-40.

4. *Ibid.*

5. Jones, P., M. Dix, M. Clarke, and I. Heggie, *Understanding Travel Behaviour*, Gower, Aldershot, UK, 1983.

6. Pas, E. I., "Is travel demand analysis and modelling in the doldrums?," In: Jones, P. M. (Ed.): *Developments in Dynamic and Activity-Based Approaches to Travel Analysis*, Avebury, Aldershot, 1990.

7. Pas, E. I., and A. S. Harvey, "Time Use Research: Implications for Travel Demand Analysis and Modeling," *Understanding Travel Behaviour in an Era of Change*, Pergamon, Oxford, 1994.

8. Mahmassani, H., "Summary of Technical Workshop on Dynamic Modelling," 1988 Oxford Conference, In: Jones, P. M. (Ed.): *Developments in Dynamic and Activity-Based Approaches to Travel Analysis*, Avebury, Aldershot, 1990.

9. Allsop, Richard, Personal communication to the first author, 1993.

10. Faiz, A., "Automotive Emissions in Developing Countries – Relative Implications for Global Warming, Acidification and Urban Air Quality," *Transportation Research - A*, 1993, 27A(3), 167-186.

11. European Commission, *The Future Development of the Common Transport Policy*, COM(92)494, Luxembourg, 1993.

12. Stopher, P. R., "Deficiencies of Travel-Forecasting Methods Relative to Mobile Emissions," *ASCE Transportation Engineering Journal*, 1993, 119(5), 723-741.

13. Buchanan, C., *Traffic in Towns*, Her Majesty's Stationery Office, London, 1963.

14. SACTRA – Standing Advisory Committee on Trunk Road Assessment (Chairman: D.A. Wood), *Assessing the Environmental Impact of Road Schemes*, HMSO, London, 1992.

15. Mogridge, M. J. H., *Travel in Towns: Jam Yesterday, Jam Today and Jam Tomorrow*, Macmillan Reference Books, 1990.

16. Raux, C., and M. E. H. Lee-Gosselin (Eds.), *Mobilite urbaine: de la paralysie au peage?/Urban mobility: from paralysis to pricing?,* Recherches en Sciences Humaines, Programme Rhone-Alpes, 1992.

17. Corporation Professionnel des Urbanistes du Quebec, Edition special: l'Etalement Urbain, *En Bref*, Hiver, 1993, vol. 4(2).

18. Harvey, G., and E. Deakin, *Toward Improved Regional Transportation Modelling Practice,* Prepared for the National Association of Regional Councils, 1992.

19. Office of the Greater Toronto Area, *GTA 2021 - Infrastructure: Report of the Provincial-Municipal Infrastructure Working Group*, Toronto, 1992.

20. Transportation Research Board, *Transportation, Urban Form, and the Environment: Proceedings of a Conference*, Special Report 231, Washington

D.C., 1991.

21. Banister, D., I. Cullen, and R. Mackett, "The Impacts of Land Use on Travel-demand, in Longer Term Issues In Transport," (Eds.: Rickard, J.H. and Larkinson, J.), Avebury: Aldershot, 1991, 81- 129.

22. *Ibid.*

23. Transportation Research Board, *op. cit.*

24. Garling, T., and L. Sandberg, "A Commons-Dilemma Approach to Households' Intentions to Change Their Travel Behaviour," In: *Understanding Travel Behaviour in an Era of Change*, Pergamon, Oxford, 1994.

25. Jones, P., and J. Polak, "Stated Preference Applications in Travel Behaviour," In: *Understanding Travel Behaviour in an Era of Change*, Pergamon, Oxford, 1994.

26. Orfeuil, J. P., "Prospects for Travel Behaviour and Travel Behaviour Research," *Journal of the International Association of Traffic and Safety Sciences*, Tokyo, 1992, 16(2).

27. Orfeuil, *op. cit.*

28. Lee-Gosselin, M. E. H., with the assistance of Scholefield, G. P., *International Study of Car Use, Part 2: Classification of Car-Use Patterns*, Report to Transport Canada, Transportation Development Centre, Montreal, 1991.

29. Pisarski, A., *Travel Behavior Issues in the 1990's*, 1990 NPTS Publications Series, US Department of Transportation, Washington, D.C., 1992.

30. Banister et al., *op. cit.*

31. Pisarski, *op. cit.*

32. Axhausen, K. W., "Gender Differences in Access to Car Use in Several Countries," Sixth International Conference on Travel Behaviour, Quebec, 1991.

33. Banister et al, *op. cit.*

34. Lee-Gosselin, M. E. H. and M. Rodriguez, "What is Different About the Exposure Patterns of Older Car Users? Some Evidence From North America and Europe," Proceedings of the Canadian Multidisciplinary Road Safety Conference VIII, Saskatoon, Saskatchewan, 1993.

35. Banister et al., *op. cit.*

36. Pisarski, *op. cit.*

37. Raux, C. and O. Andan, "Residential Mobility and Daily Mobility: What Are the Ties?" In: *Understanding Travel Behaviour in an Era of Change*, Pergamon, Oxford, 1994.

38. Howard, E., *Garden Cities of Tomorrow*, Republished by Faber, 1946.

39. Nairn, I., *Outrage - Counterattack*, Two volumes, Architectural Press, London, 1958.

40. Bussiere, Y. and M. Seguin, "Household Forms and Patterns of Mobility : the Case of the Montreal Metropolitan Area," In: *Understanding Travel Behaviour in an Era of Change*, Pergamon, Oxford, 1994.

41. Lee-Gosslein, *op. cit.*

42. Kitamura, R. and P. Mokhtarian, "Energy and Air Quality Impacts of Tele-Commuting," Conference on Transportation and Global Climate Change, Asilomar, California, 1991.

43. Wildert, S., S. Algers, and A. Daly, "Modelling Travel Behaviour to Support Policy Making in Stockholm," In: *Understanding Travel Behaviour in an Era of Change*, Pergamon, Oxford, 1994.

44. RDC, Inc., *The Next Generation of Transportation Forecasting Models: The Sequenced Activity-Mobility Simulator*, Prepared for the Federal Highway Administration, US Department of Transportation, Washington, D.C., 1993.

45. Pisarski, *op.cit.*

46. Royal Commission on National Passenger Transportation, *Directions: the Final Report*, Ottawa, Canada, 1992.

47. Mogridge, *op. cit.*

48. Mokhtarian, P. L., "A Typology of Relationships Between Telecommunications and Transportation," *Transportation Research A*, 1990, 24A, 231-242.

49. Wardrop, J. G., "Some Theoretical Aspects of Road Traffic Research," *Proceedings, Institution of Civil Engineers*, 1952, II (1), 325-378.

50. Vaughn, K. M., M. A. Abdel-Aty, R. Kitamura, P. Jovanis, and H. Yang, "Experimental Analysis and Modelling of Sequential Route Choice Behavior Under ATIS in a Simplistic Traffic Network," Paper presented at the 72nd Annual Transportation Research Board Meeting, Washington, D.C., 1993.

51. Chen, Peter S-T. and Hani S. Mahmassani, "Dynamic Interactive Simulator for Studying Commuter Behavior Under Real-Time Traffic Information Supply Strategies," *Transportation Research Record*, 1992, 1413, 12-21.

52. Adler, J. L., W. W. Recker, and M. G. McNally, "In-Laboratory Experiments to Analyze Enroute Behaviour Under ATIS," Paper presented at the 72nd Annual Transportation Research Board Meeting, Washington, D.C., 1993.

53. Kitamura, R., E. I. Pas, A. S. Harvey, and J. Robinson, "Time Use Surveys in Modeling and Analyzing Travel Behavior: A Review and Proposal," Paper presented at the 72nd Annual Meeting of the Transportation Research Board, Washington, D.C., 1993.

54. Khattak, A., Schofer, J. L., and Koppelman, F. S., "Commuters' Enroute Diversion and Return Decisions: Analysis and Implications for Advanced Traveler Information Systems," *Transportation Research A*, (27A), 1993, pp 101-111.

55. Mokhtarian, P., "The Transportation Impacts of Telecommuting: Recent Empirical Findings," In: *Understanding Travel Behaviour in an Era of Change*, Pergamon, Oxford, 1994.

56. Collins, E. G. C., "A Company Without Offices", *Harvard Business Review*, 64(1), 1986.

57. Hamilton, C. A., "Telecommuting," *Personnel Journal*, Vol.66 (4), 1987.

58. Newman, S., "Telecommuters Bring the Office Home," *Management Review*, 78 (12), 1989.

59. Taylor, G. W., "Autologger: A Long-Duration Vehicle Use Data Collection System," Sixth International Conference on Travel-behaviour, Quebec, 1991.

60. Ampt, E. S., A. J. Richardson, and A. H. Meyburg, *Selected Readings in Transport Survey Methodology*, Eucalyptus Press, Melbourne, 1992.

61. RDC, Inc., *op. cit.*

2

RESIDENTIAL MOBILITY AND DAILY MOBILITY: WHAT ARE THE TIES?

Charles Raux and Odile Andan

ABSTRACT

This paper focuses on relationships explaining daily-mobility behaviour based on residential-mobility processes. We use data from an in-depth survey of 300 households who had moved to the outskirts of Greater Lyon. The analysis of residential-mobility processes shows that households have no preliminary knowledge of their new environment and no anticipation of living conditions there. There appears to be no direct link between residential-mobility processes and daily-mobility patterns. The link must be found at an intermediate level, following the move, namely in the way households have integrated into their new locality. The impact of these integration processes is perceptible only for working individuals and only on daily trip rates and activity locations. These results show the value of tracking the influence of housing developments on patterns of daily-mobility behaviour, rather than focusing on the processes of residential migration.

INTRODUCTION

The purpose of this chapter is to focus on a number of relationships that explain mobility patterns, with a view to forecasting demand. We chose to look into the potential involvement of daily mobility in the dynamics of residential mobility. Identification of such ties is of interest insofar as the choice of the home location is partially responsible for a degree of medium-term stability in everyday mobility patterns.

While it is readily accepted that setting up home in a downtown dwelling is dictated by daily-mobility aspirations, many authors would contest that such is also the case in peripheral areas[1]. If the latter hypothesis were true, it would doom to failure any attempt to utilize the "residential-mobility process" variable to explain daily-mobility

behavioural patterns within the scope of current migrational movement of households outward to the urban peripheral areas of France.

For many years, French urbanization was heavily dominated by the development of dense (high-rise) housing in the suburbs, as well as in central neighbourhoods, with the detached dwelling representing, more often than not, only a marginal phenomenon. Today, another form of urbanization, giving preference to low-density developments of detached houses, has appeared around conurbations of the traditional type; this is linked to the strong economic growth experienced by France until the mid-1970s.

In such a setting, and before rejecting this residential-mobility parameter, we felt it would be wise to carry out greater in-depth analysis of the ties between residential migration toward peripheral areas and daily mobility. We based our analysis on a survey carried out in 1988/89[2,3,4] in five towns located between 6 and 12 miles from Lyon, on a sample population of 300 households, including 584 adults who are parents, who moved from an apartment rented in Lyon or the inner suburbs to a purchased detached house in the post-1975 period. The Lyon conurbation is made up of a central core (Lyon-Villeurbanne) of 500,000 inhabitants. This central core is surrounded on all sides, over a 9-10 mile radius, by some 50 towns and villages, the whole area housing a total of 1.2 million inhabitants. Migration occurred for over 75 percent of these households at a time when families were still being formed, i.e., they were in the under-40 age group.

We devote the first section of this chapter to an analysis of the household-move process, and pay particular attention to any element related to the anticipation of consequences for daily mobility. The next section attempts to establish relationships between daily-mobility patterns and residential-mobility processes. In the third section, we identify post-move integration modes in the new town. Finally, in the fourth section, we study the links between these integration modes and daily mobility.

RESIDENTIAL-MOBILITY PROCESSES

The decision to move home can be situated in a medium or long-term setting of choices. These decisions bring to bear a diverse set of complex factors that differ in the way they occur and when they occur. It is true that these factors may be peculiar to the household, tied to the household's background (change in family structure, change in workplace, wish to become a home owner, etc.), or connected with outside factors, such as general economic circumstances (wage hike, pressure of the real-estate market, appeal of a new way of life, etc.). These factors can play a role in decision making, either as pull factors, such as the wish to own a home, or conversely, as push factors, such as the need to leave an apartment that has become too small with the growth of the family. Lastly, they can occur at different phases of the residential-

migration process, corresponding to a chain of successive choices resulting in the move of the household from a point of departure to a point of arrival.

Method of Analysis

We chose a chronological approach to mapping the residential-migration process, as shown in Figure 1. A qualitative presurvey identified four main categories of factors that bear on residential migration; these served as a basis for structuring the survey questionnaires:

- The migrating household:

 o Factors determining the decison to move: on the basis of a group of items, each household was asked to explain the reasons that led to the decision to leave the former home;

 o Outside occurrences or influences to which households might have been subjected (role of the family, friends, housing-market professionals, etc.);

 o Criteria orienting the choice of location: from a set of criteria, households were asked to indicate those that had played a part in their choice (price, location appeal, surroundings, amenities, transportation).

- Each parent of the migrating household:

 o Referents: on the basis of a battery of opinion items, parents were asked if they agreed or disagreed with statements on town/country, apartment/house themes, and feelings about home ownership.

In Figure 1, the horizontal line starts at the time when households decide to move, and stops when they purchase their house. Above this line are the referent systems acting on the transfer process, and below are featured the outside occurrences. With this outline, it is possible to visualize rapidly the extent of control households can exert over their mobility.

Figure 1
Schematic Residential Mobility

The analysis is split into three major stages:

- An initial stage, during which each of the four categories of parameters is studied separately; for each of these categories, we set up typologies summarizing the diversity of household behavioural patterns[a].

- A second stage, in which the objectives of households underlying their moving house are identified via the interplay of move-out and relocation typologies.

- A final stage, during which the way in which these objectives were shaped is analysed by a segmentation method, taking into account referent actions and outside interventions in this migration process.

[a] Analysis combined various data-analysis methods, factorial analyses and classifications.

The overall framework of this deductive data-analysis method enabled us to classify households into eight groups of migratory-behavioural patterns corresponding to eight types of residential mobility.

Types of Residential Mobility

These eight groups may be placed under two major headings: one showing autonomous, or controlled mobility, in which the new location is selected (17 percent of households), and the other, much larger, undergoing forced or dependent mobility in which the new location is not the result of a choice (83 percent of households).

Types of autonomous or controlled residential mobility

These households differ from the others in their lack of outside interference, in other words, their autonomy. With such persons, the call of the countryside plays an active role in making the decision. These people moved with the purpose of settling in a town they had deliberately chosen as being consistent with their aspirations. This category includes two types of residential mobility.

"Climbing the social ladder" (6 percent of households)

Moving to a new kind of home and setting is an integral part of an upward-mobility process as well as being the social representation of that upward movement. These households wish to be distinguished from other social groups by their home and living surroundings. The peri-urban locality is selected within this context. By living in a neighbourhood with other social classes they consider more privileged, they seek to improve their status. The house puts distance between them and the high-rise apartment building and its inhabitants. This quest for "difference" is found among the majority to be the main migrational incentive; this may, however, be superseded for a significant minority, by the priority accorded to work by those who wished to move as close as possible to their work place.

The opinion of these households of the big city is polarised concerning their perception of the social climate; those who are mainly motivated by their jobs consider this an asset, whereas others complain about it, because they are mainly preoccupied with putting some distance between themselves and certain social classes. For the latter category, moving out can be seen as a form of avoidance. It cannot be considered simply as flight, insofar as the move is consistent with what these households can afford objectively.

"Social reproduction" (11 percent of households)

For this group, the transfer from an apartment to a house on the outskirts is not seen as a social step-up, because the move was brought about by conformity to familial values and the choice was not haphazard. The locality was chosen as being the most

suited to their preferred way of life. Town and country are not viewed here from a social-climate perspective but in light of material living conditions and of the availability of amenities for the children. Such attitudes can be formulated either in a negative way, i.e., in terms of city avoidance, or positively, in terms of "country" appeal. Several motives influenced the decision to move: the wish to live closer to the place of work, a search for shelter from an increasingly tough and hectic society, for family "togetherness" under a private roof, or a chance to materialize prior thinking on the way to raise a family.

Types of dependent or imposed residential mobility

This category covers six types of residential mobility. The common denominator, unlike the previous category, is that these households were not in full control of their own migration. The choice of the new locality was, to some degree, influenced by various exterior factors: pressure from the real-estate market, friends' advice, or property developers' advertising. Another common point is the importance of the house referent in these decision processes. However, the word "house" does not have the same significance for all.

"In favor of a country house"(11 percent of households)

The husband's wish for a house, and the call to the country felt by his wife, are the two factors that set this outward migration in motion. As seen by these households, living in a house in the country means an easier day-to-day life style, a more pleasant living environment, and more space and freedom of movement for the children. Such a dream, initially unaffected by economic pressures favoring private home ownership, nevertheless comes true in the form of a deviation from that of the original version. Outside actors play an important part in this decision process: lacking the resources that match their ambitions, these households did not locate according to their own taste, but were led instead by developers' actions, house prices, home availability, and even friends' advice. Consequently, this decision seems neither imposed, nor independently made: these households were sensitive to market forces which eventually determined the locational decision.

"Financial avoidance" (13 percent of households)

This house referent underlies the reasons of the households for moving out of the centre: a change of home at the time of changes in working life or the wish to adopt a change of life style and to seek the home best suited to this. This latent referent is something that the advertising strategies of developers work on. The financial benefits of a house are given primary consideration. The house rids you of collective apartment costs, expenses that cannot easily be controlled. The house is also implicitly associated with ownership, but in this context, two positions can be distinguished: for some (7 percent of households), owning means putting down roots, and for the others (6 percent), ownership is a step in the right direction.

"Social avoidance for the children's sake" (6 percent of households)

The children's interests appear predominantly throughout this group's migration process. Rejection of everyday life in the city seems to initiate their migration: no longer wishing their children to live in such an atmosphere, perceived as stressful and largely unsafe, they decide to leave. A simultaneous change in housing type, ownership/rental status, and living surroundings provides an answer to the desire to move away from a certain type of population. This desire is consolidated by the husband's attachment to the idea of a house and living in the country. This tentative project takes on momentum when it meets with approval from outside sources, such as the example set by acquaintances, who have made such moves. This pressure converts the initial aspiration into a concrete opportunity. Moving to a house on the outskirts becomes an increasingly attractive solution as it represents the antithesis of everything they reject.

"Aspiring to a new way of life" (8 percent of households)

Becoming a home owner means stability and financial security, insofar as the house constitutes a capital acquisition. This penchant for ownership, strongly felt by the husband and combined with the house referent, usually valued as a living environ-ment, instigates their migration. Living in a house that one owns means essential personal space, a change in the pace of life, fresh air, a chance to organize one's surroundings as one wishes, and also the satisfaction of no longer paying rent. This aspiration is boosted by developers' strategies. This is so true that these households allow the developers to guide them in their choice of location, because they lack the resources to implement such a project. The choice will still be made in a realistic manner, taking into account a number of constraints, such as the location of work and school and keeping within the limits of their budget.

"Gaining access to a new dwelling standard" (40 percent)

This is by far the largest group, representing half the number of households who were not in full control of their relocation. Here again, the desire to live in a house that they own leads these households to uproot. The dream comes true through the actions of developers, the latter channelling these households toward locations they would not have chosen if left to themselves. However, a wide gap separates them from the previous group: living in a house that they own not only means no longer wasting rental money, but also integrating into more privileged social classes and, in some cases, leaving undesirable social classes behind. Becoming a home owner does not represent the same experience for everyone: for the majority, it means reaching their residential goal; while for others, it is merely a step up toward further stages in the progression of housing status.

"The remainder, under the influence of acquaintances" (7 percent)

What can be said of those whose projects are vague? Moving home has various connotations and is not supported by any particular aspiration. A private house is more or less positively valued and consequently they let themselves be convinced by friends to make the move.

What Interest Is Taken in Daily-Mobility Conditions Within These Decision-Making Processes?

Interest focuses mainly on the private territory represented by the home for the reasons described in the following subsections.

The house as a space devoted to private life

The instigating factor of outward migration is the attraction of the house, frequently associated with ownership, and the quest for a new dwelling mode. Living in a house means, for most people, having a "private" area at their disposal, both indoors and out, as the garden is in a way a natural extension of the dwelling.

The house as a social symbol

Not everyone, however, reduces the value of a house to these benefits alone. For at least half of these households, the house possesses a social value either as a way to integrate more privileged social classes ("Social-Ladder" and "Access-to-a-New-Dwelling-Standard" groups) or as the antithesis of what is rejected ("Social-Avoidance-for-the-Sake-of-the-Children" group).

The house offers suitable surroundings for the children

For a minority, the house is related to the materialization of child-rearing principles. This is more or less openly expressed depending on the household ("Social-Reproduction," "In-Favor-of-a-Country-House," and "Social-Avoidance-for-the-Sake-of-the-Children" groups). Such a focus on the dwelling proper appears largely to divert the reasoning of households from preoccupations with living conditions offered by the new locality, in particular transportation.

Above all, the city is rejected

Evaluations of the benefits and drawbacks of the conurbation left behind and of the peripheral area settled into, thus, most frequently refer to the city and its social atmosphere (in "Social-Ladder," "Family-Conformity," "In-Favor," and "Social-Avoidance" groups). The new locality is of little interest in itself, being perceived in

most cases only as an alternative to the city. While families are acutely aware of the day-to-day living conveniences offered by the city (everything within a stone's throw), they are essentially concerned by the wish to get away from certain social groups or to flee from stressful city life ("Social-Ladder," "Family-Conformity," and "Social-Avoidance" groups), or to take advantage of living in the country where one is less anonymous. This rejection of the city leads some even to screen out the benefits of city life ("Social-Avoidance" group).

The choice of a new locality is often the result of purely market-oriented chance

It is hardly surprising to observe that the choice of the new locality usually depends in no way on consideration of the implications it may have on day-to-day life. For a large majority of the sample population, the choice of a neighbourhood was a random process for two primary reasons.

The first was that all households do not have the same financial leeway to make the choice. Only families in the first two groups made autonomous decisions. The plans of the others were altered to a greater or lesser degree by outside pressures, often resulting from fluctuations in the real-estate market. Real-estate agents foster their wish to become home owners by arranging advantageous financial terms, but at the same time this narrows, sometimes significantly, the range of locational choices.

The second reason is a problem of information. Very frequently, as home buyers do not have specific information on one particular neighbourhood or another and have no prior ideas as to what the ideal locality might be, they change their requirements when opportunities come along. Here too, the first two groups were the only ones who had knowingly chosen their new town on the basis of some kind of familiarity or, possibly, experience.

For two-thirds of families, the decisive element in the choice of a new home location was the cost of the land, or the house, or even availability within the real-estate market. Very few took account of any requirements related to amenities within the new locality or fast and/or public transportation capabilities. The best one can find with a small minority ("Social-Ladder" and "Aspiring-to-a-New-Way-of-Life" groups) is concern for moving to a locality from which rapid travel to the workplace or school was possible.

In comments regarding the outward move, it is difficult to find any trace of projects, whatever they might be, related to daily mobility. Predicting how their way of life would be affected by what the new environment had to offer does not seem to have been one of the considerations that guided their choices. Among households susceptible to the vagaries of the marketplace, residential-migration categories cannot be differentiated easily.

RESIDENTIAL-MOBILITY PROCESSES AND DAILY-MOBILITY BEHAVIOUR

The above analysis throws serious doubt on the existence of any daily-mobility project in liaison with the residential-mobility process, and raises several questions we will attempt to answer. This is not done by means of analysis of the answers given by respondents questioned on their outward move, but rather on the basis of observations among the different residential-mobility groups in the areas of travel behaviour, activities carried out, and their location. By so doing, we test for the presence or absence of *direct* links between residential-mobility processes and daily-mobility behaviour.

FROM ACTIVITIES TO TRAVEL BEHAVIOUR

Daily-mobility patterns were not recorded conventionally in the form of diaries evaluating the various comings and goings. We evaluated activities by asking respondents to outline their activities: each parent was asked about his or her habits for each type of activity (work, shopping, serve-passenger, and leisure), each activity being identified by a single associated location. Habits are positioned in terms of frequency over a week. This produces a weekly frequency measurement for different activity locations, rather than an accurate record of trips.

Is it possible simply to compute trip quantities from this record of activity-location intensity? We are tempted to assert that two trips are routinely associated with visiting an elementary activity location, one to reach the activity destination, the other for departure from that destination. Nevertheless, this supposes that all locational changes start from the home, in other words that there is no chaining of trips other than the round trip. Measurements carried out in surveys of the "activity-pattern" type in French cities show that trip chaining in the form of single round trips from the home are the vast majority (80 percent of chains in the inner suburbs of Paris[5], 75 percent in Grenoble[6], and 70 percent in peripheral Lyon in 1981[7]).

Calculations on the basis of our survey of the activities of 584 families with children show that they visited 6,727 activity locations per week. In addition, there were 1,287 activity locations, 1,019 of which were serve-passenger activities, recorded during home-to-workplace journeys and vice versa. The latter correspond to trips in addition to those carried out between the home and the workplace; thus, 19 percent (1,287/6,727) of activity locations are shown to be undertaken in the form of trip chains, other than single round trips. If it is hypothesized that each of the 6,727 activity-locations generated at least two trips, to which are added the 1,287 extra trips in the course of the change of location between home and workplace, a total of 14,740 trips per week is reached, i.e., a mean value of 3.61 trips per day per person. This mean value is to be compared to values obtained by the 1986 household survey on

greater Lyon[b,8]: a mean value of 3.24 for the overall conurbation, and mean values varying from 3.25 to 3.51 in peripheral areas corresponding to those of our survey. The extra mobility observed by our survey can be explained by the fact that our evaluation focuses on an adult population only, of whom a large majority perform professional activities, whereas the 1986 household survey studied the trips of everyone over 5 years of age, and, therefore, including young children and retirees.

Therefore, we can reasonably assert that an evaluation of activity-location habits provides a relatively good approximation of daily mobility. Testing whether residential-mobility processes induce differentiated daily-mobility behavioural patterns amounts to testing the existence of significant differences between types of residential migration according to three daily-mobility parameters: trip rate, kinds of zones frequented, and types of activities carried out.

Daily Trip Rate

We carried out several analyses of the variance of trip rates[c] according to the eight types of residential mobility covering 542 individuals[d]. The first test, on the 542 individuals as a whole, shows that there are no significant differences in overall trip rates from one category to another[e]. Consequently, the question as to whether or not a normalization of behaviour occurs as a result of work activity can be asked; this would tend to level off the differences that might exist when characterizing individuals by their type of residential mobility. In fact, if mobility is evaluated, excluding work activity considerations, the resulting test value is even lower[f].

In a second phase, we separated active (those with work activities) and non-active subjects. Here again, statistical tests are non-significant[g] for the 423 active subjects,

[b] 3,700 families surveyed in 1985-86.

[c] The hypothesis required for the test of normalcy of distribution of variables on which classification is checked, is generally verified, in view of the number of observations. This is not always the case, on the other hand, with the variance-equality hypothesis of each class, as the tables show. In fact, we use the test for our analysis in an exploratory manner, in order to retain only liaisons considered significant, a priori (value of F at 5 percent).

[d] Each individual is referenced by the type of residential mobility his household belongs to.

[e] Fisher's Test: $F(df<7.534>) = 1.07$.

[f] Free activities + shopping + accompaniments excluding home-work transfer. $F(df<7.534>)=0.45$

[g] Free activities + shopping + accompaniments including home-workplace transfer. Respectively $F(df<7.415>) = 0.79$ and $F(df<7.415>) = 0.65$.

for both total mobility and mobility excluding work activities. Consequently, we can conclude that residential-mobility processes have no impact on daily trip rates.

Daily Activity Locations

Activity locations were classified into four categories, making it possible to avoid the specific geographic identification of each location, while reporting different levels of urbanisation: home locality, surrounding localities, conurbation center (Lyon and Villeurbanne), and other neighbourhoods. For each individual, a weekly visitation rate of each type of activity-location category is defined, prorated to the number of trip ends for a particular type of activity.

An initial test of category visitation by the 542 individuals, whatever the activity, gives a non-significant result with regard to the impact of types of residential mobility on these visitations. In order to take into account the structuring effect of jobs on visitations from a spatial point of view, we separated employed and non-employed subjects. For both categories, tests remain non-significant and this holds true, whether overall activity or simply non-work-related activity is considered for the employed individual. Therefore, we can conclude that the observed visitation of different types of activity locations is also unaffected by residential-mobility processes in our surveyed population.

Activities Carried Out

Do residential-mobility processes induce differences in activity patterns? Or, if these processes are related to desired lifestyles, should we not be able to verify this with the aid of activities, more particularly with those that are not mandatory? We therefore excluded jobs and shopping, and focused on serve-passenger activities, which may be taken as an indicator of children's activities, and on leisure activities as an indicator of various forms of sociability.

When analyzing non-employed and employed subject serve-passenger activities separately (including those carried out during trips between home and workplace), there are no significant differences between types of residential mobility. However, if serve-passenger activities during the commute to and from work are analysed separately from the other serve-passenger activities of *employed* subjects, significant differences according to residential-mobility category can be found only in the case of the non-commuting serve-passenger activities. Employed subjects from the "Avoidance-for-the-Sake-of-the-Children" group (of Table 1) are those who do the most chauffering (2.54), followed by those from the "In-Favor-of-a-Country-House" group (1.89). *The behaviour of both of these groups clearly demonstrates an attitude of withdrawal into the family unit, where children are highly valued and cared for.* At the other extreme are found the employed subjects of the "Social-Ladder" group, who do not appear to take part in any kind of chauffering (0.43) and, to a lesser degree, those of the "Financial-Avoidance" group (1.02), for whom financial constraints seem to

imply a low level of childcare activity. Therefore, while specific expectations of raising children may exist within the outward-move framework, they account only marginally for the number of specific non-commuting serve-passenger activities made by employed subjects.

Analysis of leisure activities taken as a whole, whether for employed or non-employed subjects, also shows no significant effects. Such pastimes cover quite different types of activities: sport, culture, family visits, calls on friends, walking, etc. If these activities are then analysed in detail, there are still no significant differences between non-employed subjects presenting different residential-mobility profiles. On the other hand, differences are found among employed subjects in two activity types: family visits and cultural activities.

Table 1
Number of Non-Work-Related Serve-Passenger Activities Outside Job Context and Free Weekly Activities by Active Subjects Per Type of Residential Mobility

Group	Size	Nonwork Accomp		Calls on Family		Cultural Activities	
		MV*	SD*	MV	SD	MV	SD
Social Ladder	21	0.43	1.39	1.45	2.14	0.35	1.07
Family Conformity	39	1.22	1.87	1.50	1.44	0.08	0.20
Country House	45	1.89	2.95	0.82	0.94	0.14	0.40
Financial Avoidance	55	1.02	2.20	0.72	0.95	0.14	0.25
Avoidance f.s.o. children	23	2.54	2.97	0.63	0.56	0.19	0.41
New way of life	33	1.71	2.08	0.70	1.00	0.02	0.06
New dwelling norm	171	1.53	2.26	0.95	1.38	0.08	0.22
Under influence	31	1.26	1.62	0.80	0.97	0.10	0.22
Total	418	1.47	2.30	0.93	1.28	0.11	0.35
Value F(df<7.410>)		2.04		2.26		2.29	

* MV = Mean Value, SD = Standard Deviation

The two "controlled-residential-mobility" groups, (i.e., the "Family-Conformity" and "Social-Ladder" groups) are those that generally call most frequently on the family (1.45 and 1.50), and appear to be the most involved in family life. On the other hand, family visits are less frequent with dependent residential-mobility categories, in particular the "Social-Avoidance-for-the-Sake-of-the-Children" (0.63), "Financial-Avoidance" (0.72), and "New-Way-of-Life" (0.70) groups. Their flight from the city is accompanied by somewhat loose family ties. Last, with regard to cultural activities, the "Social-Ladder" controlled-mobility model would seem the most involved on average (0.35), in spite of a very high standard deviation, whereas the "New-Way-of-Life" group, shows a lack of interest (0.02).

Very Loose Ties, etc.

These results confirm the almost total absence of any daily-mobility behavioural pattern tied in directly with residential-mobility processes. No link with trip rates or spatial visitation appears. Higher serve-passenger rates, associated with the logic of the social control of children, are evidenced on the part of employed subjects ("Social-Avoidance-for-the-Sake-of-the-Children" and "In-Favor-of-a-Country-House" groups). Lastly, a degree of conscious control of residential mobility seems to be linked to a high value for certain leisure activities.

MODES OF INTEGRATION IN THE NEW LOCALITY

In observing an almost total absence of direct ties between residential-mobility processes and daily-mobility patterns, should we conclude that there is no relationship between the two? We felt it might be interesting to check out an unexplored link in the residential-mobility chain, namely modes of integration in the new locality. The fact is that not all migrants integrate into their new living setting in the same way or to the same degree. Two kinds of hypotheses can be formulated. First, integration may be influenced strongly by a number of decisive factors that led to the choice of the new locality: the knowledge the migrants may or may not have of the locality, and their expectations with regard to day-to-day family and social life. Moreover, a family's mode of integration may, in turn, influence the existence and quality of their relationship with their new living environment.

Method of Analysis

We identified these modes of integration from analyses of impressions collected in groups of items from surveyed parents on the following three aspects of their lives at this time:

- Their relationship to the home zone, i.e., with the dwelling and its possible extension, the garden, which rather comes down to a notion of the use of space that is exclusively family in nature.

- Their relationship to space beyond the dwelling with both collective and symbolic uses: are these people "mobile," i.e., do they readily go outside their dwelling, or are they "sedentary?"

- Their family and social relationships, and relationships with friends, etc.

Typologies of these modes of integration were constructed in two stages. First, we created three typologies corresponding to each of these three modes of integration. A statistical combination of these typologies then enabled us to establish a classification made up of seven types of integration. We should specify that the types thus obtained do not express behavioural patterns but, rather, attitudes towards sociability and space relationships inside and outside the dwelling.

Types of Integration

Classification results reveal outstanding convergence among the seven types thus identified and their level of sociability, and this, in turn, enables us to place types under three major headings.

The new locality seen as an area of sociability

The three types within this category have in common a will to take part in the local scene, with or without development of interpersonal relationships.

"Socio-spatial integration" (22 percent of surveyed individuals)

These people show a high level of involvement in their locality, which is expressed both in personal ties with family and friends and in neighbour-to-neighbour contact and public relations. Everyone knows them and they have a feeling of contributing to the life of the locality. They are, evidently, more "mobile" than "sedentary," although one quarter consider their movements limited by a number of constraints. They frequent their current or previous home locality rather than going elsewhere. Lyon has little attraction for them, except for shopping.

"Finding one's roots" (13 percent)

Settling in a peri-urban area apparently corresponds to a return to a familiar setting. In fact, they know everyone in the area and have a number of longstanding friendly relationships. Coming back is above all an opportunity to reunite, establish personal ties, and settle back into the comfort of village life. However, disappointment is sometimes just around the corner, because the old inhabitants do not always live up

to expectations. "Mobile" subjects are the most numerous, and their mobility is usually voluntary, except for a minority, who are dissatisfied with a home life that leaves a taste of loneliness. This group has the fewest people trapped by economic or residential constraints. Strangely, only for a minority does the "return to one's roots" trigger increased commitment to local activities. The prevailing tendency is toward centrifugal mobility in the direction of locations other than Lyon or the former home locality, with which relationships are tenuous.

"Strategic integration" (15 percent)

Marked social involvement can be observed here, both in the locality and in the neighbourhood, expressed by interest in ongoing local activities, extensive acquaintance with the local population, and the existence of a solid neighbour network. However, this group's sociability is tepid and they evidence little availability for less superficial contacts. Moreover, their lack of social receptivity rarely makes them users of local amenities; they prefer to get away from their home neighbourhood, one quarter having held on to ties with the former home locality. As many "mobile" as "sedentary" people are found within this group.

The home seen as an area of sociability

This category's sociability is geared to making the private home the venue for family, friendly, or neighbourly relations.

"Home, sweet home" (12 percent).

This seems to result from settlement into an already familiar framework. Here, closeness to friends or longstanding acquaintances is sought. Sociability is expressed more by a need to rekindle old ties, than to make new friends or to take part in local public life. Such integration is accompanied by a focus on the house, which functions as a temple of conviviality. As a matter of taste, it is true that, this group's mood is more sedentary than tending to wanderlust, but may also be so by necessity, because they are the most affected by budget and time constraints. While the private zone plays a major role in their everyday lives, the same cannot be said for the neighbourhood zone. Services and goods are purchased elsewhere, one third of this group even maintaining very strong ties with their former home location.

"Strategic family retreat" (13 percent)

This group is characterized by very low-profile social involvement in the locality and neighbourhood. This "fencing" put up around the home is accompanied, however, by a focus on the family unit. In fact, the house becomes a venue for many relatives and friends. This focus on the house is not, however, synonymous with withdrawal; actually there are barely fewer "mobile" than "sedentary" persons in this group. The neighbourhood zone is rejected functionally, and activity goes on outside it. The

resulting centrifugal spatial behaviour applies only partially to Lyon; trips to the conurbation center are most often limited to a few specific purchases. In a word, the new locality is no more than a home base.

Withdrawal to the dwelling

Voluntary or imposed retreat is peculiar to those who live locked up in their homes, and who rarely entertain.

"Forced home withdrawal" (11 percent)

These are the "excluded," who did not succeed in their attempt to integrate into the locality. Although one half of these persons arrived with some will to be sociable, they felt rejected by the population. For this half, the house then became a place to which to withdraw, only to leave when strictly necessary. However, even the house can become a place where they do not feel comfortable and, from which they would like to get away. They have therefore become marginals, who in no way take part in village life. They go elsewhere to buy the goods and services they need. Those who most value an attachment to the former home locality and to Lyon are found in this group.

"Drop-outs, or withdrawal to the home" (13 percent)

These newcomers seem to use their house as a shelter, where they willingly stay, while no particular constraint would seem to prevent them from getting around. Unlike the previous group, these people seem to want things that way. The house and its living space are appreciated, while not becoming a new venue for socializing that is preferred over public venues. In fact, relatives or friends are not invited home. They just seem to live here, with no particular ties to other people, or places. They do not go to the village, or have any particular contacts with Lyon or the former home base. Their living space belongs to the realm of "Nowhere-in-Particular."

Links between modes of integration and residential mobility

The analysis of modes of integration reveals a very widespread wish to be socially receptive. The dwelling zone appears to play a non-negligible role in sociability. The new locality is seen more as a relational than as a functional investment. Are these observations significant enough for us to evoke residential-mobility processes as an influence on integration modes? Could there, then, be some tie, mediated by integration processes, between residential and daily-mobility? Statistical analysis of the possible link between residential-mobility profiles and modes of integration reveals an almost total lack of correlation or, at best, wide dispersion across the groups[h]. There

[h] Chi-squared test on eigen values obtained by factorial analysis of contingency table crossing persons' classification under types of residential mobility and types of integration.

appears, in fact, to be a relative lack of relationship between moving-out processes and effective integration within the new setting.

MODES OF INTEGRATION AND EVERYDAY MOBILITY BEHAVIOUR

Could household modes of integration induce differentiated daily-mobility patterns? We explored this possibility with the help of various statistical tests of associations between mobility parameters (trip rates, frequented zones, and activities carried out) and classification of individuals according to modes of integration.

Modes of Integration and Trip Rate

An initial test on the 582 individuals characterized by their mode of integration reveals that there are no significant differences, with respect to these modes of integration, with regard to daily trip rates, overall activity being taken into account[i]. On the other hand, differences are very marked when considering only non-work mobility in the strictest sense (free activities + purchases + non-work serve-passenger).

Table 2 brings into clear view the two groups with the highest mean rate of non-work trips, i.e., those evidencing community sociability, the "Return-to-Base" and "Socio-spatial-Integration" groups. At the other end of the scale, with a lower mobility rate, are found the withdrawal groups: "Drop-outs," "Strategic-Family-Retreat," and "Forced-Home-Withdrawal." The two contradictory community-involvement and withdrawal logics are therefore clearly shown to have different levels of trip rates.

The distinction introduced between employed and non-employed subjects, in order to take into account the structuring effect of work activity, enhances the analysis. It is confirmed that there are no marked differences in trip rates depending on modes of integration as far as active subjects are concerned and when no activities are ruled out, whereas *significant differences* are to be found with regard to *non-work trips*, with the same conclusions as above, although the effects are weaker[j]. Conversely, differences among modes of integration of the non-employed subjects do not induce significant differences in trip rates. Thus, only employed subjects provide an obvious tie between modes of integration and daily trip rates, when the leveling-off effect of their jobs is disregarded.

[i] $F(df<6.575>) = 1.11$

[j] $F(df<6.441>) = 2.99.$

Table 2
Integration Modes and Non-Professional Trip Rates
(Number of Weekly Trips)

Groups	Size	Mean	Standard Deviation
Socio-spatial Integration	130	16.18	9.94
Return to base	74	16.46	9.63
Strategic integration	89	13.38	9.10
Home, sweet home	72	13.55	7.81
Strategic family retreat	78	13.11	8.53
Forced home withdrawal	63	13.17	9.04
Drop-outs	76	10.73	7.65
Total	582	14.01	9.15
F(df<6.575>)		4.16	

Modes of Integration and Frequented Zones

Feelings expressed by the surveyed population on their modes of integration into the new locality should be supported by their activity spaces and travel patterns. A series of tests were carried out, with a distinction between non-employed and employed subjects and, with regard to the latter, between overall activities and those excluding work-related activities. These tests show that the modes of integration of *inactive subjects* are not associated with significantly different spatial patterns; this raises a question to which we shall return. On the other hand, *employed subjects* show some markedly different spatial patterns outside the work setting, depending on their modes of integration: such is the case with the visitation of the home locality and of surrounding localities, as shown in Table 3.

Table 3
Weekly Zone Visitation by Active Subjects, Excluding the Professional Setting and According to Integration Modes

Visitation of Groups (active)		Activities (excl. professional)				
		Home locality		Sorrounding localities		Home/ Surrou- ndings
	Size	Mean	SD*	Mean	SD*	Ratio of Means
Socio-spatial integration	87	5.69	5.23	0.96	1.35	6
Return to base	55	4.23	4.87	2.06	2.14	2
Strategic Integration	78	5.00	5.02	1.19	1.42	4
Home, sweet home	60	3.83	3.65	1.94	2.60	2
Strategic family retreat	59	3.41	3.69	1.87	2.79	2
Forced home withdrawal	41	2.46	3.37	1.53	2.13	2
Drop-outs	61	3.87	4.67	1.25	1.90	3
Total	441	4.28	4.63	1.49	2.08	2.9
F(df<6.440>)		3.34		2.89		

SD = Standard Deviation

Results in this table show outstanding conformity between opinions expressed by surveyed subjects on their integration as described in the preceding section and observed behavioural patterns[k]. When studying home-locality visitation rates, it can be seen that the groups oriented towards community sociability are at the top of the list. These are, in order, the "Socio-spatial-Integration," "Strategic-Integration," and "Finding-One's-Roots" groups. However, analysis of the home-locality/surrounding localities visitation ratio reveals a number of differences among these three groups. The "Socio-spatial-Integration" group clearly can be disassociated from the other two by its strong community involvement (ratio 6); it is followed by the "Strategic-Integration" group, investing in both its own locality and the surroundings (ratio 4). On the other hand, the "Finding-One's-Roots" group, while present in the home

[k] The questionnaire was devised in such a way that opinions on integration could in no way appear as an a posteriori justification of observed everyday mobility behaviour.

locality, is as readily active in surrounding localities (ratio 2). As far as groups characterized by some withdrawal to the dwelling are concerned, they have in common their tendency to seek elsewhere what is not considered satisfactory in the home locality (ratio 2 or 3).

Modes of Integration and Activity Patterns

Socio-spatial integration modes induce behavioural differences only marginally in non-work activities. From all analyzed activities, including shopping, home-workplace serve-passenger and serve-passenger outside this setting, and leisure activities studied in detail, we are able to identify such differences only in the field of serve-passenger activities outside the work setting and some leisure activities. Moreover, separate analysis of the behaviour of employed and non-employed subjects shows that these differences are accounted for solely by the behaviour of the employed subjects as shown in Table 4. Modes of integration do not induce significantly-differentiated activity behaviour on the part of non-employed subjects.

Table 4
Integration of Modes and Number of Active Subjects' Weekly Activity-Locations

| | | Free Activities | | | | | | Accompa- niments | |
| | | Culture | | Sport | | Calls on family | | Outside Home- Work | |
Groups	Size	MV	SD	MV	SD	MV	SD	MV	SD
Socio-spatial Integration	87	0.19	0.34	1.26	1.50	0.68	0.94	1.97	2.73
Return to base	55	0.23	0.71	1.13	1.60	0.96	1.39	2.08	2.68
Strategic integration	78	0.09	0.33	0.69	1.10	1	1.34	1.66	2.44
Home, sweet home	60	0.07	0.20	0.96	1.61	1.44	1.67	1.05	1.68
Strategic family with- drawal	59	0.05	0.16	0.82	1.47	0.95	1.28	0.76	1.53
Forced homeward re- treat	41	0.06	0.14	0.48	0.67	1.20	1.42	1.31	2.23
Drop-outs	61	0.07	0.21	0.71	1.45	0.79	0.86	0.99	1.66
Total	441	0.11	0.35	0.89	1.42	0.95	1.30	1.45	2.28
F(df<6.434>)		2.56		2.34		2.60		3.31	

Detailed analysis of leisure activities results in different group classifications depending on the nature of activities. With cultural activities and sport, two community integration groups, "Finding-One's-Roots" and "Socio-spatial-Integration" are at the top of the list. With regard to calls on relatives, the homeward retreat or withdrawal groups "Home-Sweet-Home" and "Forced-Homeward-Withdrawal," rank higher than the "Socio-spatial-Integration" group.

Lastly, non-work serve-passenger activities are more numerous in community-sociability modes ("Finding-One's-Roots," and "Socio-spatial-Integration"), representing the importance of children's activities. These are in contrast to the "Strategic-Family-Withdrawal" mode, within which children's outdoor activity is seen to be valued minimally.

Modes of Integration and Ways of Life: Clearer Ties

The way in which these peri-urban dwellers integrated their new location appears to have greater influence on their everyday way of life than the nature of the outward-move process, essentially as far as employed subjects are concerned. The fact that it is only rarely possible to identify statistically-significant links with regard to the non-employed group can, from our viewpoint, be attributed to the low number of subjects in the group (134 persons surveyed), whereas the number of employed subjects (450) makes it possible to do so more often, in spite of the wide dispersions observed.

Integration-mode differences are evidenced more in the number of trips and in zone visitation than in the nature of activity patterns. It is true that in this field some instability within groups can be observed, depending on the type of activity studied.

CONCLUSIONS

These various analyses tend to confirm the hypothesis put forward by a number of authors, namely that daily-mobility plans are not linked to residential mobility in the French peri-urbanization trend. Unlike people setting up home in a city context, families moving out to peripheral areas appear to have little concern when making their decision for the opportunities and constraints afforded by their new environment. Indeed, what is striking is the lack of information most families have on their future new locality, to which they "drift" more by market-abetted chance than by intentional purpose. What counts above all is interest in everything that has to do with the house, this being associated sometimes with a type of life setting. This interest is so strong, that it suppresses any ability to anticipate the effects of the home localization on their living conditions. Could the stakes be so high that people are prepared to pay the price in terms of everyday constraints and financial burdens?

On the other hand, the degree of integration felt within the locality definitely appears to play a role. It was possible to define this with employed subjects, with regard to non-work trip rates, non-work activity locations and, to a lesser extent, the nature of these activities. Differences in daily-mobility behavioural patterns depend not so much on whether it is the home or its surroundings that are more highly valued, but rather which subjects are socially involved in the community or at home, instead of retreating into their private space. These modes of integration seem to be largely independent of residential-mobility processes. They often bring out some lack of compliance between expectations nurtured at the time of migration and reality. There is nothing surprising about such an observation given that a majority of families were not in a position to choose their new home location, through lack of information and, above all, lack of adequate financial means.

It would seem that follow-up of families through residential-migration processes holds little promise for daily-mobility forecasting. On the other hand, the impact of the home location on daily-mobility is evident by way of assimilation processes, as has been observed elsewhere[9]. This confirms the benefits to be gained from focusing on housing trends rather than on migration phenomena when analysing the effects of home location on everyday mobility behaviour.

Last, the fact that the migrations of the households are characterized by rejection of the city rather than the pull of the countryside suggests that home-planning policies in urban areas that aim to avert deterioration of the social climate could slow the peri-urbanization trend and bring its negative effects on traffic conditions under control. In conclusion, these results suggest that home-localization econometric models should be based on parameters relating to house construction by the real-estate market and environmental social-qualification variables, rather than on the criteria used by families to select a home.

REFERENCES

1. Godard, X., J. P. Orfueil, "Mobilité, Usage de La Voiture et Structures Urbaines," Colloque de Royaumont, Transports et Société, April 26th & 27th, 1978, 285-301.

2. Andan, O., B. Faivre d'Arcier, C. Raux, J. M. Cusset, J. L. Routhier, "Mobilités Résidentielles, Activités et Espaces Fréquentés en Milieux Péri-urbains," Enquête en Périphérie de Lyon, Laboratoire d'Économie des Transports, Lyon, November 1989, p. 231 and appendices.

3. Andan, O., M. A. Bouisson, J. M. Cusset, J. L. Routier, A. Vant, "Mobilités et Espaces Péri-urbains," Analyse Bibliographique, Laboratoire d'Économie des Transports, Lyon, February 1988, p. 100.

4. Andan, O., B. Faivre d'Arcier, C. Raux, J. M. Cusset, "Transports et Modes de Vie des Ménages Péri-urbains," Laboratoire d'Économie des Transports, Lyon, May, 1991, p. 100.

5. Le Foll, Y., J. C. Meneau, J. M. Molina, "Étude Sur La Mobilité des Habitants de La Proche Banlieue Parisienne," RATP Synthesis, Paris, 1981.

6. Rujopakarn, W., "Comportements de Déplacements dans La Ville et Organisation des Sorties du Domicile," Thèse de Docteur-Ingénieur, Université Lumière-Lyon II, Lyon, July 1986, p. 161 and appendices.

7. Raux, C., "Modèles et Prévision de Comportements de Mobilité Quotidienne," Thèse de Docteur-Ingénieur, Université Lumière-Lyon II, November 1983, p. 209 and appendices.

8. DDE-SYTRAL, *Survey of Travel Patterns in the Conurbation of Lyon in 1986*, Cahier de l'Enquête Ménages-déplacements de Lyon # 1, DDE, Lyon, January 1987.

9. Andan, O., F. Askevis, C. Currat, B. Matalon, J. Poitevineau, S. Reichman, I. Salomon, "Mobilité et Espace Urbain, Etude Longitudinale des Comportements de Mobilité en Fonction d'un Changement de Résidence," Paris, Centre *Analyse de l'Espace*, Rapport pour le Ministère des Transports, Mission de la Recherche, Paris, September, 1984, p. 200.

3

Household Forms and Patterns of Mobility: The Case of the Montreal Metropolitan Area

Anne-Marie Séguin and Yves Bussière

Abstract

In this paper, we tried to test the role of two factors contributing to the explanation of the mobility patterns of adult men and women in the Montreal metropolitan area in 1987: the participation of women in paid work and the membership in a particular type of household. Our results show that when we divide adults according to working/non-working status, the mobility profiles of men and women are more similar and for some dimensions quite equal. This first factor proves to be very accurate. If we add a second level to the analysis and also distinguish adults by the type of household they live in, we find that many mobility parameters tend to be sensitive to the number of adults in each household, where the household is conceived as a pool of human resources able to share trips necessary to the household life and sensitive to the presence of minor children (dependent members in the household). However, our results for households comprising two adults show that some aspects of the patterns of mobility of men and women still reflect a traditional division of work in the family.

Introduction

The Montreal Metropolitan Area (MMA) had a population of 2.9 million in 1986, inhabiting a territory of 3,298 square kilometres with a diameter of approximately 60 kilometres. This ratio gives a population density of 879 persons per square km in the MMA, which reflects a model of urban development halfway between the agglomerations with a considerable sprawl of population and denser agglomerations. With regard to density, it would be comparable to Toronto or Boston. Montreal's urban form, more concentrated than that of most North American cities has induced higher rates of utilization of public transit than most American cities of similar size. The incidence of car ownership is slightly lower than in most North American cities but the

difference has tended to diminish considerably with the continuing growth of automobile use in the past decade.

The general demographic context of the MMA is one of slow growth. Thus, in 13 years, between 1974 and 1987, the population has grown 3.3 percent, which represents an annual growth of only 0.25 percent. The relatively stationary state of the population however, masks important structural changes: pronounced aging, growth in female participation rates in the labor force, changes in family forms, and diminution of the size of households. From 1971 to 1986, the percentage of the population aged 65 and over changed from 7.0 percent to 10.2 percent, the employment rate of women rose significantly, from 34.5 percent in 1971 to 47.1 percent in 1986, and the average size of households diminished significantly, from 3.15 to 2.57. These phenomena have had important repercussions on travel behaviour, for example, they substantially raised the level of mobility.

In the following pages, we give a brief review of the main tendencies in mobility during the period 1974-1987. We then show how the analysis of family forms brings a better understanding of recent travel behaviour. The analysis is based essentially on the 1987 origin-destination (O-D) survey data of the MMA. Even though this survey does not take family ties into account, we were able to construct a typology which gives a good approximation of the types of households involved. The analysis of the results presents the travel behaviours differentiated by gender and by type of household.

RECENT TRENDS IN MOBILITY: SOME FINDINGS

For the decade of the '70s many studies[1,2], including our empirical studies for the MMA, showed distinct mobility profiles according to gender, men generally displaying a higher mobility than women. In particular, men were seen to make more trips for work purposes, and women, less mobile, to make more trips for shopping purposes and "other" purposes (personal affairs, domestic reasons other than shopping, accompaniment, etc.). These results in a sense confirmed the existence of a division of tasks in the household on the basis of gender, with the men mainly responsible for going to work and the women for domestic tasks. From 1970 to 1980, many studies tried to refine analyses of male and female trips by taking into account essentially two dimensions: the participation of women in the labor force and the presence of children in the household. Some studies analyzed the impact of the growth of female participation in the salaried labor force on the rise in the number of work trips, but few studies examined the impact of this phenomenon on the travel behaviour of members of the household taken as a whole[3]. In a study based on data of 1968, McGinnis[4]

concludes that the number of trips taken by males was almost unmodified by the participation of their spouses in the labor market, but that the travel behaviour of the women who worked was substantially modified to resemble that of the male pattern, notably because of the reduction of the number of trips for purposes other than work. In the case of Toronto, Michelson has shown not only that women who worked had a mobility index much higher than that of other women but also that their mobility profile was quite similar to that of men[5]. But he adds[6], with regard to Toronto, based on a survey of 1980, that:

> *"Husbands of women with full-time jobs participated in more household activities than other males in the sample, but in no way approached equality in household division of labor."*

In the same line of thought, McGinnis makes the assumption that when women work we may observe the occurrence of a new sharing of trips linked to domestic tasks between women and other members of the household.

Between 1974 and 1987 in the MMA, the rate of mobility per capita (defined as the average per capita daily unidirectional trips from Monday to Friday, that is, excluding the return-to-home trips) has risen by 31 percent[7]. However, 58 percent of this growth rate is attributable to the increased mobility of women which was much larger than that of men (41 percent vs. 24 percent). This marked increase in the female growth rate has led to a reduction in the differences in mobility between men and women in the MMA (Table 1). In 1974, the masculine index of global mobility was 1.04 trips per capita and the feminine index was only 0.85; the difference between indices was quite significant. In 1987, men had an average mobility index of 1.29 and women of 1.16. The difference, therefore, diminished considerably during that period, as shown by

Table 1

Indices of Total Mobility (Unidirectional Trips) by Sex, MMA, 1974 and 1987

	1974	1987
Men	1.04	1.29
Women	0.85	1.16
Ratio M/W	1.22	1.11

Source: Derived from O-D surveys of the MUCTS, data corrected for constant definition, from Séguin and Bussiére, 1990.

Table 2

Rate of Growth of the Average Mobility Index by Purpose, Men and Women, MMA, from 1974 to 1987 (percent)

	Work	Study	Leisure	Shopping	Other	Total
Men	5.8	-19.4	122.0	129.0	126.9	24.0
Women	34.2	-12.5	138.1	53.3	116.8	41.5
Total	15.3	-16.0	128.3	73.4	123.0	31.2

Source: Derived from O-D surveys of the MUCTS, data corrected for constant definition, from Séguin et Bussière, 1990.

the ratio of men to women which changed from 1.22 in 1974 to only 1.11 in 1987. The reduction of differences between the feminine and masculine indices of mobility between 1974 and 1987 is largely due to the rise in work trips which reflects the growth in the participation rate of women in the labor force and is due, to a lesser extent, to a greater increase in the number of leisure trips of women in comparison to that of men (Table 2). Furthermore, the rate of growth of the average mobility index for shopping and other purposes is high for both men and women but comparatively higher for men, especially for shopping purposes. These tendencies, observed during the period 1974-1987, show an erosion in the gender differentiation of mobility behaviour.

At this stage we can formulate two hypotheses to explain these changes in behaviour. We would be inclined to link the entry of women into the labor force with the commodification of the products and services of the domestic sphere. This commodification would modify the consumption habits of households, which would in turn bring a significant augmentation in the number of trips for leisure, shopping, and other purposes. This hypothesis must however be refined. For example, Skinner and Bourlaug[8] have shown the link between employment and the diminution of shopping trips, a link that can very well be applied to other types of trips, working persons being forced by lack of time to optimize their trip patterns.

In addition we must also ask ourselves how the employment of women has affected the way members of a household share domestic tasks. This leads us to formulate our second hypothesis: when women work outside the home, the number of differences of profile between men and women should have a tendency to diminish due to a reformulation of domestic roles[9]. This has been proven to be the case by Kostyniuk and Kitamura[10] who found that men, who more often than women own a car,

participate in the domestic tasks, especially in households with young children, by taking in charge those who require trips such as shopping and accompaniment.

As for the choice of transportation mode, numerous studies have already shown that women use public transit more than men and that women are frequently car passengers. Men, on the other hand, make most of their trips as car drivers[11,12], even work trips[13,14]. According to Hanson and Hanson[15], women working full-time do not have more extensive use of the automobile than other women. In this regard, certain analyses insist on the phenomenon of public transportation's captivity of many categories of women[16]. However the situation seems to be changing. Indeed, a few studies show the progressive tendency of women to have better access to the automobile[17].

Our observations for Montreal go in that direction: the number of automobile trips is much higher for men (60.3 percent) than for women (35.0 percent). With regard to public transit the situation is the opposite with higher rates of utilization by women (25.7 percent) than by men (16.6 percent). With respect to the length of work trips, many studies have underlined the importance of the presence of children in the household to explain the travel differences observed. Many conclude that work trip distances are shorter for women[18,19,20,21]. Many authors explain this by the double task of women's work, divided as it is between the demands of career and household[22,23,24]. On this question Hanson and Johnston[25] write:

> *"Because women are socialized to view the work/career role as less important than the household-family role...they could be less willing to endure long journeys for what is considered a secondary role."*

Furthermore, for work trips, the more frequent use by women of public transit, which is slower than automobile driving, could explain why women live closer to their work. There is not, however, a consensus on this point. For example, for the Baltimore region, Hanson and Johnston[26] show that women work closer to home than men. However, these authors were unable to conclude that there is a relation between the distance of the women's work (either real distance or time distance) and the presence in the home of children under 16 years of age. It is emphasized in the study, however, that single women are those who have the shortest work-trip distances. Michelson[27] observes that, as a consequence of the local housing market, women who are single parents live farther from their places of work than married women. The results of Villeneuve and Rose[28] for the MMA suggest that the domestic tasks of women are now

less explanatory than other factors linked more directly to the labor market, such as revenue or the spatial distribution of employment.

Many studies insist on the presence of children in the household to explain differences in travel behaviour, an insistence that appears to us to be reductive. The whole question of belonging to a certain type of household cannot be explained by this single factor. Other factors must be considered, such as the presence of one or many adults in the household. Kostyniuk and Cleveland insist on the importance of considering the household as a social unit containing a pool of economic and human resources. For example, the adults living in households that consist of only one person or of a single parent should have a higher mobility rate. Furthermore, we could expect that the men and women of these households have similar mobility profiles for trips made for shopping and "other" purposes (as shown by average mobility indices) because all of these adults, male or female, must make a minimum number of utility trips essential to the functioning of the household. The growing importance of non-traditional households, the rise in the number of single parents and of young couples without children, etc. should have a significant effect on the general adult mobility profile: frequency, purposes, and modes. Still, few studies have given attention to this phenomenon.

Do men and women with similar working/non-working status but different types of household situations have similar profiles? Our main hypothesis is that the profiles are greatly influenced by two factors: the insertion or absence of insertion of the people into the labor market and their belonging to a specific type of household. Further-more, if we take into account these two factors, the number of differences of behaviour between females and males should be greatly reduced. The Montreal case study helps us to verify these hypotheses.

SOURCES OF DATA

The origin-destination survey of 1987 produced by the Montreal Urban Community Transport Society (MUTCS) during the fall of 1987 is the main source of data that we have used. The territory covered by the survey is very similar to that of the MMA as defined in the census by Statistics Canada. The telephone survey that covered 53,384 households, is a classic household origin-destination survey that records weekday trips of all members of the household. Each trip can be analyzed in association with different variables: characteristics of household (location, size), characteristics of the individual (age, sex), characteristics of each trip (hour, purpose, origin, destination), and other characteristics (car ownership, etc.).

The purposes of the trips are represented by five main categories: work, study, shopping, leisure, and "other" purposes. The first three categories have a clear definition but the other two are less definite. The category "leisure" refers to trips made for recreative or cultural reasons; and the category, "other" is a residual category and therefore less defined than the others. It comprises such trips as those made to the restaurant, the dentist, the notary, the day nursery, or even to dinner with a parent or friend. The last category is therefore quite large and tends to overlap with the others. In American studies this is often referred to as "trips for personal and social purposes."

Because the origin-destination survey does not investigate the participation rate, we had to construct that variable. The individuals who declared a work trip were considered as working and the others as non-working. We are conscious that this variable is imperfect because a certain proportion of the population may not have declared a work trip and may still be employed (part-time work, on holiday, sick, etc.). However, we think that globally this variable will give us a good approximation of the working-population travel behaviour.

Previous analyses of individual behaviour explain part of the travel-behaviour pattern in Montreal, particularly by taking into account age and sex differences[29]. However, those analyses do not take into account an essential dimension for a better comprehension of the phenomenon, that is, the interrelations of individuals' behaviours within the household structure. However, the origin-destination survey does not contain specific questions concerning the family links that would permit a direct reconstitution of the type of household. This has led us to elaborate a typology that would permit such an approximation. The methodology developed in this paper permits a reconstitution of the main forms of households with the origin-destination survey data. As we will see in the Montreal case, this approach permits us to give a better explanation of travel behaviour. All data presented in the following pages are calculated for adults only (18-64 years) from the MUTCS origin-destination survey of 1987, crossed with distance matrices of the Department of Transportation of Quebec for graphs 15 and 16.

THE TYPOLOGY

The origin-destination survey comprises a limited number of variables among which only two could be used to build our typology of households: age and sex of the individuals of each household.

We started with a typology of the most familiar forms of households. Then, with the help of different criteria retained from a certain number of studies, particularly those

of Hamel and others[30], we defined for each type of household a series of conditions for which the different types would have to qualify in order to be assimilated into a type of household. In this process of classification, two elements are essential: the notions of a couple and of membership in the same generation. These two conditions are explained in Table 3. An abridged typology is presented in Table 4.

Table 3
Elements of Definition of the Typology of Households

Type	Type of hh.	No. of Persons/household	No. of Adults/household	Opposite Sex	No. of Children ≤ 17 yrs.	(2 Generations) Gap > 15 yrs. Between Adults & Children	(2 Generatios of Adults) Gap > 15 yrs. Between Adults	Oldest Generation of Adults) Couple or not; Opposite Sex and Gap ≤ 15 yrs.	Approximation of Family Form
1	Single person	1	1						Single person
2	Male or female of same generation	2	2	Yes	0		No		Couple without child
3	Several adults without minor child	2 >2 >1	2 >2 >1	No	0 0 0		No No Yes]]	Co-renters of same generation Parents with major children only
4	One adult with minor children*	>1	1		≥1	Yes			Monoparental family with minor children only
5	Male & female with minor children	>2	2	Yes	≥1	Yes	No		Biparental family with minor children
6	One mature adult with minor & major children	>2	≥2		≥1	Yes	Yes	No	Monoparental family with minor & major children
7	Two mature adults with minor and major children	>3	≥3		≥1	Yes	Yes	Yes	Biparental family with minor & major children
8	Residual Category	--	--	--	--	--	--	--	Residual Category

* Children is understood as referring to one or more children

Table 4
Abridged Typology Approximating Household Types

Type 1- Single person without child

Type 2- Couple without child

Type 3- Several adults without minor child

Type 4- Monoparental adult with minor children*

Type 5- Biparental adults with minor children

Type 6- Monoparental adult with minor and major children**

Type 7- Biparental adults with minor and major children**

Type 8- Residual category

"Children" is understood as referring to one or more children.adults as primary caretakers of the
**In the present paper, to simplify the interpretation of the results, we have confined our analysis to the household, and have excluded the adult children in Household Types 6 and 7.

We do not elaborate here on the complex computer programs that had to be constructed to establish this typology. The relevant details would be much too technical for the purpose of the present paper. However, we give a certain number of essential clues to the elaboration of this typology. First, we define the minor child as any child of less than 18 years old and we define the adult as any person of 18 years and over. Second, the criterion of belonging to the same generation as other individuals in the household has been defined as a difference in age of 15 years or less between these individuals.

With these criteria, we can now examine the way in which we have defined each type of household as shown in Table 3. Type 1 is the simplest form of household, the only condition being the presence of a single person in the household. Type 2, the couple without child, has been defined as a household composed of two adults of opposite

sexes with a difference in age of less than a generation gap, that is, less than 16 years. This generation gap permits one to distinguish this category from other forms of households such as, for example, a single-parent household where the father would be 37 and the daughter 19. But this same household could very well be a couple with

a great age difference between spouses. Considering the wide variety of situations that we may encounter in households containing more than one adult, such as a brother and a sister, co-tenants without family links, a single-parent household with major children ("children" is understood as referring to one or more children), etc., we have created Type 3 (several adults without minor child). This is a more general type, that is, a household composed of adults only and which is quite distinct from Type 2 (couple without child). Type 4 approximates the household of a monoparental adult with minor child or children. In this type, we find one adult only and one or more minor children who must have a difference of 16 years or more with the only adult in the household. Type 5 (biparental adults with minor children) corresponds to the biparental family with minor children only; we find here two adults of opposite sexes, belonging to the same generation, with one or more children, all minors, and having a gap of 16 years or more with the two adults of the household. The two other types of households, Types 6 and 7, can be summarized as family households composed of minor and major children. Type 6 (monoparental adult with minor and major children) is a single-parent household; Type 7 (biparental adults with major and minor children) is a biparental household.

In these last two types, we encountered another difficulty: certain adults in the household could very well be major children in the household. To check this, we had to verify another condition, that is, the presence in the household of adults belonging to two different generations. In the case of Type 6, the oldest adult has a generation gap of 16 years and over with the second oldest adult. Therefore the oldest generation contains only one adult. The difference between Type 6 and Type 7 is that, in the latter, the oldest generation is composed of two adults of opposite sexes with an age difference of 15 years or less. Finally, Type 8 (residual category) is a residual category that includes households with many adults with children, but that cannot fit in the previous seven types. Type 9, as represented in the graphics, represents the total.

This typology has been closely tested with the aid of 1,000 households chosen randomly from the origin-destination survey sample. Given the type that had been attributed to each of these households by our computer program, we have scrutinized each case individually to ascertain whether classification made sense. In most of the cases, our classification has worked extremely well even though we were conscious of the limits of this methodology. For example, in Type 4, we were unable to attest that the adult is always the parent. However, in an analysis that is centered more on the roles of the individuals in the household than on kinship links, our typology remains an extremely useful tool of analysis.

To test our typology's capacity to approximate the types of households, we made a first comparison of the results of our typology with the 1986 census data as shown in Table 5. As we will see, this comparison gives us satisfying results, although we may note certain differences in specific categories of household, for various reasons.

A first source of bias may be attributed to the origin-destination survey sample itself. Households of single persons may very well be underestimated in a telephone survey, single persons being more often absent in the evening at the hours when the survey is done than, for example, adults in households with children. On the other hand, single parents with children may be less inclined to answer such a survey than couples, due to a lack of time — single parents having the entire responsibility of the household tasks.

A second source of bias lies in the definitions of our typology as compared with those of the census. For example, according to our definition, the single-parent household must have at least one minor child at home, which is not the case with the definition of the census. Thus, according to our definition, a mother aged 64 years who lives with her 30-year-old daughter, would be classified in the Type 3 household (several adults without minor child), whereas the census would classify the 64-year-old as a single parent. This explains, at least partially, our under-representation of single-parent households. Biparental households are also underestimated for the same reason, although when they do not include minor children, they are also classified as Type 3.

To establish the comparison with the census data (Table 5), we have divided Group 3 into two sub-groups: households composed of adults of the same generation only and others. To take into account the differences between the definition of the census and that of our typology, we have isolated in Type 3 the households where we observe a generation gap between adults. We have reallocated two other categories: 40 percent of Type 3b was reallocated to Types 4 and 6 (single parents) which are grouped together in the census, and another 40 percent of Type 3b was reallocated to Types 5 and 7. Finally, the remaining 20 percent of Type 3b was reallocated to what the census classifies as non-family households. After these reallocations were made, as shown in Table 5, the proportions of each family type observed in our study based on the origin-survey data were seen as being very similar to those observed in the census. The typology we have elaborated seems, therefore, capable of satisfactorily approximating different household forms.

Table 5

Distribution of Households in Our Study Compared to Those of the Census, MMA, in Percent

1986 CENSUS			OUR STUDY (1987)		
Our typo-logy	Category		Category	Without re-allocation of type 3b	With realloca-tion of type 3b
1	Households of one person	25.2	Single person without child (1a, 1b, 1c)	21.8	
2	Families husband-wife without children at home	22.8	Couple without child (2a)	25.9	
5,7	Families husband-wife with children at home	36.2	Couple without children (8a, 9a, 10a)	22.9 4.2	22.9 4.2
			Couple with minor and major children (12a, 12b, 12c)	—	6.0
			* Reallocation of 40 percent of type 3b	27.1	33.1
4,6	Single parent families with children at home	11.1	Monoparental adult with children (5a, 6a, 7a)	3.6	3.6
			Monoparental adult with minor and major children (11a, 11b, 11c)	0.9	0.9
				—	6.0
			Reallocation of 40 percent of type 3b	4.5	10.5
3	Non-family households with several persons	5.4	Several adults of same generation (3a)	3.8	3.8
				—	3.0
			Reallocation of 20 percent of type 3b		6.8
3b	—	—	Several adults without generation gap without minor child (3b)*	15.1 *	
	—	—	Residual (13)	1.7	1.7
	Total	100.7		99.9	99.8

* Has been reallocated in the last column of the table to permit the comparison.
Source: Statistics Canada (January 1988), cat. 95–129.

RESULTS

Total Mobility

The first striking finding of our study is that the global index of mobility for men is almost equal to that of women when we consider only working adults. Measured in per capita unidirectional trips in 1987, the index was 1.56 for men and slightly higher for women (1.59), as shown in Table 6. This statistic confirms the hypothesis of McGinnis that gender differences in mobility are due mostly to working/non-working status and therefore that working women would have a global mobility almost identical to that of men.

When we desegregate by type of household, we observe few gender differences for a given type of household, as shown in Figure 1. We observe, however, that adult men

Table 6
Per Capita Mobility of Working Adults (18-64 Years), MMA, 1987

Men	1.56
Women	1.59
Ratio M/W	0.98

Source: Derived from O-D surveys of the MUCTS, data corrected for constant definition

and women who live alone with children under 18 years old (Type 4) are those with the highest mobility rate (2.07 for men and 2.01 for women): this higher mobility rate explained by the fact that, in this category, the working adult bears the entire responsibility for the functioning of the household. The second highest mobility rate is that of working women in households comprising couples with young children (Type 5); these women have a mobility rate of 1.77 compared to 1.64 for their male counterparts. In third position are persons living alone (Type 1). Because these persons have to count only on themselves for domestic tasks, their mobility rate is quite high (1.72 for men and 1.70 for women). These observations confirm those made by Kostyniuk and Cleveland (1978) that a household contains a pool of persons

for certain tasks and that it is, therefore, important to consider the household to understand travel behaviour.

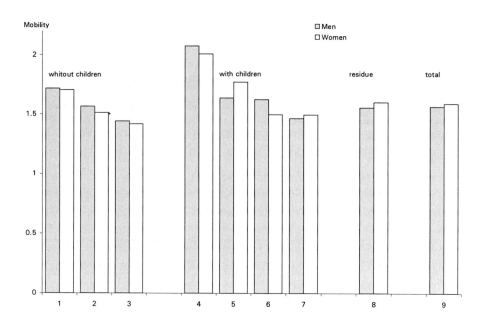

Figure 1
Total Mobility of Working Adults, 18-64 Years, by Sex, by Type of Household, O-D Survey 1987

The mobility rate of non-working adults is much lower than that of working adults, as we can see at first glance comparing Figures 1 and 2. However, if we compare themobility rate for all purposes except work, we observe that the index is clearly higher for the non-working adults, as we can see in Table 7. This finding would tend to confirm the hypothesis that people who work have a tendency to optimize their trip patterns.

Table 7
Total Mobility for Purposes Other than Work, for Working and Non-Working Adults, 18-64 Years, by Gender, MMA, 1987

	Working	Non-working
Men	0.674	0.938
Women	0.530	0.944

Source : Derived from O-D surveys of the MUCTS, data corrected for constant definition, from Séguin et Bussière, 1990

If we now compare the global mobility rate of non-working men (0.938) with that of women (0.944), they appear very similar. A comparison by household types shows that in households without children, the mobility of men is always greater than that of women. In households with children, the pattern is less clear. In the case of working adults, men have a higher mobility than women in Type 4 (monoparental adult with minor children) and Type 6 (monoparental adult with minor and major children) households. In the case of non-working adults, the mobility of men is higher in Type 4, but, in all other types of households with children, the mobility of women surpasses that of men. Would this reflect the persistence of a traditional division of tasks within households with children?

From the general form of Figures 1 and 2 we can say that two factors clearly affect the pattern of mobility by household type for both working and non-working adults: first, the smaller the number of adults in the household, the higher the mobility rate; single persons definitely have a higher mobility rate than several adults living in the same household. Second, the presence of minor children in the household increases the mobility rate of the adults as primary caretakers of the household.

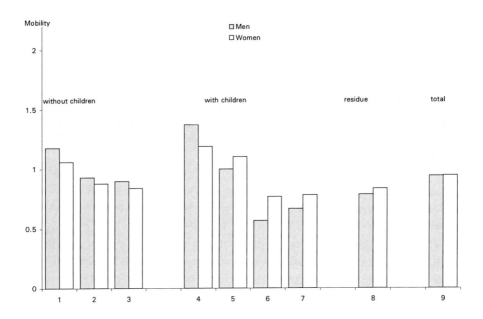

Figure 2
Total Mobility of Non-Working Adults, 18-64 Years, by Sex, by Type of Household, MMA, O-D Survey 1987

Shopping Mobility

In general, working women make many more trips for shopping purposes than do working men (mobility rate of 0.14 vs. 0.10). This pattern is compatible with the traditional gender division of domestic tasks with one exception: households containing female single parents with minor and major children (Type 6). We might

think that, in this type of household, major children make a certain number of utilitarian shopping trips. The greatest number of shopping trips is made by women living alone (Type 1), followed by women in families of two adults with minor children (Type 5). The frequency of shopping trips by working males is highest for men with children (Types 4 and 6), followed by single men living alone without children (Type 1). In Types 1 and 4, there cannot be a gender division of trips and men must make the utilitarian trips for the household. Working women with the lowest mobility indices include the women living with other adults (Type 3) and those women living alone with minor and major children (Type 6). In these cases we can suppose that certain trips are shared with other adults thanks to the pool of adults in the household.

Non-working adults have a much higher mobility rate for shopping purposes than working adults, both men and women. Here also, the women are more mobile than men (rates of 0.37 and 0.26, respectively). As for the variations according to the type of household, the pattern observed is similar to that of working adults. Again, it is the women living in households composed of adults (Type 3) or women living alone with minor and major children (Type 6) who have the lowest mobility indices. For non-working men the situation is similar. We find the lowest mobility rate in households composed of adults only (Type 3) and in households composed of men living alone with minor and major children (Type 6). The high mobility rate of men living in couples without children (Type 2) and those living in biparental households with minor children (Type 5) could reflect the type of household in which the female spouse works and the non-working male takes charge of some of the domestic tasks, for example, shopping.

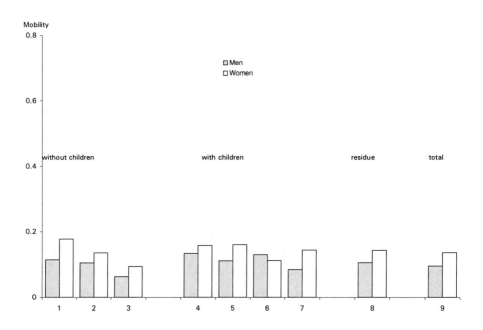

Figure 3
Mobility for Shopping Purposes, Working Adults, 18-64 Years, by Sex, by
Type of Household, MMA, O-D Survey 1987

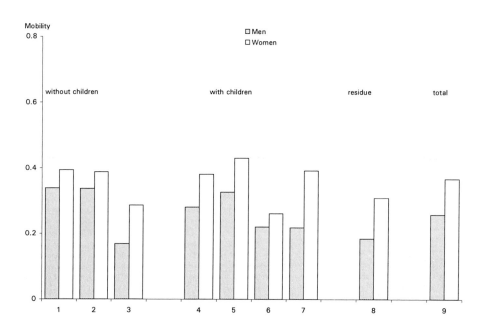

Figure 4
Mobility for Shopping Purposes, Non-Working Adults, 18-64 Years, by Sex, by Type of Household, MMA, O-D Survey 1987

Leisu

We observe equal rates of mobility for leisure purposes for working men and women. The very high leisure-mobility rate of adults living alone is worth noting because it

confirms the widespread idea of the importance of leisure outside the home for persons living alone. For non-working adults, non-working men show indices generally much higher than those of women. More specifically, two types of households are quite distinctive: men living alone (Type 1) and single men with young children (Type 4) each have a mobility index of over 0.25.

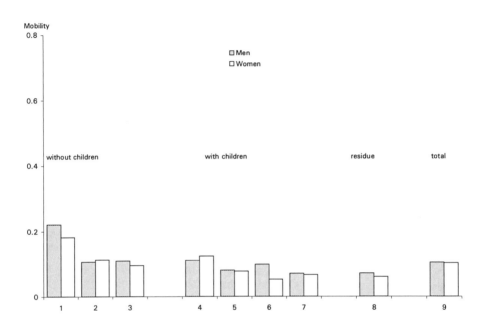

Figure 5

Mobility for Leisure Purposes, Working Adults, 18-64 Years, by Sex, by Type of Household, MMA, O-D Survey 1987

The isolation in the home of these adults probably explains these high indices. Women of these households (Types 1 and 4) show a lower mobility index than men and we could conclude that leisure inside the home is more frequent for women than

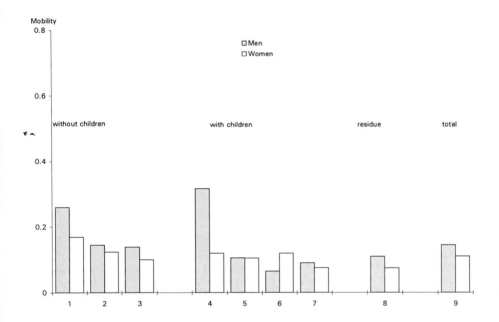

Figure 6
Mobility for Leisure Purposes, Non-Working Adults, 18-64 Years, by Type of Household, MMA, O-D Survey 1987

for men. Here we can cite differences in the socialization process of young girls and young boys, these differences having the consequence that girls and, later in the life cycle, grown women are more attached to the household interior.

Mobility for Other Pu

For all the "other" purposes, which can be referred to, as we have seen, as trips for personal and social purposes, the first striking observation (as shown in Figures 7 and 8) is the great similarity of mobility indices between working men and women

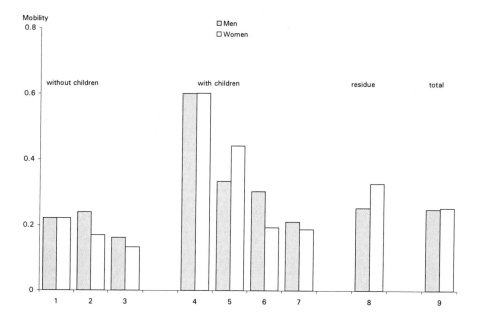

Figure 7
Mobility for "Other" Purposes, Working Adults, 18-64 Years, by Sex, by Type of Household, MMA, O-D Survey 1987

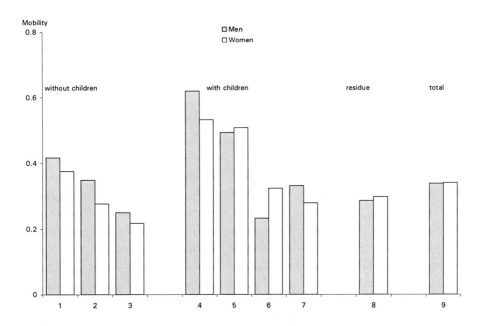

Figure 8
Mobility for "Other" Purposes, Non-Working Adults, 18-64 Years, by Sex,
by Type of Household, MMA, O-D Survey 1987

mobility of 0.25 for both men and women). Second, we observe significant differences by gender for some types of households (Types 2, 5, and 6). Third, we observe a high incidence of trips for "other" purposes for men and women who are single parents with minor children (Type 4) and parents in biparental households with young children

(Type 5). The higher mobility of women in biparental households with minor children seems to show the higher frequency of accompanying trips made by women such as taking the child to school, nursery, etc.

For non-working men and women, the mobility index is slightly higher than for those who work. The presence of minor children without the presence of major children considerably raises the mobility rate of non-working adults, as it did for working adults. The pattern of mobility according to household type for "other" purposes follows the clear general pattern linked to the presence of one or more adults and the presence of minor children. The mobility rate is high for single persons and even higher for single persons with minor children. The rate declines in relation to the increasing number of adults in the household. This category of "other" purposes groups many utilitarian trips that are shared when the household contains two or several adults.

Car Ownership

The rate of automobile ownership for working men is extremely stable, around 80 percent (as shown in Figure 9), in most family household types except for two groups: men living alone (Type 1: 70 percent) and men living with other adults (Type 3: 73 percent). These people are possibly co-renters or adults still economically dependent on their parents. What is surprising, in the case of working women, is the high car ownership for women who live alone (Type 1: 51 percent) and for those who are single parents (Types 4 and 6: 63 percent and 64 percent). In these types of households where the woman is the only adult, the high ownership rate reflects the fact that it is difficult, in a large agglomeration like Montreal, to go without a car.

In the case of non-working adults, the situation is much more complex as shown in Figure 10. First, the rate of ownership is much lower for both sexes in comparison to that observed for the working adults, especially for women. This rate is 56 percent for men (compared to 81 percent for working men) and 25 percent for women (compared to 45 percent for working women). Second, we observe very high rates for men in biparental households with minor and major children (Type 6: 80 percent). The lowest rates for non-working men are observed in men living alone, men living in households composed of adults only, and single parents with young children. For non-working women, we observe fewer variations in the car-ownership rate according to household type. However, women living in couples without children (Type 2: 23 percent) or in households composed only of several adults (Type 3) show very low

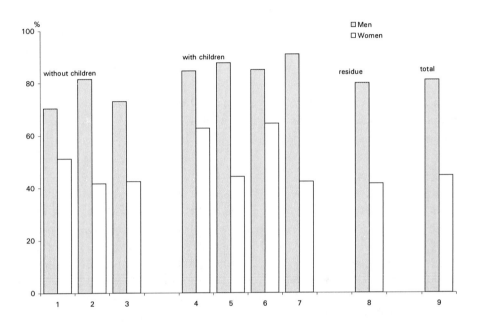

Figure 9
**Car Ownership of Working Adults, 18-64 Years, by Sex, Type of House-
hold (in percent), MMA, O-D Survey**

rates. Generally, we could say that car-ownership is closely linked to the actuality or
absence of employment, this relation being less true for men than for women.

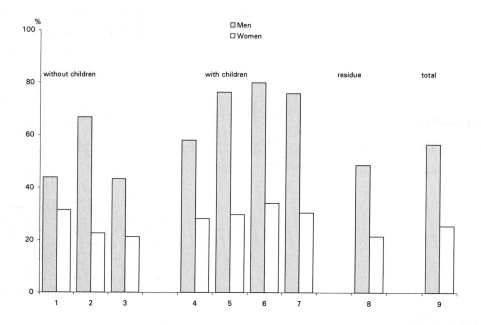

Figure 10
**Car Ownership of Non-Working Adults, 18-64 Years, by Sex, Type of
Household (in percent), MMA, O-D Survey 1987**

Mode Use - General Pattern

We observe that men are globally much more frequent car drivers than women, this higher rate reflecting most certainly the previously mentioned car-ownership rates. Working men make 78 percent of their trips as car drivers compared to only 48 percent for women (see Figure 11). For non-working adults, the rates, as shown in Figure 12, fall considerably for men (59 percent) and somewhat less for women (42 percent) thus reducing the gap between the profiles of men and women. For urban transit, working men are much less frequent users (13 percent) than women (28

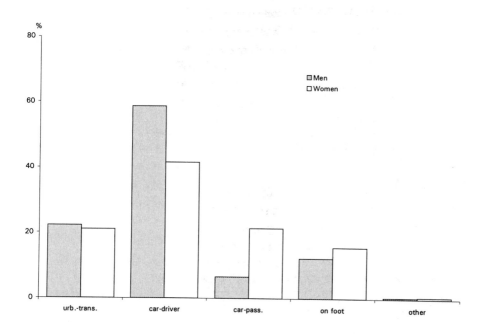

Figure 11
Mode Use, for Non-Working Adults, 18-64 Years, by Sex, All Types of Households, MMA, O-D Survey 1987

percent). For non-working adults, the differences according to gender are considerably diminished. These global trends, however, mask great differences according to household types. We present the results for urban transit.

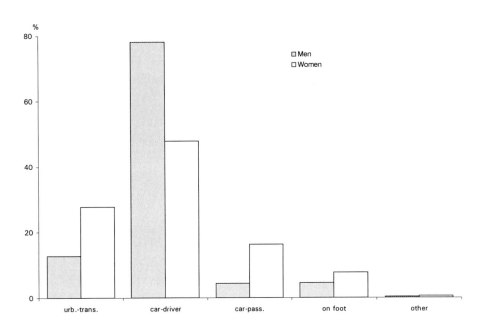

Figure 12

Mode Use, for Working Adults, 18-64 Years, by Sex, All Types of Households, MMA, O-D Survey 1987

Use of Public Transit

The utilization rate of public transit is much higher for working women than for working men (28 percent vs. 13 percent as shown in Figure 13). Whatever the type of household, this pattern remains. For working men, the highest transit users are those living alone (Type 1: 23 percent) and, to a lesser extent, those living with other adults (Type 3: 18 percent). For working women, the highest rates for public transport are also encountered in women living alone (Type 1: 36 percent) and for those living

in households of a few adults (Type 3: 36 percent). The result of Type 1 may be surprising, taking into account the high car-ownership rate of women living alone (51 percent). For other types of households where the rate of car ownership of women is lower, the rate of transit utilization is also lower, possibly due to the fact that women who live in households where there is a car may still use the car even though they do not own it.

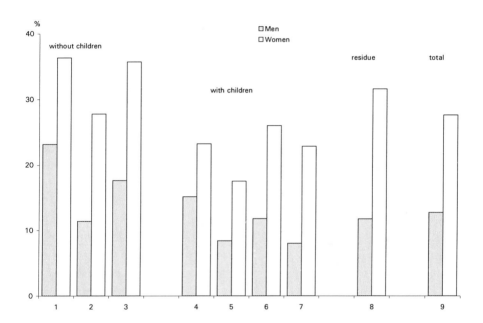

Figure 13
Use of Urban Transit, for Working Adults, 18-64 Years, by Sex, by Type of Household, MMA, O-D Survey 1987

For non-working adults, the global rates of utilization of public transit, as shown in Figure 14, are almost identical for men and women (22 percent vs. 21 percent), and the gender differences observed within each type of household are much lower than the differences observed for working adults (except in Type 6). It may seem surprising that the global rate for non-working men is slightly higher than that for women even though the rates observed are higher for women than for men in each category. This is due to a composition effect, namely that 38 percent of the total

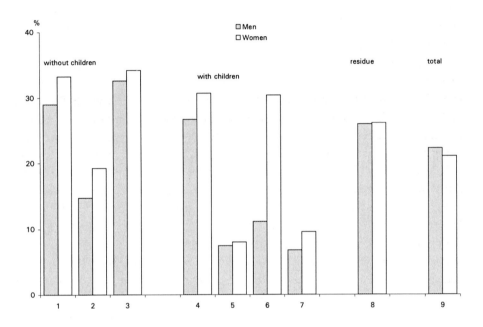

Figure 14
Use of Urban Transit, for Non-Working Adults, 18-64 Years, by Sex, by
Type of Household, MMA, O-D Survey 1987

number of trips of non-working men come from households of Type 3 (several adults without minor child), a category including students who are strong users of public transit. Since the non-working men are fewer than non-working women, Type 3 has a stronger weight in the total for men than that of women; thus it tends to raise the global rate of public transit for men.

Work Distance

Globally distances in kilometres traveled to work by men are higher than those of women (16 km vs. 11 km). In all types of households, men travel farther than women (Figure 15). We observe variations, however, in distances according to the household types, the pattern trend linked to household types being similar for both men and women. The home-work distance traveled by each individual rises with the number of adults in the household (from one to two adults) and with the presence of minor children. The working adults of households which rely on one adult only (Types 1, 4) are those adults who live closest to their place of work due to their freedom to make an individual home-work adjustment without having to compromise with another adult in the household. In households where two or more adults are present, the choice of residence must often be a compromise between two or more work locations. This factor would influence home-work distance. Another factor which would tend to reduce home-work distance for households of single parents and persons living alone is that these households are likely to represent tenants, because of the lower (single) revenue of the household, a factor which would facilitate the home-work adjustment. However, a fact worth underlining is that female single parents with minor children (Type 4) work farther from home than women living alone. This fact could apparently contradict the thesis that women with young children work close to home because of their familial responsibilities. This could be explained by factors related to the housing market and by other location factors motivating the location of the household (choice of neighborhood, quality of life, presence of self-help networks).

As for the time distance (Figure 16), the differences observed between men and women are very small (32 minutes vs. 30 minutes). This can be explained partly by the stronger use of public transit by women. They make shorter trips but, when they use public transit, they take roughly the same time as men who travel farther to work but usually take the car. We note, however, that women living alone (Type 1) and single parents (Types 4 and 6) have a traveling time distance which is slightly shorter than other women. This fact is not surprising because their trips are made for shorter distances. For the latter (Types 4 and 6), we also observed a higher car ownership.

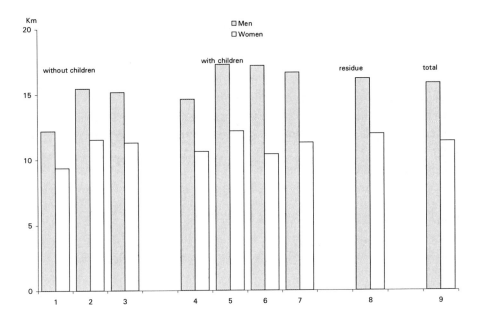

Figure 15
Average Home to Work Distance (in Kilometres), for Working Adults, 18-64 Years, by Sex, by Type of Household, MMA, O-D Survey 1987

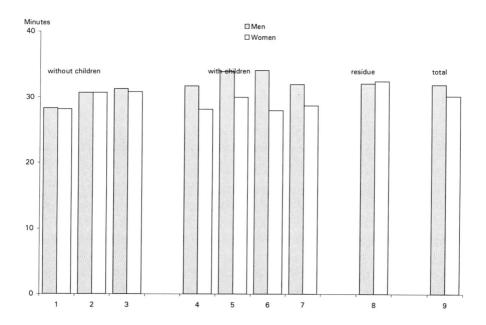

Figure 16
**Average Home to Work Distance (in Minutes), for Working Adults, 18-64
Years, by Sex, by Type of Household, MMA, O-D Survey 1987**

CONCLUSIONS

During the last decade or so, the general rate of mobility has risen considerably, particularly for women. We formulated the heuristic hypothesis that the working/non-working status and the membership to a particular type of household are the key determinants of the mobility behaviour of adults. To test the last part of the hypothesis, we have constructed a typology of households.

Our results show that if we divide adults by working/non-working status, the mobility profiles of men and women are similar, this similarity being greater for the working group. This confirms the hypothesis that part of the gender differences in mobility profiles is due to the working/non-working status. As for the type of household, we found that most of the mobility indices tend to be sensitive to the number of adults in each household and to the presence of young children. The household is then viewed as a pool of human resources able to share the trips necessary to the functioning of the household, the number of trips being closely linked to the presence of dependent members of the household (non adult children).

However, after taking into account the working/non-working status and the household types, we still observe differences between men and women even in households of one adult only. These differences reflect the distinct socialization processes of men and women. Also, for some aspects, such as mobility for shopping purposes, the differences show the persistence of a sexual division of tasks in the household of two adults.

Finally, a study of the dimensions of professional and ethnic origin, even though they were not incorporated in our analysis because of lack of data, could be useful for a still better understanding of mobility patterns, especially when combined with the type of household.

ACKNOWLEDGMENTS

The authors would like to thank: the Social Sciences and Humanities Research Council of Canada for its financial support; Mr. François Tessier, computer analyst at INRS-Urbanization for his indispensable aid in the programming of the typology; the MUCTS (Montreal Urban Community Transports Society) which gave us detailed data of various Origin-Destination Surveys; and the Department of Transportation of Quebec which gave us distance matrices.

REFERENCES

1. Michelson, W., *The impact of Changing Women's Roles on Transportation Needs and Usage*, Institute of Transportation Studies, University of California, Irvine, California, 1983.

2. Bussière, Y., R. Marcoux, and M. Tessier, *Analyse prospective de la demande de transport des personnes dans la région métropolitaine de Montréal, 1981-1996*. Montréal, INRS-Urbanization, "Etudes et documents," no 56, 152p, 1988.

3. Kostyniuk, L. P., and D. E. Cleveland, "Gender-role Identification in the Methodology of Transportation Planning," in S. Rosenbloom (ed.), 1978, 569-606.

4. McGinnis, R. G., "Influence of Employment and Children on Intra-Household Travel Behaviour," In S. Rosenbloom (ed.), 1978, 75-103.

5. Michelson, W., *op. cit.*

6. Michelson, W., *op. cit.*

7. Séguin, A-M., and Y. Bussière, "Evolution des comportements de transport par sexe dans la région métropolitaine de Montréal de 1974 à 1987: Essai d-'interprétation," Document de travail. Montreal, INRS-Urbanization, 1990.

8. Skinner, L. E., and K. L. Bourlaug, "Shopping Trips: Who Makes Them and Where," in Rosenbloom (ed.), 1978, 105-126.

9. Hanson S., and P. Hanson, "The Impact of Women's Employment on Household Travel Patterns: a Swedish Example," in S. Rosenbloom (ed.), 1978, 127-169.

10. Kostyniuk, L. P., and R. Kitamura, "Household Life Cycle: Predictor of Travel Expenditure," in *Behavioural Research of Transport Policy*, VNU Science Press, Utrecht, Netherlands, 343-362.

11. Rosenbloom, S., (editor), *Women's Travel Issues: Research Needs and Priorities*, Washington DC, US Department of Transportation, Research and Special Programs Administration, 1978.

12. Michelson, W., *op. cit.*

13. Madden, J. F., and M. J. White, "Women's Work Trips: an Empirical and Theoretical Overview," In S. Rosenbloom (ed.), 1978, 201-242.

14. Rosenbloom, S., "Differences by Sex in the Home-To-Work Travel Patterns of Married Parents in Two Major Metropolitan Areas," *Espace, populations, sociétés,* 1989, no 1, 65-75.

15. Hanson, S., and Hanson, P., *op. cit.*

16. Rutherford, B., and G. R. Wekerle, "Captive Rider, Captive Labor: Spatial Constraints on Women's Employment," *Urban Geography,* 1988, vol. 9, 173-193.

17. Hartgen, D. T., "Can Current Transportation Planning Methods Analyze Women's Travel Issues?," in S. Rosenbloom (ed.), 1978, 551-568.

18. Blumen, O., and A. Kellerman, "Gender Differences in Commuting Distance, Residence, and Employment Location: Metropolitan Haifa 1971 and 1983," *Professional Geographer,* 42,1:54-71, 1990.

19. Michelson, W., *op. cit.,* p. xi.

20. Madden, J. F., and M. J. White., *op. cit.,* p. 201.

21. Rosenbloom, S., 1989, *op. cit.,* p. 66.

22. Pickup, L., "Hard to Get Around: a Study of Women's Travel Mobility," In J. Little, L. Peake and P. Richardson, *Women in Cities, Gender and the Urban Environment,* (ed.), 1988, 98-116.

23. Wekerle, G. R., and B. Rutherford, "The Mobility of Capital and the Immobility of Female Labor: Responses to Economic Restructuring," in J. Wolch and M. Dear, (ed.), *The power of Geography,* Unwin and Hyman, 1989, 139-172.

24. Fagnani, J., "La durée des trajets quotidiens: un enjeu pour les mères actives," *Economie et statistique,* 1986, no 185, 47-55.

25. Hanson, S., and I. Johnston, "Gender Differences in Work-Trip Length: Explanations and Implications," *Urban Geography,* 1985, 6, vol 3, 193-219.

26. Hanson, S., and I. Johnston, *op. cit.*

27. Michelson, W., *op. cit.*

28. Villeneuve, P., and D. Rose, "Gender and the Separation of Employment from Home in Metropolitan Montreal, 1971-1981," *Urban Geography,* 1988, 9:155-179.

29. Bussiére, A-M., *op. cit.*

30. Hamel, P. J., C. Le Bourdais, P. Bernard, and J. Renaud , *La mobilité sociale comme processus d'allocation des rôles macro-sociaux: bilan des acquis et élaboration d'une perspective appliquée au Québec,* Final report submitted to the Social Sciences and Humanities Research Council of Canada/Conseil de la recherche en sciences humaines du Canada, 1987, project 410-85-1391.

4

THE TRANSPORTATION IMPACTS OF TELECOMMUTING: RECENT EMPIRICAL FINDINGS

Patricia L. Mokhtarian

ABSTRACT

A particular study of two telecommuting programs in San Diego, California, is used to document and illustrate a variety of transportation-related impacts of telecommuting. Original findings from these two programs are discussed here, and related to previously-reported results from other studies. The survey used to evaluate these programs obtains information on commute travel saved, new travel generated, and potential impacts on vehicle ownership, mode choice, and residential location. Ten general findings related to these areas are presented.

INTRODUCTION

Telecommuting, as the term is used in practice in the United States, may be defined as: the use of telecommunications technology to work from home or from a location close to home, instead of commuting to a conventional work location at the conventional time. It is hypothesized to have a variety of *possible* transportation impacts[1,2], such as the following[3]:

- **frequency:** work trips should decrease; non-commute trips may increase.

- **time-of-day/day-of-week:** given the flexibility to do so, trips may be shifted to off-peak periods to avoid congestion delays, and/or to different days of the week.

- **destination/length:** work trips may be made to a local center rather than to a more distant office building; non-work trips may be made closer to home rather than closer to work.

- **mode:** on the negative side, carpools and vanpools might dissolve if telecommuters drop out, and transit operators may lose revenue. Within the auto mode itself, trips made close to home may shift from a fuel-efficient vehicle used for commuting to a less fuel-efficient (and higher-emitting) vehicle. On the positive side, trips made closer to home may shift to non-motorized modes such as bicycle and walk. And if telecommuting helps flatten the peak for use of transit modes, greater operational economies may result[4].

- **trip chaining patterns:** eliminating the work trip may break up efficient, linked activity patterns, creating several one-stop trips instead of one multistop trip.

- **person(s) making the trip:** household-level assignments may change, with the telecommuter perhaps taking on more trips because she/he is at home and available, or making fewer trips because a commuting spouse now makes the stop on the way to or from work.

- **vehicle ownership:** in the medium term, the ability to telecommute may eliminate the need for a car or, more likely, an additional car.

- **residential/job location:** in the long term, telecommuting may stimulate movement farther from work to housing in more desirable and/or affordable outlying locations. The additional miles traveled on commuting days may or may not outweigh the miles saved on telecommuting days. Once the ability to telecommute has been established, the worker may change jobs, moving to a more distant employer.

Until recently, few sources of empirical data were available to test these hypotheses. Now, however, a number of telecommuting programs have been and are being evaluated with respect to changes in travel behavior[5,6,7,8,9,10,11,12]. From these programs,

some general findings are beginning to emerge. This chapter uses a particular study of two telecommuting programs in San Diego, California[12], to document and illustrate a variety of transportation-related impacts of telecommuting. While the sample for this study is small (34 telecommuters), it replicates the major patterns observed in the larger studies referenced above. In addition, the small sample invites more detailed analysis of individual behavior than is usually performed on a larger database. Thus, several anecdotal observations are made throughout this chapter, based on unusual, unexpected, or instructive outcomes found in the data. While it is noted in the summary that extreme caution should be used in generalizing from what may be statistically rare cases, it is nevertheless valuable to obtain a sense of the range of impacts that may be expected from telecommuting.

The organization of this chapter is as follows: the next section presents background information on the empirical context of this study covering: the motivation for the telecommuting programs, the transportation evaluation methodology, and some characteristics of the telecommuters. The third section discusses various findings regarding the transportation impacts of telecommuting, drawn from this specific study and supported where appropriate by results from other studies. The final section provides a summary and concluding remarks.

BACKGROUND INFORMATION

Motivation for the San Diego Telecommuting Programs

In the United States, formal telecommuting has been practiced, at least on a small-scale or trial basis, since the mid-1970s[13]. The early-adopting employers tended to be private-sector firms. They experimented with telecommuting for a variety of business-related reasons, such as the need to retain a valued employee, space savings, lower overhead, and as a recruitment advantage. The potential of telecommuting as a trip-reduction strategy has been recognized since the 1960s[14], and received considerable research attention during the energy crises of the 1970s[15,16], but did not find its way into public policy until the 1980s.

With the worst air quality and among the worst congestion in the country, Southern California has taken seriously the potential of telecommuting as a trip-reduction/air-pollution mitigation strategy since at least 1982. At that time, it was the first region in the United States to expect substantial trip reduction to occur via telecommunications substitution[17]. The years since then have seen a steady increase of interest in

telecommuting on the part of employers in the region. In addition to the same business-related reasons for telecommuting mentioned above, this interest has also been stimulated by two public policy documents. The first is the 1989 Air *Quality Management Plan*[18],which sets the ambitious (probably unrealistic) goal of reducing work trips by 30% in the year 2010 due to the combined effects of telecommuting and alternative work schedules. The second is Regulation XV of the South Coast Air Quality Management District[19], which requires employers with more than 100 staff at a single site to submit plans for achieving target vehicle-occupancy ratios (VORs) for peak-period commute trips. These targets range from 1.3 persons per vehicle in outlying parts of the region, to 1.75 in downtown Los Angeles. Telecommuting is on the menu of strategies an employer can use to achieve its target, because the telecommuter is considered to report to work (increasing the numerator of the VOR) without requiring a vehicle (therefore not increasing the denominator).

Regulation XV only applies to employers in the South Coast Air Basin – that is, Los Angeles, Orange, and the urbanized portions of Riverside and San Bernardino Counties. However, San Diego County, farther south, is not immune from the air-quality and congestion problems of the region. The City of San Diego passed a Transportation Demand Management (TDM) ordinance in September 1989, that included telecommuting as a way to reduce peak-period travel.

In response to these policies, a number of Southern California employers – both public- and private-sector – have implemented telecommuting pilots or full-scale programs. This chapter is based on data collected in conjunction with two of those programs, established in 1990: (i) the County of San Diego Department of Public Works (DPW); and (ii) District 11 (San Diego) of the California Department of Transportation (Caltrans). Both of these are government employers. Currently, in contrast to the early days of telecommuting, public-sector employers may be (i) more willing to lead the way in implementing telecommuting, due to their support of it as public policy, and (ii) more willing to permit and publish outside evaluations of their telecommuting programs, than private-sector employers. However, involvement of private firms (who are equally subject to the transportation and air-quality regulations of a state or region) is also substantial, if less well-documented.

Transportation Evaluation Methodology

A written questionnaire was developed and administered to telecommuters in the two programs. The survey obtained information on potential changes in mode choice, vehicle ownership, residential location, and activity patterns due to telecommuting. Because both agencies had already begun their programs when the author was invited

to participate in the evaluation, no true before measures were possible. The survey did ask several retrospective questions regarding changes since beginning telecommuting. Responses to these questions are likely to be fairly reliable in the cases of vehicle ownership and residential relocation, and perhaps slightly less so in the case of mode choice. The survey also requested a one-day snapshot of trips made by telecommuters during the hours they would normally be commuting or working. Further, telecommuters were explicitly asked how their travel would have been different if they had not telecommuted that day. Participants could indicate, for each activity, whether the place, time, day, person, or mode would have been different, or whether the activity would have taken place at all. Respondents were requested to draw diagrams illustrating their trip patterns while telecommuting and if they had not telecommuted. While such self-reports of a hypothetical response may not be completely reliable, they provide some comparative insights in the absence of a before measure. This set of questions also permits some inferences to be made regarding the extent to which telecommuting leads to a shift in activities (and therefore travel) among days of the week and/or members of the household.

Profile of the Telecommuters

The questionnaires were administered to the San Diego County DPW telecommuters during the week of April 23, 1990 (about three months after the start of their program), and to the California Department of Transportation (Caltrans) District 11 telecommuters the week of April 1, 1991 (8-9 months after the start of their program). A total of 34 surveys were completed and returned, 13 from DPW and 21 from Caltrans. There were 19 females (56%) and 15 males in the sample. Ages ranged from 30 to 61 years old; the mean and median ages were both 41. Seven of the respondents (21%) were single (including never-married, widowed, divorced, or separated); the rest married. Sixteen (47%) of the respondents had one or more child under 18 living at home. There was one single parent among those 16 respondents.

Twenty-eight respondents (82%) were college graduates, with 14 having done some graduate work and five of those having completed at least one graduate degree. In terms of rank, three respondents (9%) classified themselves as management; the rest as staff. Occupations were primarily professional/technical, including engineer, planner, researcher, computer analyst, legal, writer, administrative, and others.

The median before-tax household-income response fell into the category $60,001 to $80,000. Perhaps typical for affluent Southern Californians, auto ownership averaged 1.2 vehicles per licensed driver in the household. Distance lived from work ranged from 3 to 50 miles, with the mean at 16.1 miles and the median at 13.5 miles. As is

common in telecommuting programs, this is higher than the average home-to-work distance in San Diego County (10.8 miles). The assumption is that people who live farther from work are more motivated to telecommute and, in fact, commute length is sometimes used as a selection criterion in a pilot situation, where there are more applicants than desired. However, as is seen here, even those who lived as little as three miles away could and did participate.

While the travel analysis was conducted on the pooled sample due to the small size, it should be mentioned that there are some demographic differences between respondents from the two agencies. Caltrans telecommuters tend to be older, have higher vehicle ownership, and live farther from work than those from DPW.

TRANSPORTATION-RELATED IMPACTS OF TELECOMMUTING

In this section, ten transportation-related impacts of telecommuting are discussed. Under each general finding, evidence from the two San Diego programs described above is presented (details of the analysis may be found in Mokhtarian[12]). Supporting evidence from other studies is drawn upon as appropriate.

Telecommuting Is Predominantly Done Part Time

In the two San Diego programs, the average frequency of telecommuting was 27%, or a little more than one out of four working days per person. This is consistent with anecdotal and empirical evidence from numerous other studies, which cite typical telecommuting rates of 1-2 days per week[20,21]. Most people value the social and professional interaction to be found in the conventional office environment and, given a choice, would not completely relinquish that interaction.

The implication for transportation planning, of course, is that it is not sufficient just to count telecommuters. A finding or forecast that *x* people telecommute may mean that only *x/4* work trips are eliminated.

An Official Telecommuter Is Not Always Reducing Commute Travel

For five (15%) of the 34 San Diego respondents, commute trips were not replaced. For three of those participants – maternity and temporary disability cases – the alternative to working from home was not working at all. For a fourth, the alternative was continuing to work part time (three days a week only, all in the main office, instead of

three days in the office and the other two at home). The fifth respondent tele-commuted partial days, which shifted commute travel out of the peak period but did not eliminate it.

In view of the definition offered in the first sentence of this chapter, at least the first four of these cases should not, strictly speaking, be considered telecommuting[22,23]. In the last instance, peak-period travel is still eliminated, which can certainly be viewed as a positive rather than neutral transportation outcome. However, all these cases illustrate how easy it is to overestimate trip reduction under the false assumption that every telecommute occasion represents a trip saved. To be conservative, those five cases were removed from the analysis of commute travel savings reported below. They are included (where applicable) in the analysis of noncommute travel.

In the Aggregate, However, Commute Travel is Reduced

While this is obviously the expected, and presumably the most likely outcome of a telecommuting program, it cannot be considered a certain outcome. Even in the cases where person-trips are reduced (unlike the exceptions noted above), it is theoretically possible for vehicle miles to increase, if there are (a) mode shifts from ridesharing or transit into drive alone and (b), in the long run, residential relocations.

Fortunately, however, the real impacts on commute travel observed to date are positive. In this study, about 39 person-miles of commute travel, on average, were saved per telecommute occasion. More importantly, about 31 vehicle miles of (drive alone) commute travel were saved per occasion. In terms of trips, about 12% of the telecommute occasions replaced rideshare trips rather than drive alone trips (there were no transit users in this sample). That is, person-trips but not vehicle-trips were eliminated on those occasions. The impact on commute mode choice is discussed in greater detail below.

There is no Significant Relationship Between Commute Distance and Frequency of Telecommuting

Respondents who lived farther from work did telecommute slightly more often on average than those who lived closer. However, Figure 1 illustrates the weak nature of this relationship, plotting the frequency of telecommuting against one-way home-to-work distance. When a simple regression is performed on these data, the slope coefficient is found to be completely insignificant and quite small, meaning that the regression line is essentially flat. Thus, there is no empirical support in this

sample for the hypothesis that long-distance commuters are motivated to telecommute more often.

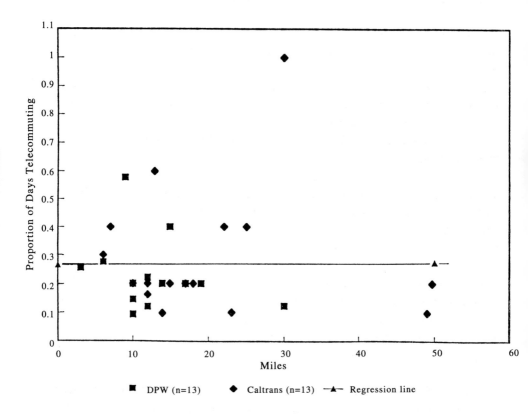

Figure 1
Frequency of Telecommuting Versus One-Way Commute Length

This is consistent with results found in other studies[5,24]. That does not mean that commute length is irrelevant. For one thing, it may be the case that commute length is a significant motivator only for a segment of the sample, and that other factors (such as family needs) motivate others to telecommute. Also, as mentioned above, it is common for telecommuters to live farther away from work than average, so commute length may have more to do with the original choice to telecommuter than with frequency of telecommuting, given the choice to do it. Again, however, for many programs (especially pilots), commute length is a factor in the selection of tele-commuters, so the observed difference may not be due totally to individual choice.

The Amount of Travel Generated on Telecommute Occasions is Far Outweighed by the Amount of Travel Saved

In the survey completed by the San Diego telecommuters, they were asked to describe the trips they made (during normal commute and working hours) on the most recent day they telecommuted, and indicate how those trips would have been different if they had not telecommuted that day. This provides a sample of travel generated on telecommuting occasions (although not necessarily because of telecommuting – see next point below) . The numbers reported here are based on the 28 respondents who were still telecommuting regularly at the time the survey data were collected.

Vehicle miles traveled (VMT) were about 56% lower than they would have been if participants had not telecommuted. On average, 38.2 vehicle miles per person were traveled during normal commute and working hours on regular commuting days, compared to 16.9 vehicle miles on telecommuting days.

The telecommuting-day average VMT is inflated by the presence in the data of two unusually long, work-related trips made on telecommuting days, both of which would have occurred anyway. If these two outliers are removed, VMT was 89% lower than it would have been otherwise (25.2 miles per person on regular days versus 2.9 miles per person on telecommuting days).

The findings for the State of California project[7] fall between these two sets of numbers (i.e. with and without the outliers). Bearing in mind that for that study, the unit of analysis was a full 24-hour day, average per person VMTs for the State participants were 49.7 before telecommuting and 12.0 on telecommuting days, a 76% decrease.

Few New Trips are Created Because of Telecommuting

It is not reasonable to assume that all travel that occurs while telecommuting is totally new travel. We must differentiate between *totally new trips, and trips that would have occurred anyway.* It is the totally new trips that are the most serious in terms of generating travel.

There are a number of ways in which telecommuting can stimulate additional non-commute travel. First, staying at home all day may lead to cabin fever, and the telecommuter makes trips just to get out of the house[25]. Second, the time otherwise

spent commuting may be devoted to new activities involving travel. Third, tele-commuting may make an automobile available to other members of the household, who use it to make new trips (although, as the vehicles-per-driving-age-household-member ratio approaches one throughout the United States[26], this effect is not likely to be large). Fourth, telecommuting itself may create the need for trips, e.g., for office supplies, or to the post office or photocopy/public fax center.

The hypothesis that telecommuting will stimulate new trips is not borne out by this study. On 17 (61%) of the 28 most recent telecommuting occasions, no trips at all were reported during normal commute and working hours. Out of a total of 16 (round) trips taken on the respondents' most recent telecommuting occasions (involving 40 destinations including home), only one was a completely new trip, and that was, a one-mile walk trip. All the other trips would have taken place anyway.

Some Impacts on Nonwork Trip Characteristics Can Occur

Even trips that would have occurred anyway should be studied to see how they are affected by telecommuting. For example, they may take place at a different time, a different place, and/or be made by different people. Among the 24 non-home destinations visited by the San Diego respondents on their most recent telecommuting days, changes were cited in time of travel for 11 destinations (46%). This is somewhat at variance with the State of California study[6], which found no significant temporal redistribution of nonwork travel due to telecommuting. The two results are compatible, however, if the shifts in time of travel were relatively small.

Changes due to telecommuting were also cited for mode of travel for four destinations, and in every case the change was from the automobile to walking or biking; destination for three destinations; and person/people traveling for three destinations.

The Effect on Commute Mode Choice Appears to be Negligible

The difference between person miles and vehicle miles saved for a given trip has been presented above. What is being explored here are potential changes in the (commute) mode-choice selection patterns induced by telecommuting. That is, will tele-commuters change the proportion of time they select a given mode for the work trip? The hypothesis is that telecommuters may be more likely than before to drive alone on the days they do commute, thereby potentially breaking up entire carpools or at least themselves creating new vehicle trips.

Such effects were not seen in the San Diego sample. One natural reason for that is that 76% of the respondents already drove alone to work 100% of the time before beginning to telecommute. Several others shared rides for a proportion of the work week, and did not change that proportion after beginning to telecommute (there were no transit users in this sample). For one respondent, the telecommuting day always replaced a rideshare trip (once a week), but the carpool remained intact. In that case, vehicle miles and vehicle trips were unchanged by telecommuting. The single instance of shifting from carpooling (50% of the time) to driving alone full-time could not, according to the respondent, be attributed to telecommuting.

Table 1 compares the total number of commute (round) trips made in a two week period, before and after telecommuting began. In the aggregate, mode shares

<div align="center">

Table 1

**Comparison of the Number of Commute Trips Made
in a Two-Week Period
(N=29)**

</div>

	Rideshare Trips	Drive Alone Trips	Total Trips
Before			
No. of Trips	47.5	242.5	290.0
Mode Share	16.4%	83.6%	100.0%
After			
No. of Trips	35.0	177.3	212.3
Mode Share	16.5%	83.5%	100.0%

remained constant, with proportionally fewer trips actually made by both drive alone and rideshare modes due to telecommuting.

No Impact on Vehicle Ownership Has Been Observed

Consistent with other findings[6], this result is not very surprising. At least four plausible reasons can be put forward: First, people would be reluctant to make major changes if the pilot is viewed as a temporary program that could shortly be removed.

Second, even if the program were considered likely to become permanent, the time frame was too short to see changes that may occur eventually. Third, telecommuting only one or two days a week on average is not enough to justify disposing of a vehicle. Fourth, a car may be considered a necessity (or necessary luxury), especially in Southern California, whether essential for commuting or not. Even nationwide, as mentioned earlier, auto ownership is at nearly one vehicle per driving-age household member (regardless of whether all drivers are commuting to work). Even though no impacts on vehicle ownership have been observed to date, it would be valuable to continue to monitor this transportation-related variable.

Telecommuting May Support Long-Distance Residential-Relocation Decisions for a Small Minority

The main hypothesis related to residential-location impacts is that the ability to telecommute could motivate people to move farther from work, to more affordable or desirable housing. In the extreme, the extra miles traveled on commute days could exceed the miles saved by telecommuting. If San Diego respondents' reports are taken at face value, this could happen over time for a small minority of telecommuters.

In particular, two people out of 34 reported considering moving some distance away, with telecommuting being an important or the most important factor in the decision. One prospective move would more than double the current commute (from 14 to 30 miles), while the second would quadruple the commute (from 10 to 40 miles). These people were telecommuting only about once every two weeks on average, so if all else remained equal, commute-miles traveled would increase considerably after such moves.

In reality, these long-distance moves would probably not be seriously attributed to telecommuting unless the respondents planned to telecommute a great deal more in the future. But the break-even points (i.e., the points at which weekly commute travel after moving equals that before moving and before telecommuting) would be for these two participants to telecommute an average of 53% of the time (2.7 days per week) and 75% of the time (3.75 days a week), respectively, beyond the present one. That represents a substantial additional commitment to telecommuting on the part of both the employee and the organization.

In practice, it is difficult to sort out the role of telecommuting in motivating a move. People do not change residential locations just because they can now telecommute; telecommuting may simply lower the barriers to a move they want to make for other

reasons. Thus, people are apt to overstate the role of telecommuting in a relocation decision. In the State of California program[27], a similarly, small proportion of participants indicated that telecommuting had influenced or would influence them to make long-distance moves. However, no statistically significant difference was found between lengths and numbers of actual moves of the telecommuters and a control group. This suggests that the moves that did occur would have taken place anyway.

Nevertheless, it is clear that telecommuting may have long-term effects not fully captured by the short-term snapshots that have been taken to date, and that these long-term effects should be monitored.

SUMMARY

Telecommuting can affect travel in obvious ways – by reducing commute trips – and in not so obvious ways. In the short run, telecommuting can create new travel; change the time, place, and frequency of travel; and affect who makes the trip and what mode is used. In the long run, telecommuting can even affect residential location, with potentially large impacts from a small number of extreme moves. This study, focusing on San Diego telecommuters, has illustrated several individual situations in which vehicle-miles traveled might not decrease, or might increase, due to telecommuting. But while it is instructive to examine extreme or idiosyncratic cases, it is also important to keep them in perspective. The fact that telecommuting may have counterproductive transportation impacts for a few may not abrogate its overall usefulness as a transportation-mitigation strategy. This can only be determined through analyzing the aggregate impacts of telecommuting for sizable groups of people.

Based on the empirical findings reported to date from San Diego and other programs, aggregate travel is clearly reduced due to telecommuting. As expected, total commute vehicle-miles traveled decreases, and some rearrangement of noncommute travel occurs. Other positive results include the observations that essentially no new travel is created due to telecommuting, and that there appears to be no disproportionate impact on shared-ride commute modes. However, it was also observed that most people who telecommute do so part time; that not all telecommuting actually replaces commute travel; that there is no significant relationship between commute distance and frequency of telecommuting; that telecommuting has not yet motivated anyone to give up an automobile; and that telecommuting may support at least a few long-distance residential-relocation decisions.

While these findings are generally positive or at worst neutral, it should be remembered that they are short-term results from small samples. It can be seen that many effects may not be observed for some time to come. Accordingly, it is important to continue to monitor the travel impacts of telecommuting over the long term.

REFERENCES

1. European Conference of Ministers of Transport (ECMT), *Transport and Communications,* ECMT Round Table 59, Paris, France, 1983.

2. Salomon, I., "Telecommunications and Travel Relationships: A Review," *Transportation Research,* 1986, 20A(3), 223-238.

3. Mokhtarian, P. L., "Telecommuting and Travel: State of the Practice, State of the Art," *Transportation,* 1991, 18(4), 319-342.

4. Jovanis, P., "Telecommunications and Alternative Work Schedules: Options for Managing Transit Travel Demand," *Urban Affairs Quarterly,* December 1983, 19(2), 167-189.

5. Southern California Association of Governments (SCAG), *Evaluation Report: Telecommuting Pilot Project,* SCAG, Los Angeles, CA, August, 1988.

6. Pendyala, R. M., K. G. Goulias, and R. Kitamura, "Impact of Telecommuting on Spatial and Temporal Patterns of Household Travel," *Transportation,* 1991, 18(4), 383-409.

7. Sampath, S., S. Saxena, and P. L. Mokhtarian, "The Effectiveness of Telecommuting as a Transportation Control Measure", *Proceedings of the ASCE Urban Transportation Division National Conference on Transportation Planning and Air Quality,* Santa Barbara, CA, July 28-31, 1991 (1992), 347-362.

8. Shirazi, E., "Results from the County of Los Angeles Telecommuting Program," Presentation to the 71st Annual Meeting of the Transportation Research Board, Washington, DC, January 12-16,1992.

9. Ulberg, C., "Update on the Evaluation of the Puget Sound Telecommuting Demonstration Project," Presentation to the 71st Annual Meeting of the Transportation Research Board, Washington, DC, January 12-16, 1992.

10. Hamer, R., E. Kroes, and H. van Ooststroom, "Teleworking in the Netherlands: An Evaluation of Changes in Travel Behaviour," *Transportation,* 1991, 18(4), 365-382.

11. Hamer, R. N., E. P. Kroes, H. P. C. van Ooststroom, and M. G. J.
 Kockelkoren, "Teleworking in the Netherlands: Evaluation Changes in
 Travel Behaviour – Further Results," Forthcoming *Transportation Research
 Record,* 1992.

12. Mokhtarian, P. L., *The Transportation Impacts of Telecommuting in Two San
 Diego Pilot Programs,* Report No. UCD-ITS-RR-91-12, Institute of Transporta-
 tion Studies, University of California, Davis, October, 1991.

13. Nilles, J. M., F. R. Carlson, Jr., P. Gray, ,and G. J. Hanneman, *The Telecom-
 munications-Transportation Tradeoff: Options for Tomorrow,* John Wiley and
 Sons, New York, 1976.

14. Memmott, III, F. W., "The Substitutability of Communications for Trans-
 portation," *Traffic Engineering,* February, 1963, 33(5), 20-25.

15. Harkness, R. C., *Technology Assessment of Telecommunications/Trans-
 portation Interactions,* Stanford Research Institute, Menlo Park, California,
 1977.

16. Lathey, C., *Telecommunications Substitutability for Travel: An Energy
 Conservation Potential,* United States Department of Commerce, Office of
 Telecommunications, Washington, DC, 1975.

17. South Coast Air Quality Management District (SCAQMD) and SCAG, *Air
 Quality Management Plan: 1982 Revision,* and *Appendix No. VIII-B, Tele-
 communications,* SCAQMD, El Monte, California (now Diamond Bar, CA),
 1982.

18. SCAQMD and SCAG, *1989 Air Quality Management Plan,* SCAQMD, El
 Monte, California (now Diamond Bar, C,), March, 1989.

19. SCAQMD, *Regulation XV: Trip Reduction/Indirect Source,* SCAQMD, El
 Monte, California (now Diamond Bar, CA), adopted December 11,1987;
 amended May 17,1990.

20. Miller, T. E., *1991 Telecommuting data from Link Resources Corporation,*
 Link Resources Corporation, 79 Fifth Avenue, New York 10003, June, 1991.

21. JALA Associates, Inc., *California Telecommuting Pilot Project Final Report,*
 Stock No. 7540-930-1400-0, State of California Department of General
 Services, North Highlands, CA, June, 1990.

22. Salomon, I., "Telematics and Personal Travel Behaviour with Special
 Emphasis on Telecommuting and Teleshopping," in H. M. Soekkha, et al.
 (editors), *Telematics - Transportation and Spatial Development,* VSP,
 Utrecht, The Netherlands, 1990, 67-89.

23. Mokhtarian, P. L., "Defining Telecommuting," *Transportation Research Record* 1305, 1991, 273-281.

24. Olszewski, P.,and P. L. Mokhtarian, "Characteristics of California Telecommuters – Some Implications for Planning Future Telecommuting Projects," Paper presented at the 6th World Conference on Transport Research, Lyon, France, June 29 - July 3, 1992.

25. Salomon, I., "Telecommunications and Travel: Substitution or Modified Mobility?" *Journal of Transport Economics and Policy, 19,* 1985, 219-235.

26. Lave, C., "Things Won't Get a Lot Worse: The Future of U. S. Traffic Congestion," *ITS Review*, November, 1990, 14(1), 4-8.

27. Nilles, J. M., "Telecommuting and Urban Sprawl: Mitigator or Inciter?" *Transportation,* 1991, 18(4), 411-432.

5

A COMMONS-DILEMMA APPROACH TO HOUSEHOLDS' INTENTIONS TO CHANGE THEIR TRAVEL BEHAVIOUR

Tommy Gärling and Lennart Sandberg

ABSTRACT

Air pollution in metropolitan areas would diminish if automobile-commuting households change travel mode, install catalytic converters in the cars they are using, or replace those cars with new ones with catalytic converters. Such behaviour changes are, however, difficult to make because, to varying degrees, they require that households restrain themselves from acting in self interest. With the aim of finding out what factors may affect such self-restraining behaviour changes, a study is reported in which 67 subjects who commuted by car to work stated their intentions to undertake them contingent on increased gasoline price, increased income, rebates on catalytic converters, increased health risks due to air pollution, and increased number of automobile commuters changing travel mode. The results showed that subjects unanimously expressed strong preferences for automobile commuting over other alternatives, at the same time that they were strongly in favor of air-pollution countermeasures. In stating their intentions, subjects took into account all the factors, that were varied independently of each other, with one single exception. There was no clear indication that those subjects, who perceived air-pollution countermeasures more important and felt more responsible for undertaking them, would be more likely to change their travel behaviour.

INTRODUCTION

Air pollution is considered to be a serious health threat in metropolitan areas all over the world[1,2]. Because exhaust from motor vehicles contributes significantly to the seriousness of the problem, its reduction is highly desirable. In the longer term, a technical solution may be to install catalytic converters in personal cars. However, short-term improvements are sought in many countries[a] through attempts to change the behaviour of automobile-commuting households. Can automobile commuters possibly be influenced to undertake behaviour changes, and, if so, by what means can they be influenced?

Acting in self interest is, in many societies, rewarded more than acting in the public interest. What has been called commons or social dilemmas[3,4] arise because, if everyone acts in this way, the benefits individuals derive are jeopardized due to depletion or pollution of vital common resources such as air, water, and land. Therefore, to prevent this from occurring, a majority must restrain themselves from acting in self interest. An example is that unless automobile-commuting households change their travel behaviour, the air will be polluted to a point where the health of everyone is at risk. As long as equivalent or better alternatives are not available, such changes in travel behaviour mean that sacrifices need to be made[5].

Hardin[6] in his well-known paper entitled *The Tragedy of the Commons* did not believe that the public would make sacrifices unless forced to by legislation. Hardin based his arguments on the assumption that human nature is fundamentally egoistic. However, more recently, the validity of this assumption has been questioned[7]. In addition, social-psychological research has identified a number of factors that seem to restrain people from acting in self interest[4,5]. Of particular interest are three factors by which automobile commuters conceivably are affected: payoff, morality, and trust in others to do the same.

The aim of the present study was to attempt to verify the importance of the three factors mentioned above for changes in travel behaviour. Three different such changes were targeted: changing travel mode for work trips, installing a catalytic converter in the car used for work trips, and replacing this car with a new one with a catalytic converter. A questionnaire was administered to automobile commuters

a Such is the case in Sweden where in 1989 catalytic converters became mandatory in new cars. However, if travel demand increases as forecasted, air pollution will nevertheless continue to increase to the beginning of the next century.

requesting them to state their intentions in these respects contingent on various changes of the existing conditions as detailed in the following hypotheses.

In econometric transport research[8], monetary incentives are considered to be the primary determinants of travel behaviour. Drawing on this assertion, an increase in gasoline price was hypothesized to affect intentions to change travel mode, availability of rebates to affect intentions to install a catalytic converter, and income increase to affect intentions to replace the old car with a new one.

No matter how important monetary incentives are, automobile commuters may not be willing to make the sacrifices required to change travel mode and install a catalytic converter, unless they perceive that automobile travel causes increased health risks due to air pollution. Conversely, monetary incentives may not be needed if health risks are perceived to increase substantially. An additional hypothesis investigated was, therefore, that information about health risks, alone or in combination with monetary incentives, affects intentions to change travel mode and install a catalytic converter.

Research on risk perceptions has documented the difficulties people have in changing their behaviour when facing health threats[9]. One reason is that they are not easily convinced that such health threats are real. In particular, when the threats are not personal, people may not feel morally responsible for undertaking any action[10]. The automobile commuters participating in the present study were all asked to respond to suggested future situations in which health is threatened. On the basis of the results of the previous research referred to, it was hypothesized that the study participants would differ in how likely they would be to change their travel behaviour in these situations depending on how serious they perceive the health threats to be and/or how strong a moral responsibility they feel for undertaking changes.

Unless a sufficient number of automobile commuters change their travel behaviour, there will be no improvement. Thus, a particular individual may be unwilling to undertake any change unless he or she trusts that others do the same. On the basis of commons-dilemma research showing such effects of trust[11,12], it was hypothesized that information about the number of automobile commuters who restrain from using their cars for work trips would affect intentions to change travel behaviour. In addition, the effect of information about increased health risks may possibly only materialize if many other automobile commuters also change travel mode. Trust in others to act in the public interest can also lead to attempts to take advantage of those who restrain from acting in self interest. Differences may therefore be observed among automobile commuters in how they react to information about how many others change travel

mode. Such differences were hypothesized to depend on the degree to which a moral responsibility to undertake actions was felt.

METHOD

Sample

The study was conducted in the city of Umeå, located in the coastal area of the second most northerly county in Sweden. The city has a population of some 85,000 people spread over roughly 100 square kilometers. Subjects were recruited among those employed by the city who have their work place in the CBD. These employees constitute a fairly representative cross-section of the population with respect to demographic characteristics, education, and income. In all, 555 (74%) were contacted by telephone, excluding those who worked in the departments of traffic planning or environmental health and those who had been granted a long-term leave of absence. Of those contacted, 270 (49%) qualified for inclusion in the sample because they stated that they used their car to commute to work at least once a week, either driving themselves or ride sharing with someone else in their household. Twenty-eight (5%) were excluded because their cars had catalytic converters and 173 (31%) because their cars could not run on unleaded gasoline[b], leaving 69 in the sample. Because two subjects refused to participate, the final sample consisted of 67 subjects.

Of those subjects finally interviewed , all of whom were between 21 and 65 years old (Mean 42.7), 32 were men and 35 women. Twenty-six had completed high school, and 43 had a college or university degree. They all lived in residential neighborhoods where public transport is accessible, at a home-to-work distance of 4 km or less (43 subjects), of more than 4 but less than 20 km (19), and of more than 20 km (5), respectively. Fifteen subjects needed their cars for work-related trips at least once a week.

Procedure

When initially contacting subjects, a few questions were asked over the telephone for the purposes of selecting the sample. For subjects who were included in the sample

[b] The intention was to include only households with cars in which catalytic converters could be installed without any additional costs for changes to their engines.

on the basis of their responses to these questions, an appointment was made to see them at their work place within a week after the initial contact. At the work place, a room was reserved where subjects came in small groups for the interviews. The interviews were all completed in February, 1990. Each time a short introduction was given by the female experimenter who then distributed questionnaires and monitored subjects filling them out. On both this occasion and when initial contact was made, subjects were only told that the purpose of the study was to learn about traffic problems that automobile commuters encounter in the CBD. The interview sessions lasted for approximately 30 minutes. Subjects were offered a lottery ticket in return for their participation.

The questionnaires consisted of three parts. Questions aiming at describing the sample were asked in the first part. These included age, home location, marital status, number of children, education, work position, and income. Other questions focused on travel to work. Subjects were first asked to rate on 5-point scales, ranging from never to always, how frequently they walked, biked, travelled by automobile, and travelled by bus. Then subjects indicated on a 9-point rating scale how much more or less they preferred automobile commuting over the other alternatives. Finally, subjects rated on 9-point scales how much better or worse they perceived automobile commuting to be than the other alternatives with respect to travel time, flexibility in departure times, cost, safety, potential of chaining trips, potential of carrying cargo, and parking constraints, respectively.

In the second part of the questionnaire, subjects expressed their attitudes towards measures aimed at reducing air pollution caused by traffic in the CBD where they worked. They used six 9-point rating scales with endpoints defined by the adjective pairs important-unimportant, justified-unjustified, possible-impossible, a moral obligation-no moral obligation, my responsibility-not my responsibility, and everyone's responsibility-not everyone's responsibility. The rating scales were presented on a single page in an order which was randomized and with the right-left positions of the adjectives randomly determined.

Finally, subjects indicated how they would change their travel behaviour under different conditions[c]. On separate pages, 25 different conditions (including the existing ones) were described. Each time, subjects rated on 9-point scales ranging from very unlikely to very likely if they intended to change mode for work trips, to

[c] Because the changes in travel behaviour may, to various degrees, be based on decisions made jointly within households, when applicable subjects were asked to take that into account in indicating their intention to undertake a change.

install a catalytic converter in the car they were using for work trips, and to replace this car with a new one with a catalytic converter. The different conditions were defined by the combinations of:

- three levels of the factor health risks due to air pollution caused by traffic in the CBD (minor risk of respiratory problems[d], slightly increased risks of respiratory problems and cancer, and much increased risks of respiratory problems and cancer);

- three levels of gasoline price (no increase, an increase equivalent to US$.33/litre, and an increase equivalent to US$.67/litre);

- two levels of price of installing a catalytic converter (the equivalent of US$500-700, and the equivalent of US$170);

- two levels of income (no increase, a 10 percent net increase);

- three levels of number of automobile commuters who change mode (0 percent, 40 percent, and 80 percent).

The factor levels were combined in five two-way, complete factorial designs. Health risks were crossed with gasoline price, price of a catalytic converter, and number of automobile commuters changing mode; number of automobile commuters changing mode was crossed with gasoline price; and gasoline price was crossed with income[e]. The factors not varied were kept constant at their lowest (highest for price of catalytic converter) levels which were also the existing ones. The different conditions were across subjects presented about equally often in each of four different random orders.

[d] The lowest (highest for price of catalytic converter) levels of each factor were intended to correspond to the existing conditions. However, in some cases these levels were nevertheless specified because subjects could be assumed to be ignorant of them.

[e] Only the interactions involving health risks were expected. The remaining were included because of the resulting increase in number of observations for estimating the main effects.

RESULTS

Attitudes Towards Automobile Commuting

The mean ratings displayed in Table 1 indicate that on average the subjects selected for the sample strongly preferred automobile commuting to work over other alternatives. That this preference was close to unanimous was furthermore suggested by the fact that 71 percent preferred automobile commuting, whereas another 12 percent were indifferent between this alternative and the other alternatives. Travel

Table 1
Mean Ratings on Adjective Scales of Attitudes
Towards Air-Pollution Countermeasures

Adjective Scales	Mean	Sd
Important-Unimportant	8.2	1.4
Justified-Unjustified	8.4	1.0
Possible-Impossible	7.5	1.8
A Moral Obligation-No Moral Obligation	7.5	1.9
My Responsibility-Not My Responsibility	7.2	2.1
Everyone's-Not Everyone's Responsibility	8.2	1.8

The rating scales ranged from 9 (much better) to 1 (much worse) with 5 defined as neither better nor worse

time, flexibility in departure times, potential of chaining trips, and potential of carrying cargo seemed to contribute about equally to the dominance of the automobile-commuting alternative. Cost, safety, and parking constraints tended to counteract this dominance.

Attitudes Towards Air-Pollution Countermeasures

As can be seen in Table 2, subjects rather uniformly expressed strong favorable attitudes towards air-pollution countermeasures. Despite restricted variability across subjects, a principal-component analysis performed on the correlations between rating scales yielded two interpretable factors. The obliquely rotated factor loadings shown in Table 3 suggest that the first factor, with high loadings for the scales important-unimportant, justified-unjustified, and possible-impossible, taps the degree of importance ascribed to countermeasures. The second factor, slightly correlated with the first, appears to tap moral responsibility. The scales with high loadings on that factor were a moral obligation-no moral obligation, my responsibility-not my responsibility, and everyone's responsibility-not everyone's responsibility.

Table 2
Mean Ratings' of How Better Than Other Alternatives Automobile Commuting Was Perceived Overall and With Respect to a Number of Attributes

	Mean	SD
Overall	7.2	2.2
Travel Time	7.4	1.9
Flexibility of Departure Times	8.0	1.7
Cost	4.1	2.5
Safety	3.9	1.8
Potential of Trip Chaining	7.6	2.2
Potential of Carrying Cargo	8.1	1.9
Parking Constraints	4.1	1.4

Table 3
Factor Loadings from Principal Components Analysis of Ratings of Attitudes Towards Air-Pollution Countermeasures

Adjective Scales	Factors		
	I	II	h^2
Important-Unimportant	.77	.15	.64
Justified-Unjustified	.71	-.06	.50
Possible-Impossible	.74	-.08	.54
A Moral Oligation-No Moral Obligation	-.07	.82	.67
My Responsibility-Not My Responsibility	.33	.67	.61
Everyone's-Not Everyone's Responsibility	-.12	.77	.59
	1.77	1.75	3.52
	30 percent	29 percent	59 percent

Intentions to Change Travel Behaviour

The statistical significance of main and interaction effects involving the different independent variables were assessed by means of sets of multivariate and univariate analyses of variance (MANOVAs and ANOVAs) performed on the ratings of how likely subjects were to change mode, install a catalytic converter, and buy a new car. These analyses included two group factors, perceived importance of air-pollution countermeasures and perceived moral responsibility for undertaking such measures, respectively. A median split on each set of factor scores, obtained from the principal-components analysis reported above, made possible the formation of four groups: 21 subjects who perceived air-pollution countermeasures less important and felt less morally responsible for them, 12 who similarly perceived such countermeasures less important but nevertheless felt more morally responsible, 12 who perceived countermeasures more important but felt less morally responsible, and, finally, 22 who perceived countermeasures more important and felt more morally responsible.

The first set of MANOVAs tested the significance of the five two-way interaction effects: health risks by number of automobile commuters changing mode, health risks

by gasoline price, health risks by price of catalytic converter, gasoline price by number of automobile commuters changing mode, and gasoline price by income (see Table 4). At the significance level of $p<.05$, none of these interaction effects was significant except for that between health risks and gasoline price which, in subsequent ANOVAs, was reliable for mode change, $F(4, 252) = 3.57$, $p<.01$. As can be seen in Table 4, because health risks already have a strong influence on intentions to change mode for the existing gasoline price, there is only room for less increase when the gasoline price increases.

The main effects of each factor, reported in Table 5, were obtained by pooling estimates from each two-way design in which the respective factor was varied. Separate MANOVAs on each factor showed that they were all significant for $p<.05$ or less. Subsequent ANOVAs revealed that increased health risks affected intentions to change travel mode, $F(2, 126) = 28.15$, $p<.001$, to install a catalytic converter, $F(2, 126) = 22.28$, $p<.001$, and to buy a new car, $F(2, 126) = 18.94$, $p<.001$; that increased number of automobile commuters changing travel mode affected intentions to change mode, $F(2, 126) = 10.42$, $p<.001$; that increased gasoline price affected intentions to change travel mode, $F(2, 126) = 27.45$, $p<.001$, and to install a catalytic converter, $F(2, 126) = 5.42$, $p<.01$; that reduced price affected intentions to install a catalytic converter, $F(1, 63) = 41.79$, $p<.001$; and, finally, that income increase affected intentions to buy a new car, $F(1, 63) = 11.59$, $p<.001$, and to install a catalytic converter, $F(1, 63) = 6.39$, $p<.05$.

The MANOVAs, furthermore, yielded significant interaction effects between the perceived importance of the group factor and gasoline price, and between this factor in conjunction with the other group factor, moral responsibility, and income, respectively. Both were found in ANOVAs to be significant for intentions to install a catalytic converter, $F(2, 126) = 3.17$, $p<.05$, and $F(1, 63) = 9.05$, $p<.01$. The former interaction reflected that an effect of increased gasoline price was confined to those subjects who perceived air-pollution countermeasures less important, the latter that an effect of income was confined to those subjects who perceived air-pollution countermeasures more important but felt less morally responsible and those who perceived air-pollution countermeasures less important but felt more morally responsible.

Table 4
Mean Intentions to Change Travel Mode, Install Catalytic Converter, and Buy New Car under Different Conditions

	Health Risks Due to Air Pollution			Increase in Gasoline Price		
	Minor	Slightly Increased	Much Increased	0 percent	40 percent	40 percent
			Change Travel Mode			
Automobile Commuters Changing Mode						
0 percent	*3.7*	*4.5*	*5.2*	*3.7*	*4.3*	*5.3*
40 percent	3.9	4.6	5.3	*3.9*	4.7	5.2
80 percent	4.2	4.9	5.7	*4.2*	4.9	5.5
Gasoline Price						
No (0 percent) Increase	*3.7*	*4.5*	*5.2*			
US$.33/Litre (40 percent) Increase	4.3	4.9	5.5			
US$.67/Litre (80 percent) Increase	5.3	5.6	5.9			
Price of Catalytic Converter						
US$500-750	*3.7*	*4.5*	*5.2*			
US$170	4.0	4.7	5.3			
Income						
No Increase				*3.7*	*4.3*	*5.3*
10 percent Net Increase				3.6	4.3	5.2
			Install Catalytic Converter			
Automobile Commuters Changing Mode						
0 percent	*3.3*	*3.8*	*4.7*	*3.3*	*3.5*	*3.7*
40 percent	3.4	3.9	4.5	*3.4*	3.6	3.6
80 percent	3.6	4.2	4.6	*3.6*	3.6	3.8
Gasoline Price						
No (0 percent) Increase	*3.3*	*3.8*	*4.7*			
US$.33/Litre (40 percent) Increase	3.5	4.0	4.4			
US$.67/Litre (80 percent) Increase	3.7	4.7	4.8			
Price of Catalytic Converter						
US$500-750	*3.3*	*3.8*	*4.7*			
US$170	5.2	5.3	6.0			
Income						
No Increase				*3.3*	*3.5*	*3.7*
10 percent Net Increase				3.5	3.8	3.9
			Buy New Car			
Automobile Commuters Changing Mode						
0 percent	*3.6*	*4.3*	*4.7*	*3.6*	*3.9*	*3.8*
40 percent	3.8	4.2	4.5	*3.8*	4.0	3.7
80 percent	3.8	4.2	4.7	*3.8*	3.9	4.1
Gasoline Price						
No (0 percent) Increase	*3.6*	*4.3*	*4.7*			
US$.33/Litre (40 percent) Increase	3.9	4.2	4.6			
US$.67/Litre (80 percent) Increase	3.8	4.4	5.0			
Price of Catalytic Converter						
US$500-750	*3.6*	*4.3*	*4.7*			
US$170	3.9	4.5	4.8			
Income						
No Increase				3.7	4.3	5.3
10 percent Net Increase				4.0	4.0	4.2

To simplify reading of the table, italicized means are reported more than once.

SDs varied between 2.6 and 3.2.

Table 5
Main Effects of Different Factors on Intentions to Change Travel Mode, Install Catalytic Converter, and Buy New Car

	Intention		
	Change Travel Mode	Install Catalytic Converter	Buy New Car
Health Risks Due to Air Pollution			
Minor	4.2	3.8	3.8
Slightly Increased	4.9	4.2	4.3
Much Increased	5.5	4.8	4.7
Automobile Commuters Changing Mode			
0 percent	4.6	3.8	4.1
40 percent	4.8	3.8	4.1
80 percent	5.1	3.9	4.1
Gasoline Price			
No (0 percent) Increase	4.2	3.7	4.1
US$.33/Litre (40 percent) Increase	4.8	3.8	4.1
US$.67/Litre (80 percent) Increase	5.5	4.0	4.2
Price of Catalytic Converter			
US$500-750	4.5	3.9	4.2
US$170	4.7	5.5	4.4
Income			
No Increase	4.4	3.5	3.8
10 percent Net Increase	4.4	3.7	4.1

Still another interaction effect involving both group factors and, in this case, health risks was found to be reliable in the MANOVAs. A subsequent ANOVA revealed that it was significant for intention to change travel mode, $F(2, 126) = 3.24$, $p<.05$. The interaction seemed to reflect a similar group difference as the other three-way interaction: both those subjects who perceived air-pollution countermeasures more important but felt less morally responsible and those who perceived air-pollution countermeasures less important but felt more morally responsible indicated they were more likely to change mode when the health risks were minor, whereas they did not become as much more likely to do that, as subjects in the other groups became, when health risks increased.

DISCUSSION

Because subjects participating in this study all travelled by automobile to work, it is not surprising that they preferred this alternative over other alternatives. It does not necessarily follow, however, that they were satisfied. In fact, whereas travel time, flexibility in departure times, potential of chaining trips, and potential of carrying cargo were all rated positively, there were some aspects rated negatively such as cost, safety, and parking constraints. Certainly, a future challenge is to design alternative travel modes that satisfy automobile commuters' demand. However, as the present results also suggested, automobile commuters may change their travel behaviour even though the transport systems are not changed. Largely independently of each other, monetary incentives, perceived health risks, and trust in others to change travel mode affected their intentions to change travel mode, install a catalytic converter, and to buy a new car with a catalytic converter. It is of particular interest to note that the three different behaviours were affected differently by the three sets of factors. Whereas replacing the old automobile with a new one did not seem to be related to increased health risks, the other two behaviours were. In addition to personal economy, factors such as social status and reliability are presumably more important for decisions to replace the car.

Despite unanimously favorable attitudes towards automobile commuting in keeping with the stated intentions to change their travel behaviour, subjects expressed strongly that they both perceived measures against air pollution to be important and felt morally responsible for undertaking such measures. Yet, the results failed to show clearly that subjects who perceived countermeasures to be more important and felt more morally responsible for undertaking them were more likely to change their travel behaviour. A likely explanation is that none of the subjects had extremely negative attitudes towards air-pollution countermeasures. Thus, the groups contrasted in the analyses of the results did not represent the extreme ends of the continua. Whether this was peculiar to the sample chosen, or is more generally true, needs to be investigated further[f].

[f] Several nationwide campaigns aimed to increase people's awareness of environmental deterioration have recently taken place. This could partly account for the findings. Employees by the city may furthermore constitute a group with more favorable attitudes.

Another reason for the observed consistency at the aggregate level is that both attitudes and intentions were assessed through self reports. Thus, the consistency may merely reflect subjects' desire to present themselves as consistent. Against this view, at least some of the observed effects were expected: for instance, the effects of the monetary incentives on intentions to change travel mode[g], install a catalytic converter, and buy a new car. On the other hand, some of the effects observed may seem illogical. If, for instance, subjects intend to change mode when health risks increase due to air pollution, why should they then intend to install a catalytic converter (or buy a new car with a catalytic converter)? Part of the reason is that different subjects intended to change mode and to install a catalytic converter. Of those 34 subjects who intended either the former or the latter, only 15 intended both. (The corresponding figures for intending to change travel mode and to buy a new car were 36 and 13, respectively.) Other reasons are that subjects might have had different time horizons when responding to the different questions, or that they also thought of other than work trips when indicating their intentions to install a catalytic converter or buy a new car. Different time horizons is a more plausible reason for why 13 of 21 subjects who intended to either install a catalytic converter or buy a new car also intended both.

Another puzzling finding was that increased health risks affected subjects' intentions to change their travel behaviour, even though no other automobile commuters changed travel mode, at the same time that the number of automobile commuters changing mode only affected intentions to change mode. Subjects were expected to act on the basis of understanding that changing one's own behaviour is pointless unless a majority of automobile commuters do the same. However, their stated intentions to change travel mode might instead have reflected a social pressure to do the same as other automobile commuters, many of whom were colleagues or friends[13]. The results may also be consistent with Dawes' argument[14] that lay people do not understand the pay-off structure of commons dilemmas.

That it has been possible, at least partially, to account for the seemingly illogical ways of responding should not detract from the possibility that intentions to change travel behaviour are far from perfectly correlated with actual changes in travel behaviour. Such inconsistencies are well known phenomena[15]. A reason is simply that people

[g] Right after the completion of the study, a tax increase caused gasoline prices to go up by about 20 percent. Subjects participating in the study were then called for another interview. Although all of those possible to reach (65) were found to know about the price increase, none stated it had caused them to drive less to work. Seven months later, when the gasoline price was about the same, 4 out of 56 (7 percent) indicated they drove less to work. Thus, even expected effects may take substantial time before they materialize.

change their minds. Another reason is that people (and investigators) overestimate the degree of control they have over their behaviour. Unforeseen events (divorce, move, job promotion, etc.) which critically change the circumstances may become obstacles to executing the best of intentions. An important future research task is to find out how accurately intentions to change travel behaviour correspond to actual changes under a wide variety of conditions.

ACKNOWLEDGMENTS

The study reported in the paper was financially supported by grant #5318269-7 to the Transportation Research Unit from the Swedish Environmental Protection Agency. The authors are indebted to Anna-Lisa Nilsson for assistance in conducting the interviews. The paper was written while the first author visited the University of California, Irvine, USA. The visit was made financially possible by a Fulbright grant.

REFERENCES

1. Evans, G. W., and S. V. Jacobs, "Air Pollution and Human Behaviour," *Journal of Social Issues*, 1981, 37(1), 95-125.

2. Stern, P. C., and S. Oskamp, "Managing Scarce Environmental Resources," in D. Stokols and I. Altman (editors) *Handbook of Environmental Psychology*, vol. 2, Wiley, New York, 1987, 1043-1088.

3. Dawes, R. M., "Social Dilemmas," *Annual Review of Psychology*, 1980, 31, 169-193.

4. Messick, D. M., and M. B. Brewer, "Solving Social Dilemmas: A Review," in L. Wheeler and P. Shaver (editors), *Review of Personality and Social Psychology*, Vol. 4. Sage, Beverly Hills, CA, 1983, 11-44.

5. Lee-Gosselin, M. E. H., "In-Depth Research on Lifestyle and Household Car Use Under Future Conditions in Canada," in *Travel Behaviour Research*, Gower, Aldershot, England, 1989, 102-118.

6. Hardin, G., "The Tragedy of the Commons," *Science*, 1968, 162(3859), 1243-1248.

7. Caporael, L. R., R. M. Dawes, J. M. Orbell and A. J. C. van de Kraagt, "Selfishness Examined: Cooperation in the Absence of Egoistic Incentives," *Behavioural and Brain Sciences*, 1989, 12(4), 683-739.

8. Morikawa, T., M. Ben-Akiva and D. McFadden, "Incorporating Psychometric Data in Econometric Travel Demand Models," *Transportation Science*, in press.

9. Slovic, P., "Perception of Risk," *Science*, 1987, 236(4799), 280-285.

10. Schwartz, S. H., "Normative Influences on Altruism," in L. Berkowitz (editor), *Advances in Experimental Social Psychology*, Vol. 10. Academic Press, New York, 1977, 221-279.

11. Komorita, S. S., J. H. Hilty and C. D. Parks, "Reciprocity and Cooperation in Social Dilemmas," *Journal of Conflict Resolution*, 1991, 35(3), 494-518.

12. Wit, A. P., and H. A. M. Wilke, "The Effect of Social Categorisation on Cooperation in Three Types of Social Dilemmas," *Journal of Economic Psychology*, 1992, 13(1), 135-151.

13. Capporel, L. R., et al., *op. cit.*

14. Dawes, R. M., *op. cit.*

15. Fishbein, M., and I. Ajzen, *Belief, Attitude, Intention, and Behaviour: An Introduction to Theory and Research*, Addison-Wesley, Reading, MA, 1975.

6

USER PERCEPTION OF PUBLIC TRANS-PORT LEVEL OF SERVICE

J. de D. Ortúzar, A. M. Ivelic, and A. Candia

ABSTRACT

Santiago is probably the most polluted capital in Latin America today and the most visible source is public transport emissions. Furthermore, a steady car-ownership increase in the last decade is at the root of severe congestion problems in several parts of the city during the peak; also, car emissions account for the less visible, but perhaps more hazardous, components of Santiago's smog. The government wants to intervene rationalising the rather chaotic public-transport supply and introducing some disincentives to the indiscriminate use of the car. However, the authorities are also convinced that policies of this nature, to be successful, require the supply of reasonable alternatives for those to be restricted; this requires understanding the perception and importance attached by users and prospective users of the public-transport system to its various level-of-service (LOS) attributes, in order to design "tailor made" services targeted to particular market segments.

Various types of surveys were conducted in order to identify, rank (in order of importance), and rate (according to actual performance as perceived by users), the most relevant LOS variables to current and potential users of the Santiago public transport system. First, a Delphi-type exercise, with two waves, was administered to several national experts; second, a set of semi-structured interviews were administered to focus groups; third, a structured survey was administered to a large sample of users of all public-transport modes available in the city (buses and minibuses, shared taxis, and underground); and fourth, a stated-preference experiment was administered to another large sample of public-transport users.

The paper briefly presents the main results of the first two surveys which allowed the identification of a set of relevant LOS variables, and concentrates on an analysis of the results of the third (rank and rate) and fourth (determination of LOS attribute weights), that allowed the team to make a diagnosis of the current state of the system from the point of view of users.

INTRODUCTION

During the last decade-and-a-half, car ownership has increased approximately fourfold in Santiago, bringing the total number of cars on the road to some 500,000 which, together with some 13,500 buses (which are organised for operating purposes into some 400 lines) and around 4,000 taxis and shared taxis (the latter operating in some 200 lines), have started to produce severe congestion problems in many parts of the city during the morning and evening peaks. On the other hand, the fumes produced by such a large bus fleet (Santiago has only 4.5 million inhabitants), which features a large proportion of old and badly-maintained buses, have contributed to generating air-pollution indices that, in recent years, have easily exceeded the safety regulations during most of the day for long periods of the year. This is the visible problem, i.e., smoke and particles due to badly-maintained diesel engines, but Santiago also has bad indices of more dangerous fumes such as carbon monoxide and nitrogen oxides which are caused by car engines. The problem in this case is not the size of the fleet (which is still rather modest), but the fact that weather conditions in Santiago are rather special: there is a "thermal inversion" effect such that, during most of the year, the mountains surrounding Santiago's valley act as a veritable pot with a lid.

The new government has promised to act on, and hopefully solve, these twin problems. Their policy is geared to maintain the still high level of usage (around 60 percent of all motorised trips) of Santiago's public transport system (which also features 27 km. of underground in two lines that join at the CBD). This calls for restrictions to the unfettered use of the private car (plans for a supplementary license scheme are being considered), and also for a drastic improvement to the quality of service provided by the bus operators, because the government does not consider it fair or realistic to impose restrictions without providing reasonable options to those suffering these restrictions. The current bus system is generally acknowledged to be very good in coverage (almost nobody has to walk more than two blocks to get to a bus stop) and with extremely good frequency, but it is also regarded to be expensive (the highest fares in Latin America), unsafe, uncomfortable, and rather slow.

The study on which this paper is based was designed with two main objectives: first, to identify relevant level-of-service (LOS) attributes to users and potential users of the public-transport system, and second, to determine the perceived importance of these variables. For this, users were stratified by income, time of day of travel, sex, and location in the city. The idea is to design customized bus services, if necessary. Secondary objectives, not dealt with in great detail here, were to find out public opinion about the influence of the transport system on the congestion problem of Santiago and about possible means of ameliorating it, and to measure, as objectively

as possible the values of these relevant LOS variables in a representative sample of the public-transport lines operating in the city.

The rest of the chapter is organised as follows: the methodology section describes the four types of survey conducted to identify the more relevant LOS variables and measure their perceived importance; the results section summarises the main results obtained; and the last section presents our conclusions. The study also featured a reasonable review of literature about the issues of interest to the study which is not discussed due to lack of space; however, we provide a list of the main references consulted at the end of the paper.

SURVEY METHODOLOGY

Identification of Relevant LOS Variables

Delphi-type survey

The objective of this survey was to obtain a first approximation to the variable-identification problem. A group of 23 public-transport specialists (academics, consultants, civil servants, and operators) agreed to participate in a two-wave survey. In the first wave, they were asked to identify what they felt to be the more relevant LOS attributes in the case of bus services, distinguishing by income level of the user. They were also asked to relate quasi-subjective variables (such as comfort and reliability) with operational characteristics of the services, and to suggest appropriate measurement methods for each such variable. Finally, they were asked to provide ideas about what characteristics of either the trips or the users could influence the perception about the services supplied.

The second wave presented each participant with a list of all the variables (some 20) thus submitted and the number of times that each had been mentioned; they were asked to select those more relevant for each income stratum. The idea was to finish up eventually with a number, not exceeding ten variables, in order to conduct a stated-preference (SP) survey as the final part of the study. Table 1 shows the final results of this exercise, indicating the ranking according to importance for each income group, in the opinion of the expert panel.

Table 1
Importance Ranking of Relevant Level-Of-Service Variables (Delphi Survey)

Variable Definition	Income Level		
	Low	Medium	High
Travel cost	1	1	7
Waiting time	2	2	2
Walking time	3	4	5
In-vehicle travel time	4	3	1
Safety (in general, this attribute was split later)	5	5	4
Reliability (in general, this attribute was split later)	6	7	6
Transfer penalty	7	8	8
Comfort (in general, this attribute was split later)	8	6	3
Stopping pattern (at predefined bus stops or hail anywhere)	9	11	11
Alternative use of the time (i.e., reading, knitting)	10	9	10
Bus driver appearance and behaviour	11	10	9

The panel also identified the following characteristics as strong determinants of differences in perception of the LOS attributes by the users:

- physical condition (old, infirm and children vs. others)

- arrival time at destination (fixed vs. flexible)

- time of day of travel (peak vs. off-peak)

- users with or without access to car and/or Metro.

Semi-structured focus-group survey

A total of 65 individuals, organised in 13 groups of five, were interviewed by a team of two researchers who were previously trained by academics of the School of Psychology. Each interview session lasted for some 1.5 hours and the participants were treated to a light snack (either tea and biscuits or soft drinks and sandwiches, depending on the time of day); conversations were recorded and later analyzed in the office. Contacts were made through parish priests and acquaintances. Individuals were chosen so that at least two-thirds were public-transport users, at least one-third travelled during the off-peak, and at least one-third were female. In order to detect possible income and/or location differences, low- and middle-income people from the North, South, and Western parts of the city (15 individuals per sector), and medium- and high-income people from the Eastern part of the city (10 individuals per stratum) were considered. Homogeneity with respect to these categories constituted the basic criterion for group formation. However, it was felt important to allow some hetero-geneity with respect to sex in order to contrast opinions and attitudes. Table 2 summarises the composition of the 13 focus groups.

Information about relevant variables was obtained on the basis of spontaneous or induced opinions, the support these gathered (unanimous, majority, minority) and the number of times each attribute was mentioned during the session. In this sense the list of variables from the Delphi exercise proved important, first, as a means of revitalising the conversation when it decayed and second, as a means of contrast with the variables mentioned freely by the interviewees. This exercise led to redefining some of the initial variables as follows:

- *Comfort*: this was disaggregated into two components, comfort associated with vehicle occupancy and comfort associated with the vehicle characteris-tics (age, appearance, seat quality, corridor room, noise, dirt). The former also considers two situations of interest, travelling either standing or seated.

- *Safety*: three variables of interest were defined in this case, accident risk, internal safety (associated with being robbed inside the vehicle), and external safety (associated with being mugged when walking to or from the bus stop, or while waiting).

- *Reliability*: this was separated into two components, travel-time variability and waiting-time variability.

Table 2
Group Composition for Semi-Structured Interviews

Group	Location	Income Level	Sex	Travel Period	Usual Mode
1	N	Low-medium	M	Peak	Public Transport
2	N	Low-medium	M/F	Peak	Public Transport
3	N	Low-medium	M/F	Off	Public Transport
4	S	Low-medium	M	Peak	Public Transport
5	S	Low-medium	M/F	Peak	Public Transport
6	S	Low-medium	M/F	Off	Public Transport
7	W	Low-medium	M	Peak	Public Transport
8	W	Low-medium	M/F	Peak	Public Transport
9	W	Low-medium	M/F	Off	Public Transport
10	E	Low-medium	M/F	Peak	Public Transport
11	E	Low-medium	M/F	Off	Public Transport
12	E	High	M	Peak	Private car
13	E	High	F	Off	Private car

- *Walking time*: an additional variable, "walking," was defined in this case; the intention was to capture the pleasure or otherwise to the user of walking to or from a bus stop.

After analyzing the results of these interviews it was clear that there are some differences in perception according to location. First, the origin-destination combination plays an important role, because travel options are not homogeneous in this sense; second, external safety is a more serious problem in the low-income peripheral parts of the city. The stratification by income is essential because several attributes (e.g., cost, comfort, and safety) are valued very differently by members of each stratum. Another important stratification is by time of day of travel, because

conditions (and hence their valuation) vary significantly between peak and off-peak periods. Finally, the stratification by sex was not found relevant, although clearly women attach more weight to the occupancy level which can be related to their discomfort with unwanted physical contact by persons of the opposite sex.

The 12 variables finally chosen for the next stage of the study follow. As can be seen, not all the redefined variables were considered because it was judged infeasible both to measure them objectively and to describe them to users in a clear-cut fashion:

- Accident risk

- Alternative use of the time while travelling

- Bus driver appearance and behaviour

- Bus occupancy (associated with comfort)

- In-vehicle travel time

- Possibility of travelling seated

- Travel cost

- Variability of travel time

- Variability of waiting time

- Vehicle comfort (seat quality and spacing, dirt, noise, etc.)

- Waiting time

- Walking time

Determining the Importance of LOS Attributes

Structured survey

The main objective of this survey was to rank the variables above in order to select those to be used in the final SP exercise. However, and particularly for the sake of this chapter, a secondary objective that appeared while designing the survey instrument became very important in its own right: to obtain an individual rating or mark (between 1 — very bad — and 7 — excellent, as in the Chilean school rating system) for each attribute, related to the user's perception of its current quality in his/her trip making.

A stratified sample of 690 bus users was taken. The 18 strata were formed on the basis of spatial location in the city (North, South, East, and West), income (low, medium, and high, the latter only in the Eastern part of the city) and period of the day (peak and off-peak). A minimum of 30 observations per stratum was obtained. Interviews for peak-period travellers were carried out at the workplace; those for off-peak travellers at their home. To check for particular bias in the perceptions of two special groups (workmen and students), an additional sample of approximately 70 labourers and 60 students was also taken. Finally, a sample of 275 Metro users and 208 shared-taxi users was gathered, but this sample was asked only to rate each LOS attribute both for their preferred service and for the bus system.

The mass of information was examined by period and by income group. Table 3 presents the number of observations on each main category for both periods of the day. The workplace interview method was judged more efficient than interviewing at the household, because it yielded many more valid interviews for the same amount of interviewer time.

Table 3
Distribution of the Stratified Sample

Class	Bus Users	Metro Users	Shared Taxi Users
Peak period			
Low income	192	69	35
Medium income	192	70	57
High income	33	12	8
Labourers	73	-	-
Students	61	-	-
Off-peak period			
Low income	121	57	39
Medium income	121	52	58
High income	30	16	11

Stated-preference survey

The final stage of the study involved submitting a sample of 284 individuals to two SP games, with four attributes each, in order to estimate the weights attached to each LOS variable in the level-of-service vector. Two games were needed because the structured survey ranking allowed selection of seven attributes and it is not recommended to design games where more than five attributes may vary at a time. In order to have a common basis to assess differences in importance, the variable *travel cost* was kept in both games.

The variables considered in the first game were the following:

- *Travel cost*, with two levels (0 and 30 percent increment)

- *In-vehicle travel time*, with three levels (-15, 0 and 15 percent increment)

- *Variability of waiting time*, with two levels (with and without variability)

- *Accident risk*, with three levels (hanging, riding in an old bus, riding in a new bus)

and those used in the second game were:

- *Travel cost*, with the same two levels

- *Waiting time*, with three levels (-50, 0 and 50 percent increment)

- *Bus occupancy*, with three levels (crowded, standing with few others, seated)

- *Vehicle comfort*, with three levels (old and dirty bus, new and clean minibus, new and clean omnibus).

As can be seen the variables *waiting time* and its variability were separated; also, more traditional and easier to measure variables, such as *in-vehicle travel time* and *waiting time*, were mixed with more subjective attributes such as *accident risk* and *vehicle comfort*.

The SP games were designed and conducted with the aid of the Game Generator program developed by the U.K. consulting firm of Steer Davies Gleave. This allowed us to build custom-made situations for each respondent, by probing initially for their usual travel costs and times. The design (only main effects) required nine options (combinations of attributes and levels) which were combined into 14 pairs of "cards" in each case. Users were asked to choose one card from each pair and these results were later analyzed using a multinomial-logit routine. Prior to this, a series of consistency checks were performed on the data (i.e., selection of dominated options, violations of transitivity) and the offending cases (or individuals if they exhibited too many inconsistencies) were removed from the data bank. Table 4 presents the total number of clean "choices" which resulted from the SP interviews (i.e., after discounting the inconsistent cases).

Both peak and off-peak period interviews were conducted at the workplace, but, in the latter case, magazine stores, located at both the CBD and the high-income district, were chosen as their employees enter work after the peak (between 9:30 and 10 a.m.).

In order to compare the importance of each attribute, direct elasticities of demand with respect to all of them were calculated first for each option. However, because the alternatives are not really distinct (i.e., they just have different LOS attributes), a weighted average was computed using as weights the proportions of users choosing each option according to the estimated model.

Table 4
Number of Choices for Logit Analysis in Each SP Game

| | Number of Cases | | |
	Peak Period	Off-Peak Period	Students
Game 1			
Low income	587	-	
Medium income	1065	1145	
High income	225	-	
Total	1877	1145	438
Game 2			
Low income	597	-	
Medium income	1039	1137	
High income	234	-	
Total	1870	1137	479

MAIN RESULTS OF THE STUDY

Ranking Results

Table 5 shows an example of the large number of results obtained from the ranking exercise on the 12 LOS variables presented to bus users. The numbers correspond to the average group rank (individual ranks vary between 1 and 12) for the peak period. It can be seen that there is enough dispersion between them, which means that there is a certain consensus of opinion about the importance of each variable among bus users in this period.

Table 5
Ranking Results for the Peak Period

Variable	Total Sample	Income Level			Additional Sample	
		Low	Medium	High	Labourer	Students
Accident risk	4.9	5.1	4.6	4.7	5.6	6.8
Vehicle comfort	5.4	5.9	5.1	4.7	5.7	7.1
Driver appearance	5.5	5.5	5.3	6.3	6.4	6.8
Travel cost	5.8	5.1	6.3	7.7	3.2	4.3
Waiting time	6.1	6.5	5.9	4.9	7.5	5.4
Travel time	6.6	6.5	6.6	6.7	6.1	5.1
Bus occupancy	6.7	7.1	6.4	5.8	7.4	6.6
Var. of wait time	7.3	7.5	7.2	5.9	8.3	6.5
Possibility of seat	7.4	7.4	7.4	7.8	7.4	7.2
Var. of travel time	8.4	8.6	8.2	7.9	9.2	7.1
Walking time	9.3	8.9	9.7	9.4	8.2	8.6
Alternat. use of time	9.9	9.8	9.8	11.9	8.8	9.5

These results are interesting not just because they confirm intuitive feelings about the relative importance of most variables for different groups. It is worth mentioning that we have good reasons to support all the differences noted, but detailed discussion of these is not attempted here due to lack of space.

After careful consideration, the seven variables discussed in the previous section were selected; they are in general those ranked highest. The exception is the variable *bus driver appearance and behaviour* which was rejected, in spite of its popularity, for two reasons: first, it was not clear how it could be measured objectively in practice, and second, the study team was not convinced that users could really view this variable as part of the level-of-service vector.

Rating Results

As explained, rates varied in this case between 1 (very bad) and 7 (excellent). However, in order to simplify the interpretation of results the rates were grouped into just two aggregate classes: Bad or Regular (marks 1 to 4) and Good or Excellent (marks 5 to 7). Table 6 presents the percentage of users of each public transport mode which rate as bad or regular their 12 LOS attributes in the peak period. As can be seen, although bus users have a very bad opinion about this service, this is not the case for Metro and shared taxi users with respect to their services.

Table 6
Percentage of Users Giving Bad or Irregular Ratings in the Peak Period

Variable	Buses	Metro	Shared Taxi
Accident risk	66	13	12
Vehicle comfort	59	5	18
Bus Driver appearance	67	na	11
Travel cost	54	7	14
Waiting time	49	7	28
In-vehicle Travel time	49	5	9
Bus occupancy	70	35	na
Variability of wait time	55	10	22

It is important to note that 70 percent of those interviewed rated the *walking time* variable as good or excellent (this is probably why this variable is not perceived as important in the ranking exercise), and 78 percent declared that they prefer that buses

should stop only at predetermined (established) bus stops. The only exception are students, 80 percent of whom declare a preference for the current "hail anywhere" system.

Table 7 compares the percentages rating the bus system attributes in the peak period as regular or bad, differentiating between bus users (stratified by income), Metro, and shared-taxi users. As can be seen, the general perception of the system is basically bad with the exception of the variables *travel cost* and *waiting time* for medium- and high-income bus users, and for usual users of shared taxi. Other attributes that are not assessed so unkindly are *in-vehicle travel time* for low- and medium-income bus users, and the *variability of waiting time* for shared-taxi users. It is important to remark that further analyses stratifying by spatial location, sex, and age did not yield any noticeable differences.

Table 7

Percentage of Users by Income Level and Mode, Which Rate as Bad or Regular the Bus System Attributes in the Peak Period

Variable	Bus Users			Metro Users	Shared Taxi Users
	Low	Medium	High		
Accident risk	65	68	63	70	61
Vehicle comfort	56	61	74	68	41
Driver appearance	69	65	70	68	50
Travel cost	64	46	43	63	34
Waiting time	52	45	47	60	33
In-vehicle travel time	49	48	60	62	55
Bus occupancy	68	72	66	65	57
Variability of wait time	58	51	56	57	48

Table 8 presents the same results as Table 6 but for the off-peak. As can be seen again, bus users have a very low opinion of this service, while this is not the case for Metro and shared-taxi users.

Table 8

Percentage of Users Giving Bad or Irregular Ratings in the Off-Peak

Variable	Buses	Metro	Shared Taxi
Accident risk	73	11	15
Vehicle comfort	58	8	14
Bus Driver appearance	64	na	12
Travel cost	62	5	10
Waiting time	61	8	15
In-vehicle Travel time	60	3	7
Bus occupancy	65	22	na
Variability of wait time	65	10	16

Due to the consistency with intuition, it is interesting to note the worse ratings given by bus users to the variables *accident risk, travel cost, in-vehicle travel time, waiting time,* and *variability of waiting time*, in relation to the peak-period conditions. However, the obvious improvement in the bus-occupancy variable was not reflected by a substantially better rating for this attribute. It is also interesting to mention that more than 70 percent of those interviewed rated as good or excellent the *walking-time* variable, that more than two-thirds considered a good or excellent idea to have a conductor on the bus services and that nearly 80 percent of respondents preferred that buses should stop only at established bus stops. Finally, Table 9 presents the same comparison as Table 7, but for the off-peak. As can be seen, the majority of results observed in the peak are not repeated here. For example, it is interesting to mention the following effects:

- The *vehicle-comfort* variable is rated more positively by low-income bus users, and so are the variables *in-vehicle travel time* and *variability of waiting time* by usual shared-taxi users.

- The variables *bus driver appearance and behaviour, waiting time,* and *bus occupancy* are rated even worse than in the peak by high-income bus users,

and so are the variables *travel cost, in-vehicle travel time,* and *waiting time* by medium-income bus users, and the attribute *variability of waiting time* by usual Metro users.

Table 9
Percentage of Users by Income Level and Mode, Who Rate as Bad or Regular the Bus System Attributes in the Off-Peak

Variable	Bus Users			Metro Users	Shared Taxi Users
	Low	Medium	High		
Accident risk	75	72	73	69	54
Vehicle comfort	48	64	73	64	38
Driver appearance	63	58	87	61	55
Travel cost	68	61	40	61	32
Waiting time	59	63	60	66	28
In-vehicle travel time	61	58	67	68	40
Bus occupancy	64	58	80	60	59
Variability of wait time	64	64	66	68	39

Finally, it is worth noting that further stratifications, particularly by spatial location, showed higher differences than in the peak period in this case.

Stated-Preference Results

Tables 10 and 11 present the main results of the SP exercise in terms of LOS-variable rankings according to their average demand elasticities, for peak and off-peak users respectively. A value of one was assigned to the relatively less-important variable in each case.

Table 10

Relative Importance of Attributes to Peak Period Users

Low Income		Medium Income		High Income	
Travel cost	29.50	In-vehicle time	5.04	In-vehicle time	2.62
In-vehicle time	9.85	Travel cost	4.88	Accident risk	1.72
Accident risk	6.13	Accident risk	2.86	Waiting time	1.67
Vehicle comfort	4.47	Vehicle comfort	2.01	Vehicle comfort	1.54
Waiting time	2.50	Var. of wait time	1.65	Travel cost	1.45
Bus occupancy	1.06	Waiting time	1.62	Var. of wait time	1.41
Var. of wait time	1.00	Bus occupancy	1.00	Bus occupancy	1.00

Table 11

Relative Importance of Attributes to Off-Peak Period Users and Students

Off-Peak Users		Students	
In-vehicle time	4.31	In-vehicle time	4.16
Travel cost	2.76	Travel cost	3.33
Accident risk	2.15	Accident risk	1.91
Vehicle comfort	1.71	Waiting time	1.53
Var. of wait time	1.31	Vehicle comfort	1.11
Bus occupancy	1.00	Bus occupancy	1.00

An important advantage of these rankings is that, apart from rankings, information is available on how much more desirable or important a given variable is in relation to the others. Thus, for example, *vehicle comfort* is two times more important than *bus occupancy* to medium-income users, and *travel cost* is almost 30 times more important than *variability of wait time* to low-income users. Finally, it is worth noting that the three more important variables in almost every case are: *in-vehicle travel time, travel*

cost, and *accident risk;* the only exception is the second one in the case of high-income users. Finally, a comparison of these results with those of the structured survey shows that both sets of ranks are fairly similar. For example, the four more important variables are the same in the case of low-income users and for the rest, at least the three highest ranked are the same in both cases, although the ordering is not the same.

CONCLUSIONS

A series of surveys allowed us to identify and select a set of 12 level-of-service attributes that are considered relevant by users of the Santiago public-transport system. The surveys also allowed us to choose the more important seven for subsequent stated-preference analysis, which revealed their ranking and relative importance. These variables include most of the typical attributes used in mode-choice models, such as travel cost, in-vehicle travel time, and waiting time. The only exception is walking time, which was not judged sufficiently important, probably because the current system allows the great majority of prospective users to access the system with a minimal walking distance. The other variables are of a more subjective nature but, in one form or another, have been mentioned and examined in the specialised literature (i.e., safety, comfort, and reliability).

The study also allowed us to make an interesting diagnosis of the current state of the system from the user's point of view. By rating the above 12 variables, it became evident that bus users are rather dissatisfied with the service they are currently receiving. This is not the case, however, with current Metro and shared-taxi users (particularly the former) who show much greater satisfaction with these services. The surveys allowed us to explore other important questions, such as the willingness of people to change the current "hail the bus" system (buses stop anywhere they are hailed, although formal bus stops are clearly signed) to a less flexible but more efficient "stop at bus stops only" system.

Finally, other aspects of the study not commented on in this chapter, but probably relevant to people interested in the field, include the design of appropriate measure-ment methods for each variable identified and their actual measurement in practice for a sample of bus services in the city. This allowed the study team to make an objective diagnosis of the system, which may be contrasted with that made from the user's point of view. Questions about the air-pollution problem, its causes and acceptable solutions to current users of the system, were also explored in the study. It was found that the public is extremely receptive to the press, in the sense that those

measures that have enjoyed a better press coverage are clearly preferred over other, less-publicised measures, but which may be as good or better for the community.

ACKNOWLEDGEMENTS

The authors would like to express their thanks to Enrique Strobl, Luis Vega, and Ronald Zamora from CADE Consulting Engineers, our partners in conducting the study, and to Pablo Valenzuela and Fernando Vergara for their help in collecting the data. Thanks are also due to Daniel Fernández from the Ministry of Transport who acted as technical counterpart for the study.

REFERENCES

1. Allen, W. G., and L. G. Grimm, "Development and Application of Performance Measures for a Medium-Sized Transit System," *Transportation Research Record, No. 746*, 1980, 8-13.

2. Benjamin, J., "Utilization of Attitudinal Measurement Techniques to Analyze Demand for Transportation Methods, Applications and New Directions," In Dutch Ministry of Transport and Public Works (Eds.), *Behavioural Research for Transport Policy*, 1986, VNU Science Press, Utrecht.

3. Chang, Y. B., and P. R. Stopher, "Defining the Perceived Attributes of Travel Modes for Urban Work Trips," *Transportation Planning and Technology*, 1981, 7(1), 55-65.

4. Koppelman, F. S., and P. K. Lyon, "Attitudinal Analysis of Work/School Travel" *Transportation Science*, 1981, 15(3), 233-254.

5. Koppelman, F. S., and E. I. Pas, "Travel Choice Behavior: Models of Perceptions, Feelings, Preference and Choice," *Transportation Research Record, No. 765*, 1980, 24-33.

6. Golob, T. F., E. T. Canty, R. L. Gustafson, and J. E. Vitt, "An Analysis of Consumer Preferences for a Public Transportation System," *Transportation Research*, 1972, 6(1), 81-102.

7. McKnight, C. E., A. M. Pagano, and R. E. Paaswell, "Using Quality to Predict Demand for Special Transportation," In Dutch Ministry of Transport and Public Works (Eds.), *Behaviourial Research for Transport Policy*, 1986, VNU Science Press, Utrecht.

8. Neveu, A. J., F. S. Koppelman, and P. R. Stopher, "Perceptions of Comfort, Convenience and Reliability for the Work Trip," *Transportation Research Record, No. 723*, 1979, 59-63.

9. Nicolaidis, G. C., "Quantification of the Comfort Variable," *Transportation Research*, 1975, 9(1), 55-66.

10. Paine, F. P., A. N. Nash, S. J. Hille, and G. A. Brunner, "Consumer Attitudes Toward Auto Versus Public Transport Alternatives," *Journal of Applied Psychology*, 1969, 53(6), 472-480.

11. Prashker, J. N., "Mode Choice Models with Perceived Reliability Measures," *Transportation Engineering Journal of ASCE,* 1979,105(TE3), 251-262.

12. Spear, B. D., "Generalized Attribute Variable for Models of Mode Choice Behaviour," *Transportation Research Record, No. 592*, 1976, 6-11.

13. Stopher, P. R., B. D. Spear, and P. O. Sucher, "Toward the Development of Measures of Convenience for Travel Modes," *Transportation Research Record, No. 527*, 1974, 16-32.

14. Van der Reis, P., "The Transferability of Rating Scales Techniques to Transport Research in a Developing Country," In E.S. Ampt, A.J. Richardson and W. Brög (Eds.), *New Survey Methods in Transport*, VNU Science Press, Utrecht, 1985.

7

CATEGORISATION AND INTERPRETATION OF URBAN AND ROAD ENVIRONMENTS

Dominique Fleury and Danièle Dubois

ABSTRACT

Research on the organisation of memorized representations and the analysis of the mental activities in which these representations are involved have shown the central role of human categorisation. The psychological principles of mental categorisation are aimed at reducing the multiplicity and the diversity of objects and tasks to proportions compatible with the needs and the processing abilities of the individual.

A research program was carried out on the categorisation and interpretation of urban and road environments, by applying theories and methods specific to contemporary cognitive approaches to research problems resulting from safety and operator-activity analyses. The safety objectives of this research were to improve the legibility of the environment in which the driving task was taking place. The experiments already completed led to conclusions on the categorisation principles used by the subjects, the type of clues used and the relevance of their co-occurrences.

INTRODUCTION

At the beginning of the 1980s, the question of road legibility became a topic requiring further thought. Local authorities and engineers responsible for urban planning, and in particular for roads running through small built-up areas and urban-approach roads, were forced to go beyond their former overly normative methods of approach, and take into account not only the traffic passing through, but also the complexity of roadside characteristics, and the demands of local users. The resulting planning principles tend to show how the characteristics and functions of the space in which drivers travel make it legible to them.

Road-accident research also deals with these particularly sensitive areas, such as roads through small built-up areas and urban-access roads. Work is directed towards examining the influence of infrastructure and the environment in accident production, and the way in which users understand the areas through which they travel.

Finally, research by psychoergonomic experts into driving behaviour tends to reveal the relevant organising mechanisms. It makes use of real-life situations, experiments, and simulations. The cognitive aspects of activity control are becoming the most important factors to be studied and taken into account.

The most recent research in this field, which has put considerable emphasis on analyzing activity and risk situations, has led to results that are often valid only within the context of the study itself. It, therefore, became apparent that it was important to study these road contexts and, in particular, permanent driver representations. A research program into the mental categorisation of road networks was carried out jointly by teams from INRETS, who contributed their skill and expertise in the field of road safety, and the Laboratory of Physiological and Cognitive Ergonomy (EPHE), which dealt more specifically with concept structure in the field of cognitive research[1].

PROBLEM AND HYPOTHESES

Recognition of Road Sites and Perception of Risk

Expectancies and perception of road hazards

To drive means having to confront situations that are liable to become critical. Such situations can arise when encountering another car or a pedestrian, particularly when the use (in the widest sense of the word) of the road varies considerably. This is the case when a pedestrian crosses a road, when a resident wants to park, or when two cars are travelling at different speeds. The physical characteristics of curves may also produce considerable dynamic demands, thus creating risk situations that differ from the previous situations, but that also have to be dealt with by drivers.

[1] Researchers from other organisations also took part in this programme: J. P. Berthélemy from the Ecole National Supérieure des Télécommunications, E. Diday and P. Bertrand from INRIA/University of Paris IX Dauphine, A. Guénoche from the Representation and Processing of Knowledge Group at the CNRS in Marseille, and J. P. Mazeau from the Multimedia Telecommunications Laboratory at the University of Paris VIII.

To be able to deal with a road situation, it must be perceived in such a way that its nature can be understood and, therefore, that appropriate action can be taken. Perception of risk involves both assessing the hazard and one's own ability to deal with it [1,2]. For a hazard to be perceived, the relevant clues must be visible, the driver's information acquisition strategy must enable him or her to detect what is relevant, and, finally, the resulting interpretation should be sufficiently consistent with the event in question to lead to effective action. This assumes that the in-situ expectancies are based on driver representations [3,4,5]. It is these processes that are taken into account when working to improve the traffic system and, more particularly, the level of safety; by modifying the perception drivers have of the network, the road, the equipment, and the environment. In France, therefore, for the past few years, emphasis has been laid on the concept of road legibility, a metaphorical way of indicating road space comprising the roadway, installations, environment, and scenery that enable the driver to bring cognitive processes into play. By thus giving a meaning to this space, the driver is able to implement actions appropriate to the situation.

The user, when travelling on a road, because of his previous experience and making use of clues which thus become relevant, recognizes the type of road, so enabling him or her to deduce problems likely to hinder or even impede his or her progression. These expectancies refer to possible encounters with other drivers, obstacles on the road, limitations linked to alignment, etc. It can also be assumed that the user has readily available schemata [2,6] with which to understand these situations. These schemata are indissolubly linked to her or his expectancies and will enable her or him to deal with these conflicts or difficulties should they arise. This formalism, derived from cognitive science [7], reveals both the orienting of information acquisition towards what seems relevant, in view of the context, and the ability to complete the gaps when information is lacking by falling back on values by default. Expectancies and comprehension schemata condition responses and, therefore, the decisions made during a driving-activity phase, particularly the level of attention, speed, vehicle trajectory, and the information acquisition strategy. Thus, confronted with a situation, the driver previews his progression, and the way in which he can deal with it so as to avoid a collision. These previews are based on knowledge that can be formalised into

[2] These schemata could first be thought to be knowledge used to analyse a specific problem, such as a pedestrian crossing the road, moving off from a parking place, a vehicle coming out from a small road, etc. Because there are correlations between conflicts, it can be supposed there are schemata that are less analytical and more generic, making it possible to process a complex situation in its entirety, e.g., a shopping street, driving through a market, or an intersection involving several streets. The comprehension schemata are used to build up action strategies and acquire information that is specific to these simple or complex situations.

scenarios, adapted to the type of problem, and that are substantiated as the situation progresses and the appropriate actions are implemented. It is, therefore, possible to provide a formal representation of the progression of the situation, in which a specific path is covered in the algorithm presenting the range of options, until the conflict is resolved or a collision has occurred [8,9].

Expectancies in movement dynamics

The analysis of driver activity, as described above, should include movement dynamics. In this way, it is possible to understand how these expectancies are built up when performing the driving task. According to Alexander and Lunenfeld [10] there are two types of expectancies :

- the first are long term and are brought into play when performing a task. They are built up through driving experience, learning, and culture,

- the second are short term and are built up specifically during each journey.

Long-term expectancies exist *a priori*. The majority of operating regulations for traffic and layout systems are the same at a national and often international level. This enables users to structure valid expectancies over a long period of time and in different sites. Thus, red is used throughout the world to indicate "danger," "stop," and green to indicate "go ahead." Similarly, but in a less normatively-structured way, types of road sites can be recognized by the driver who also knows how to predict the nature of the relevant difficulties (there are no pedestrians on motorways but they are to be found on urban roads).

Short-term (*ad hoc*) expectancies are built up specifically during a journey. They take into account the characteristics specific to this journey and in particular its dynamics, basing this on long-term expectancies. The driver has initial expectancies of the journey she or he has planned in relation to her or his own experience. These expectancies are then updated according to the accumulation of sites passed and difficulties encountered. By referring to the navigational level of the driving task [11,12], they are oriented towards directional signposting and availability of services and, at a situational level, towards road and traffic conditions. After driving through a series of bends where signs are posted to give prior warning, a driver would be surprised to find a bend with the same curve radius but with no signposting. In the same way, the planning of the transitional space between a road in the open country and in an urban

area requires considerable care. The driving dynamic reveals the importance of knowing the sequence with which different types of road are associated.

Temporal constraints and their consequences

One of the specificities of this dynamic process is to link the different stages of driving within an extremely-restricted time period. During in-depth accident studies carried out in France in the 1980s[13], kinematic accident reconstruction showed that there is a time lapse of some two to six seconds between the time an obstacle is visible and the time the collision occurs. However, it takes longer to detect and identify an unexpected event, because more time is required to search through acquired knowledge to find the programmes likely to be able to solve the problem at hand. To enable the user to deal successfully with the situation, perception, identification, and response times must therefore be reduced by confining the release of expectancies to those situations likely to be encountered. From another standpoint, but with the same objective in view, drivers should have recourse to the fastest possible cognitive-processing modes. By referring to a cognitive-operator functioning model e.g., Rasmussen[14], preference should be given, in cases when automatic functioning is not available, to procedural functioning, which is quicker than problem-resolution type of functioning. This type of functioning requires knowledge of the site and road situations encountered when using perceived clue patterns, by referring to a permanently-memorized structured representation of road objects (roads and streets).

Reading the Road Space

The road space is managed by public authorities at different levels: travel management, infrastructure design, traffic management, and road concept. In the same way, when speaking of user behaviour, a differentiation is made between levels: from travelling behaviour to driving behaviour. Memorized representations of road space are also structured in levels which correspond to the different levels at which the road is read, the semantics of which can also be used to interpret user behaviour as shown in Figure 1.

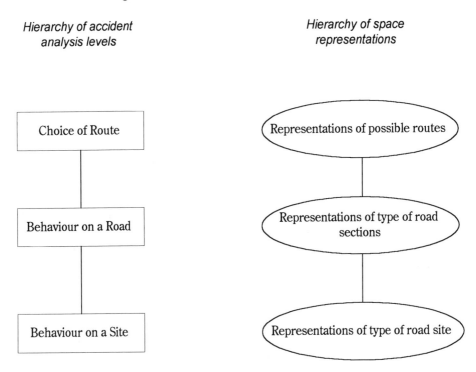

Hierarchy of accident
analysis levels

Hierarchy of space
representations

Choice of Route

Representations of possible routes

Behaviour on a Road

Representations of type of road
sections

Behaviour on a Site

Representations of type of road site

Figure 1
Levels of Analysis for Space Representation Activity

Legibility of a geographical space, route legibility

A geographical space can be represented in two dimensions. It is crossed by a lattice network which provides its structure. When the driver wishes to go on a journey, he or she selects a route either by drawing on previous knowledge and/or by using a map. It is assumed that the user has a representation of the route characteristics and the conditions in which the journey can be performed. These representations condition his or her choice and also the overall behavior she or he adopts – level of speed and attention – that can also play a part in the production of the accidents observed.

At this point, mention could be made of town legibility as referred to by Lynch[15]. Legibility was defined as apparent clarity, etc., the facility with which one can recognize the features of the town and organize them into a coherent schema. More than the town itself, Lynch focuses on collective images resulting from the perceptions

of its inhabitants. His purpose was to reveal to what extent shape, colour, and environmental layout are visible and can create a structured and useful mental image.

Legibility of a section

The legibility of a section enables the user to recognize the specificity of this section in the chosen route. The user is now placed in a driving situation and is no longer preparing his or her journey. She or he identifies sections crossed in relation to certain pre-existing categories. Certain safety-diagnostic work is based on this assumption because certain types of observed behavior are sometimes linked to the appearance of certain streets or roads (motorways, open country, urban throughways, etc.). These may not, in fact, correspond to the reality of the site, and may be a factor in explaining accident occurrence.

Legibility of a location

The legibility of a location helps a driver to understand the general functioning of a site. It makes it possible – in the event of a difficulty, such as a vehicle crossing an intersection – to anticipate how to resolve the possible ensuing conflict and, thus, implement appropriate action. A location is legible when the clues are visible on the site, but also when approaching the site, they are convergent and provide an interpretation that conforms to the reality of the problems to be solved.

Assumptions

The study of drivers' cognitive processes to improve safety by road planning leads to the formulation of the following assumptions:

- to enable the user to deal correctly with a situation, acquisition time, information-processing time, identification time, and response time should be reduced by matching expectancies to the situations likely to be encountered;

- expectancies are built up, in the context of the journey, with regard not only to identification but also to site recognition[16] and are based on long-term expectancies;

- user long-term expectancies are based on the permanent road-site representations that are organised subsequent to and for the driving activity; and

- these representations are organised around specific categories that can be recognized by certain clues linked to the difficulties likely to be encountered, the means used to deal with these situations, and the strategies adopted at these sites.

Cognitive psychological studies on the organisation of memorized representations have dealt essentially with simple objects (natural objects, fauna and flora, and artifacts, etc.), and the analysis of the mental activities in which these representations are involved (assessing belongingness, identification, and learning) [17,18,19]. For some years now, these studies have been extended to more complex objects and given a spatial context (scenes such as the beach, school, etc.)[20], a temporal context (going to a restaurant, giving a birthday party)[21], and a social context (professions, mental pathologies)[22,23,24]. It was therefore relevant to assess the importance and the limits of these assumptions applied to representations and mental categories of the road environment.

General principles of categorisation

It is within this framework that efforts were directed towards the categorisation and interpretation of urban and road environments. This was done by applying the theories and methods of contemporary cognitive approaches to research problems in the area of safety and operator activity. These approaches show that the categorisation of objects belonging to the physical world are the result of the principles governing the organisation of knowledge. This categorisation is aimed at reducing the multiplicity and the diversity of objects found in the environment to proportions compatible with the processing capacities of the individual [25].

In fact, human categorisation should not be considered as the arbitrary result of historical accidents or simple whims, but rather as the result of psychological principles. According to Rosch[26], there are two principles: a cognitive-economy principle and a reality principle. The economizing role of the categorical system amounts to providing a maximum of information for the least cognitive effort. To categorize a stimulus means it is considered, in the finality of this categorisation, not only as being equivalent to other stimuli in the same category, but also as being different to stimuli that do not belong to this category. On the one hand, it would seem an advantage for the organism to ascertain any characteristic based on any other characteristic, a principle that results in a very considerable number of categories that

are as finely differentiated as possible. On the other hand, the purpose of categorisation is to reduce the infinite differences between stimuli to proportions that can be used both cognitively and behaviourally.

The second categorisation principle states that, unlike the groups of stimuli used when forming concepts with traditional methods, in laboratories the perceived world is not a totally unstructured group of attributes with equi-probable co-occurrences. On the contrary, there are discontinuities, together with correlations or co-occurrences of characteristics to be found in the world at large. Human perceptive (cognitive) processes are able to locate these discontinuities, correlations, or similarities of shape. Thus, the represented world in the human memory reproduces these breaks and inter-categorical discontinuities in the categorical organisation, together with the similarities to be found within the categories.

Organisation of categories

The joining together of these two principles has consequences on the level of abstraction of categories formed by a culture, and on the internal structure of these categories, once they have been formed. Generalization (considering different objects to be similar) and discrimination (differentiating sufficiently to adjust behaviour), in the widest sense, leads to categories that group together examples that can be described in terms of specific characteristics or attributes. In sum, studies on natural categorisation, pioneered by Rosch, establish empirically, on the level of cognitive psychology, the four major points that follow.

First, categories are organised in hierarchical taxonomic-type structures. They are determined by relationships of inter-categorical discrimination and intra-categorical similarity or resemblance, and not independently from each other on the basis of criteria governing the necessary and adequate conditions of belongingness.

Second, there is a preferential level of categorisation: the basic level. This is defined operationally as the level of abstraction for which the categories possess the greatest number of shared attributes, which implies joint movements with similar objective shapes that are identifiable through the outline of average shapes. Research work carried out subsequently to that of Rosch, in particular our own, has made it possible to identify the existence of more precise relationships between correlative structures in the world and the regularity of man's activities in and on this environment. It was therefore shown, by using the analysis of basic-level category characteristics, that the attribute correlates showed not only similarities in shape, but more complex regularities of actions, action sequences or even problems.

Third, the objects in natural categories are described more adequately by the attribute correlates and the relationships of perceptive or functional resemblances, than by lists of characteristics that are mutually independent. This leads to an interpretation of the internal structure of categories in terms of family likenesses.

Finally, at the same organisational level, examples of a category may be placed on a typicality gradient, certain prototypical examples considered to be highly representative of the category, others less so. These typical examples share the same attributes as all other members of their category and fewer attributes with those of other categories defined at the same level of abstraction. The prototypes thus ensure the stabilization of the categorical system, and make it possible, when processing information in real time, to interpret it both rapidly and effectively.

The operational advantage of these assumptions, relating to human categorisation, stems from research into prototypical representations that form the best representatives of a category, and group together all the relevant characteristics. Would it not therefore be possible, using this premise, to improve the design of the road and its environment to render them more easily recognizable and rapidly identifiable to a user when driving? On the other hand, when equipping vehicles with intelligent driving aids, this would facilitate the detection, presentation, and representation of information in line with the operating characteristics of the drivers' cognitive system.

EXPERIMENTS

This merging of empirical questions and cognitive psychology problems has given rise to an experimental programme, a brief description of which is given in the Appendix. It includes the experiments described in the following subsections.

The Material Used

Our experimental approach was aimed at identifying user road categories, together with their specific characteristics. The experiments were based on the analysis of photographs or drawings of rural and urban sites by the subjects taking part in the experiment. Cognitive processing, based on memorized representations, was given preference, because all aspects related to the motor functions were intentionally eliminated from the experiment.

The photographs and drawings selected, provided a sample with the following specific materials:

- visual characteristics of different surfaces;

- a range of different road markings (central and roadside, central, no markings at all);

- good visibility, visibility impaired by two-dimensional or cross contours;

- contrasted environment (different densities and type of urbanisation, with or without trees, tourist area); and

- contrasting parking habits.

In the selected road sections, emphasis was placed on the possibility of encountering problems and not on the actual conflicting situations. Consequently, none of the following situations were visible:

- intersection;

- bend, unless at a distance; and

- presence of traffic.

The photographs were taken with a 50 mm. focus objective. They were developed using a 9.5 x 14 cm. format. The drawings were traced from photographs.

Experiments

A sample of 50 photographs or 33 drawings was shown to people with more than 5 years' driving experience. They were first asked to imagine themselves in the driving seat, and then to think of the problems they could encounter, based on their previous experience of these types of road. They were then asked to categorise the sites shown to them in terms of the types of problem they evoke and that, in their opinion, they could be required to solve. The number of piles was not specified. During the second experimental stage, subjects were asked to indicate, for each pile, the criteria on which they had based their differentiation. In response, the subjects mentioned either conflicts involving other users or physical characteristics of the site in the photograph.

Statistical Processing

Various statistical methods were used to check the soundness of the results: the phylogenetic-tree model[27], correspondence analysis, clustering model, dynamic scattergrams for proximity tables, and dynamic scattergrams using mobile-centre methods on qualitative variables. To interpret the results obtained using these various methods, discriminant analyses were carried out using a photograph-coding system based on expert knowledge. It was this last method that made it possible to interpret the results and, in particular, reveal the respective importance of the clues in the categorisations produced by the various statistical methods used.

Processing Verbal Data

In view of the initial choice of the categorisation task, the verbal data were used only as additional sources of information on the resulting categories. They did not, in fact, have the same status as the objective codings that were performed to describe each photograph, and that were used for the discriminant analysis.

It is possible, however, to identify the criteria most used by the subjects when forming categories. A synthesis was then made, making it possible to draw practical conclusions as to the characteristics that led the subjects to expect the problems they categorized as a certain type. This synthesis related the expected problems to the site layout and the relevant characteristics in either an independent or a correlative manner.

RESULTS

Experiment Number 1 - Photographs Showing Lightly-trafficked Roads in Rural Areas

This experiment makes use of a sample of 50 photographs (Figure 2) of rural areas taken at sites where traffic and accident data were available[28]. Each photograph shows a two-lane, lightly-trafficked road, with no apparent difficulty but with characteristics that could suggest occasional problems. The tests were carried out by 40 experienced subjects. Statistical analysis using the phylogenetic-tree model was used to differentiate 10 different categories.

The most detailed descriptions were of photographs showing approach roads to built-up areas. For the remaining categories, the criteria used to categorise photographs are:

- road markings, a clue strongly related to traffic;

- woods and forests: the only environmental factor mentioned explicitly; and

- loss of visibility, with a differentiation made between horizontal and vertical alignment.

In the open country, the main concern of users seems to be maintaining their track due to characteristics of the road surface and the difficulties linked to a junction on a bend. This is why other difficulties, that are related to more specific situations (intersections) or to specific users (pedestrians, tractor, animals, heavy goods vehicles, etc.), are given only second place, or even omitted.

The correspondence analysis compares three main groups: winding roads, straight roads and, approaches to built-up areas. Other statistical methods were used to test the soundness of the results. The results show that the categories obtained previously are reliable, particularly when the photographs are very similar. The discriminant analysis shows the relative importance of the sites where the clues are noted as shown in Table 1. The major clues used to interpret rural-road settings are linked most often to road-surface characteristics, followed by environmental factors.

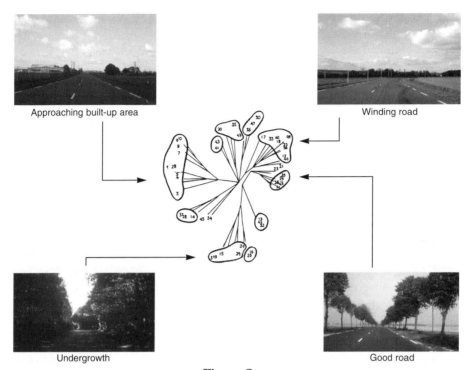

Approaching built-up area

Winding road

Undergrowth

Good road

Figure 2
Experiment No. 1

Table 1
Regularities in Urban Environment Connotations
Experiment Number 2 - Urban Photographs, Lightly-trafficked Roads

Symbol Pattern	Condition	Connotations
Isolated building in open country	Not a farm	Approach to built up area No on-street parking
Residential buildings	No open country type marking Not farms	Pedestrians likely
Line of buildings Sidewalks	No axial markings	Cyclists likely
Residential buildings Narrow shoulders crossable		Possible inconvenience by parking straddling roadway/ sidewalk
Residential buildings Authorized parking on roadway	No open country type markings No farms	possible difficulty passing oncoming vehicle
Small houses Wide distance between facades		Vehicles parked off roadway may pull out
Open country type marking	Straight road	No problem
Bend		Possible visibility problem
Wide distance between facades No marking		Possible anxiety

Experiment Number 2 - Urban Photographs, Lightly-trafficked Roads

This experiment makes use of a sample of 50 photographs (Figure 3) of minor roads, showing the same characteristics as above, but crossing through urban areas. The

results of this experiment made it possible to emphasize certain physical features of the photographs:

- distance between two opposing facades;

- depth of the visible field;

- state of the roadway and markings;

- type and density of urbanization;

- type of shoulders and parking habits;

- scenery and atmospheric factors (trees, luminosity, etc.);

These different factors are not unrelated, because their appearance is not due to random combinations. The categorisations obtained are structured by the specific co-occurrences of four factors that suggest the most typical image of the urban street in

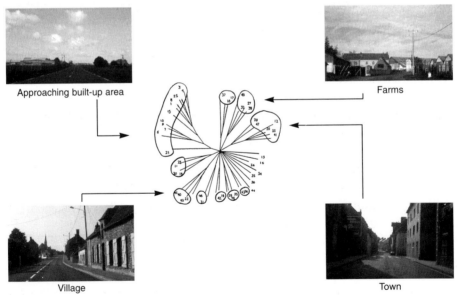

Figure 3
Experiment No. 2

this sample: limited distance between facades, dense urbanization, lack of markings, and on-street parking. These combinations of symbols suggest other factors not found on the photograph, such as the possible presence of other users. The results could

be interpreted by noting the common factors in each category, that is the distinctive features that differentiate them by using either a comprehensive and systematic coding system (type of marking, width of roadway, etc.), or expert notation (atmosphere, type of habitat, etc.).

The verbal reports can then be used by comparing what is restored for each category. Some verbal reports can be sufficiently general (pedestrians), while others refer to a specific category (2-wheelers). These two comparative approaches make it possible to compare the static symbol patterns, on the one hand, and the factors that are more closely linked to driving, on the other. Table 2 shows some examples of prediction regularities inferred by subjects during experiments based on the photographic material used.

Table 2
Results of Experiment Number 1

Road surface	35.1%
Environment (including trees)	25.8%
General aspect of scenery photographed	24.1%
Shoulder	14.8%

Care must be taken when comparing these results and actual patterns of accidents. It should however be noted that:

- There is a relationship between the categories obtained, the level of traffic and the users involved. Indeed, categorisation is linked to traffic for which the design standards of the road are a surrogate. Moreover, in our site sample, accidents involving local users are more likely to be found where there is little traffic, and those involving drivers on long journeys where there is more traffic.

- Certain features often mentioned in relation to site-photograph categories are to be found in urban accidents (pedestrian, parking, etc.).

- Intersections are only occasionally stated as being dangerous in the country while approaching built-up areas, whereas this safety problem is a general one in urban areas.

- With regard to accidents, the two-wheeler variable appears when roadside activity is involved. Two-wheelers are only mentioned by subjects when the environment is noticeably urban. These two categories do not completely overlap, with the result that certain categories include accidents involving two-wheelers, but which are not mentioned.

The correspondence analysis was used to differentiate, on the one hand, the categories that show the shape and limits of the urban area (in particular when moving into the open country) and, on the other, categories where only the network structure through which the driver is passing is visible. The second factor was the density of urbanisation: sites near rural areas were contrasted with denser urban networks. The other statistical methods showed that the most stable categories were, in descending order: approaching a built-up area, villages, farms, towns. The discriminant analysis was used to show the variables most often used by the subjects when forming categories and as shown in Table 3. This strongly confirms that, even in urban areas, the main clues used for cognitive processing in the course of the driving task are linked essentially to road-surface characteristics.

Table 3
Variables Most Often Used To Form Categories

Road surface	44.6%
Environment (including trees)	20.4%
General aspect of scenery photographed	16.9%

Experiment Number 3 - Photographs of Lightly and Heavily-Trafficked Rural Sites

The categories obtained using the two samples (experiments 1 and 2) show different characteristics. Indeed, urban characteristics evoke a much richer verbal response than do those in open country. For the former, few remarks were made. It seems, therefore, that this level of analysis is close to the basic level in urban areas, whereas in open country, the level of differentiation is too finely balanced.

It is, therefore, necessary to introduce sufficient heterogeneity to enable cognitive processing at a sufficiently generalized level, by moving away from processing based solely on the comparison of practically identical sites. To do this, the open-country sample in experiment number one was separated into two parts. The distribution of the 2 x 25 photographs was performed by dividing each of the categories thus obtained into two: there are, therefore, two matched groups, based on the previous categorisation task. Halfway through this sample 25 photographs of more highly-trafficked roads were added, including major main roads (Figure 4). This third experiment therefore makes use of a more heterogeneous sample of road sites in the open country. These range from small, very lightly-trafficked roads to three-lane highways.

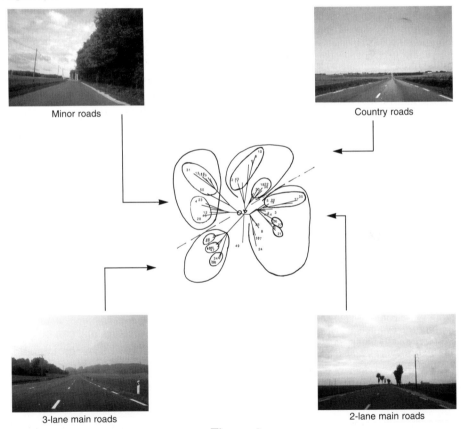

Minor roads

Country roads

3-lane main roads

2-lane main roads

Figure 4
Experiment No. 3

Four main groups of rural sites result from the tree structure produced by statistical processing:

- Three-lane National Roads;

- Two-lane National Roads;

- Departmental Roads; and

- Secondary Roads.

A National Road is considered solely as an axis linking two towns and not as something that could structure the space through which it travels. The categories obtained then form two sub-groups, depending on the number of lanes. On three-lane main roads, one has to be wary of other users, even if the centre lane is allocated. Two-lane main roads, because of their width, the quality of their markings, and, above all, the texture and colour of their surface, are said to be National, whereas the other two-lane roads in our sample are not. However the National indication is reserved for roads with a high standard of marking: uninterrupted centre line preventing overtaking in bends, arrows to indicate a move back into a lane, and so forth.

Roads termed Departmental Roads (after the regional authorities called Departments) are well equipped compared to those known as Secondary Roads that are, in the sample, the narrowest roads with the lowest standard of equipment and that are the least well-maintained. Paradoxically, these Secondary Roads are sometimes termed primary roads when referring to their role in the territory covered and their level of possible activity. All these criteria also help to differentiate these roads from National Roads.

The verbal data are extremely coherent in relation to the description that can be given of the photographed sites. Mention is also made of road width, markings, condition of the roadway, loss of visibility, and even luminosity. The correspondence analysis made it possible to identify a spectrum beginning with three-lane National Roads, then two-lane National Roads, Departmental Roads, and finally Secondary Roads.

By comparing the results produced by the different statistical methods, it would appear that the categories are generally stable. This applies particularly to the smallest road infrastructures and three-lane National Roads. The discriminant analysis shows that the variables most used by subjects are as shown in Table 4.

More than half the clues used to interpret these rural environments are linked to road-surface characteristics. A quarter are linked to the environment.

Table 4
Variables Used by Subjects in Experiment Number 3

Road surface	51.0%
Environment (including trees)	25.6%
General aspect of scenery photographed	17.0%
Shoulder	6.4%

Experiment Number 4 - Photographs of Urban and Rural Sites

An analysis of the categories obtained in experiment number two led us to question the respective importance of the road and environment clues in relation to the driving task. A sample of photographs was, therefore, built up by adding to half of the former rural sample in experiment number one, half of the former urban sample obtained using the same matching techniques, to form a mixed urban-rural sample of photographs (see Figure 5).

The analyses revealed hierarchical categorisations; 12 categories were differentiated at the lowest level. These included six that formed a whole, to which the other categories were attached, one by one. This sequence effect was not an artifact of the classification process – which can occur in some statistical methods – but was derived here from the data alone.

The most stable categories, those for which the subjects were in agreement, were in the open country where differentiations concern the sinuousness and the width of the road. Moreover, this last criterion was not based on a single clue, but groups together a number of highly-correlated features, namely, the actual width, type of markings (no markings, centre, centre and side), the presence of delineators, and surface maintenance.

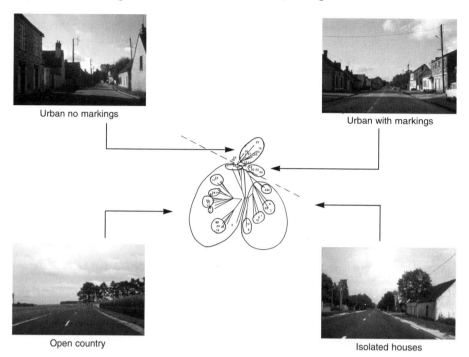

Figure 5
Experiment No. 4

The urban categories joined one after another, with this first tree section. Markings were the first criterion to be taken into account, followed by urban density. The final category, which was the largest, comprised highly urbanised sites. The subjects mentioned the narrowness of these roads, their poor surface, the lack of markings, and the need to reduce speed.

All the verbal indications were coherent in relation to the breakdown of the sites photographed. This also applied to environmental features (village, housing, vegetation, forest, etc.), potential problems (pedestrians, cycles, cars, etc.), and what should be done (paying attention, speed, overtaking, etc.). It should be noted that references to activities changed when the environment was truly urban and when the road was no longer marked. The correspondence analysis gave a true representation of what has also been demonstrated using the phylogenetic-tree model, i.e., a progressive change from the open country to an urban environment.

By comparing the results of the various statistical methods, it would seem that the categories are stable, whichever algorithm is used. The discriminant analysis shows that the variables most used by the subjects are those shown in Table 5. At this point it should be noted that clues taken from the road surface and the environment are of equal importance.

<div align="center">

Table 5

Variables Used by Subjects in Experiment Number 4

</div>

Road surface	33.5%
Environment (including trees)	33.5%
General aspect of scenery photographed	25.6%
Shoulder	7.7%

Experiment Number 5: Categorisation of Drawings of Rural Sites With an Unrestricted Number of Piles

Experiments five and six use coded drawings based on components that were the most used by subjects when categorising photographs. The criteria selected were as follows: markings (three values), horizontal alignment (two values), width of road surface (three values), environment (three values), shoulders (two values).

The photographs with the same coding were identified so as to keep only one per alignment. This prevented giving preference to certain values. In the second stage, the selected photographs were traced to produce 33 drawings representing rural road scenes (see Figure 6). The combination of values for the selected variables is not, of course, comprehensive. The instructions given to the subjects are the same as those given previously, with the exception of the number of piles:

- Unrestricted number of piles (experiment number 5), similar to the previous experiments; and

- Set number of three piles (experiment number 6).

Category Nº 2 Drawing Nº 17

Category Nº 1 Drawing Nº 19

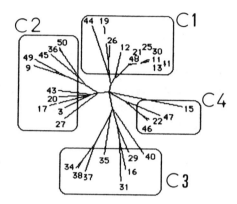

Category Nº 3 Drawing Nº 35

Category Nº 4 Drawing Nº 47

Figure 6
Experiment No. 5

Statistical processing using the phylogenetic-tree model revealed four distinct categories for experiment number five. The following criteria are found throughout the four categories: visibility, straight road, markings, and two lanes. The categories obtained are:

- Roads with intermittent markings, bordered by fields;

- Wide roads with intermittent markings, bordered by trees (forest or alignment);

- Roads with continuous markings or no markings in forests; and

- Roads with intermittent markings, bordered by fields, with loss of visibility.

Experiments three and five made use of different supporting documents – 50 photographs and 33 traced drawings. The results showed a poor overlap between experiments, because the same categories could not be found when changing to figurative support documents. The processing modes in these two cases were relatively general. Even if, in experiment number five, the environment and marking clues were preponderant, processing did not reveal any breakdown on a single criterion. It should be noted that the difference can be explained by a failure to take the quality of the road surface into account (colour, unevenness, texture), which cannot be seen from the drawings. In view of this, the indications of National Roads and Departmental Roads were not given. This confirms that these are the most important criteria when recognizing a road site.

Experiment Number Six - Drawings of Rural Sites With Three Piles Imposed

This experiment differed from the preceding one in that the drawings had to be sorted into three piles. The tree representation reveals two distinct main categories, the first of which can be divided into three subcategories. Four separate categories can therefore be noted: straight road through the forest; wide bend with intermittent markings; bend in forest; and wide or relatively wide road with intermittent markings, (see Figure 7).

The comparison between experiments five and six showed the influence of the instructions on the results, namely whether the number of piles is set or not. The two experimental conditions each produced four categories. Two categories were practically stable, whereas the others were split into three, or even four, groups.

The unrestricted-pile instruction should *a priori* encourage an analytical type of processing, clue by clue. However, this is not the case and processing is performed globally, by giving preference to environmental clues (particularly fields, forest) and markings – as with the unrestricted pile instruction – together with the straight line and bend clue. This instruction produces fewer verbal reports than the unrestricted pile instruction, which would seem to show that this experimental procedure is less likely to give access to permanent knowledge.

Category Nº 1 Drawing Nº 43

Category Nº 2 Drawing Nº 44

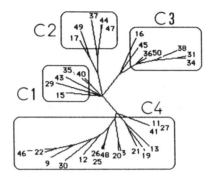

Category Nº 3 Drawing Nº 36

Category Nº 4 Drawing Nº 12

Figure 7
Experiment No. 6

CONCLUSIONS AND PROSPECTS

Results

Each experiment can be used to draw conclusions as to the categorisation principles used by the subjects, the type of clues used, and the relevance of their co-occurrences. In addition, by comparing the different experiments, it was possible to validate the results. At this point in our research work, it is, therefore possible to draw general conclusions based on the experiments that have already been carried out.

In the open country, the representations are structured around broad categories such as: three-lane or two-lane National Roads, Departmental Roads, or Secondary Roads. The National Roads are the main routes between towns, whereas Departmental and Secondary Roads serve to structure the land-use of local areas.

The results of experiments using urban sites show that the subjects, when processing a substantial number of symbols in the photograph's use: distance between opposite facades, depth of the visible field, state of the roadways and markings, the type and density of urbanisation, the type of shoulder and parking habits, scenery and atmospheric factors (trees, luminosity, etc.). These different factors are not unrelated, because their appearance is not due to random combinations. The categorisations obtained are structured by the specific co-occurrences of these factors. It seems, however, that certain categories are generally recognisable, such as access roads to residential areas (small houses) or housing estates; whereas other sites are processed in a more analytical way, by first using criteria such as width of roadway, sinuousness, etc. During this processing, the combinations of signs suggest other factors and other difficulties, linked more to dynamic-driving practices but that were not shown on the photograph, such as the presence of pedestrians or, sometimes, of two-wheelers.

All the experiments revealed the importance of road-surface characteristics, particularly in relation to the environment, when recognising road sites, even in urban areas. It would even seem that the more heterogeneous the sample, the more these clues will be used to differentiate between roads. In the mixed urban-rural sample (Experiment four), categorisation is based only on this dimension. The subjects saw a continuity of the open country in the road markings in towns, grouping together all the roads without markings, a characteristic that was undoubtedly viewed as typical of the street and its urban environment. However, attention should be paid to the extremely high correlation between the level of design standards and the amount of traffic, which may reinforce a relationship between the road categories employed by engineers and those recognized by the subject using road surface characteristics. This leads to questioning the type of markings, as they are generally designed in towns for large-scale infrastructures, in suburbs, or small built-up areas. A particular instance is an arrow indicating that the driver should move in after overtaking. This marking should be abandoned, because it is considered to be specific to the open country and tends to lead the driver to forget he is in an urban area. The importance of the texture and color of the road surface should also be noted, because they play an important part in processing. Thus, experiments five and six produce different results from experiment three because these clues are not shown on the drawings but appear on the photographs.

The subjects identify transitional sections very quickly; they respond to the change from town to open country when the end of the village can be seen from afar and recognize they are entering a town when they see a building along the side of the road in open country. Conversely, other sites are not recognizable for what they are. This applies to certain urban layouts that can only be understood on the spot[29] or asymmetrical markings on 2 x 2 lane roads that subjects do not know how to categorize.

Prospects

The Position of Clues in Structuring Representation

Thus, our experiments eveal structures in the permanent representations of road space, based on permanent combinations of symbols, that refer to other factors, particularly problem situations (not shown on the photographs or the graphic representations) that are linked more to dynamic driving practices.

They make it possible to compare the respective importance of the different road-site factors in the structuring of these representations. Therefore, among the available clues that can encourage the user either to take into account or to ignore roadside activity, they demonstrate the prevalent position of roadway characteristics (condition, colour, unevenness), partiularly in "scarcely-legible" areas. Further thought could be facilitated by using graphic-support documents in which clue combinations are easy to manipulate.

Analytical Processing And Family Likenesses

The recognition of road sites using family likenesses seems, in view of the results obtained, to conform most to the processes used in the driving activity. The first experiments, using very schematic drawings, gave rise to analytical processing using a single clue, which brings into question the validity of such supporting documents when analyzing road sites. Furthermore, the combinations of characteristics that produce these graphic-support documents raise the question of the ecological validity of the reality represented. Thus, during an experiment presenting many possibilities systematically, the subjects were extremely surprised by certain combinations of clues, such as the width of the road and type of marking, which created unreal sites. Work is now being carried out on the representations of subjects using combinations limited to those derived from a coding of actual sites. The support documents used also make it possible to see at what level of graphic sophistication analytical processing changes to overall family likeness type processing. This question is important in order

to ascertain the heuristic advantage of experiments carried out on driving simulators that also make use of schematic representations of the space travelled.

Coherency Between Type of Road and Type of Layout

Road standards define both road building and layout principles. It can be assumed, however, that there is a coherency in the representations, that means that certain layouts are more naturally expected than others on a given type of road. Taking this further, it can be assumed that there is a coherency in the representations of types of road and of the safety problems likely to be encountered when driving. This is totally in line with the detection of various levels of road-space legibility, as described previously.

Analytical methods for these coherencies should be developed, in relation to experiments carried out in other fields (e.g., triadic methods). In particular, this applies to the micro-computer-controlled video disk, an interactive tool that can be used to manage dynamic natural-image sequences and therefore study, by using reaction time, the relationship that exists between a type of road and a type of layout or potential problems.

On-the-Spot Analysis

Another approach logically follows from our analytical approach: very progressively reintegrating the different components of the driving task activity, particularly the dynamic aspect of the spatial and temporal distribution of information. This approach can be used to analyse the role of permanent images in the processes essential to the driving task, as well as the role of such images in the speed of recognition and decision, as judged by responses to the real-time processing of photographs of road sites shown on an interactive video device. Other, more complete experiments, will be possible when the French driving simulator is operational. These experiments should be compared with the analyses performed in instrument vehicles [30].

APPENDIX: RESEARCH PROGRAMME ON PERMANENT ROAD-SITE
REPRESENTATIONS

Analysis of Urban Space Representations Using Verbal Induction

Experimental work was first carried out using standard verbal procedures found in cognitive psychology for the investigation of representations (producing examples and characteristics). This experiment consisted of obtaining verbal reports using induction words indicating three levels: urban sites, roads and intersections, such as towns, villages, intersections controlled by traffic lights, roundabout, etc. To do this, words representing these different levels were proposed to the subjects who were asked to build a mental image, subsequently reconstructed, using words to describe it [31,32].

Analysis of Intersection Representations by Categorising a Series of Photographs

In contrast to the other levels, the intersection produces a considerable number of action-qualification categories. A new experiment has been aimed at analysing the process of structuring categories around morphological clues or by reference to the action to be performed. To achieve this, a series of photographs showing intersection approaches was presented to two groups of subjects, who were asked to categorise them according to two distinct instructions, one based on site characteristics, the other on the task to be performed [33].

Analysis of Road Section Representations Using Photographic-Supporting Documents

In this experiment, approximately 40 subjects were presented with selected photographs showing no traffic and no specific features. The purpose was to categorise them according to what could occur were the subject in a driving situation. During a second stage, the experimenter asked for verbal reports on the categorisation criteria (potential problems and clue patterns) and the degree of typicality for each photograph. The object of these experiments was to discover if there were categories based on route, immediate environment, and scenery variables that could, therefore, be revealed during a static experiment. Four experiments of this type have been carried out to date. The photograph samples have progressed, after examining the results, so as to vary the heterogeneity of the sites studied. This approach has

made it possible to show the processing specificity and the salient characteristics of certain clues.

Analysis of the Categorisation of the Urban Network With a View to Adjusting Speed Limits

In December 1990 in France, speed limits in towns were reduced from 60 to 50 kph, with an option to adjust this limit by creating 30 zones and raising the maximum authorized speed on some sections to 70 kph. An experiment was performed to examine how urban road categories, identified by these three speed levels, could be broken down into operating driving-activity subcategories. Experiments consisted of asking experienced drivers to categorise photographs of urban sites and questioning engineers about the speed limits at each of these sites. This experiment revealed the hierarchies drawn up by users and managers, and the site characteristics for which there was complete agreement and those for which there was no unanimous decision[34].

Analysis of Road-Site Representations Using Graphic-Support Documents

Graphic-support documents are widely used in knowledge-organisation experiments. The advantage of this method is that it is possible, using their structure coding, to build up objects on a combination of variables, either parametrically or systematically. Assumptions as to the internal structure of the categories can then be tested. This was based upon components that seemed most used by subjects to categorize photographs. These clues could be used to code, and then build up the drawings corresponding to the combination required. The experiments and statistical processing were performed in the same way as in previous experiments.

Real Time Processing of Driving Situations Using a Video Disk

The first experiment using a video disk was of an investigative nature. It was intended to develop the interactive tool that presents natural computer-controlled images to the subjects. In the course of this experiment, the subject was asked to indicate when, and based on which clues, the perceived conflict situation produced a change in driving behaviour.

Inter-Personal Differences

Finally, the question of inter-individual variability is obviously essential, even if it has not yet been dealt with in our research programme. A particular instance is that the difference between the representations produced by experienced and inexperienced drivers seems of importance to understand the position of the road and environmental clues, and how certain combinations structure the knowledge drivers have of the space they use.

REFERENCES

1 Benda, H. V., and C.H. Hoyos, "Estimating Hazards in Traffic Situations," *Accident Analysis and Prevention*, 1983, 15(1), 1-9.

2 Saad, F., "Prise de risque ou non perception du danger," RTS, 1988, 18-19, 55-62.

3 Allen, T. H., H. Lunenfeld, and G. J. Alexander, "Driver Information Needs," *H. R. B.Bulletin*, 366, 1971, 102-115.

4 Leplat, J., and J. Pailhous, "Présentation et représentation des itinéraires," Communication au V° congrès de la SELF, *Le Travail Humain*, 1967, 30, 3-4.

5 Neboit, M., "Rôle de l'anticipation perceptive dans la conduite automobile," *Etudes bibliographiques de l'ONSER*, n°4, Arcueil, France,1974.

6 Van Elslande, P., "Influence d'un schéma de traitement sur l'interprétation d'une situation routière ambigué," in IATB (editor), *Actes de la 6ème conférence internationale sur les comportements de déplacement*, Quebec, 1991, 231-243.

7 Schank, R. S., and R. Abelson, *Scripts, Plans, Goals, and Understanding*, Lawrence Erlbaum, Hillsdale, N.J., 1977.

8 Hoc, J. M., *Psychologie cognitive de la planification*, Presse Universitaire de Grenoble, Grenoble, 1986.

9 Girard, Y., "Analyse des dysfonctionnements observés dans une tâche de traversée d'intersections aménagées," in Malaterre, G., and F. Ferrandez (editor), *La prise en compte des comportements dans l'aménagement des*

intersections, Actes INRETS, n° 16, Arcueil, France, 1989, 10-20.

10 Alexander, G. J., and H. Lunenfeld, *Driver Expectancy in Highway Design and Traffic Operations*, Report No. FHWA-TO-86-1, U. S. Department of Transportation, Federal Highway Administration, Office of Traffic Operations, Washington DC, 1986.

11 Allen, T. H., H. Humenfeld, and G.J. Alexander, *op. cit.*

12 Michon, J. A., "Driver models: How They Move," (Preliminary version) Traffic Safety Theory and Research Methods, Amsterdam, 1988, 1-19.

13 Ferrandez, F., D. Fleury, and G. Malaterre, "L'étude détaillée des accidents : une nouvelle orientation de la recherche en sécurité routière," RTS, 1986, 9-10, 17-20.

14 Rasmussen, J., "Cognitive Control and Human Error Mechanisms," in J. Rasmussen, Duncan K. Duncan and J. Leplat (editor), *New Technology and Human Error*, Wiley series new technologies and work, Berlin, 1988,53-61.

15 Lynch, K., *L'image de la cité*, Edition Dunod DUNOD, Paris, 1976.

16 Rasmussen, J., *op.cit.*

17 Mervis, C. B., E. Rosch, "Catégorization of Natural Objects," *Annual Review of Psychology*, 1981, 32, 89-115.

18 Dubois, D., *La compréhension de phrases : la représentation sémantique et processus*, Thèse de Doctorat d'Etat, Université de Paris VIII, Paris, 1986.

19 Dubois, D., *Sémantique et Cognition*, Edition du CNRS, Paris, 1991.

20 Tversky, B., and K. Hemenway, "Categories of Environmental Scenes," *Cognitive Psychology*, 1983,.15, 121-149.

21 Shank, R. S., and R. Abelson, *op. cit.*

22 Cantor, N., W. Mischel and J. Schwartz, "A Prototype Analysis of Psychological Situations," *Cognitive Psychology*, 1982, 14, 45-77.

23 Dahlgren, K., "The Cognitive Structure of Social Categories," *Cognitive Science*, 1985, 9, 379-398.

24 Peraita Adrados, H., "Representacion de categorias sociales, roles o professiones, en una muestra de sujetos adultos de un medio rural," *Informes de Psicologia*, 1985, 73-84.

25 Rosch, E., "Human Categorisation," in Warren N., (editor), *Advances in Cross Cultural Psychology,* Vol. 1, Academic Press, London, 1978.

26 Rosch, *op. cit.*

27 Barthélemy, J. P., and A. Guénoche, *Les arbres et la représentation des proximités,* Masson, Paris, 1988.

28 Fleury, D., C. Fline, and J.F. Peytavin, "Diagnostic de sécurité sur un département," *Application au cas de l'Eure et Loir,* Rapport INRETS n° 125, Arcueil, France, 1990.

29 Fleury, D., D. Leroux and H. Moebs, "Catégorisation de l'infrastructure par l'usager et sécurité," *Analyse de sites urbains et ruraux sur routes à faible trafic,* Rapport INRETS N° 69, Arcueil, France, 1988.

30 Saad, F., P. Delhomme, and P. Van Eslande, "Drivers Speed Regulation When Negotiating Intersections," in Koshi, M., (editor), *Transportation and Traffic Theory,* Elsevier Science Publishing Co, Inc., New York, 1991, 193-212.

31 Mazet, C., *Perception et action dans la catégorisation: Le cas de l'environnement urbain et routier,* Thèse pour le doctorat d'Université, Université de Paris V, Paris, 1991.

32 Mazet, C., D. Dubois, and D. Fleury, "Catégorisation et interprétation de scènes visuelles : le cas de l'environnement urbain et routier," *Psychologie Française,* Numéro spécial : la psychologie de l'environnement en France, 1987, 32-1-2, 85-96.

33 Dubois, D., D. Fleury, and C. Mazet, "Représentations catégorielles: perception et/ou action ?" Publication atelier PIRTTEM Représentations pour l'action, Edition du CNRS, Paris, 1992.

34 Fleury, D., C. Fline and J.F. Peytavin, "Modulation de la vitesse en ville et catégories de voies urbaines," *Expérimentations sur les représentations de sites routiers,* Rapport INRETS n° 144, Arcueil, France, 1991.

PART II

MEASURING FUTURE CONTEXTS: THE STATED PREFERENCE APPROACH

8

USING STATED-PREFERENCE METHODS TO EXAMINE TRAVELLER PREFERENCES AND RESPONSES

John Polak and Peter Jones

INTRODUCTION

One of the most significant methodological developments to have taken place in travel-behaviour research during the past two decades has been the emergence of Stated-Preference (SP) techniques. Since the publication of the first SP studies in transport in the early 1970s[1,2,3,4] interest in SP has blossomed and in the past decade in particular, SP methods have come to be used routinely by academics, governments, and the transport industries in many countries.

Today the term stated preference is used within transport research to refer to a broad class of methods based on the study of individuals' responses in hypothetical contexts consisting of one or more travel alternatives that are typically defined in terms of combinations of levels of attributes. Although there is considerable variation of style and emphasis among different SP approaches (ranging, for example, from relatively open-ended gaming simulation exercises to tightly-controlled experimental-design procedures), the essential feature common to all SP approaches is that they seek to draw conclusions regarding individuals' preferences or behaviour based on the study of responses elicited under experimental or quasi-experimental conditions. Thus, in principle, SP methods differ fundamentally from more traditional revealed-preference

(RP) methods, in which the analysis of preferences and behaviour is based on the observation of actual market outcomes[a,5].

The growth in popularity of SP methods is in part a reflection of the general trend over the past two decades towards greater use of dissaggregate data and analysis procedures. Of greater significance, however, has been the fact that SP methods have been perceived to offer a number of important advantages compared to methods of analysis based solely on conventional revealed-preference (RP) data. These advantages include: the ability to reduce, or eliminate altogether, statistical problems such as multicollinearity and lack of variance in explanatory variables; the scope to include within the analysis attitudinal and qualitative factors that might be difficult or impossible to ascertain from RP data; and, crucially, the capability to assess users' preferences and responses to entirely new products and services, or to changes in the characteristics of existing products falling outside the range of prevailing market conditions.

The extensive use now being made of SP methods has promoted rapid developments both in underlying SP techniques and in the diversity and scale of the accumulated applications experience. Transport researchers are increasingly defining a distinctive style and approach to SP methods that draws upon, but is also clearly separate from, those associated with related disciplines, such as marketing, psychology, economics, and economic geography. In recent years increasing attention has also been directed to the discussion of more fundamental theoretical and methodological issues relating, for example, to the internal and external validity of SP data. All in all, these developments can be seen as indications of the healthy dynamism characteristic of a young, expanding,but also rapidly maturing, field of study.

Within this general context, the objectives of this chapter are to provide a brief historical perspective on the development of SP methods, to discuss some important recent developments in both the application and methodology of SP studies, and to highlight some key research directions for the future. Our emphasis throughout is on general methodological issues rather than detailed technical matters. More detailed

[a]In practice, the distinction between SP and RP data may not be quite so clear cut: RP data frequently consist of a mixture of measured and reported information, each with a distinct patern of errors and potential biases. Similarly, SP exercises are often designed around an existing pattern of behaviour and so record both kinds of information. The relationship beetween RP and SP data is discussed in more detail later in this paper.

discussions of technical questions can be found in the collections edited by Bates[6] and Louviere[7], in the review papers by Hensher , Louviere and Timmermans , and Timmermans[10] and in the guides compiled by Louviere[11] and Pearmain[12].

BACKGROUND AND DEVELOPMENT OF SP METHODS IN TRANSPORT

Historical Context

The emergence of SP methods in transport can be seen as part of a much broader methodological movement that has gained momentum in recent decades within the social and behavioural sciences. This movement has drawn attention to the limitations (both theoretical and empirical) of modes of enquiry based solely on the observation of natural market behaviour[13] and has sought to establish a complementary paradigm of experimental enquiry for investigating individual and collective judgement and choice[14,b,15]. Proponents of this experimental paradigm point to a number of key advantages including:

- The opportunity for the systematic testing of alternative theoretical propositions and the identification of causal relationships.

- The opportunity to eliminate the statistical problems that typically contaminate observational data from natural markets.

- The opportunity to examine the influence of theoretical constructs for which there may not be directly or easily measurable counterparts in natural markets.

- The opportunity to explore behaviour in response to circumstances that are either currently unobserved or in principle unobservable under prevailing natural-market conditions.

This emphasis on a more experimentally-oriented mode of enquiry has found expression through the development of a wide range of different techniques in many different areas of study. Among the most prominent are:

- In psychology, marketing, and behavioural geography methods of conjoint analysis, information integration, and functional measurement

[b] Louviere traces the history of the experimental analysis of judgement and choice back to the work of Thurstone.

have been used extensively to explore the structure of individuals' preferences for goods and services and in the context of spatial choice[17,18,19].

- In welfare economics, methods of contingent valuation have been developed to investigate individuals' valuation of public goods and natural resources[20,21].

- In the study of microeconomic behaviour, laboratory experiments and market-simulation procedures have been developed to explore the validity of axiomatic theories of individual and collective choice, especially under conditions of strategic bargaining and in the presence of risk and uncertainty[22,23].

- In the assessment of certain public-policy measures (e.g., the impact of major tax reform on labour-market participation) forms of social experimentation have been developed in which groups of individuals and households take part in controlled real-world trials for extended periods[24,25].

- In the decision and management sciences, interactive gaming-simulation procedures have increasingly been used as a means of exploring and understanding individuals' decision making in complex institutional and other settings[26].

Stated-preference methods in transport are squarely located within this broader historical and intellectual tradition of experimental enquiry and have drawn extensively, albeit rather selectively, on parallel streams of work within the tradition. In particular, the early development of SP methods was strongly influenced by the ideas and techniques of conjoint analysis, functional measurement, and information-integration theory. Later on, transport researchers also took on board concepts of gaming/simulation and laboratory experimentation.

However, in the past decade, as the acceptance of SP methods has increased and they have become important elements in many practical studies, the main force shaping the development of SP methods has been the concrete priorities of applied forecasting. Indeed, over this period, SP methods have come to be perceived and deployed largely in a role that is essentially complementary to existing demand-modelling and forecasting techniques; as means of collecting data that extend the scope and/or

reduce the cost of practical implementations. This highly-applied and policy-oriented mode of use has had both positive and negative consequences.

On the positive side, it has been the key motivation for considerable methodological innovation, especially in the area of extending traditional conjoint methods to accommodate choice-oriented responses[27] and in the development of procedures for the joint use of RP, SP, and attitudinal data in model estimation[28,29,30,31], as is also discussed below. Moreover, the applied focus of much SP work has also meant that transport researchers have generally enjoyed the benefit of much larger and more representative samples than have been available in many other (less applied) fields of study. The practical requirements of dealing with large and diverse samples has also been an important motivation for the development of improved survey-administration techniques, especially the growth of computer-based interviewing[32].

However, there has also been a negative side. We must recognise that the overwhelming emphasis that has been placed on applied work has meant that relatively little use has been made of SP methods as either theory-generating or theory-testing devices, that is potentially one of their most important roles and a key advantage of experimentally-oriented methods compared to conventional observational methods. Historically, work of this type has been largely confined to the use of functional analysis techniques to explore alternative specifications of travellers' utility functions[33] and to the interactive simulation experiments into the dynamics of drivers' route and departure-time choice performed over a number of years by Mahmassani and colleagues[34,35,36]. More recently, the need for better understanding of the ways in which travellers are likely to acquire and make use of the information made available by advanced traveller-information systems has prompted the development of driving and travel simulators of various types[37,38,39,40,41,42] that are mainly being used in an essentially exploratory manner to investigate the nature of travellers' responses and evaluate alternative modelling approaches. We return to the issue of the mode of use of SP methods in a later section.

Issues of Validity and Acceptance

Irrespective of mode of use, however, all experimentally-oriented approaches must at some stage confront the question of how to relate findings, obtained in artificial markets under experimental conditions, to behaviour in actual markets under real-world conditions. This issue of validity has recently attracted renewed attention in other areas of experimental work (i.e., in contingent valuation[43] and experimental economics[44]). It has also been a recurrent theme throughout the development of SP methods in transport.

During the 1970s, SP methods encountered considerable resistance on grounds of concern regarding the issue of validity. In part, such concerns were well founded, because some of the early studies, carried out in applied contexts using a stated-intention approach, were indeed poorly conceived and poorly executed and produced results that proved extremely unreliable. Such studies were often used to forecast the demand for new bus or rail services. Fowkes and Preston[45] carried out both SP and stated-intention surveys to look at the demand for local rail services, and found that the latter overstated demand by at least 50% – though they suggest that the results might be scaled by carrying out a complementary SP survey. Koppelman[46] has also emphasised recently the dangers of attempting to infer demand directly from stated-intentions data.

However, we suspect that to some degree this resistance also reflected particular disciplinary outlooks and institutional rigidities. In the United Kingdom (UK), the turning point, as far as the general acceptance of SP methods is concerned, probably occurred during the mid-1980s when the Department of Transport supported a major study into the value of travel time, largely based on SP methods[47]. In some countries concerns regarding validity still severely limit the application of SP methods.

In recent years, discussions of the validity of SP data have usually identified two distinct dimensions[48]. Internal validity refers to the consistency and reproducibility of the experimental responses themselves, whereas external validity refers to the degree to which experimental responses correspond to real-world responses. Clearly these two dimensions of validity are not independent; approaches that lack internal validity are most unlikely to lead to externally-valid predictions and forecasts.

At one level, the question of the external validity of SP data can be viewed purely as an issue of predictive performance (in absolute terms and/or relative to RP-based models) and, as such, can, in principle, be investigated directly through suitably-designed comparative studies. Unfortunately, such studies are still rather rare, although encouraging results have been obtained[49,50]. Moreover, the general indications obtained from those studies where some degree of formal comparison between SP and RP data has been possible[51,52,53,54] is that best practice SP procedures are capable of producing results that are broadly comparable, in terms of both the relativities among variables and the predictions of market shares, with those obtained from RP data. This is, however, clearly an area in which much greater efforts are needed in the future (the chapter in this volume by Fujiwara and Sugie, that investigates the temporal stability of stated-preference data is an important contribution to work of this sort).

Another approach to the question of validity is to adopt a more diagnostic perspective, focusing, in the first instance, on issues of internal validity, and to seek to identify the specific characteristics of hypothetical SP contexts that might undermine the validity of results. A number of diagnostic studies of this type (focusing on the effect of different response scales and different design procedures) have recently been carried out[55,56,57] and this, too, is an area in which further work is to be welcomed.

Alternative SP Approaches

A broad distinction can be drawn between the use of SP methods to identify preferences and their use to measure behavioural responses. In the former case, the interest is usually in designing a transport-service product and deciding which combination of attributes and levels will best meet the aspirations of the intended market of travellers (e.g., a cheaper/less frequent service or a more expensive/more frequent one). Often there may be an explicit interest in identifying how much people would be willing to pay for a particular product improvement (e.g., new rail rolling stock). SP studies may also be designed to assess directly how behaviour would change as a result of a product improvement, in which case the focus is on alternative forms of behavioural response.

Behavioural response may either be measured by asking respondents to select a preferred alternative from a set of travel options (stated responses, where explicit trade-offs are required) or by asking them what they would do if confronted with different travel scenarios, in a more open-ended, stated-intentions type of experiment. Some recent studies[58,59] have sought to combine aspects of these two approaches by presenting a series of travel scenarios (constructed according to an experimental design) and allowing respondents to nominate a behavioural response from a pre-determined repertoire of alternatives.

The most common way of designing SP studies is for the analyst to devise a set of options comprising varying levels of a given set of attributes; then to combine the options into one or more choice sets; and finally to ask the respondents to choose from among these choice set(s) in some way. An alternative approach is to let the respondent devise an optimum package, given a set of constraints. In SP studies designed to measure preferences, the latter is usually done by means of a "Priority-Evaluator" technique[60,61] whereby the cost of moving from one level of each attribute to another is identified, and the respondent is invited to choose the best package, given a fixed budget to spend. The equivalent in a behavioural response study would be to let the respondent optimise his or her behaviour, given various personal time and family constraints.

Where predetermined options are shown to respondents, they may be invited to express a preference or behavioural response in one of three ways: by rating individual options on a common scale (e.g., strength of preference on a scale from 1 to 10), by ranking a set of options simultaneously, or by making pairwise (or multinomial) choices (sometimes, using a semantic scale to indicate strength of choice). The selection of analysis method is closely related to the method that has been used to measure preference or choice; for example, rating scales are commonly analysed using regression techniques, while choice data are analysed using discrete- choice modelling techniques[62,63]. (See Louviere[59] or Hensher[60] for a more detailed discussion of analysis issues.)

Another important source of variation is in terms of the conditions under which respondents are surveyed: this may be in the form of a mailback self-completion questionnaire, or a face- to-face interview with a paper questionnaire, or increasingly, a computer-based interview[64]. Telephone interviews have also been used in some cases.

RECENT DEVELOPMENTS IN APPLICATION AND METHODOLOGY

Key Areas of Application

We can identify a number of different purposes for which SP studies have been carried out, in both the public and private sectors, that are here grouped under three broad headings:

- Valuation of attributes

- Derivation of preferred transport packages

- Estimation of travel behaviour responses

Valuation of Attributes

Transport-project evaluation in many countries requires an estimate to be made of the value that travellers place on the time savings that are usually the major benefit of road or rail investment. Such values are difficult to estimate from revealed-preference data, because, unless there are tolled roads or other situations where travellers are explicitly trading between time and money, it is difficult to collect relevant data on travel choices from which time values can be estimated. SP methods enable the trade-off between the various components of time and money to be examined in a

systematic way, for various trip purposes and types of traveller. For a recent review of developments in the use of SP techniques to value travel time, see Polak[65].

Up until the early eighties, values of time for road-project appraisal in the UK had been based on limited revealed-preference data plus theoretical considerations. The Department of Transport decided to update and broaden the set of values by commissioning a set of surveys based primarily on SP, but with some parallel RP work where possible, to validate the SP findings. Results are reported in MVA Consultancy *et al.*[66]. The study generally found a good agreement between RP and SP values, but, it was also possible by using SP surveys, to estimate directly values of time for purposes such as recreation, that it had not been possible previously to estimate in the UK usingRP methods. A study has recently begun to update these values through further SP surveys.

Subsequently, SP techniques have been used to estimate values of time for project evaluation in a number of countries, including the Netherlands and Norway. In the Dutch Study[67], the use of SP enabled a wide range of potential influences on time values to be examined. Previously untested variables that proved to be important were:

- an inverse relationship between time valuation and the amount of free time per week: travellers with 35 or fewer free hours per week valued their time at 28 percent higher for commuting and 17 percent higher for other than travellers with at least 64 free hours per week.

- a strong relationship for commuters between willingness to pay for time savings and average current motorway travel speeds for the journey: compared with someone travelling in urban traffic, a commuter experiencing a motorway speed of over 110 kilometers per hour (kph) had a premium of 10 percent, compared with 68 percent for a driver with a motorway speed of less than 90 kph.

One finding that is common to several SP studies is that the increases in value of time are less than proportionate to the increase in income of the traveller; it thus seems inappropriate simply to inflate time values in line with the projected growth in real incomes – that is traditionally what has been done.

Because of the degree of control that can be exercised in a well-designed SP survey, it is possible to investigate the nature of time valuation in more detail than in an RP study. Aspects that have been studied include the effect of both the size and sign of

the time change. For example, there is some evidence to suggest that a unit time loss is valued at a higher rate than a unit time saving; in the Dutch study referred to above, commuters valued time losses per minute at about three times the rate of time savings. This raises a further issue of the difference between time valuation in the short term (when such asymmetries are likely to be strong) and in the long term (when a more symmetrical value of time might be expected).

One consequence of the move towards the privatisation of new roads and the introduction of tolls, is that the values of mean time savings used in government project evaluation are no longer appropriate; it becomes necessary to measure the distribution of values of time among potential users. This strengthens the case for an SP-based approach, because in RP studies there is usually only enough data to estimate single values.

Hensher *et al.*[68] report on an SP study to estimate values of time for a series of proposed urban tolled roads in the Sydney area. SP techniques are also being used to evaluate demand for toll roads in many other countries.

Derivation of Preferred Transport Packages

Public transport operators have been among the first in the transport sector to recognise the benefits of SP as a means of identifying which elements of the service/product are more important to travellers, and hence how to design a service package that will meet customer needs best, given certain budget constraints. SP is ideally suited to this role, because respondents express preferences among package options in a trade-off context. Some of these studies have dealt just with hard variables, such as fare, frequency, and travel time, but the unique benefits of SP techniques are to be found when the importance to travellers of softer variables is being assessed.

In the UK and the Netherlands, several studies have been commissioned to look at traveller preferences for station or rolling-stock improvements. Pearmain[69] reports on studies to obtain passenger valuations of train and station improvements on the London underground, that included measures of comfort and appearance.

The paper by Hensher *et al.*[70] in this volume represents an interesting extension of this approach to look at preferences among residents for different types of traffic-calming schemes. The study illustrates how local residents might become involved in the design of local schemes, but also shows how residents' preferences can shift as a result of direct experience of a scheme; to allow for this, the authors recommend that

preferences should be sought from residents who have direct experience of the options.

Estimation of Travel Behaviour Responses

It is only relatively recently that SP techniques have been used widely to estimate responses directly, but applications are now widespread in many areas of transport policy. An early example was a study of cyclists' route choice for local journeys in the Netherlands[71], that included variables such as surface quality and traffic level, as well as travel time.

In an urban context, many aspects of traveller behaviour have now been examined using SP methods, including residential choice[72], mode choice[73,74], time of day choice[75,76], parking choice[77,78] and drivers' response to traffic reports[79]. Some studies have also looked at car ownership decisions using SP, particularly in the context of new vehicle technology. Bunch *et al.*[80] report on one such study in California, looking at consumer reaction to electric and other clean-fuel vehicles, given different purchase and operating costs, and performance characteristics; they find that vehicle range between refuelling is an important variable.

SP exercises have recently been carried out in a more strategic context. Preston and Wardman[81] describe an SP mailback survey that was used to calibrate a set of forecasting models to estimate car-driver responses to long-term urban-strategy options in the city of Nottingham. In an interurban context, Hooper[82] discusses how an SP approach was used in Australia to look at the potential for packaged travel (rail plus accommodation) as one market for the Very Fast Train project between Sydney and Melbourne, and Morikawa *et al.*[83] report on the results of SP and RP studies to look at the impacts of upgrading an existing interurban rail service.

While most applications of SP in the transport sector have dealt with passenger movement, some studies have looked at freight. Fowkes *et al.*[84], for example, use an SP technique to investigate the market for intermodal freight technologies for longer-distance movements.

Issues Arising From These Practical Applications

Much of the impetus for advancing the methodology of SP techniques has come from the requirements of practical applications, and it is mainly in this context that new questions have arisen. The most fundamental question of all – whether what people say they would do in SP surveys bears any relationship to what they would do in reality – seems largely to have been resolved in the affirmative.

However, SP applications have thrown up a number of more subtle issues, in particular:

- Respondents seem to value individual attributes of a package (e.g., station improvements) more highly than the package as a whole. Studies reported in Pearmain[85] show that summing the values of individual attributes may overestimate the value of the equivalent package as a whole by a factor of three to four.

- Studies that have found a willingness to pay for improved service quality find little evidence of this translating into an increased use of the service once the improvement has been introduced (holding fare constant).

- In the context of forecasting, the question also arises of the time frame of response; for example, SP exercises give respondents "perfect information" about options, that in reality it may take a respondent years to acquire, if ever.

Some of these issues are taken up in later sections of this paper.

Recent Methodological Developments

Over the past decade, considerable advances have been made in SP methodology, both to improve the reliability of SP-based models and to extend their range of application. In this section, we highlight briefly four areas of particular importance.

Development of Choice-Oriented Decision Tasks

A major development in SP over the past decade has been the move away from preference-oriented judgemental tasks and towards choice-oriented decision tasks. As with many other aspects of the development of SP, the key motivation for this transition has stemmed from the practical requirement of analysts to be able to use SP techniques as part of existing demand-forecasting procedures.

The use of models based on preference-oriented SP tasks for prediction and forecasting of market shares can be awkward because the transformation between preference and choice requires the application of the preference-modelling results in a simulated-choice context. Louviere and Hensher[86] were the first to demonstrate how the experimental-design procedures used to develop preference-oriented (conjoint) judgemental tasks could be extended to create choice-oriented tasks in which individuals choose single options from among sets of alternatives. Choice data of this form can then be modelled using conventional discrete-choice models to produce

direct estimates of market shares and elasticities. The key step in Louviere and Hensher's procedure is the forming of separate alternatives into choice sets. This can be carried out in a number of different ways, resulting in either fixed or variable choice sets. Louviere and Woodworth[87] discuss the relative merits of alternative choice-set formation procedures.

Aside from offering greater ease of application for prediction and forecasting, there is also some evidence that choice-oriented tasks may be easier for respondents to understand and therefore less prone to generating internally-inconsistent responses[88].

Combining SP, RP, and Attitudinal Data Sources

The emergence of choice-oriented SP approaches has enabled the increasing use of SP methods as part of demand-forecasting procedures. It soon became clear, however, that the direct use of SP data for forecasting and/or the naïve pooling of RP and SP choice data in model estimation could produce seriously-misleading results. The key problem, highlighted by Bates[89], Bradley and Kroes[90] and others, is that RP and SP data are subject to different types of errors, the effect of which is to make it most unlikely that RP and SP data will share a common distribution of unobservables. Because the nature of this distribution essentially determines the scale of the utility variable, naïve pooling of RP and SP in model estimation will, in general, be invalid and, moreover, forecasts based solely on SP data (that depend not only on the relativities between model coefficients, but also on their absolute scale) may misrepresent the sensitivity of travellers to changes in system attributes.

Morikawa[91] was the first to suggest a systematic treatment of this problem. He proposed a procedure for the joint estimation of discrete-choice models using RP and SP choice data, in which the variance of the SP dataset is scaled, relative to the RP data, thereby allowing data from both sources to be pooled. A key requirement of Morikawa's approach is that there be at least one system attribute (i.e., independent variable) common to the utility functions of both the RP and the SP models. In a chapter in this volume, Bradley and Daly[92] give an example of the application of this approach to forecasting the demand for a new mode and also illustrate how the computation of the joint RP+SP estimator can be performed easily using existing logit-model estimation software.

The scope of Morikawa's framework also extends to the integration of attitudinal data within an econometric-modelling framework, by means of LISREL-style latent-variable structural models. This approach offers an alternative, and more rigorous, treatment of the impact of attitudinal factors than is possible using the conventional, dummy-variable approach to accommodating attitudinal variables. An example of the

application of this technique to the modelling of interurban mode choice is given in Morikawa *et al.*[93].

Developments in Experimental Design Procedures

A number of important developments have occurred over the past decade in the way in which SP exercises are designed and carried out. Some of these issues relate to the gradual transition from preference-oriented to choice-oriented decision tasks and have already been touched on above.

Among the other changes that have taken place, perhaps the single most significant has been the almost universal adoption of the practice of the customising of SP exercises to the circumstances of a particular individual and journey. The overall objective of customisation is to reduce SP-specific errors and biases by ensuring that the hypothetical contexts presented to respondents are plausible and as close to actual experience, as possible. Typically, this involves collecting detailed information on an existing (target) journey and using this information in the setting of the values of the levels of the design variables for the hypothetical alternatives. The hypothetical alternatives are then presented as variants of the target journey. By taking an actual journey as the base, respondents are able to consider more carefully their responses to new travel alternatives and particularly to take into account any constraints that might limit their ability to modify their current behaviour.

Customisation can be taken a stage further with respondents having the opportunity to select the actual variables that will figure in the description of alternatives (as well as the values of their levels), as in the studies reported by Bradley *et al.*[94] and Jones *et al.*[95]. However, this is still not, on the whole, a common practice.

A second important development in survey design has been the growing use of adaptive designs, in which the levels of the design variables are modified during the course of the SP exercise, on the basis of previous choices, with the aim of increasing the precision of parameter estimates. There are various devices for achieving this; in particular, use of a grid technique, the elimination of dominated options, or through the incremental estimation of trade-off points and attempts to refine estimates around these points[96,97,98,99]. Similar types of adaptive-design procedures have also become popular in recent years in the mainstream marketing literature[100].

Adaptive designs are very appealing intuitively, and have become popular among practitioners, not least because they tend to reduce the amount of questioning that needs to be carried out and because respondents typically report adaptive exercises to be easier and more interesting to complete. However, some disadvantages are also

becoming apparent. First, almost any form of adaptation will result in nonorthogonal-estimation data, reducing the statistical advantages of SP data. Second, poorly-designed adaptive procedures can run out of control, especially in the case of respondents with extreme preferences. Third, and potentially most significant, Bradley and Daly[101] have recently drawn attention to a potentially serious source of bias in adaptive designs, arising in cases where the process of adaptation leads to a correlation being introduced between the levels of the design variables in the SP exercise and the unmeasured components of utility, that is not accounted for in model estimation. Certain doubts have also recently been raised regarding the use of popular adaptive-conjoint methods in marketing[102].

A further significant area of development in the design of SP exercises focuses particularly on issues surrounding the use of SP to make assessments of relative valuation (e.g., values of time). Fowkes and Wardman[103] were the first to point out that the ability of an SP exercise to identify variations in such relative valuations across a population depends on the range of critical trade-offs (or boundary values) between, say, travel time and cost embedded within a design. This led to the idea that the design of this type of SP exercise should be based explicitly around the notion of designing-in an adequate range of such boundary values[104]. Holden *et al.*[105] describe a computer-based SP-design tool that implements these design principles. The use of the boundary-value concept, either in its own right as a guiding principle of design, or as a check applied to more conventionally derived designs, is becoming increasingly popular in practice[106].

An issue that can arise in the context of boundary-value design problems (as well as more generally) is that of preserving design-variable orthogonality. Small departures from strict orthogonality are often made in practice in order to maintain the realism of an exercise by, for example, excluding an alternative that is both very fast and very cheap. Recent work has, however, suggested that there may also be more positive reasons for wishing to depart from strict orthogonality.

In a series of papers, culminating in Fowkes *et al.*,[107] Fowkes and colleagues have argued that, while strictly orthogonal designs are indeed statistically optimal in terms of the precision of the estimates of the coefficients of all the design variables jointly, if the interest in a particular experiment is the precision of the estimate of the ratio of the coefficients of two design variables (i.e., travel time and cost, as in the context of value-of-time estimation), then certain departures from orthogonality may be positively beneficial. In particular, they demonstrate that some degree of negative correlation between the numerator and denominator design variables (typically time and cost, respectively) will lead to a reduction in the variance of the ratio of coefficients, with

corresponding benefits in terms of either improved precision, reduced sample-size requirements, or both.

Use of Computer-Based Interviewing

Many of the developments that have occurred in the design and conduct of SP exercises, especially the emphasis on the customisation and adaptation of SP exercises, have been closely linked with the increasing use of computer-based interviewing methods. The use of computers in SP interviewing began during the mid-1980s, essentially to enable greater customisation of conventional pen-and-paper methods[108]. However, the rapid development of computer technology (especially the capabilities of portable computers) soon meant that it was possible to carry out the entire interview (including the presentation of SP alternatives and the recording of the response) directly on the computer, dispensing with pen-and-paper altogether. For a summary of these early developments see Jones *et al.*[109].

Aside from allowing greater customisation of the SP-contexts presented, the use of computer-based interviewing methods also brings benefits in terms of improved data quality (through, for example, the elimination of routing errors and the use of range and logic checks at the point of data entry), easy randomisation of survey parameters, and greater control over the presentation of alternatives. In addition, research in other fields has suggested that computer-based modes of administration are less prone to bias due to interviewer effects[110,111,112], although there is a marked lack of systematic research into this topic in the field of transport. Moreover, the subjective reaction of both interviewer and respondents to the use of computer-based methods has also been found to be extremely positive.

However, perhaps the most significant implication of the use of computer-based interviewing is that it has enabled the extension of SP techniques into spheres of research where practical complexities (either of design or implementation, or of respondent comprehension) had hitherto prevented effective progress; examples include activity scheduling in multiperson households[113,114] and travellers' choice of time of travel in the context of complete tours[115].

FUTURE DIRECTIONS FOR RESEARCH

Although great strides have been made in SP methods over the past decade, there are inevitably some areas where further work is needed. In this section we identify briefly five general areas of activity in which future research efforts usefully might be concentrated.

Design, Validity and Validation

The validity of the data and results obtained under experimental conditions is a crucial issue. Although the empirical record of SP research is generally encouraging, there is still a lack of systematic understanding of the nature and relative importance of the factors influencing the internal and external validity of SP data and models.

In terms of internal validity, some of the key issues on which further work is required include:

- Statistical design effects (e.g., fixed versus individually, customised versus fully adaptive, orthogonal versus non-orthogonal, optimal number of replications, etc.).

- Presentation and response scale effects (e.g., individual options evaluated on a rating scale versus full profile-ranking exercise versus pairwise or multinomial-choice contexts).

- Instrument effects associated with different modes of interviewing (e.g., paper versus computer, interviewer-administered vs. self-completion, face-to-face versus telephone) and the effect of wording, layout, use of colour, and so on.

- Information effects associated with the type and amount of supporting contextual information given to respondents before or during the interview (e.g., textual versus static graphic versus animated graphic), especially in the case of studies of new modes.

- Model-estimation techniques to take account of serial correlation among SP replications and among SP replications and RP data[116,117].

In terms of external validity, there is an urgent need for further systematic investigations of the predictive and forecasting performance of SP methods. In this context, two issues are likely to be of particular importance:

- The temporal stability of SP-based preferences, both in absolute terms and relative to the temporal stability of comparable RP-based preferences.

- The effect of variables omitted from the specification of SP exercises and models on prediction and forecasting performance.

Extending the Scope of Behavioural Responses

There are a number of travel choices that are not at present well treated in SP work and for which further development would be useful. These include:

- The treatment of travel frequency. The tendency to focus on one specific journey or event in SP surveys (in order to increase the realism of responses), has the drawback that it is difficult to deal with issues of frequency of travel; because at the single-trip level, the option becomes simply to make or not make that journey, that is too crude to estimate frequency changes.

- The treatment of system unreliability and choice under uncertainty. The problem here is essentially one of finding an adequate characterisation of the magnitude and the frequency of variability, unreliability, or uncertainty, from the point of view of both individual behaviour and manageable survey procedure. Recent work in this area has been carried out by Black and Towiss[118], Pells[19] and Senna[20] and this provides a useful basis for further developments in the future.

- The treatment of 'complex' behavioural responses. In common with travel-demand analysis generally, SP methods have traditionally focused on simple (typically unidimensional) choice contexts (e.g., a choice of mode or route). In order to address a range of emerging policy concerns it is, however, becoming increasingly necessary for transport analysts to deal with more complex forms of behavioural response, involving inter-linked travel and activity participation decisions. The recent studies by Ettama *et al.*[121], into household activity scheduling and by Polak *et al.*[122], into the timing of travel and activity participation

decisions illustrate how SP methods can be extended to accommodate these issues. Bradley and Jones[123] discuss a number of general questions relating to the use of SP methods within the context of Activity Analysis.

SP in the Context of Behavioural Dynamics

The development of better understandings of the dynamic aspects of travel behaviour is a major challenge for behavioural research. SP methods offer a number of potential advantages in this context including: the capability to study behaviours that occur infrequently or are otherwise difficult to observe, and the ability to control for covarying factors and to distinguish between genuine change as opposed to random variation in behaviour.

However, there are two major issues that confront the potential use of SP methods in the context of behavioural dynamics. The first is the question of the implicit timescale of SP responses. In SP exercises, respondents are typically asked what they would do if confronted now with the SP alternatives. In reality, however, prevailing patterns of travel behaviour may, in fact, take some time to adjust to changes in service attributes (as a consequence, for example, of the acquisition of information about changes in the real-life options being delayed, incomplete, or distorted). It may be unclear exactly when the changes identified in an SP exercise would take place and thus, for example, whether to interpret SP-based forecasts as applying to the long-term or the short-term. One approach to dealing with this issue is to attempt to identify within the the SP exercise itself, those factors that might impede adaptation in behaviour and make some estimate of the distribution of these factors within the population.

The second issue touches on a rather paradoxical point. While one of the great advantages of SP methods is their ability to deal with new and possibly quite radically-different travel options, the practical experience to date is that SP works best in cases of marginal behavioural change, where the new behaviour closely mirrors aspects of existing behaviour. Moreover, even in cases where there are incentives for more fundamental structural changes in behaviour, it may be difficult for travellers to appreciate the full range of responses that might follow. Axhausen[124] and Bradley and Jones[125] have suggested that one way of dealing with this question might be to combine conventional SP procedures with gaming/simulation procedures[126] so that respondents are encouraged to explore more extensively the implications of particular changes. Similar notions of role playing have been advocated in a much broader context by Harr *et al.*[127].

New Interview Media and Technology

Rapid developments continue to be made in underlying computer technologies, that will dramatically expand the options open to researchers in the design of interview contexts. Some of the directions that are currently becoming available include:

- The expanded use of computer graphics within interviews, especially as an aid to conveying to respondents complex concepts such as variability.

- The increasing ability to make use of detailed geographical and other data to increase the degree of customisation and realism of the interview experience (e.g., the geographical or topological details associated with a route or destination could be displayed using a realistic map background).

- The use of affordable and programmable sound and video capabilities for the development of substantially-enhanced product simulations.

One question that arises with all these developments is the uncertain effect of new media and display formats on responses. As more use is made of new interview technology and media it is important that basic methodological research be carried out to provide guidelines for appropriate forms of application.

Use of SP for Theory Testing and Refinement

Potentially, one of the most important capabilities of SP methods is their ability to provide a context in which alternative theoretical frameworks can be tested, refined, or refuted. Yet, to date, little use has been made of this capability; with SP methods instead being viewed largely as a source of complementary data to support the estimation and application of existing modelling approaches. While these developments have been of great practical importance and benefit, they have tended to overshadow other potential uses of SP methods.

A range of recent developments in both transport policy and transport technology have highlighted weaknesses in operational modelling techniques and in aspects of underlying theory[128,129,130]. Many researchers are now arguing that new theoretical formulations are required to cope with these new pressures. We believe that an important lesson to be learned from the past is that theoretical approaches must be subject to rigorous empirical scrutiny. Given an appropriate shift in theoretical

outlook, much of the experience that has been gained in the development and use of SP techniques is directly relevant to the more ambitious goal of theory development and refinement.

CONCLUSIONS

In this paper, we have sought to provide a broad overview of the history, development, current status, and future directions of SP methods in transport. The picture that emerges from this overview is one of a vigorous, dynamic, and exciting field of study, offering great potential for fundamental advance in understanding, yet also embodying many of the contradictions, tensions, and uncertainties that are inherent in applied-research activity.

In order to establish the practical *bona fides* of SP methods, researchers have had to concentrate on a limited set of research issues, principally focused on forecasting applications. In our view, this battle has now been won and the practical usefulness of SP methods as a complement to existing RP data has been established beyond question in this type of work. While further refinements of forecasting procedures remain a key priority, we believe strongly that the time is right to broaden the scope of SP research in order to explore its potential contribution to the development of the theory of travel behaviour.

Looking towards the future, we see every indication that, in the years to come, incentives will exist for this broadening of scope, as new developments in transport technology and policy[131] coupled with new priorities in behavioural modelling and research[132] give rise to a growing need for new theoretical insights into travellers' preferences and responses, particularly to novel travel contexts and policy initiatives.

REFERENCES

1. Davidson, J. D., "Forecasting Traffic On STOL," *Operations Research Quarterly*, 1973, 24 (4), 561-569.

2. Hatch D. and M. Flack, "Priority Research Techniques Applied to Public Transport Investment," *Journal of Marketing Research*, XXVIII, 215-222.

3. Hoinville, G., "Evaluating Community Preferences," *Environment and Planning*, 1971, 3(1), 33-50.

4. Rowley, G., and Wilson, S., "The Analysis of Houisng and Travel Preferences: A Gaming Approach," *Environment and Planning*, 1975, A-7A, 171-177.

5. Ortuzar, J. de D., "Fundamentals of Discrete Multimodal Choice Modelling," *Transport Reviews*, 2(1), 47-48.

6. Bates, J. J. (editor), "Stated Preference Methods in Transport Research," *Journal of Transport Economics and Policy*, 1988, XXII(1), 1-137.

7. Louviere J. J. (editor), "Special Issue on Experimental Choice Analysis," *Journal of Business Research*, 1992, 24(2), 89-189.

8. Hensher, D. A., "Stated Preference Analysis of Travel Choices: The State of Practice," *Transportation*, 1994, 21(2), 107-133.

9. Louviere, J. J. and H. J. P. Timmermans, "Stated Preference and Choice Applied to Recreational Research: A Review," *Leisure Sciences*, 1990, 12, 9-32.

10. Timmermans, H. J. P., "Decompositional Multiattribute Preference Models in Spatial Choice Analysis: A Review of Some Recent Developments," *Progress in Human Geography*, 1984, 8, 189-221.

11. Louviere, J. J., "Conjoint Analysis Modelling of Stated Preferences," *Journal of Transport Economics and Policy*, 1988, XXII(1), 93-119.

12. Pearmain, D., J. Swanson, E. Kroes, and M. A. Bradley, "Stated Preference Techniques: A Guide to Practice," 1991, Steer Davies Gleave and Hague Consulting Group.

13. Wong, S., *The Foundations of Paul Samuelson's Revealed Preference Theory*, 1978, Routledge and Kegan Paul, London.

14. Smith, V. L., "Theory, Experiment and Economics" *Journal of Economic Perspectives*, 1989, 3(1), 151-169.

15. Thurstone, L. L., "A Law of Comparative Judgement," *Psychological Review*, 34, 273-286.

16. Davis, D. D. and C. A. Holt, *Experimental Economics*, 1993, Princeton University Press, Princeton, NJ.

17. Anderson, N. H., "Functional Measurement and Psychological Judgement," *Psychological Review*, 1970, 77, 153-170.

18. Hensher, D. A. and J. J. Louviere, "Identifying Individual Preference for International Air Fares," *Journal of Transport Economics and Policy*, 1983, XVII(3), 225-245.

19. Timmermans, H. J. P., *op. cit.*

20. Jones-Lee, M. W., "The Value of Transport Safety," *Oxford Review of Economic Policy*, 1990, 6(2), 39-60.

21. Mitchell, R. C. and R. T. Carson, "Using Surveys to Value Public Goods: The Contingent Valuation Method," *Resources for the Future*, 1989, Washington, DC.

22. Davies, D. D. and C. A. Holt, *op. cit.*

23. Hey, J. D., *Experiments in Economics*, 1991, Blackwell, Oxford.

24. Hausman, J. and D. A. Wise, (eds), *Social Experimentation*, 1985, University of Chicago Press.

25. Neuberg, L. G., *Conceptual Anomalies in Economics and Statistics: Lessons from the Social Experiment*, 1989, Cambridge University Press, Cambridge.

26. Rosenhead, J. (editor), *Rational Analysis for a Problematic World*, 1989, John Wiley and Sons, London.

27. Louviere, J. J. and D. A. Hensher, "On the Design and Analysis of Simulated or Allocation Experiments in Travel Choice Modelling," *Transportation Research Record, Number 890*, 1982, 11-17.

28. Ben-Akiva, M., T. Morikawa, "Estimation of Switching Models From Revealed Preferences and Stated Intentions," *Transportation Research A*, 1990, 24A(6), 485-495.

29. Bradley, M. A. and A. J. Daly, "Estimation of Logit Choice Models Using Mixed Stated Preference and Revealed Preference Information," in Stopher, P. R. and M. E. H. Lee-Gosselin, *Understanding Travel Behaviour in an Era of Urban Change*, Pergamon Press, Oxford, 1994.

30. Morikawa, T., *Incorporating Stated Preference Data in Travel Demand Analysis*, 1989, Ph. D. Dissertation, Department of Civil Engineering, Massachusetts Institute of Technology, Cambridge, MA.

31. Morikawa, T., M. Ben-Akiva, and K. Yamada, "Forecasting Intercity Rail Ridership Using Revealed Preference and Stated Preference Data," *Transportation Research Record, Number 1328*, 1991, 30-35.

32. Jones, P. M. and J. W. Polak, "Collecting Complex Household Travel Data by Computer," in Ampt, E. S., A. J. Richardson, and A. Meyburg (eds), *Selected Readings in Transport Survey Methodology*, 1992, Eucalyptus Press, Melbourne.

33. Lerman, S. R. and J. J. Louviere, "Using Functional Measurement to Identify the Form of Utility Functions in Travel Demand Models," *Transportation Research Record, Number 673*, 1978, 78-86.

34. Mahmassani, H. S. and Jayakrishnan, R., "System Performance and User Response Under Real-Time Information in a Congested Traffic Corridor,"

Transportation Research A, 1991, 25A(3), 293-307.

35. Mahmassani, H. S. and R. Herman, "Interactive Experiments for the Study of Tripmaker Behaviour Dynamics in Congested Commuting Systems," in P. M. Jones (ed.), *Developments in Dynamic and Activity-Based Approaches to Travel Analysis*, 1990, Avebury, Aldershot.

36. Mahmassani, H. S., C. Caplice, and M. Walton, "Characteristics of Urban Commuter Behaviour: Switching Propensity and Use of Information," 1990, paper presented to the 69th Annual Meeting of the Transportation Research Board, Washington.

37. Adler, J. L., W. W. Recker, and M. G. McNally, "In-Laboratory Experiments to Analyse Enroute Driver Behaviour Under ATIS," 1993, paper presented to the 72nd Annual Meeting of the Transportation Research Board, Washington.

38. Bonsall, P. W. and T. Parry, "Using an Interactive Route-Choice Simulator to Investigate Drivers' Compliance With Route Guidance Advice," *Transportation Research Record, Number 1036*, 1991, 59-68.

39. Chang, P. and H. S. Mahmassani, "A Dynamic Interactive Simulator for the Study of Commuter Behaviour Under Real-Time Information Supply Strategies," 1993, paper presented to the 72nd Annual Meeting of the Transportation Research Board, Washington.

40. Koutsopoulos, H. N., T. Lotan, and Q. Yang, "A Driving Simulator and its Application for Modelling Route Choice in the Presence of Information," 1993, paper presented to the 72nd Annual Meeting of the Transportation Research Board, Washington.

41. Polak, J. W. and P. M. Jones, "The Acquisition of Pre-Trip Information: A Stated Preference Approach," *Transportation*, 1993, 20, 179-198.

42. Vaughn, K. M., M. A. Abdel-Aty, R. Kitamura, P. Jovanis, H. Yang, N. E. Kroll, R. B. Post, and B. Oppy, "Experimental Analysis and Modelling of Sequential Route Choice Under ATIS in a Simplistic Traffic Network," 1993, presented to the 72nd Annual Meeting of the Transportation Research Board, Washington.

43. Hausman, J. (ed.), *Contingent Valuation: A Critical Assessment*, 1993, North Holland.

44. Starmer, C. and R. Sudgen, "Does the Random-Lottery Incentive System Elicit True Preferences? An Experimental Investigation," *American Economic Review*, 1991, 81(4), 971-978.

45. Fowkes, A. S. and J. Preston, "Novel Approaches to Forecasting the Demand for New Local Rail Services," *Transportation Research A*, 1991, 25A(4), 209-218.

46. Koppelman, F. S., C. R. Bhat, and J. L. Schofer, "Market Research Evaluation of Actions to Reduce Suburban Traffic Congestion: Commuter Travel Behaviour and Response to Demand Reduction Actions," *Transportation Research A*, 1993, 27A(5), 383-393.

47. MVA Consultancy, Institute of Transport Studies University of Leeds, Transport Studies Unit University of Oxford, "The Value of Travel Time Savings," *Policy Journals*, 1987, Newbury, Berkshire.

48. Bradley, M. A. and P. M. Jones, "Developments in Stated Preference Methods and Their Relevance for Activity-Based and Dynamic Travel Analysis," Paper presented to the International Conference on Dynamic Travel Behaviour Analysis, July 1989, Kyoto.

49. Benjamin, J. and L. Sen, "Comparison of the Predictive Ability of Four Multiattribute Approaches to Attitudinal Measurement," *Transportation Research Record, Number 890*, 1983, 1-6.

50. Louviere, J. J., D. H. Henley, G. G. Woodworth, R. J. Meyer, I. P. Levin, J. W. Stoner, D. Curry, and D. A. Anderson, "Laboratory-Simulation Versus Revealed-Preference Methods for Estimating Travel Demand Models," *Transportation Research Record, Number 794*, 1981, 42-51.

51. MVA Consultancy, et al., *op. cit.*

52. Bradley, M. A. and H. F. Gunn, "Stated Preference Analysis of Values of Travel Time in the Netherlands," *Transportation Research Record, Number 1285*, 1990, 78-88.

53. Fujiwara, A. and Y. Sugie, "The Characteristics of Mode Choice Models Based on Stated Preference Data," *Memoirs of the Faculty of Engineering*, 1991, Hiroshima University, 11(1), 31- 42.

54. Wardman, M., "A Comparison of Revealed and Stated Preference Models of Travel Behaviour," *Journal of Transport Economics and Policy*, 1988, XXII(2), 71-91.

55. Ben-Akiva, M., T. Morikawa, and F. Shiroishi, "Analysis of the Reliability of Preference Ranking Data," *Journal of Business Research*, 1992, 24(2), 149-164.

56. Bradley, M. A., and A. J. Daly, "Uses of the Logit Scaling Approach in Stated Preference Analysis," paper presented at the 6th World Conference on Transport Research, 1991, Lyons.

57. Ortuzar, J. de D., R. Garrido, "Rank, Rate or Choice? An Evaluation of SP Methods in Santiago," Proceedings of the 19th PTRC Summer Annual Meeting, 1991.

58. Polak, J.W., P. M. Jones, P. C. Vythoulkas, S. Meland, and T. Tretvik, "The Trondheim Toll Ring: Results of a Stated Preference Study of Travellers' Responses," Report to the European Commission DRIVE Programme, Transport Studies Unit, University of Oxford, 1991.

59. van der Waerden, P., H. Oppewal, and H. J. P. Timmermans, "Adaptive Choice of Motorists in Congested Shopping Centre Parking Places," *Transportation*, 1993, 20(4), 395-408.

60. Hoinville, G., *op. cit.*

61. Copley, G. and J. J. Bates, "Using the Priority Evaluator to Measure Traveller Needs," paper presented to the Oxford Conference on Dynamic and Activity-Based Methods in Transport, Lady Margaret Hall, Oxford, 1988.

62. Louviere, J. J., 1988, *op. cit.*

63. Hensher, D. A., 1993, *op. cit.*

64. Jones, P. M., *et al.*, 1992, *op. cit.*

65. Polak, J.W., "Recent Developments in the Use of Stated Preference Techniques for the Valuation of Travel Time," Paper presented to a seminar on the Value of Travel Time, Institute of Transport Economics, Oslo, 1992.

66. MVA Consultancy, *et al.*, *op. cit.*

67. Bradley M. A., and H. F. Gunn, *op. cit.*

68. Hensher, D. A., F. W. Milthorpe, N. C. Smith, and P. O. Barnard, "Urban Tolled Roads and the Value of Travel Time Savings," *The Economic Record*, 1990, June, 146-156.

69. Pearmain, D., *op. cit.*

70. Hensher, D. A. and H. C. Battellino, "The Role of Stated Preferences and Discrete-Choice Models in Identifying Individual Preferences for Traffic Management Devices," Stopher, P. R. and M. E. H. Lee-Gosselin, eds., *Understanding Travel Behaviour in and Era of Change*, Pergamon Press, Oxford, 1994.

71. Bradley, M. A., and P. H. L. Bovy, "A Stated Preference Analysis of Bicyclists Route Choice," Proceedings 12th PTRC Summer Annual Meeting, 1984.

72. Borgers, A., H. J. P. Timmermans, and van der Waerden, P., "Contextual Modelling of Multi-Person Choice Processes: Transport Facilities and Residential Choice Behaviour," paper presented at the 6th World Conference on Transport Research, Lyons, 1992.

73. Preston, J. and M. Wardman, "Forecasting Motorists Long Term Behaviour in the Greater Nottingham Area," Working Paper 322, Institute for Transport Studies, University of Leeds, 1991.

74. Hirobata, Y. and S. Kawakami, "Modelling Disaggregate Behavioural Modal Switching Based on Intention Data," *Transportation Research B*, 1990, 24B(1), 15-25.

75. Bates, J. J., N. R. Shepherd, and A. I. J. M. van der Hoorn, "Investigating Driver Reaction to Peak Hour Surcharges," Proceedings 17th PTRC Summer Annual Meeting, 1989.

76. Polak, J. W., P. M. Jones, P. C. Vythoulkas, D. Wofinden, and R. Sheldon, "Travellers Choice of Time of Travel Under Road Pricing," Proceedings 21st PTRC Summer Annual Meeting, 1993.

77. Axhausen K. W. and J. W. Polak, "The Choice of Parking Type: Stated Preference Experiments in the UK and Germany," *Transportation*, 1991, 18(1), 59-81.

78. van der Waerden, *et al., op. cit.*

79. Khattak, A. J., J. Schofer, and F. S. Koppelman, "Commuters Enroute Diversion and Return Decision: Analysis and Implications for Advanced Traveller Information Systems," *Transportation Research*, 1992, 27A(2) 101-111.

80. Bunch, D. S., M. A. Bradley, T. F. Golob, R. Kitamura, and G. P. Occhiuzzo, "Demand for Clean-Fuel Vehicles: A Discrete-Choice Stated Preference Pilot Project," *Transportation Research A*, 1993, 27A(3), 237-253.

81. Preston, J. and M. Wardman, *op. cit.*

82. Hooper, P. G., "Estimating the Demand for Packaged Travel for a Proposed High-Speed Surface Transport System Using Stated Preference Response Methods, Paper presented at the 6th World Conference on Transport Research, Lyon, 1992.

83. Morikawa, T., *et al.*, 1991, *op. cit.*

84. Fowkes, A. S., C. A. Nash, and G. Tweddle, "Investigating the Market for Inter-modal Freight Technologies," *Transportation Research A*, 1991, 25A(4), 161-172.

85. Pearmain, D., "The Measurement of Users' Willingness to Pay for Improved Rail Facilities," Proceedings 20th PTRC Summer Annual Meeting, 1992.

86. Louviere, J. J. and D. A. Hensher, *op. cit.*

87. Louviere, J. J. and G. G. Woodworth, "Design and Analysis of Simulated Consumer Choice or Allocation Experiments: An Approach Based on Aggregate Data," *Journal of Marketing Research*, 1983, 20 350-367.

88. Ortuzar, J. de D. and R. Gerrido, *op. cit.*

89. Bates. J. J., "Econometric Issues in Stated Preference Analysis," *Journal of Transport Economics and Policy*, 1988, XXII(1) 59-69.

90. Bradley, M. A. and E. P. Kroes, "Forecasting Issues in Stated Preference Research," in E. S. Ampt, A. J. Richardson, and A. Meyburg (eds) *Selected Readings in Transport Survey Methodology*, Eucalyptus Press, Melbourne, 1992.

91. Morikawa, T., *op. cit.*

92. Bradley, M. A. and A. J. Daly, 1994, *op. cit.*

93. Morikawa, T., M. Ben-Akiva, and D. McFadden, "Incorporating Psychometric Data in Econometric Travel Demand Models," paper presented to the Banff Invitational Symposium on Consumer Decision Making and Choice Behaviour, 1990.

94. Bradley, M. A., P. M. Jones, and E. Ampt, "An Interactive Interview Method to Study Bus Provision Policies," Proceedings 15th PTRC Summer Annual Meeting, 1987.

95. Jones, P. M., M A. Bradley, and E. S. Ampt, "Forecasting Household Responses to Policy Measures Using Computerised, Activity-Based Stated Preference Techniques," in International Association for Travel Behaviour (ed), *Travel Behaviour Research*, Averbury, Aldershot, 1989.

96. Bradley, M. A., *et al.*, 1987, *op. cit.*

97. Fowkes, A. S., *et al.*, 1991, *op. cit.*

98. Pearmain, D., *et al.*, *op. cit.*

99. Polak, J. W., P. M. Jones, G. Stokes, G. Payne, and J. Strachan, "Computer Based Personal Interviews: A Practical Tool for Complex Travel Surveys," Proceedings 17th PTRC Summer Annual Meeting, 1989.

100. Johnson, R. M., *Adaptive Conjoint Analysis*, Sawtooth Software Inc., Ketchum, Idaho, 1987.

101. Bradley, M. A. and A. J. Daly, "New Analysis Issues in Stated Preference Research," Proceedings 21st PTRC Summer Annual Meeting, 1993.

102. Green, P. E., A. M. Krieger, and M. K. Agarwal, "Adaptive Conjoint Analysis: Some Caveats and Suggestions," *Journal of Marketing Research*, XXVIII, 215-222.

103. Fowkes, A. S., and M. Wardman, "The Design of SP Travel Choice Experiments With Special Reference to Taste Variation," *Journal of Transport Economics and Policy*, XXII(1), 1988, 27-44.

104. Fowkes, A. S., "Recent Developments in Stated Preference Techniques in Transport Research," Proceedings 19th PTRC Summer Annual Meeting, 1991.

105. Holden, D. G., A. S. Fowkes, and M. Wardman, "Automatic Stated Preference Design Algorithms," Proceedings 20th PTRC Summer Annual Meeting, 1992.

106. Swanson, J., D. Pearmain, and D. Holden, "New Approaches to the Design of Stated Preference Experiments," Proceedings 21st PTRC Summer Annual Meeting, 1993.

107. Fowkes, A. S., M. Wardman, and D. Holden, "Non-Orthogonal Stated Preference Designs," Proceedings 21st PTRC Summer Annual Meeting, 1993.

108. Ampt, E. S., M. A. Bradley, and P. M. Jones, "Development of an Interactive, Computer-Assisted Stated Preference Technique to Study Bus Passenger Preferences," paper presented to the 66th Annual Meeting of the Transportation Research Board, Washington, 1987.

109. Jones, P. M., *et al.*, 1989, *op. cit.*

110. Costigan, P. and K. Thomson, "Issues in the Design of CAPI Questionnaires for Complex Surveys," in A. Westlake *et al.*, (eds), *Survey and Statistical Computing*, Elsevier, North Holland, 1992.

111. Martin, J., C. O'Muircheartaigh, and J. Curtice, "The Use of CAPI for Attitude Surveys: An Experimental Comparison with Traditional Methods," forthcoming in the Journal of Official Statistics, 1993.

112. Simpkins, H. "Using CAPI to Ensure Consuistency and Quality in International Studies," in A. Westlake *et al.*, (eds) *Survey and Statistical Computing*, Elsevier, North Holland, 1992.

113. Ettema, D., A. Borgers, and H. J. P. Timmermans, "Using Interactive Computer Experiments for Investigating Activity Scheduling Behaviour," Proceedings 21st PTRC Summer Annual Meeting, 1993.

114. Jones, P. M., *et al.*, 1989, *op. cit.*

115. Polak, J. W., *et al.*, 1993, *op. cit.*

116. Hensher, D. A., *op. cit.*

117. Morikawa, T., M. Ben-Akiva, and K. Yamada, "Estimation of Model Choice Models With Serially Correlated RP and SP Data," paper presented at the 6th World Conference on Transport Research, Lyons, 1992.

118. Black, I. G. and J. G. Towriss, *Demand Effects of Travel Time Reliability*, Report to the London Congestion Pricing Research Programme, Department of Transport, 1993.

119. Pells, S. R., "The Evaluation of Reductions in the Variability of Travel Times on the Journey to Work," Proceedings 15th PTRC Summer Annual Meeting, 1987.

120. Senna, L. A. D. S., "Risk of Delays, Uncertainty and Traveller Valuation of Reliability," Proceedings 19th PTRC Summer Annual Meeting, 1989.

121. Ettama, G., *et al.*, *op. cit.*

122. Polak, J. W., *et al.*, *op. cit.*

123. Bradley, M. A. and P. M. Jones, *op. cit.*

124. Axhausen, K. W., "The Role of Computer-Generated Role-Playing in Travel Behaviour Analysis," forthcoming in *Transportation*, 1993.

125. Bradley, M. A. and P. M. Jones, *op. cit.*

126. Jones, P. M., "HATS: A Technique for Investigating Household Decisions," *Environment and Planning A* , 1979, 11A(1), 59-70.

127. Harr, R., D. Clarke, and N. de Carlo, *Motives and Mechanisms - An Introduction to the Psychology of Action*, Methuen, London, 1985.

128. Ducca, F. W., "Improving Travel Forecasting Procedures," Proceedings 21st PTRC Summer Annual Meeting, 1993.

129. Kitamura, R., C. Lula, and E. Pas, "AMOS: An Activity-Based, Flexible and Truly Behavioural Tool for the Evaluation of TDM Measures," Proceedings 21st PTRC Summer Annual Meeting, 1993.

130. Lee-Gosselin, M. E. H. and E. I. Pas, "The Implications of Emerging Contexts for Travel Behaviour Research," in (eds.) Stopher, P. R. and M. E. H. Lee-Gosslein, *Understanding Travel Behaviour in an Era of Change*, Pergamon Press, Oxford, 1994.

131. *Ibid.*

132. Kitamura, R., *et al. op. cit.*

9

ESTIMATION OF LOGIT CHOICE MODELS USING MIXED STATED-PREFERENCE AND REVEALED-PREFERENCE INFORMATION

M. A. Bradley and A. J. Daly

ABSTRACT

The need for cost-effective research techniques in transport has led to increasing use of stated-preference data, as well as the development of mixed models, based on multiple-data sources. Different types of data, as used in such models, may have different accuracy and sources of error. Such differences exist between revealed-preference and stated-preference data. The magnitude and source of errors in different types of data will be reflected in differences in both the measured components and in the unmeasured components (variance) captured in the corresponding models. When choice models are estimated on multiple-data sources, such as various types of revealed- and stated-preference data, these differences must be taken into account explicitly in the specification of the model structure and the utility functions.

The chapter discusses the main issues involved in the estimation and application of discrete-choice models with mixed data, covering:

- the theoretical framework for combining data sources;
- the specification of the model and the likelihood function;
- the suitability and accessibility of different estimation techniques;
- a case study that compares binary probit- and logit-estimation methods;
- a case study that incorporates a new mode into a nested-logit model;
- issues involved in interpreting and applying mixed-model results.

In particular, the paper describes a new approach for estimating models on mixed-data sources using the "tree-logit" estimation technique.

INTRODUCTION

Methods for using "revealed-preference" (RP) disaggregate data to model travel demand have now become well established[1]. Usually, such data contain choices reported from traveller surveys, that are then related to the characteristics of the travel alternatives available to them: either self-reported or measured from road and public-transport network data. A number of forecasting methods have been developed to extrapolate such models to the wider population and the longer-term time horizon[2,3].

Increasingly, "stated-preference" (SP) data, based on responses to hypothetical travel situations from a survey context, have been used in cases where observed choice behaviour cannot tell us enough about the choice context of interest. SP data may be used, for example, because one is interested in travel alternatives or characteristics that do not yet exist, or one is interested in qualitative factors that are very difficult to measure in actual circumstances.

In early transport applications that used SP data, such as Kocur *et al.*[4] and Sheldon and Steer[5], the methods used remained quite close to those that had been widely adopted in the field of market research[6]. In recent years, the emphasis has shifted somewhat from "stated-preference" data to "stated-choice" data that resemble RP data as closely as possible and can be analyzed with similar techniques, such as discrete choice logit or probit estimation[7]. Concerns remain, however, that stated choices may actually be measuring different aspects of behaviour than revealed choices, with the two types of data being subject to different levels of accuracy and different types of error and bias. Such differences may be particularly important in forecasting, where the size of the explanatory-variable effects relative to the unexplained variation in behaviour becomes critical[8,9,10].

For forecasting purposes, one would ideally like a methodology that can derive the essential information from SP data (the information that cannot be obtained from RP data) and that can incorporate it into a model that is suitable for application to RP-type data and that reflects actual (or expected) choice conditions. That is, it is desirable to combine the stronger features of RP and SP data. The issue addressed by the present chapter is how this combination can be achieved.

Structure of the Paper

This chapter discusses and illustrates the main issues involved in the estimation of mixed RP-SP discrete-choice models:

The second section provides background on the theoretical framework of the integrated-estimation approach, the structure of the model, and the specification of the joint-utility function. This section includes a statistical derivation of the "tree-logit" estimator of the joint likelihood function.

The third section describes a test of the tree-logit method in the binary-choice case. This case study was performed with data used in previously-published research[11], providing a direct comparison of binary-logit and probit estimation techniques.

The fourth section presents a second case study, a more difficult but more typical case, where stated-preference data are used to supplement a model from independent revealed-preference data in order to add to the model a travel mode that does not yet exist. Here, the joint-estimation approach is tested within a nested multinomial-logit structure. The fifth section provides a brief summary and some conclusions regarding the methods and results described in the paper.

THE THEORETICAL FRAMEWORK

The theoretical framework that we have adopted for integrated analysis of RP and SP data was developed by Morikawa, Ben Akiva, and McFadden[10, 11]. The framework is that of individual utility maximization by travellers. While other behavioural paradigms can be used for analysis of this type, utility maximization has been studied in detail by many other researchers and there is a consistent and coherent body of theory based on utility maximization to which reference can be made.

Formulation of the Analytical Problem

For consistency, notation similar to that used by Morikawa *et al.*[12] is used. In this notation, the (latent) utility maximized by travellers in their revealed preferences, u^{RP}, for a given traveller, for a given alternative, is given by:

$$u^{RP} = \beta.X^{RP} + \alpha.W + \epsilon \tag{1}$$

where:

X^{RP}, W are vectors of the measured variables influencing the RP decision;

β, α are vectors of unknown parameters (to be estimated);

ϵ represents the sum of the unmeasured utility components of utility influencing the RP decision.

Similarly, the SP decision can be represented as being decided on the basis of the utility function u^{SP}:

$$u^{SP} = \beta.X^{SP} + \gamma.Z + v \qquad (2)$$

where:

X^{SP}, Z are vectors of the measured variables influencing the SP decision;

β, γ are vectors of unknown parameters (to be estimated);

v represents the sum of the unmeasured utility components of utility influencing the SP decision.

In this notation, it is possible to allow for the existence of measured variables W that occur only in the RP context, or Z that occur only in the SP context. These variables would also incorporate average biases or modal preferences, which may be different in the two contexts. Generally, the mean biases are captured by including "alternative-specific constants" in the utility functions for the alternatives. These constants represent the mean net effect of all the unmeasured components of utility. This incorporation of mean bias in the measured variables allows the assumption that the mean value of the unmeasured components ϵ and v is zero for each alternative.

Among the variables that are present only in one of the contexts (W or Z) should be included all likely context-specific biases. Among these, it is necessary to allow for any "inertia" effect, where the biases may be systematically related to each SP respondent's actual revealed behaviour. The existence of such "inertia" and other context-specific biases make it necessary in many cases to include the alternative-specific

constants within the context-dependent variables W and Z, rather than in the joint variables X. The interpretation and use of such effects is an important issue that we return to in the last section.

The key to the use of the joint-estimation approach lies in the variables X that appear in *both* utility functions. Their coefficients, β, can be estimated using the information from *both* surveys. By this formulation, therefore, the objective is achieved of exploiting data from the two contexts to make *joint* estimates. This can be done, of course, only when there is an overlap of two or more of the X variables indicated in equations (1) and (2) above. When there is only one X variable in common, one utility function simply can be scaled to the other, using the ratio of the independent RP and SP coefficients for that variable; no joint estimation is necessary. (The same applies when there are two or more variables in common, but they have "exactly" the same *relative* coefficient values in independent RP and SP models.) Joint RP/SP estimation is thus needed when there are two or more variables in common, for which the different types of data, used independently, give somewhat conflicting or inconclusive results. In joint estimation, we assume that the "true" underlying relative effects of the variables in X are the same in the RP and SP contexts, i.e. that their marginal contribution to utility indicated by β is identical. This assumption should be tested in estimation using the likelihood-ratio test[13].

Distributional Assumptions

The theory of utility-maximizing models (see, for example, Ben-Akiva and Lerman[14]) derives choice probabilities directly from the assumptions made about the distributions of the unobserved components ϵ and v. Thus, to derive the probability models necessary to analyze the data, it is necessary to specify distributions for these variables.

Apart from the assumption that the marginal utility of each common variable is equal in each of the contexts, which is necessary to make any joint use of the data, it is also necessary to make an assumption about the distribution of the unmeasured components within the population. Because of the presence of alternative-specific constants, as explained above, it is acceptable to assume that the mean value of ϵ and v is zero. However, further assumptions are required about the interdependence (both between observations and between alternatives), variance, and distributional form to be taken by these variables. As is usual in analysis based on utility maximization, ϵ and v are treated as random variables.

The issue of interdependence between observations is difficult. In most practical cases, a single RP choice observation is taken from each traveller and there is little question that it is reasonable to assume independence of these observations. One of the chief advantages of SP surveys, on the other hand, is that several observations can be taken from each individual. In that case, the assumption of independence must be, at best, a poor approximation. Nevertheless, this assumption is routinely made and the success that has been achieved in previous studies suggests that the problems caused by this assumption are limited in their practical effect. Until a more satisfactory theoretical framework is established for repeated choices, the assumption will be maintained. Similarly, interdependence between RP and SP observations from the same individual cannot be treated fully at present.

The existence of interdependence between SP observations from the same individual makes it impossible to assume that the variance of the unmeasured components ϵ and v is equal. The existence of the correlation in the SP data suggests that the variance of v will be less than that of ϵ. However, there are many other effects at work here, such as the omission of many relevant variables from most SP contexts and the existence of substantial measurement error in many RP contexts. In general, it cannot be stated *a priori* which of the two unmeasured components will have the greater variance; however, it is clear that it is *not* possible to assume that their variances are equal.

The functional form assumed for the distributions of ϵ and v determines the functional form of the probability model that is used to estimate the coefficients α, β, and γ. In the work of Morikawa *et al.* the assumption is made that ϵ and v are distributed normally (with zero mean and unequal variance, as suggested above), leading to 'probit' models of probability. This assumption of normal distribution facilitates analytical study of the models, but can lead to severe difficulties in empirical work, particularly in choice contexts with more than two alternatives. Special computer software is required that can require long run times and present other difficulties in finding optimum values of the parameters.

An alternative-distributional assumption is to take the limiting-value distribution, often described as "Gumbell" or "Weibull" to describe the variation of ϵ and v. This assumption, suggested for the present context by Daly [15], leads to the use of logit models for the probability calculations. These models are characterized by their much greater simplicity in empirical work; this feature is illustrated in the subsequent sections of the present paper.

From a theoretical viewpoint, the use of the logit model is equally as appropriate as the use of probit. Intuitively, the logit model is appropriate when an alternative is viewed as being an aggregation of a number of "sub-alternatives." The probit model, on the other hand, is appropriate when the unmeasured part of the utility function is viewed as the sum of a large number of components. Because both of these viewpoints appear to be partial descriptions of the reality being modelled, there appears little theoretical basis for the choice of one model over the other.

From an empirical point of view, the results achieved for binary-choice models with the two forms are very similar, as is illustrated in the third section. The reasons for this are explained by Daly and Zachary[16]. Briefly, the major difference between the two model forms is the greater sensitivity of the probit model to "outliers" (unusual observations) in model estimation. For less unusual observations, estimation is almost identical; in forecasting there is also almost no difference between the two model forms.

For more complicated models with more than two alternatives, the differences between logit and probit forms are more significant. Logit models extend easily to a large number of alternatives, provided that an assumption of symmetry among the alternatives is made. Some forms of asymmetry can be handled with "tree-logit" forms. Very general model forms can be included in the probit family, although the computational difficulties become very severe indeed. It may be concluded that there is scope for the use of logit models in the integration of RP and SP data. While some researchers may prefer to use probit models for specific research needs, the logit model is theoretically attractive and empirically advantageous.

The "Tree-Logit" Estimation Procedure

It is assumed, as sketched out in the previous discussion, that the non-measured components of the utility ϵ and v are distributed independently (across both individuals and alternatives, and independently of each other) with the limiting-value distribution, but with unequal variance. If we define θ^2 to be the ratio of the variances,

$$\theta^2 = var(\epsilon) \,/\, var(v) \tag{3}$$

then the SP utility can be scaled by θ:

$$\theta.u^{SP} = (\theta.\beta).X^{SP} + (\theta.\gamma).Z + (\theta.v) \tag{4}$$

so that the random variable (θ,v) now has a variance equal to that in the RP utility (ϵ). It is now possible to use both RP and SP observations in a logit-estimation procedure that requires equal variance across the observations.

While for the RP estimation, the parameters to be estimated are the simple values of α and β, for the SP estimation the coefficients are $(\theta.\beta)$ and (θ,γ). This scaling has no other effect on the distributional assumptions, or on the conversion of the utility functions to choice probabilities. In the case of (θ,γ), because the scale of g is arbitrary, the presence of θ is not necessary; but in the case of $(\theta.\beta)$ the scaling by θ is the essential link between the RP and SP models. The SP model, however, is no longer a linear function of the parameters — an estimation problem that can be solved by existing "tree-logit" estimation software, by setting up an artificial tree structure as follows.

The artificial tree is constructed to have as many elementary alternatives as there are in all RP and SP choice sets combined. Only the RP alternatives are set as available for the RP observations, while only the alternatives from the relevant SP experiment are available for each SP observation. The utility functions in each case are as given in equations (1) and (2) (i.e. without θ). As indicated in Figure 1, the RP alternatives are placed just below the root of the tree; while the SP alternatives are each placed in a single-alternative nest. For an RP observation, the SP alternatives are set unavailable and the choice is modelled as in a standard logit model. For an SP observation, the RP alternatives are set unavailable and choice is modelled using the tree-logit structure.

Figure 1
Artificial Tree Structure for Joint Estimation

For SP observations, the mean utility of each of the "dummy" alternatives is composed as usual in a tree-logit model (see Daly[17]):

$$V^{comp} = \theta. \ \log(\sum \exp(V^{SP}))$$

(5)

In equation 5, the sum is taken over all of the alternatives in the nest corresponding to the composite alternative.

$$V^{SP} = u^{SP} - v = \beta.x^{SP} + \gamma.z$$

(6)

is simply the measured part of the SP utility. Then, because each "nest" contains only one alternative in this specification:

$$v^{comp} = \theta.u^{SP} = (\theta.\beta).X^{SP} + (\theta.\gamma).Z$$

(7)

This is exactly the form required by equation 4, as long as the value of θ is constrained to be the same for each of the dummy alternatives. This approach can also be generalized to data from two or more different SP experiments, by using a different set of available SP alternatives and a different set of dummy alternatives with its own θ parameter for each experiment.

Because the dummy-composite alternatives are placed just below the root of the tree, as are the RP alternatives, a full-information nested-logit estimation procedure, such as Hague Consulting Group's ALOGIT program, will ensure that θ is estimated to obtain uniform variance at this level.

This method exploits software that was developed for a different purpose — the estimation of models for simultaneous nested-choice structures. It is important to note that the construction used here is artificial in that individuals are not modelled as choosing from among the RP and SP alternatives simultaneously and no assumption is required about consistency of preferences between RP and SP alternatives. Thus, the usual requirement for tree-logit models that θ should not exceed unity does not apply. The scale for SP relative to RP may be either greater than or less than unity. In fact, the decision as to whether to apply the scale factor to the RP data or the SP data is rather arbitrary, and will depend mainly on the type of data to which the model will eventually be applied for predicting behaviour.

Finally, the structure indicated above, in which the models of choice over the RP and over the SP alternatives are each simple logit in form, can be generalized. Nested-

choice structures among the RP and/or SP alternatives may be introduced. An example of scaling with nested models is given in the fourth section.

CASE STUDY 1: APPLICATION TO BINARY CHOICE CONTEXTS

This section describes the application of the proposed logit estimation technique to the same data set studied by Morikawa[18]. Comparisons are made between Morikawa's probit-estimation results and results of estimation using logit models.

The Study Context

Hague Consulting Group, along with Steer Davies Gleave, was contracted by Netherlands Railways (NS) to study the potential for substitution between car and train, for intercity travel in the Netherlands as a function of rail service levels and fare. A sample of 235 individuals was selected who had recently travelled by car or rail from the Dutch city of Nijmegen, near the German border, to Amsterdam, Rotterdam, or Den Haag, all located about 125 kilometres to the West.

A computer-based home interview was designed to elicit first a detailed account of the journey that the respondent had made, including all journey costs, times, and interchanges. Respondents were then asked to give their perceptions of making the same journey by the alternative mode. These data were used as a basis for the attribute levels to be varied in stated-preference (SP) experiments, but also provided data suitable for estimating revealed-preference (RP) models, albeit with self-reported values of the car and train attributes.

The first SP experiment (SP1) was designed to measure the relative importance of four train attributes: fare, journey time, number of interchanges, and comfort level. This was thus a within-mode experiment, where all respondents compared different train options against each other. Pairwise choice questions were used, with a five-point response scale: (1) Definitely A, (2) Probably A, (3) Not Sure, (4) Probably B, and (5) Definitely B.

A second SP experiment (SP2) was a mode-choice experiment, always comparing car against train. The same four attributes for train were varied as in the first experiment. For car, although both travel cost and time were shown as attributes, only the cost was varied during the experiment. In order to create situations in which people might be induced to switch from the actual mode, the train attributes were varied to become worse than the reported levels for train users and better than the reported levels for car users. The same five-point response scale was used as in SP1. Further information on the survey and analysis results is reported in Bradley *et al.*[19]

Case Study Results

Morikawa[20] used ordered-probit estimation to analyze the interval information in the five-point scale responses in the SP1 and SP2 data, and binary-probit estimation for the RP train versus car choice. (*Ordered probit* estimates the threshold in the utility function where respondents shift from one response to the next.) For the mixed RP/SP models, Morikawa programmed the joint-likelihood function using the GAUSS microcomputer package. The results, reproduced in Table 1, contain a number of results that can be typical for the types of data used:

- the RP model does not yield a significant estimate for in-vehicle time, presumably due to insufficient variation or correlation with other variables such as cost and number of transfers (such problems are more typical when network-based attribute data are used);

- the SP1 within-mode model has the most significant estimates, but coefficients can be estimated only for the four variables that were varied in the experiment;

- the SP2 across-mode model contains fairly significant estimates for all level-of-service variables, but has values of the rail-mode constants that are different than for RP, and shows a strong inertia effect;

- the scale parameters show that the within-mode SP1 responses have significantly *less* unexplained variance than the RP data ($q>1$), and the across-mode SP2 responses have significantly *more* unexplained variance when compared to the RP data ($q<1$).

Table 2 contains results for models estimated on exactly the same data, with the same variable specifications as in Table 1. The models in Table 2, however, were estimated using binary-logit models and tree-logit models for the mixed RP/SP models, as explained in the second section. Estimation was done using Hague Consulting Group's ALOGIT microcomputer package.

In order to estimate binary-logit models on the five-point scale SP responses, we interpreted "Definitely A" and "Probably A" as simple choices for A, "Definitely B" and "Probably B" as simple choices for B, and "Not Sure" as half of a choice for A and half for B. (One could also omit the "Not Sure" responses to give a true discrete-choice variable.)

Table 1
Probit/Ordered Probit Parameter Estimates

Model :	RP	SP1	SP2	RP+SP1	RP+SP2	RP+SP1+SP2	RP2
N.Obs. :	235	2965	1628	3200	1863	4828	228
ρ^2 :	.295	.315	.372	.314	.366	.334	.299

(coefficients, with absolute t-values in parentheses)

RP/SP Joint Variables

	RP	SP1	SP2	RP+SP1	RP+SP2	RP+SP1+SP2	RP2
Cost/pers	-.026	-.081	-.0072	-.024	-.024	-.025	-.027
(gld.)	(4.4)	(25.3)	(5.3)	(4.9)	(4.9)	(5.4)	(4.4)
In-V.Time	.0005	-.016	-.0032	-.0047	-.0046	-.0050	-.0050
(min.)	(0.2)	(11.7)	(2.7)	(4.6)	(1.9)	(5.1)	(1.3)
Out-V.Time	-.026		-.0066	-.026	-.025	-.025	-.026
(min.)	(4.4)		(3.2)	(4.6)	(4.7)	(4.9)	(4.7)
Transfers	-.344	-.156	-.053	-.049	-.245	-.052	-.144
(number)	(2.6)	(4.9)	(1.6)	(3.6)	(2.7)	(3.9)	(1.0)

RP-Specific Variables

	RP	SP1	SP2	RP+SP1	RP+SP2	RP+SP1+SP2	RP2
Non-work	-.900			-.870	-.900	-.864	-.691
(0/1-RP)	(4.0)			(4.1)	(4.2)	(4.1)	(2.2)
Rail ASC	1.74			1.44	1.61	1.43	0.35 *
(0/1-RP)	(5.5)			(5.9)	(5.5)	(6.0)	(1.2)

SP-Specific Variables

	RP	SP1	SP2	RP+SP1	RP+SP2	RP+SP1+SP2	RP2
Comfort		-.500		-.150		-.156	
(0/1/2-SP1)		(14.8)		(4.7)		(5.2)	
Non-work			-.025		-.129	-.075	
(0/1-SP2)			(0.3)		(0.5)	(0.3)	
Rail ASC			-.966		-2.96	-3.18	
(0/1-SP2)			(7.9)		(3.4)	(3.8)	
Inertia			1.49		4.84	4.90	
(0/1-SP2)			(17.5)		(4.2)	(4.4)	

Scale Parameters

	RP	SP1	SP2	RP+SP1	RP+SP2	RP+SP1+SP2	RP2
SP1 scaled to RP				3.33		3.22	
				(4.8)		(5.3)	
SP2 scaled to RP					.294	.298	
					(4.3)	(4.5)	

* Two additional dummy variables were included in the RP2 model, mainly affecting the value
 of the rail constant.

Table 2
Logit/Tree logit Parameter Estimates

Model :	RP	SP1	SP2	RP+SP1	RP+SP2	RP+SP1+SP2
N.Obs. :	235	2965	1628	3200	1863	4828
ρ^2 :	.303	.148	.338	.158	.332	.218

(coefficients, with absolute t-values in parentheses)

RP/SP Joint Variables

Cost/pers	-.025	-.081	-.0061	-.026	-.022	-.026
(gld.)	(4.3)	(19.8)	(3.5)	(4.7)	(4.6)	(5.0)
In-V.Time	.0040	-.016	-.0045	.0050	-.0083	-.0051
(min.)	(1.0)	(10.7)	(3.2)	(4.4)	(2.8)	(4.7)
Out-V.Time	-.024		-.0043	-.024	-.023	-.025
(min.)	(3.9)		(1.7)	(4.0)	(4.1)	(4.5)
Transfers	-.286	-.176	-.065	-.058	-.269	-.058
(number)	(2.3)	(5.4)	(1.3)	(3.6)	(2.7)	(3.8)

RP-Specific Variables

Non-work	-.690			-.660	-.684	-.664
(0/1-RP)	(3.3)			(3.2)	(3.3)	(3.2)
Rail ASC	1.44			1.27	1.33	1.28
(0/1-RP)	(5.1)			(5.0)	(4.9)	(5.1)

SP-Specific Variables

Comfort		-.517		-.166		-.165
(0/1/2-SP1)		(14.6)		(4.5)		(4.8)
Non-work			-.092		-.278	-.319
(0/1-SP2)			(1.1)		(1.0)	(1.0)
Rail ASC			-.880		-2.67	-3.14
(0/1-SP2)			(6.9)		(3.2)	(3.2)
Inertia			1.42		4.50	4.86
(0/1-SP2)			(15.3)		(4.2)	(3.9)

Scale Parameters

SP1 scaled to RP				3.12		3.16
				(4.6)		(4.8)
SP2 scaled to RP					.299	.276
					(4.2)	(3.9)

There is some information lost in the transformation from the scale response to binary choice, as indicated by the lower ρ^2 measures of fit for the SP models in Table 2 as

compared to Table 1. This extra explanation in the ordered-probit models is provided by two extra parameters (omitted from Table 1) that indicate the threshold utility differences that define the five symmetric scale intervals. In terms of likelihood measures, this loss of information appears more important for SP1 within-mode choices, where individuals are comparing very similar alternatives, than for the SP2 mode choices. In terms of the coefficients and their significance, however, the difference is quite small, particularly for the SP1 model.

The clearest way of comparing the probit and logit results is to compare the parameter estimates and their statistical significance in Tables 1 and 2. The logit coefficients have been divided by a factor of $\pi/\sqrt{3}$ in order to normalize the Weibull error distribution to the standard normal distribution assumed in probit[21]. None of the results are significantly different from each other in the two tables. The two coefficients which change sign between the tables — in-vehicle time for RP and the rail constant for non-workers for SP2 — are not significant in either case. The *t*-statistics are slightly lower for the logit models than for the probit models, but are very similar in the case of the RP+SP models. Perhaps most importantly, the scale factors for the RP+SP models are nearly identical in Tables 1 and 2, indicating that the tree-logit method for estimating the scale differences gives comparable results.

The estimates are most precise in the SP1 within-mode models. In particular, the inferred value of in-vehicle time from the SP1 models — about 12 gld/hr. — is very well estimated. Joint estimation on RP plus SP1 leads to a scale on the time and cost coefficients similar to RP alone but a value-of-time ratio similar to SP1 alone. If we are willing to make the reasonable assumption that this value of time is also appropriate in actual choice contexts, then the approach is successful in combining useful aspects of both data sets. Because this analysis was meant to compare the two estimation approaches, further discussion of the individual variables in the models is beyond the scope of this chapter. The inertia effect is discussed further in the fifth section.

A further interesting point is that certain results from this analysis suggest that the difference between the probit and logit results is caused by the presence of outliers, i.e. responses that are very poorly predicted by the model, often due to errors in the data. Because the error distribution assumed in probit has smaller tails than that assumed in logit, probit estimates tend to be more distorted by outliers[13]. Further evidence is provided by the RP2 model in Table 1, reported in a subsequent paper by Morikawa et al.[22] after 7 respondents had been deleted from the RP sample. These results now appear somewhat more similar to those for RP in Table 2, particularly the change of sign for in-vehicle time. The sensitivity to outliers is not a strong point for or against the use of either technique, because the best modelling practice in both

cases is to identify such outliers, examine them, and eliminate them from the sample if appropriate.

CASE STUDY 2: APPLICATION TO MULTINOMIAL CHOICE CONTEXTS

The previous case study has shown that the tree-logit approach, which can be performed with currently available logit estimation software, gives results consistent with those obtained from a more complex, probit-estimation procedure. This difference is especially important for models with more than two alternatives. Existing logit-estimation packages such as ALOGIT can estimate nested, multinomial discrete-choice models, while such estimation is not currently feasible using probit analysis. The following case study shows how the scaling approach can be applied to such models. In the previous example, RP data were obtained during the SP interviews as a small supplementary data source to use in scaling the sensitivity of the SP models to that reflected in current choices. A more challenging case study is described in this study, where SP is the supplementary data source used to add additional parameters to a model that is based on *independent* RP data and independent network-based attribute data.

The Study Context

Hague Consulting Group, along with study team members from Macquarie University (now at the University of Sydney) and Cambridge Systematics, was contracted by CSIRO in Australia to study the market potential for a proposed high-speed rail system connecting the cities of Sydney, Canberra, and Melbourne. The objective was to identify the sensitivity of demand to key variables, such as fare and travel time, and also to predict the absolute level of demand, requiring estimation of a choice model including a mode which did not yet exist.

The first stage of the study included intercept surveys among car, air, bus, and train travellers along all routes for which the proposed Very Fast Train (VFT) would be a relevant alternative. Over 30,000 such questionnaires were completed. These data were expanded to produce origin-destination matrices of existing travel in the corridor and were also analyzed, in combination with network-based travel time and cost data, to produce RP models of mode choice among the existing alternatives.

The second stage involved over 2,500 home interviews, with roughly half of the respondents recruited out of the intercept samples, and the other half contacted at random also to include non-travellers. The SP experiment began by collecting a number of details of the most recent actual journey and of certain attributes of the alternative modes for that journey, (e.g., access/egress times from airports and

train/coach stations). The VFT service was then introduced, using a realistic information/advertising brochure. The stated-preference experiment used an orthogonal design, with the travel times and costs of the existing modes and the VFT varied independently, with each respondent considering three relevant sets of hypothetical mode alternatives, supplemented with the information that they provided on access/egress times and costs. Three stated mode choices were obtained per respondent.

Although data from only the mode-choice SP experiment are discussed here, the survey also included a second, within-mode SP experiment that asked for choices among different versions of the VFT, with attributes including fare, type of seating, and entertainment facilities. Further details of the study are given in Gunn *et al.*[23]

Case Study Results

First, we should note that, because of continuing development, the models described in this section are not those that are used to forecast demand for the VFT system — the specific models shown here have been estimated for the purposes of this chapter.

Table 3 shows nested mode-choice model results, separately for business and non-business trips. For the cost variable, all models use the travel cost per person divided by the average wage per worker in the travel party, which results in a cost in units of the minutes of work time required to pay for the journey using each mode. Other variables are main line-haul in-vehicle time for each mode, access time to and egress time from each mode, mode-specific constants, and a few segmentation variables related to the choice of air travel. Note that this example uses "generic" travel-time variables across modes, but that the same approach could be extended to include different travel-time coefficients for different modes.

In the separate RP and SP models, all passenger modes — air, coach, rail, and VFT — are included in a single nest versus car, reflecting the closer substitution between those modes. The structure of the joint RP/SP nested model is shown in Figure 2. The "logsum" parameters associated with alternatives *RP Pass.* and *SP Pass.* are nested-logit structural parameters and should have a value between 0 and 1. That is the result in Table 3, with values of around .90 for the business models and .60 for the

Table 3
Nested Mode Choice Models with New Mode

	Business			Non-Business		
Data	RP	SP	RP+SP	RP	SP	RP+SP
Num. Obs.	12586	1924	14510	16317	3673	19990
ρ^2	0.368	0.261	0.343	0.129	0.203	0.141
Log-likel.	-5074	-1340	-6463	-15544	-3128	-18693

(coefficients, with absolute t-values in parenthesis)

RP/SP Joint Variables						
Cost/Wage	-0.0016	-0.0021	-0.0016	-0.0013	-0.0009	-0.0013
(min.)	(28.2)	(6.6)	(29.3)	(40.4)	(6.9)	(40.8)
Main Time	-0.0047	-0.0057	-0.0049	-0.0022	-0.0018	-0.0021
(min.)	(32.0)	(12.8)	(34.9)	(41.2)	(9.1)	(42.5)
Access Time	0.0024	-0.0098	-0.0006	0.0012	-0.0030	0.0005
(min.)	(3.7)	(7.5)	(1.1)	(2.8)	(3.4)	(1.3)
Air-Travel	2.11	-0.216	2.10	0.069	0.300	0.075
Alone	(23.5)	(1.7)	(23.3)	(1.5)	(1.7)	(1.6)
Air-Age	-0.836	0.140	-0.831	-0.434	0.254	-0.432
<35	(11.2)	(1.1)	(11.1)	(9.7)	(1.4)	(9.7)
Air-Day	0.469	0.154	0.454	0.958	-0.094	0.930
Trip	(5.4)	(1.3)	(5.2)	(14.6)	(0.3)	(14.3)
Pass. mode-	0.823	0.943	0.821	0.566	0.683	0.579
(logsum)	(40.0)	(9.7)	(41.0)	(28.0)	(8.7)	(29.7)

RP-Specific Variables						
Air	-1.57		-1.20	-1.28		-1.12
(RP)	(11.1)		(9.1)	((12.3)		(11.6)
Coach	-2.31		-2.06	-1.69		-1.57
(RP)	(19.8)		(19.0)	(18.4)		(18.4)
Train	-2.35		-2.14	-1.73		-1.63
(RP)	(23.1)		(22.3)	(20.4)		(20.6)

SP-Specific Variables						
Air		0.377	-0.594		-1.23	-1.30
(SP)		(1.1)	(3.7)		(3.6)	(8.6)
Coach		-1.73	-2.55		-0.698	-0.931
(SP)		(2.8)	(4.1)		(3.1)	(6.3)
Train		0.615	-0.228		-0.185	-0.364
(SP)		(1.8)	(0.7)		(0.9)	(2.6)
VFT		3.00	2.22		2.00	1.80
(SP)		(9.9)	(7.8)		(7.5)	(10.9)
Inertia		2.68	2.4		2.14	2.17
(SP)		(15.1)	(11.7)		(28.8)	(23.5)
Scale Parameter			1.17			0.932
SP scaled to RP			(12.4)			(19.6)

non-business models. The SP logsum estimate is not significantly different from the RP estimate in either case. The joint RP/SP model estimate is close to the RP-only estimate in both cases.

Figure 2
Tree Structure for Joint Nested Estimation

The scale parameter applied to the SP "dummy" alternatives is not a typical structural parameter, as was discussed in section 2. The resulting scale parameters in Table 3 fall on either side of unity, but quite close in both cases. This means that the proportion of unexplained variance is (coincidentally) about the same in both types of data. This is different from the results of Case Study 1.

One finding is similar to the results of the first case study: the RP models give the incorrect sign for access time, perhaps as a result of correlation with the other network-based time and cost variables. The SP models, on the other hand, give more reasonable estimates for access time at about twice as high as for main in-vehicle time. In contrast to Case Study 1, however, combining the RP and SP data did not produce a significant access-time coefficient for either purpose. The difference, in this example, is the fact that the RP sample is quite large compared to the SP sample and has a similar scale ($\theta \doteq 1$). There is no within-mode SP data with high enough measurement precision to "overrule" the RP data, as was the case in Tables 1 and 2. In practice, if one believed that the SP results were more "correct," it would be best simply to constrain the main and access-time coefficients in the RP or RP+SP model to have the same ratios as estimated in the SP-only model. This is similar to the "sequential" estimation approach, where the SP results are used to constrain the *relative* values of the coefficients of the β parameters in the RP model.

The ratio of the main in-vehicle time coefficient to the "work time-equivalent" cost coefficient is about 3.0 for the RP and SP business models, and about 2.0 for the RP and SP non-business models. For the mixed RP+SP models, the results are closest to the RP-only results due to sample size. Although not shown here, it was found that the SP and RP data did not give such similar estimates for the relative value of time and cost until *after* a nested-model structure was adopted with car versus the passenger modes. This result confirms the importance of using a correct model specification and the value of being able to apply the joint RP/SP estimation approach to nested models.

A number of further points can be made about these results. First, the extra variables for the air mode, related to day trips, travelling alone, and younger travellers, are much more significant for the RP models than the SP models. This may reflect the fact that such "background" effects have less influence on SP data, because of the highly controlled nature of the independent variables and the choice context. One might decide not to estimate these segment-specific variables for air jointly, because the two separate data sets give different results.

Second, in Table 3, two separate sets of modal constants are estimated in the joint RP/SP models. The most important constant is that related to the new VFT mode, because this is necessary for forecasting and cannot be derived from the RP data. Mode-specific constants for the existing modes are not constrained to be the same as those from the RP data, because different types of unobserved effects may influence the two types of data. The two data sources give somewhat different trends for these constants, although the SP constants are highly correlated with the "inertia" effect (see below).

Third, the SP models in Table 3 again contain an "inertia" effect, to reflect the higher probability of each respondent selecting their actual mode during the SP choice experiment. The size of the inertia effects is similar to that found in Case Study 1. Note that the inertia variable may reflect a number of unobserved effects that would otherwise be captured in the mode-specific constants. Also note that the "intertia" coefficient is similar in size to the VFT modal constant — if the inertia variable is excluded from the model (not shown here), the VFT constant becomes close to zero, while the constants for the existing modes become much larger negative. The use of the "inertia" effect and the constant for the new mode are important issues in application, and are discussed further in the final section.

Fourth, according to the likelihood-ratio test, the final likelihood of the mixed RP/SP model is significantly worse than the combined likelihoods of the separate RP and SP models for both trip purposes. This result seems to be typical for this approach[9]; the

likelihood-ratio test seems to be quite a strict test for combining different data sources. One can try to improve the fit of the joint model by estimating variables separately that may be expected to have different RP and SP effects. An example in Table 3 would be to estimate RP- and SP-specific variables for the three air-related segment variables.

Finally, as noted earlier, joint estimation is not necessary (or possible) when SP experiments have only a single variable in common with RP models. An example here was a within-mode experiment, trading off a number of VFT qualitative service variables against fare level. Models, based on such data, can be applied by simply scaling all SP coefficients by the ratio of the fare coefficient in the RP model to the fare coefficient in the SP model.

SUMMARY AND CONCLUSIONS

Experience in transportation planning has confirmed the usefulness of both revealed-preference and stated-preference data. However, these two types of data each offer specific and different strengths and weaknesses. Analysis exploiting both types of data simultaneously can use the strengths of each type of data to help overcome the weaknesses of the other.

The key points in combining the two types of data are the differing systematic *biases* and random *errors* that occur in the two differing contexts. Coping with biases introduces no new methodological issues, but the fact that different levels of error are present requires special treatment in modelling.

The proposal presented in this paper is that the combination of RP and SP data can be achieved using models of the logit form. Accommodation of the differing error variances then requires the use of an artificial tree-logit construction. However, the resulting model can be estimated conveniently using existing commercial software.

The tree-logit method developed has been tested on two separate case studies. In the first case study, it was shown that the results obtained from the logit approach proposed here correspond closely with those obtained from the probit approach investigated by Morikawa *et al.* Remaining differences appear to be associated with the higher sensitivity of probit models to unusual observations (outliers).

The second case study confirms the results of the first, in showing that the combined RP and SP data can improve and expand upon the results of RP data alone, while retaining the reliability of association with actual behaviour. This second example was

a more rigorous test, in that it used RP and SP data from different surveys, and it used nested-logit model specifications on both types of data.

The examples demonstrate that the method can be performed using currently available software. The advantages of combining data of these two types are substantial and the results appear reliable thus far. Further examples of research and applications of this new approach will be important in making it a part of standard travel-demand modelling practice. As in using any new method, a body of experience needs to be built up in order to judge how this approach should be used best in practice — particularly in forecasting.

One important issue is the use of parameters that can be estimated only from SP data. For example, should the VFT-mode constant in the previous example be used "as is" in forecasting (after adjusting for the scale difference), or should we somehow determine its value *relative* to the SP-specific constants for the competing modes? The sensitivity of forecasts to this decision should be tested, because the "correct" approach is not obvious.

In this same line, the use of inertia effects needs to be considered carefully. These effects are in some ways analogous to those that can be found in longitudinal data, using information on previous behaviour. While it is clear that significant effects can be found, it is not obvious what they represent — heterogeneity in the population, actual reluctance, or "costs" of changing behaviour, or other effects that are specific to the SP experiment. In any case, such variables may be valid only for predicting switches away from the current mode in the short term. For longer-term forecasting models that are not conditional on current choices, it may be better not to include such variables in SP models, or at least to check that their inclusion does not greatly affect the SP-based estimates which *are* used in prediction.

In closing, we should point out that the joint-estimation method demonstrated here may have other uses than in combining RP and SP data in analysis. The scaling approach can also be applied to combine different types of RP data, or even to look for differences in data from different stages during a single SP experiment[24]. It could also be useful in combining RP information with information from other types of data from hypothetical contexts, such as "stated intentions" or "transfer prices"[25].

ACKNOWLEDGMENTS

The authors are grateful to the anonymous reviewers for their useful suggestions. The structure of the paper has been revised from that of the original Quebec version, and the second case study has been updated to take advantage of further experience using this approach since the date of the conference.

REFERENCES

1. Ben-Akiva, M., and S. Lerman, *Discrete Choice Analysis: Theory and Application to Travel Demand.* MIT Press, Cambridge, Massachussettes, 1985.

2. *Ibid.*

3. Daly, A., and J. de D. Ortúzar, "Forecasting and Data Aggregation: Theory and Practice," *Traffic Engineering and Control,* December, 1990.

4. Kocur, G., T. Adler, and W. Hyman, *Guide to Forecasting Travel Demand with Direct Utility Assessment,* U.S. Dept. of Transportation, Washington, D.C., 1982.

5. Sheldon, R., and J. Steer. "The Use of Conjoint Analysis in Transport Research," Proceedings of PTRC 10th Annual Summer Meeting, July, 1982.

6. Green, P., and V. Srinivasin, "Conjoint Analysis in Consumer Research: Issues and Outlook," *Journal of Consumer Research,* 1978, Vol. 5, pp 103-123.

7. McFadden, D., "The Choice Theory Approach to Market Research," *Marketing Science,* 1986, Vol. 5 (4).

8. Ben-Akiva, M., and B. Boccarra, "Integrated Framework for Travel Behavior Analysis," *Proceedings of the International Conference for Travel Behavior,* Aix-en-Provence, October 1987.

9. Bradley, M., and E. Kroes, "Forecasting Issues in Stated Preference Survey Research," *Selected Readings in Transport Survey Methodology,* Eucalyptus Press, Melbourne, 1992.

10. Bradley, M., and E. Kroes, "Simultaneous Analysis of Stated Preference and Revealed Preference Information," *PTRC 18th Annual Summer Meeting-Proceedings of Seminar H,* September 1990.

11. Morikawa, T., *Incorporating Stated Preference Data in Travel Demand Analysis,* Doctoral dissertation, MIT, Cambridge, Massachussettes, June 1989.

12. Morikawa, T., M. Ben-Akiva and D. McFadden, "Incorporating Psychometric Data in Econometric Demand Models," Proceedings of the Invitational Symposium on Consumer Decision Making and Choice Behavior, Banff,

May 1990.

13. Ben-Akiva, M. and S. R. Lerman, *op. cit.*

14. Ben-Akiva, M. and S. R. Lerman, *op. cit.*

15. Daly, A., "Integration of Revealed Preference and Stated Preference Data in Model Estimation," Proceedings of the Invitational Symposium on Consumer Decision Making and Choice Behaviour, Banff, May 1990.

16. Daly, A., and S. Zachary, "Commuters' Values of Time," *Local Government Operational Research Unit - Report T55*, Reading, January 1975, pp. 55-60.

17. Daly, A., "Estimation of Tree Logit Models," *Transportation Research*, 1987, Vol. 21B, pp. 251-267.

18. Morikawa, T., *op. cit.*

19. Bradley, M., T. Grosvenor, and A. Bouma, "An Application of Computer-Based Stated Preference to Study Mode Switching in the Netherlands," *PTRC 16th Annual Summer Meeting - Proceedings of Seminar D*, September 1988.

20. Morikawa, T., *op. cit.*

21. Ben-Akiva, M. and S. R. Lerman, *op. cit.*

22. Morikawa, T., *op. cit.*

23. Gunn, H., M. Bradley, and D. Hensher, "High Speed Rail Market Projection: Survey Design and Analysis," *Presented at the 3rd International Conference on Survey Methods in Transportation*, Washington, D.C., January 1990.

24. Bradley, M., and A. Daly, "Uses of the Logit Scaling Approach in Stated Preference Analysis," *Presented at the 6th World Conference on Transportation Research*, Lyon, 1992.

25. Bonsall, P., "Transfer Price Data - Its Definition, Collection and Use", *New Survey Methods in Transport*, VNU Science Press, Utrecht, 1985.

10

THE ROLE OF STATED PREFERENCES AND DISCRETE-CHOICE MODELS IN IDENTIFYING INDIVIDUAL PREFERENCES FOR TRAFFIC-MANAGEMENT DEVICES

David A. Hensher and Helen C. Battellino

SUMMARY

Responsible local governments recognize the need to be sensitive to the local environmental implications of decisions taken in the course of developing strategies to ensure the efficient use of scarce resources. Rather than rely on the pressures of lobby groups to direct government behavior in relation to community concerns, a preferred strategy is to identify the preferences and choices of the community as a whole and to use information from a representative cross-section of the community to aid in making environmentally-linked decisions that maximize the benefits to the affected community. This paper demonstrates how discrete-choice models can be used to identify community choices among alternative traffic-management devices designed to improve the traffic environment within and in the vicinity of local residential streets. Using a "before" and "after" survey strategy, the study provides evidence to support the view that a set of guidelines representing the community's preferences for different devices should be based on an empirical model estimated on a sample of residents who have already had exposure to a range of devices.

INTRODUCTION

More and more local governments are becoming sensitive and responsive to community concerns that identify the impacts of outcomes linked to decisions taken by them. Often, the concerns expressed by community groups are strongly influenced by a vocal minority who may not represent the views of the silent majority. While recognizing concerns expressed by lobby groups, it is important to establish the extent

to which such views are associated with the community as a whole. One way to establish symbiosis is to develop a set of procedures to determine the preferences and choices of a representative sample of community members with respect to the issue of concern.

This paper demonstrates how discrete-choice models can be combined with conjoint-choice data obtained from a sample of residents, to identify community choices between alternative ways of improving the traffic on sub-arterial roads that pass through local areas. Such traffic is attributable to decisions regarding the location of residences, offices, factories, and retail outlets. The approach represents an appealing method to assist local government in responding to the complaints of the vocal minority, so that effective decisions on environmental matters will be consistent with the needs and concerns of the population as a whole.

This paper presents the findings of a "before" and "after" study (two-wave panel) of community preferences and attitudes towards alternative traffic-control devices in the Willoughby Municipality, within the Sydney metropolitan area. Many sub-arterial roads are predominantly residential streets. Typically levels of traffic on many sub-arterial roads normally would be associated with major arterial roads (including freeways). Such devices become necessary when traffic from major arterial roads is diverted into residential areas to avoid congestion. This creates problems for the local residents such as increased exposure to risk, higher noise levels, and a deterioration in the quality of residential life. As a result of such developments the Willoughby Council decided to introduce small roundabouts, midblock islands, and thresholds into three residential streets. The traffic-control devices combine to form a scheme that is referred to as Sub-Arterial Traffic Management (SATM). It is designed to improve the safety of the sub-arterial residential streets by reducing the maximum speed of traffic and the variability of speed along a road. These aims must not be achieved at the expense of filtering traffic into local residential streets.

The study was undertaken in two parts. First-stage interviews were conducted before the installation of SATM devices with a follow-up survey of the same residents after the scheme was completed. The "before" study identified the particular devices and schemes the community found to be preferable. An "after" study evaluated community reaction to the installation of the individual devices. This approach represents an appealing method to planners, because it involves the local community in the decision-making process and helps to minimize their fears about the scheme, enabling local government to plan with, rather than simply for, the local community. It also avoids the need for planners to try out various schemes. The savings in scarce resources and image are substantial.

Defining a Community Preference Study

Any plan to improve the local traffic consequences of the locational decisions of an activity supported by local government requires careful assessment of both the benefits and costs. Benefits are primarily reductions in mean speeds, variability of speeds along the road, and reductions in noise levels. The main costs are actual outlays on installation and maintenance. A number of well-tested traffic-management devices can combine to define a SATM scheme, each of which has different speed, noise, and cost implications. Our task is to establish a mechanism for measuring preferences of the affected communities, and hence their choices in relation to alternative devices and possible combinations of devices (i.e., schemes). The devices considered by local government traffic engineers are small roundabouts, mid-block islands, and thresholds.

To investigate the community impacts of alternative devices and schemes, we undertook the initial "before" study as a basis for identifying community preferences for alternative devices. The knowledge obtained from this first phase was used together with engineering considerations to assist the traffic engineers and municipal planners in the selection, design, and placement of a number of devices along three busy sub-arterial roads in the Willoughby Municipality.

Three devices and four SATM schemes were proposed. We sought to measure individual preferences for these schemes using a survey instrument in which residents evaluated different devices and schemes. A rating scale was used to obtain a metric measure of relative utility. This scale can be transformed into a choice index in a number of ways. Ratings can be approximated by rankings (including ties), treated as ordinal categories, and/or the highest actual or predicted rating treated as a first-preference choice. These alternative-ratings transformations can be analyzed at the individual or group level. The former generates choice probabilities, the latter generates choice proportions. We use the highest rating as the first-preference choice, and use the multinomial-logit technique to model these preferences.

Table 1
Levels of the Attributes for the Before and After Surveys

Attributes	Levels	Definition
Before and After		
Speed at Device	3	20kph, 45kph, 70kph
Speed 100 meters from Device	3	30kph, 55kph, 80kph
Noise Level at Device	3	More, Same, Less
Source of Funding	3	Council, State Government, Rates Increase
After Only		
Speed at Device	3	20kph, 40kph, 60kph
Speed 100 meters from Device	3	40kph, 60kph, 80kph
Noise Level at Device	3	More, Same, Less
Source of Funding	3	Council, State Government, Rates Increase

The results of studying the choice among the four schemes in the "before" survey are reported in Hensher[1]. In this paper we concentrate on the choice of devices *per se*. This emphasis is chosen for a number of important reasons. First, given that one objective is to assist the Roads and Traffic Authority of NSW in the preparation of some guidelines on the way community preferences and attitudes can be used in the process of selecting SATM schemes, it is necessary to treat each device in a way that enables us to evaluate the community's preferences for all possible combinations of devices. The emphasis on a limited number of schemes (as reported in Hensher[2]) is a significant constraint on the transferability of information to settings in which other combinations of devices may be more appropriate either from a community view point, or from an engineering perspective, or both.

We recognized this limitation in the "before" study and made provision for an investigation of devices *per se* by having two preference experiments: one for devices *per se* without any reference to specific siting locations, and one for specific schemes

that were combinations of devices positioned at actual locations in the Willoughby Municipality. Schemes *per se* are extremely difficult to assess without reference to particular device placements; whereas devices can be evaluated with or without reference to specific locations. This is important for the "after" study, which is interested in evaluating both the community responses to schemes actually introduced, some of which are not one of the four schemes evaluated in the "before" study, and the transferability of responses to devices *per se*, the latter enabling us to evaluate a large number of schemes.

Hensher and Battellino[3] have shown by a nested-logit model that there is no meaningful relationship between the probability of choosing devices and the probability of choosing schemes conditional on device. The empirical assessment of the linkage between scheme choices and device choices involved the estimation of a nested-logit model in which the lower level represents the choice among schemes conditional on a device being present in the scheme, and the upper level represents the choice among devices. The relative utility associated with a device was found to be statistically independent of the scheme configuration containing the device.

It is generally accepted that each device has a logical positioning in a sub-arterial traffic-management scheme that is primarily determined by road design. If we can establish empirical evidence, from a comparison of the "before" and "after" responses, that enables us to conclude that the preferences for devices expressed prior to the introduction of particular devices in schemes are not statistically significantly different to the community preferences after the introduction of the devices, then we are in a very good position to set out empirical guidelines without having to undertake substantial new surveys of community attitudes and preferences.

The Preference Experiment

A preference experiment specified in terms of four attributes was used to define each traffic management device. The attributes were 1) traffic speed at the device, 2) traffic speed 100 meters from the device, 3) noise level at the device, and 4) the source of funds to pay for the facility. Each of the attributes had three levels (Table 1); a full factorial would require 81 combinations of attribute levels. An orthogonal, main-effects fraction generated a sample of nine alternatives. This design limits us to estimates of main effects. The final set of nine devices selected from the full factorial treatments reduced to six per device in the "before" survey and eight per device in the "after" survey, after allowing for dominance. The "before" and "after" designs are identical with respect to the fractional factorial design; however the "after" study used two sets of levels of the attributes. These are given in Table 2 for the design common to both surveys and in Table 3 for the "after" survey only. One set was identical to the

"before" study, while another set was substantially different. This enabled us to investigate the presence or absence of any systematic differences in responses due to the combinations and levels of attributes. The "after" sample was a subsample of the "before" sample, limited to the residents living on or close to the streets subject to the SATM treatment.

Each respondent who participated in the "before" study with a fixed design was randomly assigned to one of the "after" experiments and two sets of device cards representing particular levels of each attribute for each device. They rated each description of each device on a 10 point scale. The experiment was administered as a personal interview.

Budget constraints prevented us from re-surveying the sample of residents within the Willoughby Municipality who are not local or close-by residents. The "before" study had shown, however, that location was not a statistically significant influence of one's attitudes to devices. This is an encouraging finding for a study concerned with the temporal and spatial transferability of community preferences towards SATM devices. In addition, the "after" study exposed each respondent to two replications of the device experiment, whereas the "before" study administered only one replication.

THE SURVEY STRATEGY

The "after" survey took place in February, 1991, 18 months after the "before" survey. In the "before" survey the Willoughby Municipality was divided into three sub-populations:

Local: all residents in streets where SATM was proposed to be installed,

Close-by: those residents in streets surrounding the three local streets;

Remaining: all other residents in the Municipality.

Table 2
Device Experiments: Attribute Combinations for Before and After Design

Card	Device	Cost	Paid by	Speed at Device	Speed Between	Impact on Noise
R01	Roundabout	$7,000	Council	45kph	80kph	Same
R02	Roundabout	$7,000	Council	20kph	55kph	More
R03	Roundabout	$7,000	State Govt.	45kph	55kph	Less
R04	Roundabout	$7,000	State Govt.	20kph	30kph	Same
R05	Roundabout	$7,000	State Govt.	70kph	80kph	More
R06	Roundabout	$3.00	Rates Increase	20kph	80kph	Less
M01	Midblock	$5,000	Council	45kph	80kph	Same
M02	Midblock	$5,000	Council	20kph	55kph	More
M03	Midblock	$5,000	State Govt.	45kph	55kph	Less
M04	Midblock	$5,000	State Govt.	20kph	30kph	Same
M05	Midblock	$5,000	State Govt.	70kph	80kph	More
M06	Midblock	$2.50	Rates Increase	20kph	80kph	Less
T01	Threshold	$4,000	Council	45kph	80kph	Same
T02	Threshold	$4,000	Council	20kph	55kph	More
T03	Threshold	$4,000	State Govt.	45kph	55kph	Less
T04	Threshold	$4,000	State Govt.	20kph	30kph	Same
T05	Threshold	$4,000	State Govt.	70kph	80kph	More
T06	Threshold	$2.00	Rates Incraese	20kph	80kph	Less

Table 3

Device Experiments: Attribute Combinations for After-Only Design

Card	Device	Cost	Paid By	Speed at Device	Speed Between	Impact on Noise
R11	Roundabout	$7,000	State Govt.	40kph	80kph	Same
R12	Roundabout	$7,000	State Govt.	20kph	60kph	More
R13	Roundabout	$3.00	Rates Increase	40kph	60kph	Less
R14	Roundabout	$3.00	Rates Increase	20kph	40kph	Same
R15	Roundabout	$7,000	Rates Increase	60kph	80kph	More
R16	Roundabout	$7,000	Council	40kph	40kph	More
R17	Roundabout	$7,000	Council	20kph	80kph	Less
R18	Roundabout	$7,000	Council	60kph	60kph	Same
M11	Midblock	$5,000	State Govt.	40kph	80kph	Same
M12	Midblock	$5,000	State Govt.	20kph	60kph	More
M13	Midblock	$2.50	Rates Increase	40kph	60kph	Less
M14	Midblock	$2.50	Rates Increase	20kph	40kph	Same
M15	Midblock	$2.50	Rates Increase	60kph	80kph	More
M16	Midblock	$5,000	Council	40kph	40kph	More
M17	Midblock	$5,000	Council	20kph	80kph	Less
M18	Midblock	$5,000	Council	60kph	60kph	Same
T11	Threshold	$4,000	State Govt.	40kph	80kph	Same
T12	Threshold	$4,000	State Govt.	20kph	60kph	More
T13	Threshold	$2.00	Rates Increase	40kph	60kph	Less
T14	Threshold	$2.00	Rates Increase	20kph	40kph	Same
T15	Threshold	$2.00	Rates Increase	60kph	80kph	More
T16	Threshold	$4,000	Council	40kph	40kph	More
T17	Threshold	$4,000	Council	20kph	80kph	Less
T18	Threshold	$4,000	Council	60kph	60kph	Same

In the "local" population all residents living in those streets were included in the sample. In the" close-by" and "remaining" populations, residents were randomly sampled from randomly-selected blocks. The "before" survey of 201 residents comprised 100 "local" residents in the streets where the devices were placed; 60 "close-by" residents who live in streets close to the these streets; and 41 respondents from the "remaining" population of the Municipality. In the "after" study, only residents in "local" and "close-by" populations were interviewed. Of the 160 respondents in these categories in the "before" survey, 116 residents were reinterviewed. Response rates for both stages were high, indicating a strong interest in the community in traffic-management schemes. The response rate in the "after" survey was 73 percent. All of the other 27 percent of residents were accounted for, with 17 percent (27 respondents) who had moved or been on holiday at the time of interview, 7 percent (11 respondents) who could not be located either by the interviewer having a wrong address or after a number of call backs, 3 percent (five respondents) refusing to do the survey and 0.6 percent (one respondent) having died. Fifty-five percent of the two-wave sample (64 respondents) lived in a street in which devices were located.

The survey contained questions on:

1. The respondent's perception of the level of traffic in his or her street;

2. The respondent's general perceptions and attitudes towards the overall scheme of devices proposed and then installed;

3. Attitudes towards a particular roundabout, midblock and threshold with which the respondent is familiar, concerning the effectiveness of the device, safety, aesthetics, and noise levels;

4. A stated-preference experiment requiring the respondent to evaluate each of the selected devices in terms of the cost, source of funding, speed at the device, speed after leaving the device, and noise level;

5. In the "before" survey only, device combinations were evaluated as particular schemes;

6. Socioeconomic and demographic data on the resident such as income, years living in the Municipality, household size and composition, occupation, and vehicle ownership.

The "after" questionnaire contained many questions common to the "before" questionnaire to enable a "before" and "after" analysis of respondents' opinions. However, a number of important changes were made. Questions about the resident's general perception of traffic conditions in his or her street were replaced with questions relating to the reactions to the scheme of devices that had been put in place and its impact on traffic flows. These included opinions on the advantages and disadvantages of the scheme overall, the respondent's overall opinion of the scheme, questions concerning the actual devices through which the respondent travels or avoids, and perceptions of the speed of the traffic travelling both between and through, the devices. Details of these results are reported in Gee et.al[4]. After the devices were in place, the questions about attitudes to types of devices were based on three particular devices — one roundabout, one midblock and one threshold — with which the respondent was familiar. The main descriptive findings from the attitudinal questions in the "after" survey are[5]:

(i) Sixty-one percent of the respondents were pleased with the in-place scheme overall.

(ii) The scheme had succeeded in reducing speed and increasing safety, but not in reducing the volume of traffic. There did appear to be some negative spin-off into an adjacent street.

(iii) Respondents generally found devices to be visually attractive, with landscaping being an important requirement. Some disapproved of the strong color used on the threshold in one of the roads.

(iv) There was a concern expressed that the devices should have better lighting, because they are difficult to see at night.

(v) Thresholds were seen as being the least effective, because those installed are not narrow enough to slow traffic.

(vi) The main advantages of devices were reduced speed and increased safety.

(vii) The majority of residents still believed that the spending of the Council's money was justified.

(viii) The majority of residents found no disadvantages with the scheme.

(ix) Some residents expressed concern that motorists did not know how to use the devices correctly, and that driver education is necessary.

Analysis of the Stated-Preference Experiment

The conjoint-choice data were transformed into a first-preference response (choice) set with the highest rating assumed to be the most-preferred alternative. The unit of analysis is an individual respondent, each respondent had a choice set of three devices. The multinomial-logit technique[6] was used to obtain parameter estimates for both design variables and the covariates.

Discrete-choice methods such as multinomial logit or probit estimated on individual data require the differencing on the attributes to be the **chosen minus each and every non-chosen.** Combined with the natural correlation in the real world of certain attributes, such as speed at devices that cannot plausibly be greater than speed between devices, maintenance of design orthogonality is difficult. One tries to minimize correlations resulting from differencing by using fractional factorial designs. Hensher and Barnard[7] illustrate the difficulty of retaining design orthogonality when individual-choice data (in contrast to aggregate-choice proportions) are used to estimate discrete-choice models. The attribute differencing problem can be circumvented by aggregating data over replications either within or across individuals, and analyzing choice frequencies[8,9,10].

The primary purpose of the discrete-choice model is to investigate the extent of transferability of community preferences identified from the "before" data base to situations that will exist after the implementation of devices. By comparing the results from the "after" study with the "before" study we can establish the extent to which a once-off "before" study is able to provide reliable information on community preferences towards SATM devices. If the transferability evidence is positive, then future SATM studies can be guided by community attitudes at the stage of evaluating alternative SATM strategies, to ensure that the selected devices (and schemes) are those that will receive greatest community support.

The following empirical approach was implemented to evaluate the transferability potential of community preferences for SATM devices:

1. The "after" model for choice of devices was estimated and used as the basis for determining community preferences. Three "after" models were estimated: (i) for the entire sample, (ii) for the sample of residents asked to respond to combinations of attribute levels identical to the levels administered to the

"before" sample, and (iii) for the sample of residents asked to respond to the new attribute levels.

2. The "before" model was estimated using the specification of the "after" model. Three "before" models were also estimated: (i) for the entire sample, (ii) for the sample of residents who participated in the "after" study, and (iii) for the sample of residents who did not participate in the "after" study.

The segmentation of the sample, according to participation in the two surveys and the administered attribute levels in a common experimental design, provides an important basis for establishing confidence in the results in respect of sampling strategy and attribute-level specification. Both of these dimensions are potential sources of bias in transferability of community preferences.

The literature on transferability is extensive[11]. In the current context, there is one "test" worthy of consideration. It involves a comparison of the marginal effects and the choice elasticities with respect to the design attributes, especially speed at the devices and speed 100 meters from the devices. Greene[12] suggests that the parameter estimates from a discrete-choice model are in themselves uninformative and, thus, direct comparisons of the absolute magnitudes of a given attribute between models is not very useful. A more appropriate basis of comparison involves the application of the parameter estimates in the derivation of the marginal effects and the choice elasticities. Because the marginal effects and the choice elasticities are related to each other, where the particular device attribute is continuous (notably the two speed variables), it makes good sense to use the elasticity measure as the basis for establishing the transferability potential of community preferences. The marginal effects can be used where the attributes are dichotomous (namely the level of noise and "who pays").

Formally, the marginal effect of an attribute is a measure of the effect of the particular attribute on the probability of choosing a particular device P_j, holding all other influences constant, and algebraically is given by:

$$dP/dx_j = P_j(1 - P_j)b \qquad (1)$$

where,

$$j \quad = \quad 1,...,3,$$
$$x_j \quad = \quad \text{level of design attribute, and}$$

b = parameter estimate associated with x_j.

The (direct) elasticity of the probability of choosing a device with respect to an attribute is defined as the percentage change in the probability of choosing the device divided by the percentage change in the attribute level. Formally, this is defined as $DE_j = x_j (1-P_j)b$ and all other terms are as defined above. Note that the marginal effect and the device-choice elasticity are related; the marginal effect is $DE_j * P_j / x_j$.

Major Empirical Results

The empirical evidence on device-choice elasticities and marginal effects are summarized in Tables 4, 5, and 6 for the six applications contexts, together with the models from which they were derived. Table 4 presents the results of the models[13]: three "before" models and three "after" models. The base model is in the final column, being the entire sample from the "after" survey. Table 5 presents the means and standard deviations of the Marginal Effects. Table 6 gives the means for the Device-Choice Elasticities and Choice Probabilities. Pseudo-r squared measures the overall explanatory power of the models. Best practice suggests that a value between 0.2 and 0.4 is a good explanatory model[14].

Prior to comparing the six models, it is important to discuss the base model for the "after" situation, because all the other models have been estimated on the same set of attributes, with differences due to sample composition and attribute levels. The device-choice model tells us that given the cost, the speed at the device and 100 meters from a device, and noise levels around the device, we are able to identify the predisposition of the community towards supporting one or more devices. This is identified in terms of the device(s) providing the greatest level of relative satisfaction to each sampled member of the community, who in total represent the population from which they were sampled. This knowledge is important in the determination of community support for future plans to introduce devices both within the locational context actually studied and possibly in other locations.

Table 4

The Empirical Evidence on the Transferability of Community Preferences for Devices - Marginal Effects

Attribute	Stage I "Before"			Stage II "After"		
	Both Stages	Stage I Only	Full Sample	Old Design	New Design	Full Sample
Council Pays (M)	0.0407*	0.0379*	0.0082*	-0.087	0.0277*	-0.1338
	0.0208	0.0261	0.0033	0.0471	0.0176	0.0823
Council Pays (R)	0.0448*	0.0464*	0.0078*	-0.086	0.0295*	-0.1302
	0.0173	0.0194	0.0038	0.0465	0.0158	0.0833
Council Pays (T)	0.0412*	0.0441*	0.0074*	-0.085	0.0296*	-0.1213
	0.0215	0.0233	0.0045	0.0471	0.0168	0.0835
Less Noise (M)	0.2879	0.3311	0.1910	0.3126	0.4094	0.2259
	0.1469	0.2279	0.0771	0.1686	0.2606	0.1390
Less Noise (R)	0.3335	0.2244	0.4206	0.2545	0.3284	0.2627
	0.1287	0.0937	0.2047	0.1378	0.1759	0.1681
Less Noise (T)	0.2310	0.2882	0.1729	0.2627	0.2176	0.3923
	0.1201	0.1525	0.1041	0.1452	0.1236	0.2700
Personal Inc (M)	-0.00017*	-0.0003	0.00007*	0.00030	0.0005	0.0001*
	0.00009	0.00022	0.00004	0.00016	0.0003	0.00006
Dangerous Landscaping (M)	-0.1077*	-0.0797*	-0.2115	-0.3519	-1.827*	-0.4523
	0.05497	0.05486	0.08534	0.1898	1.163	0.2783

Notes: Mean and standard deviation are given for the marginal effects;
Items starred (*) are derived using parameter estimates which are not statistically significant

Table 5

The Empirical Evidence on Transferability of Community Preferences for Devices-Attribute Models

Attribute	Stage I "Before"			Stage II "After"		
	Both Stages	Stage I Only	Full Sample	Old Design	New Design	Full Sample
Device Specific	0.776	-1.738	-0.6470	-0.3859	0.9480	0.2460
Constant for M/block	0.59	-1.23	-0.72	-0.29	0.52	0.24
Device Specific	-1.141	-1.595	-1.397	-0.9189	-0.5461	-0.5501
Constant for R/about	-0.933	-1.19	-1.58	-0.77	-0.30	0.95
Speed at	-0.0244	0.0019	-0.0104	0.0013	-0.0355	-0.0188
Device (M,R,T)	-1.80	0.015	-1.20	0.10	-2.33	-2.25
Speed 100m from	-0.0491	-0.0258	-0.0393	-0.0759	-0.0559	-0.0548
Midblock	-2.45	-1.39	-3.14	-3.52	-2.42	-4.00
Speed 100m from	-0.0190	-0.0424	-0.0274	-0.0489	-0.0424	-0.0381
Roundabout	-1.08	-2.16	-2.24	-2.73	-1.76	-2.91
Speed 100m from	-0.0498	-0.0626	-0.0549	-0.0564	-0.0557	-0.0445
Threshold	-2.46	-3.24	-4.19	-3.36	-2.31	-3.59
Council Pays	0.2722	0.0519	0.2614	0.2039	-0.9949	-0.5831
Dummy Variable (M,R,T)	0.49	0.09	0.68	0.38	-2.09	-2.05
Noise Reduction	2.380	1.204	1.85	3.012	1.681	2.085
Dummy Variable (M)	2.90	1.64	3.57	4.00	1.93	4.43
Noise Reduction	1.317	2.789	1.944	2.267	2.007	1.729
Dummy Variable (R)	2.00	3.67	4.10	2.98	2.37	3.5
Noise Reduction	1.779	1.209	1.458	1.499	1.796	1.796
Dummy Variable (T)	2.73	1.56	3.07	2.02	3.67	3.74
Personal Income	-0.0023	0.00045	-0.0011	0.0036	0.0007	0.0020
Effect for M/block	-1.59	0.33	-1.20	2.62	0.522	0.31
Landscape Danger	-0.5729	-1.333	-0.6922	-13.44	-3.365	-2.348
Effect for M/block	-0.88	-1.76	-1.49	-0.01	-2.75	-2.36
Pseudo-r squared	0.29	0.30	0.26	0.35	0.40	0.32

Note: Estimated paarmeters and t-values are given for each attribute in the models

Table 6
The Empirical Evidence on the Transferability of Community Preferences for Devices - Device Choice Elasticities & Choice Probabilities

Attribute	Stage I "Before"			Stage II "After"		
	Both Stages	Stage I Only	Full Sample	Old Design	New Design	Full Sample
Speed at Device:						
Mid-Block	-0.163*	-0.370	0.028*	-0.270	0.018*	-0.440
Roundabout	-0.162*	-0.370	0.028*	-0.270	0.018*	-0.450
Threshold	-0.162*	-0.370	0.028*	-0.270	0.018*	-0.439
Speed After Device:						
Mid-Block	-0.353	-0.388	-0.240*	-0.478	-0.588	-0.450
Roundabout	-0.285	-0.200*	-0.379	-0.332	-0.436	-0.326
Threshold	-0.480	-0.433	-0.509	-0.392	-0.493	-0.414
Mean Probabilty of Choice:						
Mid-Block	0.287	0.250	0.333	0.401	0.385	0.421
Roundabout	0.408	0.423	0.389	0.279	0.281	0.276
Threshold	0.305	0.326	0.278	0.320	0.333	0.303
Sample Size	72	92	164	76	96	172
No. of Cases	216	276	492	228	288	516

Notes: Means are given for the elasticities

Items starred (*) are derived using parametr estimates which are not statistically significant.

The emphasis herein is not on spatial transferability of community attitudes and preferences but on temporal transferability. We have, however, recognized the value of a method capable of spatial transferability and thus have excluded any potentially important influences on choice that are too location-specific. The empirical enquiry actually failed to identify any factors of statistical significance that are site-specific, thus opening the opportunity to apply the models in other locations. The final set of attributes that have a strong statistical influence on individual preferences for particular devices have been identified from the testing of a large number of hypotheses. With the exception of personal income, the attributes in the model are all device attributes.

Some important conclusions can be drawn from the comparison of the marginal effects and device-choice elasticities. The evidence suggests that residents with some experience with devices "after" have different preferences to residents with little or no experience with devices "before." This is particularly borne out by the device-choice elasticities with respect to speed at the device, where we see a much greater sensitivity after the introduction of devices than before. Of particular note is the almost reversed device-choice probabilities for midblocks and roundabouts (with threshold probabilities remaining almost unchanged). We suspect that, in the "before" study, community preferences for roundabouts were greater than for mid-blocks because there was greater awareness of the speed benefits of a roundabout when compared to an essentially unknown device, the midblock. However, after the implementation of the devices, the speed benefits of midblocks became much more apparent, resulting in greater support for midblocks than there was prior to their introduction. The results for thresholds tend to go in the opposite direction, suggesting that the expectations of speed benefits associated with the introduction of thresholds were not realized.

The respondents in column one, "both stages in the before" study, and the fourth column, "old design in the after" study, were both administered the same choice-attribute levels. Where the marginal effects are statistically significant, we find that the impact of a change in the attribute levels (primarily noise level) changes the probability of device choice significantly more for midblocks and roundabouts after their implementation and significantly less for thresholds. The midblock-specific personal income effect changes sign, being negative in the before situation and positive after the introduction of the devices. For roundabouts and midblocks, most ratings fell over time. For thresholds, all ratings decreased over time, some quite substantially.

This is an important message. It suggests to us that community-preference models, estimated prior to the introduction of devices, are not an appropriate medium for

establishing the community's real levels of support for devices. In setting guidelines for community acceptance of devices, we strongly support the application of community-preference models estimated from a sample of residents who have been exposed to the full range of potentially-applicable devices.

In interpreting the device-choice models, it is important to recognize that the models are concerned with the probability that a resident will prefer a particular device, given the available set of devices, as a SATM "solution" to improve levels of speed, noise, and safety. That is, they are conditional choice models. They are not models concerned with whether a resident likes devices *per se* or not (i.e., the choice between having or not having devices). This distinction is very important. What we learn from this study is the likely range of support that the local Council could expect from the community, consequent on a number of alternative devices being introduced. Given the predicted changes in speed along the affected streets, the noise levels, and the income of residents (the latter as a proxy for commitment of views and influence), the model can be used to provide indications of likely differences in community support for alternative schemes.

A number of comments should be provided to appreciate some of the findings that led to the exclusion of potential sources of relative community support and the inclusion of other effects.

1. The location of devices is essentially an engineering decision. We found no significant relationship between preferences for one device or another and the amount of traffic currently on a resident's street.

2. Thresholds gather community support in respect of their cost, especially if the Council has to pay for them; however the financial dimension, when placed in the context of safety and noise considerations, is of less relevance. There is no evidence to support the hypothesis that residents with the devices currently installed in their street or residents who live on streets with a bad accident history (including particularly bad spots) prefer one device over another device.

3. Safety is the overriding concern of residents. This is very much correlated with the speed profile of the traffic in the street and the way that each device can assist in improving this profile. In the "after" study, the midblock has come to the fore as a much more desirable SATM construct than the evidence from the "before" study suggested. This is, we believe, due primarily to a lack of experience with mid-blocks compared with the more common roundabouts and thresholds. As a result of this newly gained experience, residents now see the midblock as a most

desirable device with respect to the way it has slowed down the traffic. It should be recognized that a roundabout, in particular, is situated at an intersection or junction where drivers traditionally exert more caution in the absence of a device; whereas a midblock is situated some distance from an intersection in a location that is traditionally susceptible to relatively higher speeds. Consequently the placement of a midblock is expected to have a significant impact on the change in speed. There is a concern, however, that midblocks are also potentially the most dangerous device from a driver's perspective, in that the design if not very carefully landscaped can be a safety hazard. Compared to roundabouts and thresholds, midblocks require careful thought with respect to landscaping, so as to minimize the risk of injury to vehicle occupants.

Application of the Model

To illustrate the way in which the model can be applied, let us set out the three equations associated with the "full" sample model for the three devices in the "after" situation, that are derived from the device-choice model. Given the levels of the attributes on the right-hand side of each equation, we can identify the relative satisfaction associated with each device.

$$
\begin{aligned}
\textit{Midblock} \quad = \quad & 0.2460 - 0.0188*SPEEDAT - 0.0548*MSPDFRM - 0.5831*MRTCNCL \\
& + 2.085*MNSLESS + 0.0020*MPINC - 2.348*MLDNG
\end{aligned} \tag{2}
$$

$$
\begin{aligned}
\textit{Roundabout} \quad = \quad & -0.5501 - 0.0188*SPEEDAT - 0.0381*RSPDFRM - 0.5831*MR \\
& +1.729*RNSLESS
\end{aligned} \tag{3}
$$

$$
\begin{aligned}
\textit{Threshold} \quad = \quad & -0.0188*SPEEDAT - 0.0445*TSPDFRM - 0.5831*MRTCNCL \\
& + 1.796*TNSLESS
\end{aligned} \tag{4}
$$

Where:

SPEEDAT	=	speed at the device;
jSPDFRM	=	speed 100 meters from device *j* (*j=M, R, T*);
MRTCNCL	=	council pays dummy variable (1=Council pays, 0= Other source);
jNSLESS	=	device provides a reduction-in-noise dummy variable for device *j* (*j=M, R, T*);
MPINC	=	personal income effect specific to mid-block;
MLNDG	=	midblock-specific landscape-danger effect (dummy variable).

For example the equation for midblock is made up of: its specific constant, the speed at the device attribute, the speed 100 meters from the midblock, the council-pays dummy variable, a noise-reduction dummy variable, a personal-income effect for midblock, and the landscape-danger effect for a midblock.

Table 7
Attributes of Each Scenario

	All Devices				Mid-Block Only	
Scenario	Speed at (kph)	Speed from (kph)	Council Pays	Noise Re-duction	Avg. Inc. ($'000)	Dangerous Landscaping
1	20	30	0	0	35.899	0
2	20	40	0	1	35.899	1
3	20	60	0	0	35.899	0
4	20	80	1	1	35.899	0
5	40	60	0	1	35.899	1
6	40	80	0	0	35.899	1
7	45	55	1	1	35.899	1
8	45	80	0	0	35.899	1
9	60	80	1	0	35.899	0
10	70	80	0	0	35.899	1

The set of equations can be applied using a spreadsheet to identify the relative levels of utility associated with devices, given the particular attribute levels. That is, the levels of the attributes can be altered and the devices themselves changed, with the equations predicting the outcomes. Figure 1 was calculated using a spreadsheet, depicting the relative ratings of different devices with the same attributes as specified in Table 7.

From Figure 1, we can see that the relative ratings differ depending on the device, when all attributes are the same. The midblock has the highest relative utility rating for scenarios 1 to 3, and the lowest for the remaining scenarios. The roundabout and the threshold have relative utility ratings that are similar for every scenario, crossing each other on a number of occasions. Scenario 2 has the highest relative utility rating for each device, with scenario 10 receiving the lowest rating. However, engineering

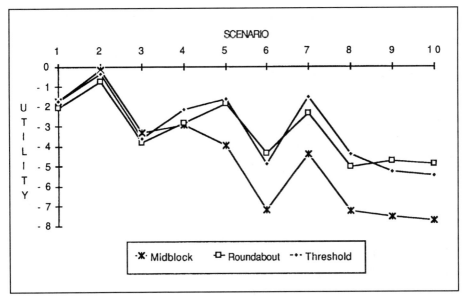

Figure 1.
Relative Utility Ratings for Devices Using Different Scenarios

constraints will usually decide the most appropriate type of device for a particular situation, while a spreadsheet can provide an insight into the best combination of attributes for the chosen device.

Different schemes can also be evaluated with respect to mixes of devices and predicted attribute levels, automated by a spreadsheet application. The planning agency can identify which scheme is likely to provide the highest level of community support as measured by its ability to generate the maximum level of expected satisfaction (EMS) from the evaluated set of schemes.

An example of a scheme with one of each device would be:

$$EMS = \ln [\exp(M) + \exp(R) + \exp(T)] \qquad (5)$$

A scheme involving only a midblock and a roundabout would be:

$$EMS = \ln [\exp(M) + \exp(R)] \qquad (6)$$

A scheme involving two roundabouts and one midblock would be:

$$EMS = \ln [\exp(R) + \exp(R) + \exp(M)] \qquad (7)$$

CONCLUSIONS

It is important to involve potentially-affected communities in any traffic plan to resolve public-issue responsibility. The choice-modelling approach provides an appealing framework within which to address public-policy issues that impact on local communities. A combination of discrete-choice models and stated-preference data, at an individual resident level, provides a method to identify which traffic-management decisions will accord with the greater desires of the community. The approach outlined above is relatively simple to implement and provides intuitive outputs to assist in making effective decisions.

Overall the study found that the sample of residents approve of the scheme. They believe that, since the introduction of SATM, the speed of the traffic in the area has decreased, and safety has increased as a result. Therefore, the scheme has been successful in the area. However, a majority of respondents expressed a concern about the volume of traffic in the area. Perhaps this is due to an expectation that the scheme would reduce the volume of traffic in the area. Traffic counts in the area, however, have shown that the volume in the area has actually decreased. We believe that this is because SATM schemes were unknown to the community until they were installed in this area. The residents are familiar with local area traffic-management schemes (LATM) that divert the traffic. Therefore, although SATM is not designed to divert traffic away from the area, the residents may have expected this due to their experience with other traffic-management schemes. This finding is an important one for planners. In future there should be more community education about the effects of SATM schemes, and especially in comparison with LATM schemes.

The before and after approach has shown that the results from the "before" survey were not totally indicative of the results obtained in the "after" survey. This is due to the lack of experience of the residents with the scheme and its devices. When setting guidelines for community acceptance of devices, we strongly suggest that they are based on a sample of residents who have been exposed to the devices under consideration. However, this should be combined with a community-education program before the installation of the devices, and/or an attitudinal survey. Local residents must be involved in the decision-making process if maximum acceptance of

a scheme is to be achieved. There should be opportunities for the community to provide input to the planning process, and the community should be kept informed of any proposed developments.

The results, while not transferable over time, may be transferable between locations. We recommend that a follow-up study should be carried out in a different location to assess the attitudes and preferences of another sample population in comparison to those of the current study. The discrete-choice model used in the study used attributes that were not specific to a location so that this hypothesis can be tested. The model can be used with a spreadsheet to predict the preferences for devices and combinations of devices. This technique is an important tool for planners.

ACKNOWLEDGEMENTS

The impetus for this study came from Kam Tara, who saw an opportunity to introduce stated-preference methods into the evaluation of traffic-management schemes. Eugene Smith supported this initiative and invited us to explore the possibility of developing and applying the method in the context of Willoughby Municipality's immediate problem with traffic in three residential streets. We are indebted to Kam Tara, Eugene Smith, and Bill Dewer (Municipal Engineer, Willoughby Council). Financial support was given by the Roads and Traffic Authority of New South Wales and Julie Gee of the Institute of Transport Studies (University of Sydney).

REFERENCES

1. Hensher, D. A., "The Use of Discrete Choice Models in the Determination of Community Choices in Public Issue Areas Impacting on Business Decision Making," *J. Business Research*, 23(4), December, 299-309.

2. *Ibid.*

3. Hensher, D. A., and H. C. Battellino, "The Use of Discrete Choice Models in the Determination of Community preferences Towards Sub-Arterial Traffic Management Devices," paper presented at the 6th World Conference on Transport Research, Lyon, July, 1992.

4. Gee, J. L., H. C. Battellino, and D. A. Hensher, "Resident Perceptions and Preferences Towards Alternative Traffic Management Strategies to Improve Roadside Safety: A Two-Wave Experiment," Institute of Transport Studies Working Paper ITS-WP-92-1, University of Sydney, 1992.

5. *Ibid.*

6. Offen, W. W., and R. C. Little, "Design of Paired Comparison Experiments when Treatments are Levels of a Single Quantitative Variable," *Journal of Statistical Planning and Inferrence*, 15, 1987, 331-346.

7. Hensher, D. A. and P. O. Barnard, "The Orthogonality Issue in Stated Choice Designs," in *Spatial Choices and Processes,* Manfred Fischer, Peter Nijkamp, and Y. Papageorgiou, eds., North Holland, Amsterdam, 1990, 265-278.

8. Van Berkum, E. E., *Optimal Paired Comparison Designs for Factorial Experiments,* Centre for Mathematical and Computer Sciences, Amsterdam, 1987.

9. Hensher, D. A. and H. C. Battellino, "Sub-Arterial Traffic Management: A Study of Community Attitudes Using Stated Preference Methods," Working Paper, Institute of Transport Studies, University of Sydney, February, 1990.

10. Hensher, D. A. and L. W. Johnson, *Applied Discrete-Choice Modelling,* Wiley, New York, 1981.

11. Offen, W. W., *et al., op. cit.*

12. Greene, William H., *Econometric Analysis,* MacMillan, New York, 1990.

13. Louviere, J. J., "Conjoint Analysis Modelling of Stated Preferences," *J. Transport Economics and Policy,* XXII, January, 1988, 93-120.

14. Offen, W. W., *et al., op. cit.*

11

TEMPORAL STABILITY OF STATED PREFERENCE DATA

Akimasa Fujiwara and Yoriyasu Sugie

ABSTRACT

This study aims to examine the temporal stability of individuals' stated preferences (SP) for modal choice, using panel data. SP surveys for the New Transit System, now under construction in Hiroshima, Japan, were carried out at three different points in time: 1987, 1988, and 1990. The data were analyzed to identify within-wave and between-wave variations. The latter temporal variation was related to three causal factors: the different levels of travel service set up in the SP experiments, the change of individuals' characteristics, and other unobserved specific biases inherent in SP data. The effects of these factors were measured by developing the mode-choice models based on the stated-preference panel data. As a result, the levels of travel service and unobserved specific biases at each wave were found to affect significantly the temporal variation of the SP data. It was also shown that the relative importance of level-of-service variables in determining individuals' preference was temporally stable.

INTRODUCTION

The stated-preference (SP) method was first developed in marketing research in the early 1970s to evaluate newly-proposed commodities[1]. The demand for hypothetical new alternatives that combine various attributes can be estimated through SP experiments. This method has attracted increasing attention since the end of the 1970s in travel-behaviour research. Because new alternatives in transport policy are often highly visible and would require a lot of time and cost to implement them, there is often not an opportunity to evaluate actual responses to a trial of an experimental project through the collection of revealed-preference (RP) data. This seems to be an important reason why the SP method has been used intensively in recent transport research.

Many empirical studies have examined the reliability of the SP method using cross-sectional data. One of the important results obtained from these studies is that some kinds of biases do exist in SP data. For example, Bonsall[2] indicated that there existed four kinds of biases in transfer-price data: affirmation bias, unconstrained-response bias, rationalization bias, and policy-response bias. It was also found that the effects of these biases on SP data depended on the survey methods. Bradley *et al.*[3] and Hensher *et al.*[4] compared three ways in which SP responses could be presented, consisting of ranking, rating, and choice of options[5,6]. As a result, Hensher *et al.* indicated that the choice designs were the easiest for respondents to complete and the best understood; they were more successful in identifying respondents' preferences than the ranking and rating designs. Jones *et al.*[7] developed an interactive interview technique with microcomputers to set up the attributes in an SP experiment that corresponded to each respondent's present travel environment. In recent studies that tried to improve the validity of SP models, Ben-Akiva *et al.*[8] and Bradley *et al.* proposed a technical method that combined SP data with RP data simultaneously. All these studies were based on cross-sectional SP data collected at one point in time.

The most recent development in transport research is dynamic analysis of travel behaviour using panel data[10]. This approach would make it possible to investigate the interaction between temporal changes of travel behaviour and causal factors, with more accuracy than the traditional approach based on cross-sectional data. However, most of these studies have been based on RP data and it is rare to have a paper with an emphasis on a panel approach to studying the usefulness of SP data.

As opposed to new commercial products, the introduction of a new transport service requires a longer period of time from planning to putting it into operation. Therefore, some biases may change, depending on when the SP survey is carried out. For example, because respondents are expected to have more awareness and interest in a new service as it comes closer to fruition, the policy-response bias might become more (or less) significant over time. In order to improve the reliability of SP data, it is believed to be important to investigate the variation in preferences for the same project over time; there have yet been few studies that addressed this point of view. The objective of this study is to examine the stability of SP over time, using panel data collected at three different points in time. The analysis of SP variations was carried out by relating them to the biases and effects caused by several factors used in the SP experiments, through the calibration of a set of mode-choice models.

STATED PREFERENCE PANEL SURVEY

The new transit system (NTS) in Hiroshima will be opened in 1994 to relieve the traffic congestion caused by commuters from the northwestern residential areas to the city center. SP panel surveys were carried out to estimate the mode-choice behaviours of work and school journeys after the opening of the NTS. Besides the NTS, we considered in this study two other modes: car and bus. Because the SP panel surveys were all done in November, 1987, 1988, and 1990, the seasonal effect in SP responses could be avoided. The details of the SP panel survey are summarized in Table 1.

Table 1
Results of SP Panel Survey

	Wave		
	1	2	3
Time of survey	November, 1987	November, 1988	November, 1990
No. of respondents	46	46	46
No. of replications	3	5	4
No. of responses	135	188	177

The number of respondents at each wave is indicated along with the attrition rate in Table 2. The reason for the very high attrition at wave 2 is that only respondents who provided their address and telephone number in wave 1 were interviewed at wave 2. The 54 respondents at wave 2 reduced to 46 in wave 3. In order to examine specifically the between-wave variation in the SP data, only the sample of 46 respondents who participated in all three waves were used for the analysis reported in this paper, even though new respondents were recruited at waves 2 and 3. Thus, we must discuss carefully the results of the analysis, because of the limited sample size.

Table 2
Number of Respondents at Each Wave

	No. of respondents	Attrition rate (per-cent)	NTS share (per-cent)
Wave 1	310	—	54.7
Wave 2	54	82.6	65.5
Wave 3	46	14.8	63.2

Table 3 lists the progress of the NTS planning during the three years of the panel survey. The public hearing held between wave 1 (1987) and wave 2 (1988) to explain the project enhanced the respondents' interest in the planning of the NTS. The partial opening in March, 1988, of the highway above which the NTS was to be installed did not greatly reduce car travel times. The detailed planning of the NTS took on a more definite shape between waves 2 and 3 (1990). In this period, the location of stations was officially announced and a signature campaign took place asking for better facilities, including the demand for escalators at all stations. Because these were all known facts for respondents through newspapers and television news, no further information was supplied on each occasion of the SP experiments.

Table 3
Progress of the New Transit System Project

Between waves 1 and 2

 1. The operating company (the third sector) was founded.

 2. The public hearings to explain the NTS planning to residents were held.

 3. The highway above which the NTS is to be installed was partially opened.

 4. The permission of construction by the Central Government was given.

Between waves 2 and 3

 1. The location of stations was announced.

 2. Further extension of the NTS route was decided.

The reported changes in respondents' travel times and costs in the three waves are shown in Figure 1. Even though the extension of the freeway north of Hiroshima in December, 1988, made a contribution to excluding through traffic from the city center, car travel time was not improved significantly. The bus fare was raised by ¥29 (8 percent) between wave 1 and 2 and also by ¥58 (15 percent) between wave 2 and 3, on the average. The average bus travel time has continued to increase over the three years.

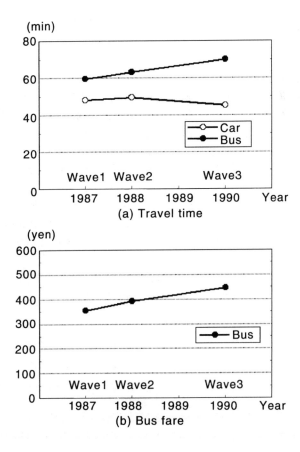

Figure 1.
Change of Actual Travel Time and Bus Fare

Respondents were selected randomly from the residential area concerned and asked to make a series of hypothetical rankings between three modes. Twenty seven sets of tri-modal options were generated by combining different levels of travel factors,

using a fractional factorial design. Because it was thought to be troublesome for an individual to respond to all of them, the numbers of sets of options presented to him/her were selected at random and were limited to less than five: three in wave 1, five in wave 2, and four in wave 3. These small numbers of repeated questions were expected to minimize the fatigue effect of replication in the SP experiments. The order of presentation was also randomized at each wave to eliminate order bias, and it was devised that each set of options was presented approximately the same number of times within each wave. Therefore, it is believed that there is no correlation between the replication effect and the levels of travel attributes presented in SP experiments.

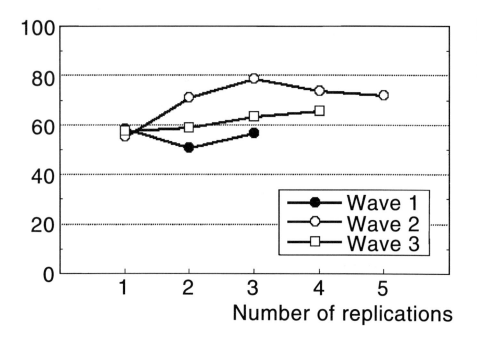

Figure 2.
Change of Stated NTS Shares With Waves

As shown in Table 4, nine travel attributes were used in the experiment at wave 1, and two other variables, *Seat dummy* for bus and the NTS, were added to them at waves 2 and 3. Three different levels were determined by travel mode for all travel attributes in the experimental design, by considering the observed values at each wave, and the average of three levels is indicated in Table 4 for reference. According to the temporal change of actual travel service, these levels set up in the SP experiments varied between waves.

The proportion of occasions when the NTS was ranked as the best mode are compared within waves in Figure 2. The NTS shares are variable across the replications within waves; the greatest difference was 23.7 percent at wave 2. The shares of three alternatives (i.e., NTS, car, and bus) are compared between waves in Figure 3. The variation of NTS shares can also be seen over time; the most interesting point is that the NTS share at wave 2 is fairly high, compared with those at the other waves, while the market share of bus does not vary considerably over the three waves. It is, therefore, significant to investigate the source of temporal variation of SP, within and between waves.

Table 4
Average Level-of-Service Values Set Up at Each Wave

Variable	Wave 1	Wave 2	Wave 3
Car			
Travel time (min)	65.1	74.6	76.2
Out-of-pocket travel cost (yen)	513.6	532.3	588.3
Bus			
In-vehicle travel time (min)	48.6	53.3	67.1
Waiting time (min)	11.3	5.8	3.0
Fare (yen)	376.0	450.1	442.8
Seat dummy	—	0.36	—
New Transit System			
In-vehicle travel time (min)	25.6	23.8	24.2
Access time (min)	10.0	9.0	9.1
Waiting time (min)	3.3	3.5	3.3
Fare (yen)	456.4	459.8	464.1
Seat dummy	—	0.26	0.22

Seat dummy = 1, if possible to have a seat all the way,
 = 0, otherwise.

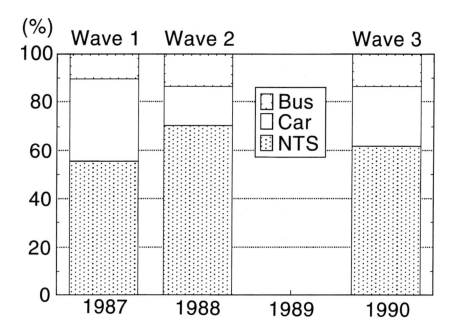

Figure 3.
Change of Stated Modal Shares Between Waves

The respondents' sociodemographic characteristics did not change significantly over the three years. The proportions who changed their travel modes for work and school journeys are shown in Table 5. These were nine percent from wave 1 to 2, and 15 percent from wave 2 to 3, the higher number in the latter case reflecting a greater

Table 5
Switching of Travel Modes Between Waves

Between Wave 1 and Wave 2

from / to	Car	Bus	Total
Car	22 (48 %)	1 (2 %)	23 (50 %)
Bus	3 (7 %)	20 (43 %)	23 (50 %)
Total	25 (55 %)	21 (45 %)	46 (100 %)

Between Wave 2 and Wave 3

from / to	Car	Bus	Total
Car	21 (46 %)	4 (9 %)	25 (54 %)
Bus	3 (7 %)	18 (39 %)	21 (46 %)
Total	24 (52 %)	22 (48 %)	46 (100 %

switch from car to bus.

CAUSAL FACTORS UNDERLYING THE TEMPORAL VARIATIONS IN THE SP DATA

The variation of SP responses was divided into within-wave and between-wave variations. The former represents the variation between multiple responses or replications by one individual in a wave. The latter indicates the temporal variation of SP responses by an individual between the three waves. The relationship of these variations can be set out as shown in Figure 4. This concept was developed from the idea that was employed in the analysis of measurement biases in the Dutch Mobility Panel Data by Meurs *et al.*[11] The mobility variables used in their study were obtained from actual travel-behaviour data, so that there was no "non-commitment bias" in the observations. It was, therefore, possible to observe directly that the reported mobility would decrease proportionally with the increase of measurement biases.

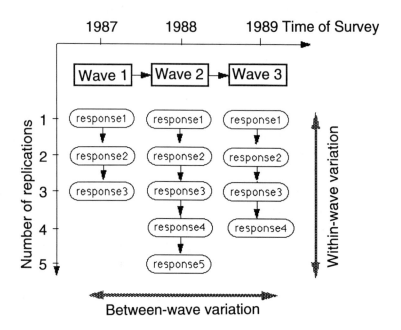

Figure 4.
The Relationship of Within- and Between-Wave Variations

On the contrary, the SP data, that we discuss in the rest of the chapter, included a number of biases, as previously described, so some additional problems arise in examining the temporal stability of SP data. One of them is that it is not clear whether some SP biases are positive or negative. For example, we wonder if the bias caused by repeated rankings will result in more or less preference for the NTS. Another problem is how to distinguish SP biases from the effect of experimental conditions. That is to say, in some SP options, the NTS is superior to car and bus in terms of level-of-service, and in other options the opposite is true. The temporal variation of SP data cannot be analyzed as directly as that of RP data.

We assumed that the within-wave variation was related to two causal factors, as follows:

 1. The difference in the characteristics of the options (i.e., combinations of different levels-of-service) presented at each replication in a given wave, and

 2. The replication effect such as fatigue, learning, warming up, etc.

The first factor concerning mode characteristics can be controlled by the analyst. That is to say, the travel environment presented at each replication is different for every individual, and options where the NTS is better or worse than the others are presented at random. The second factor may not matter within the first three to five responses.

On the other hand, the between-wave variation was regarded as being caused by three factors as follows:

1. The difference in levels-of-service associated with the actual travel environments at each wave,

2. The change of individual characteristics including their choice of actual travel mode,

3. Some unobserved biases that are generated at each wave, such as a policy-response bias and an omitted-variable bias.

The third causal factor can be predetermined in the same way as the first one. The fourth one (i.e., individual characteristics) can be observed. The fifth (the various between-wave biases) will not be observed directly and cannot be controlled in the experiment. Because of the limit of information that an individual can manage at a time, some important variables might be omitted from the SP experiment. Furthermore, because the bias of omitted variables also seems to change with years, it is included in the fifth between-wave bias.

The hypothesis of temporal stability of SP data is that the effect of between-wave biases (the fifth factor) is smaller than each effect caused by the four other factors listed above. This is empirically tested in the following sections. If the hypothesis is accepted, it could be concluded that SP data are temporally stable and they could be used with greater confidence in the future.

ANALYSIS OF TEMPORAL STABILITY OF SP DATA

Mode-choice models were developed in order to test the hypothesis concerning the temporal stability of SP data. Taking the first ranked alternative as the chosen one and the other two modes as the rejected alternatives, multinomial-logit (MNL) models, defined as in equation (1), were specified using the three-wave data sets.

$$P_{ijt} = \frac{\exp{(V_{ijt})}}{\sum_{j'=1}^{J_{it}} \exp{(V_{ij't})}} \tag{1}$$

where,

P_{ijt} = the probability that respondent i will choose alternative j at wave t,

V_{ijt} = the systematic component of the utility function of alternative j for respondent i at wave t,

J_{it} = the number of alternatives that respondent i can choose at wave t.

Let us assume that, if the data sets in the mth question at wave t are pooled for developing mode-choice models, the systematic component of the utility function V_{ij} consists of four variables as follows (the subscript i and j are not shown for abbreviation);

$$V = \sum_{k} \beta_{LK} LOS_k + \beta_M MODE + \sum_{m} \beta_{RM} RESP_m + \sum_{t} \beta_{Wt} WAVE_t \tag{2}$$

LOS_k indicates the kth level-of-service (LOS) attribute presented to respondent i. If the unknown coefficient β_{LK} is constant over the waves, the hypothesis of temporal stability in terms of the relative importance of LOS variables would be accepted.

$MODE$ is a dummy variable depending on whether the respondent is a car user at the time of the survey or not. The car user is generally hypothesized to be reluctant to change his or her mode to the NTS compared to the bus user. This is easily explained by the fact that, for example, some people might use their cars on business during the day and others might be obliged to take their children to school by car on their way to the office. Thus, the car-choice inertia effect can be examined by the coefficient β_M.

$RESP_m$ is a NTS-specific dummy variable, that is defined as 1 when it is the mth question ($m = 2,3,...,M_t$, $M_t =$ the number of questions) at wave t and 0 otherwise. This variable indicates the within-wave variation of SP data. The positive (negative) sign of the coefficient β_{Rm} means that the utility of the NTS in the mth response is larger (smaller) than that given by the first one.

The last term $WAVE_t$ is a NTS-specific dummy variable and the coefficient β_m corresponds to the genuine between-wave bias excluding the effect of changed LOS_k and the within-wave variation. The positive sign of this coefficient indicates that the utility of the NTS at the tth wave is greater than at the first wave. If the coefficient of $WAVE_t$ is not statistically significant, the hypothesis of temporal stability of SP data would be accepted. On the other hand, when the coefficient is significant in specified MNL models, SP data would be variable over time. The definition of these variables used in developing MNL models is given in Table 6.

Table 6
Explanatory Variables of MNL Models

Variable	Definition
Level-of-service	
IVTT	In-vehicle travel time (minutes)
ACCT	Access time (minutes)
WATT	Waiting time (minutes)
OPTC	Out-of-pocket travel costs (100 yen)
SEAT	Seat dummy = 1, if possible to have a seat = 0, otherwise
Bias	
MODE	Actual mode dummy = 1, if the actual mode is car, = 0, otherwise
$RESP_m$	Replication m dummy = 1, if the m th reponse, = 0, otherwise
$WAVE_t$	Wave t dummy = 1, if the t th wave, = 0, otherwise

If the model is specified based on data from each wave, then the systematic component of utility function V_t at wave t is given by eliminating $WAVE_t$ from equation (2) and adding a subscript t to all other variables and coefficients as shown in equation (3).

$$V_t = \sum_k \beta_{Lk,t} LOS_{k,t} + \beta_{M,t} MODE_t + \sum_m \beta_{Rm,t} RESP_{m,t} \tag{3}$$

The coefficients $\beta_{Lk,t}$ indicate the relative importance at wave t in deciding individuals' preferences. MNL models based on each wave data were employed to examine whether they are temporally stable or not. The asymptotic t test was used to test the equality of coefficients between two sequential waves. The null hypothesis is that $\beta_{Lk,t}$ = $\beta_{Lk,t+1}$. The statistic t' is of the form;

$$t' = \frac{| \hat{\beta}_{Lk,t} - \hat{\beta}_{Lk,t+1} |}{\{\sigma (1/n_t + 1/n_{t+1})^{1/2}\}} \tag{4}$$

$$\sigma^2 = \{ (n_t - 1) \ n_t \sigma_t^2 + (n_{t+1} - 1) \ n_{t+1} \sigma_{t+1}^2 \} / (n_t + n_{t+1} - 2) \tag{5}$$

where,

$\hat{\beta}_{LK,t}$, $\hat{\beta}_{Lk.t+1}$	=	the estimated coefficients of LOS_k in wave t and $t+1$ models,
$\sigma_{Lk,t}$, $\sigma_{Lk,t+1}$	=	the standard deviations of the estimated coefficient
n_t, n_{t+1}	=	numbers of responses in wave t and $t+1$ models.

If the statistic t' is not significant, the null hypothesis could not be rejected. This means that the temporal stability in terms of the relative importance of LOS variables would be accepted. When the hypothesis is accepted, we could employ the LOS data in developing SP models without needing to consider the timing of the experiments.

EMPIRICAL RESULTS

Comparison of Coefficients of Three Models Each with Data From One Wave

The MNL models developed, each using data from one wave, are set out in Table 7. Because the alternative-specific constants were highly correlated with the other independent variables, they were excluded here. Being based on only a single-wave

data set, the models do not include $WAVE_t$ which indicates any between-wave biases.

Table 7
Comparison of three SP models

| | Coefficient (t-statistic) | | |
Variable	Wave 1	Wave 2	Wave 3
Level-of-service			
IVTT	-0.075 (-4.84)	-0.042 (-4.57)	-0.036 (-3.56)
ACCT	-0.088 (-1.74)	0.035 (0.77)	-0.135 (-2.17)
WATT	-0.159 (-3.96)	-0.106 (-1.99)	0.009 (0.12)
OPTC	-0.269 (-2.33)	-0.350 (-2.92)	-0.261 (-2.42)
SEAT	——	0.247 (0.88)	-0.351 (-1.00)
Bias			
MODE	2.112 (4.76)	0.864 (2.17)	1.051 (3.02)
$RESP_2$	-0.255 (-0.55)	0.350 (0.72)	0.589 (1.30)
$RESP_3$	0.126 (0.26)	0.577 (1.08)	0.714 (1.55)
$RESP_4$	——	0.218 (0.45)	0.745 (1.66)
$RESP_5$	——	-0.165 (-0.32)	——
L(0)	- 148.3	- 206.5	- 194.5
L(β)	- 99.5	- 132.9	- 151.4
Adjusted Rho-squared	0.311	0.339	0.201
Number of responses	135	188	177

L(0) : the value of the log likelihood function when all the coefficients are zero,

L(β) : the value of the log likelihood function at its maximum.

All the coefficients of *IVTT*, *OPTC* and *WATT*, with the exception of *WATT* at wave 3, have the expected signs and their *t*-statistics are significant at the 95 percent confidence level. This result suggests that the levels of these LOS variables were

confidence level. This result suggests that the levels of these LOS variables were reasonably designed in the SP experiments. Because the adjusted Rho-squared values, that indicate the goodness-of-fit, are all significantly high, it is concluded that the mode-choice models specified here, using the SP data, have a high degree of explanatory power.

We can see that the estimated coefficients of the actual-mode dummy variable *MODE* are also significant all in three models. This means that car users have a tendency to prefer their present mode to the NTS, as hypothesized. Accordingly, there seems to exist a high mode-choice inertia bias in SP surveys. All the coefficients of the replication-dummy variables (which indicate a within-wave variation) are not significant at the 95 percent level. Besides, the signs of these coefficients are variable over the three waves. The results demonstrate that the use of not more than five replications with any respondent does not result in a specific bias in the SP responses, as we expected.

Estimation of a Model Using Pooled Data from the Three Waves

The MNL model developed with pooled data from all three waves is given in Table 8. The variables *ACCT* and *SEAT* were excluded from the set of explanatory variables, because their *t*-statistics were not significant in each of the one-wave models, as shown in Table 7. The coefficients of LOS_k and *MODE* are all more significant than in the models based on one-wave data alone. As the coefficients of $RESP_m$ are not significant, it is confirmed again that the within-wave variation would be minor. The hypothesis of temporal stability of SP data can be examined by interpreting the estimated coefficient of $WAVE_t$. It is significant at the 95 percent level at wave 2, but is insignificant at wave 3. These results suggest that the hypothesis of the temporal stability of SP data is not supported.

In order to establish whether the higher NTS share found in wave 2 (see Figure 3) was caused by the effect of this between-wave bias (i.e. β_{W2} which is defined in Equation 2), the NTS shares at waves 1 and 2 were predicted by using two MNL models. These differed in whether the coefficient β_{W2} is included or not in the pooled model shown in Table 8. The following enumeration method[12] was employed to aggregate the individual probability obtained from Equation 1 over the pooled data sets.

$$S_{NTS,t} = (1/N) \sum_{i=1}^{N} P_{i,NTS,t} \qquad (7)$$

Table 8
SP Model With Pooled Data

Variable	Coefficient	t statistic
Level-of-service		
IVTT	-0.035	-6.96
WATT	-0.123	-4.77
OPTC	-0.263	-4.29
Bias		
MODE	1.227	6.00
RESP$_2$	0.112	0.45
RESP$_{3+}$	0.193	0.84
WAVE$_2$	0.645	2.79
WAVE$_3$	-0.043	-0.17
L(0)	-549.2	
L(β)	-395.9	
Adjusted Rho-squared	0.273	
Number of responses	500	

RESP$_{3+}$ = 1, if at the third response and after,
 = 0, otherwise

The results are shown in Figure 5. The predicted share $S_{NTS,1}$ using the model without β_{W2} is shown as a striped bar at wave 1, while $S_{NTS,2}$ with β_2 at wave 2. The stated shares at two waves are also drawn as plain bars in the same Figure for comparison.

We can see that predicted and stated shares for the NTS are almost equivalent at both wave 1 and wave 2. Besides, the difference of predicted shares (14.7 percent) between two waves is not significantly different from that of stated shares (13.1 percent). This suggests that the major part of between-wave variation is caused, not by the temporal change of individuals' attributes (including the numbers of actual car users), nor the LOS design used in the SP experiment, but by the between-wave (temporal) biases +inherent in the SP data. As a result, the hypothesis that the effect of SP biases

between waves (fifth causal factor) is smaller than the ones caused by the other factors defined previously cannot be accepted.

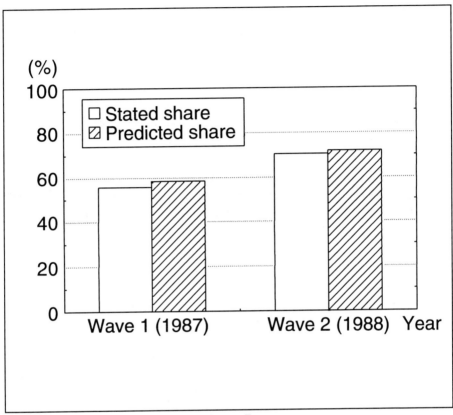

Figure 5.
Comparison of Stated and Predicted NTS Shares

Temporal Stability of the Relative Importance of Level-of-Service Factors

In order to examine the change in relative importance of each LOS variable between waves, the models based on a common set of explanatory variables were recalibrated for each wave, excepting *ACCT* and *SEAT* which were not significant in previous studies. The asymptotic t test for the equality of LOS coefficients in MNL models were made between two sequential waves using the t' statistics that were given by equation (4); results are shown in Table 9. The hypothesis that there are no differences in the LOS coefficients between waves was not rejected in all cases, because of their insignificant t' statistics at the 95 percent level. This will lead to the conclusion that

there is temporal stability in the weighting of LOS attributes when choosing the best mode in SP surveys.

CONCLUSIONS

Several hypotheses concerning the temporal stability of SP data were tested by examining the coefficients of variables in mode choice that were included to measure temporal biases. The results of this study are summarized as follows:

1. SP responses were closely related to the levels of travel-service attributes included in the SP experiments. Their relative importance in making up individuals' preferences was temporally stable.

2. The effect of repeated ranking replication in SP questions (which is one of the within-wave biases) was insignificant in the mode-choice models developed here. Not more than five ranking questions per individual can be accepted within the allowable level of replication biases.

3. Because the actual travel mode was an important determinant in the SP models, there seems to be a mode-choice inertia bias in the SP data. In other words, this will imply the importance of person-specific variables that could change over time in explaining the temporal variation.

4. The between-wave variation, caused by temporal change in the biases inherent in SP panel data, was not so small that it can be neglected in model building. However, we could not relate it definitely to progress in the planning of the NTS, because of the limited number of waves.

The temporal stability of the LOS coefficients in mode-choice models is a very important result of the study, indicating the validity of travel-demand models based on

Table 9
Asymptotic t Test for the Difference of LOS Coefficients
Between Two Sequential Waves

LOS Variable	Waves 1 and 2	Waves 2 and 3
IVTT	0.951	1.482
WATT	0.703	0.871
OPTC	0.334	0.782

SP data. However, the temporal instability of SP data may give us unexpected bias in travel-demand analysis of new transport alternatives. This is thought to be closely related to the biases caused by omitted variables and policy-response bias. Interactive interviewing using microcomputers may make the former bias smaller to some extent, because it can easily customize important LOS variables and their levels for each respondent. On the other hand, the latter bias is difficult to exclude completely.

The limited sample size and number of waves did not permit much more detailed modeling. However, we are planning to carry out another survey in 1993, one year before the opening of the NTS, in which the policy-response bias will be studied more fully.

ACKNOWLEDGMENTS

The authors are grateful to Peter Jones, University of Westminster and two anonymous referees for their helpful comments and suggestions on an earlier version of this paper.

REFERENCES

1. Kroes, E. and R.Sheldon, "Stated Preference Methods: An Introduction," *Journal of Transport Economics and Policy*, 1988, 22(1), 7-26.

2. Bonsall, P., "Transfer Price Data - Its Definition, Collection and Use," in E. Ampt, et al. (editors), *New Survey Methods in Transport*, VNU Science Press, 1985, 257-271.

3. Bradley, M. and P. Bovy, "A Stated Preference Analysis of Bicyclist Route Choice," The 12th PTRC Summer Annual Meeting, Seminar H, 1984, 39-54.

4. Hensher, D., P. Barnard, and T. Truong, "The Role of Stated Preference Methods in Studies of Travel Choice," *Journal of Transport Economics and Policy*, 1988, 22(1), 45-58.

5. Jones, P., M. Bradley, and E. Ampt, "Forecasting Household Response to Policy Measures Using Computerized, Activity-based Stated Preference Techniques," *Travel Behaviour Research*, edited by the IATB, Avebury, 1989, 41-63.

6. Ben-Akiva, M. and T. Morikawa, "Estimation of Switching Models from Revealed Preference and Stated Intentions," *Transportation Research*, 1990, 24A(6), 485-495.

7. Bradley, M. and E. Kroes, "Simultaneous Analysis of Stated Preference and Revealed Preference Information," Presented at the 18th PTRC Summer Annual Meeting, Seminar H, 1990.

8. Goodwin, P., R. Kitamura, and H. Meurs, "Some Principles of Dynamic Analysis of Travel Behaviour," in P. Jones(editor), *New Developments in Dynamic and Activity-Based Approaches to Travel Analysis*, Gower Publishing, 1990, 56-72.

9. Meurs, H., L. Van Wissen and J. Visser, "Measurement Biases in Panel Data", *Transportation*, 1989, 16(2), 175-194.

10. F. Koppelman, "Guidelines for Aggregate Travel Prediction Using Disaggregate Choice Models," *TRB Record No.610*, 1976, 19-24.

PART III

INCORPORATING THE DYNAMICS OF BEHAVIOUR IN TRAVEL ANALYSIS

12

DYNAMICS OF COMMUTER BEHAVIOUR: RECENT RESEARCH AND CONTINUING CHALLENGES

Hani S. Mahmassani

ABSTRACT

This chapter presents a review of selected developments over the past decade in the area of modelling commuter decisions, particularly departure time and route choice, day-to-day dynamics of these decisions in interaction with system performance, and the role of information. The chapter addresses models of departure time and route choice, daily switching decisions, and learning rules. Results of laboratory-like experiments, computer simulations and actual surveys are highlighted. Recent issues arising in connection with IVHS (advanced traveller-information systems) are also discussed. Throughout, issues and challenges facing the travel-behaviour research community are highlighted.

INTRODUCTION

This chapter presents an overview of developments that have taken place over the past decade in the area of modelling commuter decisions, particularly with regard to departure time and route, and the day-to-day dynamics of these decisions in interaction with the performance of the transportation system. It is intended as a guidepost along the way, in an area that is still very much under active development. While a foundation for conducting research in this area has been forming slowly, significant breakthroughs remain to be made both substantively and methodologically. Because of the inherent complexity of gathering and subsequently analyzing observations of the dynamic phenomena of interest, research in this area has tended to be more open to experimentation with novel approaches, and somewhat less constrained by

traditional precepts than the mainstream of travel-demand analysis. A dramatic increase in interest in commuter behaviour, user- response dynamics, and the time-dependent patterns of demand and flows in networks over the past couple of years, among both researchers and operating agencies, promises to generate an exciting body of work and challenging lines of inquiry in the next decade.

The importance of commuter-tripmaking decisions and their dynamic characteristics stems from their central role in determining the effectiveness of solutions devised in response to some of the most critical problems affecting the quality of life in the world's large urban areas. Elsewhere in this volume[1,2], the key developments in the policy context that travel-behaviour research is called on to inform and support are aptly reviewed. For several of these, the solution or mitigation strategies are critically dependent on the ability to influence the temporal and spatial characteristics of commuter behaviour and decisions. A partial list of these motivating problems and opportunities includes:

- Peak-period congestion and peak spreading[3,4,5]

- Travel demand management

- Air quality and Clean Air Act Amendment compliance

- Planned supply disruptions (e.g. reconstruction activities)[6]

- Information dissemination strategies

- Congestion pricing[7,8]

- IVHS/Advanced Traveller-Information Systems (ATIS)[9]

The essence of all the above issues is a concentration of vehicular flows in space (over certain portions of the network where bottlenecks tend to develop) and time. In its simplest form, congestion arises because the available capacity cannot serve the desired demand during a certain period. This imbalance may be a daily occurrence (routine congestion) or due to unusual occurrences such as traffic incidents or special events (non-recurrent congestion). The result is a degradation of the level of service provided to the users, and the associated costs in terms of mobility, delays, air quality, fuel consumed, and higher cost of transported goods. Its effect is accentuated by unpredicted fluctuations in demand (such as special events) or supply (e.g., traffic incidents or malfunctioning equipment). It is also accentuated by the fact that the

service rate itself (i.e. effective capacity) of transportation facilities typically diminishes with increasing congestion (e.g., bumper-to-bumper traffic on freeways, and gridlock).

One might seek to reduce congestion by either increasing capacity (supply-side measures) or reducing demand (demand-side measures), at least during certain times, thus more generally shifting the spatial and temporal characteristics of demand, especially during the peak periods where commuting traffic is dominant. Effectively, a combination of both types of measures is required. It is well accepted that the projected mobility needs in cities in the US and throughout the world exceed the urban areas' ability and willingness to increase capacity exclusively through construction. Supply-side measures in the form of better traffic control are an essential part of the overall strategy, though not sufficient to meet the imbalance. Demand-side measures, such as flexible hours, carpooling, and many others continue to be pursued more or less vigorously by various agencies, though much of their potential probably remains untapped in many urban areas. Emerging IVHS technologies offer meaningful promise for enhanced system efficiency through the exploitation of local imbalances between supply and demand, using information as the primary mechanism to influence user decisions. Congestion pricing provides another possible mechanism that appears to be gaining greater acceptance to influence the spatial and temporal distribution of demand.

The above discussion highlights that the analysis of congested systems and evaluation of relief strategies must, by necessity, consider: (1) the time-dependent pattern of flows, and their distribution over space; (2) the systematic changes and fluctuations of these decisions from day to day; and (3) the interaction of user decisions with the system performance. One must, therefore, be concerned with the user decisions that generate these patterns, namely trip timing and path selection, and the mechanisms through which users adjust these decisions in response to experienced congestion, control measures, supplied information, and other strategies such as pricing. Much remains to be learned about the users' responses to these strategies, and the effectiveness of the resulting strategies.

Of course, departure-time choice and path selection are not the only choice dimensions available to commuters, nor are they the only ones that the various strategies above seek to influence. However, they constitute the primary mechanisms available to commuters to respond to congestion and the various strategies in the short term, with limited expenditure of additional resources or major shifts in activity patterns. In some contexts, mode choice may be another such dimension; in most US cities, the time frames for mode shifts tend to be of a longer term nature than the above two dimensions. Similarly, decisions to telecommute, relocate one's residence,

or change places of employment are not made everyday by commuters. On the other hand, the interaction of these decisions with the commuter's activity patterns, individually and at the household, and possibly the workplace levels, are an integral element to a meaningful analysis of commuter behaviour in congested urban systems. For instance, the chapter by Mahmassani, Hatcher and Caplice[10] in this volume highlights the importance of trip chaining along the commute in determining the variability of trip-timing and route-choice decisions. An extensive discussion of activity-based approaches to travel behaviour is given in the survey chapter by Kitamura[11]; additional comments on the interactions between activity patterns and tripmaking decisions are also given by Jones et al.[12].

It should be noted that this chapter is not meant as an exhaustive review of available references on dynamic travel-behaviour modelling, nor, for that matter, of commuter behaviour. Rather, it is a reflection of the author's own perspective on the field, and appreciation of where important challenges and opportunities exist for researchers interested in these problems. It is also an attempt to communicate and organize into a coherent framework the research on commuter-behaviour dynamics undertaken by the author in collaboration with various students and colleagues over the past decade, and to place it in the context of the growing body of contributions to the field.

In the next section, we discuss some conceptual issues in modelling commuter decisions and time-dependent flows and attempt to identify the principal types of phenomena and problems addressed. This is followed by a review of trip-scheduling models, in the context of the within-day variation of traffic flows. The day-to-day dynamics of commuter decisions form the focus of the subsequent discussion, which addresses results from both laboratory experiments and surveys of actual commuters. A rapidly emerging area of current investigation is the real-time dynamics of user responses, especially in the context of IVHS technologies and real-time information-supply strategies, as discussed in the fifth section. Concluding comments and future directions are given in the last section.

CONCEPTUAL BACKGROUND AND ISSUES

Consider the number of users $X(i,j,d,k,a,t)$ leaving origin i for destination j at departure time d along path k and present on link a (part of path k) at time t. This variable conveys the various dimensions of choice that must be considered in analyzing the time-dependent patterns of commuter flows in a network. It also illustrates the three principal time frames of interest in the analysis of the temporal aspects of commuter decisions and associated flow patterns in urban networks.

Furthermore, it underscores some of the daunting difficulties that face researchers in this area, as discussed hereafter.

The ultimate quantities of interest to modellers are values of $X(i,j,d,k,a,t)$, for all i, j, d, k, a, and t pertinent to a particular problem. Leaving aside issues of discrete versus continuous time formulations, because these are only incidental to the underlying behavioural questions that form the focus of this discussion, we are interested in path-level and link-level values of the demand as a (continuous or discrete) function of time, on the various components of the transportation system. The scope of this discussion, and of most analyses of user-behaviour dynamics, normally does not include changes in the tripmaker's origin i or destination j. To the extent that one is dealing with work commutes, both origin i and destination j are normally stable for a given commuter in the short run. However, even the work end of a commute may change, though this is likely to be part of a process that may be considered as exogenous to the analysis. On the other hand, intervening destinations that are part of a trip chain ending at the workplace (or home on the return trip) appear to be subject to short-term fluctuation and specific adjustments made by commuters in response to information about congestion. A typical example would be a worker deciding to pursue an activity near the workplace (e.g., exercise, or meeting with a co-worker for happy hour) until traffic clears[13,14]. So while the ultimate trip ends (i and j) may be stable and repetitive, or may change according to an exogenous planned activity schedule, the intervening stops or destinations along the way, especially for non-routine discretionary purposes, should be recognized as variable on the same time frames as path and departure time (both of which are impacted directly by the trip-chaining decisions). This underscores the importance of considering trip chains as the basic entity for demand analyses, especially in the time-dependent context, unlike the long-established practice of considering any intervening stop as the destination of a separate independent (non-home based) trip in traditional demand-forecasting practice.

Taking i and j as fixed and known, the time of departure from i, denoted by d, is the result of a decision made by the commuter. The timing of the trip determines the temporal pattern of origin-destination trip demand for the network, and is thus at the essence of capturing the within-day variation of demand. The commuter may change the timing of the trip from one day to the next, depending on his or her experience with the facility, information, etc. Furthermore, the timing of the trip may be changed on a real-time basis, rather than a planned basis, such as delaying one's departure from work, or starting earlier from home, to avoid congestion.

The path k is also the result of a decision made by the commuter, thereby directly determining the spatial distribution of trips in the network. One of the subjects of

ongoing investigations is the extent to which path selection is interdependent with the departure-time decision. Path choice follows similar time frames to the departure-time decision, with the greater opportunity for real-time changes to this decision, in the form of en route diversion in response to observed congestion, real-time information as part of an ATIS, or variable-message signs.

Given i, j, d and k, the rest (i.e., when a certain commuter will reach link a along path k) would seem straightforward. However, this is perhaps the source of greatest difficulty and complexity in solving for time-dependent flows in a network, because it is a manifestation of the existence of often highly nonlinear interactions among individual decisions made non-cooperatively by the commuters. In particular, the time needed to reach a particular link along a particular path is dependent on the congestion levels generated along that path, which depend on the decisions of all other commuters[15]. The fact that the travel times are not constant introduces the need for simultaneous consideration of the user decisions and the performance of the system. This simultaneity is considerably more complicated than in the static case.

The above discussion illustrates the three principal time frames of interest in the analysis of the temporal aspects of commuter decisions and associated flow patterns in urban networks, namely:

1. Within-day, time-dependent demand and flow patterns, namely the $X(i,j,d,k,a,t)$'s defined above, especially with regard to representing the build-up and dissipation of congestion on the various system components. This dimension primarily introduces the choice of departure time into a previously static framework, in which trip times and flow rates are assumed constant over the peak period. The limitations of these assumptions are now well recognized[16,17], and have motivated a large body of work over the past decade, as discussed in the next section.

2. Day-to-day dynamics of commuter decisions, including the characterization of the extent of variability in these decisions, and the representation of the mechanisms that govern the departure-time and route decisions of users in response to experienced congestion and exogenous information. Consideration of these decisions allows the examination of the daily evolution of the time-dependent flow patterns, and introduces an entirely new perspective on the analysis and prediction of demand in transportation systems. Rather than focus on a presumed time-dependent

equilibrium pattern, this line of investigation seeks the behavioural mechanisms operating at the individual level (e.g., search, adaptation, and learning) that might lead the system to some (time-dependent, within-day) steady state (if such a state exists)[18,19]. The evaluation of transportation options thus shifts from being exclusively an exercise in comparative statics to one where the path of the evolution of the system adjustment in response to control actions and policies may be of equal (if not greater) concern than the eventual final state (itself possibly dependent on interventions along the evolution path)[20,21,22,23]. To the extent that transportation systems are complex, nonlinear, dynamic systems; transportation planners and demand specialists might have to recognize, accept, manage, and eventually take advantage of the possible presence of chaotic behaviour in these systems.

3. Real-time dynamics is concerned with the flow patterns that result from the real-time decisions of motorists in the network, in response to perceived or anticipated prevailing conditions, as well as supplied information, especially in-vehicle information. Ongoing interest in IVHS, especially ATIS, has resulted in a growing group of active researchers in this area, and particularly innovative experimental methodologies. Of particular concern are enroute path-switching decisions (including diversion in response to advisories during incidents), and trip timing at the origin. Recent developments in this area are discussed in the fifth section.

Before reviewing research in each of the above three areas, four issues encountered in the investigation and measurement of commuter decisions are discussed.

Measurement Issues

The notion of equilibrium has been a tenet of most theories and has provided a solution concept underlying the demand-forecasting methodologies of the past four decades. For the context under consideration (peak-period commuter decisions in networks), the dominant equilibrium concept is based on Wardrop's principle of individual time-minimizing tripmakers, resulting in a Nash equilibrium in what is akin to a non-cooperative game, where the payoff depends on nonlinear interactions among all commuters in the traffic system[24,25,26]. This User Equilibrium (UE) is characterized by equal trip times on all used paths between a given O-D pair. Yet, no scientific evidence has been reported to confirm the existence of such an equilibrium in actual networks. However, evidence has been reported to support the notion that travel

conditions are not static over the peak commuting period, suggesting, at the very least, that whatever equilibrium might be prevailing is time dependent. To the extent that some steady state might be reached, the conditions characterizing it are not known and do not necessarily correspond to a behavioural model of the tripmaker as an economically-rational, fully-informed agent. For instance, Mahmassani and Chang proposed the notion of a Boundedly-Rational User Equilibrium (BRUE) in traffic systems, where user behaviour follows Simon's well-known satisficing notion[27,28]. Essentially, a BRUE is obtained when no user wishes to change their commuting-trip decisions (route, departure time), because the consequences of these decisions are within some indifference band acceptable to the user. Results of several laboratory-like interactive commuter experiments were found consistent with a BRUE[29,30].

Among the properties of a BRUE (and other equilibrium concepts that depart from the strict precepts of microeconomic rationality) that have direct implications for travel-behaviour modelling and measurement are its probable non-uniqueness for a given transportation system, and its likely dependence on the dynamic (day-to-day) process that might lead to it[31,32]. The associated complications for demand forecasting, heretofore focused on equilibrium choices, are evident. The evolutionary path becomes of comparable (if not greater) importance than an eventual final state. Any description of user behaviour that seeks to capture and eventually predict equilibrium choices would require explicit representation of the behavioural processes governing the system's evolution.

The above point does not necessarily refute or preclude the existence of an equi-librium, but merely questions the conditions that define it. A considerable degree of regularity and repeatability is present in commuter behaviour, yet day-to-day variability of up to 20% (of departure time and/or route decisions) has been documented in commuter behaviour in systems that would normally be considered at equilibrium[33,34,35,36]. Under these conditions, what do observations of a given individual's actual decisions on a given day truly represent? What would be the applicability of behavioural models calibrated on such measurements? Would a model of departure-time choice calibrated under such conditions capture the true underlying processes that govern departure-time choice in that system? At the very least, careful qualification of the domain of applicability of particular models intended for this context would be in order.

Another measurement issue facing the modeller arises from the strong interaction of behaviour and the systems' performance, and the often constrained nature of the tripmaker's choice set. In particular, the highly-congested nature of certain commuting systems may not offer the opportunity to observe tripmakers' relative

preferences for attributes such as trip time and schedule delay in their choice of departure time and route (see next section for more discussion), because the range of options available to them offer only particular combinations of these attributes. Thus, observed values of the attributes may reflect a particular strong pattern of correlations that correspond to the reality of the traffic system, precluding extension of the models' applicability to evaluate measures aimed specifically at relaxing or eliminating some of the operating constraints by improving the operational characteristics of the system.

In dynamically-evolving systems, especially where the interactions between the behavioural processes of interest and the system's performance are strong (such as traffic systems), a major obstacle to model development is the observation of actual behaviour at the desired level of richness, simultaneously with measurements of prevailing conditions. An important role has been recognized for laboratory experiments for this purpose[37,38,39]; an experimental procedure was introduced by Mahmassani, Chang and Herman in which actual commuters, interacting through a traffic-simulation model, provide daily choices of route and departure time. The simulation model ensures consistency of the stimuli with traffic reality, as well as with the decisions of the commuters. This approach has since been adopted and advocated by others[40], and recently a slew of contributions have appeared on the use of simulators to study users' responses to real-time information.[41,42,43].

Finally, the above discussion clearly highlights the inadequacy of conventional single-day surveys to study the dynamic processes of commuter behaviour. As discussed elsewhere in this book, significant developments have taken place in the area of survey methodologies for travel behaviour research[44]. The development of panel approaches, travel diaries, and the acquisition of time-series (multi-day) data are all necessary to study commuter behaviour adequately[45,46].

WITHIN DAY: TRIP SCHEDULING MODELS

This section addresses models developed to represent the variation of demand over the course of the day and, more specifically, within the (AM and PM) peak periods of commuting. These models belong to the first category identified in the previous section. A good overview and discussion of these models, primarily from a microeconomic-theory perspective, though somewhat lacking in behavioural content, was recently presented by Small[47]; earlier reviews were given by Alfa and Mahmassani and Chang[48].

Work in this category has been concerned primarily with equilibrium choices of departure time, in some instances jointly with route. Two broad types of models can be distinguished: those that seek to capture the choice of departure time given fixed and known values of the transport-system's attributes and those that aim to describe the time-dependent pattern of demand jointly with the service attributes (congestion pattern) in the system. The second type usually embeds models of the first type in an equilibrium framework.

The first type of models includes those by Cosslett[49], Abkowitz[50], Small[51], McCafferty and Hall[52], and Hendrickson and Plank[53], who formulated and empirically estimated work-trip scheduling models in a standard random-utility maximization (RUM) framework. The problem is treated as a choice among discrete alternative time slices, each characterized by a different utility level to the tripmaker. Attributes typically in the specification of the utility function include the trip time associated with each departure-time alternative, and the corresponding penalty for late or early arrivals (captured by the schedule delay, usually the difference between the actual and the desired arrival times). Indeed, the standard microeconomic theory of trip scheduling holds that the departure time selected is the result of a trade-off between trip time and schedule delay; short trip times are typically associated with either very early or very late departure times that result in long schedule delays. Shorter schedule delays usually entail a longer commuting time because of congested conditions prevailing at those times. Empirical results seem to suggest the strong relative importance of schedule delays in determining departure-time choice and the existence of an asymmetry in the relative valuation of schedule delay for early versus late arrival (the latter being of greater concern to work commuters). While quite insightful into this important choice dimension of commuters, none of the above models can be considered to have a definitive specification for this problem, because small sample sizes and other data limitations seemed to preclude convincingly clear-cut model results and statistical indicators. For instance, the coefficients of the (two) trip-time variables in Hendrickson and Planck's model are not statistically significant at the usual levels of significance adopted for such applications.

Some of the limitations of the above models may be due to the issues identified in the previous section regarding the measurement of presumed equilibrium choices and system attributes. A more extreme manifestation of these problems is evident in similarly-specified models by Tong, using observations from laboratory-like experiments with a simulated and highly-congested traffic corridor[54,55]. The coefficient of travel time in those models was either not significant or had an incorrect sign, undoubtedly a reflection of the fact that the particular system under consideration did

not offer combinations of trip time and schedule delay that offered meaningful trade-offs between these attributes. Long trip times had to be accepted because shorter trip times would entail unacceptably long schedule delays. Of course, it is also probable that alternative behavioural processes are governing commuter choices in such highly congested systems.

Several variants on the basic discrete-choice modelling framework for departure-time choice have been presented. De Palma et al.[56] used a continuous version of the logit-model form instead of discrete departure-time slices; no calibration of that model was presented. Abkowitz' model also included mode choice in addition to trip scheduling, because that work was motivated by the desire to evaluate the effect of improvement in transit service reliability on ridership. The joint choice of route and departure-time was modelled by Tong[57], who considered alternative nested structures versus a simultaneous logit specification, also using the above-mentioned results of laboratory-like experiments. A discrete-continuous formulation of the route-departure-time joint-selection problem was presented and empirically realized by Mannering et al.[58]. In their formulation, the tripmaker has a choice of travel time, or speed (the continuous choice variable), and a simultaneous (discrete) choice of route. Departure-time is then given by subtracting the travel time from the desired arrival time.

The second type of models of within-day time variation of commuter trips recognizes the interrelation between user decisions and system performance, and thus treats the system attributes as endogenous. In addition to a departure-time choice rule, a model of congestion is necessary. The bulk of early developments along this line considered a highly-idealized system consisting of an unique route connecting a given origin to a single destination. Commuters in this context were assumed identical maximizers of a utility capturing their relative preferences for trip time and schedule delay. Independently following an analysis presented a decade and a half earlier by Vickrey[59], Hendrickson and Kocur[60] solved for a so-called Dynamic User Equilibrium (DUE) departure pattern, a direct extension of Wardrop's static conditions, such that no users can improve their utility by unilaterally switching departure-time (and route when available). Stochastic versions have used a RUM model instead of a deterministic departure-time choice rule[61]. In all these models, congestion was represented by considering a single bottleneck, treated as a deterministic queue with constant and congestion-independent service rate, along the available route. Mahmassani and Herman represented congestion using a traffic flow theoretic model and extended the framework to consider multiple parallel routes.

Even in a highly idealized context, some of the issues in representing congested traffic movement correctly in time-dependent assignment models become apparent.

Furthermore, the ability to derive closed-form analytic solutions dramatically decreases as additional realism is introduced in either the demand or the performance side of the problem. Thus, simulation has been the next logical approach to extend these models. For instance, Ben-Akiva et al.[62] performed simulations of models with multiple bottlenecks, still taken as deterministic queues, on multiple routes, and Chang et al.[63] developed a special-purpose traffic simulation model for the study of commuter-behaviour dynamics. Mannering et al.[64] presented an iterative procedure to compute a stochastic DUE in a three-route system in conjunction with their econometric departure-time and route-choice model. Jayakrishnan solved for a stochastic DUE in a traffic-corridor system with real-time information availability (ATIS) on prevailing traffic conditions to the tripmakers.

Most of the above contributions have considered problems with a single destination only. Solution in a general network with multiple destinations is an area of active research, with the focus primarily on algorithmic procedures for computing the time-dependent equilibrium pattern of path and/or link volumes. Unfortunately, the terminology and concepts used in these papers have tended to be inconsistent across different researchers, with the generic, dynamic network assignment referring to problems that may or may not involve departure-time choice explicitly as part of the formulation. The bulk of contributions to date have been concerned with finding a path assignment in the network given a known time-dependent origin-destination trip pattern (with only route choice available to tripmakers). A few recent efforts have also attempted to incorporate trip timing explicitly. A detailed discussion of this topic is outside the scope of this chapter. A recent overview of related methodological issues and partial review of formulations is given by Mahmassani et al[65]. In general, most existing formulations have serious limitations either in terms of traffic realism, user behaviour, and/or the lack of computationally, efficient solution procedures for large networks.

In closing this section, two primary directions remain for further work in this category of within-day time-dependent commuter-demand patterns. On the behavioural side, we noted that satisfactory specifications for trip-scheduling models remain to be developed. Substantively, capturing the effect of service reliability and fluctuations in performance on departure-time choice has been a continuing item of interest in the modelling community. Capturing the interrelation of departure-time choice with other tripmaking decisions, such as route and mode choice, have also not been resolved convincingly. A rich observational basis is essential for any further meaningful development on this front and the issues noted earlier in this regard are not trivial. Incorporating trip scheduling in a more comprehensive activity-scheduling framework, as explored by van Knippenberg[66] in a study of departure-time pre-ferences of transit

riders, offers challenges for both theoretical and empirical work. However, further probing into the behavioural mechanisms underlying trip scheduling, and user response to congestion and supplied information almost invariably leads to the necessity of considering these decisions in a day-to-day framework. As such, the RUM formulations, under the assumption of a stable and measurable equilibrium, may not be adequate; alternative decision-process structures that explicitly recognize learning and adjustment mechanisms in a dynamically varying system need to be investigated, as discussed in the next section.

The other direction for further development is in the computation of time-dependent flow patterns in networks. The single bottleneck problem has provided particular insights into the implications of different forms of congestion pricing[67]. Thorough discussions of the economic aspects of these models are given by Arnott et al.[68,69] and Small[70,71]. However, there remains little else to be derived from the single bottleneck (even multiple parallel bottlenecks) problem and its value today is primarily pedagogical. While efforts to solve the network-level problem have been primarily methodological in nature, the substantive aspects that arise from the network interactions have received virtually no attention, undoubtedly because of the associated methodological difficulties. However, given that the existence and nature of a time-dependent equilibrium is itself a tentative proposition at best, one might question the wisdom of investing much effort to solve a problem of formidable difficulty that may not be particularly relevant to reality. This is especially true in light of the limited behavioural content of most formulations and algorithmic procedures proposed for the network problem. In contrast, moving away from any assumption about equilibria, a simulation-assignment model that tracks individual trips through the network over the peak period, with explicit representation of user decision rules, has been developed by Mahmassani and co-workers over the past few years, primarily for IVHS applications. Rather than impose a rigid set of assumptions for the sake of mathematical and computational convenience, it provides a framework for examining the network-level implications of richer behavioural rules for the various tripmaker decisions, in a manner that is consistent with traffic reality. As such, it can be viewed as the network level realization of a more general microsimulation demand-analysis procedure[72].

DAY-TO-DAY DYNAMICS

In the same text in which they established the classic mathematical-programming formulation of the transportation network equilibrium problem, Beckman, McGuire and Winsten discussed the possible mechanisms that might lead a system to such an equilibrium[73]. They considered a very simple rule by which tripmakers chose their path on the basis of the trip times of the previous day; this simple myopic rule has also been considered subsequently by others. When used in conjunction with a probabilistic choice function to obtain decisions for a given day, a Markovian discrete-time stochastic process results[74]. This myopic rule is one instance of a family of simple learning rules considered by Horowitz[75] for the process by which users predict the travel times on a given day, based on the preceding days' system performance. In its general form, the predicted trip time on day t is taken as a weighted sum of all previous days' trip times; by varying the relative magnitudes of the weights, different assumptions about amount of memory recall and saliency of recent versus old experience could be implemented. Horowitz investigated the convergence properties and the stability of a stochastic-user equilibrium (time-invariant route choice) in a simple network consisting of a single origin-destination pair connected by two single-link routes. His results provided a theoretical backdrop for emerging questions regarding the existence, nature, and stability of equilibria in traffic systems and motivated further investigation into the underlying behavioural mechanisms operating at the individual tripmaker level.

A framework for the day-to-day adjustment of departure decisions in response to experienced congestion was introduced by Mahmassani and Chang[76], and incorporated with a traffic-simulation model to investigate the day-to-day dynamics of a commuting system under alternative simple rules for departure-time adjustment and learning. This exploratory work evolved in two directions. First, the behavioral-process models were subsequently refined and calibrated on the basis of interactive laboratory-like experiments with actual commuters. Second, the overall modelling framework was expanded to perform simulations of the day-to-day evolution of the commuting system under alternative scenarios to evaluate the effectiveness of various traffic-management strategies. Both aspects are described in some detail in an earlier overview paper by the author[77]. The principal features are highlighted hereafter.

Behavioural Processes

A basic premise of this effort has been that commuter daily-adjustment behaviour is guided by simple heuristic strategies and mental rules. As such, it has departed from the formal utility-maximization paradigm, and viewed the behaviour of the individual tripmaker engaged in daily commuting as a boundedly-rational search for an

acceptable outcome. The case for this perspective is supported by evidence in the psychological and behavioral decision-theory literature, as articulated in Mahmassani and Chang[78]. Two basic types of mechanisms govern the decisions of route and departure-time from day to day. The first determines whether the commuter will change his or her latest choices (of route, departure-time, or both); the second sets the amount by which the departure-time is adjusted and/or the route that the commuter switches to, conditional upon the decision to change one or the other (as determined by the first set of models). The second type of mechanism subsumes a process by which the user might be learning from repeated experience with the facility and/or exogenous sources of information.

A key quantity in this framework is the commuter's preferred arrival time at the workplace, *PAT*, for user *i*, which has been shown to reflect inherent preferences, attitudes towards risk, as well as workplace conditions. For given departure-time DT_{it} on day *t*, the commuter arrives at time AT_{it}. The travel time is thus given by $TT_{it} = AT_{it} - DT_{it}$, and the schedule delay by $SD_{it} = PAT_i - AT_{it}$. The boundedly-rational character of the decision process is operationalized via a satisficing rule. Initially introduced for departure-time switching only, the rule specified that the user does not change departure-time (for day *t+1*) if the schedule delay (on day *t*) is within a user-specific indifference band, i.e., if $\{0 \le SD_{it} \le IBE_{it}$ or $-IBL_{it} \le SD_{it} \le 0\}$, where IBE_{it} and IBL_{it} are respective indifference bands for early and late arrivals (relative to PAT_{it}) respectively. The asymmetry of the indifference band of schedule delay for departure-time switching for early versus late arrivals has been confirmed in the laboratory-like experiments described later in this section.

The indifference-band mechanism is extended to predict route switching, separately and/or jointly with departure-time, by introducing a second indifference band, governing route decisions, also with separate early-arrival and late-arrival components. Depending on the relative values of the schedule delay and the corresponding indifference bands, the user may switch either one or both of the two choice dimensions.

The indifference bands have been shown to vary dynamically in response to experienced congestion, and to be influenced by the availability of external information, as discussed later in this section. These bands are treated as random variables distributed over days and across tripmakers, with systematically-varying mean values. For example, $IBE_{it} = f_1(X_i, Z_{it}) + e_{it}$, where the systematic component is a function $f(.)$ of user characteristics X_i and a vector of performance characteristics Z_{it}. Through the specification of the four systematic components, as well as the structure of the error-term distributions, the interrelation between the four quantities can be captured.

Detailed expressions for the probability of switching either choice dimension are given elsewhere[79], along with a discussion of the econometric techniques to estimate the parameters of the resulting choice models. Note in this regard that the mean magnitude of the route-indifference band is greater than the mean magnitude for the departure-time band, explaining the considerably greater extent of departure-time switching observed in laboratory experiments as well as in actual commuter surveys.

The second type of mechanism is conditional upon the decision to switch. The departure-time for the next commute is set as $DT_{it+1} = PAT_i - ETR_{it}$, where DT_{it+1} denotes a predicted trip time for that commute, based on the user's cumulative and immediate past experience with the facility, as well as any external-supplied information. As such, this mechanism is intended to capture the learning taking place at the individual tripmaker level. Specifications have been developed and estimated for the latter, generally confirming the dominant role of the immediate past experience with the facility[80,81]. The route-selection model, given that the commuter intends to switch, may be given by a probabilistic-choice rule; because the experiments used to generate observations included only two routes, the conditional route-selection mechanism was trivial, and the behavioural processes governing route selection and the role of information in this process could not be fully investigated.

The resulting framework has been illustrated for various applications where the system's day-to-day evolution is of concern, such as following major changes in supply or in connection with major disruptions, e.g., planned reconstruction activities that involve capacity reductions over extended periods of time[82,83]. Joseph et al.[84] adapted the framework to evaluate alternative ramp-metering control strategies for freeways; instead of the usual assumption that the traffic pattern is invariant with respect to the control strategy, the effect of the control on user decisions was explicitly incorporated in the framework, allowing a more complete investigation of the relative desirability of alternative controls. In addition, three classes of users were defined on the basis of their behavioural-response rule: utility maximizers, boundedly-rational users, and those that comply fully with exogenously-supplied guidance intended to optimize system performance. The framework has also been used to investigate the fundamental dynamic properties of the commuting system, particularly with regard to system evolution, and the existence and characteristics of a boundedly-rational user equilibrium. An interesting result that has been established through both numerical simulation investigation and analytic derivation, and supported by the laboratory-like experiments with actual commuters described in the next subsection, pertains to the interrelation between the users indifference bands of tolerable schedule delay (governing departure-time and/or route switching), the overall demand and congestion levels in the system, and the evolution and dynamic properties of the latter.

In particular, as congestion increases in the system, increasingly large indifference bands are required in order for the system to reach a steady-state in which users are no longer making switching decisions. As such, congested systems appear to be characterized by greater day-to-day switching activity, and greater schedule delay.

Controlled, Laboratory Experiments

As noted previously, controlled, laboratory experiments provide a critical observational basis for the study of complex large-scale dynamic systems, providing a bridge between speculative or highly idealized theoretical development on one hand, and full-scale field studies, in which the desired degree of experimental control may not be practical, on the other. The kinds of insights that could be gained from such experiments and the extent of their applicability on a larger scale are discussed in Mahmassani and Herman[85]. Gaming and simulation approaches have been used to some degree in travel behaviour and activity-scheduling research, primarily with a small number of non-interacting participants (or interactions limited to members of an individual household), and providing mostly qualitative responses,[86,87,88]. The study of the day-to-day dynamics of user decisions in congested systems requires simultaneous quantitative measurements of individual-user decisions, along with the associated traffic-performance characteristics. Thus the experimental approach introduced by Mahmassani, Chang, and Herman[89] involves actual commuters interacting through a detailed computer simulation model of a typical traffic-commuting system, as briefly described below.

Given a description of the commuting context and of the rules at the workplace, both of which are specified to be similar to actual realistic conditions, the commuters independently supply decisions of departure-time and/or route to the work destination. These decisions form the time-varying input function to a traffic simulator that yields the corresponding arrival times and associated performance measures. Information on these consequences is subsequently provided to the participating commuters, who are asked for updated tripmaking decisions for the next day. The experiment is continued over a period of several weeks. By controlling the type and amount of information supplied to the participants, the researcher can study the effect of alternative information strategies on user behavior as well as the dynamic properties of the system. The data from the experiment include the sequence of decisions made by each participant, along with the stimuli (i.e., the complete time-series of system attributes) provided to them (consistently with traffic reality as represented by the simulator). As such, the data can be used to develop and calibrate the kinds of day-to-day switching and adjustment mechanisms incorporated in the above framework.

Following the above general approach, three experiments have been conducted and reported by Mahmassani and co-workers, all dealing with the morning home-to-work commute. The first two involved a single-route corridor, allowing users only a choice of departure-time. The two differed in the amount and type of information given to each commuter, with only limited information (on the commuter's own performance on the preceding day, i.e., arrival time) in one, and complete information (on the arrival times corresponding to the full spectrum of possible departure-time alternatives) in the other. All other aspects of the commuting system were identical for the two experiments, each of which involved about 100 commuters (no repeat participants). In the third experiment, two alternative routes were available, thereby adding the route-choice dimension to that of departure-time. Furthermore, the participating 200 commuters were separated into two information-availability groups: limited versus complete information. The details of the individual experiments, including the characteristics of the commuting corridors and facilities are described elsewhere[90,91].

A comparative analysis of the dynamic properties of the system under the three experiments is presented in Mahmassani and Herman[92]. A result worth noting is that, when all users received complete information, overall switching frequency was greater, reflecting higher user expectations and the system took longer to converge than under the limited-information experiment. However, in the third experiment, when users with complete information competed with limited-information users, the latter group exhibited greater switching activity. Thus, the effect of information on overall turbulence in the system and on the persistence of individual users in seeking satisfactory outcomes depends critically on the population fraction with access to such information, and, more generally, on the distribution of the type and extent of information across the population. This result has far-reaching implications for real-time information systems (ATIS), and has now been confirmed by several simulation studies. In the third experiment, when the additional route-choice dimension was available and the overall congestion level was greater, higher switching frequency was observed, and the system had not converged to a steady-state (after 36 days!), unlike the first two. Comparison of the respective equilibria attained in the first two experiments, in terms of the average travel time and average schedule delay experienced by users in each sector suggests that: 1) the two states are not identical (therefore, neither is unique), 2) the state attained may depend on the evolutionary path followed, and 3) the final state attained under complete information is superior, in terms of lower user costs, to that reached under limited information. The latter point underscores the trade off that might exist between the quality of the eventual equilibrium state on the one hand, and the costs incurred in the process of reaching this state on the other. This trade off is of particular concern in situations where the time needed to reach an equilibrium is not short relative to the time frame over which

this equilibrium can be expected to hold (before it is disrupted by exogenous factors); such situations arise in connection with planned disruptions due to reconstruction activities.

Several insights were obtained from the model-calibration results regarding the day-to-day dynamics of the indifference band and associated learning rules. In particular, 1) the band tends to increase in response to unsuccessful experiences (i.e., as evidenced by switching on the next day), reflecting a lowering of aspirations, whereas successful decisions have the reverse effect; 2) the impact of an unsuccessful experience is generally more drastic and tends to last longer than that of successful ones; and 3) users will tolerate greater schedule delay in order to accommodate larger fluctuations in travel time. These and similar insights from the various models are summarized elsewhere[93].

In summary, the controlled laboratory experiments have allowed considerable progress in the investigation of commuter-decision dynamics, both in terms of insights into overall system behaviour, as well as into the underlying individual behavioural processes. Furthermore, by providing an observational basis for behavioural-model development and calibration, they have produced very useful indications regarding model form and specification, as well as the relative importance of the various determinants of day to day commuting decisions. Of course, the next logical step is to establish the extent to which insights, data, and models obtained in such experiments are relevant to actual traffic systems and useful as a basis for planning and operations. This would require expanding the observational basis to include the behaviour of tripmakers in actual commuting systems. Recent developments in this regard are discussed next.

Surveys of Commuter Behaviour in Actual Systems

As discussed previously, traditional single-day travel surveys are not adequate for the study of the dynamic aspects of commuter behaviour. New survey approaches and instruments are required to capture these decisions at the desired level of detail. However, the associated system-performance attributes cannot be readily obtained from only demand-side surveys, and would require considerable expenditure of resources, typically not available for such activities. While the latter aspect may be solved as greater instrumentation and automation are deployed as part of IVHS, it remains a rather formidable task with the capabilities typically available at present.

Nevertheless, a considerable amount of information can be obtained about actual behaviour of commuters under relatively uncontrolled conditions. A survey diary approach has been developed for this purpose and initially tested using a sample of

commuters in Austin, Texas[94]. Commuters provided detailed information about times of departure and arrival, detailed link composition of the path followed, intermediate stops, and their characteristics (purpose, timing, and duration), for both a.m. and p.m. commutes, over a two-week period. A discussion of results pertaining to the variability of commuter decisions during the morning peak is included in a separate chapter in this volume, so is not repeated here[95]. A similar analysis has subsequently been performed for the evening commute, including a.m.-p.m. interactions in terms of commuting behaviour and associated activity scheduling[96,97]. The trip-chaining aspects of the commute, heretofore ignored in most travel-demand forecasting procedures, emerged as a major feature of commuter tripmaking and a key determinant of the day-to-day variability of trip-scheduling and path-selection decisions[98].

A similar but larger survey has been conducted in Dallas, Texas, for the same general purpose[99]. The results analyzed to date have confirmed the general patterns revealed in the Austin survey[100]. Comparisons between the two cities have revealed remarkable similarity between the general patterns observed, as well as the magnitude of several characteristics. The differences observed appear to be induced primarily by the relatively larger size of the Dallas area, its subsequently greater number of path opportunities in the network, the associated longer commutes, and greater and longer periods of congested operation. Thus, the estimated coefficients of variables capturing network characteristics, in models of the frequency of day-to-day switching of departure-time and route, exhibited significant differences between the two cities; on the other hand, the coefficients of variables reflecting socioeconomic and demographic attributes of the commuters were quite similar in the two cities. Several of the substantive insights were also consistent with the previous findings of Mannering and co-workers, based on recall-mode small cross-sectional surveys of commuters in Seattle, Washington,[101].

Perhaps the most encouraging findings from the survey results relate to the methodological issue of the pertinence of the results derived from the kind of labo-ratory experiments described in the previous subsection to those obtained from actual surveys. Of course, any comparisons performed to examine these issues on the basis of the results to date can only be considered as exploratory and suggestive, and far from definitive, as neither the experiments nor the surveys were designed explicitly for such methodological comparisons. In general, the laboratory experiments provided useful, reliable, and apparently robust insights into the dynamics of commuter trip scheduling and route choice. For example, the central role of the preferred arrival time as anchor for departure-time choices, and as an indicator of inherent commuter preferences and attitudes towards risk, was confirmed in both sources of data. Similarly, the critical role of schedule delay as a determinant of

commuter-choice dynamics and user response to congestion was established in both types of studies. The considerably greater extent of daily departure-time switching relative to route switching, initially observed in a laboratory experiment, was strongly confirmed in both the Austin and Dallas surveys. In fact, no general substantive behavioural insights from the experiments have been subsequently denied by the survey results, even though the latter were conducted in systems that exhibited considerably less day-to-day variation than the controlled experiments. Furthermore, the specifications of the dynamic indifference-band models, which govern the acceptability of departure-time and route choices, appeared to transfer remarkably well to the survey data. However, any such transfer has to be performed with considerable caution. In particular, the controlled experiments precluded the possibility of trip chaining along the commute, even though this phenomenon is a major feature of actual commuting behaviour; thus the conclusions from the experiments would have to be incorporated within a more complete framework that recognizes trip chaining.

Real-time Dynamics

Recent interest in information-based strategies, mostly under the IVHS umbrella, has contributed significantly to the awareness of the important role of user decisions and commuter responses in such strategies and led to an emerging body of investigations of commuter response to information[102,103,104,105,106]. ATIS aims to assist drivers in trip planning and destination selection, departure-time and route choices, congestion avoidance, and navigation, to improve the convenience and efficiency of travel,[107]. Various ATIS classes have been defined from Class 0 – static, open loop systems, – to Class 4 – dynamic, closed-loop systems enabling two-way communication between the vehicle and the traffic control center[108]. Due to limited real-world implementation of ATIS technologies, it has been impractical for researchers to evaluate how real-time information availability influences driver behavior.

Driver behavior and response to real-time traffic information systems is the result of a complex process involving human judgment, learning, and decision-making in a dynamic environment. The dynamic nature of traffic systems is such that a recommended path predicated on current link-trip times may turn out to be less than optimal as congestion in the system evolves. Hence, the accuracy of the information provided to participating drivers and the resulting reliability of this information as a basis for route-choice decisions are governed by the dynamic nature of the driver-decision environment and the presence of collective effects in the network as a result of the interactions of a large number of individual decisions[109]. Consequently, driver decisions on the acquisition of the information system and compliance with its instructions are influenced by the user perceptions of the reliability and usefulness of the system, formed mostly by learning through one's own experience with the system,

as well as reports by friends, colleagues, and popular media. This is a long-term process that depends on the type and nature of the information provided, in addition to the individual characteristics and preferences of the driver.

The ideal way to study this long-term process is through observations of actual driver decisions in real-world systems. However, as noted earlier, in the absence of sufficient deployment of the technologies of interest, it is difficult in practice to obtain real-world data on the actual behavior of drivers under different real-time information strategies, on a daily basis, together with the various performance measures affecting these responses. A set of controlled laboratory-like interactive experiments involving real commuters in a simulated traffic system is now underway, following earlier work on interactive experiments for the study of tripmaker-behaviour dynamics. Such experiments could play an important transitional role in gaining fundamental insights into behavioural phenomena that will play a key role in deter-mining the effectiveness of ATIS and ATMS strategies.

Several methodological approaches have been proposed for assessing the effec-tiveness of various possible forms of ATIS in reducing recurrent and non-recurrent traffic congestion and examining the interactions among key parameters, such as nature and amount of information displayed, market penetration, and congestion severity[110,111,112,113]. Furthermore, various human-factors studies have been carried out concerning the attentional-demand requirements of in-vehicle navigation devices and their effects on the safety of driver performance, using either a driving simulator or specially-adapted vehicles in real urban environments [114,115,116]. Mail-back surveys and telephone interviews on drivers willingness to divert en route in response to real-time traffic information and their preferences towards the different features of these systems have also been conducted [117,118,119,120].

Several computer-based interactive simulators have been developed in the past few years to study commuter behavior through laboratory experiments as an alternative and precursor to real-world applications. IGOR (Interactive Guidance on Routes) was developed by Bonsall et al. for investigating factors affecting drivers compliance with route-guidance advice, such as quality of advice and familiarity with the network[121]. Allen et al.[122] used an interactive simulator to study the impacts of different information systems on drivers' route diversion and alternative route selection. FASTCARS (Freeway and Arterial Street Traffic Conflict Arousal and Resolution Simulator), developed by Adler et al.[123], was used to predict en route driver behavior in response to real-time traffic condition information, based on conflict-assessment and resolution theories. A simulator has also been under development at M.I.T.[124] All these simulators are deterministic, with all traffic conditions and consequences of driver

actions predetermined, and no consideration of network-wide traffic characteristics. These simulators can only interact with one subject at any given time, ignoring interactions among drivers in the same traffic system. Bonsall et al.'s simulator provides different preset levels of information quality to the experimental subject in a preset sequence. In addition, the effect of the driver's responses to the information on the traffic system is not considered. Both Allen et al. and Adler et al.'s simulators assume the information supplied to be perfect and static, which is not representative of actual real-time ATIS environments.

A new simulator has been developed at the University of Texas at Austin[125], that offers the capability for real-time interaction with and among multiple driver participants in a traffic network under ATIS strategies. The simulator allows several tripmakers to drive through the network, interacting with other drivers and contributing to system evolution. It considers both system performance, as influenced by driver response to real-time traffic information, and driver behavior, as influenced by real-time traffic information based on system performance. The simulators reviewed earlier are primarily computer-based devices for the display of predetermined stimuli and elicitation and collection of the participants responses. The simulator described here actually simulates traffic. Its engine is a traffic-flow simulator and ATIS information generator, that displays information consistent with the processes actually taking place in the (simulated) traffic system under the particular information-supply strategy of interest. The decisions made by the driver participants are fed directly to the simulator and, as such, influence the traffic system itself and the subsequent stream of information stimuli provided to the participants.

In addition to studying user response to ATIS information for a particular commute on a given day, the simulator allows the investigation of the day-to-day evolution of individual decisions under such information strategies. This longer-term dimension is missing from most available studies of the effectiveness of real-time information systems. Our experiments consider system evolution and possible equilibration by including the participants and the performance simulator in a loop, whereby trip-makers may revise their decisions from one iteration day to the next. These experiments are intended to investigate both the real-time and day-to-day dynamic properties of traffic networks under alternative information strategies, particularly issues of convergence to an equilibrium, stability, and benefits following shifts in user trip-timing decisions.

CONCLUSIONS

The above tour of recent work on the dynamics of commuter behaviour has highlighted the wealth of opportunities that remain for both substantive and methodological contributions to this important aspect of travel behaviour. All three research streams reviewed in this chapter continue to be active and fertile areas of investigation, increasingly driven by the realization that a fundamental understanding of commuter behaviour holds the key to some of the most pressing challenges faced by urban transportation planners and policy-makers. Several of these concerns were listed in the first section.

Particular areas of opportunity for future work include:

- Developing theoretical constructs for representing commuter behaviour, especially with regard to (i) integrating trip chaining/activity participation and scheduling with departure time and route choice, and (ii) capturing day-to-day learning and travel-time prediction processes of commuters in response to actual experience and exogenous information.

- Integrating user decisions in the context of traffic flow models, at the network level, thereby incorporating commuter decisions firmly in network- flow assignment and modeling processes.

- Developing novel measurement techniques that yield the desired level of temporal and spatial richness, for a large number of users. In addition to advances in longiudinal survey techniques, and the growing acceptance of laboratory-like eperiments, it is particularly fascinating to consider the potential of emerging recording and communications technologies. These may contribute to travel-behaviour research to the same extent that the scanner data at supermarkets and passive electronic home-based devices have revolutionized consumer-buying behaviour and entertainment - viewing behaviour, respectively.

- Developing econometric and psychometric-modeling frameworks that recognize the complex nature of the dynamic processes of interest, and the resulting challenges for analyzing data generated from observation of these processes.

- Developing demand-forecasting frameworks that recognize (i) the temporal evolution of transportation systems, rather than focusing on some future final state with limited likelihood of occurrence, (ii) the existence of significant daily fluctuations even as systems might be considered at equillibrium, and (iii) trip chains as the meaningful unit of trip making analysis.

It is notable that most of the body of research accumulated in this area over the past decade has been generated primarily on very limited research budgets, fueled by the researchers' own interests and conviction of the significance of the topic. As such, innovative measurement techniques have been devised, and only relatively small samples have been obtained in a limited number of geographic areas. In this regard, commuter- behaviour research has been different from earlier phases of mainstream travel-demand analysis studies, for which large-scale home interview surveys were routinely available. However, it is expected that growing awareness of the significance of this topic to major policy questions, and the accomplishments to date, will bring about the kind of concerted effort necessary to develop more definitive understanding of commuter-behaviour dynamics as well as operational predictive models to support planning and policy decisions.

REFERENCES

1. Stopher, P. R., "Measurement, Models and Methods: Recent Applications", *Understanding Travel Behaviour in an Era of Change*, Pergamon Press, Oxford, 1994.

2. Lee-Gosselin, M. E. H., and E. I. Pas, "The Implications of Emerging Contexts for Travel Behaviour Research", *Understanding Travel Behaviour in an Era of Change*, Pergamon Press, Oxford, 1994.

3. Cervero, R., *Suburban Gridlock*, 1986.

4. Lindley. J., "Urban Freeway Congestion and Solutions: An Update", *ITE Journal* 59, No. 12, 1989, pp. 21-23.

5. Goodwin, P. B., "Understanding Congestion", *Recherche-Transports-Sécurité*, INRETS, Vol. 5, June 1990, pp. 75-80.

6. Joseph, T., H. S. Mahmassani, and R.-C. Jou, *Dynamic Framework for the Analysis of User Responses to Traffic System Disruptions and Control Actions*, Research Report 1216-2F, Center for Transportation Research, The University of Texas at Austin, 1992.

7. Vickrey, W. S., "Congestion Theory and Transport Investment", *American Economic Review Papers and Proceedings*, Vol. 59, 1969, pp. 251-260.

8. Button, K. J., and A. D. Pearman, "Road Pricing - Some of the More Neglected Theoretical and Policy Implications", *Transportation Planning and Technology*, Vol. 8, 1983, pp. 15 - 28.

9. IVHS America, *Strategic Plan for Intelligent Vehicle-Highway Systems*, Washington, D.C., 1992.

10. Mahmassani, H. S., S. G. Hatcher, and C. Caplice, "Daily Variation of Trip Chaining, Scheduling and Path Selection Behavior of Work Commuters", *Understanding Travel Behaviour in an Era of Change*, Pergamon Press, Oxford, 1994.

11. Kitamura, R., "An Evaluation of Activity-Based Travel Analysis", *Transportation*, Vol. 15, 1988, pp. 9-34.

12. Jones, P., F. Koppelman, and J-L Orfeuil, "Activity Analysis: State-of-the-Art and Future Directions", Chapter 2 in Jones, P. (ed.), *Developments in Dynamic and Activity-Based Approaches to Travel Analysis* , Avebury, Aldershot, 1990.

13. Hamed, M., and F. L. Mannering, "Modeling Travelers' Post-Work Activity Involvement: Toward A New Methodology", 70th Annual Meeting of the Transportation Research Board, Washington, D.C., 1991.

14. Mannering, F. L., and M. Hamed, "Occurrence, Frequency, and Duration of Commuters' Work-to-Home Departure Delay", *Transportation Research*, Vol. 24B, 1990.

15. Cascetta, E., G. E. Cantarella, and M. DiGangi, "Evaluation of Control Strategies Through a Doubly Dynamic Assignment Model", *Transportation Research Record* 1306, 1991, pp. 1-13.

16. Herman, R., and T. Lam, "Trip Time Characteristics of Journeys to and from Work", *Proceedings of the Sixth International Symposium on Traffic and Transportation Theory*, Elsevier, Amsterdam, 1974.

17. Hendrickson, C., D. Nagin, and E. Plank, "Characteristics of Travel Time and Dynamic User Equilibrium for Travel to Work", *Proceedings of the Eighth International Symposium on Traffic and Transportation Theory*, University of Toronto Press, Toronto, 1983.

18. Mahmassani, H. S., and R. Herman, "Interaction of Trip Decisions and Traffic System Dynamics", *European Journal of Operational Research* Vol. 30, 1987, pp. 304-317.

19. Chang, G-L., and H. S. Mahmassani, "The Dynamics of Commuting Decision Behaviour in Urban Transportation Networks", *Travel Behaviour Research*, IATB, Avebury, Aldershot, 1989, pp. 15-26.

20. Mahmassani, H. S., and R. Jayakrishnan, "Dynamic Analysis of Lane Closure Strategies", *ASCE Journal of Transportation Engineering,* Vol. 114, 1988, pp. 476-496.

21. Mahmassani, H. S., "Dynamic Models of Commuter Behavior: Experimental Investigation and Application to the Analysis of Planned Traffic Disruptions", *Transportation Research*, Vol. 22A, 1990, pp. 465-484.

22. Joseph, T., H. S. Mahmassani, and R-C. Jou, *op. cit.*

23. Goodwin, P., R. Kitamura, and H. Meurs, "Some Principles of Dynamic Analysis of Travel Behaviour", Chapter 3 in Jones, P. (ed.) *Developments in Dynamic and Activity-Based Approaches to Travel Analysis*, Avebury, Aldershot 1990.

24. Devarajan, S., "A Note on Network Equilibrium and Noncooperative Games", *Transportation Research*, Vol. 15B, 1981, pp. 421-426.

25. Fisk, C. S., "Game Theory and Transportation Systems Modelling", *Transportation Research*, Vol. 18B, 1984, pp. 301-314.

26. Mahmassani, H. S., and R. Herman, "Interaction of Trip Decisions and Traffic System Dynamics", *op. cit.*

27. Simon, H., "A Behavioral Model of Rational Choice", *Quarterly Journal of Economics*, Vol. 69, 1955, pp. 99-118.

28. Mahmassani, H. S., and G. L. Chang, "On Boundedly-Rational User Equilibrium in Transportation Systems", *Transportation Science*, Vol. 21, 1987, pp. 89-99.

29. Mahmassani, H. S., G-L. Chang and R. Herman, "Individual Decisions and Collective Effects in a Simulated Traffic System", *Transportation Science*, Vol. 20, 1986, pp. 258-271.

30. Mahmassani, H. S., and R. Herman, "Interactive Experiments for the Study of Tripmaker Behaviour Dynamics in Congested Commuting Systems", Chapter 13 in Jones, P. (ed.), *Developments in Dynamic and Activity-Based Approaches*

to Travel Analysis , Avebury, Aldershot, 1990.

31. Mahmassani, H. S., and G-L Chang, *op. cit.*

32. Mahmassani, H. S., *op. cit.*

33. Mahmassani, H. S., S. G. Hatcher, and C. Caplice, *op.cit.*

34. Hanson, S., and J. O. Huff, "Systematic Variability in Repetitious Travel", *Transportation*, Vol. 15, 1988, pp. 111-135.

35. Huff, J., and S. Hanson, "Measurement of Habitual Behaviour: Examining Systematic Variability in Repetitive Travel, Chapter 11 in Jones, P. (ed.), *Developments in Dynamic and Activity-Based Approaches to Travel Analysis,* Avebury, Aldershot, 1990.

36. Pas, E. I., and F. S. Koppelman, "An Examination of the Determinants of Day-to-Day Variability in Individuals' Urban Travel Behavior", *Transportation*, Vol. 13, 1986, pp. 183-200.

37. Horowitz, J. L., "Travel Demand Analysis: State of the Art and Research Opportunities", *Transportation Research*, Vol. 19A, 1985, pp. 441-453.

38. Jones, P., and J. Polak, "Using Stated Preference Techniques to Examine Traveller Preferences and responses", *Understanding Travel Behaviour in an Era of Change*, Pergamon Press, 1994.

39. Mahmassani, H. S., and R. Herman, *op.cit.*

40. van Knippenberg, C., "Recommendations: Potential Policy Applications", Chapter 22 in Jones, P. (ed.), *Developments in Dynamic and Activity-Based Approaches to Travel Analysis* , Avebury, Aldershot, 1990.

41. Adler, J. L., W. W. Recker, and M. G. McNally, "In-Laboratory Experiments to Analyze Enroute Driver Behavior under ATIS", 72nd Annual Meeting of the Transportation Research Board and forthcoming in *Transportation Research Record*, 1993.

42. Chen, P. S., and H. S. Mahmassani, "Dynamic Interactive Simulator for the Study of Commuter Behavior Under Real-time Traffic Information Supply Strategies", 72nd Annual Meeting of the Transportation Research Board and forthcoming in *Transportation Research Record*, 1993.

43. Koutsopoulos, H. N., T. Lotan and Q. Yang, "Driving Simulator and its Application for Modeling Route Choice in the Presence of Information", 72nd

Annual Meeting of the Transportation Research Board and forthcoming in *Transportation Research Record*, 1993.

44. Stopher, P. R., *op. cit.*

45. Kitamura, R., "Panel Analysis in Transportation Planning: An Overview", *Transportation Research*, Vol. 24A, 1990, pp. 401-416.

46. Mahmassani, H. S., T. Joseph. and R-C Jou, "Survey Approach for the Study of Commuter Choice Dynamics", 72nd Annual Meeting of the Transportation Research Board and forthcoming in *Transportation Research Record*, 1993.

47. Small, K. A., *Urban Transportation Economics*, Harwood, 1992.

48. Mahmassani, H. S., and G-L. Chang, "Experiments With Departure Time Choice Dynamics of Urban Commuters", *Transportation Research,* Vol. 20B, 1986, pp. 297-320.

49. Cosslett, S., "The Trip Timing Decision for Travel to work by Automobile", *Demand Model Estimation and Validation*, the Urban Travel Demand Forecasting Project Phase I Final Report, Vol. V, Institute for Transportation Studies, University of California, Berkeley, 1977.

50. Abkowitz, M., "Understanding the Effect of Service Reliability on Work Travel Behavior", *Transportation Research Record* 794, 1981, pp. 33-41.

51. Small, K. A., "The Scheduling of Consumer Activities: Work Trips", *American Economic Review*, Vol. 72, 1982, pp. 467-479.

52. McCafferty, D., and F. L. Hall, "The Use of Multinomial Logit Analysis to Model the Choice of Time to Travel", *Economic Geography ,* Vol. 58, 1982.

53. Hendrickson, C., and E. Plank, "The Flexibility of Departure Times for Work Trips", *Transportation Research*, Vol. 18A, 1984, pp. 25-36.

54. Tong, C-C., "Information Availability and Departure-time Decision Dynamics", MS Thesis, Department of Civil Engineering, The University of Texas at Austin, 1987.

55. Tong, C-C., "A Study of Dynamic Departure-time and Route Choice Behavior of Urban Commuters", *op. cit.*

56. de Palma, A., M. Ben-Akiva, C. Lefevre and N. Litinas, "Stochastic Equilibrium Model of Peak-period Traffic Congestion", *Transportation Science*, Vol. 17, 1983, pp. 430-453.

57. Tong, C-C., *op. cit.*

58. Mannering, F. L., S. A. Abu-Eisheh and A. T. Arnadottir, "Dynamic Traffic Equilibrium with Discrete/Continuous Econometric Models", *Transportation Science*, Vol. 24, 1990, pp. 105-116.

59. Vickrey, W., "Congestion Theory and Transport Investment", *American Economic Review*, Vol. 59, 1969, pp. 251-260.

60. Hendrickson, C., and G. Kocur, "Schedule Delay and Departure-time Decisions in a Deterministic Model", *Transportation Science*, Vol. 15, 1981, pp. 62-77.

61. de Palma, A., M. Ben-Akiva, C. Lefevre, and N. Litinas, *op. cit.*

62. Ben-Akiva, M., A. de Palma, and P. Kanaroglou, "Effects of Capacity Constraints on Peak-Period Traffic Congestion", *Transportation Research Record* 1085, 1986, pp. 16-26.

63. Chang, G-L., H. S. Mahmassani and R. Herman, "A Macroparticle Traffic Simulation Model to Investigate Peak-Period Commuter Decision Dynamics", *Transportation Research Record* 1005, 1985, pp. 107-120.

64. Mannering, F. L., S. A. Abu-Eisheh, and A. T. Arnadottir, *op. cit.*

65. Mahmassani, H. S., S. Peeta, G-L. Chang, and T. Junchaya, "A Review of Dynamic Assignment and Traffic Simulation Models for ATIS/ATMS Applications", *Technical Report DTFH61-90-R-00074-1*, Center for Transportation Research, The University of Texas at Austin, 1992.

66. van Knippenberg, C., *Time in Travel*, doctoral thesis, Rijksuniversiteit te Groningen, 1987.

67. Newell, G. F., "The Morning Commute for Nonidentical Travelers", *Transportation Science*, Vol. 21, 1987, pp.74-88.

68. Arnott, R., A. dePalma, and R. Lindsey, "Schedule Delay and Departure-time Choice of Heterogeneous Commuters", *Transportation Research Record* 1197, 1988, pp. 56-67.

69. Arnott, R., A. dePalma and R. Lindsey, "Economics of a Bottleneck", *Journal of Urban Economics*, Vol. 27, 1990, pp. 111-130.

70. Small, K. A., *op. cit.*

71. Small, K. A., "Trip Scheduling in Urban Transportation Analysis", *AEA Papers and Proceedings*, Vol. 82, 1992, pp. 482-486.

72. Goulias, K., and R. Kitamura, "Travel Demand Forecasting with Dynamic Microsimulation", *Transportation Research Record* 1357, 1992, pp. 8-17.

73. Beckman, M., C. McGuire, and C. Winsten, *Studies in the Economics of Transportation*, Yale University Press, New Haven, CT., 1956.

74. Alfa, A. S., and D. Minh, "A Stochastic Model for the Temporal Distribution of Traffic Demand - The Peak Hour Problem", *Transportation Science*, Vol. 13, 1979, pp. 315-324.

75. Horowitz, J. L., "The Stability of Stochastic Equilibrium in a Two-Link Transportation Network", *Transportation Research*, Vol. 18B, 1984, pp. 13-28.

76. Mahmassani, H. S., and G-L. Chang, *op. cit.*

77. Mahmassani, H. S., *op. cit.*

78. Mahmassani, H. S., and G-L. Chang, "Dynamic Aspects of Departure-Time Choice Behavior in a Commuting System: Theoretical Framework and Experimental Analysis", *Transportation Research Record* 1037, 1985, pp. 88-101.

79. Mahmassani, H. S., *op. cit.*

80. Chang, G-L., and H. S. Mahmassani, "Travel Time Prediction and Departure-Time Adjustment Behavior Dynamics in a Congested Traffic System", *Transportation Research,* Vol. 22B, 1988, pp. 217-232.

81. Tong, C-C., H. S. Mahmassani, and G-L. Chang, "Travel Time Prediction and Information Availability in Commuter Behavior Dynamics", *Transportation Research Record* 1138, 1987, pp. 1-7.

82. Mahmassani, H. S., and R. Jayakrishnan, *op. cit.*

83. Joseph, T., H. S. Mahmassani, and R-C. Jou, *op. cit.*

84. Joseph, T., H. S. Mahmassani, and R-C Jou, *op. cit.*

85. Mahmassani, H. S., and R. Herman, *op. cit.*

86. Brog, W., and E. Erl, "Interactive Measurement Methods - Theoretical Bases and Practical Applications", 59th Annual Meeting of the Transportation Research Board, Washington, D.C., 1980.

87. Jones, P. M., "Interactive Travel Survey Methods: the State-of-the-art", in Ampt, E.S., Richardson, A.J. and Brog, W. (eds.), *New Survey Methods in Transport*, VNU Science Press, Utrecht, 1985.

88. Lee-Gosselin, M. E. H., "The Dynamics of Car Use Patterns Under Different Scenarios: A Gaming Approach", Chapter 12 in Jones, P. (ed.), *Developments in Dynamic and Activity-Based Approaches to Travel Analysis*, Avebury, Aldershot, 1990.

89. Mahmassani, H. S., G-L Chang and R. Herman, "Individual Decisions and Collective Effects in a Simulated Traffic System, *op. cit.*

90. Mahmassani, H. S., and C-C. Tong, "Availability of Information and Dynamics of Departure-time Choice: Experimental Investigation", *Transportation Research Record* 1085, 1986, pp. 33-47.

91. Mahmassani, H. S., and D. G. Stephan, *op. cit.*

92. Mahmassani, H. S., and R. Herman, *op. cit.*

93. Mahmassani, H. S., *op. cit.*

94. Caplice, C., "Analysis of Urban Commuting Behavior: Switching Propensity, Use of Information, and Preferred Arrival Time", Master's Thesis, the University of Texas at Austin, 1990.

95. Mahmassani, H. S., S. G. Hatcher, and C. Caplice, "Daily Variation of Trip Chaining, Scheduling and Path Selection Behavior of Work Commuters", *Understanding Travel Behaviour in an Era of Change*, Pergamon Press, Oxford, 1994.

96. Hatcher, S. G., and H. S. Mahmassani, "Daily Variability of Route and Trip Scheduling Decisions for the Evening Commute", *Transportation Research Record* 1357, 1992, pp. 72-81.

97. Mahmassani, H. S., and S. G. Hatcher, "Day-to-Day Variability of Commuter Behavior: Analysis of Path Selection, Trip Timing and Trip Chaining Using Two-Week Trip Diaries", Presented at the World Conference on Transportation Research, Lyon, France, 1992.

98. Hatcher, S. G., *Daily Variation of Trip Chaining, Departure-time, and Route Selection of Urban Commuters*, Master's thesis, The University of Texas at Austin, 1991.

99. Mahmassani, H. S., T. Joseph, and R-C. Jou, *op. cit.*

100. Jou, R-C., H. S. Mahmassani, and T. Joseph, *Daily Variability of Commuter Decisions: Dallas Survey Results*, Technical Report 1216-1, Center for Transportation Research, The University of Texas at Austin, 1992.

101. Mannering, F. L., and M. Hamed, "Occurrence, Frequency, and Duration of Commuters' Work-to-Home Departure Delay", *Transportation Research*, Vol. 24B, 1990.

102. Khattak, A. J., F. S. Koppelman, and J. L. Schofer, "Stated Preferences for Investigation Commuters' Diversion Propensity", Presented at the 71st Annual Meeting of the Transportation Research Board. Washington, D. C., 1992.

103. Chen, P. S., and H. S. Mahmassani, "Reliability of Real-Time Information Systems for Route Choice Decisions in a Congested Traffic Network: Some Simulation Experiments", *Proceedings of Vehicle Navigation and Information Systems Conference*, Vol. 2, Society of Automotive Engineers, Inc., Dearborn, Michigan, 849-856, 1991.

104. Koutsopoulos, H. N., and T. Lotan, "Motorist Information Systems and Recurrent Traffic Congestion: A Sensitivity Analysis of Expected Benefits", *Transportation Research Record*, 1281, 148-159, 1990.

105. Bonsall, P. W., and T. Parry, "Using an Interactive Route-Choice Simulator to Investigate Drivers' Compliance with Route Guidance Advice", *Transportation Research Record* 1306, 59-68, 1991.

106. Adler, J. W., W. W. Recker, and M. G. Mcnally, "A Conflict Model and Interactive Simulator (FASTCARS)", Presented at the 71st Annual Meeting of the Transportation Research Board, Washington, D. C., 1992.

107. Rillings, J. H., and R. J. Betsold, "Advanced Driver Information Systems", *IEEE Transactions on Vehicular Technology*, Vol. 40, No. 1, 1991, pp. 31-40.

108. OECD, *Route Guidance and In-Car Communication Systems*, Road Transport Research, Paris, France, 1988.

109. Chen, P. S., and H. S. Mahmassani, *op. cit.*

110. Mahmassani, H. S., and R. Jayakrishnan, "System Performance and User Response under Real-Time Information in a Congested Traffic Corridor", *Transportation Research,* Vol. 25 A, No. 5, 1991, pp. 293-307.

111. Mahmassani, H. S., and P. S. Chen, "Comparative Assessment of Origin-Based and En-Route Real-Time Information under Alternative User Behavior Rules",

Transportation Research Record 1306, 1991, pp. 69-81.

112. Tsuji, T., H. Kawashima, and Y. Yamamoto, "A Stochastic Approach for Estimating the Effectiveness of a Route Guidance System and Its Related Parameters", *Transportation Science,* Vol. 19, No. 4, 1985, pp. 333-351.

113. Koutsopoulos, H. N., and T. Lotan, *op. cit.*

114. Dingus, T. A., J. F. Antin, M. C. Hulse, and W. W. Wierwille, "Attentional Demand Requirements of an Automobile Moving-Map Navigation System", *Transportation Research A,* Vol. 23A, No. 4, 1989, pp. 301-315.

115. Parkes, A. M., M. C. Ashby, and S. H. Fairclough, "The Effects of Different In-Vehicle Route Information Displays on Driver Behavior", *Proceedings of Vehicle Navigation & Information Systems Conference, Vol. 1,* Society of Automotive Engineers, Inc., Dearborn, Michigan, 1991, pp. 61-70.

116. Walker, J., E. Alicandri, C. Sedney, and K. Roberts, "In-Vehicle Navigation Devices: Effects on the Safety of Driver Performance", *Proceedings of Vehicle Navigation & Information Systems Conference, Vol. 1,* Society of Automotive Engineers, Inc., Dearborn, Michigan, 1990, pp. 499-525.

117. Shirazi, E., S. Anderson, and J. Stesney, "Commuters' Attitudes Toward Traffic Information Systems and Route Diversion", Presented at the 67th Annual Meeting of the Transportation Research Board, Washington, D.C., 1988.

118. Haselkorn, M., J. Spyridakis, and W. Barfield, "Surveying Commuters to Obtain Functional Requirements for the Design of a Graphic-Based Traffic Information System", *Proceedings of Vehicle Navigation & Information Systems Conference, Vol. 2,* Society of Automotive Engineers, Inc., Dearborn, Michigan, 1991, pp. 1041-1044.

119. Khattak, A. J., J. L. Schofer, and F. S. Koppelman, "Factors Influencing Commuters' Enroute Diversion Behavior in Response to Delay", Presented at the 70th Annual Meeting of the Transportation Research Board, Washington, D.C., 1991.

120. Khattak, A. J., F. S. Koppelman, and J. L. Schofer, *op. cit.*

121. Bonsall, P. W., and T. Parry, *op. cit.*

122. Allen, R. W., A. C. Stein, T. J. Rosenthal, D. Ziedman, J. F. Torres, and A. Halati, "Human Factors Simulation Investigation of Driver Route Diversion and Alternative Route Selection Using In-Vehicle Navigation Systems" *Proceedings*

of Vehicle Navigation & Information Systems Conference, Vol. 1, Society of Automotive Engineers, Inc., Dearborn, Michigan, 1991, pp. 9-26.

123. Adler, J. L., W. W. Recker, and M. G. Mcnally, "A Conflict Model and Interactive Simulator (FASTCARS)", Presented at the 71st Annual Meeting of the Transportation Research Board, Washington, D. C., 1992.

124. Koutsopoulos, H. N., T. Lotan, and Q. Yang, "Driving Simulator and its Application for Modeling Route Choice in the Presence of Information", 72nd Annual Meeting of the Transportation Research Board and forthcoming in *Transportation Research Record,* 1993.

125. Chen, P. S., and H. S. Mahmassani, "Dynamic Interactive Simulator for the Study of Commuter Behavior under Real-time Traffic Information Supply Strategies", 72nd Annual Meeting of the Transportation Research Board and forthcoming in *Transportation Research Record,* 1993.

13

TIME USE RESEARCH AND TRAVEL DEMAND ANALYSIS AND MODELLING

Eric I. Pas and Andrew S. Harvey

ABSTRACT

The field of time-use research has potentially much to offer travel-demand analysis and modelling, especially from the perspective of the activity-based approach to travel demand. This paper reviews time-use research and examines the implications of this work for travel-demand analysis and modelling. The discussion includes conceptual and methodological developments as well as empirical findings. The paper concludes that mutual benefits would accrue from greater interaction between these related fields of research. In particular, travel-demand researchers should find considerable value in the time-use research developments in data collection and in the empirical knowledge in the time-use literature concerning activity participation, especially trends in activity participation over time and among societies. On the other hand, some modelling efforts undertaken by travel-demand researchers, especially models of activity participation and scheduling, should be of considerable interest and value to time-use researchers.

INTRODUCTION

Most first year graduate students of traveller behaviour can trace the idea that travel is a derived demand back to the classic book "An Analysis of Urban Travel Demands" that was published 30 years ago by Oi and Shuldiner[1]. Nevertheless, the original paradigm of travel behaviour, and the one that underlies most existing models of travel demand, pays only lip service to the notion that travel is a derived demand by distinguishing between trips made for different purposes. Recent work, however, in what has become known as the activity-based approach to travel-demand analysis, examines travel in the context of the activities that generate the demand for travel.

Using this approach, one begins to see travel from a very different perspective. Most importantly, one begins to see time as more than one element of the "cost" of making a trip (in the sense of travel time). For example, the question of the scheduling of travel becomes important; not only peak versus off-peak travel, but the actual timing of a trip and the sequence in which the daily activities, that generate the demand for travel, are undertaken. This point is discussed further in the second section of this chapter.

Over the past 50 years or so, social scientists (primarily sociologists and economists) have developed a sub-field of enquiry that historically was termed "time-budget" research but that is now more appropriately known as "time-use" research. As the name implies, workers in this field are concerned with how people use their time; that is, the allocation of time to the various activities in which people engage daily. Thus, an *a priori* argument can be made that time use researchers and travel-demand analysts should have a great deal in common, particularly when travel is properly viewed as a demand that is derived from activity participation.

The objective of this paper is to examine the field of time-use research and to identify what can be learned about travel behaviour and travel-demand analysis from time-use research. The remainder of this chapter is organized in an attempt to meet this objective as follows. In the second section, we review briefly the development of travel demand analysis with a focus on the conceptualization of time in travel-demand research. The third section provides a brief overview of the development of time-use research. In the fourth section, we discuss the lessons about travel behaviour and the modelling and analysis of travel behaviour that can be learned from time-use research; while the final section provides some ideas for future collabouration between researchers in these two fields and draws some conclusions.

A Perspective on Travel Demand Modelling and Analysis: the Conceptualization of Time

In an earlier paper, Pas[2] argues that travel-demand analysis and modelling is a relatively new field that has undergone considerable development in its short life. Most of the development in this field (as we would expect) has been what Kuhn[3] terms "normal science". One can however, Pas argues, identify one paradigm-shift (or revolution) in travel-demand analysis and modelling.

The original paradigm in travel-demand modelling viewed daily travel in terms of a set of separate trips, where each trip is a movement between an origin and a destination, for a particular purpose, by a particular mode, along a particular route. That is, under

this paradigm each trip is considered as an entity in itself and is characterized by its purpose, origin, destination, mode, and route. This, as we shall see below, represents a considerable simplification of an extremely complex phenomenon, although it is still the basis of the vast majority of travel-demand forecasting models used in practice. In particular, this view of travel does not deal adequately with the derived demand nature of daily travel, nor does it deal well with the interdependencies between trips and between people that are inherent in travel choices that people make. As a result, constraints on travel behaviour tend to be ignored in the traditional trip-based framework, while the elements of choice that are involved in travel behaviour are emphasized in this paradigm.

The important point to note here is that the developments in travel-demand modelling over the first 20 years or so (mid-1950s to mid-1970s) can be considered as modifications of the details in the application of the original trip-based framework. For example, the development of disaggregate travel-choice models, that began in the late 1960s[4,5,6,7], did not really change the conceptualization of travel although it does represent a major change in the way travel (as a set of elemental trips) is modelled. That is, while the development of disaggregate models changed the unit of analysis (from the zone to the individual or household) and it was based on an explicit theory of travel behaviour, the basic conceptualization of travel as a set of elemental trips did not change. Similarly, the application of psychometric-scaling techniques to quantify multidimensional attributes such as comfort, convenience and reliability[8,9,10,11], or to measure other preference and choice-related constructs such as affect[12], did not represent a change in the paradigm under which travel was analyzed.

The first, and only, revolutionary shift in the framework under which travel is analyzed came about in the mid-1970s. The origins of what has become known as the activity-based approach to travel-demand analysis can be traced to pioneering work conducted at the Transport Studies Unit at Oxford University[13]. Spurred in part by Hagerstrand's[14] time-space geographic framework, this view of daily travel recognizes the complexity of the phenomenon. The activity-based approach to travel demand analysis spans a variety of theoretical and methodological approaches, but several themes recur in this body of work. Pas[15] has characterized these themes as follows:

1. analysis of the demand for activity participation (and the analysis of travel as a derived demand),
2. the scheduling of activities in time and space,
3. the constraints (spatio-temporal and interpersonal) on activity and travel choice,

4. the interactions between activity and travel decisions over the course of a day (or longer time period), as well as the interactions between different persons, and

5. the structure of the household and the roles played by the various household members.

A major difference between the activity-based approach to travel demand analysis and that of the original, trip-based paradigm of travel demand is the way in which time is conceptualized and treated in these two frameworks. While the trip-based approach employs a narrow view of time, the activity-based approach focuses considerable attention on issues surrounding time, not only time use directly, but also the important related questions of the scheduling and sequencing of activities (and the associated travel).

In the trip-based framework, time is considered in terms of travel time (the amount of time expended to move from one location to another), with the reasonable assumption that travellers prefer to reduce (if not minimize) travel time. In this context, time is considered as a characteristic of alternative destinations, modes, and routes. Thus, a given destination is considered more or less attractive on the basis of how long it takes to access that destination from a given origin when compared with alternative destinations, and similarly for alternative modes and routes of travel. In this paradigm, issues of scheduling and sequencing of trips are essentially ignored, except that peak-period travel is generally differentiated from non-peak-period travel.

In the activity-based approach, on the other hand, time is a central component of the framework, and not just in terms of travel time. The identification of the temporal constraints, within which travel choices are made, is an important contribution of the activity-based approach to the understanding of traveller behaviour. In the activity-based approach, the time allocated to various activities is considered, not just whether the activity was engaged in or not. That is, the intensity of activity participation (as measured by duration) is recognized, not just the frequency of participation.

Similarly, time is treated as a continuum in much the same way as space in the activity-based approach. In pictorial representations of Hagerstrand's[16] time-geographic framework, space and time are integrated with time considered as the third dimension with the other two dimensions describing the horizontal plane of movement. This aspect of the activity-based approach leads to the consideration of the scheduling and sequencing of activities (and the related travel). Thus, we are not only concerned with whether a trip to the grocery store is made during the off-peak period, but whether it is made on the way from home to work, on the way from work to home,

or is made either as a "stand-alone" trip or together with other activities at some other time of the day.

Given that the activity-based approach to travel-demand analysis deals explicitly with activity participation, and thus the time allocated to various activities, as well as the scheduling and sequencing of activities in time and space, a *prima facie* case can be made for the desirability of learning from other disciplines that are concerned with related problems of human behaviour. One such area of enquiry generally ignored by travel-demand analysts is the field of time-use research. The following section of this chapter provides a brief review of the work in this field, with an emphasis on the travel-related aspects of that work.

TIME USE RESEARCH

With roots in family-budget studies originating in the mid-1800s, time-budget studies are a product of this century. The first study emerging in the literature with a specific focus on travel is Kate Liepmann's[17] investigation of the time consumed in commuting. Studies by von Rosenbladt[18], Chapin[19], and Elliott, Harvey and Procos[20], are especially significant from a travel-analysis perspective, because they are time-space studies, collecting both temporal and spatial coordinates of activities.

The most pervasive undertaking is the Multinational Comparative Time Budget Project emanating from an international conference in 1963[21]. That project aimed to systematically study and compare daily activities in different countries, to develop methods of collecting and evaluating time-budget data, and to promote cooperation, standardization of research techniques, and the exchange of quantitative data at an international level. The project, under the direction of Dr. Alexander Szalai, resulted in the collection of nearly 28,000 diaries on which were recorded nearly 700,000 activities.

The cooperation that started with the Multinational Time Use Project has been ongoing in terms of both collection and analysis. Cooperative data collection is evidenced in the recent collabouration between researchers in the United States of America and the former Soviet Union[22], as well as in the work of Andorka, Harcsa, and Niemi[23] and Harvey and Grönmo[24].

Since the mid-1960s, time-use data collection has steadily gained favor with government statistical bureaus in Europe. In Eastern Europe and the former Soviet Union, there have been countless studies over the past quarter century. While countries in Western Europe were slower to adopt the time-budget approach, time-budget data

collection has been gaining momentum since the mid-1970s. Yet, to date there has not been an official time-use study in the United States.

Linder[25] and Juster[26] present a notion of utility that highlights the importance of measuring and understanding how people use their time to participate in activities and, most importantly, the satisfaction they gain from those activities. Juster argues that utility is always gained from activity participation, and that goods contribute to utility by increasing or decreasing the satisfaction one gains from the activity.

Time-budget data collection entered a new phase during the 1970s and 1980s. Replication of earlier studies made possible cross-temporal comparisons of time use, permitting the study of the changing use of time. Norway was the first country to publish a comparative report on changes in time use over a decade[27]. Most of these studies entailed new samples drawn from previously-studied populations. However, at least two studies were panel studies getting new diaries from the same respondents at two different points in time. A study by the ISR at the University of Michigan studied a U.S. population between 1975-76 and 1981-82[28]. The second study, carried out at Dalhousie University (Halifax, Canada), studied a panel of respondents in the Halifax metropolitan area in 1971 and again in 1981[29].

Since 1985, national time-use studies have been carried out, or are being planned, by central statistical agencies in over 15 countries. Currently, a major European time-use data-collection exercise is being considered by EUROSTAT. Many of these studies are the beginning, or continuation, of a regular schedule of time-use data collection. In addition to official studies, the collection of time-use data for research purposes is also finding growing favor among academics.

An extensive literature on time-use data addresses many activity and subpopulation related concerns, both general and specific. Among the general concerns related to activities are the improved measurement of total productive activity, including the measurement of the size and structure of previously-unmeasured productive activity, often denoted the informal economy. Specific activities examined, using time-use data, include domestic work, child care, market versus non-market activity, shopping behaviour, drinking behaviour, leisure, modelling household production, and travel behaviour. Other concerns are focused on subpopulations, the sexual division of labour, children's use of time, and the elderly. Time-use data have also been used to examine aspects of societal structure and change. Work-schedules, social-interaction, urban time use, social change, the context of activities, social and economic accounts, and the supply of labour, have all been examined using time-use data. In developing

0countries, concerns related to time use have had a narrower focus. The major focus of most of these studies has been on the time allocation of women.

Of particular interest, from a travel perspective, are time-use studies with an urban-planning focus. Many such studies have been carried out in Eastern Europe, but documentation and results in English are rare. As part of the multinational time-use project, von Rosenbladt[30] collected spatial detail for activities on the time diaries and separate information on the number and distribution of all kinds of urban facilities. The most notable work on empirical time use and planning is that of Chapin[31] and associates at the University of North Carolina. Chapin, in his empirical work, viewed behaviour in space and time as the outcome of a motivation-choice sequence. Cullen, and his colleagues at the University of London, also made significant contributions on the role of time use in urban planning during the early and mid-1970s[32]. The Dimensions of Metropolitan Activity (DOMA) Study in Halifax, Canada[33] in 1971-72 was explicitly designed to yield extensive data for urban planning in general, and travel in particular. During this period, work on time use and urban planning was underway at the Martin Centre at Cambridge University[34].

A seven-day activity-diary survey was conducted in Reading, England during 1973 to support the time-use research at the Martin Centre[35]. The data collected in this survey, that have been used in many studies of travel behaviour (see, for example a study by Prendergrast and Williams[36]) show clearly that activity (or time-use) surveys provide information about trips that are typically not reported in conventional travel surveys. These tend to be the short, incidental trips, as well as those that are linked together on multipurpose journeys.

Concurrent with, but independent of, the collection and analysis of time use data during the 1970s, Hagerstrand and his associates were formulating the elements of a temporal-spatial geography that is given life in the construction of time-space prisms[37]. They viewed behaviour as subject to several constraints. Cullen and his associates saw the Hagerstrand approach as a simple fixed-unfixed dichotomy[38] and argued for a more elabourate range of flexibility defined in terms of an individual's degree of commitment to an activity and the time-space fixity of it.

Most of the time-use work to date focuses on summary time allocations to target activities or by target groups. The work reports time allocated to activities disaggregated by characteristics of the individuals performing them, or possibly by characteristics of the day. Thus, the studies have thrown away or ignored the richness of the data on which they are based. Time allocation to each activity is collected with a rich array of data on attendant dimensions and is often presented devoid of this

context. Even where attention is on an activity such as television or drinking, analysis has typically been limited to a series of one-way disaggregations. Multidimensional analysis, dimensioned by specific activity characteristics independent of socio-demographic variables, is extremely rare. However, an activity occurs in relation to (before, after, or concurrently with) other activities; it occurs at a specific time of the day, week, year; it occurs in a specific location; and it occurs with a given cadence. It is not only performed by a person with specific characteristics for an identified period, as traditionally studied.

The inherent strength of time-use data is in the areas that are routinely ignored in its analysis. It is this generally-ignored richness that offers individuals seeking to model travel a rich and virtually untouched smorgasbord of data.

IMPLICATIONS OF TIME-USE RESEARCH FOR TRAVEL-DEMAND ANALYSIS AND MODELLING

The above overviews of travel-demand and time-use research suggest that the two fields are moving in the same direction. Travel-demand analysis is increasingly concerned with how people spend their time participating in activities and the resultant implications for travel behaviour, while some time-use researchers recognize that the phenomenon of interest to them (time use) cannot be studied in isolation. What people "do" with their time is but one of several dimensions of concern in more recent work on time use. Among other concerns must be included concurrent activities: where people are, who they are with, and even how they feel. The increasing interest in the spatial patterns of time use is of particular relevance to travel-demand analysis. This section of the chapter draws on the theoretical, methodological, and empirical findings in time-use research and identifies implications for travel-demand analysis.

Theoretical Perspectives

Time-use researchers (and their critics) have consistently berated themselves over the lack of theory in the study of time use. However, clear elements of a theory of time use do exist. Over the past two decades, progress has been made in identifying concepts needed to develop useful theories of time allocation. This progress has occurred across a range of disciplines. Economists, sociologists, geographers, planners, and architects, among others, have all contributed and, to their credit, each has often gone beyond the boundaries of his or her discipline.

Time-use researchers generally accept that there are three or four (depending on how one disaggregates) main uses of time. Three would be work/obligatory, personal/ necessary, and free or discretionary/leisure time. If obligatory is divided into paid

work and non-paid work there are four. Aas[39] proposed four basic groupings; namely, contracted time (time related to gainful employment and education), committed time (time related to domestic work), necessary time (related to basic needs), and free time.

Becker[40], building on an idea of Carincross[41], views a household as a small economic unit that manufactures and then consumes "basic commodities." These commodities are produced by combining purchased inputs and household time. Gershuny[42] uses time as the measure in presenting what he calls a new technique for accounting for (both describing and explaining) long-term social and economic structural change.

Chapin[43] argues that activities are classifiable acts that can be used to study human behaviour, and "urban-activity systems" are the patterned way in which daily activity unfolds in time and space. Time is the common denominator for linking the various subsystems of the general activity system. Chapin's model, based on a motivation-choice-outcome sequence, stresses the choice or preference aspect in individual behaviour. He also recognizes that the consummation of an activity is dependent on "supply" considerations.

Hagerstrand[44] emphasizes constraints on individual behaviour. These constraints are imposed by the abilities and resources of individuals, their need to join with others, and by social and political controls. Cullen and Godson[45] argue that behaviour is shaped by the degree of time-space fixity involved in specific activities. Cullen and Phelps[46] consider behaviour an "interactive" function of the social, economic, and physical context in which it occurs. They emphasize situations rather than organisms and explicitly introduce consideration of individuals' perceptions. Perception plays a stronger role in the framework established by Horton and Reynolds[47] to predict urban-travel behaviour. Their travel model examines an individual's action space as a function of his or her socioeconomic characteristics, perception (cognitive images) of the urban environment, and preferences for travel.

Heidemann[48] argues that social regimens — the rules and regulations governing the availability of public and private goods and services — play an important role in shaping enacted behaviour. On the demand side, he argues that behaviour is affected by budgets that emphasize the dispositional possibilities for individuals,groups, and other societal decision units as a prerequisite for making decisions about different utilizations. Although he sees budgets constrained by the general level of societal development he believes they offer scope for decision making that is a precursor of enacted behaviour.

Role theory[49] also contributes to understanding time allocation. People occupy many statuses in which their expectations and the expectations of others interact with the person's skills and capacities appropriate to the role, and result in enacted behaviour. Besides roles within the family and the labour force, people often assume roles related to involvement in neighborhood activities and in various organizations. These roles interact to shape enacted behaviour.

Building on these insights, Harvey[50] argues that role and context shape behaviour. Persons can meaningfully be grouped within the context of roles in an integrating manner that mediates against omitting significant aspects of their lives[51]. Certain role-related variables are repeatedly documented as significantly affecting daily time use. These include gender, employment status, marital status, and the numbers and ages of children. Such role variables pervade the analysis and presentation of time-use data consistently yielding differing role-related time-use profiles.

Respondent and activity context impose constraints both on the time allocation of individuals to activities and on the activity episodes themselves. Location (in terms of both an in-home/out-of-home orientation and the macro-spatial structure), temporal location (time of day, day of week, day of year), presence of others (alone, family, friends, others) all represent significant contextual elements. The existence of subjective elements is also widely accepted but their characterization is less clearly understood.

Drawing on the work of Hagerstrand, Chapin, Cullen and others, Harvey[52] argues that activities engaged in are mediated by opportunities (or constraints that can be viewed as negative opportunities), preferences, and perceptions. The importance of constraints emanates from Hagerstrand who sees time and space as imperatives limiting what activities are possible. Michelson, in conversation, has suggested that time-use theory may well do better at showing what cannot be done, than at showing what is done. This is an interesting hypothesis, especially as a similar conclusion was reached by a group of travel researchers with respect to the activity-based approach to travel-demand analysis[53].

Behaviour is the result of many interacting forces. Objective spatial structure, comprising the actual locations of potential activities and their associated levels of attractiveness, sets the outer limits on behaviour[54]. As used by Horton and Reynolds[55], the objective spatial structure lacked a time dimension. However, one must deal with a spatial-temporal objective structure. To do so, allows both for the fact that spatial opportunity has a temporal dimension and for the fact that present behaviour may be as much shaped by the future as by the past. Where one can be, or what one can be

doing at any given moment, emanates both from where one was and what one was doing, and where one has to be and what one has to do. Falling inside the boundaries imposed by the objective spatial structure are three limiting sets, the interaction of which determines the "enacted behaviour" of the individual. These sets are the preference set, the perception set, and the opportunity set. Enacted behaviour — that is what time-use studies measure — reflects the overlap of what is preferred, perceived, and possible.[56]

In summary, the study of time use exists in a plethora of theories about time allocation and behaviour. An integrative theory that can transcend disciplines and provide more solid guidance to research is needed. However, the multiplicity of theories does provide a basis for anticipating changes in time allocation over time and differences in time allocation among places. Spatial and temporal availability of many elements in the opportunity set can be expected to vary with scale of place. Also, it seems reasonable that preferences and perceptions will differ. Unfortunately the reality and meaning of these expectations have not been explored adequately.

Land-Use (Activity) Modelling

In spite of the considerable body of theory to provide guidance in developing time-allocation models, there is a dearth of activity-model building. The limited amount of time-use modelling has been dominated by economists focusing on labour-supply analysis using a labour-leisure model. Time-diary data, that are much richer than the more traditionally-used employment and hours data, facilitate the inclusion of all activities, including market and non-market work, leisure, and personal care. Still, data-based modelling has, with few exceptions, concentrated on market and non-market work, and leisure. In an excellent review of behavioural models, on which we draw extensively in this discussion, Juster and Stafford[57] suggest that recent work using time-use models incorporates feedbacks, joint production, inter-temporal time use, and inter-temporal time use with feedbacks.

Examining household production following Becker[58], one can conclude that differing time values lead to differing production strategies. Evidence of this is found in the work of Gronau[59] that relates mode choice to decisions to minimize total trip cost including time and money costs. This leads persons with higher time values to economize on travel time. Juster and Stafford[60] highlight the value of time-use data in going beyond a simple labour-leisure tradeoff to incorporate alternative leisure activities. They also focus attention on the role of changing home technology in labour supply and other time-allocation decisions. The contribution of non-market activities

to market productivity is also highlighted, as is a life-cycle pattern of time allocation to market work showing greater participation in ones' middle years.

Based on their review of modelling literature, Juster and Stafford[61] offer some insights into the role that labour-leisure and the more inclusive household-production models, drawing heavily on time-use data, can play in understanding behaviour. They postulate that the income effects of growing wages will offset substitution effects thus leading to declining market work, and that production choice can illuminate travel mode choice better and an interplay of home technologies and labour supply decisions.

Juster and Stafford[62] argue for a need to place greater emphasis on the collection of concurrent time-use and expenditure data. While they express concern over respondent burden attendant with the joint collection of data, such an approach was recently implemented successfully in Bulgaria. They also argue that there is a problem in defining the activities. As an example, they question whether a trip itself is a final activity or just an input to a final activity. Additionally, they call for more emphasis on joint production of outputs to be consumed later, and the possibility of direct benefits of time use in an activity. They highlight several additional data-related needs. These include the need for data from respondent-spouse pairs to study-time allocation, marriage-gain models, and the need for the collection of preference data.

Actual modelling of daily-activity patterns has been rare. Work in the 1970s at the Centre for Land Use and Built Form Studies at Cambridge University focuses on the modelling of daily-activity patterns. Researchers there, working with activity data for students, developed models attempting to predict the distribution of students to activities and locations in various situations. Where the results can be compared with actual data they are fairly accurate[63]. Other similar work was also undertaken at the Centre looking at daily activity in an urban environment[64].

Methodology

In preparing this chapter, we examined the methodological implications of time-use research for travel-demand analysis and modelling in terms of both data collection and model estimation. While behavioural modelling is routinely applied in travel analysis, there has not been a parallel development of applied general-activity modelling. Time-use modelling efforts, in the few cases where they exist, have generally been in the area of model building and hypothesis testing, with much less emphasis on estimating models to be used in forecasting future patterns of time use. This section of the

chapter, therefore, focuses on the lessons about data collection that travel-demand modelers can learn from the time-use research literature.

By examining time-use surveys completed using different approaches, Harvey[65] develops guidelines for time-use data collection. The following section draws heavily on Harvey's report to which the reader is referred for more detail. Because there are differences in the purposes of time-use and travel-demand surveys one should be cautious about transferring conclusions from one field to the other, especially without regard for the differences. However, some general observations that can be based on the results/experience in data collection in time-use research should be of interest to travel-demand researchers.

The discussion below includes several data-collection related topics that are examined separately. However, it is important to recognize that there are interactions among many characteristics of data collection that must be considered in designing a data-collection effort.

Historically, most travel-behaviour surveys used the "yesterday approach" in conjunction with a home interview. That is, respondents were typically asked to report their travel behaviour for the previous 24-hour period during an interview in the respondents' home. Some travel surveys have, more recently, used the tomorrow (or diary) approach. The time-use experience with these alternatives is mixed and no strong conclusion can be drawn[66]. Since it is easier to recall activities, as opposed to trips, this conclusion might, however, not be readily transferable to travel surveys. As noted earlier, there is evidence that activity surveys do uncover higher levels of trip-making than travel surveys.

Most time-use and travel surveys have asked respondents to report their behaviour over a period of 24 hours (or less). However, some time-use surveys, and a few travel surveys, have asked respondents to report their behaviour for several successive days (ranging from two to 35 days). The analyses that have been undertaken with the data collected in such surveys have revealed that there is substantial variation from day-to-day in both time use and travel behaviour. Such day-to-day variation has implications for the optimal length of the reporting period, as has been noted by both time-use and travel-demand researchers[67,68]. While there appear to be some differences in the level of day-to-day variability in time use and trip making, there is some agreement that two to three days is the optimal reporting period, especially when one considers the fact that longer periods result in higher levels of nonresponse.

Travel surveys (in which a diary is not used) generally ask for travel behaviour on the previous day, so the recall period is generally not an issue. However, the choice of the number of days in the reporting period and the use of yesterday versus tomorrow surveys are not independent. If one wishes respondents to report their behaviour over a period longer than two days, one would probably want to use the diary (tomorrow) format to avoid the recall problem.

Time-use surveys have employed personal- and telephone-interview procedures along with self-completion and mail-back protocols. Harvey[69] reports that there may be little difference between the personal- and telephone-interview approaches in collecting time-use information, and he also notes that time-use researchers have found self-completion and mail-back surveys to be effective, if appropriate measures are taken to maintain the response rate.

If one needs information only of a general nature, such as the time devoted to each of several different activities, a telephone interview or self-completion survey would suffice. On the other hand, if one were conducting a study in which one wished to explore with the respondent(s) the implications of some change in the transport system (or other environmental factor) on their travel behaviour (the type of investigation that has been undertaken by researchers at TSU, Oxford), then a personal interview is almost essential.

Empirical Findings

Studies of time use between the mid-1960s and the mid-1980s tend to register declining total work time. Among countries registering declines in paid work time are Japan[70], Canada[71], Hungary[72], Latvia[73], and Czechoslovakia[74]. A Norwegian study[75] found paid work time constant throughout the 1970s and early eighties and a U.S. panel study[76] found total work time — paid and unpaid — remained relatively constant from the mid-1970s to the mid-1980s. These studies found a convergence in the paid work time of men and women, the extent of which generally varies by age. Niemi[77], in a wide–ranging review of trends in time use, concludes that changes in time use correlate with the general trend in working time that, she claims, provides a time frame for other time uses. There has been a slowing in the decline in work time since the 1970s, an increase in free time, and a reduction in the quantitative differences in free time between the sexes. The general trend in the use of free time, Niemi argues, has been an increase in passive leisure activities.

Comparison of panel and general population change provides greater insight into shifting time use. A 10-year panel study (1971-1981), in Halifax Canada, reveals a

reduction of roughly two hours in time devoted to sleep and personal care and an increase in free time[78]. These findings run contrary to general societal change in that period. Persons who were working in 1971 showed a decrease in time devoted to paid work, while females who were unemployed in 1971 showed a large increase in paid work time over the decade, as some of them became employed. The increase in work time was offset by a decline of approximately 12 hours per week in home and family-care time.

Parallel random and panel samples in Halifax, over the decade of the 1970s, reveal competing and complementary trend and aging forces in changing time use. The greatest differences are registered by those activities — paid work (main job), housework, television, passive leisure — that are frequently highlighted in discussions of change across the various countries. The greatest difference over the decade is exhibited by paid work and study, with the panel showing declining time and the random sample indicating constant or increasing time[79].

There was a significant increase in paid work time and a significant decrease in free time over the period 1981 to 1986 for Canadians living in cities for which time-use data were collected in the two periods. Over the period 1981 to 1986, total productive time — paid work time, education time,and housework time — increased by 0.3 hours per day, 2.1 hours per week. This change, and others that are surfacing, are consistent with Niemi's[80] observation of a slowing decline in work time. In fact, the decline may be being reversed.

The bulk of time-use research has been oriented toward evaluating population time-use patterns. Little work has focused on activities. There is a virtual vacuum in time-use research with respect to episode analysis — the analysis of activities in context. While episode analysis has been the child of travel research, it has been the orphan of time-use research. Here time-use researchers have much to learn from travel researchers.

Of particular interest to travel research is the home/out-of-home orientation of activities, but explicit reference to this factor is noticeably absent in most of the time-use studies reviewed. Yet, it is in such areas that time-use data can greatly supplement travel research. One study that did examine episodes (using data for Jackson, Michigan and Halifax, Canada) shows that approximately two-thirds of discretionary time is home-oriented and one third out-of-home oriented, and that various discretionary activities have strong orientations either to in-home or away from home[81]. In brief, the results show active leisure occurs predominantly away from home and passive leisure occurs predominantly at home. While early work[82] suggests that activities can

be classified as home based, non-home based, or footloose (in that they are equally probable either at home or away from home), it appears that footloose activities are an extremely small part of the total. This finding coincides with that of Simonsen[83] that most daily activities are linked to a fixed location. Based on an analysis of distance relations in daily activity patterns, Simonsen argues that the fixity makes accessibility, that is dependent on the place of residence as an operational base, a decisive factor for people's possibility to carry out alternative activities.

Simonsen shows that people living near the city center of a Danish town have more time for discretionary activities out of the home, and more out-of-home and less in-home activities than those living away from the center. She also shows that greater distances to work and the city center influence in-home activities to be more passive in nature, but do not affect social visiting. She concludes that planning that makes a strong spatial separation of different activities will constrain peoples possibilities to exploit leisure hours actively.

The lesson from the above findings is that there have been shifting patterns of time allocated to paid work, household work, and leisure. More women are spending time in the paid labour force. Single-earner households are being replaced by dual-earner households. The locus of leisure is shifting. More in-depth analysis of time-use data can be expected to reveal shifts in the location and nature of such activities as paid work, child care, as well as shopping. The clear implication of increased passive leisure is increased home-oriented leisure. The changes identified have clear implications for travel research. One major implication is that dual-earner households will generate new commuting patterns. Commuting trips can be expected to increase and be different. Other travel behaviour can also be expected to change.

Some of these observations have not gone unnoticed. Reviewing urban models, with their implicit behaviour, Hanson and Pratt[84] argue that early urban models focusing on a home-work linkage, with workplace dominant, were based on one household type, namely the one-earner family. Many households now have more than one worker and thus more than one workplace. According to Hanson and Pratt, while recent studies recognize the increasing diversity of household types, they don't incorporate many contextual variables describing housing and labour market conditions. Hanson and Pratt argue that other models, while recognizing previously-missed relationships between housing markets and labour markets, have only weakly, if at all, grasped the realization that choices are not solely male-dependent, and not only where to live and where to work.

Simonsen[85] shows that while work functions as a constraint on choice of residence, it does so to a lesser extent than suggested in micro-economic theories. Hanson and Pratt[86] see the work decision, especially for women, as a social process shaped by the environmental context. They see the home environment as important to the work decision in terms of potential employment opportunities, potential support services, and as an agent for socialization. They argue for a redefining of the home environment both by expanding home outward to include the surrounding neighborhood and inward to include intra-household interactions. They further note that the link between home and work varies across population subgroups, particularly those defined by occupational class and number of household earners. In another vein, they suggest that, as more women work in paid employment, patterns of socializing may become reoriented from the neighborhood to work, and that social ties formed in the workplace can explicitly affect the home-work link. In concluding, they argue that home and work cannot be treated as separate spheres and it is inappropriate to oversimplify assumptions about home-work linkages.

The research focus, at both the population and activity level, must shift toward greater emphasis on the context of activities. This will provide a common meeting ground for time-use and travel researchers. Time-use researchers can benefit from the experience of travel researchers in the analysis of episodes. Travel researchers can benefit from the experience of time-use researchers in analyzing the broad spectrum of human activity.

CONCLUSIONS

We undertook the development of this chapter with the belief that travel-demand analysts could gain considerable insight from an examination of the literature on time use. The chapter documents the variety of knowledge that travel-behaviour researchers can obtain from closer examination of the work of time-use researchers. This knowledge ranges from theoretical and conceptual developments to empirical findings. It also appears that existing time-use data sets represent a potentially rich, untapped resource for travel-demand researchers.

While writing this paper it became clear to us that the fields of travel-demand analysis and time-use research are starting to converge and that researchers in each field can benefit considerably from the lessons learned in the other field. Travel-demand researchers now recognize the vital importance of understanding time use in trying to understand and model travel behaviour. In particular, the activity-based approach highlights the importance of time use in travel-demand analysis, beyond the narrow concern with travel time evident in more traditional approaches to travel demand. On

the other hand, time-use researchers could benefit from examining the contextual aspects of the use of time, particularly the spatial context, a context that is of primary interest to travel-demand analysts.

It is our hope that time-use and travel-demand researchers will seek greater cooperation in the future. This would be to the benefit of both those research communities and to the population whose behaviour we try to understand in order to improve public policy and decision making. An area that seems a prime candidate for cooperation is that of data collection, where the collection of expensive data sets might be justified better in the future if the data were of use to those working in both the time-use and travel-behaviour fields. The necessary cooperation might be facilitated by establishment of a liaison between the International Association for Time-Use Research and the International Association for Travel Behaviour.

ACKNOWLEDGMENTS

The preparation of this paper was supported in part by the University Transportation Centers Program of the U.S. Department of Transportation through a sub-grant to Duke University from the Southeastern Transportation Center at the University of North Carolina.

REFERENCES

1. Oi, W. and P. W. Shuldiner, *An Analysis of Urban Travel Demands*, Northwestern University Press, Evanston, Illinois, 1962.

2. Pas, E. I., "Is Travel Demand Modeling and Analysis in the Doldrums ?", in P. Jones, ed., *Advances in Dynamic and Activity-Based Approaches to Travel Analysis*, Oxford Studies in Transport, Avebury, Aldershot, U.K., 1990, 3-33.

3. Kuhn, T., *The Structure of Scientific Revolutions*, University of Chicago Press, Chicago, IL., 1968.

4. Lisco, T. E., "The Value of Commuters' Travel Time: A Study in Urban Transportation," Ph.D. Dissertation, Department of Economics, University of Chicago, 1967.

5. Lave, C. A., "Modal Choice in Urban Transportation: A Behavioral Approach," Ph.D. Dissertation, Department of Economics, Stanford University, 1970.

6. Quarmby, D. A., "Choice of Travel Mode for the Journey to Work: Some Findings." *Journal of Transport Economics and Policy*, 1967, 3, 273-314.

7. Stopher, P. R., "A Probability Model of Travel Mode Choice for the Work Journey," *Highway Research Record No. 283*, 1969, 57-65.

8.	Neveu, A. J., F. S. Koppelman, and P. R. Stopher, "Perceptions of Comfort, Convenience and Reliability for the Work Trip," *Transportation Research Record*, 723, 1979, 59-63.

9.	Nicolaidis, G. C., "Quantification of the Comfort Variable," *Transportation Research*, 1975, 9, 55-66.

10.	Prashker, J. N., "Development of a Reliability of Travel Modes' Variable for Mode-Choice Models," Ph.D. Dissertation, Department of Civil Engineering, Northwestern University, 1976.

11.	Spear, B. D., "The Development of a Generalized Convenience Variable for Models of Mode Choice," Ph.D. Dissertation, Cornell University, 1974.

12.	Koppelman, F. S. and E. I. Pas, "Travel Choice Behavior: Models of Perceptions, Feelings, Preference, and Choice," *Transportation Research Record No. 765*, 1980, 26-32.

13.	Jones, P. M., "New Approaches to Understanding Travel Behavior: The Human Activity Approach." in Hensher, D. and P. Stopher, eds. *Behavioral Travel Modelling*. Croom Helm, London, 1979, 55-80.

14.	Hagerstrand, T., "What About People in Regional Science?" *Papers and Proceedings of the Regional Science Association*, 1970, 24, 7-21.

15.	Pas, E. I., "State-of-the-Art and Research Opportunities in Travel Demand: Another Perspective," *Transportation Research A*, 1985, 19A, (5/6), 460-464.

16.	Hagerstrand, T., *op. cit.*

17.	Liepmann, K. K., *The Journey to Work*, Oxford University Press, Oxford, 1944.

18.	Von Rosenbladt, B., "The Outdoor Activity System in an Urban Environment," in Szalai, A. ed., *The Use of Time*, Mouton, The Hague, 1972.

19.	Chapin, Jr., F. S., *Human Activity Patterns in the City*, John Wiley and Sons, Toronto, 1974.

20.	Elliott, D. H., A. S. Harvey, and D. Procos, "An Overview of the Halifax Time Budget Study," *Society and Leisure*, 1973, 3, 145-159.

21.	Szalai, A., ed., *The Use of Time*, Mouton Publishers, The Hague, 1972.

22.	Robinson, J., V. G. Andreyenkkov, and V. D. Patruschev, *The Rhythm of Every Day Life: How Soviet and American Citizens Use Time*, Westview Press, London,

1989.

23. Andorka, R., I. Harcsa, I. Niemi, "Use of Time in Hungary and in Finland: Comparison of Results of Time Budget Surveys by the Central Statistical Offices of Finland and Hungary." Central Statistical Office of Finland, Helsinki, Tutkimuksia Undersokningar Studies No. 101, 1983.

24. Harvey, A. S., and S. Grömo, "Social Contact and Use of Time: Canada and Norway: a Comparative Analysis of Time Use Patterns," in Aas, D., A. S. Harvey, E. Wunklipinski and I. Niemi, eds. *Time Use Studies: Dimensions and Applications*. Central Statistical Office of Finland, Helsinki, 1986

25. Linder, S. B., *The Harried Leisure Class*, Columbia University Press, New York, 1970.

26. Juster, F. T.,"Rethinking Utility Theory," *The Journal of Behavioral Economics*, 1990, 19 (2), 155-179.

27. Lingsom, S. and A. L. Ellingsaeter, "Work, Leisure and Time Spent With Others: Changes in Time Use in the 70s," Kongsvinger, Statistisk Sentralbyra, Oslo, (Statistiske analyser 49), 1983.

28. Juster, F. T., "A Note on Recent Changes in Time Use," in Juster, F. T., F. P. Stafford, eds., *Time, Goods and Well-Being*, University of Michigan, Survey Research Center, Institute for Social Research, Ann Arbor, 1985, 313-332.

29. Harvey, A. S., and D. H. Elliott, "Time and Time Again: Explorations in Time Use," Explorations in Time Use Series No. 4, Ottawa, 1983.

30. Von Rosenbladt, B., *op. cit.*

31. Chapin, F. S., Jr., *op. cit.*

32. Cullen, I. G., V. Godson, and S. Major, "The Structure of Activity Patterns." in Wilson, A. G., ed., *London Papers in Regional Science: Patterns and Processes in Urban and Regional Systems*, Pion, London, 1971, 3, 281-296.

33. Elliot, D. H., et al., *op.cit.*

34. Bullock, N., P. Dickens, P. Steadman, E. Taylor, and J. Tomlinson, "Development of an Activities Model," Land Use and Built Form Studies Centre, (Working Paper 41), Cambridge, University of Cambridge, 1971.

35. Shapcott, M., "Comparison of the Use of Time in Reading, England with Time Use in Other Countries," *Transactions of the Martin Centre for Architectural and*

Urban Studies, 1978, 3, 231-257.

36. Prendergrast, L. S. and R. D. Williams, "An Empirical Investigation into the Determinants of Travel Time," Transport and Road Research Labouratory Supplemental Report 555, 1980.

37. Lenntorp, B., "Paths in Space-Time Environments: A Time-Geographic Study of Movement Possibilities of Individuals," Lund Studies in Geography, Series B, 44, 1976.

38. Cullen, I. G. and V. Godson, "The Structure of Activity Patterns," Research Paper No.1, Joint Unit for Planning and Research, University of London, 1972.

39. Aas, D., "Studies of Time-Use: Problems and Prospects," *Acta Sociologica*, 1978, 21(2), 125-141.

40. Becker, G. S., "A Theory of the Allocation of Time," *Economic Journal*, 1979, 75, 493-517.

41. Cairncross, A., "Economic Schizophrenia," *Scottish Journal of Political Economy*, February, 1958, 15-21.

42. Gershuny, J., "Technical Change and the Work Leisure Balance: A New System of Socio-economic Accounts," in Silberston, A., ed., *Technology and Economic Progress*, Macmillan, 1989, 181- 215.

43. Chapin, F. S., Jr., *op. cit.*

44. Hagerstrand, T., *op. cit.*

45. Cullen, I. G. and V. Godson, *op. cit.*

46. Cullen, I. and E. Phelps, "Diary Techniques and the Problems of Urban Life," Final report to the Social Science Research Council, London, Grant No. HR 2336, 1975.

47. Horton, F. E. and D. R. Reynolds, "Action Space Formation: A Behavioral Approach to Predicting Urban Travel Behaviour." *Highway Research Record No. 322*, 1970, 136-148.

48. Heidemann, C., "Spatial Behavior Studies: Concepts and Contexts." Resource paper to the 4th International Conference on Travel Modelling, 1979.

49. Biddle, B. J., *Role Theory: Expectations, Identities, and Behaviours*, Academic Press, New York, 1979.

50. Harvey, A. S., "Role and Context: Shapers of Behavior," *Studies of Broadcasting*, 1982, 18, 69-92.

51. Clark, S., D. H. Elliott, and A. S. Harvey, "Hypercodes and Composite Variables: Simple Techniques for the Reduction and Analysis of Time Budget Data," in Staikov, Z., ed., *It's About Time: Proceedings of the International Research Group on Time Budgets and Social Activities*. Bulgarian Sociological Association, Institute of Sociology at the Bulgarian Academy of Sciences, Sofia, Bulgaria, 1982, 66-92.

52. Harvey, A. S., "Urban Modeling and Time Budgets: A Behavioral Framework," Paper presented to the twenty-third annual conference of the North American Regional Science Association, Toronto, Canada, 1976.

53. Pas, E. I., "Workshop Report: Workshop on Activity Analysis and Trip Chaining, in Behavioral Research for Transport Policy," *Proceedings of the 1985 International Conference on Travel Behavior*, VNU Science Press, Utrecht, The Netherlands, 1986.

54. Horton, F. E. and D. R. Reynolds, *op. cit.*

55. *Ibid.*

56. Harvey, A. S., *op. cit.*

57. Juster, F. T. and F. P. Stafford, "The Allocation of Time: Empirical Findings, Behavioral Models, and Problems in Measurement." Working paper series, Survey Research Center, Institute for Social Research, Ann Arbor, University of Michigan, 1990.

58. Becker, G. S., *op. cit.*

59. Gronau, R., "The Value of Time in Passenger Transportation: The Demand for Air Travel," Occasional Paper No. 109. National Bureau of Economic Research, New York, 1970.

60. Juster, F. T. and F. P. Stafford, *op. cit.*

61. *Ibid.*

62. *Ibid.*

63. Bullock, N., et al., *op. cit.*

64. Wilson, W. C., "You Are What You Do: The Self-Organization of Daily Activity in the Urban Environment," Doctoral dissertation, University of Cambridge, St. John's College, Cambridge, England, 1983.

65. Harvey, A. S., "Guidelines for Time Use Data Collection," General Social Survey Working Paper No. 5, Statistics Canada, Ottawa, Canada, 1990.

66. *Ibid.*

67. Pas, E. I., "Miltiday Samples, Parameter Estimation Precision, and Data Collection Costs for Least Squares Regression Trip Generation Models," *Environment and Planning A*, 1986, 18, 73-87.

68. Kalton, G., "Sample Design Issues in Time Diary Studies," in Juster, F. T. and F. P. Stafford, eds., *Time, Goods and Well-Being*, University of Michigan, Survey Research Center, Institute of Social Research, Ann Arbor, 1985, 93-112.

69. Harvey, A. S., 1990, *op. cit.*

70. Nakanishi, N. and Y. Suzuki, *Japanese Time Use in 1985*, Public Opinion Research Division, NHK, Tokyo.

71. Harvey, A. S. and D. H. Elliot, *op. cit.*

72. Harcsa, I., "Worktime on the Individual and the Society Level," Paper presented at meetings of the International Association for Time Use Research, Budapest, Hungary, 1988.

73. Eglite, P. and I. Zarina, "Changes of Time Use of the Town Population in the Latvian SSR," Report for a joint meeting of Soviet-Finnish working group for cooperation in the field of sociological research, May 16-20, 1988, Sochi. Riga, The Institute of Economy of the Academy of Sciences of the Latvian SSR, 1988.

74. Viteckova, J., "Basic Trends in the Structure of Time Fund in Czechosolovakia: Primary Information," mimeo. (no date).

75. Grönmo, S., G. Haraldsen, and S. Lingsom, "Age Differences in Time Use: Stability and Change in Norway in the 1970s," Paper prepared for the Meeting of the International Research Group on Time Budgets and Social Activities, Budapest, June 14-16, 1988.

76. Juster, F. T., *op. cit.*

77. Niemi, I., "Main Trends in Time Use from the 1920s to the 1980s," Paper prepared for the International Meeting on Studies on Time Use, Budapest,

 1988.

78. Harvey, A. S. and D. H. Elliot, *op. cit.*

79. *Ibid.*

80. Niemi, I., *op. cit.*

81. Harvey, A. S., 1982, *op. cit.*

82. Harvey, A. S., "Discretionary Time Activities in Context.", Dalhousie University, Institute of Public Affairs, Regional and Urban Studies Centre, Halifax. Presented to World Congress of Sociology Ad Hoc Group 10, Time Budgets and Social Activities, 9th World Congress of Sociology, Uppsala, Sweden, 1978.

83. Simonsen, K., "Household Activities and Environmental Constraints," A paper presented to Ad Hoc Group No. 10 Time-Budgets and Social Activity, 9th World Congress of Sociology, Uppsala, Sweden, August 14-19, 1978.

84. Hanson, S. and G. Pratt, "Reconceptualizing the Links Between Home and Work in Urban Geography," *Economic Geography*, 1988, 64(4), 299-321.

85. Simonsen, K. *op. cit.*

86. Hanson, S. and G. Pratt, *op. cit.*

14

TEMPORAL UTILITY PROFILES OF ACTIVITIES AND TRAVEL: SOME EMPIRICAL EVIDENCE

Ryuichi Kitamura and Janusz Supernak

INTRODUCTION

Studies that have examined the decision process underlying the choice of activity duration are few. Previous time-use studies[1,2,3,4,5] tended to examine the aggregate sum of time allocated to each category of activities. Some studies of activity engagement and time use[6,7] adopt a utility-maximization framework and formulate econometric model systems. Other studies take on purely empirical approaches to determine the distribution of activity durations based on observation[8,9]. The decision to terminate activity engagement, however, is not explicitly addressed in these studies.

In some instances, the duration of an activity is externally determined and no disengagement decision really takes place. An example is going to a theater to see a play. In this case, the beginning and ending times of the activity — seeing a play — are externally determined. In other cases, activity durations are governed by stochastic processes that are beyond the control of the individual. Examples include visiting a bank to deposit checks. The time spent in the bank depends on the time spent waiting and the time required for the service. Both are clearly random.

The third class may contain situations where the beginning or ending times or both are determined by externally-set or previously-established constraints. For example, the duration of a visit to a grocery store may be curtailed by a previously-set appointment to see a friend. Yet, in another set of situations, the individual may

determine the duration of an activity entirely on the basis of its merit, i.e., purely based on whether or not it is beneficial to continue to pursue the activity. If not, the individual will disengage himself from the activity and move on to engage in another activity.

The focus of this study is on the fourth case, where an activity duration is determined by the individual without external constraints. Visits to shopping malls or recreational parks are likely to fall into this category. In analyzing the engagement decision in these activities, we may postulate that the individual evaluates the gain in utility as he pursues the activity, and he will disengage from the activity when the marginal-utility gain decreases below some threshold level. Even activities with an externally-set ending time may be analyzed from this viewpoint; a person in a movie theater may leave when it becomes evident that the film is extremely poorly done.

In this study, detailed movement and time-use data of a small number of zoo visitors are examined. The intent of the analysis is to shed initial light on the temporal profile of utility through the examination of observed activity-engagement/disengagement behaviour from a theoretical viewpoint.

SUPERNAK'S UTILITY-PROFILE APPROACH

Supernak[10] proposed to view the activity-engagement decision along the time dimension. The utility of an activity is compared with that of an alternative activity (the in-home activity is used as a reference) over time, with the assumption that the individual attempts to maximize the utility measured at the end of a decision time-span (a day, say).

By itself, time used to travel is viewed as producing negative utility because of monetary travel costs and discomfort. Thus, the utility declines during the time of travel. If the utility of an out-of-home activity, less the disutility of travel, does not exceed the utility of in-home activities that can be pursued during the same time period, then that out-of-home activity will not be pursued. On the other hand, if the out-of-home activity is engaged in, then its duration is selected so as to maximize the total utility.

In a later study, Supernak[11] views the activity engagement decision as a decision under uncertainty. Namely, engagement and disengagement decisions are assumed to be made on the basis of the utility that will be gained by a certain future time point. This future utility, which cannot be predetermined, is treated as a random variable.

A decision to disengage from an activity is made when the anticipated utility at the end of the day becomes greater by disengaging from the activity than by continuing to pursue it. This assumption is used in this study. The concepts graphically illustrated in Supernak[12,13] are represented as a mathematical relationship to form a statistical model, then to quantify the relationship empirically.

MODEL FORMULATION

Suppose an individual visits a complex that contains multiple opportunities. He selects opportunities and spends certain amounts of time at these opportunities. It may be assumed that the individual will leave the complex when no opportunities are left there to contribute to his overall utility, i.e., when leaving the complex and engaging in activities elsewhere will contribute more to the overall utility.

Let $U_q(t)$ be the utility of activity at node q when an amount of time t is spent for the activity. Suppose the cumulative utility, when n opportunities, or nodes, have been visited, can be expressed as:

$$\psi(n) = -\Upsilon + \sum_{j=1}^{n} U_{q(j)}(t_{q(j)}) - \eta \sum_{J=1}^{n} w(q(j-1), q(j)) \tag{1}$$

where

$\psi(n)$	=	the utility of visiting n nodes,
Υ	=	the cost of visiting the complex (travel time cost, admission fee, etc.),
$q(j)$	=	the jth node,
η	=	the cost of walking time, and
$w(m,n)$	=	walking time between from node m to node n.

Now, with the assumption that the visit will continue if the utility of leaving the complex after visiting n nodes, is less than that of leaving after visiting (n+1) nodes,

$$\Psi(n) - \eta w(q(n),o) + V(T-\tau_n - w(q(n),o)) < \psi(n)$$

$$+ U_{q(n+1)}(t_{q(n+1)}) - \eta w(q(n),q(n+1)) - \eta w(q(n+1),o) \tag{2}$$

$$+ V(T - \tau_{n+1} - w(q(n+1),o))$$

where

$$\tau_{n+1} = \tau_n + t_{q(n)} + w(q(n), q(n+1))$$

and

$T =$ the total time available for all activities (including ones outside the complex) at the beginning of the visit,

$V(t) =$ the collective utility of all activities that can be engaged outside the complex when the amount of time t is allocated,

$S_n =$ the cumulative amount of time spent in the complex till the end of visit at node n; and

$o =$ the exit node.

Simplifying this,

$$-\eta w(q(n), o) + V(T - \tau_n - w(q(n), o) < U_{q(n+1)}(t_{q(n+1)})$$

$$- \eta w(q(n), q(n+1)) - \eta w(q(n+1), o)$$

$$+ V(T - \tau_{n+1} - w(q(n+1), o)) \tag{3}$$

Now, from the viewpoint that each individual allocates time optimally to the respective nodes visited, time allocation in any portion of the visit must be optimal. This leads to the relation that the marginal utilities of the respective nodes must be identical to each other, i.e.,

$$dU_{q(j)}(t) / dt = \Omega \quad at \ t = t_{q(j)}, \quad j = 1, \ldots, n \tag{4}$$

where, as before, $t_{q(j)}$ is the time allocated to activity at the jth node.

This assumption offers a behavioural interpretation that is intuitively appealing. Consider, for example, a window shopper on a shopping street who proceeds from show window to show window, spending a certain amount of time at each window. Upon arriving at a new show window, the shopper sees new items, new trends,

obtains price information, etc. After a while, however, the initial excitement subsides, while the flow of information starts slowing down. Eventually, the window becomes no longer entertaining or informative and the shopper decides to move on to the next window. In this context, it is not unnatural to assume the presence of a threshold; as the information obtained or amusement gained per an additional unit of time declines below that threshold, the shopper decides to move on. This is consistent with the expression in Equation (4).

Now, it is anticipated that randomness exists in the perception of utility. Suppose U_q can be formulated as

$$U_q(t) = \begin{cases} 0, & t = 0 \\ \beta_q \ln t + \varepsilon_q, & t > 0 \end{cases} \qquad (5)$$

where

$$\beta_q \sim N(\bar{\beta}_q, \sigma_{q^2}), \; \varepsilon_q \sim N(0, S_{q^2}), \; \forall q \; \varepsilon \; Q$$

$$Cov(\beta_q, \varepsilon_r) = 0, \; Cov(\beta_q, \beta_r) = 0, \; Cov(\varepsilon_q, \varepsilon_r) = 0, \; \forall q, r \; var \varepsilon \; Q$$

$N(a,b)$ refers to a normal distribution with mean a and variance b, and Q is the set of all nodes. Note that the utility of not visiting node q ($t = 0$) is assumed to be zero. Coefficient b_q is assumed to vary randomly across individuals, representing variations in preference.

Then,

$$U'_q(t) = \beta_q / t = (\bar{\beta}_q + \varepsilon_q) / t, \; \varepsilon_q \sim N(0, \sigma_q^2) \qquad (6)$$

and

$$U_q(t_q^*) = (\bar{\beta}_q + \varepsilon_q)/t_q^* = \Omega, \qquad t_q^* > 0 \qquad (7)$$

where $Cov(n_q, e_q) = 0$, and t_q^* is the time allocated to node q. Therefore,

$$\beta_q = \bar{\beta}_q + \varepsilon_q = \Omega t_q^*$$
(8)

and

$$U_q(t_q^*) = \beta_q \ln t_q^* + \varepsilon_q = \Omega t_q^* \ln t_q^* + \varepsilon_q$$
(9)

Note that t_q^* is independent of \dot{e}_q.

Now, suppose the utility of other activities can be expressed as

$$V(t) = \beta_o \ln t = \ln t$$
(10)

where $b_o = 1$ for normalization. Equation (3) can now be expressed as

$$-\eta w(q(n), o) + \varepsilon T_n < \Omega t_{q(n+1)}^* \varepsilon t_{q(n+1)}^* + \varepsilon_{q(n+1)}$$
$$- \eta w(q(n), q(n+1)) + w(q(n+1), o) + \varepsilon T_{n+1}$$
(11)

where

$$T_n = T - \lambda_n - w(q(n), o)$$

Therefore,

$$Pr[\psi(n) < \psi(n+1)]$$

$$= Pr[-\epsilon_{q(n+1)} < \Omega t^*_{q(n+1)} lnt^*_{q(n+1)} - lnT_n + lnT_{n+1} \qquad (12)$$

$$+ \eta K(n,n+1)]$$

where

$$K(n,n+1) = w(q(n),o) - w(q(n),q(n+1)) - W(q(n+1),o)$$

On the assumption that ϵ is an independent normal random variable,

Pr[n+1 nodes are visited, given that n nodes have been visited]

$$= Pr[\psi_n < \psi_{n+1}] \qquad (13)$$

$$= 1 - \Phi[\{\Omega t^*_{q(n+1)} lnt^*_{q(n+1)} - lnT_n + lnT_{n+1} + \eta K(n,n+1)\}/\sigma_{q(n+1)}]$$

If the ϵ's are i.i.d. normal with a mean of 0 and a variance of r^2, i.e.,

$$\epsilon_q \sim N(0,\sigma^2), \quad Cov(\epsilon_q,\epsilon_r) = 0, \quad \forall q, \ r \in Q. \ q \neq r, \qquad (14)$$

then the probability that the visit at the complex terminates, given that n nodes have been visited, can be expressed as

$$P(n) = \phi(\theta_n) \prod_{j=1}^{n-1} (1 - \phi(\theta_j)) \qquad (15)$$

where

$$\theta_j = \{\Omega t^*_{q(j+1)} ln t^*_{q(j+1)} + lnTAU_j - lnTAU_{j+1} + \eta K(j,j+1)\}/\sigma$$

EMPIRICAL ANALYSIS

This framework is applied to study the disengagement behaviour of visitors at a zoo. A zoo is chosen as an interesting and desirable setting for the study, because it can be anticipated that large degrees of freedom are associated with activity-engagement/disengagement decisions made there.

A zoo is a complex that contains a number of opportunities (or, exhibits) from which the visitor can freely compile a desirable set that would maximize his utility profile. It is likely to serve as a setting where a visitor can pursue an optimum activity pattern. It can be expected that, because the time spent at each exhibit is to a large extent controlled by the visitor himself, the assumption of the equality in marginal utilities across exhibits is likely to hold. The total duration of a visit can be fine-tuned toward an optimum by selecting the number of exhibits and the time spent at the respective exhibits.

The disengagement decision, in this case, is a choice between continuing on the tour by visiting another exhibit, and ending the visit. Because a tour involves visits to discrete exhibits, it can be assumed that a choice is made at the end of each visit at an exhibit. Thus, the final disengagement decision is a result of a series of repeated (but not identical) choices. It is thus clear that the model structure described in the previous section is well suited for the disengagement decision under study.

The San Diego Zoo was selected as the study site and surveys of zoo visitors were conducted on a few weekends in the spring of 1990. Groups of young-to-middle-aged adults were selected at the entrance for an entrance survey. Those who met a set of selection criteria were then monitored as they moved through the zoo. The groups were not informed that they were being followed in order to avoid any conditioning. At the exit, they were interviewed again with an exit questionnaire.

The results of these detailed surveys are used in the present study. The data show the exhibits visited, arrival time at and departure time from each exhibit, and a few categories of special activities (e.g., eating lunch). The arrival time at the zoo is also

included. Of a total of 14 groups surveyed, records for 10 groups were made available to this study.

The 10 groups in the data file visited a total of 151 exhibits, leading to a set of 151 binary choices. As an initial attempt to analyze this data set, Equation (13) is used together with the assumption in this initial effort that the error terms, the ϵ's, are i.i.d. normal. As a value for T, the number of hours between the time of entrance to the zoo and midnight is selected.

All elements are available from the data to estimate the unknown coefficients of Equation (13), except the location and duration of an alternative next exhibit for the last visit after which the tour ended. This information was generated by randomly selecting an exhibit near the last exhibit from the itinerary of another group, i', say, who visited a similar set of exhibits as group i. The duration at this exhibit is determined for group i as

$$t_{si} = t_{si}^*(t_{ci}/t_{ci}^*)$$
(16)

where

s = alternative $(n+1)$th exhibit,
t_{si} = hypothetical duration of stop at exhibit s by i,
t_{si}^* = observed duration at exhibit s by i, and
c = exhibit visited by both i and i'.

This is consistent with Equations (4) and (5).

Maximum-likelihood estimation of the binary probit model led to the following coefficient estimates and t-statistics:

X/r_e = 4.32 (5.79)
$1/r_e$ = 2.42 (0.40)
w/r_e = 0.0338 (0.94)

or,

$r_e = 0.413$
$X = 1.79$
$w = 0.0140$

with

$$L(0) = -104.7, \quad L(b) = -56.3$$

which yields a likelihood-ratio chi-square of $-2[L(0)-L(b)] = 96.8$, with 3 degrees of freedom (note that the model does not involve an alternative-specific constant term). Not all coefficients are significant, presumably reflecting the small sample size. However, all signs are consistent with the theory and the model as a whole is very significant.

The results suggests a large marginal utility of an exhibit at t_q^* ($X = 1.79$), compared with the disutility of walking per unit time ($w = 0.0140$). This may reflect the pleasant environment in the zoo: a zoo is a park in which walking along, in itself, may produce some utility that partially offsets the cost of overcoming spatial separation.

Equating the marginal utility of zoo exhibits implied by X to that of other activities pursued after exiting the zoo, the amount of time spent for these activities is estimated to be $exp(X) = 6.0$ hours. This appears to be a very reasonable estimate of the time spent on average for in-home and other activities after a weekend outing to a zoo.

Despite the small sample size, the coefficient estimates offer a plausible depiction of activity-engagement behaviour. The results lend support to the formulation of the engagement/disengagement decision set forth in the previous section.

CONCLUSION

This study has been conceived as an initial empirical effort to quantify the behavioural relationships postulated in Supernak's analysis of utility profiles. The focus of the analysis was set on the decision to leave a complex that offers a number of opportunities for activity engagement. A theoretical decision model was formulated and applied to a data set obtained at the San Diego Zoo, selected as an ideal setting for the study.

A key element in the theoretical derivation of the decision model is the assumption that the marginal utilities of the exhibits that are visited by a visitor to the zoo, are identical. This assumption allowed the depiction of activity-engagement behaviour as a result of a set of sequential decisions associated with individual exhibits, while keeping intact the assumption that the duration of the entire visit is optimized, considering the utilities of activities that can be pursued outside the zoo.

Despite the extremely small sample size, the empirical analysis presented in this chapter produced results that are consistent with the theory postulated for the activity-engagement/disengagement decision. The results are encouraging and suggest that the sequential depiction of the activity-engagement decision using the assumption of equalized marginal utilities, can be pursued futher as a model of activity duration. In particular, the model framework, almost in its current form, is applicable to the analysis of the behaviour of individuals in a shopping mall, or at other traffic generators that contain multiple opportunities. With some modifications, the approach can be applied to analyze individuals' use of discretionary time.

Future applications of this approach will undoubtedly benefit from further refinement of the model. For example, unobserved differences across individuals should be incorporated into the model. Individual-specific and time-invariant error components can be used effectively to represent this variation. More realistic depiction of travel networks, treatment of a set of exhibits as a bundle in engagement choice, and incorporation of "look-ahead" decision making are all possible future extensions of the model framework presented here.

ACKNOWLEDGMENTS

The authors wish to express their thanks to the San Diego Zoo for its support of the study and the students in the 1990 Civil Engineering Course 696 at San Diego State University, who conducted the surveys at the Zoo. Special thanks are due to Mr. Robert Yamada who prepared the survey data file and the network model of the Zoo that were used in this study. The effort by the first author was in part supported by funding from the U.S. Department of Transportation Region Nine Transportation Center at University of California.

REFERENCES

1. Allaman, P. M., T. J. Tardiff, and F. C. Dunbar, "New Approaches to Understanding Travel Behavior," *NCHRP Report 250, Transportation Research Board*, Washington, D.C., 1982.

2. Palm, R., "Women in Nonmetropolitan Areas: A Time-budget Survey," *Environment and Planning A*, 1981, 13, 373-78.

3. Prendergast, L. S. and R. D. Williams, "Individual Travel Time Budgets," *Transportation Research A*, 1981, 15A, 39-46.

4. Robinson, J. P., P. Converse and A. Szalai, "Everyday Life in Twelve Countries," in A. Szalai, ed., *The Use of Time: Daily Activities of Urban and Suburban Populations in Twelve Countries*, Mouton, The Hague, 1972, 113-144.

5. Tomlinson, J., N. Bullock, P. Dickens, P. Steadman, and E. Tayler, "A Model of Students' Daily Activity Patterns," *Environment and Planning*, 1973, 5, 231-66.

6. Damm, D., "Parameters of Activity Behavior for Use in Travel Analysis," *Transportation Research A*, 1982, 16A(2), 135-48.

7. Kitamura, R., "A Model of Daily Time Allocation to Discretionary Out-Of-home Activities and Trips." *Transportation Research B*, 1984, 18B, 255-66.

8. Kitamura, R. and M. Kermanshah, "Identifying Time and History Dependencies of Activity Choice," *Transportation Research Record*, 1983, 944, 22-30.

9. Lerman, S. R., "The Use of Disaggregate Choice Models in Semi-markov Process Models of Trip Chaining Behavior." *Transportation Science*, 1979, 13(4), 273-91.

10. Supernak, J., "A Dynamic Interplay of Activities and Travel: Analysis of Day Utility Profiles," in Jones, P., ed., *Developments in Dynamic and Activity-Based Approaches to Travel Analysis*, Avebury, Aldershot, England, 1988, 99-122.

11. Supernak, J., "Temporal Utility Profiles of Activities and Travel: Uncertainty and Decision Making," *Transportation Research B*, 1992, 26B(1), 61-76.

12. Supernak, J., 1988, *op. cit.*

13. Supernak, J., 1992, *op. cit.*

15

DAILY VARIATION OF TRIP CHAINING, SCHEDULING, AND PATH SELECTION BEHAVIOUR OF WORK COMMUTERS

Hani S. Mahmassani, S. Gregory Hatcher, and Christopher G. Caplice

ABSTRACT

This study addresses the day-to-day variation of three key aspects of the home-to-work commute: (1) the time of departure from home, (2) the frequency, purpose, and duration of intervening stops between home and work, and (3) the path actually followed through the network. It is based on detailed two-week diaries of actual commuting trips completed by a sample of auto commuters in Austin, Texas.

The paper examines alternative definitions and measures of variability in the context of the daily commute by comparing a "day-to-day" approach to a "deviation-from-usual" approach for defining individual switching behaviour. Models are developed to relate observed trip-chaining, route, and departure-time switching patterns to the commuters' characteristics, such as workplace conditions, socioeconomic attributes, and network-performance characteristics. In addition, this study provides valuable confirmation of insights previously suggested in stated-preference laboratory experiments involving actual commuters in a simulated traffic system.

About 25 percent of all reported commutes contained at least one non-work stop, underscoring the importance of trip-linking in commuting behaviour. These multipurpose trips are shown to influence significantly the departure time and route-switching behaviour of commuters. In general, commuters change departure times more frequently than routes, confirming previous results from laboratory experiments.

INTRODUCTION

Commuter behaviour is a central element in the formulation and implementation of demand-side peak-period congestion-relief measures, and a major determinant of the effectiveness of advanced in-vehicle information technologies. This chapter addresses the day-to-day variation of three key aspects of the home-to-work commute: 1) the time of departure from home, 2) the frequency, purpose, and duration of intervening stops between home and work, and 3) the path actually followed through the network. It is based on two-week detailed diaries of actual commuting trips completed by a sample of auto commuters in Austin, Texas. Such level of detailed commuting-trip information over such a period of time has not been available previously to travel-behaviour researchers.

Current planning procedures generally treat the work-trip commute as one of the more stable and repetitive elements of urban tripmaking. Only recently have researchers begun to highlight the extent of daily variation exhibited in various aspects of routine urban tripmaking, such as trip frequency[1]. Characterizing and interpreting such variation raises definitional and measurement issues, that can seriously influence one's conclusions[2,3,4]. In this work, we examine alternative definitions and measures for characterizing the daily variability of commuting behaviour.

The importance of trip-chaining behaviour in the work-trip commute was pointed out by Hanson[5], though it remains largely ignored in practice. Spatial aspects of trip chaining by central-city workers have also been addressed recently[6]. In this study, we address the daily variation of trip-chaining behaviour of commuters, and relate it to various attributes of the commuter, the workplace, and the commute.

One of the principal impediments to developing a larger body of knowledge on the dynamic aspects of commuter behaviour continues to be the lack of sufficient data at the desired level of richness. Such data require much effort from the respondent, especially if detailed diaries are required. This is particularly true for network-path choice, a topic on which scant link-by-link data appears to be available. The dynamics of departure-time and route-switching behaviour have been the focus of a series of interactive laboratory-like experiments involving actual commuters in a simulated traffic system[7,8]. Such experiments provide a useful approach to the study of complex human-decision systems. Nevertheless, actual observations of behaviour in one's natural setting are essential to confirm the substantive conclusions resulting from such experiments. The present study affords an opportunity to go beyond laboratory experiments and into the field, partly at least, to assess the usefulness and meaning of results obtained from such experiments.

The next section describes the survey procedure and the nature of the available data. The third section addresses the day-to-day dynamics of trip-chaining behaviour by urban work commuters. The fourth section then examines the interaction between route and departure-time switching decisions, and presents models relating switching frequency to the commuter's characteristics, such as workplace conditions (particularly lateness tolerance), socioeconomic attributes, and network-performance characteristics. Concluding comments are given in the final section.

SURVEY DESCRIPTION AND GENERAL COMMUTER CHARACTERISTICS

A two-phase mail survey was conducted in Spring, 1989, to collect data from commuters residing in the Northwest section of Austin, Texas, which is a moderately affluent suburban residential area adjacent to major technology-based manufacturing and R&D activities. Commuting in the area is not exclusively CBD-oriented, but includes a large inter- and intra-suburb component. The first phase, sent to 3,000 randomly-selected households[a], consisted of three main parts: screening questions, personal characteristics, and commuting habits. The screening questions helped identify suitable participants for the second-phase. Specifically, second-phase surveys were sent only to those commuters who indicated a willingness to participate in the second phase, worked outside their homes, and drove automobiles to work. The personal characteristics questions included job title, gender, age, type of work hours, tolerance of lateness at the workplace, and dwelling tenure (own or rent). The commuting-habits questions requested the commuters' preferred arrival times at work, travel times to and from work, traffic-report information sources, and route and departure-time switching habits. The questions related to switching habits on the survey were intended to capture the propensity of the respondent to make deliberate departure-time or route switches "specifically with traffic conditions in mind" (e.g., "Do you normally adjust the time at which you leave specifically with traffic conditions in mind?"). A total of 482 households responded yielding 638 (in some cases partially) completed surveys. Exploratory analyses can be found in Caplice and Mahmassani[9,10], including the estimation of switching models completed solely on the first phase of the survey, and also a detailed description and example of the survey instrument.

The second phase of the survey was intended to address some of the shortcomings of the first phase, which collected only static data that was influenced by the perceptions, interpretations, and recollections of the respondents. Second-phase trip-diary forms were sent to 331 out of the 638 first-phase respondents, all automobile commuters (98.8 percent of the first-phase respondents commuted by auto). This second phase, that is the focus of

[a] All daily work commuters in a household were asked to complete separate survey forms.

this chapter, contained detailed morning and evening commute-trip information for a period of two weeks (ten work days). The diary included actual trip departure and arrival times, link-by-link route descriptions, and information on the location, purpose, and timing of stops in multi-purpose chains. Commuters were also asked to provide official work start times. The diary was designed so that the participants could simply fill in the specific detailed information as it occurred. Figure 1 shows a sample trip diary form. A total of 164 respondents completed at least three days of the diary. The subsequent analysis is based on the morning (trip-to-work) portion of these diaries. The scope of our analysis is limited to those trips that begin and end with the usual home and work locations (for each commuter), resulting in 1,339 usable home-to-work trips. Table 1 contains general commuting information on the diary respondents. Figure 2 shows the frequency distribution of the number of morning commutes documented in the travel diaries. As shown, 153 of the participants completed and documented five or more commutes.

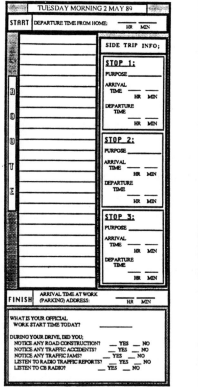
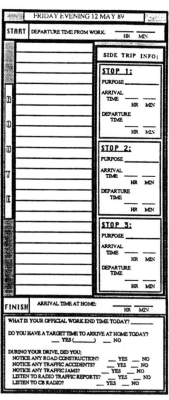

Figure 1.
Sample Trip-Diary Form

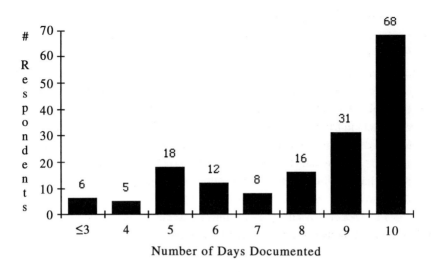

Figure 2.
Frequency Distribution of the Number of a.m.
Commutes Documented in the Diaries.

Table 1.
Characteristics of the 164 Diary Respondents

Characteristic	Value
Average usable trips per commuter (10 is maximum)	8.16
Average actual travel time to work (no intervening stops)	20.2 min
Commuters with	
Regular work hours	84.8%
Flexible work hours	10.4%
Shift/Other work hours	4.8%
Males/Females	67.7/32.3 (%)
Percentage with lateness tolerance (>5 min) at work	42.6
Average preferred arrival time before work start	15.6 min
Age	
18-29	4.3%
30-44	48.7%
45-60	42.7%
over 60	4.3%
Commuters who rent	8.5%

The diary participants prefer to arrive about fifteen minutes on average before their official work-start time. About 43 percent of the commuters reported tolerance of lateness at the workplace in excess of five minutes (an important variable for departure-time switching models). The average travel time from home to work for commuters on days with no intervening stops is 20.2 minutes. Interestingly, the mean travel time to work reported by the same commuters in the first phase of the survey is 21.4 minutes, suggesting a tendency by commuters to overestimate slightly their travel time (significant at the 1 percent level). Comparisons of the distributions of the variables in Table 1 to those in the first-phase survey indicate that the diary participants are representative of the first-phase respondents.

As is typical in any multi-phase survey effort, the overall response rate decreases with each phase, even though a 50-percent response rate was observed from those who agreed to participate in the second phase. Several limitations result from the survey methodology and corresponding small sample size. The analytical results are constrained to a particular commuting environment in one city and are not directly transferrable to other urban areas and commuting populations. Some bias may have been introduced by the fact that the detailed commuting habits of the unrepresented population of the commuting area are unknown. For example, those who agreed to participate in the trip-diary phase may be more interested in traffic conditions than others, and may in fact display different commuting habits. Because the diary participants appear to have similar characteristics to all those who completed the first-phase survey, any significant bias in these results would most likely have come from the unrepresented population of the first phase (i.e., those who filled out the first phase may not be representative of the population in this part of town as a whole).

Other limitations or potential sources of bias in the data may result from the self-reported nature of the diaries. Those with irregular commuting patterns (such as making several intermediate stops or using multiple routes) may have found these harder to record and so may not have completed the diary. Respondents may not have filled in the diary diligently during each trip as requested, in which case they would have had to rely on recall and may have forgotten about deviations from their "normal" pattern. Lastly, reported times may have been rounded such that minor variations were lost.

As in any survey, the potential limitations must be viewed in light of the valuable characteristics of the data. The trip diaries document actual commuting decisions in a real environment over a two-week time period, providing a wealth of detailed information. The diaries were designed to be user-friendly and to minimize the amount of interpretation required of the commuters. Considerable effort was made in the design of the diaries and instruction forms to minimize the identified potential sources of bias (e.g., participants were

specifically instructed *not to round* their departure and arrival times). In addition, extensive error checking on the validity of the reported information was conducted. The emphasis in this work is on capturing and characterizing commuting behaviour in our study area; however, the general trends and relationships identified should be transferrable to other urban areas and commuting populations.

TRIP-CHAINING HABITS OF COMMUTERS

An understanding of trip-linking behaviour of commuters is important to the forecasting ability of travel-demand models, and to the design and marketing of targeted transit services. Work trips with nonwork stops contribute to vehicle-miles and vehicle-hours travelled in an urban area. In the rest of this chapter, stops refer to nonwork stops (work is considered a destination, not a stop). During-work trip chains (beginning and ending at work) and home-based trip chains (beginning and ending at home), not recorded in the travel diaries, have been addressed by other authors[11]. Thus, the trip-chaining behaviour reported here does not provide a complete picture of the entire day, but represents the habits of workers during the critical commuting periods of the day. For the purposes of this chapter, the trip represented by the morning commute is referred to simply as a trip chain. Because only before-work paths are considered in this paper, all trips begin at home and end at work. These trips may or may not have intermediate stops.

Frequency, Variability, Purpose, and Duration of Observed Stops

Diary information available for each stop includes the location, purpose, arrival time, and departure time. Stop locations were coded to the nearest node (or centroid) of the Austin network. Twenty-one initial stop purposes were coded, then subsequently combined into four major groups for analysis: 1) serve passenger, 2) personal business, 3) food/ shopping/ social, and 4) other (includes meetings, medical appointments, and work-related errands). The frequency of stops during the morning commute is shown in Table 2. Only those stops made along the drive are included (stops completed during the walk from parked car to office are not considered in the analysis). A total of 337 (25.2 percent) out of 1,339 morning work trips had one or more stops. Only 5.2 percent of all morning trips had more than one stop. In comparison, Hanson found that 29.4 percent of trips by car drivers contained one or more stops between home and work[12].

Table 2.
Number of Stops on Morning Commuters

Number of stops	Frequency of trips (percent)	
none	1002	(74.8%)
one	268	(20.0%)
two	57	(4.3%)

For each commuter, a stops ratio was calculated by dividing the number of trips with stops by the total number of trips reported by that commuter. For example, a stops ratio of 0.5 indicates that the commuter stopped on exactly half of his or her morning commutes. The relative-frequency distribution of the stops ratio across the commuters in our sample is shown in Figure 3. Sixty-four commuters (38.8 percent) did not report making a stop on any of their morning commutes during the survey period (stops ratio = 0.0). At the other extreme, ten commuters (6.1 percent) made stops on every trip (stops ratio = 1.0). The distribution indicates a wide spread of values for the stops ratio, reflecting both different commuter trip-linking habits and daily variability in the commuting pattern of each participant (both inter- and intra-personal variability). Commuters with a high stops ratio (≥ 0.7) are likely to make the same stop on many trips.

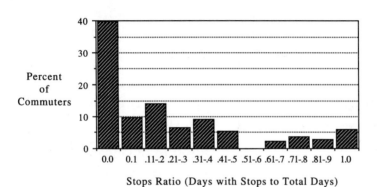

Figure 3.
Distribution of Stops Ratio for Commuters (Morning Trips)

The commuting trip to work has generally been treated as a stable, repetitive phenomenon by transportation planners. One way to assess such regularity is to quantify the number of distinct trip chains in each user's diary. A distinct trip chain here refers to an unique sequence of stop locations (or no stop), regardless of the actual route followed to link these stops. For example, a commuter who has three no-stop trips, four trips with a stop at a specific node, and three trips with a stop at another node has three distinct trip chains. One

indication of trip-linking variability is the relative frequency with which each commuter follows his or her mode (most frequent) trip-chaining pattern. Thus, for each commuter, we define the distinct trip-chain ratio (number of distinct trip-chain patterns/total trips[b]) and the mode-chain ratio (number of trips with mode chain /total trips).

Figures 4A and 4B depict the cumulative distributions of these two variables, respectively. Only 42 percent of the tripmakers had a single distinct trip-chain (and a mode-chain ratio of 1.0). The remaining 58 percent exhibited at least two chaining patterns. Of those with two or more patterns, the average distinct trip-chain ratio was 0.358. In fact, 7.3 percent of all commuters displayed a trip-chain ratio greater than 0.5. The average mode-chain ratio is 0.833. About 30 percent of the commuters had a mode-chain ratio of 0.75 or less.

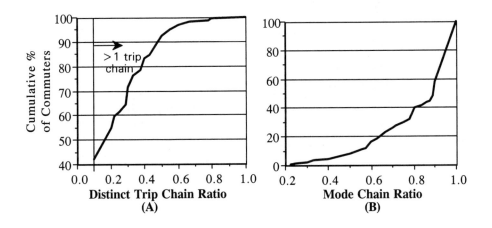

Figure 4.
Cumulative Distributions of (A) Distinct Trip Chain Ratio
and (B) Mode Chain Ratio.

Some workers routinely make a stop along their morning commute, such as a parent dropping off a child at school. The behaviour of routine stoppers may vary significantly

[b] Computed only for those with two or more trip-chaining patterns.

from that of those making non-routine stops. With this in mind, stops were separated into routine and non-routine stops. Though several definitions are possible[c], a stop was classified as routine if it is made (for a given commuter): 1) at the same location and 2) in at least three out of five commuting trips[d].

By this definition, 141 (33.6 percent) of the morning stops are routine stops. Furthermore, 134 (39.8 percent) of the morning trips with stops contain routine stops. Eighteen commuters (11 percent of all commuters, 18 percent of those with stops) had at least one routine stop. Seven of those eighteen made the routine stop on every recorded commute (in fact, 85 percent of all trips completed by routine-stop commuters contained routine stops). Of interest is the relative propensity of routine-stop commuters to make extra stops, compared to those without routine stops. Commuters made extra stops on about 14.2 percent of their trips *with* routine stops, while those without routine stops made stops on 16.5 percent of their trips. In a chi-squared test of independence, the hypothesis that these distributions are similar could not be rejected at the 40-percent significance level, indicating that those with routine stops also make non-routine stops at about the same rate as others.

The type of activities pursued at these stops and their associated durations are of direct interest in any trip-linkage analysis. Table 3 shows the frequencies and average durations for different activities completed at both routine and non-routine stops, revealing large differences between the two types of stops. As expected, the serve-passenger activity (or purpose) tends to be a routinely-pursued stop, while personal business and other are predominantly non-routine stops. A test for independence leads to a clear rejection of the null hypothesis that the stop-purpose frequency distributions are similar for the two stop types ($x^2= 63.82$, $df =3$, $p<0.001$). As indicated, routine stops are typically shorter than non-routine stops. These differences are statistically significant for all trip purposes (at the one percent level for all, personal business, and other; and at the 10 percent level for food/shop/social) other than serving passengers.

[c] Huff and Hanson (1990) used core stops to describe a similar phenomenon and studied the effect of three different core-stop definitions.

[d] As it turned out, this definition was equivelent to ensuring that the snae stop purpose (by the four category groupings) was also pursued at tht location, although this need not be true in general.

<div align="center">

Table 3.

Stop Frequency and Average Duration (Minutes) by Stop Type and Purpose

</div>

		Stop Purpose				
	Stop Type	Serve Pax	Personal Bus	Food/Shop	Other	All
Num. Of Stops	Non-Routine	53 (19.1)	114 (41)	67 (24.1)	44 (15.8)	278
(%)	Routine	75 (53.2)	17 (12.1)	36 (25.5)	13 (9.2)	141
Avg. Duration	Non-Routine	3.5 (5.0)	4.3 (4.3)	10.4 (11.2)	55.4 (42)	13.6
(Std. Dev.)	Routine	3.4 (3.9)	1.3 (0.8)	6.8 (6.8)	21.8 (24)	5.7

Daily stop time and added route distance

In addition to the duration of stops of various types, the total time devoted to stops relative to the commuter's trip length are important characteristics of commuter behaviour. In this paper, *stop time* refers to the total time spent at all stops on a given commute trip, while *stop duration* refers to the time spent at an individual stop.

Following the differentiation between routine and non-routine stops, the total stop time for each trip can be broken into two categories: routine and non-routine stop time. By definition, trips without routine stops do not have any routine (R) stop time, but may only have non-routine (NR) stop time. Alternatively, trips with routine stops can have both routine and non-routine stop time. These trips have non-routine stoptime only if stops are made in addition to the routine stop(s) (19 trips in the diaries have both of these stop times). Table 4 contains the relative-frequency distribution of trips with stops in routine (R), non-routine (NR), and total stop-time intervals (in minutes). As shown, the stop-time distribution for routine-stop trips has a lower central tendency than the distribution for trips without routine stops. The mean stop time for trips without routine stops is 17.2 minutes vs. 7.8 minutes for routine-stop trips, whereas the non-routine stop time mean is 16.8 vs. 5.9 for routine-stop time. Furthermore, tests indicate that the total stop-time distribution is significantly different for trips with and without routine stops ($\chi^2 = 25.7$, $df = 4$, $p<0.001$), and that the routine and non-routine total stop-time distributions are significantly different ($\chi^2=371$, $df = 4$, $p<0.001$).

Table 4.

Percentage of Trips *with Stops* in Stoptime Groups (Total Stoptime Unless Otherwise Specified; R = Routine; NR = Non-Routine).

Category	≤ 2	3-5	6-9	10-19	20-39	≥ 40	total trips[a]
			Stoptime Group (minutes)				
all trips	37.0	20.9	11.8	12.7	10.0	7.6	330
w/o R stops	29.5	24.5	12.0	10.0	13.0	11.0	200
w R stops	48.5	15.4	11.5	16.9	5.4	2.3	130
R stoptime	55.4	12.3	10.8	16.1	4.6	0.8	130
NR stoptime (all trips)	30.6	24.7	12.3	9.6	11.9	10.9	219
NR stoptime (w R stops)	42.1	26.3	15.8	5.3	0	10.5	19

[a] Total trips with non-missing stoptime information.

The additional travel distance that a commuter is willing to travel in order to make stops has been shown to be correlated positively with stop duration[13]. The rationale for this behaviour is that commuters are willing to travel long distances only if the stop location offers a large benefit to compensate for the large travel distance, that in turn, leads to a longer stop duration[14]. To study this relationship with the diary information, we define the added travel distance for a trip with stops as the total trip distance minus the minimum trip distance for a given commuter. The reason for using the minimum trip distance is that it gives a base value of a shortest-distance route travelled by an individual from home to work. An added distance of zero indicates that the commuter made the stop(s) on his or her shortest distance path. Table 5 shows the relationship between average stop time and added distance and contains relative frequency information on additional distance for our sample.

Table 5.
Percentage of Trips with Stops and Average Stoptime (Minutes) in Each Added Distance Category, by Trip Type. (R = Routine).

Trip Category	Added Distance Category (miles)						
	0	.01-.99	1-2.99	3-7.99	8-14.99	≥15	Total[a]
All Trips	43.9	23.6	13.3	12.7	3.7	2.8	330
(Avg. Stoptime)	(6.8)	(9.7)	(19.7)	(28.7)	(42.5)	(13.0)	(13.5)
Trips w/o R Stops	39.5	24.0	13.0	14.5	4.5	4.5	200
	(7.4)	(13.2)	(27.6)	(35.4)	(39.0)	(13.0)	(17.2)
Trips w/R Stops	50.8	23.1	13.8	10.0	2.3	0.0	130
	(6.1)	(4.1)	(8.3)	(13.6)	(53.0)		(7.8)

[a] Trips with non-missing values for stoptime.

As expected, extra distance and stop time are positively correlated, up to a point (the over 15-mile category shows a decrease). Notice that this trend is less apparent for routine-stop trips, possibly another indication that these trips should be analyzed separately from other trips with stops. Interestingly, the relative-frequency distributions of stop time and added distance appear to be quite similar for the given trip types. Less added distance is typically incurred on trips with routine stops compared to trips without routine stops (this can be misleading, though, because some commuters have a stops ratio of one, in which case the added distance is more likely to be zero). However, nearly 40 percent of trips without routine stops are made on a minimum-distance route. Significant differences at the 6 percent level occur in the added-distance category distribution for trips with and without routine stops $\chi^2 = 7.52$, $df = 3$, $p = 0.057$). Clearly, most trips with stops in the morning do not take commuters more than one mile from their shortest driven path during the survey, and only 19.2 percent of all trips with stops take commuters more than three miles from their minimum-distance routes.

This subsection has explored the morning-commute trip-linking behaviour of the participants. The frequency, repetitiveness, purpose, and duration of nonwork stops on the way to work have been examined in order to illustrate trip-chaining variability. The positive correlations between total stop time and extra route distance, previously identified in the literature, were verified further for the sample of Austin commuters. The analysis further indicates that behaviour exhibited by users with routine stops varies sharply from the behaviour of those without routine stops. In the following subsection, a Poisson-regression

model is introduced to relate the frequency of stops observed during the morning commute to the characteristics of the commuter.

Poisson-Regression Model of Daily Stop Frequency

Insights into the factors that influence trip-chaining behaviour in connection with the morning commute would contribute to the ability to develop and analyze demand-management policies. To this end, a Poisson-regression model of the number of daily stops made by commuters is described in this section. In light of the nature of the process and the inherent randomness in the number of stops made by different commuters, the Poisson distribution provides a reasonable description of the total number of stops made by a commuter during the study period. This distribution is particularly appropriate because the dependent variable naturally assumes non-negative integer outcomes, including a relatively large number of commuters with zero stops (a problem that makes OLS regression biased)[15].

One difficulty encountered here, and in surveys of this type, is that participants may have completed an unequal number of days for analysis (e.g., some participants completed the full ten diary trips, but for various reasons others completed less than ten). Standard Poisson-regression applications assume an equal number of trials. In our work, the model was derived for different numbers of observed days per commuter. For commuter i, let d_i denote the total number of days recorded, y_i the total number of stops made, $l_i = E(y_i)$, and a_i the mean number of *daily* stops, i.e., $a_i = l_i / d_i$ The model postulates that the mean daily-stop frequency for commuter i can be related systematically to the characteristics of the commuter. Assuming that $log\ a_i = bX_i$, then $log\ l_i = log\ q_i$ $l_i = bX_i + log\ d_i$, where b is a vector of estimable parameters and X_i is a vector of commuting and socioeconomic attributes for individual i. Note that the value of $exp\ (bX_i)$ represents the mean *daily* number of stops for individual i. The probability of a commuter making y_i stops in d_i days is given by

$$P(y_i) = \exp \frac{(-\lambda_i)\lambda_i^{y_i}}{y_i^l}$$

The parameter vector b can be estimated by the maximum-likelihood method[e]. The log-likelihood function for the above specification (substituting for l_i) is given by

[e] The user-defined maximum likelihood estimation technique of the SST statistical package was used for model setin\mation. The same methodology can also be applied to switching models such as departure-time or route switching models, discussed in the next section.

$$\log L(\beta) \;=\; \sum_{i} \left[-\log y_i! \;-\; \exp(\beta x_i + \log d_i) \;+\; y_i(\beta x_i + \log d_i) \right]$$

Table 6 provides the estimation results of the daily-stop frequency model. All the coefficients are statistically significant. The log-likelihood value for a specification consisting of only a constant term (i.e., that all observations in the sample have the same mean daily-stop frequency) is also given. The results highlight the importance of socioeconomic characteristics, travel time to work, and other attributes of the commute in the trip-chaining behaviour of commuters. Frequency of stops is highly correlated with travel time, probably because long commutes offer more stopping opportunities, and commuters facing long work journeys may be more concerned with meeting stop needs during their work-trip than those with short commutes. Female commuters have a higher propensity to make stops than males, which is consistent with findings that gender affects multi-purpose travel behaviour[16]. Tripmakers forty-five years and older appear less likely to make frequent stops than younger drivers. Workers who preferred to arrive at work at least fifteen minutes prior to the official work start time are somewhat more likely to make stops during commutes.

Several workplace characteristics influence the average daily-stop frequency of commuters. Workers with 8:00 a.m. or earlier work-start times are likely to make fewer stops than those with later work-start times, which conforms to intuition in that many potential activity centers do not open until 8:00 a.m. or later. Workers in low-power, schedule-driven jobs (clerical workers, labourers, etc.) make fewer stops than other workers. Job power determines workplace flexibility, which in turn influences stop behaviour. The walk time from parked car to office is a significant explanatory variable in the model. Those with long walks are less likely to make stops along their drive. Possible explanations for this include: 1) those with long walks at the destination do not wish to add more time to their commute by making stops, and 2) commuters with long walks may encounter stopping opportunities during their walks (e.g., to buy a newspaper or to use an automated bank teller), which may substitute for stops along their drive. These post-trip stops were not captured in the diaries. Hanson has shown that a large proportion of work-linked stops are made on foot[17].

Table 6.
Daily Stop Frequency Model for Trip to Work.

Independent variable	Estimated coefficient	t-statistic
constant	-1.739	-14.78
average no-stop travel time (minutes)	0.066	14.59
gender (1 if male, 0 if female)	-0.386	-5.41
45 and over age indicator (1 if ≥ 45)	-0.316	-5.04
early work start indicator (1 if W.S.≤ 8:00)	-0.156	-2.05
low power job type indicator (1 if yes)	-0.535	-6.66
preferred arrival time variable (min; 0 if PAT≤15; [PAT-15] if 15<PAT≤60; and 45 if PAT> 60)	0.010	3.33
walk time from parked car to office (minutes; WALKTM if WALKTM≤ 10, 10 if WALKTM>10)	-0.171	-7.81

Log-likelihood at zero	-808.93	Log-likelihood at convergence	-336.58
Log-likelihood for constant only	-394.38	Number of observations	144

[a] If stops ratio = 1.0, reported travel time is used.

The above model considers only stops made along with the home-to-work commute, and does not address interactions with trips made at other times of the day. A possibly important variable that was not available to this study is the number of dependents living in the household. Another might be the density of stopping opportunities near home, work, and along the commute. However, these are probably controlled for by the fact that all observations were selected from the same section of the city. On the other hand, the model provides a plausible explanation of the factors affecting daily-stop frequency along the commute, and is based on detailed diaries of actual behaviour rather than stated preferences or phone surveys.

VARIABILITY OF DEPARTURE TIME AND ROUTE DECISIONS

Critical to the modelling of commuter behaviour in transportation systems are the mechanisms by which users choose routes and departure times, and the factors that determine the variability of these decisions from day to day. Mahmassani and co-workers have addressed these decisions in prior work, focussing particularly on the changes in these decisions in response to experienced congestion in the system, as well as exogenously-supplied information on the system's performance[18,19,20]. This prior work has been based primarily on laboratory-like experiments under controlled conditions. In the present study, commuter decisions are observed in an uncontrolled environment, in which they are influenced by a multitude of interacting factors, including trip-chaining considerations, that were controlled for in the laboratory experiments. In this light, we analyzed the departure times and street paths taken by each commuter for the journey to work over the two-week survey period.

Exploratory Analysis

A departure-time switch can be defined in several ways. In previous work, Mahmassani, *et al.* defined a departure-time switch in a dynamically-evolving context as a day-to-day change of a certain magnitude (e.g., five minutes)[21]. Mannering, *et al.* described a time change as a deviation from a normal departure time with the intent of avoiding traffic congestion and/or decreasing travel time[22]. Given the large amount of actual departure-time information in our study, we perform a comparison of alternative switching definitions and thresholds, and illustrate the dependence of certain behavioural conclusions on these definitional issues.

Two ways of capturing departure-time switching behaviour are discussed here: 1) switching from a commuter's median departure time (median switching), and 2) switching from a user's previous day's departure time (day-to-day switching). The former is intended to capture deviations from a usual daily routine. The median was chosen for this purpose, instead of the mean, to avoid the undue influence of outliers in a commuter diary. By the day-to-day definition, the current day is considered a switch from the previous day if the absolute difference between their respective departure times exceeds (or meets) some minimum threshold.

We also explore two definitions of a route switch. First, we define a mode-route switch as a deviation from the normal or mode (most frequently used) network route (a route is an unique sequence of network nodes), in which the commuter follows a different-from-usual set of nodes to arrive at work. This criterion recognizes the observed dominance of one route over all others for most commuters. Second, we define a day-to-day route switch when the chosen route is different from the previous day's route (again using the network

paths to define routes). In order to minimize capturing trivial route switches, minor deviations around the trip ends (neighborhood streets) or a network node (e.g., a minor cut-off street to avoid an intersection) are not considered route switches.

Results of the departure-time and route-switching analysis are presented in Table 7. Departure-time switching thresholds of three, five, and ten minutes are considered: deviations (absolute values) greater than or equal to the thresholds are considered switches. We attempt to control for departure-time switching that is directly induced by a different work start time by limiting the analysis to commuter trips with the same work-start time (for median switching, definition 2) or trips in which the work-start time is within five minutes of the previous work start (for day-to-day switching, definition 4)[f].

Clearly, users engage in a substantial amount of departure-time switching. Even at the 10-minute level from a median departure time, 20 percent of the trips are switches. As expected, the day-to-day definition indicates a higher percentage of switches than does the median definition. The 3-minute threshold tends to confound what may be considered noise with actual intended changes in departure-time. The 5- and 10-minute thresholds appear to be the most plausible for the purpose of this study. The results in this table provide a striking illustration of the observation made by Huff and Hanson that our assessment of variability and repetition in individual travel behaviour can be colored by the specific measurement used[23]. Findings indicate that the aggregate rate of switching remains about the same over the 10-day period, although daily oscillations around the average rate are detectable. For example, the range of the daily switch rate is about 14-15 percent for the median and 10-11 percent for the day-to-day definitions. Furthermore, the cumulative departure-time distribution exhibits daily variability over the 10-day period. For a given departure-time, the range of the corresponding value of the daily cumulative departure distribution varies from 1.9 to 9.5 percent.

[f] By keeping trips with a work start within five minutes of the previous one, we allow more trips for those with flexible hours to be included.

Table 7.
Results of Departure Time and Route Switching Analysis. (WS=Work Start)

Percent of trips that are switches

Departure time switching

Definition	Switch threshold (min)			
	3	5	10	Considered trips
1. median	63.8	47.7	28.3	1329
2. median (WS controlled)	58.3	40.5	20.1	1077
3. day-to-day	73.2	62.1	42.1	1167
4. day-to-day (WS controlled)	69.8	57.0	34.4	965

Route switching

Definition	% Switches	Considered trips
1. mode-all days	17.5	1339
2. mode-days with no stops only [a]	6.5	1002
3. day-to-day	26	1175

Joint switching

Definition	Switch threshold (min)			
	3	5	10	Considered trips
1. median/mode [b]	12.6	10.5	7.3	1329
2. median/mode (WS cont)	9.7	7.5	4.3	1077
3. day-to-day [c]	21.2	19.3	15.3	1167
4. day-to-day (WS cont)	17.5	15.5	11.6	965

[a] Mode routes were redefined by selecting only days with no stops.
[b] Median definition used for departure time switch, mode (all days) definition used for route switch.
[c] Day-to-day definition used for departure time and route switch.

Note that the above results correspond to actual departure-time decisions observed in the network. Therefore, changes in departure-time are not limited to those due to a particular reason, as in the work of Mannering that specifically considered departure-time switching

in order to avoid congestion or to decrease trip travel time[24]. The underlying reason(s) for particular departure-time switches are not addressed here (e.g., wanted to avoid congestion, woke up later than usual, had to make a stop). One of the useful contributions of this study is that it captures actual decisions of commuters in an uncontrolled environment, yielding a characterization of the natural variability of these decisions in a real system. For this reason, the frequency of actual departure-time switches will be higher than that corresponding to switches made exclusively to avoid congestion. In a commuter phone survey in Seattle, Mannering found that, on average, users reported making only 2.32 departure-time changes (from the normal departure-time) per month with the intent of avoiding traffic congestion[25]. Under our most conservative switch definition (10-minute median with controlled work start), our data indicate an average of at least four actual switches per month.

Route switching is not as frequent as departure-time changing for the morning commutes. Less than one in five trips utilize a non-mode (i.e., other than the usual) route, clearly reflecting the existence of a usual route for most workers. When trips with stops are excluded from the data, non-mode trips account for only 6.5 percent of the remaining trips. As in departure-time switching, the day-to-day definition captures more switching (26 percent of all trips). About 52 percent of all trips with stops are actually mode routes, which supports the concept of routine stops and the fact that some stops are made along one's usual (non-stop) itinerary. In addition, 22.2 percent of all trips with stops follow the same routes as those taken on days with no stops. The lower frequency of route switching relative to departure-time switching is consistent with the results of stated-preference experiments under simulated traffic conditions[26].

The fraction of trips with both route and departure-time switches is also shown for the various definitions. The highest percentage of trips in which such joint switches take place is 21.2 percent, obtained using the 3-minute day-to-day departure-time and the day-to-day route-switching definitions. The lowest percentage is 4.3 percent, obtained with the 10-minute median departure-time (work start controlled) and mode route definitions. The median/mode definition reflects switching from a usual routine while the day-to-day definition would also capture changes relative to non-routine days. Consistently with the stated-preference experiments of Mahmassani and Stephan, departure-time and route-switching decisions are not independent of each other, as confirmed by Chi-squared tests for the various definitions. The tests confirm that the dependence increases as the departure-time switch threshold increases (as reflected in higher computed Chi-squared values).

The values in Table 7 do not highlight differences across individuals, especially because different commuters may have reported different numbers of trips during the survey period.

Switching ratios were obtained by dividing the number of switches by the number of possible switches, for each individual and for each of departure-time, route, and joint switching (a ratio of 1.0 indicates a switch on every possible day). Figure 5A depicts the differences between departure-time switching definitions by showing the cumulative relative frequency distributions (across commuters) of the alternative departure-time switching ratios (for the controlled-work start-time case). For example, the percentage of workers never switching departure-time is 38 percent according to the 10-minute median definition, 30 percent by the 10-minute day-to-day definition, 13 percent by the 5-minute median definition, or seven percent by the 5-minute day-to-day definition. These discrepancies underscore the importance of definitional issues with regard to departure-time switching. The cumulative distributions of three route-switching ratios are given in Figure 5B. When all days are analyzed, 46 percent of the users never switch from the mode route. Only eight percent switch with a frequency over more than one in two days. Furthermore, very little switching relative to the mode route occurs if only no-stop routes are considered, because 79 percent of the users never switch routes under these circumstances, and only two percent have a switch ratio of over 0.5.

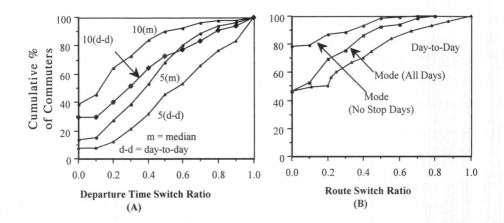

Figure 5.
Cumulative Distributions of (A) Departure-Time and (B) Route
Switching Ratios by Definition (Departure-Time Switching
Is Controlled for the Work Starting Time).

Interaction with Trip Chaining

A commuter needing to make a non-routine stop(s) on the way to work will generally incur the stop duration(s) and the stop-induced extra travel time. Accordingly, this commuter may decide to shift departure time at home, arrival time at work, or both. With respect to route choice, users may have to deviate from their mode route in order to make a non-routine stop(s). We address the impact of trip chaining on departure-time and route switching behaviour in two ways. First, we test whether trips with stops are more likely to be switches. Second, we test the explanatory power of the stops ratio in the daily-switching models of the next section.

To perform the first test, the Chi-squared statistic was computed for the hypothesis that the presence of a stop on a given commute is independent of whether that trip is a switch. For the day-to-day definition, the presence of a stop on the current or previous trip results in the stop-influence on the current trip. The results led to the rejection of the independence hypothesis with over 90-percent confidence for all departure-time switching definitions. The independence hypothesis was rejected for both route and joint switching, confirming that trips with stops or stop-influence have a higher likelihood of inducing a switch in departure-time, route, or both. Table 8 summarizes the percentage of trips with stops conditional on the various switch indicators. As shown, the proportion of trips with stops increases as the threshold increases. For all categories, this proportion is larger than the corresponding unconditional proportion. At least 67 percent of all route switches and 72 percent of all joint switches contain stops, indicating the importance of trip chaining in these behaviours.

Table 8.
Impact of Trip Chaining on Switching Behaviour (Uncontrolled Work Start).

Threshold	Median Departure Time	Day-to-Day Departure Time	Mode Route	Day-to-Day Route	Joint Median-/Mode	Joint Day-to-Day
3 min.	0.269	0.389			0.726	0.810
5 min.	0.283	0.408	0.676	0.801	0.764	0.849
10 min.	0.314	0.436			0.794	0.855

Daily Departure-time and Route Switching Models

In this section, we investigate the effect of the characteristics of the commuter and of the commuter environment on the frequencies of departure time, route, and joint switching, respectively. Poisson-regression models of these switching behaviours are developed and estimated using the methodology described in the earlier section on Poisson-regression

models. The stops ratio (number of trips with stops to total trips) is used as an explanatory variable in the model specification. Daily-frequency models are estimated to account for varying numbers of trips across commuters.

Because the alternative departure-time definitions exhibit the same general trends, the models are presented only for the day-to-day switches that exceed a 10-minute threshold, for days with the usual working start time. Table 9 contains the corresponding parameter estimates.

Table 9.
Daily 10-Minute Day-To-Day (WS) Departure Time Switching Frequency Model, Calibrated for Those with at Least Three Switching Opportunities.

Independent variable	Estimated coefficient	t-statistic
constant	-2.019	-11.66
lateness tolerance at workplace (1 if over 5 min)	0.813	5.14
flexible work hours indicator (1 if yes)	0.604	2.96
low power job type indicator (1 if yes)	-0.393	-2.65
stops ratio, if less than 0.75	1.651	4.89
mode route travel time variability indicator	0.246	1.95
(1 if std. deviation of $tt \geq$ 3 min)		
high preferred arrival time indicator	0.371	2.31
(1 if PAT \geq 15 min <u>and</u> has no lateness tol.)		
young male with no lateness tol. indicator	0.609	3.65
(1 if male, less than 45, and no lateness tol.)		

Log-likelihood at zero	-543.56	Log-likelihood at convergence	-241.83
Log-likelihood for constant only	-283.39		
Number of observations	134		

Several workplace characteristics are important in the model. Commuters with flexible work hours tend to switch departure times more often than those with regular or shift schedules (even though the estimation-data set controlled for work-start time). Although flexible work hours may help to spread the peak period, they may also increase the variability of these periods. Commuters with low-power, schedule-driven jobs are less likely

to switch departure times than others, while those with lateness tolerance at work are more likely to switch. Note that the first-phase survey results indicated that these same commuters were *less* likely to switch departure times *with traffic conditions in mind*. This seeming contradiction arises from the fact that, while those with lateness tolerance need not be as concerned with traffic as those without such tolerance, their actual departure-time switching behaviour reflects their ability to meet their needs better through more flexible scheduling of stop activities in connection with their commute.

Several commuter and commute-related attributes are also significant in the departure-time switching model. Those with a preferred arrival time greater than or equal to fifteen minutes and no lateness tolerance have a higher tendency to switch than others. A substantial safety margin before the work start enables the constrained commuter to absorb changes in departure time and still get to work on time. We did *not* find a similar effect for those with lateness tolerance. In terms of socioeconomic attributes, young males without lateness tolerance have a greater propensity to switch than others. Presumably, these users exhibit more risk-seeking behaviour than others. The significance of this interaction variable illustrates that the lateness tolerance indicator has a different effect on the switching behaviour of the younger males in the sample, which was not found for the other gender and age subgroups. As expected, trip chaining increases switching behaviour: the stops ratio is positively correlated with time switching, but only up to a point. Stop ratios higher than 0.75 usually reflect routine stopping, which actually decreases departure-time variability to the point that the ratio loses its explanatory power. Lastly, those with moderately high travel-time variability on the most often-used route tend to switch times of departure more frequently than others.

Poisson-regression estimation results for the daily frequency model of route switching (from the mode route) are presented in Table 10. The stops ratio is clearly the most statistically significant determinant of route switching. As expected, the route-switching frequency increases as the stops ratio increases, again up to a point (0.75 in this model). Beyond this threshold, the likelihood of route switching actually decreases (negative coefficient for additional stop ratio), because routine stoppers (with high stop ratios) may travel the same route on most trips. The only workplace and socioeconomic variable with significant explanatory power in this model is a combination of lateness tolerance and gender. Males with lateness tolerance at the workplace switch routes less often than others, although the statistical significance of the coefficient is not entirely convincing. Another interaction variable captures the attributes of the commute and the network: users with medium length, variable travel times, having good access to alternative routes have a higher propensity to switch routes than do other commuters. This variable complements first-phase findings which indicated that short or very long trips are not likely to display much route switching[27,28]. Further, it indicates that those with high travel-time variability on mode

routes are willing to switch routes (possibly in hope of finding a more reliable route). The inclusion of the alternative-routes indicator is based on the first-phase analysis that identified certain commuting corridors in the Austin network as having meaningful major-route alternatives. We find that the explanatory power of these three commute descriptors (length, variability, and access) is significant only when they are combined.

Table 10.
Daily 10-Min Day-To-Day (WS) Departure Time Switching Frequency Model, Calibrated for Those with at Least Three Switching Opportunities.

Independent variable	Estimated coefficient	t-statistic
constant	-2.432	-24.34
stops ratio, if less than 0.75 (0.75 if ratio ≥ 0.75)	2.694	11.10
additional stop ratio over 0.75	-4.186	-5.40
(ratio-0.75, if ratio ≥ 0.75)		
males with lateness tolerance indicator	-0.237	-1.69
(1 if male and has over 5 min tolerance)		
mode route travel time variability and access indicator	0.589	2.83
(1 if std. deviation of tt≥ 3 min, additional routes are available, and		
avg. tt is between 15 and 30 minutes)		

Log-likelihood at zero	-981.48	Log-likelihood at convergence	-243.34
Log-likelihood for constant only	-293.26		
Number of observations	160		

Estimation results for the day-to-day joint switching-frequency model are in Table 11. As expected, the explanatory variables in the joint model are derived from the two individual switching models. The stops-ratio variable is specified as in the route-switching model, with similarly signed but larger coefficients, possibly indicating that the stops ratio has even greater influence on joint switching. The lateness-tolerance and preferred arrival-time indicators, significant in the departure-time switching model, are significant here as well. The sole transportation system variable in the model is the mode route travel-time variability indicator, which in some form is also contained in the two other models. Again, those who experience highly variable commuting times tend to make more joint switches than others. Lastly, the only socioeconomic variable to be included is a binary variable

which indicates that females over age 44 exhibit a higher joint-switching frequency than others. Examination of this group did not entirely explain the underlying reason for this effect, that may be due to particular activity patterns.

Table 11.
Daily Joint Switching Frequency Model for Trip to Work, Calibrated for Those with at Least Three Switching Opportunities.

Independent variable	Estimated coefficient	t-statistic
constant	-4.477	-12.73
stops ratio, if less than 0.75 (0.75 if ratio \geq 0.75)	3.427	7.27
additional stop ratio over 0.75	-11.761	-4.74
(ratio-0.75, if ratio \geq 0.75)		
lateness tolerance indicator (1 if late tol. >5min.)	1.564	4.50
high preferred arrival time indicator	1.313	3.70
(1 if PAT \geq 15 min <u>and</u> has no lateness tol.)		
mode route travel time variability indicator	0.479	1.91
(1 if std. deviation of tt\geq 3 min and avg. tt is between 15 and 30 minutes)		
female over age 44 indicator (1 if yes)	0.646	2.55

Log-likelihood at zero	-751.76	Log-likelihood at convergence	-128.41
Log-likelihood for constant only	-174.65		
Number of observations	133		

The above three daily switching models provide helpful insights into the factors affecting commuter-switching behaviour and peak-period variability. The workplace, commuter, trip-chaining, and transportation-system variables exhibit plausible signs and significance in all three models. The significance of the stops-ratio variable suggests that more attention should be placed on recognizing and understanding trip-chaining behaviour in a commuting context (as well as overall). The limited availability of personal and socioeconomic exogenous variables, such as marital status and family responsibility, preclude their inclusion in the model specification.

CONCLUDING REMARKS

This analysis has provided insight into the trip-chaining, scheduling, and route-choice behaviour of commuters for the trip from home to work. The presentation focused on the observed variability of the work trip, which has traditionally been treated as a stable and repetitive phenomenon. About 25 percent of all reported commutes contained at least one nonwork stop, underscoring the importance of trip linking in commuting behaviour. Furthermore, trip chaining significantly impacted switching behaviour: trips with stops were much more likely to involve switching than trips without stops (or stop influence). In general, commuters tend to change departure times more frequently than routes, possibly a reflection of a limited route-choice set in comparison with a seeming continuum of available departure times.

Emphasis was placed on the definitional issues that arise when studying these behaviours. The analysis utilized both a day-to-day and a deviation from normal approach to switching behaviour. The day-to-day definition captured a higher frequency of switching than did other definitions. Future studies of multiday trip data should clearly identify the switching definitions and thresholds, so that interpretation of reported switching behaviour can be placed in context with the trends shown here.

The models of daily-switching frequency related the characteristics of the commuter, workplace, and transportation system to the switching behaviour exhibited by the users. The stops ratio and commuting trip-time variability are important determinants in all reported switching models. Workplace and commuter-preference variables such as lateness tolerance and preferred arrival time otherwise dominate the departure-time and joint-switching behaviour. Socioeconomic variables such as gender, age, and interaction variables containing gender also display explanatory power, but their effect is not as clear cut. Other personal and household characteristics may be important, but human behavioural considerations may obscure forming theoretical expectations for their impact.

The limitations of the data are recognized by the authors. The analysis is based on a small sample of commuters, and results cannot be extrapolated directly to larger samples or different urban areas. Also, the self-reported nature of the diaries leads to some unavoidable inaccuracies. Nevertheless, the insights learned from this study are plausible and important in that actual behaviour was observed over a two-week period rather than one or two days only. Furthermore, the documentation of actual switching habits is subject to fewer problems than a phone or mail survey in which commuters are asked confusing switching questions that may be subject to numerous interpretations, and which involve recall by the respondent. In addition, this survey has provided valuable confirmation of insights

previously suggested in stated-preference experiments involving actual commuters in a simulated traffic system. With demand-side congestion-relief measures continuing to gain urgency in urban areas, it seems that further attention should be directed at commuting and tripmaking fundamentals in an attempt to aid in the design of these measures.

ACKNOWLEDGMENTS

This paper is based on research initiated under the sponsorship of the General Motors Research Laboratories and partially funded through the Texas Advanced Technology Program and the Texas State Department of Highways and Public Transportation. The authors have benefitted from the suggestions of Drs. Robert Herman, Richard Rothery, C. Michael Walton, and Chee-Chung Tong. The views expressed in this paper are solely those of the authors.

REFERENCES

1. Pas, E. and F. Koppelman, "An Examination of the Determinants of Day-to-Day Variability in Individuals Urban Travel Behaviour," *Transportation* , Vol. 13, 1986, pp. 183-200.

2. Hanson, S. and J. Huff, "Classification Issues in the Analysis of Complex Travel Behaviour," *Transportation*, Vol. 13, 1986, pp. 271-293.

3. Hanson, S. and J. Huff, "Systematic Variability in Repetitious Travel," *Transportation*, Vol. 15, 1988, pp. 111-135.

4. Huff, J. and S. Hanson, "Measurement of Habitual Behaviour: Examining Systematic Variability in Repetitive Travel," in Jones, P. (ed), *Developments in Dynamic and Activity-Based Approaches to Travel Analysis*, Avebury, Aldershot, 1990, pp. 229-249.

5. Hanson, S., "The Importance of the Multipurpose Journey to Work in Urban Travel Behaviour," *Transportation*,1980, pp. 229-248.

6. Kitamura, R., K. Nishii, and K. Goulias, "Trip Chaining Behaviour by Central City Commuters: A Causal Analysis of Time-Space Constraints," in Jones, P. (ed), *Developments in Dynamic and Activity-Based Approaches to Travel Analysis*, Avebury, Aldershot, 1990, pp. 145-170.

7. Mahmassani, H. and R. Herman, "Interactive Experiments for the Study of Tripmaker Behaviour Dynamics in Congested Commuting Systems," in Jones, P. (ed), *Developments in Dynamic and Activity-Based Approaches to Travel Analysis*, Avebury, Aldershot, 1990, pp. 272-298.

8. Mahmassani, H., G. L. Chang, and R. Herman, "Individual Decisions and Collective Effects in a Simulated Traffic System," *Transportation Science*, Vol. 18, pp. 362-384.

9. Caplice, C. , "Analysis of Urban Commuting Behaviour: Switching Propensity, Use of Information and Preferred Arrival Time," unpublished M.S. thesis, 1990, Department of Civil Engineering, University of Texas, Austin, Texas.

10. Mahmassani, H., C. Caplice, and C. M. Walton, "Characteristics of Urban Commuter Behaviour: Switching Propensity and Use of Information," *Transportation Research Record,* Vol. 1285, 1990, pp. 57-69.

11. Kitamura *et al., op. cit.*

12. Hanson, S., *op. cit.*

13. Kitamura *et al., op. cit.*

14. *Ibid.*

15. Mannering, F., "Poisson Analysis of Commuter Flexibility in Changing Routes and Departure-times, " *Trnaportation Research,* Vol. 23B, No. 1, 1989, pp. 53-60.

16. Hanson, S. and P. Hanson, "The Impact of Married Womens Employment on Household Travel Patterns: A Swedish Example," *Transportation,* Vol. 10, 1981, pp. 165-183.

17. Hanson, *op. cit.*

18. Mahmassani and Herman, *op. cit.*

19. Mahmassani *et al.*, 1986, *op. cit.*

20. Mahmassani, H. and D. Stephan, "Experimental Investigation of Route and Departure-time Dynamics of Urban Commuters," *Transportation Research Record* , Vol. 1203, 1988, pp. 69-84.

21. Mahmassani and Herman, *op. cit.*

22. Mannering, *op. cit.*

23. Huff, *op. cit.*

24. Mannering, *op. cit.*

25. *Ibid.*

26. Mahmassani and Stephan, *op. cit.*

27. Caplice, *op. cit.*

28. Mahmassani, Caplice, and Walton, *op. cit.*

16

SATCHMO: A KNOWLEDGE-BASED SYSTEM FOR MODE-CHOICE MODELLING

Laurent Hivert

ABSTRACT

In mode-choice modelling, the realistic understanding of individual behaviour requires an explicit integration of various contextual factors, as well as variables describing individual perception, attitudes, and situational constraints. However, such external factors are often missing (or only implicit) in conventional econometric modelling. On the other hand, phenomenological approaches based on in-depth comprehension of behaviour are seldom operational. The new approach presented in this chapter, SATCHMO, aims at going beyond this contradiction. By using a constraint-based logic, this disaggregated knowledge-based system attempts to reproduce and restrain individual choice universes automatically, detecting captivities and, if possible, determining actual choices. It formalizes the situational and objective constraints system (socioeconomic, geographic, temporal, vehicle availability) explicitly, that affect usual mode choices made by commuters, by taking into account interrelations within households. Two kinds of rules are applied to each fact base representing a household: first, certain rules aim at reducing the universe of modes of each commuter; and, second, uncertain rules aim at estimating choice probabilities.

We first describe SATCHMO's framework, after which we present one of its possible applications. Using data from any classical household survey, SATCHMO allows us to eliminate, with very little error, some of the possible choices, ending in a formalized reliable system for the restriction of choice sets, i.e. for the manifestation of captivity. Therefore, such a tool can be used in two different ways, either as an independent simulator, or as a complement to a logit model:

- As a simulator, SATCHMO enables us to evaluate quantitatively the range of possibilities in several individual situations, without completely modelling the choices. This function can prove useful in future research by:

Providing answers in terms of remaining choices in response to simulated changes in household car ownership, personal car access, or work location,

- Simulating possible states, i.e. quantifying mobility, and assessing the effect of specific changes that strictly do not concern the transport-studies field.

- As the initial phase of a logit model, SATCHMO is a formalized operational tool designed to reduce individual choice sets through multiple constraints eliminating modes. In this way, it takes into account socioeconomic variables that affect the choice process, and splits a population into subsamples facing homogeneous alternative sets.

An experiment, using the SATCHMO approach with data from a French national household survey, is presented at the end of this chapter. In order to assess this new approach in terms of explanatory and predictive power, we compare the results given by three types of models: the simulator alone, a logit specification, and a chained model (SATCHMO + logit).

INTRODUCTION

It is a necessity of transport planning to analyse, simulate, and forecast individual behaviour in mode-choice situations. Numerous books and papers emphasize the importance of these topics. More or less complex formalized tools are used to model individual behaviour, explicitly or implicitly, in order to reproduce the complex demand process. The different approaches can be classified into (at least) two groups:

- Most sophisticated econometric approaches (logit, and several theoretical extensions[1]), based on microeconomic assumptions, produce discrete probabilistic and disaggregated choice models that evaluate economic competition between alternatives.

- Some recent studies in mobility analysis, based on "phenomenological" analysis and sometimes using less quantitative approaches, try to understand processes by studying mobility within its constitutive environment: family organization, lifestyles and social norms, and linking of trips or activities (activity-pattern approaches[2,3], and more sociological aspects[4,5,6,7]).

The diversity of approaches attests to the wealth of research, but also, paradoxically, to the weakness of each approach taken separately, because their explanatory fields seem disjointed in practice.

It seems crucial to us[8] to go beyond the split between seemingly complementary approaches, and to integrate behavioural observations resulting from several studies

based on different logics. It is the ambition of the proposed model, SATCHMO (*"Systè-me Automatique de Traduction des Choix Modaux"*: Automatic System for Translation of Mode Choice), to provide a framework in which these approaches can meet, and to model, while taking into account the complex reality of behaviour and of its determinants.

Rather than choice modelling, we have tried to formalize the multi-dimensional system of objective limitations that notably affect individual choice (constraints stemming from household characteristics: socioeconomic structure, number and type of vehicles and licences, work locations and schedules, and the need to drive children to school). From a technical point of view, we formalize all these situational constraints, whether they are deterministic or not, as production rules integrated into a knowledge-based system, in order to model the mode choice for home-to-work trips.

We thought it necessary to present our approach after a brief description of conventional disaggregated models because:

- Disaggregated econometric models remain the most sophisticated among the operational approaches,

- The new tool we present uses notions from this family of models (particularly its statistical-validity criteria),

- From the conceptual standpoint, our tool is developed out of the criticism of the application of these models.

DISTINCT CHARACTERISTICS OF MOBILITY IN FRANCE

Our work is set in the context of everyday mobility in France; more precisely, it concerns commuting, which is the category of mobility which has the greatest impact on the structure of activities. First, we present some of its main features.

People do not often modify commuting mode choices, which depend on former decisions (e.g. location and car ownership). Such choices entail usual and repetitive behaviour, and have a clear impact on less regular mobility choices (e.g., purchases, or leisure purposes, etc.). It is around the work activity, and the repetitive mobility it produces, that most of the other daily activities and movements are organized — for commuters as well as for other members of the household, who often do not have a car at their disposal when workers are at work.

In France, the employed population is about 50 percent of the people over 17. Even if more than 15 percent of these people are not subject to home-to-work trips (often independent workers, craftsmen, and shopkeepers), commuting traffic represents the most important share of daily movements: 30 percent of daily trips for French people, and a much greater share in terms of mileage covered and time spent, from 30 minutes to 70 minutes round trip, depending on residential location[9].

Other topics have to be mentioned here, contributing to the distinct characteristics of France:

- Car-pooling is not common; the car used by a commuter belongs to his household;

- Mode choice is particularly affected by the availability of a parking place at work and the return to the residence for lunch.

REPRESENTATION OF THE MODE-CHOICE PROBLEM

In order to divide up a population among several modes and to simulate individual-choice processes, we have chosen the following representation. We consider a population Q of individuals t commuting using one of the five alternatives in the universal choice set:

$$A = \{walk, two-wheeler, public\ transport, car\ passenger, car\ driver\},$$
$$A = 1,...,M$$

We calibrate our models on a survey sample T ($t \in T$, $T=1,...,N$) of data describing individuals in a choice situation. Then we infer the behaviour of the overall population Q. For each individual t of T, we want to find out:

- What are the mode choices actually possible in the universal choice set A, (i.e., the determination of a personal choice set A_t ($A_t \subset A$, $A_t=1,...,m$))?

- Within this individual choice set A_t, what is the alternative $c(t)$ finally chosen by t ?

Several remarks can be made about this model:

- Accounting for the behaviour at a disaggregated level (individual or household) is necessary in order to fit closely the complex process of demand. This constitutes unquestionable progress in modelling methods compared to the approaches based on zonal averages.

- We are here at a generality level where we try to emphasize competition or "monopolistic" shares between clearly-defined, but abstract mode aggregates, such as walk, public transport, two-wheelers, and household car.

- The fact that any alternative is part of an individual choice set A_t may depend on several constraints such as: physical availability, individual resources, time availability, information and perception, etc.

The observed choices are not always uniformly "rational" relative to the sample, nor repetitive. This inconsistency prevents any use of a deterministic model, as in some applications of multiple-criteria optimization: choices have to be represented in a probabilistic form. Such a formulisation aims at assessing choice probabilities $(P_t(i)) i \in A_t$, for each individual t (without information, $P_t(i)$ is set to $1/m$).

The estimation of such a model is done through maximization of a likelihood function L, so that the probabilities of the chosen modes reach their maximum values. Statistical indicators traditionally used to assess the goodness-of-fit of disaggregated models (likelihood function and ratio, per cent right, prediction success table[10]) can also be used to assess the goodness of fit of SATCHMO. For instance, we use the likelihood ratio estimating the relative growth of the likelihood function given by: $\rho^2 = 1 - L_{final} / L_{initial}$ (quite analogous to R^2 in regressions). The shares of the different modes can then be computed by reaggregation (e.g., with the sample-enumeration method).

DISAGGREGATED MODELS (OR SHARE MODELS)

These probabilistic models are based on the assumptions of consumer behaviour. Each choice probability (or share) is written as:

$$P_t(i) = \frac{U_i}{\sum U_j} \qquad j \in A_t$$

where U_i denotes a valuation (utility) attributed by t to i, a function of pertinent socioeconomic and supply variables[11,12]. Among these models, the most popular is the logit multidimensional linear model (or multinomial logit), because of its simple analytical form: $U_i = exp(V_i)$; utility V being expressed as a linear combination of explanatory variables.

In theory (microeconomics or decision theory[13]), such a utility function provides a common comparison scale for the performances of the existing supply; in practice however, several socioeconomic characteristics specific to the individual are introduced to explain variations within the observed choices.

Theory and practice of this econometric model reveal several basic drawbacks, that we mention briefly. In order to move beyond some of the operational drawbacks, many alternatives have been developed, but they often seem to be theoretical refinements rather than a questioning of the underlying microeconomic paradigm.

In theory and in practice, the model has some operational drawbacks[14], that can also be found in several other regression techniques:

- This equation presents us with the problem of the statistical unit: complex inter-relations, particularly between members of the household, cannot be taken into account;

- The formula denotes a strong sensitivity to the number of alternatives actually available to each individual; coherence and consistency depend on the correct specification of the choice sets;

- when looking for the most likely specifications, socioeconomic characteristics introduced in the utilities become very important, and affect the values strongly and the significance of the estimated parameters and their relations into (particularly time values);

- Moreover, taking into account such factors in a linear utility function is not always sufficient to describe their own effect: segmentations of samples according to these characteristics often show major structural differences (questions of homogeneity and statistical inconsistency in the sample).

Theoretical criticism stems mainly from this too-simplistic classical paradigm (demand as a direct response to limited stimuli: supply and standard socioeconomic characteris-

tics of individuals). The simplicity of this conceptual framework has subsequently been studied widely[15]. Persons and trips seem too isolated, disconnected from the complex and constrained reality. External social stimuli — such as, the urban environment; as well as the economic, cultural, and familial context; and historical and psychological factors characteristic of the individual that produce habits, attitudes, perceptions, and subjective practices — are considered as implicit[16], or even missing in this conventional econometric model. There are objective and subjective limitations to the individual choice universe, that must be taken into account in a comprehensive approach to modelling demand. Choices seem confined in this strict and inflexible framework, thereby producing a poor and foreshortened view of reality.

MODELLING THE CONSTRAINTS AND USING A RULE-BASED APPROACH

The analysis and understanding of the mechanisms of demand go quite beyond the conceptual framework described previously, and require the integration and explicit processing of the surrounding constraints. The information gain is undeniable.

In order to place choice processes in a realistic behavioural perspective, most recent research on activity and transportation modelling has integrated several types of constraints into activity-based approaches: spatio-temporal[17], subjective, expressions of "values, standards and socially-determined opinions[18,19]," or even constraints related to life-cycle stages.

Closely related to this constraint-based approach is the idea of market segmentation[14]. Sample partitioning by the exploration of decision-trees is often used to show differences in preferences, whether we consider physical limitations in the objective possibilities of mode use, explanations of attitudes and perceptions, interpersonal constraints, or even trip-duration evaluation. Instances of this approach can be found in several recent studies:

- In spatial analysis[20], there is much interest in taking into account behavioural rules in all kinds of micro-simulation exercises; the degree of freedom in choices is strongly limited by actual, more-or-less trivial, logical and normative, and formal or informal rules;

- Also, in route choice[21], attitudes, perception, and knowledge about opportunities are key elements, not to be neglected in rule-based approaches;

- More generally, in the analysis of travel behaviour[22], realistic explanations of disparities in behaviour require market-analysis methods, often leading to segmentation; explicit and random situational constraints can be integrated in probabilistic models of individual choice-set formation.

It should also be observed that this approach — i.e., formalization of constraints in order to reduce the choice problem — goes beyond the transport-research field. In Operations Research, where the reality to be modelled generally involves multiple criteria, it is necessary to *"admit that there are several rationalities, and different logics for a variety of actors"* , thus one has to *"limit the choices considered as possible: to internalise, as constraints, some facts which otherwise would interfere in the comparison."* In order to explain this complex reality, one must not *"disguise the criteria as constraints, but also not model the limit beyond which there is a radical impossibility"*[23].

Segmentation using a constraint-based approach can be represented as follows: when exploring a decision tree, the path to be chosen at each node is imposed by constraints that state impossibilities in the choice sets. The essence of this formulation suggests the use of an approach based on production rules[24], such as: "IF <conditions..> THEN <conclusions..>;" these rules may be certain or uncertain depending on whether they express deterministic or random constraints.

This segmentation-analysis method leads more and more often to the use of a rule base in behavioural simulation approaches, concerning trips as well as activities[16,17,18]. This is not the only reason for the use of a knowledge-based system. Modelling complex processes and social interactions between members of the same household requires a specific representation of knowledge and data. Declarative languages and methods here reveal their efficiency, flexibility, and modularity, compared to more conventional programming methods.

However, the problem is how to obtain and formalize knowledge. We do not take for granted that it is possible to identify and reproduce a behavioural automatism using a few contextual socioeconomic characteristics[25]: this would lead to the explanation of choices by the classification of observations, a tautology that would create as many rules as observed cases. On the contrary, if it is true that one cannot induce a rule that forces a choice from the recognition of a standard situation, then constraints can be defined with certainty by stating impossibilities on the basis of a few contextual variables. The rules are developed here independently of the data sample. The problem is to identify the conditions that create the constraints, in order to identify their effects and to reduce the choice sets. It can be useful in solving this problem, but nonetheless "the whole is more than the sum of its parts." It is probably impossible

to find overall explanations of this kind, global conclusions at the disaggregated level of the decision process[26].

SATCHMO, AN APPROACH TO MODE CHOICE THROUGH CONSTRAINTS

Principle, Field and Purposes of the System

The principle of SATCHMO is to place mobility in its specific environment; rather than formulize the choices themselves, we want to formulize explicitly a system of multiple constraints (spatial, temporal, vehicle availability, individual, and interindividual), while maintaining the possibility of using it in conjunction with disaggregated models[27,28].

Stemming from the operational drawbacks of the logit model, SATCHMO aims at delimiting, as far as possible, individual choice universes, or even at providing a final conclusion in some particular cases (captivity), by studying problems related to transport-mode availability for each commuter in a household by using a large set of rules as shown in Figure 1, such as:

> "**IF** *a commuter does not have a driving licence*
> **THEN** *he is not a driver*
> **AND** *no other commuter can be his passenger*"

Because the commuter is the only employed person in the household, he is therefore not a car passenger; because he does not own a two-wheeler and lives more than 3 kilometers from his job, he will neither walk nor use a two-wheeler; because he is coming back home for lunch, we can assume that he is not a public transport user. Thus, the rules indicate at every node of a decision tree (or alternatives-availability tree) the branch to follow by stating mode (non)availabilities. The application of such a set of discriminant rules leads either to the conclusion of the only remaining choice or to a relevant restricted choice set.

We intend to provide a new methodological approach that:

- Integrates the benefits of knowledge about mobility,

- Can adapt to the data, and provide partial conclusions if data are insufficient,

- Enables many simulations that integrate changes in supply availability and in context (e.g., changes in activity schedules).

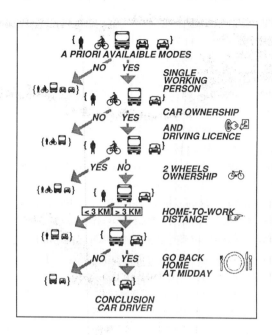

Figure 1.
SATCHMO Constraints Logic

Our concern is home-to-work commuting observed via classical surveys, where the individuals are in situations of usual-mode-practice, rather than of mode choice. We focus on objective constraints, on a relatively short-term approach (where former decisions are not questioned). The system works on the basis of standard data collection (household surveys) and must provide elements of conclusion at several levels (local, national, and even international). At some levels, the constitution of a detailed and disaggregated supply base proves to be quite impossible. In the case study presented below, the sample is representative of the overall French population, With the Ile-de-France Region excluded because of its extremely unusual situation.

Our first objective is to carry out this modelling of constraints by segmenting an observation sample, before studying the problem of choice between the various transport-supply options. We must offer a detailed formalized framework, prior to any other modelling work.

This sequential processing (constraints formalization prior to choice modelling) offers several advantages:

- We reduce the problem, thus reducing the errors produced by the choice model;

- This reduction limits the cost of the supply-data collection. The sample is partitioned into subsamples having the same choice sets, and the quantification of the supply for each subsample can be limited;

- This is done while maintaining the potential to link to an econometric model, even if this model represents the choices with other preference structures (e.g., ordinal).

Formalization and Constitution of the System

Knowledge-based system (KBS)

We develop a rule-based approach, that is quite well adapted to our problem-solving because:

- Representing a complex reality requires the use of much information, which is "atomistic" and heterogeneous in nature;

- Available information, i.e., knowledge, is often incomplete or uncertain, and is more heuristic than algorithmic;

- The qualitative analysis of the problem prevails over the quantitative analysis, and the symbolic processing of information prevails over numerical processing.

"To make a program intelligent, give it extensive knowledge related to the considered domain"[29].

In 1970 for the first time, the difference between Expert Systems and Knowledge-Based Systems was outlined: *"Researchers belong to two families: some want to understand how our brain is functioning, while others want to extend the application field of computers. The goal of these researchers is to obtain good results. In order to evaluate a program designed in such a perspective, one must consider the quality of the results"*[30].

We do not want to imitate the brain of a human expert, but to develop an operational system according to the French definition of knowledge-based systems[31]:

- On the basis of formalized scientific or technical knowledge,

- By programming a problem-solving procedure specifically developed for the "machine" and not imitating that of an expert,

- By using, as much as possible, certain knowledge (a simple system, minimizing the number of heuristics, and processing the uncertainties as formally as possible).

The programming and problem-solving technique characteristic of Expert Systems is used here rather than the collaboration of an actual human expert.

SATCHMO is a knowledge-based system; its internal structure is similar to that of an expert system and is shown in Figure 2. Apart from several input/output interfaces, it consists of a fact base on which an inference engine starts a rule base:

- The fact base represents household data, according to a model; these data are collected either by an on-screen interactive simulation or by extraction from survey files;

- The rule base represents the mode availabilities and the possibilities of car-pooling for commuters in the same household; the rules restrict the choice sets; they can have different status, such as deterministic and absolute, or uncertain and probabilistic, or parametric or non-parametric.

An inference engine is in charge of applying a rule base (here constraints) on a fact base (here a household) in order to infer the possible conclusions (mode eliminations and then mode penalizations for every employed person in the household).

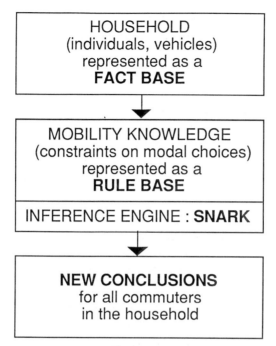

Figure 2.
Representation of SATCHMO Knowledge Base

Assumptions About Behaviour

The following set of hypotheses, which we will call "weak rationality", is required: we assume that individuals obey several logical rules, "natural" or "legal", that seem commonplace in relation to observed reality. For instance, we assume that in a household without a car, no commuter can drive to work in a car belonging to the household; similarly, we will assume that each driving person holds a licence; or that there are limits of distance beyond which walking seems unreasonable, etc.

What seems normal and commonsense is sometimes in contradiction with the information contained in data files; however, in this case, the problem is not rationality, but often comes from coding and erroneous data.

More generally, we admit that there are several major standards that:

- Are related to family and social status,

- Can be observed and obtained through traditional surveys,

- Are considered as constant in the short-term,

- Notably affect individual behaviour by limiting the set of possible choices ("revealing constraints").

Whether the constraints are physical or *de facto*, social or cultural, we do not intend to clarify their influence; we restrict the analysis to search, through several sources, for a set of socioeconomic factors that affect choice. What we call "knowledge about mobility" derives from identifying this set of "explanatory" factors and taking their effects into account.

Representation, Description of the Knowledge Base, Implementation

SATCHMO was written, on a Bull DPS8 machine (Multics OS), with the SNARK language (Snark II release), developed at INRETS, currently rewritten with AIDA language (also developed at INRETS) on a UNIX Workstation[22]). A tribute to Lewis Carroll, the name SNARK also means Symbolic Normalized Acquisition and Representation of Knowledge[32]. It is a declarative language associated with a first-order logic inference engine for developing knowledge-based applications. The framed paragraph, as shown in Figure 3, presents basic elements of knowledge representation and syntax. The SATCHMO knowledge base is an application of this formalism.

The FACT Base is made up of about 20 facts per household, plus 30 facts per employed person. It represents the survey data, according to a fixed model as shown in Figure 4, quite complex (containing many variables and inter-relationships inside the household) and which has evolved throughout its development.

This figure shows the relational representation of the fact-based model. Each first line indicates the list of attributes of several objects (household, individual, mode); each second line provides a concrete example of attributes in this model (household with three persons, the individual, Person 1being a 35-year-old commuter).

KNOWLEDGE REPRESENTATION : SNARK AND SATCHMO

SATCHMO's functions are to reproduce and restrain commuters modal choice sets, on the basis of a knowledge-based system (KBS). KBS approach joins two aspects of artificial intelligence : knowledge representation and automatic resolution theorem proving. Constructing this rule-based system requires the use of the technic of "Expert system" ; the system contains two parts : a knowledge base (KB), formulating the conditions of the problem and the knowledge of its context in an intelligible, declarative form and an inference engine (IE) which is in charge of applying this knowledge in order to activate reasoning and to solve the problem.

The knowledge base is separated in a fact base (FB) and a rule base (RB). This knowledge is used by SNARK software (declarative language + inference engine). Syntax is the following :
- FB : an object ("quark" in SNARK) is defined in the KB as the set of properties (facts) attached to it. Each fact expresses this property in the form of a triplet
 "<object> <relation> <value>" (ex: **$10, commuter, true**
 indicates that the quark $10 in FB is a commuter)
- RB : the inference engine processes this knowledge to reach new conclusions. It uses the first-order logic : rules operate on variables ("djinn" in SNARK) and manipulate objects (predicate calculus). The inference method is forward chaining reasoning. The type of rule used is production rule expressed as:
 "IF <conditions> THEN <actions>".
 (ex : {nr_driving-licence(household)=1
 driving_licence(!t)=true
 commuter(!t)=true
 available_mode(!t)=!i
 name(!i)=car_passenger}
-->
 killall [satchmo .fact, !i]
 ct_possible(!t)<--substract [ct_possible(!t),1]
 killall [satchmo .ft, !t, possible_driver]
 killall [satchmo .ft, !t, ct_driver]
 end rule ; indicates that the commuter owning the only one licence in the household can never be driven)

"!t" and "!i" are "djinns" that will be substituted for "quarks" in the inference process; with an exhaustive examination of the households' situation in the FB , the IE selects the production rules to be applied (conditions satisfied in the FB) and produces every possible new facts or actions.

Figure 3.
Knowledge Representation: SNARK and SATCHMO

HOUSEHOLD=(WEIGHT,	AREA,	NB-PERS,	CARS,	INDIV., ...)
HH	5,475	rural	3	1	{$10,$11,$12}
INDIVIDUAL=(NAME,	AGE,	STATUS,MODES,		AVAIL.,...)
$10	Pers1	35	working {$11,...,$15}		{$12}
MODE=(NAME)			
$12	2-wheels				

Figure 4.
A Sample FACT BASE Layout

Some examples of facts:
"*the household includes 4 individuals, 2 adults, 1 employed person,*"
"*the household does not own a car,*"
"*individual t is between 35 and 50,*"
"*individual t is a male,*"
"*individual t is a specialised worker,*" etc.

The RULE BASE is made up of about 75 rules, grouped in 10 steps: the inference engine enables a sequential process according to the inference steps.
It is first made up of deterministic rules (about 40) which eliminate modes of A_t and possibilities of accompanying (updating for each commuter lists of possible drivers and of possible modes) according to several premises:

- Availability of cars, driving licences

- Distances and timetables, location of work

This first step ends in the initialization of choice probabilities at the value :

$$P_t(i) = \frac{1}{Card(A_t)}$$

The following steps are made of uncertain inferences that modify these choice probabilities according to:

- The size of the urban area, and the place of residence

- Sex, age, SPC (for the head of the household and for the employed person), etc.

- Presence of children, and return home for lunch;

- Availability of a parking place, timetable and home-to-work distance (for the employed person);

- Number of available cars related to the number of employed persons, etc.

Uncertain inferences are processed, as in the earlier medical diagnosis expert systems[33], by managing the certainty factors of the deductions obtained (on the basis of the probabilities-composition formula, assuming independence of the rules). As in any expert system, this uncertainty processing is not completely satisfactory from a theoretical point of view.

Here are some examples of rules:

- *If there is only one commuter in the household, then he or she is not a passenger in one of the household cars*

- *If home-to-work distance is more than 2 km, then the commuter does not walk*

- *If the difference between two commuters' work schedules is more than 30 minutes, then no one can give someone else a lift.*

- *If the commuter is a senior executive, then he or she is not likely to drive a two-wheeler (quantified).*

SATCHMO : APPLICATION ON A NATIONAL SURVEY

System Architecture

Figure 5 shows the three different interrogation methods. The input/output interfaces are represented by squared rectangles, the data files are represented by rounded rectangles. The core of the system, represented in grey, is detailed in Figure 2. SATCHMO can be used in three ways, depending on the input interface used:

- Simulation by interactive questioning ("questor," earlier releases version);

- Retrieval and interrogation of a household in the sample ("factor," stepwise refinements, error detection); and

- Application to the national sample ("factor," large scale simulation).

With these interfaces, which display data according to the previously described model, the system can process actual household situations. A random sample allows us to check the rule base, by identifying extreme cases.

An output interface, "result", is dedicated to the statistical processing of the conclusions (error detection, statistical diagnostics, and computation of modal shares by reaggregation).

The system, which processes the observations (considered as structured facts) with formal logic rules, is well-adapted to inconsistency detection in a survey file and could be the core of a checking system for survey data that would improve the precision of data collection. It could also be used to assist in the generation of realistic households and the constitution of large surveys for simulations in the Monte-Carlo manner.

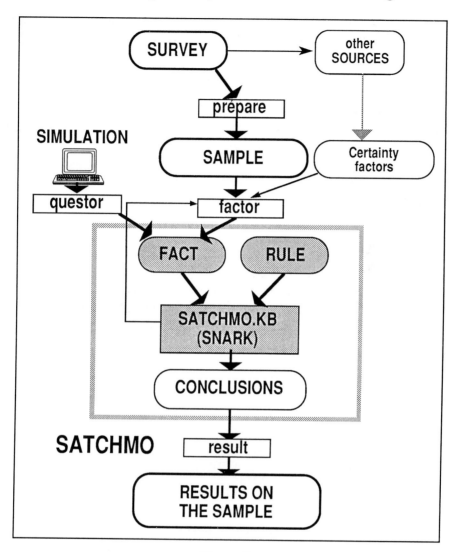

Figure 5.
Architecture of SATCHMO System

Application Results

The sample comes from the panel "Everyday Journeys of the French" (INRETS-/SOFRES/AFME, 1984), weighted to be representative of French households[34]. The sub-sample is made up of households, with the Parisian Region excluded, for which

at least one employed person has made a trip with one of the five modes of A on the day of the survey: 645 households, 873 employed persons, gross values (6.234 million households and 8.187 million employed persons, weighted values). For a household, the average processing time is 10 seconds, which is similar, on the same computer, to a linear logit (6 modes and 30 variables, with P2 software[35]).

Figure 6 and 7 show the results obtained. Certain discriminations lead to high disparities in the individual choice set size ($Card(A_t)$). The per cent correctly predicted and the likelihood ratio are calculated from the estimated probabilities, like in conventional disaggregate models. Modal splits are then obtained by sample enumeration.

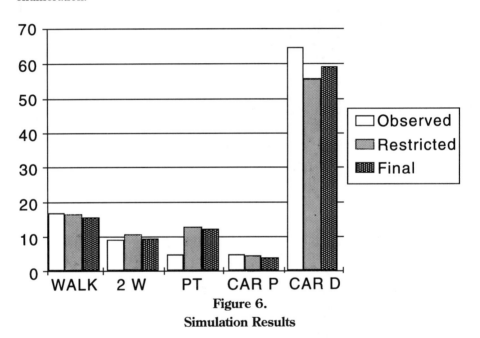

Figure 6.
Simulation Results

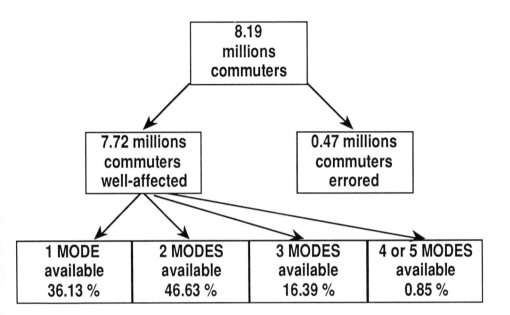

Figure 7.
Simulation Results from SATCHMO

First Step: Certain Discriminations

The error rate is 5.7 percent (SATCHMO conclusions incompatible with choices stated in the survey). A manual detailed analysis shows that only 20 percent of these cases are the responsibility of the system; the remaining 80 percent of cases are inconsistencies and coding errors at survey time. Some quite exceptional cases are ones not taken into account by SATCHMO (drivers external to the household; working people without licence, driven by an unemployed person of the household). The discriminating power (frequency distribution of $Card(A_i)$) shows that the number of possible choices is less than or equal to three for more than 99 percent of the active population, less than or equal to two for more than 83 percent of the active population. More than one third of the sample appears as "captive", and nearly one employed person out of two is confronted with a simple binary choice.

The observations can be sorted in a contingency table "choice universe versus actually chosen mode", that allows the marginal computation of the share of the survey correctly assigned and predicted (extension of the MacFadden prediction-success table[36]). In this phase, the prediction is correct for walk, two-wheelers and car driver, but is less successful for car passenger and public transport.

The average number of available modes per employed person in the survey is 1.82. This result shows that, on the average, each employed person does not even have the choice between two modes.

With probabilities $P_i(i)=1/Card(A_i)$, the computation of the likelihood ratio of this simulation is $\rho^2=0.6724$, which proves that a system based on deterministic constraints provides a good explanation.

Second Step : Contribution of Probabilistic Rules

The choice probabilities are distorted by the uncertain rules. The final ratio is $\rho^2=0.688$. Although the observed phenomenon is well explained, the growth of the likelihood is nonetheless divided very unequally between the certain discriminations and the extra contribution of uncertain rules ($\rho^2=0.05$). These uncertain rules prove to be theoretically unsatisfactory as well as inefficient from a practical standpoint.

The values of probabilities show notable differences according to the mode chosen. Both steps are still insufficient to lower some probabilities (particularly car). The per cent correctly predicted denotes the share of the population for which the actually chosen mode has the highest probability in A_i. The conclusion is true for two

employed persons out of three: SATCHMO results are correct, even at the dis-aggregated level.

Computation of Predicted Mode Shares

The mode shares, predicted by SATCHMO during both of these steps, are computed (aggregation by sample enumeration) and compared to the observed repartition (the histogram in Figure 6). This aggregation is biased, which mainly concerns the competition between car and public transport. The results would of course have been better if index values for the public transport supply were available. Given the minor difference between the repartitions at each step, uncertain rules can be left aside without major drawback.

Chaining SATCHMO and Logit

Principle of the Combination: SATCHMO as Pre-Modelling

This example of chaining uses SATCHMO only in its phase of certain restrictions of A_t universes; the probabilistic computation being left to the logit model. Thus, the theoretical drawbacks of uncertain facts-management and uncertain inferences can be avoided. The great merit of this composite approach is to guarantee an unbiased modal repartition owing to the logit model (by introducing *n-1* constants for *n* alternatives). Moreover by restricting the number of choices, this chaining restricts the errors that could arise from a purely econometric approach. Besides, more reliable models (that is, models more adapted to the notion of compensation between characteristics of supply in accordance with utility theory) could be obtained by using this chaining approach. By segmenting the population into homogeneous groups, by closely examining the actual availability of the modes, and by first dealing with the problems related to socioeconomic constraints, SATCHMO simplifies logit specifica-tions. It also focuses them on the actual comparison between alternatives, that is, on the supply variables that are the basis of modal competition.

The few observations concerned with "first-step errors" (elimination of the mode actually chosen by the commuter) must be left aside. The chained model is applied to the remaining sample, made up of 766 working people observations (121,166 in weighted value). In the following text, "with SATCHMO" means that the first deterministic step of the knowledge-based system is used.

Comparing the Results from Different Logit Specifications

Now, the search for the best logit specification is rapid. All the socioeconomic variables that affect the choice of one or more modes are specified as factors of the modal-utility functions. Three synthetic index values for public-transport supply, related to the residence conurbation (number of lines, kilometre per inhabitant, and number of steps per square kilometre) are then introduced. The different models are denoted as follows:

M1: logit model on the overall universe *A* with only 4 constants (4 first modes);
M2: similar to M1, "with SATCHMO";
M3: in addition to M1 constants, 24 dummy variables describe socioeconomic items that affect mode choice (sex, age, PSC, license, distance, etc.);
M4: similar to M3, "with SATCHMO";
M5: in addition to M3 variables, 3 synthetic supply variables;
M6: similar to M5, "with SATCHMO";
M7: SATCHMO's certain discriminations; and
M8: complete SATCHMO simulation.

The models are thus to be compared in pairs: M1-M2, M3-M4, M5-M6, in order to assess the contribution of SATCHMO to econometric models as shown in Table 1 and Figure 8. For the record we include SATCHMO's simulation results.

The results of different models are given in Table 1. The graph in Figure 8 shows the total ρ^2 evolution according to the entered variables.

Table 1.
Results of Econometric Specifications With and Without SATCHMO

	M1	M3	M5
	-	-	-
	CSTES	CSTES	CSTES
Without SATCHMO	-	Soc. Eco.	Soc. Eco.
	-	-	Supply
param	4	27	31
D.F.		23	27
L Ratio Test		72032	74005
L(O)	-195009.2	-195009.2	-195009.2
L(DISCR)	-	-	-
L(CSTES)	-117022.3	-117022.2	-117022.3
Lfinal	-117022.3	-117022.3	-117022.3
ρ^2 (0)	0.3999	0.5846	0.5897
ρ^2 (CSTES)		0.3078	0.3162
Per cent right	70.23%	72.64%	73.63%

	M2	M4	M6	M7	M8
	DISCR.	DISCR.	DISCR.	DISCR.	TOTAL
	CSTES	CSTES	CSTES	SATCHMO	SATCHMO
With SATCHMO	-	Soc. Eco.	Soc. Eco.	Alone	Alone
	-	-	Supply	-	
param	4	27	31	-	-
D.F.		23	27	-	-
L Ratio Test		19313.25	20253.9	-	-
L(O)	-195009.2	-19509.2	-195009.2	-195009.2	-195009.2
L(DISCR)	-64909.5	-64909.5	-64909.5	-64909.5	-64909.5
L(CSTES)	-52130.9	-52130.9	-52130.9	-64909.5	
Lfinal	-52130.9	-42474.2	-42281.6	-64909.5	-60813.7
ρ^2 (0)	0.7327	0.7822	0.7832	0.6671	0.6881
ρ^2 (CSTES)		0.1852	0.1889		0.0631
Per cent right	75.98%	80.94%	81.07%	33.20%	67.26%

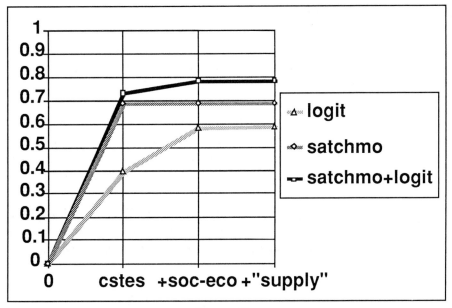

Figure 8.
Results of Econometric Specifications With and Without SATCHMO

Discussion of the Results

The results of these different models can be compared by using the statistical criteria used in econometric models: likelihood ratio (ρ^2) and "per cent right" (PCR). Both criteria must be used together: PCR gives an indication of the predictive power at the disaggregated level, and ρ^2 reflects the overall statistical adequacy of the chosen specification.

In all these models, PCR is relatively high; our work takes place in a constrained context, where choices are strongly oriented by a predominant mode, the car as driver. For SATCHMO used alone, PCR in M7 seems to be relatively low, because of the fact that the remaining modes are equiprobable. In contrast, in a logit model, an artificially high PCR is guaranteed by those constants designed to ensure unbiased repartition, because the estimated probabilities adjust around the observed shares.

The likelihood level of a specification is a global indicator. The likelihood ratio assesses the information provided by a particular specification (from 0 for a model without variables, where utilities are uniformly null, to 1 for an ideal model perfectly explaining the choices).

As a few remarks, we can note that:

- The simplest econometric model (M1) leads only with constants to a non-negligible likelihood value and ratio, but also to a tautological and worthless explanation of choices;

- On the other hand, with SATCHMO alone (M7), without introducing constants, the choice and mode probabilities are only obtained through constraints external to the observed phenomenon; the relatively high value of the likelihood ratio is due to the knowledge introduced;

- The increase of the ratio between nested specifications is not at all linear according to the number of explanatory factors. The tiniest "explanation" brings a lot to a null model; on the contrary an extra explanatory variable does not automatically bring much to an already satisfactory specification. The better specified a model is, the more difficult it is to improve it (as if there were a maximum value that cannot be surpassed, due to the quality of data). For instance, supply index values taken into account in the logit bring a few more likelihood points, but their effect is much less marked because the model is already very likely (M3 to M5 and M4 to M6).

Therefore, sensitive likelihood gains provided by SATCHMO's certain discriminations are particularly valuable. Hence, the composite approach (M6) is far better than either M5 or M7 taken separately.

CONCLUSION

SATCHMO is a discriminant system implying certain restrictions of choice sets. Although it does not simulate mode choice completely, it provides a good explanation of the choice universe. The formalization of constraints is satisfactory, thanks to the consideration of some major factors, such as vehicle availability, distances and work location. This modelling structure permits the weights of constraints to be assessed; it also reveals the constituent elements of constraints and allows the degree of capitivity and availability to be defined closely.

SATCHMO can work as an independent simulator, but also as a complement to the classical disaggregated approach.

A knowledge-based system improves classical choice models notably. By using knowledge concerning the study field, we get a restricted set of rules that structure a system of constraints affecting mobility. Furthermore, used as a preliminary step in an econometric model, it may allow simplification of data collection (not including the quantitative and qualitative description of nonchosen alternatives). By restricting the set of possible choices, it reduces the error rate, especially if choice sets are wide, *a priori*.

Moreover, such choice restriction could be used with more complex preference models (we could, for instance, assume that the usual choice is not unique and that alternative possibilities exist). In conclusion, we could summarize SATCHMO's approach with two main points:

- It provides a relevant explanation of availability and of choice behaviour;

- It simplifies the use of more or less complex preference models.

These potential contributions are reinforced by the fact that SATCHMO requires a restricted set of hypotheses.

Among conceivable extensions, we should mention:

- The disaggregated accounting of supply variables,

- The constitution of rules describing the influence of home-to-work mobility on other employed persons and the influence of the mobility of employed persons on the mobility of other members of the household,

- The elaboration of rules focusing on activities, and not just on trips.

ACKNOWLEDGMENTS

Acknowledgments to Dr. J. P. Orfeuil, head of the Economics of Space and Mobility Division at INRETS--DEST and to Dr. B. Schnetzler, researcher at the Computer Centre INRETS-CIR who provided valuable advice and suggestions for this conceptual and applied work. The subject of this paper originated in my earlier thesis dissertation for which I have also benefited from the invaluable training of my thesis supervisor, Prof. J.Y. Jaffray, University P. et M. Curie, Paris VI.

REFERENCES

1. Ben-Akiva, M., and S. R. Lerman, *Discrete Choice Analysis*, MIT Press, 1985.

2. Jones, P. M., M. C. Dix, M. I. Clarke, and I. G. Heggie, *Understanding Travel Behaviour*, Oxford Studies in Transport, 1983.

3. Jones, P. M., F. S. Koppelman, J. P. Orfeuil, "Activity Analysis: State of the Art and Future Directions," *Developments in Dynamic and Activity-Based Approaches to Travel Analysis*, Oxford Studies in Transport, 1990.

4. Bourgin, C., "Les évolutions dans l'usage des modes de transport, influence des moments de transition dans le cycle de vie," Arcueil, Oct. 78, *Rapport de Recherche*, I.R.T. No. 36, 1978.

5. Brög, W., "Le comportement, résultat de la décision individuelle dans des situations sociales", in *Actes de la conférence internationale sur la mobilité dans la vie urbaine*, tenue du 28 au 3 septembre à l'IRT, Arcueil, 1978.

6. Brög, W., "Mobility and Lifestyle-Sociological Aspects," in *8th Symposium on Theory and Practice of Transport Economics*, C.E.M.T., Istanbul, 24-28 September, pp. 1-82, 1979.

7. Lenntorp, B., "Les déplacements considérés comme une part de la vie : un cadre conceptuel pour l'analyse de la distinction des possibilités de déplacement au sein d'une population," in *Actes de la conférence internationale sur la mobilité dans la vie urbaine*, 28-30 September, 1978, IRT, Arcueil.

8. Hivert, L., M. H. Massot, J. P. Orfeuil, and P. Troulay, "The Analysis of Present and Future Mobility: New Challenges, New Paradigms," presented to the 5th ICTB, 20-23 October 1987, La Baume-lès-Aix.

9. INRETS, *Un milliard de déplacements par semaine, La mobilité des Français*, La Documentation Française, Paris. Cf. notamment Chapitre 7: L. Hivert, J. P. Orfeuil, Les déplacements domicile-travail, pp. 103-118, 1989.

10. MacFadden, D., "Quantitative Methods for Analysis of the Travel Behaviour of Individuals: Some Recent Developments," in Hensher & Stopher, *Behavioral Travel Modelling*, Croom Helm, London, 1979.

11. Ben-Akiva, M., and S. R. Lerman, *op. cit.*

12. Gaudry, M., *Quelques innovations en économie des transports*, Cahier #673 du C.R.T., University de Montréal, 1990.

13. Jaffray, J. Y., *Théorie de la Décision*, cours du Diplôme d'Etudes Approfondies: "Modèles et Algorithmes de la Décision", University P. et M. Curie, Paris VI, 1984.

14. Hivert, L., J. P. Orfeuil, and P. Troulay, *Modèles désagrégés de choix modal: réflexions théoriques autour d'une prévision de trafic*, Rapport INRETS No. 67, 1988.

15. Bonnafous, A., "La demande de transports de voyageurs en milieu urbain: méthodologie de l'analyse et de la prévision," *Rapport de la Table Ronde 32 de la C.E.M.T.*, tenue les 4 et 5 dec. 1975 à Paris, 1976.

16. Ben-Akiva, M. and B. Boccara, "Integrated Framework for Travel Behavior Analysis," presented to the 5th ICTB, 20-23 oct. 1987, La Baume-lès-Aix, 1987.

17. Lenntorp, B., *op. cit.*

18. Brög, W., 1978, *op. cit.*

19. Brög, W., 1979, *op. cit.*

20. Clarke, M. and E. Holm, "Microsimulation Methods in Spatial Analysis and Planning," *Geografiska Annaler*, 69 B, No. 2, 1987.

21. Bovy, P. H. L. and E. Stern, *Route Choice: Way Finding in Transport Networks*, KLUWER Academic Publisher, 1990.

22. Ben-Akiva, M. and B. Boccara, *op. cit.*

23. Roy, B., "Des critères multiples en recherche opérationnelle: pourquoi, Cahiers du LAMSADE," Cahier No. 80, September 1987.

24. Pitrat, J., *Un programme de démonstration de théorèmes, Monographies d'informatique de l'AFCET*, Dunod, Paris, 1970.

25. Wolfe, R. A., "A Non Parametric Estimation Method for Ranked Utility Models," presented to the Oxford Conference on Dynamic Activity Based Approaches, June 1988.

26. Gärling, T., K. Brännäs, J. Garvill, R. G. Golledge, S. Gopal, E. Holm, and E. Lindberg, "Household Activity Scheduling", presented at the Fifth World Conference on Transport Research, Yokohama, July 10-14, 1984.

27. Hivert, L., "SATCHMO: base de connaissances pour la formalisation du choix modal, communication présentée: 1) au séminaire "informatique et décision"

de l'University de Paris VI, mars 1989; 2) à la journée spécialisée CETUR, INRETS, LET, SERT: "Recherches sur la mobilité quotidienne et renouvellement des méthodes de modélisation", mars 1989.

28. Hivert, L., "Modèles économétriques et système à base de connaissances, SATCHMO: une application à la modélisation du choix du mode de transport," Thèse de Doctorat de l'University P. et M. Curie Paris VI, 1989.

29. Waterman, D. A., *A Guide to Expert Systems*, Addison-Wesley Publishing Company, Inc., 1986.

30. Pitrat, J., *op. cit.*

31. Schnetzler, B., *AIDA : un langage (informatique) déclaratif*, Rapport INRETS No. 55, 1988.

32. Laurière, J. L., *Un langage déclaratif : SNARK, Symbolic Normalized Acquisition and Representation of Knowledge*, Rapport de l'Institut de Programmation, Université de PARIS VI, 1984.

33. Shortliffe, E. H., *Computer-Based Medical Consultations: MYCIN*, Elsever Computer Science Library, 1976.

34. INRETS, 1989, *op. cit.*

35. Gaudry, M. and T. C. Liem, *P-2 : A Program for the Box-Cox Logit Model with Disaggregate Data*, cahier #527 du CRT No 527, Université de Montréal, 1987.

36. MacFadden, D., 1979, *op. cit.*

PART IV

IMPROVING THE PRACTICE OF BEHAVIOURAL TRAVEL MODELS

17

MEASUREMENT, MODELS, AND METHODS: RECENT APPLICATIONS

Peter R. Stopher

INTRODUCTION

This chapter examines five areas of applications of travel-behaviour models and methods, in terms of recent developments and new directions for applications. The five primary areas covered are:

- Data and survey methodology
- Exogenous inputs
- Extensions beyond mode choice
- Transferability in applications
- Non-traditional areas of application

Over the years, the principal applications of travel-behaviour methods have been in urban travel-demand analysis and this continues to be the major area in the early 1990s. However, there are applications being made that enhance areas other than urban travel forecasting and these are touched on in the final section of the paper.

Although not specifically an integral part of travel-behaviour modelling, the development of data and survey methodology is key to calibration and validation, while the development of exogenous inputs is key to forecasting. Furthermore, in the area of estimating exogenous inputs, application is appearing of the same basic approaches as are used in travel-behaviour models. Hence, both of these areas are important to

consider in a treatment of applications, and are also placed logically in the opening sections of the chapter.

This chapter does not attempt to summarize all applications work that has been undertaken around the world in the past three or four years, but rather attempts to highlight a number of interesting and important areas of applications. It is intended that some of these highlights will provide context to the papers that follow and will also knit together some useful application areas that may assist future applications.

It is also appropriate to note that travel-demand modelling in the United States is undergoing a level of scrutiny never before experienced here[1]. Furthermore, there is a resurgence of interest in attempting to do a better job of travel-demand modelling in practice, particularly within a context in which models may not only have to withstand professional criticism, but may also be subjected to judicial challenge[2]. The genesis of these changes in the U.S. is the Clean Air Act Amendments (CAAA) of 1990, coupled with both the earlier (1989) California Clean Air Act (CCAA) and the subsequent Intermodal Surface Transportation Efficiency Act (ISTEA) of 1991. These three pieces of legislation have focused the spotlight in the U.S. on travel-demand models as a key element in estimating and forecasting emissions from mobile sources. The CAAA also opened the door to environmental groups to use judicial process if clean-air mandates are not seeming to be implemented as set out by the U.S. Congress. This is interpreted as opening the door to lawsuits against planning agencies, in which the travel-demand models may be examined and the results obtained questioned. Furthermore, it is also being interpreted as mandating that metropolitan-planning agencies must use state-of-the-practice techniques[3] and that, where such techniques fail to produce reasonable results or to show appropriate sensitivities, a case may be able to be made that model improvements could be ordered by the courts. The CAAA has now codified the requirements for modeling through the Final Conformity Rules published in November 1993[4].

The result of all of this is a resurgence of interest in improving travel-forecasting models, and efforts by many planning agencies to update and improve their existing models. Much of the effort in these directions is yet to be completed and reported in the literature. However, some preliminary efforts in these directions have taken place and are discussed in the subsequent sections of this chapter.

DATA AND SURVEY METHODOLOGY

As noted in the introduction, data and the methods by which data are collected are key components in model development and applications. Because of decennial censuses that have taken place close to the beginning of the decade in several countries and because of the renewed interest in travel-demand modelling, the past four or five years have been a time of unusually heavy activity in data collection. Along with this activity, there have also been a number of notable efforts at using new methods to collect travel data.

Survey Methods

Four major areas of survey methodology have shown some change in the past few years. The first major area relates to issues of sample size and sampling methodology. In the area of sample size, there is increasing use being made in the U.S. of sample size calculations based on the procedures set out by Smith[5] and modified by Stopher[6]. This method seems to work reasonably well, either by using coefficients of variation that are typical of those found in various urban areas over the past one or two decades, or by using default values suggested in the original papers. However, it is also important to keep in mind that these procedures have been developed for producing good estimates for standard disaggregate (household-level) trip-generation models and may not always produce ideal data sets for mode-choice models. In fact, the combination of a geographic-sampling structure (often required for political reasons in a region) and a stratification by one or two household-related variables, generally produces data sets that are seriously deficient in carpools and transit riders.

One result of these inadequacies in survey coverage is that there has been an increase in the use of supplemental survey data, such as on-board transit surveys. In some instances, perception that such problems would arise has led to the use of a choice-based sample in place of a geographic and household-characteristic-based stratification. The surveys conducted in the past several years in the Puget Sound Region (Seattle, Washington)[7] are a good example of this approach. In this case, the sample was stratified by mode of travel used for work by at least one member of the household, such that one stratum contained households in which one worker used transit at least three days per week, a second stratum comprised households in which one worker used a carpool at least three days a week, and the third stratum comprised households in which no workers used transit or carpool more than twice in the week. In a much more recent survey in Portland,Oregon, stratification is based on a rating of neighbourhoods that classifies them into those that are transit "friendly" and those

that are pedestrian/bicycle "friendly." These neighbourhoods are sampled much more heavily than the more common auto-dominated areas.

Another component of these changes in sampling methodology has been a trend to return to larger sample sizes. It seems that there has been an increasing acceptance of the fact that a claim made some years ago that disaggregate models could be calibrated with very small samples is a myth[8]. Recent sample sizes have generally been on the order of 2,500 or more households, from which at least 5,000 work trips are usually captured, together with about 4,000 non-home based trips and 10,000 home-based nonwork trips. These and larger samples have become considerably more common and should lead to substantially better calibrations over the next few years, as these data are utilized.

The second major area in survey methodology is the use of evolving technologies for conducting surveys. Specifically in the methodology for collecting travel behaviour data, use of the telephone and computers in conjunction has become a significant emerging area of new application. This has ranged from the use of a telephone for the initial contact, with random-digit dialling and management of the call/recall process by computer, to a full computer-aided telephone interview (CATI), in which the data are retrieved by telephone from a mailed-out instrument. In addition, there has been significant use made of direct computer entry in response to a survey[9], and use of laptop computers for face-to-face interviewing[10]

The use of CATI is a controversial issue at this point in time. There is no question that the telephone retrieval interview is generally likely to obtain responses from a larger number of households than the use of a mailed-back survey instrument[11]. However, two problems arise in the apparent higher response. The first concerns the degree to which the higher response is real, because the reporting of people and even entire households staying home all day tends to be substantially higher in CATI surveys than mail-back surveys[12]. In almost any type of survey, there is a tendency for households to reduce effort by claiming that some household members have not left the house all day[13]. However, this type of response seems to grow significantly in CATI surveys, so that true responses may be substantially lower than the number of households interviewed in the data-retrieval exercise. The second problem is the lack of a document that has been filled out by the household. No matter how sophisticated the design of the instrument may be in making very clear what information is desired, people do not read instructions and do not fill out survey forms correctly. Nevertheless, careful examination of the written survey instrument will often reveal the nature

of the errors made by a person or household and frequently permits reconstruction of the instrument. However, when the only record is the computer file, this is rarely possible. Furthermore, interviewers also make errors in recording information and, once those errors are entered in the computer file, they are almost impossible to correct. In contrast, data entry from a survey instrument permits tracing and correction of the errors, although it is a much more time-consuming activity and is subject to data-entry errors.

Probably the future of CATI lies in combining the present programming of survey instruments with an expert system that can check for a wide range of potential respondent and interviewer errors and correct them. Anecdotally, one recent U.S. survey that used CATI without incorporating relatively simple, programmed logic checks appears to have resulted in collection of a substantial number of trips that had the same time for starting as ending, and a substantial number of children under the age of 12 who drove alone! This illustrates an obvious pitfall of CATI. In this instance, many of those errors will be uncorrectable and will reduce substantially the final response rate. Another variation on these retrieval methods, which is currently being tried in Portland, Oregon, is to combine CATI for personal and household data with paper-and-pencil recording of diary data. However, as programming for CATI becomes more sophisticated, particularly as expert systems are combined with the more-traditional CATI programming, and as both screen-refresh rates and the capability to display multiple windows improve, it seems likely that CATI may become an increasingly-popular method of retrieval.

The third major area of changes in survey methodology relates to the instrument. During the 1980s, most surveys on travel behaviour adopted some form of travel diary as the mechanism for collecting data[14]. The travel diary represented a procedure for collecting details of travel in a chronological manner for a 24-hour or longer day. In a few instances[15,16], the diaries have been for multiple days, most notably in Germany for the KONTIV surveys and in the Netherlands. However, most diaries administered in the past decade have been one-day diaries. The newest development in this type of instrument is to change the focus of the diary from trips to activities[17], with reporting of the travel required to reach each activity conducted during the day. Activity diaries of this type have been used in Boston, Southern California, and the Salt Lake City area, are currently being used in Detroit and Portland, and are expected to be used within the next year in Dallas and Houston, among other places. From initial analyses, these diaries seem to show promise at collecting more complete data on non-home-based trips, which have always been substantially underreported in trip-oriented surveys.

There is, however, substantial variability present in the data collected, depending on how the diary data are retrieved. It appears that significantly more research is warranted on the design of surveys of this type in order to determine trade-offs between different features of the designs.

With the emergence of increased interest in pursuing activities as the basis of a new paradigm for travel-behaviour modelling[18], it appears that the activity diary may be of increasing interest for travel-behaviour research and applications. Extensions of activity diaries to multiple days and to the collection of more data on in-home activities are potential directions of further development. In Seattle and San Francisco, a limited number of two-day diaries were included. Currently, the Portland survey is using a two-day diary, and it is currently expected that the Dallas survey will also use two-day diaries. The value of multiple-day diaries has clearly been articulated[19,20,21]. In the meantime, there is also a need to develop methods to trace the sequence of use of travel modes and to obtain more route-specific data than are captured in current activity-diary designs.

An issue brought to the fore by the various diary-based methods is that of recall versus real-time recording of activities and travel. Certainly, one of the primary causes of incompleteness in the earlier survey methods was the complete reliance on recall of travel made on the preceding day. Comparison of trip rates from home-interview surveys with roadside interviews at cordons and screenlines invariably showed a serious undercounting of non-home-based trips and short trips, because people simply did not remember these trips even one day later. With the introduction of travel diaries in the late 1970s, part of this problem was corrected by providing respondents with a diary in advance of the survey day, and asking respondents to complete the diary on that specific day. This was assisted further by providing in the diary a "Memory Jogger," which was designed to allow the "lazier" respondent to complete enough information about each trip to jog his or her memory at the time that the diary was filled out retrospectively at the end of the day, or within the following days. Even with this assistance, it still appeared that trips were not always being reported. Again, the shift to the activity-based diary was partly an attempt to remove the balance of this problem, which seemed to stem mainly from the fact that travel is often viewed as an incidental occurrence, necessary for undertaking specific activities. The activity diary, together with a memory jogger, seems to show evidence of yet better capture of the short trips and short-duration activities, as well as providing improved capture of non-home-based travel. One should also note that there is evidence of further differences in the completeness of the data obtained between self-administered diaries (i.e., mail-

back diaries), and interviewer-completed diaries, particularly those with sophisticated CATI systems in use. In the latter case, the interviewer may be able to prompt for additional activities (or trips) that show as an unaccounted-for block of time within the respondent's diary day, so uncovering activities and trips that would otherwise be lost. Finally within this area of effort, the increasing use of trip tours or trip chains has also created difficulties in reporting of travel, some of which seem to be improved by use of activity diaries. When it is stipulated that each activity beyond, say, five-minutes' duration or that requires travel should be reported, the construction of multi-stop trip or activity tours are more easily retrieved from the resulting data. Thus, analysis of trip chains is made more practicable with the advent of these changes in the design of survey instruments.

The fourth major area of survey-methodology changes is the increased interest in the use of longitudinal panels. It is, perhaps, more appropriate to comment on the lack of the use of panels in travel-behaviour research than on the emergence of recent interest in such surveys. Panel surveys have been reported on in travel-behaviour conferences in prior years, particularly relating to the Dutch Panel Survey[22]. This constituted the major example of a panel survey for travel behaviour until recently. More recently, panels have been developed for the Puget Sound region[23] and there are additional discussions in this book on the development and use of panels[24]. Obviously, there are several benefits to longitudinal panels and the major problems relating to panels are attrition and a secure funding source. Travel behaviour, like many other phenomena relating to human behaviours and decisions, is a dynamic process. Therefore, it seems that the fact that longitudinal panels have not been used widely to study transportation and travel behaviour is more worthy of comment than that there is now an emerging interest in such methods.

There appear to be two primary reasons for the lack of use of longitudinal panels, particularly for urban-travel behaviour. The first is the fact that the primary agencies involved in planning, designing, constructing, and operating urban-transportation systems are public agencies. Public agencies are not generally oriented to the notion of longitudinal panels, except in areas relating to medicine. Neither the use of longitudinal data, nor the budgeting mechanism to commit funds over several years are common in public agencies. The result is that methods have not been developed to analyse and utilise data from panel surveys, and well-intentioned initiatives of panels are often terminated prematurely because of a lack of funds to undertake even second-wave surveys.

The second reason for the lack of panel surveys is the perception of the potential impacts of attrition on the panels. In many fields of study where panels are used routinely, the geographic locations of the households are relatively unimportant. Thus, if people move home locations during the life of the panel, membership in the panel is generally unaffected. In urban-transportation studies, on the other hand, geographic location, at least within the same urban area, is often seen to be critical to relevance in the panel. (This may, however, be a misapprehension.) Therefore, in addition to the attrition that occurs in all panels over time, there is additional loss in an urban travel-behaviour panel resulting from household relocations. In the U.S. in particular, households have tended to be quite mobile, with the average household moving every five years. This holds the potential of adding as much as an additional 20 percent attrition each year.

Nevertheless, replacement procedures and their effects on analysis of the panel data are well understood and documented[25,26] and review of the statistics of panels shows that even relatively high levels of attrition still leave many benefits in the use of panels. These benefits include reduced error in estimating changes from one wave to another, and the ability to identify dynamic changes that will not be apparent from series of cross-sectional surveys. In this latter aspect, for example, the Seattle panel has revealed that while aggregate transit ridership may appear relatively stable from year to year, there is a continual flux of ridership, with existing transit riders shifting to auto modes and new individuals starting to ride transit[27]. Furthermore, procedures for replacement can be used to maintain panel integrity over time, so that the benefits of panel surveys can be realized despite the different circumstances pertaining to travel-behaviour analyses and concerns.

Data Collection

As noted earlier, the past four or five years have seen a local peak in the number of data-collection activities undertaken in urban areas in the U.S., as well as in other countries. As more complex sample designs and improved survey instruments have been utilized, new implications are being realized concerning the impact of data collection on the subsequent calibration and use of travel-behaviour models.

First, and rather surprisingly, the issue of data expansion and reweighting seems to be fairly poorly understood within the applications arena[28,29]. As sample designs become more complex, more attention must be paid to correct weighting and expansion of sample data, particularly for designs that result in different sampling rates for different population segments, and different response rates within the various

segments of the population. Implications of certain sample designs on data for different modelling steps is also a concern that is not well understood. Samples drawn to provide sample sizes that are "politically correct" by jurisdiction and geographic subarea are likely to produce problems of insufficient data on use of certain transportation modes, such as transit and carpools. This has occurred for several recent surveys in the U.S.

In turn, the sampling deficiencies that may arise compel augmentation of the data from other sources, such as choice-based samples of transit use and carpooling. This raises issues concerning the appropriateness and methods for combining data from different surveys based on different sampling procedures. Work performed some years ago by McFadden[30] seems to indicate that weighting of data is not required when combining different samples for calibrating logit models provided that a full set of alternative-specific constants are included in the calibrated models. All bias is supposedly captured in the constants, which can then be corrected after calibration. This procedure has been used in a number of instances, and models have been developed that appear to test out adequately, provide reasonable and rational values for coefficients, and provide no basis for assuming the presence of serious bias[31]. Nevertheless, there is an emerging swell of opinion that data should be weighted in the calibration process and recent developments in software capabilities for calibrating logit models[32] seem to make it possible to perform such weighting in the calibration process. However, whether or not the results are any less biased from such a procedure, or, indeed, whether the results are actually in any way consistent between the alternative procedures, is an issue that has not been addressed satisfactorily to date. As a result, there are currently three "camps" with respect to the issue: those who hold to the McFadden procedure, those who believe that weighting in calibration must be undertaken, and those who either do not care or are ignorant of the issue. The last of these three groups covers the majority of practitioners in the U.S. This appears to be an area of data application that merits immediate research, particularly because there are likely to be a number of new logit models calibrated in the next few years in the U.S., as a result of a substantial number of data-collection activities that have taken place recently.

Reports of the data-collection activities show some other trends that merit comment. First, there is an almost complete shift now to collecting data through telephone and mail, to the exclusion of other techniques. The face-to-face home interview, for example, seems to be a methodology of the past, largely due to the high expense associated with the method. Second, there are reports that the use of the telephone

as the mechanism of first contact and, sometimes, subsequent retrieval, is becoming increasingly subject to problems associated with the increased communications capabilities of the telephone system. Among problems that arise with this is an increasing number of telephone lines that are dedicated to data transmission (modem or fax) that will be reached by a random-digit dialling procedure. The proliferation of such dedicated lines threatens the efficiency of random-digit dialling procedures, as well as leading to additional problems in determining whether the line is a dedicated line or is also used for voice transmissions. Another problem relates to the proliferation of portable and cellular telephones, for which the person receiving the call is charged on a time basis. When an interviewer calls such a telephone and involves the respondent in even a relatively short introductory interview, the costs to the respondent can be high and the potential for damage to the credibility of the survey is significant.

The increase in the capabilities for automatic dialling of telephone numbers and use of recorded, in addition to live, sales pitches, has also contributed to a heightening of the sensitivity of people to sales and interviews over the telephone, particularly where such calls may result in an effort to sell the respondent something. This serves to increase the rate of outright refusals to be interviewed as well as increasing the number of premature terminations. Frequently, the experience is that private individuals are increasingly likely not to wait to hear what the survey is about, and also that there are so many entities using the telephone for surveys of various types that any telephone survey is automatically assumed to be burdensome. An additional technological capability has not been reported on yet but seems likely to have further negative impacts on the potential of the telephone as a data-collection instrument is the ability to display the telephone number of the person calling you. Already, there are frequent reports of answering machines being used to screen calls, with the result that such screening uses result in never contacting a live human being at the other end of the telephone line. Display of the calling number is likely to add to this, given that people called will not recognize the telephone number and will likely refuse to answer. This capability may also be seriously damaging to the use of survey firms from out of town and out of state.

There also seems to be a significant emergence of the necessity to "bribe" people to respond to a survey. Most of the surveys that have reported reasonable response rates also indicate the use of a monetary incentive. While such incentives are currently as little as $1 per survey questionnaire to be completed, it seems likely that this will be subject to inflation that runs well beyond inflation in the national economy.

More and more survey entities are finding the need to provide an incentive, so that the discriminating respondent will soon find it necessary to select only those surveys willing to pay above the average! This experience may currently be fairly well isolated to the United States. However, it should seem likely that it may begin to emerge as an issue in other countries as they experience the same changes in capabilities of communications and survey technology.

Data Errors and Bias

It is somewhat alarming to note that, while survey methodologies have changed and new survey technologies have been developed, relatively little attention still is paid to the issues of errors and bias in the data. Recent literature seems to show a willingness to accept quite low response rates[33,34], without questioning the validity of the data or the extent to which the response rate may indicate the presence of substantial respondent bias. Questions of measurement error are even less likely to be raised. Out of fifteen papers reporting on various aspects of recent transportation and travel surveys at the 1993 Annual Meeting of the Transportation Research Board, only one reported on any aspect relating to bias[35], and none reported on measurement errors.

In this volume, the paper by Hautzinger[36] addresses some important issues relating to survey design and measurement errors. In particular, he points out that the measures often derived from transportation surveys are ratios of means from the samples. Such measures have different error properties from those of simple sample means, and therefore often dictate different sample sizes and designs than those usually developed. In general, it can be concluded from Hautsinger's work that sampling errors are typically underestimated from travel surveys, particularly when the measures of interest are ratios and secondary means, and that sample sizes and sampling strategies are often not designed in an optimal fashion, because of not utilizing the correct error properties of the measures of interest.

EXOGENOUS INPUTS

Application of travel-behaviour models and methods requires the input of exogenous forecasts that drive the estimates of travel behaviour. For many years, the effects of these exogenous inputs have been largely ignored. However, recent concern over the appropriateness and accuracy of forecasts of transit ridership[37] has resulted in a more intense scrutiny of the effects of input forecasts on the results from the models.

In the applications context, forecasts are generally required of the following variables, among others, in order to produce travel-behaviour forecasts for a future year:

- Population
- Employment
- Auto ownership
- Residential location
- Job location
- Income
- Workforce participation

Population and employment forecasts are usually derived from national or state/provincial forecasts that are undertaken by various governmental bodies. This review does not deal with these. The remaining variables are not usually forecast by national or state governments and must be forecast, instead, by agencies whose focus is most closely on the planning region of concern. In some instances, these forecasts must be produced by the agency involved in transportation planning. In addition to simply forecasting these variables, it is also frequently necessary to prepare estimates of the means, medians, and distributions of many of these variables at the level of the Traffic Analysis Zone (TAZ). While the issue may have seemed too trivial or too obvious to document in professional papers, there is no question that the allocation of population and employment, and the estimation of the other socio-demographic variables and their distributions at the TAZ level, is capable of having a profound effect on the results of applying travel-behaviour models. There are substantial sensitivities of most travel-behaviour models to these variables, and there is a potential for forecasts to be substantially biased by certain assumptions made in producing these values.

In many applications in the U.S. over the years, the task of producing these exogenous inputs has often been left to staffs that have no direct involvement in the travel-forecasting activities, with the result that some very questionable allocations and distributions have sometimes been used in producing travel forecasts. The old adage that "garbage in equals garbage out" holds very true in the arena of travel forecasting. Only very recently, in the U.S., has attention begun to be paid to these exogenous inputs by the travel-forecasting profession, particularly as capital-intensive projects have come under more careful and detailed scrutiny, and also as the entire travel-forecasting process has begun to be scrutinized in adversarial litigation. Consequently, one of the emerging directions in the applications area is to look more at the potential to use the same principles that underlie travel-behaviour models as a means to develop improved capabilities to forecast some of these exogenous inputs.

There are several examples of the development of such capabilities. Probably one of the oldest such efforts was the inclusion of an auto-ownership choice model in the travel-forecasting models developed for the San Francisco Bay Area in 1980[38]. This area of auto ownership and use is one that is currently receiving renewed attention, particularly as a result of global changes of considerable magnitude in the trends of auto ownership and specialization in the use of automobiles. Three of the chapters in this book deal directly with this issue[39,40,41] in one form or another, while the Stockholm model described by Algers, Daly, and Widlert[42] includes auto-ownership choice as one of the model steps. In comparison to older, deterministic models of auto ownership, particularly those that were based on assumptions about a saturation level of auto ownership, these newer choice-based models show promise of providing considerable improvement in estimation of auto ownership. Furthermore, and of considerable importance as the profession moves more to examining strategies to change trends in travel behaviour, these models offer some promise of showing responsiveness in auto-ownership decisions to changes in the transportation system.

Residential location and employment location are also receiving increasing interest as areas in which principles derived from choice behaviour may have potential application. At one end of the spectrum, the recent developments and improvements in the Lowry-type land-use models, such as DRAM-EMPAL[43,44] represent the addition of some sensitivity to the transportation system in residential choice modelling. At the other end of the spectrum are models that attempt to predict residential choices directly, using models that are behavioural in structure. There are a number of examples of approaches that utilize some aspects of travel-behaviour theory in residential location, although the methodology has not advanced far enough for widespread application[45,46]. In some instances, there is an attempt to treat both residential and employment location together in one model, as done by Mackett[47], or just employment decisions, as done by Bhat and Koppelman[48]. There are also some new findings of interest that have been developed relating to the effects of location choices on travel choices[49]

Finally, in the area of household demographics, research is underway to develop methods of microsimulation and other procedures for forecasting household life-cycle changes[50,51]. Again, however, the methods are not yet sufficiently developed to have appeared in practical applications. However, the methods are of importance as a trend towards shifting from reliance on aggregate, deterministic methods for forecasting such exogenous inputs to travel-behaviour models.

Finally, two other areas of exogenous inputs should be touched on: choice-set formation and captivity, where the latter really represents a lack of choices. In the applications area, these two issues have been dealt with relatively lightly. The traditional applications approach is to assume that all individuals have the same choice set, and that the choice set is a universal choice set. In one instance[52], an explicit attempt was made to develop a model of captivity to modes, which was then used to subdivide the population into three groups: those with all choices available, those with only auto drive alone available, and those with transit and auto shared ride available. This application has some important information to impart in that it was found that no individuals appeared to be entirely captive to transit, because almost all individuals could be considered to have potential access to a ride in someone else's car, while some individuals, particularly those who drive for a living, may be captive to drive-alone auto.

Applications are undergoing substantial change in relation to choice sets for mode choice, as the potential to use nested logit models has shifted into the applications arena. In older models, there were frequently quite restricted choice sets, resulting in part from limitations of the software to handle many alternatives, in part to limitations in some software packages that could only include an observation if there were data on all alternatives in the choice set, and in part to problems with the IIA property of logit models that required limitations in choice set definition in order to avoid IIA problems. In most contemporary models in the U.S., as well as many that are being developed in other countries, there are typically at least two nests, one of which is the auto nest and contains auto, drive alone; auto with one passenger; and auto with 2 or more passengers; and the other of which is a transit nest that typically includes transit with walk access and transit with auto access[53]. New structures are also being considered as new modes become significantly more popular in the U.S., so that commuter rail and sometimes differentiation between bus and urban rail are considered.

EXTENSIONS BEYOND MODE CHOICE

By far the greatest number of applications of the multinomial logit model have been in the area of person mode choice, with much of the experience being in the specific application to home-based work trips. Relatively few applications can be found of even a mode-choice model for other than work trips[54]. In the U.S., the standard travel-demand forecasting procedure in use by most Metropolitan Planning Organizations consists of a household-based, cross-classification model for trip productions and a regression-based model for trip attractions, a gravity model for trip distribution, a

multinomial logit model for mode choice (mainly, but not always, for home-based work trips only), and a network assignment procedure for each of highway and transit networks. Thus, the mode-choice model tends to be the only applications model that is reasonably defined as a behavioural model and the model also has to be operated within a highly aggregate framework.

Recent developments, particularly assisted by improvements in the software for model calibration, show promise of developing more widely-applicable behavioural models for other parts of the sequential modelling process. For a considerable time, the profession has relegated such models to the research arena and has not considered applications of them to be in the realm of feasibility. Partly, this is a result of misperceptions and misapprehensions about the relationship between behavioural models and zone systems, as used in most contemporary transportation-planning practice. It is also partly a result of a lack of in-depth training in models for many of the staff people in MPOs, whose responsibility it is to design and use such models. A good example of an implementable (potentially) model system that utilizes multinomial logit models throughout is provided in this book[55]. This model system actually utilizes a combination of simple multinomial logit and nested logit models. Similar models are being developed in the DRIVE project[56], although these were not developed far enough at the time of the conference to permit reporting in this book.

Given current developments in travel-forecasting methodology in the U.S., it is not clear how far progress along the lines of implementing multinomial or nested-logit models should or will continue. In the U.S., at least, the standard UTPS approach that incorporates logit models only in mode choice seems likely to remain the preferred methodology for the next few years. The principal change that seem likely in this methodology would be the introduction of models of trip frequency and choice of time of day as possible substitutes for current procedures of trip generation and diurnal splitting that are performed in current models. Major developments in destination and route choice still seem somewhat far from practice. In the event that there emerges in the next few years a new and credible paradigm for travel forecasting that is different from the present one, extensions of behavioural models into areas other than mode choice, trip frequency, and time-of-day choices seem less likely.

On the other hand, if a new paradigm does not emerge that has relatively immediate acceptance by the transportation-planning professional, there yet remains a need to provide a demonstration of the overwhelming superiority of behavioural approaches to trip distribution and assignment. Even with the examples from Stockholm and the

DRIVE project, the justification for using behavioural approaches resides more in the convictions of the model developers than in actual demonstrations that the results of using such models produce better results and lead to significantly different decisions on policies and strategies in the transportation arena. The profession could use a side-by-side demonstration in which a system of "conventional" models is developed alongside a system of fully "behavioural" models, and each system is used to project the same future horizon year and response to the same strategic plans. Even then, it will require that either a "back-casting" exercise is undertaken, or that a sufficient time is allowed to ealpse to show which modeling system comes closer to the mark, in order to determine which system may be preferable.

A last point that is worth making in this context is that the rapid shift from mainframe computers to desk-top computers could also spell more significant change in these approaches to travel forecasting. There is no question that the shift of most applications work into the desk-top computer environment has made modeling much more accessible to the average transportation-planning professional. Frustration with the general insensitivity and cumbersomeness of the present travel-forecasting models and aggregate application contexts may lead to a more rapid potential acceptance of alternative approaches. Particularly if efforts succeed to utilize Geographic Information Systems (GIS) to retain highly disaggregate information and obviate the need for zone systems, the potential for disaggregate procedures that rely heavily on travel-behaviour constructs is greatly enhanced. Coupled with this is the relative ease and greater sensitivity likely to be available from such approaches to examining a variety of "what if" scenarios. Given the rapidity with which computer technology is advancing and changing, and these advances and changes are assimilated by consumers, it may yet occur that more widespread use of behavioural models will occur, even while the new paradigms are being developed.

Transferability in Applications

Practically from the outset of the adoption of behavioural mode-choice models, considerable use has been made of the claims of transferability of models. Many examples can be quoted of the wholesale transfer of mode-choice models from one location to another. For example, a number of different regions in the U.S. can trace their mode-choice models back to an original calibrated model for the Minneapolis-St. Paul region. A major impetus behind transfer in paractice has been the lack of data in the local area for undertaking a calibration. Two approaches have been used to deal with this data deficiency. The first, and probably more common, has been to borrow a model from another locality. The second has been to construct "synthetic" models,

that is, models based on conventional wisdom about comparative weights of different attributes in the model, with an overall scaling factor to provide a match between limited available data on actual market shares and the performance of the models.

Recently, there have been a number of new instances of borrowing models or parts of models. These recent instances may be useful for several reasons, including that they may help to identify situations in which transfer has been successful and has been undertaken as closely as possible to theoretically correct conditions and procedures, and that there are other instances in which dangers of transferring models are demonstrated by the experience.

Conditions for Transferability

The most fundamental condition for transferability is that the model (or models) to be transferred should have been fully calibrated in the donor region. Transferring a model that has been transferred already, or that has been partially or wholly synthesized is likely to result in serious failure. A second, fairly obvious, condition for transferability is that the donor region should be in a similar category as the recipient region. In other words, if the recipient region is a large metropolitan area (say above 1 million population), then the donor region should probably **not** be a region with less than 200,000 population, but should be one that is also larger than 1 million. Third, the range of alternative choices in the donor region should encompass all of those available in the recipient region, because is is not normally possible to extend choice sets in a donated model without calibration data and recalibration of the model.

Fourth, considerable care should be taken on determining any special circumstances or contexts used in developing the donor model. For example, if the donor region uses a time-of-day split before trip distribution and then calibrated the mode-choice models against choices by time period and purpose, the recipient region should do the sajme. Similarly, if the donor region includes captives in the data set without special treatment, the recipient region must do the same, because serious errors could arise in inconsistencies between these treatments. Fifth, the donor model must contain alternative-specific constants for all but one of the alternatives in each nest or for the entirety of a simple multinomial model. If alternative-specific constants are not included, transfer of the model is not possible.

The final requirement relates to the recipient region. This region must have market shares of each alternative to be included in the model for each purpose and time

period for which a donor model is sought. The market shares may be from direct measurement, or may be inferred from other data, but a capability to produce these is essential.

Additional conditions may need to be set on transfer of models, but it is safe to state that, if the above conditions do not hold, transfer should not take place. If the above conditions are met, then successful transfer may be possible. A serious issue in transfer is that it may not be apparent in the transfer process that the transfer is not successful. In other words, it is always possible to transport a model from one location to another and to adjust it statistically so that it can replicate aggregate market shares to a reasonable level of accuracy. The problems arise in the application of the model in forecasting, where failure of the transfer may only be revealed by the production of seriously implausible results, while production of results that are within the range of plausibility may still mask a failure in the transfer.

From this discussion, it should be clear that transferability is not a simple issue and that some significant research is required into the donor models as well as some minimal data from the recipient region. It is also clear that there are a number of instances of transfer that have been undertaken in practice that do not meet these criteria. While it is not considered useful to cite specific examples of such transfers, it should be taken as a warning that any region working with donated models should probably examine the history of the transfer to determine if it was done appropriately.

Successes in Transferability

In many respects, logit models of mode choice have been found to be highly robust and to appear to transfer very well. In two recent projects, models calibrated in Dallas-Fort Worth were transferred to Orange County, California[57] and to the entire Los Angeles Metropolitan Region[58]. The donor models were calibrated on data collected in the Dallas-Fort Worth metropolitan area in 1985, and calibration was completed in 1991. The available choices in both regions were automobile, with varying levels of occupancy, and transit provided by both local and express buses.

REFERENCES

1. Pas, Eric I. and Martin Lee-Gosselin, *Title*, chapter 1 in this book.

2. JHK Associates, Inc., *Travel Forecasting Methods*, Report to Caltrans, Sacramento, CA, 1992.

3. Harvey, G. and E. Deakin, *A Manual of Transportation -Air Quality Modeling for Metropolitan Planning Organizations*, Report (Revised Draft) prepared for the National Association of Regional Governments, Washington, D.C., 1992.

4. U.S. EPA, *Final Conformity Rules for Transportation Projects*, , November, 1993.

5. Smith, M. E., "Design of Small-Sample Home-Interview Travel Surveys," *Transportation Research Record No. 701* , Transportation Research Board, Washington, D.C., 1979, pp. 29-35.

6. Stopher, P., "Small-Sample Home-Interview Travel Surveys: Application and Suggested Modifications," *Transportation Research Record No.886*, Transportation Research Board, Washington, D.C., 1982, pp. 41-47.

7. Murakami, Elaine, W. T. Watterson, and Mary Toelle, "Puget Sound Transportation Panel After Two Years," *Proceedings of the Third National Transportation Planning Methods Applications Conference*, Dallas, Texas, April, 1991.

8. Stopher, Peter R., "Conventional Wisdom in Building Mode-Choice Models: Some Fallacies and Other Myths," *Proceedings of the Thirty-third Annual Meeting of the Transportation Research Forum*, New Orleans, 1991, pp. 133-145.

9. Papacostas, C. S., Nicolaos E. Synodinos, and Glenn E. Okimoto, "Computer-Administered Surveys at the Honolulu Airport," *Transportation Research Record No. 1412*, Transportation Research Board, Washington, DC, 1993, pp. 33-38.

10. Jones, Peter and Polack, John, "Title," *this book*.

11. Ng, Jerry C.N., and Paul M. Sarjeant, "Use of Direct Data Entry for Travel Survey," *Transportation Research Record No. 1412*, Transportation Research Board, Washington, DC, 1993, pp. 71-79.

12. Stopher, Peter R., "Use of an Activity-Based Diary to Collect Household Travel Data," *Transportation*, 1992, Vol. 19, pp. 159-176.

13. Lee, Martin E. H., "Development of a Methodology for Estimating the Kilometrage of Drivers throughout Quebec," *Proceedings of the Canadian*

Multidisciplinary Road Safety Conference IV, May, 1985, Équipe de Sécurité Routière de l'École Polytechnique, pp. 563-572.

14. Purvis, C. L., "Survey of Travel Surveys II," *Transportation Research Record No. 1271*, 1990, pp. 23-32.

15. Sozialforschung Brög, *KONTIV 75-77 – Continuous Survey of Travel Behavior. Summary Volumes 1-3.* Prepared for the Ministry of Transport, Federal Republic of Germany, Munich, 1977 (in German).

16. Golob, T. F., L. J. M. Schreurs, and J. G. Smit, "The Design and Policy Applications of a Panel for Studying Changes in Mobility Over Time," *Behavioural Research for Transport Policy*, VNU Press, Utrecht, The Netherlands, 1986, pp. 81-95.

17. Stopher, Peter R., "Use of an Activity-Based Diary to Collect Household Travel Data," *op. cit.*

18. Spear, Bruce D., "Title," source, 1993.

19. Koppelman, Frank S. and Eric I. Pas, "Estimation of Disaggregate Regression Models of Person Trip Generation with Multiday Data," *Ninth International Symposium on Transportation and Traffic Theory*, 1984, VNU Science Press, pp. 513-531.

20. Pas, Eric I., "Multiday Samples, Parameter Estimation Precision, and Data Collection Costs for Least Squares Regression Trip-Generation Models," *Environment and Planning A,* 1986, Vol. 18, pp. 73-87.

21. Pas, Eric I. and Frank S. Koppelman, "An Examination of the Determinants of Day-to-Day Variability in Individuals' Urban Travel Behavior," *Transportation*, 1987, Vol. 14, pp.3-20.

22. Golob, T. F. and H. Meurs, "Biases in Response Over Time in a Seven-Day Travel Diary," *Transportation*, 1986, Vol. 13, No.2, pp. 163-181.

23. Murakami, Elaine and W. T. Watterson, "Developing a Household Travel Panel Survey for the Puget Sound Region," *Transportation Research Record No. 1285*, 1990, pp. 40-46.

24. Kitamura, Ryuichi and Janusz Supernak, "Temporal Utility Profiles of Activities and Travel: Some Empirical Evidence," chapter 14 of this book.

25. Yates, Frank, *Sampling Methods for Censuses and Surveys*, Charles Griffin & Co. Ltd., London, 1965.

26. Kish, Leslie, *Survey Sampling*, John Wiley & Sons, Inc., New York, 1967.

27. Murakami, *et al., op. cit.*

28. Stopher, Peter R. and Stecher, Cheryl, "Blow Up: Expanding a Complex Random Sample Travel Survey," *Transportation Research Record No. 1412*, Transportation Research Board, Washington, D.C., 1993, pp. 10-16.

29. Kim. Hyungjin, Jing Li, Stephanie Roodman, Ashish Sen, Siim Sööt, and Ed Christopher, "Factoring Household Travel Surveys," *Transportation Research Record No. 1412*, Transportation Research Board, Washington, D.C., 1993, pp. 17-22.

30. McFadden, Daniel, "Quantitative Methods for Analyzing Travel Behaviour of Individuals: Some Recent Developments," in *Behavioural Travel Modeling*, Hensher, David A. and Peter R. Stopher, Editors, Croom Helm Ltd., London, 1979.

31. Ryan, James M., "Mode-Choice Models for Dallas-Fort Worth: Implications for the State-of-the-Art," paper presented to the Annual Meeting of the Transportation Research Board, Washington, D.C., January, 1988.

32. Daly, Andrew, *ALOGIT (Versions 2.3x) User Manual*, Hague Consulting Group, Den Haag, Netherlands, September, 1989.

33. Kim, *et al., op. cit.*

34. Hassounah, Mazen I., Loy-Sai Cheah, and Gerald N. Steuart, "Under-Reporting of Trips in Telephone Interview Travel Surveys," *Transportation Research Record No. 1412*, Transportation Research Board, Washington, DC, 1993, pp. 90-94.

35. Thakuriah, Piyushimita, Ashish Sen, Siim Sööt, and Ed Christopher, "Nonresponse Bias and Trip Generation Models," *Transportation Research Record No. 1412*, Transportation Research Board, Washington, DC, 1993, pp. 64-70.

36. Hautzinger, Heinz, "Design and Analysis of Travel Surveys," chapter 18 of this book.

37. Pickrell, Don H., *Urban Rail Transit Projects: Fortecast versus Actual Ridership and Costs,* Report prepared by the Transportation Systems Center for the Urban Mass Transportation Administration, U.S. Department of Transportation, Washington, DC, October, 1989.

38. Cambridge Systematics, Inc., *Travel Model Development Project Phase 2 Final Report: Volume 2: Detailed Model Descriptions*, Report to the Metropolitan Transportation Commission, Berkeley, CA, June, 1980.

39. de Jong, G., "A Microeconomic Model of the Joint Decision on Car Ownership and Car Use," chapter 20 in this book.

40. Chandrasekharan, Radha, Patrick S. McCarthy, and Gordon P. Wright, "Models of Brand Loyalty in the Automobile Market," chapter 21 in this book.

41. Madre, Jean-Loup and Alain Pirotte, "Regionalization of Car Fleet and Traffic Forecasts," chapter 22 in this book.

42. Algers, Staffan, Andrew Daly, and Staffan Widlert," Modelling Travel Behaviour to Support Policy Making in Stockholm," chapter 23 in this book.

43. Putman, Stephen H., *Integrated Urban Models*, Pion Ltd., London, England, 1983.

44. Watterson, W. T., "Adapting and Applying Existing Urban Models: DRAM and EMPAL in the Seattle Region," *Journal of the Urban and Regional Information Systems Association,* 1990, Volume 2, Number 2, pp. 35-46.

45. Matsura, Yoshimitsu and Michiyo Numada, "The Effects of Transport Facility Improvements on Residential Location and Housing Size," *Selected Proceeding of the Sixth World Conference on Transport Research: Land Use, Development and Globalization, Volume I*, World Conference on Transport Research Society, 1992, pp. 31-42.

46. Martinez, Francisco J. "Towards the 5-Stage Land Use-Transport Model," *Selected Proceeding of the Sixth World Conference on Transport Research: Land Use, Development and Globalization, Volume I*, World Conference on Transport Research Society, 1992, pp. 79-90.

47. Mackett, Roger L., "Policy Analysis Using a Microsimulation Model of Land Use and Transport Systems," *Selected Proceeding of the Sixth World Conference on Transport Research: Land Use, Development and Globalization, Volume I*, World Conference on Transport Research Society, 1992, pp. 67-77.

48. Bhat, C. R. and F. S. Koppelman, "An Endogenous Switching Simultaneous Equation System of Employment, Income and Car Ownership," Paper presented to the Sixth International Conference on Travel Behaviour, Quebec, May, 1991.

49. Kirby, Howard R. annd F. A. O. Raji, "Location Behaviour and the Journey to Work," *Selected Proceeding of the Sixth World Conference on Transport Research: Demand, Traffic and Network Modeling, Volume II,* World Conference on Transport Research Society, 1992, pp. 715-726.

50. Kitamura and Supernak, *op. cit.*

51. Goulias, Konstadinos G. and Ryuichi Kitamura, *Travel Demand Forecasting with Dynamic Microsimulation,* Research Report UCD-ITS-RR-92-4, Institute of Transportation Studies, University of California, Davis, March, 1992.

52. Ryan, James M., *op.cit.*

53. Parsons, Brinkerhoff, Quade and Douglas, *Service and Patronage Methods Report,* Red Line Extension Alternatives Analysis Project, Prepared for the Los Angeles County Transportation Commission (now the Los Angeles County Regional Transit Authority), Los Angeles, CA, 1992.

54. Stopher, Peter R., "Conventional Wisdom in Building Mode-Choice Models: Some Fallacies and Other Myths," *op.cit.*

55. Algers, S., *et al., op. cit.*

56. Axhausen, K.A. and Goodwin, P.B., "EUROTOPP – Implementing a Dynamic and Information Sensitive Modelling Framework," Paper presented to the Sixth International Conference on Travel Behaviour, Quebec, Canada, May, 1990.

57. Parsons, Brinkerhoff, Quade, and Douglas, *Orange County Rail Study – Final Report,* Report prepared for Orange County Transportation Commission, Santa Ana, CA, 1991.

58. Parsons, Brinkerhoff, Quade and Douglas, *Service and Patronage Methods Report,* report prepared for the Los Angeles County Transportation Commission's Alternatives Analysis for the Metro Rail Extension Project, March, 1993.

18

DESIGN AND ANALYSIS OF TRAVEL SURVEYS

Heinz Hautzinger

ABSTRACT

This chapter deals with the main statistical design concepts for travel surveys. A general conceptual framework for travel and transport surveys is presented first. Then, several important sampling schemes for travel surveys (panel surveys, systems of independent subsamples, interpenetrating subsamples, and rotation sampling with partial replacement of units) are investigated and estimators are derived. The statistical properties of these estimators are discussed and practical applications of point- and interval- estimation procedures for travel-survey data, using appropriate computer software, are described.

INTRODUCTION

Household travel surveys are of fundamental importance for travel-behaviour research and travel-demand modelling. In recent years, substantial progress has been made in such fields as administration of the survey, proper design of questionnaires or adequate instruction of interviewers, efficient automatic processing of the resulting data, and the like. Similarly, our knowledge of sources of systematic errors in travel surveys has improved considerably[1,2].

Whereas many technical and measurement problems — which are largely non-statistical — have already been solved, a comprehensive statistical basis for travel surveys is still lacking. Questions of the representativeness of a travel survey, its validity, the choice of appropriate sampling procedures, methods of estimation of population characteristics, and the properties of these estimators, as well as legitimate interpretation of the results, all depend vitally on the proper application of statistical

ideas. A "technically" perfect survey may be virtually useless if a disregard of statistical design considerations makes it impossible to measure the accuracy of the results[3].

For several reasons, statistical design and analysis of travel surveys is difficult:

1. in most cases the sampling plan of a travel survey becomes inevitably complicated (e.g., multistage sampling);

2. the population totals and means to be estimated often do not refer to a specific date, but to a rather long time period (e.g., total length of all automobile trips made in a certain region during one year, or mean length of these trips);

3. most of the population characteristics we want to estimate are ratios, where both the numerator and denominator are unknown (e.g., mean number of trips per person per day);

4. in most cases we have to deal with "current" travel surveys, where every single person or household in the sample is reporting only for a limited number of periods (e.g., for a single day or two successive days);

5. the nonsampling errors in travel surveys call for an appropriate correction of the results (e.g., correction for different mobility levels of responding and nonresponding households).

All these features of a travel survey make it difficult to obtain unbiased estimates and to estimate the confidence intervals for the population characteristics under study.

A General Conceptual Framework for Travel Surveys

Problem Formulation

The study units of a travel survey are usually persons or households and it is, of course, the travel behaviour of these units which is of interest. To describe an individual's travel behaviour over time, it is convenient to divide the observational period into disjoint intervals (e.g., days or weeks), and record the number of trips or, equivalently, the number of non-home activities of the individual, in each interval. Both trips and activities can be regarded as travel-related "events" occurring in time and space. If we are investigating rare events like vacation trips we usually use longer time intervals, e.g., weeks or months. Besides the number of such events (trips or activities) in successive time intervals, we are also interested in certain characteristics of these events. Well-known examples are, for instance, length and mode of trips, or

duration and type of activities. For the population of persons or households as a whole and for a specific period of study (often a year) we are then interested in:

- totals of certain quantitative trip or activity characteristics (e.g., total length of all car trips made in a country during one year)

- mean values of trip or activity characteristics

 o mean per trip or activity (e.g., mean length of trips)

 o mean per person or household and unit of time (e.g., mean distance travelled per person and day)

- ratios of two totals of trip or activity characteristics (e.g., total length of car trips divided by total length of all trips)

Similarly, with respect to the number of travel-related events we may be interested in:

- total number of trips or activities (of all population members during the specified time period)

- total number of trips or activities of a certain type (e.g., total number of recreational trips)

- mean number of trips or activities per person or household and unit of time (e.g., mean number of recreational activities per person per week)

- ratios of two totals (e.g., number of trips per activity)

Except for very specific situations, the true values of these totals, means, proportions, or ratios, cannot be known precisely. Instead, these measures have to be estimated from a sample. As can easily be imagined, a variety of alternative sampling designs are possible in this situation. Some of the most important designs are investigated in this chapter.

Formal Description of the Population

In travel surveys usually, we are dealing with a special type of population consisting of combinations of behavioural units (persons or households) and time intervals (e.g., days). If behavioural units are labelled by $i=1,...,N$ and time intervals are indexed by $j=1,...,T$, the population is formed by the set of all combinations (i,j). Thus, it is convenient to speak, for instance, of a population of "person-days" or "household-weeks." Frequently, the number N of behavioural units in the population cannot be regarded as constant over time. In this case, the description of the population has to be modified appropriately. If not stated otherwise, we will consider N and T to be constant and known. Symbolically, the population of a travel survey may be represented as shown in Figure 1.

Time Intervals

		1	j	T
Behavioural	1	(1,1)	(1,j)	(1,T)
Units	i	(i,1)	(i,j)	(i,T)
	N	(N,1)	(N,j)	(N,T)

Figure 1

Description of the Population of a Travel Survey

If we think of (i,j) as a "person-day," we may write x_{ij} $(x_{ij}=0,1,2,...)$ for the number of trips (or activities) completed by person i during day j. If $x_{ij} \geq 1$, i.e. if person i is "mobile" on day j, we may use the symbol y_{ijk} to denote the value of a certain characteristic of the kth trip of person i on day j, e.g., trip length. Thus, the two sets describe the travel behaviour of our N persons over a time period of T days with respect to the intensity of trip-making and to the length of the trips made, respectively.

$$\{x_{ij} | i=1,...,N; \quad j=1,...,T\}$$

$$\{y_{ijk} | i=1,...,N; \quad j=1,...,x_{ij} \quad where \quad x_{ij} > 0\}$$

Types of Population Parameters to be Estimated

Since x_{ij} denotes the number of trips made by unit i during time interval j, the sum

$$X = \sum_{i=1}^{N} \sum_{j=1}^{T} x_{ij} \qquad (21.1)$$

is the total number of trips made during the study period. This is, of course, an unknown quantity. In transportation planning, the quantity X is often referred to as "total trip volume" or "aggregate trip production." The mean number of trips per population unit (e.g., per person and day) is given by:

$$\bar{X} = X/(NT) \qquad (21.2)$$

This is the well known "mean trip rate" of classical trip-generation analysis.

If $x_{ij} \geq 1$, i.e., if person i is mobile during day j, we use the symbol y_{ijk} to denote the value of a certain characteristic of the kth trip of person i on day j $(k=1,..., x_{ij})$. The population total of the characteristic under consideration is given by:

$$Y = \sum_{i=1}^{N} \sum_{j=1}^{T} \sum_{k=1}^{x_{ij}} y_{ijk} \qquad (21.3)$$

Aggregate mileage per annum is a typical example for such a population total. Obviously, if $x_{ij} = 0$ summation over k in (2.3) yields zero. Again, the total value Y is unknown and has to be estimated from a sample.

In this context we may distinguish two different types of mean values:

$$\bar{Y} = Y/(NT) \quad (e.g.\ mean\ travel\ distance\ per\ person\ per\ day) \qquad (21.4)$$

$$\overline{\overline{Y}} \;=\; Y/X \quad (e.g. \; mean \; trip \; length) \tag{21.5}$$

As can be seen, this is a situation similar to two-stage cluster sampling with person-days as primary and trips as secondary units, and we may speak of x_{ij} as the "size" of cluster *(i,j)*. Consequently, $\overline{\overline{Y}}$ and \overline{Y} may be regarded as mean per primary and secondary unit, respectively. It should be noted, that only \overline{Y} is a mean value in the usual sense, whereas $\overline{\overline{Y}}$ is a ratio of two totals.

In a travel survey, we normally consider a variety of quantitative trip characteristics like trip time, length, or cost. Consequently, we have totals $Y,Z,...$ of several trip characteristics and we are frequently interested in ratios of the type

$$R \;=\; Y/Z \tag{21.6}$$

If, for instance, Y and Z denote the population totals of trip cost and trip length, respectively, then R represents mean trip cost per unit of distance travelled.

Consideration of qualitative trip characteristics like trip purpose also leads to ratio-type population parameters. If, for instance, X_p denotes the total number of trips with purpose p, then we may, of course, call

$$Q_p \;=\; X_p/X \tag{21.7}$$

the proportion of trips with purpose p. Strictly speaking, the population parameter Q_p is, however, a ratio. A true proportion would be, for instance, the quantity

$$Q \;=\; M/(NT) \tag{21.8}$$

where M denotes the number of person-days *(i,j)* where $x_{ij} > 0$. In travel behaviour analysis the proportion Q is termed "proportion of mobile persons," "travel participation rate," and the like.

Sometimes the totals, means, or ratios are of interest, not only for the study period as a whole, but also for each or some of the time intervals $j=1,...,T$. In this case we may define

$$X_j = \sum_{i=1}^{N} x_{ij} \qquad (j=1,...,T) \qquad (21.9)$$

and so forth. Eventually, we are also interested in the change of a total mean or ratio from one time interval to the next, i.e. in ratios of the form

$$Q_j(X) = X_j/X_{j-1} \qquad (21.10)$$

As can be seen, a wide variety of population parameters may be of interest in a travel survey, most of which are ratios. These parameters have to estimated from a sample.

A Note on Correlation Structures in the Population

For every day j of the study period we may consider the N individual values x_{ij} $(i=1,...,N)$ as values of the variable "trip frequency for day j." Empirical investigations suggest that persons who make many trips on a specific day j, tend to make many trips also on subsequent days $j+1, j+2, ...$, or previous days $j-1, j-2, ...$. Consequently, we can expect that some correlation structure exists in our population. This means, that the N trip frequency values x_{ij} for day j $(i=1,...,N; j$ fixed$)$ are related to the corresponding values x_{ij-1} for the previous day.

From the N pairs $(x_{i,j-1}; x_{ij})$ of variable values that at least in principle, may be plotted in a two-dimensional scattergram or presented in an appropriate two-dimensional contingency table, the (true) correlation coefficient r_{j-1j} could be computed, if these values were known. Although computation is not possible in practice, one can expect r_{j-1j} to be positive. This correlation structure always needs to be considered carefully when developing a sampling scheme for a travel survey. It depends on the purposes of the survey whether the correlation pattern should be exploited.

SAMPLING SCHEMES FOR TRAVEL SURVEYS

The Basic Model: Simple Random Sampling of "Person-Days"

Under the general conceptual framework presented above, any travel survey may be regarded as a random sample from the population $\{(i,j) \mid i=1,...,N; j=1,...,T\}$ of combinations of behavioural units and time intervals. It is easy to imagine that a great variety of possible sampling schemes exists in this case. Some important designs are discussed in this chapter. As usual, we start with simple random sampling.

If we draw n combinations (i,j) without replacement so that, at each stage, every remaining combination has the same probability of being chosen, we have a simple random sample of size n from the population of NT person-days. Figure 2 is an example.

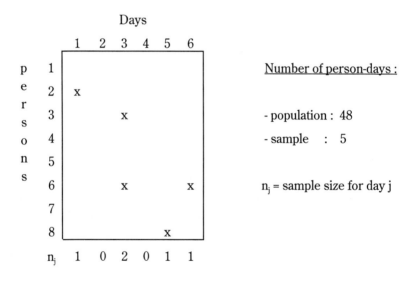

Figure 2

Simple Random Sample of Person-Days

Now, if, for every person-day (i,j) in the sample, we obtain the associated number of trips x_{ij} and for every trip k $(k=1,...,x_{ij})$ the variable values $y_{ijk}, z_{ijk},...$, we may, of course,

estimate all the different population parameters presented earlier by applying the well-known formulae from elementary sampling theory.

Despite the simplicity of this procedure, it seems necessary to point out that a clear distinction has to be made between analyses at the level of person-days (primary units) and at the level of trips, respectively. Obviously, in the first case we may apply the standard formulae for simple random sampling. If, however, trip characteristics are to be analyzed, we have to be careful.

If, for instance, the proportion of work trips is to be estimated from the sample, the point estimate is clearly

$$r = \frac{y_T}{x_T} = \frac{number\ of\ work\ trips\ per\ sample}{total\ number\ of\ trips\ per\ sample} \tag{31.1}$$

Since r is a ratio, the estimate of the variance of r is given by

$$s^2(r) = \frac{1-f}{n(n-1)\bar{y}^2}\sum_{h=1}^{n}(y_h - rx_h)^2 \tag{31.2}$$

where $f=n/(NT)$ is the sampling fraction and x_h is the total number of trips associated with the hth person-day in the sample and y_h is the number of work trips among these[4]. This variance estimate is clearly different from the crude estimate shown in equation 3.3, which is to be found in many empirical studies on travel behaviour.

$$r(1-r)/x_r \tag{31.3}$$

The use of equation 13 instead of equation 12 is completely inappropriate because it assumes that trips rather than person-days had been selected under a simple random sampling design! If trip characteristics are investigated, we always must recognize that our sampling design corresponds to a cluster sampling scheme with person-days as clusters of trips. It should be noted that the two estimates in equations 12 and 13 may differ considerably.

Direct Sampling of Person-Days versus Stepwise Selection and Assignment Procedures

Point and interval estimation of population parameters is easy under the simple random-sampling design. Despite this clear advantage the design is only of limited importance. This is mainly due to the fact that, in practice, certain operational constraints do not allow direct sampling of person-days. If, for instance, no complete list of the N persons is available, simple random sampling of person-days is hardly possible. In this case, the necessity usually arises to separate the problem of selecting person-days into two parts:

- Step 1: Random selection of persons

- Step 2: Random assignment of persons to days.

The schemes for selecting persons according to Step 1 differ widely. Frequently, procedures are encountered where, at a first stage, districts or municipalities, and at a second stage, households are drawn. This means that persons are selected under a two-stage cluster sampling design, with municipalities as primary and households as secondary units. The persons in the selected households then form the third level and the trips made by these persons the fourth level. At both of the first two stages of the above sampling procedure, we may make use of some stratification scheme to improve our estimates. In addition, at each stage, we may have a choice between sampling with equal or unequal selection probabilities (e.g., selection with probabilities proportional to size). The situation becomes even more complicated if only some of the persons that live in the selected households are to be interviewed.

Step 2 consists of assigning each of the n persons selected in Step 1 (if households are drawn, n is not a fixed quantity but rather a random variable) to one of the T days of the study period. Again, various procedures of randomized assignment come into question. One possible strategy could be to draw a number between 1 and T for each person in the sample and to collect travel data for the corresponding person-days. Whereas in the case of simple random sampling according to the previous section the same person may be interviewed two or even more times (e.g., if as in Figure 1 person-days (6,3) and (6,6) are selected), this is not possible under the design just described. It lies beyond the scope of this chapter to derive the formulae for point and interval estimation of population parameters. However, it is quite obvious that especially variance estimates crucially depend on

- the method of selecting n out of N persons as well as on

- the technique of assigning each of the selected persons to one of the T days, where typically n is much larger than T.

Sampling Schemes where the Study Period is Covered by Non-overlapping Subsamples

Simple random sampling of person-days as well as the stepwise selection and assignment procedure described at the conclusion of the previous section has the disadvantage that the daily number n_j of persons reporting is not constant. In the example shown in Figure 1 we have, for instance, the situation shown in Figure 3.

day (j)	1	2	3	4	5	6
number of persons reporting (n_j)	1	0	2	0	1	1

Figure 3

Simple Random Sampling of Person-Days

Even if the sample size n is large (e.g., $n = 10,000$ person-days) the daily sample size n_j may vary considerably, if the study period is long (e.g., $T = 365$ days). This feature not only makes survey management more difficult, but it may also impair the quality of our estimates. The latter is due mainly to the fact that most travel attributes show a cyclic variation both over the week and over the year.

Already this brief discussion suggests that sampling schemes are to be preferred where the number n_j of persons reporting for day j is fixed and predetermined. This may be achieved in several different ways. Two alternative strategies of considerable practical importance are characterized subsequently.

Independent subsamples – one sample for each unit of time

We draw T independent subsamples of size n_j ($j=1,...,T$) from the population of persons. All n_1 members of the first subsample are assigned to day one. The n members of the second subsample give information for day two, and so on. This leads to a system of T independent subsamples covering the complete study period.

Formally, we may regard this selection procedure as a stratified sample of person days where the population of all *(i,j)*-combinations has been divided into T strata, each of size N. Since the subsamples are drawn independently it may – at least in principle – occur that the same person appears in two (or even more) subsamples. Consequently, the estimates obtained from the different strata are not (as usual) independent, because of the relationship that exists between the travel behaviour attributes of the same person at subsequent days of the year (see the section on Correlation Structures in the Population, above). This problem can, however, be neglected if, as usual, the sampling fractions n_j/N are small. Figure 4 shows an example of independent subsamples of equal size covering the complete study period.

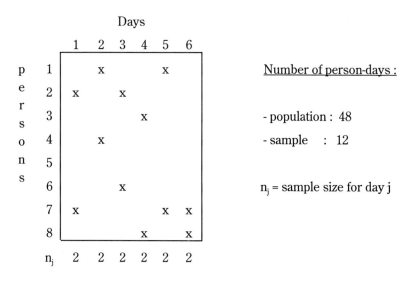

Figure 4

Independent Subsamples Covering the Study Period

Interpenetrating subsamples - one sample for each unit of time

In this case we draw a sample of n persons in Step 1. Then, in Step 2 the assignment of persons to days is accomplished as follows: The complete sample is divided at random into T subsamples, where the jth subsample contains n_j elements. The elements of the first subsample are reporting for day one, the elements of the second subsample for day two, and so forth. Under this design the same person cannot be

assigned to several subsamples. Again, the estimates $x_1, x_2,...$ obtained from the successive subsamples are generally not independent. This is due to the fact that a person who has been assigned to a specific subsample cannot appear in any other subsample.

From a practical point of view the designs are equivalent when N is large and n_j is small as is usually the case in travel surveys. Moreover, the well-known formulae of stratified random sampling may be applied. It is, however, important to distinguish between different methods of selecting persons[5].

Sampling Schemes where the Study Period is Covered by Overlapping Subsamples

The costs of a survey tend to be lower if the same units report for $d>1$ time intervals. Moreover, under this design, it is possible to quantify the intraindividual variability of travel behaviour. There are, however, two main problems associated with such sampling schemes. First, individuals or households may be averse to being interviewed repeatedly on the same subject. This well-known phenomenon is often referred to as a "panel effect." Panel attrition is of considerable importance in longitudinal transport surveys. Second, to reduce the number of interviews per person or household, the interviewee may be asked about his or her behaviour in several past time intervals. Because, however, memory factors play an important role in social surveys the respondents' statements may be inaccurate[6].

If every single person in the sample is reporting for d $(d>1)$ days (either by being interviewed repeatedly or by reporting behaviour in several time intervals during one interview), it is quite natural to develop a system of overlapping subsamples as shown in Figure 5.

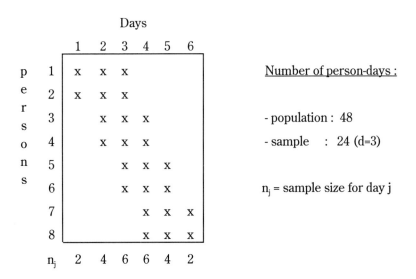

Figure 5

Overlapping Subsamples Covering the Study Period (Rotation)

In Figure 5, we have four subsamples, each containing two persons: Subsample 1 consists of persons number 1 and 2; subsample 2 comprises persons number 3 and 4; and so forth. For every single person in a subsample, we collect information about travel behaviour on three different (subsequent) days ($d=3$). Sampling schemes of this type are quite common in transport statistics and empirical travel-behaviour research.

We may also look at Figure 5 in a different way. For day 3, for instance, we have a sample of 6 persons. Now, as we proceed to day 4, two of the respondents (persons 1 and 2) are withdrawn from the sample and replaced by two "new" elements (persons 7 and 8). Sampling schemes, where part of the respondents are replaced in this way, are usually called "rotation designs." We may also speak of "partial replacement of units" during the study period. Clearly, the sampling schemes discussed in the preceding section may be regarded as designs with complete rotation (no overlapping). On the other hand, a panel survey is a design with no rotation, as shown in Figure 6.

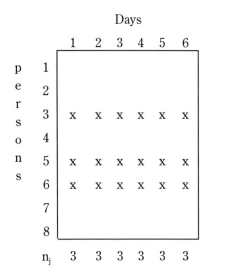

Figure 6

Panel Survey (No Rotation)

From areas other than transportation research, additional designs are available that eventually could be of interest for travel surveys. One design that deserves special attention is a rotation policy, in which a respondent remains in the sample for d time intervals and then drops out for k intervals[7,8].

An Evaluation of Alternative Sampling Schemes for Travel Surveys

In practical work, sampling schemes are to be preferred where the number n_j of persons reporting for day j is a fixed and predetermined number, as is the case for the sampling schemes described in the preceding two sections. Consequently, in a "current" travel survey, we have to decide on the following features of the survey:

- number of units to be sampled (n)

- method of selecting the units to be interviewed

- number of time intervals for which a selected unit has to give information (d)

- method of assigning reporting time intervals to every selected unit.

The sampling schemes discussed in the above sections can be regarded as special cases of the following general designs:

Design I: Panel survey – one sample for the whole study period

If the units selected give information for every time interval, then $d=T$ and we may speak of a panel survey. In this case, we have no statistical problem of assigning time intervals to units, but only the technical problem of deciding whether the person or household should be interviewed repeatedly in every time interval of the study period or only at certain points in time.

Design II: Independent subsamples – one for each reporting period

This design can be characterized in the following manner. First, a decision is made on the length d of the individual's reporting time period. Once d has been fixed, $m=T/d$ independent samples of units are drawn from the same population. All members of the first sample are assigned to the first reporting period, which comprises time intervals 1 to d. The members of the second sample are giving information for time intervals $d+1$ to $2d$, and so on. An important special case is, of course, the design where $d=1$ (e.g., giving information on travel behaviour during one specific day).

A frequently-encountered modification is the scheme with interpenetrating subsamples. In this case a random sample of n units is divided at random into m $(m \leq T)$ subsamples, where the kth subsample contains n_k $(k=1,...,m)$ elements. We assume that T is a multiple of m. Every selected unit gives information for $d=T/m$ time intervals. Thus, the elements of the first subsample are reporting for time intervals 1 to d, the elements of the second subsample for time intervals $d+1$ to $2d$ and so forth.

Design III: Rotation sampling – partial replacement of units during the study period

This design arises as follows: A sample of n units is drawn from the population and every unit sampled reports for time intervals 1 to d. Then, an independent sample of size n_2 is drawn from the same population. The members of this second sample are giving information for time intervals 2 to $1+d$. Generally, the units belonging to the rth sample reports for time intervals r to $r+d-1$. Because each time interval of the study period is to be covered by the survey, we need at least $R=T-d+1$ subsamples of the type

just described. If we consider the set of all respondents that give information for a specific time interval j, we have parts of the respondents that are matched with interval $j-1$, parts that are matched with interval $j-2$, and so on. Because from interval to interval, part of the respondents are replaced, we speak of a rotation sample. Recently, statistical models for sampling in time have been given increasing attention, and both classical as well as time-series approaches have been developed for rotation sampling[9].

The properties of Designs I, II, and III (no rotation, complete rotation, and partial rotation, respectively) have been investigated to some extent in the statistical literature[10,11,12]. The suitability of the designs depends on the nature of the estimation problem. Three types of problems are usually distinguished:

1. The change of a population total (or mean) from one interval to the next, i.e., the quantity $X_j/X_j\text{-}1$ or $X_j\text{-}X_j\text{-}1$

2. The population total (or mean) over all time intervals of the study period, i.e., the quantity $X=X_1+...+X_T$

3. The population total (or mean) for the most recent interval, i.e., the quantity X_j.

In transport planning and research, all three types of estimation problems may occur. If, under the different designs, units are selected according to the same sampling scheme, the designs can be compared according to the precision of the corresponding estimates. If simple random sampling of units is assumed, the following statements can be made about the suitability of the designs:

1. For estimating change, Design I (panel survey) is optimal.

2. For estimating the total over all periods, Design II (independent subsamples) proves best suited.

3. For estimating the most recent total or mean, Designs I and II are of equal precision whereas design III (rotation) may be better than either of these two.

It can be conjectured, that these properties remain qualitatively the same also under sampling schemes other than simple random selection of units.

Under the assumption of $T=2$ time periods and simple random sampling of units, the precision of Designs I, II, and III has been compared in detail[13,14]. As can be expected, under Designs I and III, the variance of the estimator for the change and for the total

over all time intervals depend on the correlation between the measurements on the same unit on two successive occasions. An analysis of Design III in the case where each unit is reporting for two successive time intervals *(d=2)* and where $T >> 2$ can also be found[15,16].

The modification of Design II mentioned briefly has originally been developed in an investigation of the interviewer's influence on survey results[17]. Instead of assigning *m* interviewers to each of the interpenetrating subsamples, in our context a specific reporting time period of length *d* is assigned to each subsample.

Now, which sampling design is to be preferred? There is of course, no general answer to this question, besides the statement that the design should always be chosen so that the main objectives of the survey are accomplished best. Frequently, in practice, we are at the same time interested in efficient estimation of change between time intervals, means (totals, ratios) within each time interval, and average level over a number of time intervals. Rotation sampling (Design III) offers a way to balance out these different requirements.

There are, however, two major problems associated with rotation sampling: rotation bias and complexity of variance estimation. Rotation requires respondents to be exposed to the survey several times *(d>1)*. This, however, may affect the quality of the data. In a multi-day travel survey, for instance, underreporting of trips may increase with time. As a consequence, estimates from the different overlapping subsamples (rotation groups) relating to the same time interval may not have the same expected value. If this is the case, the rotation bias has to be quantified and corrected, which may be a difficult task.

Even if no rotation bias has to be accounted for, the variances of the estimators (e.g., mean trip rate, total mileage, and so forth) are difficult to estimate under a rotation sampling scheme. Here, variance estimation requires substantial knowledge of sampling theory.

In the remaining two sections, we present practical examples of travel surveys. It is demonstrated that the methods of data analysis and especially variance estimation depend critically on sampling design.

TRAVEL SURVEYS WITH INDEPENDENT SUBSAMPLES: A CASE STUDY

Description of the Sampling Scheme

This section deals with a regional travel survey conducted in 1981[18]. In this chapter, an estimation method for the type of repeated sampling applied here is presented. The study area consisted of five districts in the southern part of Germany and the study period comprised 84 days in spring 1981. The population of interest was the population of foreign households (Turkish and Jugoslav households only) in the study region. For every district and nationality a separate subfile of persons was created. Then, from the 10 subfiles, independent samples of persons were drawn. The sampling fraction was 7.7 percent in each case and the sampling method was systematic sampling with random choice of starting point. Once a person was drawn, the corresponding household was considered to be selected.

For every member of a selected household aged 10 years and over, a self-administered questionnaire had to be completed. The data collected were on the individual's travel behaviour during a specific day. All members of a household were assigned the same reporting day. The method of assigning households to specific days was as follows. During the study period of 84 days, every day of the week (Monday,, Sunday) appears exactly 12 times. First, for each combination of district and nationality, the number of households to be interviewed on a specific day of the week was determined. Then, the sample of all households of the district and nationality considered was divided at random into 7 subsamples of unequal size, one for each day of the week. Finally, within each of these subsamples every household was assigned at random to one of the 12 Mondays, Tuesdays, etc., respectively, such that on each of the 12 Mondays (similarly for Tuesdays, etc.) approximately the same number of households was interviewed.

An Idealization of the Selection and Assignment Procedure

This selection and assignment procedure may be considered as an example of Design III "interpenetrating subsamples" with one-stage stratified cluster sampling of households and random division of the sample within each stratum. For each of the $5 \times 2 = 10$ strata the actual selection method was systematic sampling but, for simplicity, we assume that households have been drawn with replacement and with selection probabilities proportional to household size. This idealization appears to be admissible.

A second idealization seems to be acceptable. Because the main interest of the study was on the mean of the travel characteristics over the complete study period and not on day-to-day (or week-to-week) change, we can imagine that within each stratum of households, seven independent samples of unequal size — one for each weekday — had been drawn and that no distinction is necessary between the 12 Mondays (similarly for Tuesdays, etc.). With this additional idealization, we can speak of a travel survey based on Design II "independent subsamples," where units are selected according to stratified cluster sampling without replacement and with unequal selection probabilities.

If these idealizations are accepted, estimation can be based on standard results of sampling theory. We simply have to consider the weekday as a further characteristic for stratification. Thus, the set of NT "household days" ($T=84$) is divided into 10 x 7=70 strata, from which independent subsamples are drawn. A single stratum may be denoted by (g,h), where the indices g and h are used for grouping households and days, respectively ($g=1,...,10$; $h=1,...,7$).

Estimating Population Characteristics: Totals, Means, and Ratios

Let N_g and T_h denote the number of households in group g and the number of days of type h, respectively. Further, let z_{gi} denote the number of persons living in the ith household of group g. The probability of selecting the ith household on a single draw is then $p_{gi}=z_{gi}/Z_g$, where Z_g is the total number of persons living in households of group g. Consequently, the probability of selecting the ith household of group g and assigning it to one of the T_h days of type h is $p_{ghi}=z_{gi}/(Z_g \cdot T_h)$.

Estimating ratios of the form $R=X/Y$ is of special importance in travel surveys. One simple example is the total length X of all trips made by persons belonging to our population of households during the study period divided by the total number Y of these trips (i.e., mean trip length). We write n_{gh} for the sample size of stratum (g,h), i.e., for the number of households that have been selected from group g and assigned to a day of type h. The number of trips made by members of the ith household in the sample from stratum (g,h) will be denoted by Y_{ghi}, whereas X_{ghi} represents the sum of the lengths of these trips. Similarly, the symbol P_{ghi} denotes the selection and assignment probability for the ith household in the sample from stratum (g,h).

A consistent estimator for R is

$$\hat{R} = \frac{\hat{X}}{\hat{Y}} = \frac{\displaystyle\sum_g \sum_h (1/m_{gh}) \sum_i^{m_{gh}} X_{ghi}/P_{ghi}}{\displaystyle\sum_g \sum_h (1/m_{gh}) \sum_i^{m_{gh}} Y_{ghi}/P_{ghi}}$$

The relative variance of R, i.e., the quantity

$$V^2_{\hat{R}} = var(\hat{R})/\hat{R}^2$$

can be estimated by

$$\hat{V}^2_{\hat{R}} = \hat{V}^2_{\hat{X}} + \hat{V}^2_{\hat{Y}} - 2\hat{V}_{\hat{X}\hat{Y}}$$

where

$$\hat{V}_{\hat{X}\hat{Y}} = \frac{1}{\hat{X}\hat{Y}} \sum_g \sum_h \frac{1}{m_{gh}(m_{gh}-1)} \sum_i (X_{ghi}/P_{ghi} - \hat{X}_{gh})(Y_{ghi}/P_{ghi} - \hat{Y}_{gh})$$

with

$$\hat{X}_{gh} = (1/m_{gh}) \sum_i^{m_{gh}} X_{ghi}/P_{ghi}$$

being an unbiased estimator for the total length of trips made by persons from households of group g during the days of type h (Y_{gh} defined analogously), and

$$\hat{V}^2_{\hat{X}} = \hat{V}_{\hat{X}\hat{X}} \quad , \quad \hat{V}^2_{\hat{Y}} = \hat{V}_{\hat{Y}\hat{Y}}$$

More details on ratio estimators and estimators for totals, means and proportions, in the case of stratified cluster sampling with unequal selection probabilities, can be found in advanced books on sampling theory[19].

Using a special computer program for estimation of totals, means, ratios, and their variances (developed by the author and his collaborators) the data of the survey have been analyzed[20]. Based on the information obtained from n=4,460 responding households with 9,640 persons aged 10 years and over, the estimation results shown in Table 1 were obtained.

Table 1
Estimates for Some Population Characteristics

Population characteristic	Estimate		Estimated c.v.of estimate
1. Total number of trips	16.6×10^6	trips	0.013
2. Number of trips made per person per day	2.66	trips	0.008
3. Total of trip length	13.2×10^7	km	0.049
4. Mean trip length	7.97	km	0.047
5. Distance travelled per person per day	21.22	km	0.046
6. Total of trip duration	40.08×10^7	min	0.029
7. Mean trip duration	24.21	min	0.018
8. Time spent travelling per person and day	64.52	min	0.019
9. Proportion of immobile persons	24.5	%	0.028
10. Proportion of walk trips	33.0	%	0.024

Obviously, the relative precision of the estimates differs considerably. Using a normal approximation to the distribution of the estimate, one can compute confidence intervals for the population characteristic.

For instance, from the results in Table 1 the intervals shown in Table 2 are obtained.

Table 2

Confidence Intervals for Some Population Characteristics

Population characteristic	Estimate		95 percent confidence interval
Number of trips made per person and day	2.66	trips	2.62 to 2.70
Distance travelled per person and day	21.2	km	19.3 to 23.1

It is important to recognize that even when sample size is fairly large (in our example we have 4,460 households with 9,640 persons and a total of 25,317 trips), some estimates may have surprisingly little precision. Thus, great care is necessary in interpreting results.

Normally, standard statistical-software packages are used to analyse data from travel surveys. With these packages, variance estimation is impossible for most cases. To get an idea of the accuracy of a certain estimate, researchers sometimes compute, for instance, the sample mean and standard deviation of trip length and the "standard error of the mean" by dividing the standard deviation by the square root of the number of trips in the sample. A 95-percent-confidence interval is then computed as *mean ± 2x (standard error)*. This procedure implicitly assumes simple random sampling and thus neglects the so-called "design effect." As a consequence, confidence intervals computed in this way may be far too narrow. More details can be found in the statistical literature[21]. Our experience with the design described in the beginning of this section suggests that the standard error of the mean, as obtained from a statistical package, should be multiplied by a factor of approximately 2 to make it a more realistic estimate.

Estimation of Totals, Means, and Ratios Broken Down by Certain Characteristics

In empirical studies of travel behaviour, mean trip length, for instance, is not only estimated for the complete population of households over the complete study period. Instead, one is normally interested in mean trip length broken down by certain characteristics of the trip (e.g., trip purpose), the person (e.g., occupational status), the day (e.g., weekday), or the household (e.g., car ownership). If we restrict ourselves to trips having a specific property (e.g., work trips made by part-time

employed persons), due to this "subgroup effect," the estimate of mean trip length becomes inevitably less precise.

To see this, we denote by x_{ghi} the total length of all work trips made by part-time employees associated with the ith element of stratum (g,h). Obviously, for many elements i $(i=1,...,(N_g T_h))$ we will have $x_{ghi} = 0$, simply because in most households there are no part-time employed persons. For elements with non-zero x_{ghi}, this variable may take on fairly large values. As a consequence, the variability of the household-day characteristic "length of all work trips of part-time employees associated with the household day" is relatively large and estimation becomes imprecise. For an example see Table 3. Practical experience shows that confidence intervals may increase rapidly in width if estimates are calculated for certain subgroups of trips. Therefore, the interpretation of differences between several means or ratios requires great care.

Table 3

Estimated Coefficient of Variation of Distance Travelled Per Person and Day Broken Down by Occupational Status of Tripmaker

Occupational status of tripmaker	Number of cases in sample		Estimated c.v. of "Distance travelled per person and day"
	persons	trips	
Housewife	911	2.555	0.182
Retired	44	0.123	0.721
Apprentice	435	1.099	0.063
Pupil	1,363	3.544	0.319
Unemployed	206	0.597	0.170
Employed (part)	354	1.035	0.117
Employed (full)	5,776	15.009	0.044
No statement	551	1.355	0.161
Total	9,640	25.317	0.046

TRAVEL SURVEYS WITH ROTATION OF SAMPLING UNITS: A CASE STUDY

Description of the Sampling Scheme

Recently, a large-scale travel survey was carried out in the Federal Republic of Germany to collect detailed data on holiday and business travel expenditures of German residents abroad[22]. The study population was the population of persons aged 14 years and over and the study period ranged from the beginning of October, 1985, to the end of September, 1986. After completion of the field work, the author was asked to develop an appropriate estimation procedure.

The method of sampling actually applied did not belong to the class of techniques treated in the literature and its precise description is beyond the scope of this paper. It proved necessary to consider a somewhat idealized version of the actual sampling procedure, in order to obtain tractable formulae for interval estimation. The idealized form of the sampling procedure can be described as follows: the population of persons was stratified according to the town size of their place of residence; for persons in "small" and "large" towns different selection methods were applied.

For small towns a two-stage procedure was chosen. Towns were further stratified by regional characteristics and within each substratum g of towns, $m_g = m_{g1} + ... + m_{g10}$ independent drawings of towns (with replacement and selection probability proportional to the number of inhabitants) were carried out. The first m_{g1} drawings of primary units (towns) were considered to form the first subsample, the next m_{g2} drawings, the second subsample, and so on. After every drawing of a specific primary unit, a constant number of 27 secondary units (persons) were selected from the corresponding primary unit by simple random sampling. A single primary unit of this type was called a "sample point." If, among the m_{gi} drawings for the ith subsample, the same town was selected several times, the selection of 27 persons was repeated independently in this town. Each subsample was assigned to a specific reporting period consisting of 2, 3, or 4 subsequent months (e.g., subsample 1: October, 1985 to November, 1985; subsample 2: October, 1985 to December, 1985, subsample 3: November, 1985 to January, 1986; etc.).

Persons living in "large" towns can be considered as having been selected by stratified random sampling from the population. In this case, again, stratification was with respect to regional characteristics of the place of residence. This sampling procedure was repeated 10 times to obtain 10 independent subsamples. The assignment of subsamples to reporting periods was the same as for persons living in "small" towns.

Subsequently, a method for point and interval estimation for these two types of travel surveys is described. Problems of nonresponse and response errors are discussed at the end of this section.

Estimation Method for the Two-Stage Design

$$Y = \sum_{j=1}^{12} y_j \tag{51.1}$$

Because estimation is identical within each substratum, it is sufficient to show how to proceed for a specific substratum. Moreover, it is important to remember that the aim of the survey was to estimate total travel expenditures Y of the population members (small towns only) during a 12-month period. Obviously, Y may be written as

where y_j denotes total travel expenditures in month j.

Let Z_{hi} be the number of responding persons among those who have been contacted within the hth sample point of the ith subsample and let Y_{hij} be the travel expenditures of these persons in month j. Of course, one can define

$$Y_{ij} = \sum_h Y_{hij} \; ; \qquad Z_i = \sum_h Z_{hi} \tag{51.2}$$

and use

$$\hat{Y}_{ij} = Y_{ij}/Z_i \tag{51.3}$$

as an estimator for y_j/z where z is the total number of persons in the population. Thus, by equation 22 we have several independent estimators for the travel expenditures in month j per person — one estimator for each subsample that coincides with month j. These estimators are unbiased, if the probability of responding is independent of travel expenditures. Now, we proceed as follows[23]:

Combine the \overline{Y}_{ij} to a single estimator \overline{Y}_j for y_j/z, the travel expenditures per person in month j.

1. Construct a confidence interval for y_j/z .
2. Combine the month specific estimators \overline{Y}_j to a single estimator \overline{Y} to a single estimator \overline{Y} for Y/z, the annual travel expenditures per person.
3. Construct a confidence interval for Y/z, taking into account, that the estimators \overline{Y}_j are not independent.

Let $A(jj')$ be the set of subsamples that coincide with months j and j'; let $A(j) = A(jj)$. Furthermore, let $v(jj') = |A(jj')|$ denote the number of subsamples coinciding with months j and j' and

$$n(jj') = \sum_{i \in A(jj')} n_i \qquad [n(j) = n(jj)]$$

where n_i represents the number of sample points in the ith subsample.

We can use

$$\overline{Y}_j = \sum_{i \in A(j)} n_i \overline{Y}_{ij} / n(j) \qquad (5.4)$$

as an (unbiased) estimator for y_j/z . Since we have independent subsamples, the variance of this estimator, i.e., the quantity var (\overline{Y}_j), can be estimated bias free by

$$S^2_j / \{v(j) - 1\} \qquad (5.5)$$

where

$$S^2_j = \sum_{i \in A(j)} n_i (\overline{Y}_{ij} - \overline{Y}_j)^2 / n(j)$$

$$= \sum_{i \in A(j)} \frac{n_i}{n(j)} (1 - \frac{n_i}{n(j)}) \overline{Y}^2_{ij} - \sum_{\substack{i,i' \in A(j) \\ i \neq i'}} \frac{n_i}{n(j)} \frac{n_{i'}}{n(j)} \overline{Y}_{ij} \overline{Y}_{i'j} \qquad (5.6)$$

Thus, a 95-percent confidence interval for y_j/z is given by

$$\left[\overline{Y}_j - 1.96 \sqrt{\frac{S^2_j}{v(j) - 1}} \; ; \; \overline{Y}_j + 1.96 \sqrt{\frac{S^2_j}{v(j) - 1}} \right] \qquad (5.7)$$

Obviously, an unbiased estimator for Y/z is

$$\bar{Y} = \sum \bar{Y}_j \qquad (5.8)$$

Estimation of var (\bar{Y}) is complicated by the fact that the \bar{Y}_j are not independent. Their dependence stems from the temporal overlapping of the various subsamples. Now, the covariance, cov $(\bar{Y}_j , \bar{Y}_{j'})$ can be estimated for all pairs of months, where $v(jj')>1$. To simplify the presentation, we assume that the dependence mentioned above plays a role only for months j and j', which are adjacent. In this case,

$$S^2 = \sum \frac{S^2_j}{v(j) - 1} + \sum_{j*j'} \frac{n^2(jj')}{n(j)n(j')} \frac{S_{jj'}}{v(jj') - 1} \qquad (5.9)$$

where

$$S_{jj'} = \sum_{i\in A(jj')} \frac{n_i}{n(jj')} \left(1 - \frac{n_i}{n(jj')} \right) \bar{Y}_{ij} \bar{Y}_{ij'} - \sum_{\substack{i,i'\in A(jj') \\ i*i'}} \frac{n_i}{n(jj')} \frac{n_{i'}}{n(jj')} \bar{Y}_{ij} \bar{Y}_{i'j'} \qquad (5.10)$$

is an unbiased estimator for var (\bar{Y}). Summation for the second term on the right hand side of (5.9) is over all adjacent j, j'. The desired confidence interval for Y/z can be computed in the usual way with the help of (5.9).

Estimation Method for the stratified Random Sampling Design

Within a specific substratum we may denote for subsample i by Y_{ijk} the travel expenditures in month j of the kth person in the sample. In the ith subsample the sum of travel expenditures in month j is

$$Y_{ij} = \sum_k Y_{ijk} \qquad (5.11)$$

and Z_i is, as before, the number of responding persons. From every subsample i coinciding with month j we obtain an unbiased estimator

$$\bar{Y}_{ij} = Y_{ij} / Z_i \qquad (5.12)$$

$$\bar{Y}_j = \sum_{i \in A(j)} \sum_{k=1}^{z_i} Y_{ijk} \Big/ \sum_{i \in A(j)} Z_i \tag{5.13}$$

for y_j/z. Therefore,
is also an unbiased estimator for y/z .

Now, we define

$$z(jj') = \sum_{i \in A(jj')} Z_i$$

$$\tilde{S}_{jj'} = \frac{1}{z(jj')} \sum_{i \in A(jj')} \sum_{k=1}^{z_i} Y_{ijk} Y_{ij'k} - \frac{1}{z(jj')} \frac{1}{z(jj')-1} \left[\sum_{i \in A(jj')} \sum_{k \neq k'} Y_{ijk} Y_{ij'k'} \right.$$

$$\left. + \sum_{\substack{i,i' \in A(jj') \\ i \neq i'}} \sum_{k,k'} Y_{ijk} Y_{i'j'k'} \right]$$

and $Z(j) = Z(jj)$, $S_j^2 = S_{jj}$. With this notation

$$\tilde{S}_j^2 / Z(j) \tag{5.14}$$

is an estimator for var (\bar{Y}_j) .

The estimator

$$\bar{Y} = \sum \bar{Y}_j \tag{5.15}$$

for the annual travel expenditures per person is unbiased. An estimator for var (Y) is

$$\tilde{S}^2 = \sum_j \frac{\tilde{S}_j^2}{Z(j)} + \sum_{j \neq j'} \frac{\tilde{S}_{jj'}}{Z(jj')} \tag{5.16}$$

This estimator for var (\bar{Y}) takes fully into account the possible correlation over time of the individual's travel expenditures, not only the correlation for pairs of adjacent months. Using equation (38) a confidence interval for Y/z can be built directly.

Aggregation over the Strata

For both designs the computation of estimates for the whole population is simply as follows. If the (regional) substrata are indexed by $r = 1, 2, ...$ we can write $\bar{Y}_j(r)$ for the unbiased estimator for travel expenditures in month j per person from substratum r. Using the symbol $z(r)$ to denote the total number of persons in substratum r (in the population) it follows immediately that

$$\sum_r \bar{Y}_j(r) \, z(r) \tag{5.17}$$

and

$$\sum_r z(r) \sum_j \bar{Y}_j(r) \tag{5.18}$$

are unbiased estimators for the total travel expenditures of the population in month j and per year, respectively.

An estimator for the variance of equation (40) is simply

$$\sum_r V(r) \, z^2(r) \tag{5.19}$$

where equations 29 and 38 have to be substituted for $V(r)$ in the case of two-stage sampling and in the case of stratified random sampling of units, respectively.

Nonresponse and Response Errors

Under the stratified-random sampling design, it is possible to correct for bias due to nonresponse. If the propensity to respond is different for different sociodemographic groups, the response rate varies among groups. In this case, poststratification according to sociodemographic characteristics is possible. Poststratification, of course, increases the variance of the estimator, but this increase is small as long as the number of sample units per stratum is reasonably large[24].

Response errors in travel surveys have been investigated empirically to some extent[25]. Response error models also exist[26]. If valid information is available on the extent to which individual responses are incorrect (e.g., systematic overestimation of travel expenditures), it is recommended that appropriate correction factors be introduced.

With the present state of the art, however, we must treat these factors as exactly-known population characteristics, instead of estimates. Incorporating the response error into the formulae for variance estimation is one of the difficult problems still to be solved.

REFERENCES

1. Hensher, D. A., "Longtitudinal Surveys in Transport: an Assessment," Paper presented at the 2nd Int. Conf. on New Survey Methods in Transport, Hungerford Hill, Australia, 1983.

2. Stopher, P. R., "The State-of-the-Art in Cross-Sectional Surveys in Transportation." Paper presented at the 2nd Int. Conf. on New Survey Methods in Transport, Hugerfort Hill, Australia, 1983.

3. Barnett, V., *Elements of Sampling Theory*, Hodder and Stoughton, London, 1984.

4. *Ibid.*

5. Cochran, W. G., *Sampling Techniques*. John Wiley & Sons, New York, 1977.

6. Gray, P. G., "The Memory Factor in Social Surveys," *Jour. Amer. Stat. Assoc.*, 1955, 50, 344-363.

7. Graham, J. E., "Composite Estimation in Two Cycle Rotation Sampling Designs," *Comm. in Stat.*, 1973, 1, 419-431.

8. Rao, J. N. K. and J. E. Graham, "Rotation Designs for Sampling on Repeated Occasions," *Jour. Amer. Stat. Assoc.*, 1964, 59, 492-509.

9. Binder, D. A. and M. A. Hidiroglou, "Sampling in Time," in P. R. Krishnaiah and C. R. Rao, eds., *Handbook of Statistics*, Vol. 6, Elsevier Science Publishers B. V., 1988, 187-211.

10. Cochran, *op. cit.*

11. Binder and Hidiroglou, *op. cit.*

12. Yates, F., *Sampling Methods for Censuses and Surveys*, Charles Griffin and Co., London, 1960, third edition.

13. Hansen, M. H., W. N. Hurwitz and W. G. Madow, *Sample Survey Methods and Theory*, Vols. I and II, John Wiley and Sons, New York, 1953.

14. Kulldorff, G., "Some Problems of Optimum Allocation for Sampling on Two Occasions," *Rev. Int. Stat. Inst.*, 1963, 31, 24-57.

15. Cochran, *op.cit.*

16. Hansen, *et al.*, *op.cit.*

17. Mahalanobis, P. C., "Recent Experiments in Statistical Sampling in the Indian Statistical Institute," *Journal of the Royal Statistical Society*, 1946, 109, 325-370.

18. Socialdata, "Kontistut-Survey on Travel Behavior of Foreign Households in the Stuttgart Area." (in German), 1982.

19. Hansen, *et al.*, *op.cit.*

20. Hautzinger, H. and B. Schorer, "Statistical Software System for Estimation of Sums and Ratios and Their Variances." Unpublished working paper (in German), 1985.

21. Kish, L., *Survey Sampling*, John Wiley & Sons, New York, 1965.

22. Infratest, Project Handbook for the Survey "Travel Expenditures in Foreign Countries," (in German), 1986.

23. Hautzinger, H. and H. Stenger, "Estimation Method for the Infratest-Survey Travel Expenditures in Foreign Countries," Unpublished working paper, (in German), 1986.

24. Cochran, *op. cit.*

25. Wermuth, M. J. "Effects of Survey Methods and Measurement Techniques on the Accuracy of Household Travel-Behavior Surveys," in P. R. Stopher, A. H. Meyburg, and W. Börg, eds., *New Horizons in Travel Behavior Research*, Chapter 28, Lexington Books, D. C. Heath & Co., Massachusetts, 1981.

26. Hautzinger, H., "Stochastic Response Error Models for Transport Census Data," Paper presented at the 2nd Int. Conf. on New Survey Methods in Transport, Hungerford Hill, Australia, 1983.

19

VEHICLE USES AND OPERATING CONDITIONS: ON-BOARD MEASUREMENTS

Michel André

ABSTRACT

A large-scale experiment has been carried out by INRETS to identify actual vehicle-use conditions. Fifty-five privately-owned cars were equipped with sensors and data-acquisition systems and studied under actual use conditions with their own drivers. Vehicle and engine speeds, engine and ambient temperatures, and fuel consumption were recorded at one-second time intervals over 71,000 kilometres and 9,900 trips. The data obtained yielded very accurate information on the actual car use and operating conditions: daily vehicle use, trip characteristics (trip length, duration, and so on), speed and acceleration profiles, engine running conditions (engine speeds, choke use, etc.), and thermal conditions, while taking into account the influence of the vehicle type, driver behaviour and geographical location.

Vehicle uses were very frequent (5 to 6 trips per day) and often short: one trip in two did not exceed three kilometres. Time spent at rest or at low speed was very significant. The uses were highly diversified according to the drivers and the areas of origin of the vehicles studied.

The results are compared to those obtained during a driving diary survey conducted by INRETS. Significant discrepancies are to be observed concerning trip lengths and vehicle-use frequencies. The INRETS on-board measurement method is described and discussed, including its specificity, its advantages, and its limits.

INTRODUCTION

Vehicle uses (trip type, frequency, length, etc.), speeds and accelerations, and engine operating conditions are surely among the main parameters that influence fuel consumption and pollutant emissions. In order to create a database on actual vehicle use and operating conditions, a first experimental study was carried out by INRETS in 1983, using 35 privately-owned vehicles equipped with an on-board data-acquisition system to record their operating conditions at one second time intervals. The result[1] obtained, relating to about 3,300 trips recorded and 23,300 kilometres travelled, showed the significant lack in the knowledge of actual vehicle uses and the necessity of such experiments, and led the different partners to complete and update this database by programming a second test set (20 recent vehicles in 1990).

In particular, the 1983 study concluded that:

- the very short trips, the limited range of engine operation and use, and the low operating temperatures demonstrate that the vehicle is not always optimally tuned for the use it gets;

- the extreme variety (and even some obvious eccentricities) of uses and operating conditions show the limit of laboratory tests, with "professional" drivers[2];

- the uses, distances travelled, trip durations, and speeds experienced can be known with a high degree of accuracy;

- the analysis of the traffic conditions showed the low representativity of conventional standard test cycles and procedures for emissions and fuel-consumption measure-ment[3,4].

METHOD

The basic principle of this study was the observation of use and operating conditions of vehicles, driven for their normal purposes by their owners. With this aim in view, privately-owned vehicles were equipped with sensors and data-acquisition systems to record the main parameters of vehicle operation once every second. They were then returned to their owners who used them normally[5].

Nine models were selected among the most representative of the French fleet: three small-sized vehicles (Renault 5, Citroën AX and Visa) and six medium and up-market vehicles (Renault 14, Renault 18, Renault 21, Peugeot 305, Citroën CX, and Talbot Horizon). Vehicles were selected in the three main French urban areas (Greater Paris, Marseilles, and Lyons), rural areas, and small or medium-sized towns.

The vehicles to be tested were selected by random sampling from an address list of owners of the selected models in the relevant geographical areas, and then according to criteria of representativity and variety: age, sex, driver's professional and marital status, and annual mileage.

The vehicles were equipped with data-acquisition systems (data logger placed in the boot and sensors under the bonnet), and they were then used for their normal purposes by their owners for periods of about one month; five to seven vehicles were tested simultaneously. The main parameters of vehicle operation recorded at one-second time intervals were: date and time, vehicle speed, engine speed, throttle position, fuel consumption, engine and ambient temperatures, and use of auxiliary equipment such as wipers, brake, and choke. Data acquisition started with vehicle start-up.

In the two test series, a total of 55 vehicles were successfully tested. These measurements represent 1,930 days of vehicles monitoring, i.e., 5.3 years; 9,940 trips were correctly recorded, and represent 71,300 kilometres travelled for a driving duration of 1,840 hours.

VEHICLE USES

Average Daily Uses

The analysis of 1,523 vehicle-monitoring days yielded data on daily trip frequencies, durations, and distances. The daily average use frequency was about 5.3 trips for one hour of driving and 40 kilometres travelled.

Table 1

Vehicle Average Daily Uses

	Number of Trips per day	Daily Driving Durations (min)	Daily Distances (km.)
Together	5.3	60	39.1
Large-sized towns	4.4	61	37
- Others	6.4	61	43
Small-sized vehicles	5.3	59	36
- Others	5.4	62	43
Week	5.3	58	35
Saturday	6.5	70	47
Sunday	4.4	64	52

In large urban areas, fewer trips and shorter daily distances were observed (4.4 trips per day and 37 km.), for equivalent driving durations.

Small vehicles were used for shorter daily distances (36 km. and 43 km. respectively), while driving durations and trip numbers remained relatively similar (5.3 and 5.4 trips per day, 59 and 62 minutes). However, considering only weekdays (Saturdays and Sundays excluded), the uses were very similar for small cars and other cars: 5.3 and 5.4 trips per day, 37 and 36 kilometres.

Distribution of the Daily Vehicle Uses

A frequent use of the vehicles can be noted, even on very short distances: vehicles were not used for 14 percent of the days (i.e., one day out of seven or 55 days per year); they were used once or twice for 15 percent of the days studied, 3 to 6 times for 37 percent , 7 to 10 times for 24 percent, and over 10 times for 10 percent of the days. Daily distances were less than 20 kilometres for 35 percent of the days studied (i.e., 120 days in a year); they ranged from 20 to 60 kilometres for 35 percent, and exceeded 60 km. for 16 percent of the cases (i.e., 58 days per year).

It should be noted that uses were highly differentiated according to the day of week studied: on Saturdays the number of trips was significantly higher (6.5 compared to 5.3 during the week), and averaged both longer distance and duration (see Table 1).

As shown in Figures 1 and 2, on Sundays, the average number of trips was lower (4.4) for the longest distances (52 kilometres). The non-use percentage decreased on Saturdays (13 percent of the total number of days) and increased significantly on Sundays (20 percent of the days). Daily distances less than 10 kilometres were observed for 13 percent of the weekdays and for 19 percent of the Sundays. Conversely, long trips were far more frequent on weekends: the travelled distances exceeded 100 kilometres for 12 and 14 percent of Saturdays and Sundays, but for only 6 percent of weekdays (see fig. 1 & 2).

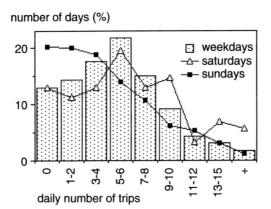

Figure 1

Distributions of the Daily Number of Trips

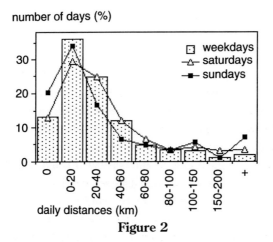

Figure 2

Distributions of the Daily Distances Travelled

The trips performed during the week represented 71 percent of the total amount and 64 percent of the travelled distances; Saturday trips represented 17 percent of the total number and mileage, and Sunday trips 12 percent of the total number and 19 percent of the distances. Eighty-eight percent of the trips recorded were performed by day (7 am - 7 pm) and represented 84 percent of the distance covered (12 percent were performed by night representing 16 percent of the mileage, see Figure 3). On Sunday, the number of trips by night increased (5 percent of the trips before 5 a.m compared to 2 percent during the week; and 7 percent of the trips after 8 p.m compared to 5 percent in the week), with a significant percentage of the trips performed (or started) between 10 a.m and 12 noon.

number of trips (%)

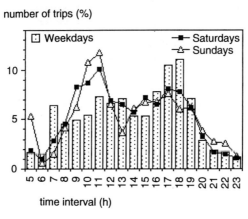

time interval (h)

Figure 3

Time Distribution of Vehicle Uses

Uses and Drivers

Variations between drivers were very significant: the average daily number of trips ranged from 2 to 10 and the daily distances from 8 to 100 kilometres. The distribution of the drivers was as follows: 13 percent of the subjects drove less than 20 kilometres per day on average, 43 percent drove from 20 to 40 km./day, 37 percent covered 40 to 70 km./day, and 6 percent exceeded 70 km. per day. Eleven percent of the drivers used their car less than 3 times a day on average, 30 percent from 3 to 5 times, 28 percent from 5 to 6 times, and 30 percent more than 6 times per day.

For a large number of drivers, high numbers of trips per day were observed: thus ten trips in one day were observed at least once for 68 percent of the drivers. Fifteen trips

in a day were observed for 27 percent of the drivers. This represents a large number of successive, short, closely-timed trips with varied purposes (shopping, etc.).

Trip Chaining

Figure 4 shows that a great number of trips were performed after a short break (34 percent after less than 15 minutes, 45 percent after less than half an hour). One trip out of two was performed within a 45-minute period after the previous trip. This may correspond for example to one (or more) shopping trips. Trips involving longer times with the vehicle parked represented 11 percent for a parking period ranging from 1 to 2 hours, 19 percent from 2 to 5 hours (or half a day), 7 percent from 5 to 10 hours, and 13 percent over 10 hours.

intervals between trips (in hours)

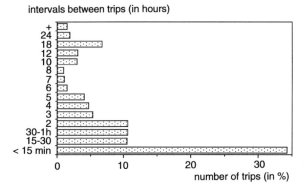

Figure 4

**Histogram of Time Intervals Between Two
Successive Trips**

TRIP FEATURES

The average trip distance recorded was seven kilometres. The significant number of very short trips shown in Figure 5 should be noted: the median trip was only three kilometres and 67 percent of the trips studied did not exceed the average value (seven kilometres). Short trips were distributed as follows: 15 percent did not exceed 500 metres, 11 percent ranged from 500 metres to one kilometre, and 26 percent from one to three kilometres, i.e., 52 percent of the trips recorded did not exceed three kilometres. Trips exceeding 10 kilometres represented 15 percent of the total amount

and those exceeding 50 kilometres only 2 percent. One percent of the trips exceeded 100 kilometres.

Nevertheless, short trips represented a limited part of total mileage. Trips of less than three kilometres accounted for 8 percent of the distances, while those under five kilometres accounted for 16 percent. Trips were broadly distributed by thirds: under ten kilometres (35 percent), from ten to fifty kilometres (36 percent) and over fifty kilometres (29 percent of the total mileage). Wide differences were also observed among the sampled drivers. Average trip lengths ranged from two to twenty-seven kilometres. It should nevertheless be noted that for 60 percent of the drivers, the average trip length ranged from four to eight kilometres; for 12 percent of them, the trip length was less than four kilometres; and for 28 percent it exceeded eight kilometres (for 5 percent of which it exceeded 15 kilometres). The trip-length distributions for each driver were also highly differentiated, clearly showing different vehicle-usage patterns.

number of trips in %

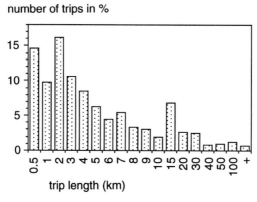

Figure 5

Histogram of Trip Length

VEHICLE SPEEDS

The average vehicle speed measured for 71,000 kilometres covered was 37 kph. Time spent at stop or at low speed was significant, as shown in Figure 6. Vehicles at stop represented about 18 percent of trip duration. Thirty percent of the driving duration and 12 percent of the distance were travelled at a speed lower than 30 kph. The 30-60 kph range represented 28 percent of the trip duration and 32 percent of the distance

covered. Fifteen percent of trip duration and 28 percent of distance were performed at speeds ranging from 60 to 90 kph. Finally, about 30 percent of total mileage (10 percent of trip duration) as covered at speeds exceeding 90 kph, of which 9 percent was at speeds exceeding 120 kph. Speeds exceeding 150 kph were observed for 0.1 percent of driving duration and 0.5 percent of trip distances.

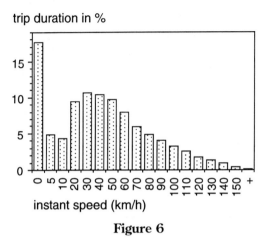

Figure 6

Instant Speed Histograms

Figure 7 shows that average speeds for each vehicle tested ranged from 16 to 58 kph; but 77 percent of the drivers drove between 20 and 45 kph on average. Twenty-seven percent of the vehicles experienced an average speed ranging from 30 to 35 kph and 12 percent exceeded a 45 kph average speed. Speed exceeding 90 kph represented less than 10 percent of driving duration for 38 vehicles tested (i.e., 68 percent); they reached 10 to 20 percent for 13 vehicles (23 percent) and exceeded 20 percent for 5 vehicles (i.e., 9 percent). This means that a relatively low number of vehicles experienced frequent high speeds.

number of vehicles

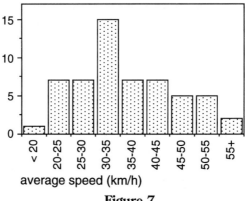

Figure 7

Average Speed of the Vehicles Tested

COMPARISONS WITH A DRIVING-DIARY SURVEY

The above results must be compared to those obtained in other studies, in particular in a previous driving-diary survey conducted by INRETS over 43,000 trips and 600 to 1,000 vehicles during three different periods of the year[6]. Table 2 shows that average annual mileages are very close (four percent deviation), while the average number of daily trips and average trip length differ (from 2.7 to 5.3 daily trips ranging from 12 to 7 km., Table 2). Trip-length distributions show significant discrepancies for very short and long trips (less than one kilometre and over 50 to 100 kilometres). These discrepancies and the consistencies of annual mileages recorded can certainly be explained by:

- the difficulty in recording all the very short trips performed during the survey, in particular manoeuvers to move the vehicle, to park it in a garage, short trips performed between two shops, etc.,

- intermediate stops that are likely to occur during a long trip (break, stop for refuelling, etc.) and that are not considered as "trip purposes." As a consequence, they are not taken into account in the diary survey,

- survey inaccuracy for short distances (of hectometre order), and

- finally, a different trip definition: the driving-diary survey considers the trip purpose, while the instrumented study considers the vehicle starting up.

Table 2

Comparing the Results of the Driving Diary Survey
and the Instrumented Study
(Figures in Brackets Correspond to the Three Periods Studied : Winter, Spring, Summer)

	Diary survey[6] (over the 3 periods)	Instrumented study
Annual mileage (km.)	13,800	14,300
Weekly mileage (km.)	278 (248/261/350)	274
Average daily trip number	2.7 (2.3/3/2.9)	5.3
Average trip length (km.)	12 (9/12/15)	7
Trip length distribution		
< 1 km.	9 to 12	24
1-3 km.	24 to 27	28
3-5 km.	14 to 16	16
5-10 km.	18 to 21	18
10-50 km.	21 to 26	13
50 and over	5 to 7	2

This comparison shows that 40 to 50 percent of the trips of less than one kilometre would not be taken into account in a diary survey, which leads to significant discrepancies in the derivation of the number of trips per day. It should be noted that, in a diary survey, weekly kilometrage, obtained by multiplying by the average trip length, will be an underestimate compared to that obtained from vehicle monitoring. Both studies agree on the significance of short trips, but these are given a different definition: one trip in two is less than three kilometres in the instrumented study and less than five kilometres in the driving-diary survey.

During the diary survey, fuel consumption was assessed: the fuel tank was filled up at the beginning and at the end of vehicle monitoring. The results recorded are similar to the results obtained in the instrumented study. The diary survey yielded somewhat lower estimates in each vehicle class: 7.3 l/100 km. (diary) versus 7.7 l/100 km. (instrumented) for four to five horsepower vehicles, 8.9 versus 9.4 l/100 km. for six to seven horsepower vehicles, and 9.2 versus 10.2 l/100 km. for eight to nine horsepower vehicles.

DISCUSSION

Vehicle instrumentation is necessary when micro and/or chronological data on vehicle operating and usage conditions are to be recorded. For example, it is essential if we are to understand mechanisms of fuel consumption and pollutant emissions for which instantaneous conditions play a significant part, to know speeds and accelerations experienced and their incidence on safety, or engine operating conditions (driving ranges, thermal conditions); or to study driving behaviour. It enables the tracking of traffic, geography, and weather conditions. Finally, it allows trip data to be collected reliably.

This method was used in particular for the European DRIVE research program using 60 vehicles. It allowed the development of realistic measurement procedures for pollutant emissions performed on a test bench and the provision of accurate input data concerning vehicle-operation simulation[7,8].

The main limitation of the instrumented method is its high cost and the complexity of the equipment installed. This and the amount of collected data (some tens of data points at each one-second time interval) led us to study a limited number of sampled vehicles (56 vehicles). Compared to a diary survey, this method does not provide access to certain information mainly relating to travel behaviour: trip purpose, type of roads used, etc. At present, instrumented studies seem to supplement diary surveys for the collection of data of different kinds and enable highlighting driving behaviours from another perspective (speeds experienced, accurate knowledge of very short trips, of fuel consumption, etc.).

It can be suggested that, with technological development, on-board instrumentation will eventuallly constitute an alternative investigation method to a diary survey: in Canada, the development of a low-cost simplified system ("Autologger" 8), including a black box recording data on a credit-card sized data card and rudimentary sensors (distance or speed, logic data, even acquisition of data coded by the driver: purposes, road type, etc.), designed for large-scale survey applications, is an example of this

evolution. This system is quick to install (under one hour) and adaptable to any size of vehicle. This would enable very long-duration monitoring (annual) and data capture and checking will be made easier by using this data-recording system.

ACKNOWLEDGMENTS

This study was carried out with the financial support of the Direction de la Sécurité et de la Circulation Routière (D.S.C.R), the Agence Française pour la Maitrise de l'Energie (A.F.M.E) and the Peugeot SA - Régie Renault grouping.

REFERENCES

1. André, M., "Experimental Study on the Actual Uses of the Cars (EUREV)," International Congress and Exposition, Detroit, Michigan, U.S.A., February 27- March 3, 1989 - S.A.E. Technical Paper Series No. 90874 - ISSN 0148 - 7191, 7p., 1989.

2. André, M., "Utilisations réelles des véhicules – Caractérisation des uses des véhicules," International Symposium on Driving Behaviour in a Social Context, Paris, France, May, 1989.

3. Crauser, J. P., M. Maurin, and R. Joumard, "Representative Kinematic Sequences for the Road Traffic in France," International Congress and Exposition, Detroit, Michigan, U.S.A., February 27- March 3, 1989 - S.A.E. Technical Paper Series No. 890875.

4. Joumard, R., and M. André, "Real Exhaust Gaseous Emissions and Energy Consumption from the Passenger Car Fleet," Passenger Car Meeting and Exposition, Dearborn, Michigan, U.S.A., October 31- November 3, 1988 - S.A.E Technical Paper No. 881764.

5. André, M., "Actual Operating Conditions of the Cars : Measurements with an On-Board Data acquisition System," 20th International Symposium on Automotive Technology & Automation ISATA, Florence, Italy, Proceedings Vol. 1, pp 501-512, June, 1989.

6. Vallet, M., J. L. Ygnace, and M. Maurin, "Enquête sur l'utilisation réelle des voitures en France (EUREV)," Rapport IRT Bron NNE50, France, October, 1982, p. 141.

7. Joumard, R., A. J. Hickman, J. Nemerlin, and D. Hassel, "Modelling of Emissions and Consumption in Urban Areas," Final Report, DRIVE Project V1053, INRETS Report LEN9213, Bron, France, 54p. 1992.

8. Taylor, G. W. R., and P. Eng, "AUTOLOGGER: A Long Duration Vehicle Use Data Collection System," 6th International Conference on Travel Behaviour, Québec, May 1991, Proceedings, Vol. 2, pp 432-443.

20

A MICROECONOMIC MODEL OF THE JOINT DECISION ON CAR OWNERSHIP AND CAR USE

Gerald C. de Jong

ABSTRACT

In this paper, a model for the joint household decision on car ownership and car use is developed, estimated, and applied in simulation. It is a new extension of a previous model that excluded two-vehicle households. The model is explicitly based on the microeconomic theory of consumer behavior. A household is assumed to maximize a utility function with three goods: annual kilometrage in the first car, annual kilometrage in the second car, and other goods. The specific functions used are all non-linear. In estimation (done by maximizing a single likelihood function) these non-linear forms themselves are used instead of linear approximations. Estimates on data sets for The Netherlands, Israel, and Norway are presented. Simulation results involve the impact of changes in variable car costs, fixed car costs, income, and combinations of these on car ownership and use.

INTRODUCTION

In aggregate (so-called four-step) transportation models, car ownership is most often determined outside the model. In the model itself, it is an explanatory variable at best. In a disaggregate transportation model, such as the Dutch National Traffic Model[1], household car ownership is explained in one of the constituent submodels. The car ownership probabilities, according to this submodel, are exogenous factors in subsequent submodels for trip frequency, mode, and destination choice. As far as car ownership and car use are concerned, such a model might be called a sequential model: ownership is determined first and car use next, dependent on — among other things — car ownership.

A sequential model does not reflect the simultaneity of household choices of car ownership and use. Because of the presence of considerable fixed costs, car ownership is only worthwhile if one uses the car regularly. The formal derivation of this kilometrage threshold from microeconomic theory is in the next section. From the same theoretical analysis, it follows that both the fixed and variable car costs will affect both car ownership and use. The model presented in this paper accounts for this.

A model in which car ownership not only influences car use, but where car ownership also depends on "desired" car distance, is the UMOT model of Zahavi[2]. The operation of this model relies on the assumption of travel budgets that are more or less fixed for each socioeconomic class. Simultaneous models of car ownership and car use, that do not require this assumption, have been developed recently, using the technique of joint discrete/continuous modelling. Examples can be found in the work of Train[3], Hensher[4], and Kitamura[5]. An overview of discrete/continuous models in transportation analysis is given in de Jong[6].

The microeconomic model in this paper, when looking at its statistical properties, also falls in the class of discrete/continuous models or tobit models. In a theoretical sense the model is similar to (econometric) models for an individual's decisions on labour participation and hours of work. A key reference here is Hausman[7]. As in these models, the presence of fixed costs causes the budget set to be non-convex. Therefore, the optimum solution cannot be found by comparing variable costs with its shadow price, but we must make explicit (direct or indirect) utility comparisons.

The model is thus a simultaneous model of ownership and use. Another way in which it differs from usual transport models is that mobility is measured directly as kilometres. Car kilometres is one of the arguments to the utility function. In most transport models kilometres travelled is an indirect output; it is calculated using trip frequencies and trip lengths. For a number of applications — for example when one studies the emission of pollutants by traffic — kilometres is the most relevant variable. On the other hand, the microeconomic model of car ownership and car use does not distinguish travel purposes and, by itself, cannot give an origin-destination matrix for assignment. The two most important possibilities for application are:

- using the ownership/use outcomes as inputs or constraints in a larger transport-model framework; and

- using the model to simulate the impact of socioeconomic changes and policy measures working through fixed and/or variable car costs on overall car kilometrage and therefore also on emissions.

The model was originally developed for the ownership and use decisions of the first private car in the household, as can be found in de Jong[8,9]. Recently, in the course of work undertaken by the Institute of Transport Economics from Oslo and the Hague Consulting Group for the Norway Climate Project[10], the model was extended to include two-vehicle-households. This extension constitutes the primary contribution of this chapter over earlier papers[11,12].

In the second section, the theoretical background is discussed, followed by the model specification in the third section. In both sections the 0/1 model is introduced first and the 0/1 - 1/2 car ownership and use model next. The fourth section contains the data used in application of the model for The Netherlands, Israel, and Norway. The estimation results for these countries are given in the fifth section. Various simulation results are presented in the sixth section. Finally, the last section is a summary and conclusion section.

THE THEORETICAL BACKGROUND

The 0/1 Ownership and Use Model

The model is based on the microeconomic theory of consumer behavior. This theory depicts the household-decision problem as maximizing utility under a budget constraint.

In the 0/1 car ownership and use model framework, we consider two goods: A, automobile use in kilometres (x100) for private purposes (including home to work travel) per year, and X, the volume of all other goods and services in money units (for instance Dutch guilders or Norwegian kröner) per year. A has two prices: fixed costs of C money units a year and variable costs of v money units per 100 kilometres. The price of X is unity for normalization. C consists of the bulk of depreciation and of insurance, road tax, and some of the expenditure for maintenance and repair; v contains the remainder of depreciation, maintenance and repair, but is dominated by fuel costs.

The direct utility function now is:

$$U = U(A,X) \qquad (1)$$

and the budget restriction is:

$$Y \geq X \qquad \qquad \textit{if no car}$$
$$Y \geq vA + C + X \qquad \textit{if 1 car} \qquad (2)$$

Y represents net household income.

The budget set is non-convex. This can be seen in Figure 1, where the utility function is represented by indifference curves. The indifference curves cut the X-axis (or "other goods-axis") but not the A-axis (kilometres), because zero private kilmetrage is perfectly feasible, while zero consumption of all other goods is not. If a household does not own a car, it can spend all income on other goods; the household will be at point Y. If, starting from this situation, the household decides for car ownership, it is confronted with a decline in utility because of the presence of fixed costs. In the figure this would mean it drops from Y to $Y - C$. This disutility can only be overcome by driving a positive number of kilometres. This implies that there is a threshold at work: a minimum kilometrage for car ownership to occur. The budget line goes from Y to Y-C and then continues in the familiar way to the A-axis. For this slanting part of the budget line, three possibilities (labelled I, II and III) are depicted, depending on the variable costs.

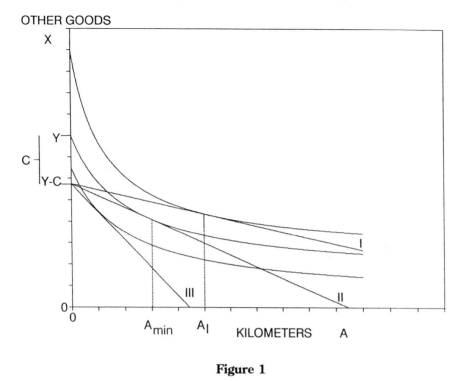

Figure 1

Consumer Behaviour at Three Levels of Variable Costs

In situation I, the household will choose for car ownership and it will drive A_I kilometres. In situation II (higher variable costs), the household will be indifferent between owning and not owning a car; both the optimum kilometrage point and point Y are on the same indifference curve. A_{min} is the threshold kilometrage here. If the variable costs rise even higher we will reach situation III, where the household will attain maximum utility at point Y, without a car. At given income and given fixed costs, there thus exist a maximum variable cost and a minimum kilometrage that act as thresholds for car ownership.

In Figure 2, we let income vary instead of variable costs. For each of the income levels corresponding to the budget lines 1, 2 and 3, we have drawn a tangent indifference curve. The fixed costs C and the variable costs stay the same. At income level 1, the household is better off at K, without a car. Car ownership does not occur up to income level 2, which marks indifference to car ownership. Income level 2 is the threshold income of this household; the ensuing threshold kilometrage is A_{min}. Beyond this

income, for instance at level 3, there will be ownership coupled with more than A_{min} kilometres[a][13].

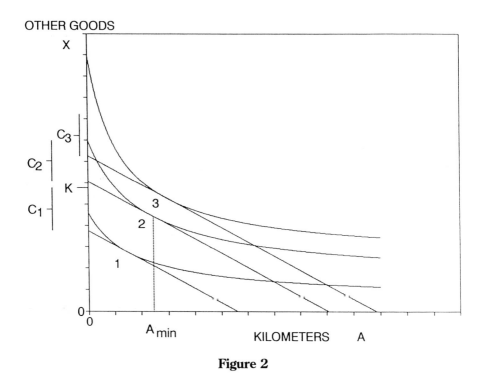

Figure 2

Consumer Behaviour at Three Income Levels

Fixed-cost variation is represented in Figure 3. If the fixed costs amount to C_1, the household will be indifferent. In the case of a rise to, for instance C_2, the same indifference curve can still be reached by deciding against ownership. At the lower level of fixed costs C_3, utility is maximized by deciding for a car and driving a certain

<hr>

[a] A threshold kilometrage cannot be derived from income variation for every set of indifference curves; for sufficient conditions see de Jong. An important conclusion from the preceding graphical analysis, is that in this rather standard microeconomic framework, both the fixed and the variable car costs will influence both car ownership and car use. In many transportation models this is not the case.

kilometrage, which will exceed that at C_1 if car use is not an inferior good (inferiority seems very unlikely here).

OTHER GOODS

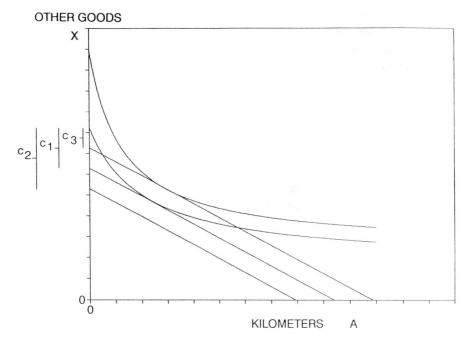

Figure 3

Consumer Behaviour at Three Levels of Fixed Costs

The above analysis also provides the basic mechanism of the car ownership and use model. A household will only choose for car ownership and drive a positive number of kilometres if the maximum utility of car ownership, given by the tangency point of the slanting segment of the budget line with an indifference curve, exceeds the utility $U(0,Y)$ of not having a car (point Y in Figure 1). The tangency point can come from the conditional indirect utility function $\chi(v, Y\text{-}C)$, which gives the (sub)optimum solution to the constrained optimization problem conditional on car ownership. In case of ownership, car use is defined by the optimal amount of A. If the indirect utility of owning a car and driving the optimal number of kilometres does not exceed the utility of not owning a car, the household will decide against car ownership.

The 0/1-1/2 Car Ownership and Use Model

This model is an extension, developed for the Norwegian Climate Project, of the 0/1 car ownership and use model. The new feature is that it also accommodates two-vehicle households. The kilometrage in the second car of the household is a separate item in the direct utility function. In its general form the household-decision problem now is (the subscripts 1 and 2 here indicate the first and second car in the household):

Maximize:

$$U = U(X, A_1, A_2) \tag{3}$$

subject to:

$$
\begin{array}{ll}
Y \geq X & \textit{if } 0 \textit{ cars} \\
Y \geq v_1 A_1 + C_1 + X & \textit{if } 1 \textit{ car} \\
Y \geq v_1 A_1 + C_1 + v_2 A_2 + C_2 + X & \textit{if } 2 \textit{ cars}
\end{array} \tag{4}
$$

An alternative approach would have been to distinguish only total kilometrage (of both cars together). The advantage of using two kilometrages is that the utility derived from a kilometre in the first car may be different from the utility of a kilometre in the second car. This seems reasonable, because the second car is usually of a different type and most of the time is driven by another person. Furthermore, in the alternative case of only total kilometrage in the utility function, a second car can only be chosen because it has lower variable costs. Otherwise, the extra kilometrage would be driven in the first car.

MODEL SPECIFICATION

The 0/1 Car Ownership and Use Model

The specific functional form of the indirect and direct utility functions is derived from the form of the demand function for kilometres. The form of the demand function, in turn, is based on a statistical analysis of car ownership and use in The Netherlands in which the double-logarithmic form (in kilometres and income) proved superior; variable costs are included linearly as in Train[14]. The demand function gives the number of kilometres the household desires to drive in a year:

$$lnA = \alpha ln(Y - C) + Z - \beta v + e \tag{5}$$

Here Z is a vector of demographic and socioeconomic characteristics of the household, e is an independent and identically normal-distributed disturbance term and α, β and θ are parameters to be estimated. The relationship between the demand function and the indirect utility function is given by a formula from microeconomics called Roy's identity (see Hausman[15]):

$$(\delta x/\delta v)/(\delta x/\delta Y) = -A \tag{6}$$

We use this identity to derive the following indirect utility function from the demand function:

$$x(v, Y-c) = [1/(1-\alpha)](Y-C)^{1-\alpha} + (1/\beta)\exp(Z+e-\beta v) \tag{7}$$

This indirect utility function gives the optimum utility, in terms of the exogenous variables, conditional on car ownership. The direct utility function for the situation without a car, which in turn follows from the indirect utility function, is:

$$U(0,Y) = [1/(1-\alpha)]Y^{1-\alpha} \tag{8}$$

Thus, functions used — the demand function, the indirect utility function and the direct utility function — fit into a single, consistent framework.

Car ownership now results from comparing the last two equations. Car use for car-owning households follows from the demand function. For households without a car we observe:

$$P(x(v, Y-C) \leq U(0,Y)) \tag{9}$$

For car-owning households we observe:

$$P(x(v, Y-C) > U(0,Y), lnA) \tag{10}$$

In the likelihood function, these probabilities are combined for all households in the sample. The model is estimated by maximizing the log-likelihood function with respect to the parameters.

The 0/1 - 1/2 Car Ownership and Use Model

The demand functions and the utility functions are specified analogously to the ones of the 0/1 model:

Conditional indirect utility functions:

$$wo\ cars:\ x_2 = [1/(1-\alpha)](Y-C_1-C_2)^{1-\alpha} + (1/\beta_1)\exp(_1Z+e_1-\beta_1v_1) \tag{11}$$
$$+ (1/\beta_2)\exp(_2S+e_2-\beta_2v_2)$$

$$One\ car:\ x_1 = [1/(1-\alpha)](Y-C_1)^{1-\alpha} + (1/\beta_1)\exp(_1Z+e_1-\beta_1v_1) \tag{12}$$

$$Zero\ cars:\ U_0 = [1/(1-\alpha)]Y^{1-\alpha} \tag{13}$$

Demand functions.

$$Use\ of\ only\ car: \quad lnA_1 = aln(Y-C_1) + q_1Z - \beta_1v_1 + e_1 \tag{14}$$

$$Use\ of\ first\ car\ out\ of\ two:\ lnA_1 = aln(Y-C_1-C_2) + q_1Z - \tag{15}$$
$$\beta_1v_1 + e_1$$

$$Use\ of\ second\ car\ out\ of\ two:\ lnA_2 = aln(Y-C_1-C_2) + \tag{16}$$
$$q_2S - \beta_2v_2 + e_2$$

The link between the indirect utility functions and the demand functions is again Roy's identity. If we compare the indirect utility of one car with that of two cars, we see that the decision on the second car does not depend on the elements of the kilometrage function of the first car other than the fixed costs. The second car is chosen if it adds to utility, in spite of the extra costs incurred. S may be different from Z.

Ideally, we would now have to find out which of the three conditional indirect/direct utility functions renders the highest utility. This is computationally infeasible. The approach adopted is that we give households with one driving license the choice between zero and one car and households with two or more licenses the choice between one and two cars, as depicted in Figure 4. A-D are the symbols we use for representing the different categories.

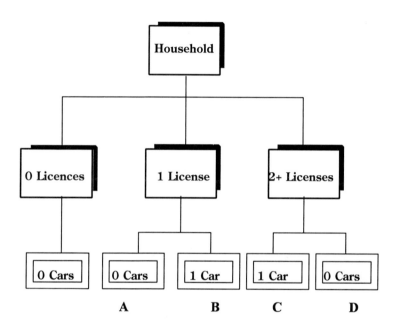

Figure 4
Structure of 0/1 — 1/2 Car Ownership and Use Model

This is the same approach of linking license holding to car ownership as was used in the Dutch National Traffic Model[16]. The rationale for this approach is that hardly any households without a license have a car (in Norway 0.4 percent), few one-license households have two cars (1.3 percent) and also few households with two or more licenses have no car (1.0 percent). In prediction these percentages are kept constant. It is true that the model does not account for the possible simultaneity of decisions on license holding and car ownership. Intended car ownership or use does not affect

driving-license decisions here. The model focuses on the simultaneous explanation of car ownership and use. For predicting license holding, a submodel from the Dutch National Traffic Model can be used. In the Norwegian Climate Project, a similar license-holding model was used.

Using this structure in which car ownership is conditional on license holding, we get the following elements in the likelihood function:

Households with one license:

$$A: \text{ if } 0 \text{ cars: } P(x_1 \leq U_0) \tag{17}$$

$$B: \text{ if } 1 \text{ car: } P(x_1 > U_0, lnA_1) \tag{18}$$

Households with two or more licenses:

$$C: \text{ if } 1 \text{ car: } P(x_2 \leq x_1, lnA_1) \tag{19}$$

$$D: \text{ if } 2 \text{ cars: } P(x_2 > x_1, lnA_1, lnA_2) \tag{20}$$

A household with one license thus has the same choice as the households in the 0/1 model. A household with two or more licenses has at least one car. It decides for a second car if owning it and driving the optimal mileage in it adds to utility. In the likelihood function, all these elements are combined. Estimation is done using a single likelihood function because the 0/1 and 1/2 submodels have parameters in common (notably the coefficients of the demand for kilometres in the first car).

THE DATA USED

The 0/1 model was estimated on household data for The Netherlands, Israel, and Norway; the 0/1 - 1/2 model was only estimated for Norway. The Dutch data set comes from the national "Doorlopend Budgetonderzoek" (meaning: continuous budget survey) of the Centraal Bureau voor de Statistiek. For this survey, each year a new sample of almost 3,000 households is drawn. We have at our disposal the

surveys of 1978, 1980 and 1985. For Israel we use the 1984 Survey of Travelling Habits, which comprises more than 4,600 households in the three most urbanised areas (Jerusalem, Tel-Aviv and Haifa). It was collected by the Israeli Central Bureau of Statistics. The 1984/1985 Norwegian "Reisevaneundersokelsen" (Travel Survey) of the Institute of Transport Economics was the main data source for Norway. In total it contains more than 5,800 households (a uniform national sample and a sample for Oslo). In Table 1 some statistics from these samples and other sources for the countries under consideration are given.

Table 1.

Some Statistics for The Netherlands, Israel, and Norway

	The Nether-lands	Israel	Norway
	1985	1984	23.341
	numbers:		
0/1 estimation subset:			
0 car households	553	768	701
1 car households	1791	1254	2133
0/1 - 1/2 estimation subset:			
1 license, 0 car			115
1 license, 1 car			920
2+ licenses, 1 car			1150
2+ licenses, 2 cars			575
	means (all in 1985 guilders) :		
Net household income per year	40,784	28,958	41,013
Fixed costs per year of first and only car	2,536	3,699	3,068
Variable costs/100 lm of first and only car	21.09	27.60	25.46
	mean (x 1000) :		
Kilometres per car per year	15.9	9.5	13.5

ESTIMATION RESULTS

All models were estimated by maximizing the complete likelihood function for all observations together. This method was selected as opposed to sequential estimation methods which are also sometimes used for discrete/continuous models, but which are less efficient. Estimation for The Netherlands and Israel was performed in the general maximum likelihood package GRMAX[17], which uses the Bernd, Hall, Hall, and Hausman algorithm. The model for Israel was re-estimated with the PC package GAUSS, using the Broyden, Fletcher, Goldfarb, and Shanno optimization algorithm. This gave virtually the same results as estimation with GRMAX. After that, the models for Norway were both estimated with GAUSS. Table 2 contains the estimation results for the 0/1 model for all three countries.

Table 2

Estimation Results for 0/1 Car Ownership and Use Model

Variable	The Netherlands 1985		Israel 1984		Norway 1984/85	
	Coeff.	T-Value	Coeff.	T-Value	Coeff.	T-Value
Ln (Y-C)	0.33	(7.61)	0.20	(3.11)	0.14	(10.42)
v	-0.031	(-26.22)	-0.016	(-13.84)	-0.009	(-40.29)
LNUMB	0.016	(0.50)	0.020	(0.96)	0.16	(9.46)
AGEH	-0.016	(-4.13)	-0.031	(-2.57)	-0.003	(-5.56)
DF	-0.094	(-1.94)	-0.037	(-1.15)	-0.11	(-6.63)
DA	0.048	(0.97)				
POPD					-0.001	(-4.82)
Constant	1.80	(3.89)	2.70	(3.83)	3.53	(19.80)
Sigma-e		0.26		0.27		0.22
Sigma-w		0.50		0.62		0.53
Sigma-u		0.57		0.68		0.58
Observations		2344		2022		2834
Log L per obs.		-0.394		-0.533		-0.324

In Table 2, *ln (Y-C)* and *v* are defined as before. The variables in *Z* of the demand function and the indirect utility function are:

LNUMB: log of (household size x10).

AGEH: age of the head of the household; in The Netherlands and Israel this is in five-year classes; in Norway it is in years.

DF: dummy-variable which equals one if female head of household and zero otherwise.

DA: dummy-variable for farmer head of household.

POPD: population density, measured as percent of population living in built-up area.

σ_e, σ_w, and σ_u are the standard errors of the disturbances in the desired kilometrage equation, the disturbance between observed and desired kilometrage and the total disturbance respectively.

The first estimate is the short-term (or direct) income elasticity of kilometrage (remember that the continuous part of the dependent variable is a logarithmic function). The long-term version, which includes ownership effects, can only be calculated by simulation. The direct income elasticity in Norway turns out to be lower than in The Netherlands and Israel. The direct fixed-cost elasticity of kilometrage is minus the direct income elasticity.

The second coefficient is not an elasticity. A direct variable-cost elasticity can be calculated from it (at the cost level used in estimation). This is -0.65 for The Netherlands, -0.44 for Israel, and -0.71 for Norway. These numbers may seem rather high. A brief discussion on this can be found at the end of the next section.

In general the results for the 0/1 model for Norway are as good as or even better than for The Netherlands: the residual variation is of the same order, the t-values are better and the log likelihood per observation is better. The model for Norway is by all measures better than the model for Israel.

The 0/1 car ownership and use model was also estimated on a pooled sample for The Netherlands, consisting of the Budget surveys of 1978, 1980 and 1985. The purpose of this was to include some price variation in time. This strengthens the estimates, as

can be seen from the t-values in Table 3. The values of the most important parameter estimates are only slightly different from the ones for The Netherlands in Table 2.

Table 3.
Estimation Results for 0/1 Car Ownership and Use Model

Variable	Coeff.	T-Value	Variable	Coeff.	T-Value
			The Netherlands 1978, 1980 and 1985 combined		
ln(Y-C)	0.35	(15.01)	Cons(80)	1.70	(6.68)
v	-0.029	(-46.49)	Cons(85)	1.64	(6.52)
AGEH	-0.024	(-10.79)	σ_e	0.28	
DF	-0.14	-6.72	σ_w	0.52	
Const(78)	1.73	-6.71	σ_u	0.59	
Observations				6320	
Log L per observation				-0.44	

In Table 4 the estimates for the 0/1 -1/2 model for Norway are given. All symbols have the same meaning as before. New are:

AGE45: Age (of head) minus 45 if age above 45; zero otherwise.

AGE65: Age (of head) minus 65 if age above 65; zero otherwise.

All coefficients turn out to be significant. As can be seen from the Sigma-w and Sigma-u, the kilometrage in the second car cannot be explained as well as the kilometrage in the first car. The unexplained variation is larger. This is probably also the reason for the somewhat lower Log Likelihood per observation (which still is comparable to the 0/1 model for The Netherlands).

The direct income elasticity of kilometrage (constrained to be the same for both cars) now is 0.18. The short-term fixed costs elasticity thus is -0.18. The direct variable costs elasticity of kilometrage is -0.65 for the first (or only) car and -0.43 for kilometres in the second car (at the value of variable costs used in estimation). Long-term (including ownership effects) elasticities of kilometrage can be calculated by doing simulations. We report on this in the next section.

Table 4.

Estimation Results for 0/1 - 1/2 Car Ownership and Use Model

	Norway 1984/1985			
	Kilometres in car 1		Kilometres in car 2	
Variable	Coeff.	T-Value	Coeff.	T-Value
Ln (Y-C)	0.18	(9.1)	0.18	(9.1)
v	-0.008	(-26.8)	-0.007	(-30.8)
LNUMB	0.16	(7.1)	0.13	(4.0)
DF	-0.14	(-5.5)		
AGE45			0.010	(4.8)
AGE65			-0.054	(-2.9)
POPD	-0.002	(-4.6)	-0.001	(-3.0)
Constant	3.04	(12.5)	1.96	(6.3)
σ_e	0.24		0.28	
σ_w	0.51		0.64	
σ_u	0.56		0.70	
Observations			2760	
Log L per obs.			-0.42	

SIMULATION RESULTS

The parameter estimates for a country, as presented in the preceding section, can be used together with a household sample (the sample used in estimation, but possibly also another), in micro-simulation.

As a first example, we examine the impact of a (hypothetical) changed variables scheme in The Netherlands[18]. Here the road tax is reduced by 50 percent, while fuel prices are increased by 14 percent, so as to keep government revenue and average total car costs constant at present kilometrage. In the model, this means that the fixed costs are decreased by about 8.7 percent, while the variable costs increase by 9.1 percent. Using the estimates on the combined sample as in Table 3 and that sample itself, the impact of introducing these two changes simultaneously is:

number of households with one private car: +4.9 percent
total number of kilometres in the sample: -2.1 percent
average annual kilometrage per car: -6.7 percent

The policy objective of such a scheme is to reduce total kilometrage. Success is limited. However, the impact on kilometrage of the scheme consists of a significant reduction of car use due to the increase in variable costs and of almost compensating growth in kilometrage because of the lower fixed costs. Raising the variable costs without compensation in the fixed costs would be much more effective. This can be seen by considering the elasticities.

As a second example, we list some elasticities (see Table 5). These are long-term elasticities, including the effects on kilometrage working through ownership. They are calculated by comparing a 'base case' simulation with a simulation in which an exogenous variable is changed by some 10 percent. For Israel, no simulation exercises were performed.

Table 5.
Elasticities of Car Kilometrage (From Simulation)

Variable changed	The Netherlands 78+80+85	Norway 84/85
Fixed costs	-0.68	-0.48
Variable costs	-1.02	-0.80
Income	+0.62	+0.38*

*: Including income effects through license-holding

The (long-term) income elasticities are rather similar to those found by most other researchers. On the other hand, the cost sensitivities from this model, especially those for The Netherlands, are higher than those commonly found. Among the factors which might account for this are four suggested in the following paragraph.

First, one must bear in mind that the elasticities presented here also include car-ownership effects (and therefore should be regarded as long-run sensitivities). Second, not all variable costs are fuel costs; the fuel-cost elasticity in this model will be lower. Third, in The Netherlands, the model is for the private use of private cars, which is likely to be a rather cost-sensitive segment of the car market. Finally, the model does not incorporate a number of features (e.g., time constraints, dynamics, car-

type choice), which may be important in practice. Some of these issues are discussed in Bradley and Gunn[19].

SUMMARY AND CONCLUSIONS

A model for the joint household decision on car ownership and car use was developed. The model is explicitly based on the microeconomic theory of consumer behavior. A household is assumed to maximize a utility function with three goods: annual kilometrage in the first car (in the household), annual kilometrage in the second car, and other goods. The first two goods each have two prices: fixed and variable costs.

If a household has no car, no fixed and variable costs are incurred. If it decides for car ownership, the household is confronted with a decline in utility because of the presence of fixed costs. This disutility can only be overcome by driving a positive number of kilometres (thus there is a threshold kilometrage). A household, facing the choice of one car versus no car, now chooses for car ownership, if the utility of having a car and driving the optimal kilometrage in it (represented by the indirect utility function) exceeds the utility of having the maximum amount of other goods, and no car (represented by the direct utility function at the point where all income is spent on other goods). The kilometrage, in this case, follows from the demand function for kilometres. A household, facing the choice of one car versus two cars, chooses the latter, if owning the second car and driving the optimal kilometrage in it adds to the utility, in spite of the extra costs incurred.

The relationship between the direct utility functions, the indirect ones, and the demand functions follows from microeconomic theory (for instance from Roy's identity). The specific functions used are all non-linear, based on a statistical analysis of the demand for kilometres in The Netherlands. In estimation (done by maximizing a single likelihood function), these non-linear forms themselves are used instead of linear approximations. Estimation results on data sets for The Netherlands, Israel (both for a 0/1 car ownership and use model), and Norway (also for a 0/1 - 1/2 car ownership and use model) were presented.

Perhaps the most interesting way of using the model is in simulating changes in the fixed and variable car costs. These changes can be the result of changes in policy variables such as the fuel and road tax. In the model, changes in variable costs will affect both car ownership and use, because lower demand for kilometres will decrease the probability of (multiple) car ownership. Changes in fixed costs also influence both ownership and use. The long-term cost elasticities of car kilometrage thus can be split into a direct effect on the kilometrage per car and an indirect effect working through

car ownership. Other studies, with exogenous car ownership, often only give this direct effect. The presence of the indirect effect in the model presented here is one of the reasons for the cost elasticities being higher than usual.

ACKNOWLEDGMENTS

The 0/1 model was developed when the author was employed at the Institute of Actuarial Science & Econometrics of the University of Amsterdam, with financial support from the Netherlands Organization for Scientific Research (NWO). The extended model was developed at Hague Consulting Group, under subcontract to the Institute of Transport Economics in Oslo. The author wishes to thank Mark Bradley, Andrew Daly and an anonymous referee for helpful comments.

REFERENCES

1. Hague Consulting Group, "Creation of the Landelijk Model. HCG," The Hague, 1990.

2. Zahavi, Y., "The UMOT Project," U. S. Department of Transportation, Washington, D.C., 1979.

3. Train, K., *Qualitative Choice Analysis; Theory, Econometrics and an Application to Automobile Demand.* The MIT Press, Cambridge, Massachusetts, 1986.

4. Hensher, D. A., "Dimensions of Automobile Demand: An Overview of an Australian Research Project," *Environment and Planning*, 1986 A, 18, 13391374.

5. Kitamura, R., "A Panel Analysis of Household Car Ownership and Mobility," *Proceedings of the Japan Society of Civil Engineers*, 1987, 383, 13-27.

6. de Jong, G. C., "Discrete/Continuous Models in Transportation Analysis," *Proceedings of PTRC's 18th Summer Annual Meeting*, Brighton, 1990.

7. Hausman, J. A., "The Econometrics of Non-linear Budget Sets," *Econometrica*, 1985, 53, 1255-1282.

8. de Jong, G. C., "Some Joint Models of Car Ownership and Use," Academic thesis, Faculty of Economic Science and Econometrics, University of Amsterdam, 1989.

9. de Jong, G. C., "An Indirect Utility Model of Car Ownership and Private Car Use," *European Economic Review*, 1990, 34, 971-985.

10. Hague Consulting Group, *A Model System to Predict Fuel Use and Emissions from Private Travel in Norway.* Final report by Hague Consulting Group under subcontract to the Institute of Transport Economics in Oslo, HCG, The Hague, 1990.

11. deJong, 1989, *op. cit.*

12.　deJong, "An Indirect Utility Model...," 1990, *op. cit.*

13.　deJong, 1989, *op. cit.*

14.　Train, *op. cit.*

15.　Hausman, *op. cit.*

16.　Hague Consulting Group, "Creation of the Landlijk...," 1990, *op. cit.*

17.　Ridder, G. (with Bekkering, J.), *Manual GRMAX*, Foundation for Economic Research, University of Amsterdam, 1986.

18.　de Jong, G. C., "Simulating Car Costs Changes Using an Indirect Utility Model of Car Ownership and Annual Mileage," *Proceedings of PTRC's 17th Summer Annual Meeting*, Brighton, 1989.

19.　Bradley, M. A. and Gunn, H. F. "Issues Involved in Using Travel Demand Model Systems to Assess Environmental Policy," Paper presented at the 6th International Conference on Travel Behavior, Quebec, 1991.

21

MODELS OF BRAND LOYALTY IN THE AUTOMOBILE MARKET

Radha Chandrasekharan, Patrick S. McCarthy, and Gordon P. Wright

ABSTRACT

The purpose of this paper is to study loyalty and competition in the U.S. automobile market, using a parameterised logit-captivity model, where the loyalty and shopping behaviour of consumers is explicitly modelled as separate functions of several explanatory variables. Specifically, the probabilities that an individual is a Loyal or a Shopper are each derived from a multinomial logit model. In an empirical application of the parameterised logit-captivity model, an extensive automobile-purchase data base, from J.D. Power and Associates for the year 1989, is used to determine key explanatory variables for loyalty and shopping behaviour in the U.S. automobile market. Among the findings, the number of dealer visits and the scope of a consumer's search activities were found to be important determinants of brand loyalty. In addition, and similar to the results of previous studies on automobile demand, vehicle attributes related to cost, performance, and size were important factors in an automobile purchaser's vehicle-type choice.

INTRODUCTION

Automobile replacement purchases are the result of a series of choices in a complicated decision process, by which information from a variety of sources is used to determine the optimal size, make-up (automobile types), and vintage of a household's automobile fleet. The uses and experiences associated with a household's fleet, advertised new offerings of automobile manufacturers, discussions with friends and acquaintances, government recalls, and automobile evaluations by the media are examples of sources of information for making automobile-purchase decisions. Also, changes in fuel prices, the age distribution of a household, or maintenance expenditures, for example, have implications for future automobile-purchase decisions.

Automobile-purchase decisions typically involve a time-consuming and expensive process of information search. Today, there are as many as 41 makes and 191 models in the passenger automobile and light truck categories. There are many variations across makes and models by features, such as, engine size, transmission, body style, color, interior, and drive type. Consequently, for a household, the search costs associated with undertaking a comparative analysis of the attributes of each make and model are often enormous. However, it is possible for a household to achieve sizeable reductions in search costs by restricting the choice set of alternatives to a small subset of all the available makes and models. For example, a simple rule for a household in considering restricting choice sets of alternatives is to purchase the brand of automobile previously purchased.

Previous research on automobile purchase and ownership decisions has long recognized the importance of the concept of transaction costs and its relationship with brand loyalty. Manski and Sherman[1] estimate automobile-ownership models of one- and two-automobile households using a transactions-indicator variable as an explanatory variable, to distinguish previously-purchased from currently-purchased automobiles. Hocherman, Prashker, and Ben-Akiva[2] generalize Manski and Sherman's transactions-cost approach by including a set of indicator variables to represent brand loyalty, market size, and the effect of the age of an automobile. The key assumptions of the two studies are: (1) increased information leads to reduced search costs; and (2) the disturbances are serially independent, given the use of the transactions variable as a lagged dependent variable. In most of these studies and for the purposes of this discussion, a lagged dependent variable refers to an explanatory variable that equals one if the currently-purchased automobile is of the same make/model as the previously-purchased automobile. A violation of the second assumption leads to biased and inconsistent estimates of the parameters. As pointed out by the authors, modelling serial dependence of disturbances using lagged dependent variables complicates the estimation problem significantly. They choose to include the transactions-indicator variable and ignore serial dependence, arguing that the mis-specification error from excluding the transactions variable would be greater than the error associated with assuming independent disturbances.

Mannering and Winston[3] estimate a dynamic model of automobile ownership and utilization in which they distinguish between brand preference and brand loyalty. Brand preference reflects a consumer's inclination towards a particular brand, assuming all else constant, including automobile attributes; while brand loyalty is determined by past ownership experience. A positive ownership experience with a particular brand increases the likelihood that a household purchases the same brand a second time, due to the lower associated transactions costs. As expected, the

empirical analysis in Mannering and Winston[3] shows that most of the lagged utilization variables have a positive (i.e., significantly greater than zero) effect on brand purchase. The incorporation of past automobile utilization as a variable in their model avoids the problem of biased estimates of the coefficients of lagged-endogenous variables. However, they assume that brand loyalty can be completely determined by incorporating past utilization as an exogenous variable, even though it is likely that past utilization has independent effects on the choice of the type of automobile, as well as on brand loyalty.

Mannering and Winston[4] use automobile-purchase histories of a sample of consumers to estimate models of new automobile choice for the two periods, before and after 1980. The objective of their analysis is to estimate the effect over time of brand loyalty, defined as the number of previous consecutive purchases of the same brand, on the choice of automobile. The empirical results in Mannering and Winston show that from the time period before 1980 to the time period after 1980, there is an increase in brand preference for domestic automobiles. On the other hand, for Japanese automobiles, there is a significant increase in brand loyalty. Based on several tests, they conclude that their model captures brand loyalty rather than consumer heterogeneity. However, as we have already discussed, the incorporation of brand loyalty, defined in terms of previous purchases of the same brand as an exogenous variable in their model, introduces the possibility of biased and inconsistent estimates.

This chapter attempts to develop a model of brand loyalty, shopping, and repeat purchasing in which brand loyalty and the choice of automobile are *separately modelled and simultaneously* estimated. By explicitly modelling brand loyalty, the potential problem of obtaining biased and inconsistent coefficient estimates of indicator variables for brand loyalty in automobile-type choice models is avoided. Also, estimating structural parameters of both the choice of automobile type and brand loyalty, rather than just using a model that gives reduced-form estimates, allows the determination of the independent effects of explanatory variables that influence the choice of automobile type and brand loyalty.

PARAMETERISED LOGIT-CAPTIVITY MODEL

Let $C = \{1, \ldots, J\}$ be the set of J possible alternatives available to a consumer and $C_j = \{j\}$ the set containing only a single alternative j ($=1, \ldots, J$). The parameterised logit-captivity models[5] assumes that consumers are of two types: Loyals and Shoppers.

For each consumer t (subscript dropped) let

$$P_j \quad = \quad \text{the probability that the consumer chooses alternative } j \qquad (1)$$

$$P_{Cj} \quad = \quad \text{the probability that the consumer is loyal to } j \text{ (i.e., chooses from the choice set } C_j \text{ containing the single alternative } j) \qquad (2)$$

$$P_C \quad = \quad \text{the probability that the consumer is a Shopper} \qquad (3)$$

$$P_{j|C} \quad = \quad \text{the probability that the consumer chooses } j \text{ from the full set of alternatives } C \qquad (4)$$

$$X_j \quad = \quad \text{the vector of } n \text{ socioeconomic characteristics of the consumer and/or attributes of alternative } j \text{ that possibly explain loyalty} \qquad (5)$$

$$Y_j \quad = \quad \text{the vector of } m \text{ socioeconomic characteristics of the consumer and/or attributes of alternative } j \text{ that possibly explain choice conditional on shopping.} \qquad (6)$$

For each consumer let

$$\alpha_j \quad = \quad \text{a vector of } n \text{ parameters associated with the vector } X_j \text{ of explanatory variables} \qquad (7)$$

and

$$\beta_j \quad = \quad \text{a vector of } m \text{ parameters associated with the vector } Y_j \text{ of explanatory variables.} \qquad (8)$$

Then the parameterised logit-captivity (PLC) model is:

$$P_j \;=\; \frac{\exp(\alpha_j X_j)}{\left(1+\sum_k \exp(\alpha_k X_k)\right)} + \frac{1}{\left(1+\sum_k \exp(\alpha_k X_k)\right)} \; \frac{\exp(\beta_j Y_j)}{\sum_k \exp(\beta_k Y_k)} \qquad \textit{for all } j \in C \qquad (9)$$

The odds of being loyal to alternative j are given by $\exp(a_j X_j)$ so that the first term in (9) expresses the probability (P) that the consumer is loyal to alternative $j \in C$. The second term in equation (9) is the product of two probabilities: (1) the probability (PC) that a consumer is a Shopper which is , and (2) the conditional probability

($Pj|C$) of choosing j given that the consumer chooses from the full choice set C, which is given by $exp(b_jY_j)$ /.

As formulated in (9), the probability (P) of a consumer being a Loyal, as well as the probability (P_c) of his or her being a Shopper is a function of the known vector X_j of socioeconomic and alternative attributes. The probability ($P_j|C$) of choosing alternative j, given that the consumer is a Shopper, is a function of a different, although not necessarily mutually exclusive, known vector of socioeconomic and alternative characteristics Y_j. We estimate the vectors a_j and b_j of parameters by the method of maximum likelihood. A number of interesting and important features of the PLC model are described below.

Choice-set generation

Although the assumption of the PLC model in (9), that all consumers are either Loyals or Shoppers, is restrictive, the model gives a process for the generation of individual consumer's choice sets. That is, rather than assuming that each consumer actively considers the full spectrum of alternatives before making his or her choice, the PLC model hypothesizes two types of consumers: Loyals with choice sets, $\{1\}, \ldots, \{J\}$ and Shoppers with the choice set $\{1, \ldots, J\}$. Therefore, the PLC model is used to identify those factors that determine not only the consumer's choice of alternative but also his or her choice set. See Manski[6] and Swait and Ben-Akiva[7] for a discussion of more general, but less tractable, choice-set generating processes.

Hierarchy of choices

The PLC model can be viewed as part of a more general choice hierarchy that characterizes a consumer's initial decision to transact, the type of transaction (buy, sell, replace, or some combination), and the market(s) in which to transact (new, used). In this study, the PLC model is conditioned upon the decision to transact in the new automobile market.

Relationship with brand-switching models

Several brand-switching models that use switching matrices as input data[8,9] also make the assumption that consumers are of two types: Loyal and Shoppers. The parameters of such brand-switching models can be calculated from estimates of the parameters of the PLC model[10]. The usefulness of deriving the relationship between the PLC model and a brand switching model lies in the fact that market-structure statistics (e.g., the total proportion of Loyals and repeat-purchasing Shoppers in the market) can be derived from the estimated parameters of brand-switching models to evaluate a hypothesized competitive market structure.

Equivalence to the Dogit model

The term $exp(a_jX_j)$ in (9) which expresses the odds that a consumer is loyal to brand j, is assumed to be a linear function of a vector of explanatory variables X_j. Replacing the term $exp(a_jX_j)$ in (9) with a parameter y that is not a function of the vector X yields the Dogit captivity model of Gaudry and Dagenais[11]. Gaudry and Dagenais developed the captivity model from the perspective of relaxing or dodging the independence of Irrelevant Alternatives (IIA) property of the multinomial logit model. Ben-Akiva[12], on the other hand, starting from the perspective of modelling choice-set generation, developed various models with simple choice-set generating processes. When combined with the multinomial-logit model, Ben-Akiva's captivity model yields the Dogit model.

The multinomial-logit model as a special case

If, for every alternative j and for every consumer, the term a_jX_j in (9) equals minus infinity, then the odds that a consumer is loyal to the alternative is zero. In this case, the PLC model reduces to the standard multinomial logit (MNL) model.

MODEL ELASTICITIES

The sensitivity of the unconditional choice probabilities P_j in (9) to changes in the values of explanatory variables in the vectors X_j and Y_j for all alternatives j, are given by the relevant direct- and cross-elasticity measures. A general case is that of an explanatory variable given by $Z_j = X_{kj} = Y_{lj}$, where X_{kj} is the kth component of vector X_j and Y_{lj} the lth component of vector Y_j. Then, the effect of a unit increase in Z_j on the probability that a consumer chooses alternative j and i, respectively, is

$$E^{P_j}{}_{Z_j} = exp(\alpha_j\chi_j)\ P_C(\frac{1-P_j}{P_j})(\alpha_kZ_j) + P_C(\frac{P_{j/C}}{P_j})\ E^{P_{j/C}}{}_{Z_j} \qquad (10)$$

$$E^{P_i}{}_{Z_j} = -exp(\alpha_j\chi_j)\ P_C\ (\alpha_kZ_j) + P_C\ (\frac{P_{i/C}}{P_i})\ E^{P_{i/C}}{}_{Z_j} \qquad (11)$$

and

where and are the direct- and cross-conditional elasticities, respectively, of Z_j that characterize the standard MNL model. When the variable Z_j is present only in the vector Y_j, then and are given by the second term in (10) and (11), respectively.

Alternatively, when the variable Z_j is present only in the vector X_j then and are given by the first term in (10) and (11), respectively.

The expressions for direct- and cross-elasticities in (10) and (11) give some interesting insights into the effect of incorporating explanatory variables of brand loyalty in the model. In general, it might be expected that incorporating loyalty variables in the model would necessarily reduce the sensitivity of choice probabilities to attribute changes[13]. This is true as long as the elasticities in (10) and (11) are computed with respect to an explanatory variable Z_j that explains only shopping (i.e., present only in the vector Y_j). In such a case, the first term in equations (10) and (11) are zero. Also, since PC and $(/Pj)$ $(j = 1, \ldots, J)$ in (10) and (11) are positive and less than one, their product is also positive and less than one. Therefore, the PLC elasticities and given by (10) and (11), respectively, are less than the corresponding MNL elasticities. We note that if the explanatory variable Z_j is present in both vectors X_j and Y_j. It is not possible to determine the effect of incorporating explanatory variables of brand loyalty in the model from the expressions in (10) and (11).

DATA

The data for this analysis are obtained from a 1989 New Car Buyer Competitive Dynamics Survey of J.D. Power and Associates. In February and March of 1989, survey questionnaires were sent to November and December, 1988, registrants of new automobiles, respectively. The questionnaires elicited information on numerous aspects of the new automobile-purchase decision, including automobile description, the search process, financing arrangements, sales source, and repair and maintenance. In addition, demographic information for the household and the purchaser were obtained. In our empirical analysis, we use an approximate 7% random sample from the J.D. Power data set after eliminating responses with missing data on key variables. The sample is drawn under the constraint that the sample proportion of each make and model equals the proportion in which the make and model is represented in the new automobile population. This guarantees consistent maximum-likelihood estimates. The original sample, stratified on make and model, was choice based which yields inconsistent estimates if the exogenous sample maximum-likelihood is used. However, in the special case where the sampling fraction equals the population shares, the exogenous sample maximum-likelihood is appropriate[14].

We use data on the automobile attributes of price, warranties, exterior and interior size, fuel economy, reliability, and safety to complement the J.D. Power survey data for each of the 191 makes and models available in 1989. The *Automotive New Market Data Book 1989*, *Consumer Reports*, J.D. Power and Associates, and the *1989 Car Book*

provided this information. For computational tractability, we assign alternative choice sets for each individual in the sample. Each choice set comprises the automobile purchased by the consumer and 14 randomly-selected automobiles from the 191 makes and models available in 1989. This procedure satisfies a uniform conditioning property that guarantees that the coefficient estimates are efficient[15].

ESTIMATION RESULTS

This section presents estimation results for the PLC model of automobile choice and brand loyalty that is subsequently compared with the MNL formulation of automobile-type choice (i.e., a comparison of the assumption that consumers are Loyals or Shoppers with the assumption that consumers are Shoppers only). Table 1 identifies and provides descriptive statistics for the shopping and loyalty explanatory variables used in the estimation of the PLC model. Table 2 gives the results of estimating the MNL and PLC models, including: (1) the estimated coefficients and their t-statistics, (2) the log likelihood of the sample, and (3) the goodness-of-fit statistics and rho-squared. Based on parameter estimates from the PLC model, Table 3 gives direct and cross elasticities for representative Asian, Domestic, and European makes of automobile with respect to automobile price/household income and operating cost of the automobile based on city mileage.

Table 1
EXPLANATORY VARIABLES FOR LOYALTY AND SHOPPING

Shopping Variables	Description	Mean (Std Dev)
Cost Related Attributes		
Price/Household Income	Purchase price of automobile divided by annual household income	0.330 (0.26)
Operating Cost	Fuel cost (cents) per mile, defined as the average gasoline price in the respondent's state divided by EPA's fuel mileage for city driving	4.080 (0.81)
Performance Attributes		
Net Horsepower	Automobile horsepower	119.300 (50.70)
Turning Radius	Turning radius of automobile (feet)	26.090 (19.00)
Size Attributes		
Length	Total exterior length of automobile (inches)	182.200 (13.80)
Height	Total exterior height of automobile (inches)	56.870 (6.58)
Width	Total exterior width of automobile (inches)	69.260 (3.93)
Style Attributes		
Convertible	Dummy variable which equals 1 for a convertible, 0 otherwise	0.005 (0.0049)
Station Wagon	Dummy variable which equals 1 for a station wagon, 0 otherwise	0.038 (0.037)
Safety Attributes		
Crash Test	Equals 1 if automobile identified as one of the most crashworthy in the 1989 model year, 0 otherwise	0.118 (0.11)
Passive Seat Belt	Equals 1 if passive seat belt is standard, 0 otherwise	0.305 (0.21)
Carrying Capacity		
Trunk Space	Trunk space (cubic feet) if sedan, 0 otherwise	14.470 (3.69)
Payload	Total payload if a pickup, 0 otherwise	1868.300 (489.0)

Table 2
PLC AND MNL ESTIMATION RESULTS*
B. Loyalty Variables

Explanatory Variable**	MNL Model	PLC Model
Dealer Visits (A)	- ∞	0.153 (0.20)
Dealer Visits (D)	- ∞	-1.018 (-1.70)
% Visits - Regional Submarket	- ∞	4.703 (7.26)
Regional Submarket - Substitute	- ∞	1.917 (5.54)
Size Related Submarket - Replaced	- ∞	1.010 (7.14)
Fleet Size (A)	- ∞	-1.079 (-0.66)
Fleet Size (D)	- ∞	0.718 (0.62)
Fleet - % Regional	- ∞	0.124 (0.29)
Constant (A)	- ∞	-2.057 (-1.51)
Constant (E)	- ∞	-4.111 (-6.06)
Constant (D)	- ∞	-3.107 (-1.95)

C. Summary Statistics

Log-likelihood at 0	-1197.0	-1197.0
Log-likelihood at convergence	-1061.9	-893.6
Rho-squared	0.113	0.253
Number of parameters	15	26

* ASYMPTOTIC T- STATISTICS ARE IN PARENTHESES.

** THE LETTERS A, E, AND D IN PARENTHESES INDICATES THAT THE VARIABLE IS SPECIFIC TO AN ASIAN, EUROPEAN, OR DOMESTIC AUTOMOBILE, RESPECTIVELY.

Table 3
ESTIMATED ELASTICITIES FOR SELECTED VARIABLES AND ALTERNATIVES

A. AUTOMOBILE PRICE/HOUSEHOLD INCOME

	Ford Taurus	Volkswagen Jetta	Honda Accord
Ford Taurus	-.0134	.0000	.0000
Volkswagen Jetta	.0012	-.0002	.0001
Honda Accord	.0002	.0000	.0040

B. OPERATING COST

	Ford Taurus	Volkswagen Jetta	Honda Accord
Ford Taurus	-.0862	.0000	.0000
Volkswagen Jetta	.0015	-.0003	.0001
Honda Accord	.0005	.0000	-.0106

Table 1 - Explanatory Variables for Shopping

The explanatory variables for shopping are grouped as follows: cost-related attributes, performance, size, style and safety attributes, carrying capacity, and other attributes. It is expected that cost attributes will decrease the probability of purchase, given that all other variables are constant. Increases in net horsepower, decreases in turning radius (which reflects better automobile handling), improved customer satisfaction, previous dealer experience, and the presence of safety attributes are expected to increase the probability of purchase. Although large automobiles are typically safer and more comfortable than are small automobiles, they have poorer handling characteristics so that the net effect on automobile-type choice is ambiguous. In preliminary analyses of the models, interior size characteristics reflected by front seat leg room and front seat head room were included but led to inferior fits. An increase in trunk space would increase the probability of purchase, if it does not imply that there is a corresponding decrease in interior space (i.e., given constant exterior dimensions). Therefore, the net effect of an increase in trunk space cannot be predicted. The effect of payload is also ambiguous because the pickups included in the sample are primarily consumption-related rather than work-oriented vehicles. Therefore, increasing the work payload of a pickup could adversely affect other characteristics valued by the consumer. Automobile style reflects preferences for

these automobiles, given that all other variables are held constant. In addition to *convertible* and *station wagon*, style variables for hatchbacks, vans, pickups, and sport utility vehicles were included in preliminary analyses. Since they were consistently insignificant, these variables were excluded from the final models reported.

Table 1 also provides sample means and standard deviations for the shopping variables included in the MNL and PLC models. Capital cost of a new vehicle represents 33% of annual household income and operating costs, based on city driving, average just over 4 cents per mile. Average size characteristics – length, width, and height – for vehicles included in the sample are similar to those of a mid-size vehicle such as a Pontiac Grand Prix or an Oldsmobile Cutlass. In addition, the sample comprises 0.5 percent and 3.8 percent convertibles and station wagons, respectively, in comparison with a 1989 national representation of 0.9 percent and 3.7 percent, respectively. Of the automobiles included in the sample, 11.8 percent have high ratings on the government's crash test and 30.5 percent include passive seat belts as standard equipment. The index for dealer maintenance and repair of vehicles varies from a low of 73 to a high of 149 and has a mean value of 117.79 for vehicles included in the sample. Finally, 49 percent of the sample had prior experience with the dealer from which the current vehicle was purchased.

Table 1 - Explanatory Variables for Loyalty

From the findings of other studies[16,17] brand loyalty in the automobile market is expected to depend on consumer-search activities and the make-up of a household's vehicle fleet. Whereas an increase in the total number of dealers visited by a consumer is expected to decrease brand loyalty, because it reflects a larger number of alternatives considered; an increase in the proportion of dealer visits by the consumer to the same submarket as a given alternative reflects more intensive search in that submarket and is expected to have a positive impact on brand loyalty. For similar reasons, the number of vehicles in a consumer's household fleet and the proportion of these that are in the same submarket as a given alternative are expected respectively to decrease and increase brand loyalty. Moreover, to the extent that there are common factors influencing a consumer's previous, current, and substitute choice (i.e., choice of vehicle if current make and model were not available), brand loyalty is also expected to increase if a respondent's replaced or substitute vehicle is in the same submarket as that of a given alternative. To determine whether there exist any nationalistic brand-loyalty effects, some of these variables were interacted with dummy variables reflecting the major manufacturing regions of the world — Asian, European, and Domestic. Last, socioeconomic characteristics were included in the loyalty equation but, in preliminary runs of the model, were either insignificant or failed to converge and were, therefore, excluded from the final specification.

The descriptive statistics for the loyalty variables suggest that consumers expand their choice sets by searching intensively in submarkets, rather than by searching across submarkets. For empirical purposes, two submarkets are defined: the regional submarket, which classifies vehicles according to the location of the primary manufacturing site — Asian, European, and Domestic; and the size-related submarket, a classification scheme used by J.D. Power that classifies vehicles primarily by size and price characteristics.

Although 44 percent of the consumers visited three or more dealerships, 83 percent of the dealers visited, on average, were in the same regional submarket as the vehicle purchased. Supplementing this evidence, 59 percent of a household's vehicle fleet is in the same regional submarket as the vehicle actually purchased. It is also seen that 29 percent of the respondents purchased a vehicle in the same size-related submarket as the vehicle replaced, whereas 81 percent of the consumers identified a substitute choice in the same regional submarket as the vehicle purchased. It is not surprising that the proportion of consumers buying in the same size-related submarket on both the previous- and current-purchase occasions is relatively low because the replaced vehicle satisfied consumer needs in a previous period that are less likely to reflect current needs.

Table 2A - Estimated Coefficients for Explanatory Variables in the MNL Model

Table 2 reports the estimation results for the MNL model. Assuming that all individuals are Shoppers, the MNL model appears to fit the data well and, with few exceptions, yields coefficients with signs that are consistent with expectations. Similar to the studies of Manski and Sherman[18] and Mannering and Winston[19], each of the variables associated with cost, performance, and size has its expected sign and is significantly different from zero. Each safety characteristic carried its expected sign and was significantly different from 0, where it is noted that interacting the *crash test* variable with a dummy variable representing younger respondents (35 years old or less) led to a superior fit. In contrast, the carrying-capacity variables—*trunk space* for automobiles and *payload* for pick-up trucks—have no effect on vehicle type choice which may be due to the inclusion of the exterior vehicle dimensions of *length, width,* and *height* in the model. Although inclusion of *convertible* improved the overall fit of the model, the only style for which there was a significant preference was for *station wagons.* Improvements in dealer performance of vehicle repairs and/or maintenance led to an expected increase in the probability of purchase. An unexpected result of the estimation of the MNL model is the negative sign on *dealer experience* for Asian vehicles, which indicates that, for purchasers of Asian automobiles, previous dealer experience reduces the probability of automobile purchase.

Tables 2A and 2C - Comparison of the MNL and PLC Models

Allowing consumers to be either Shoppers or Loyals provides some interesting contrasts with the MNL results. First, there is a noticeable improvement in the rho-squared statistics. Notwithstanding that the MNL model provides a reasonable fit to the data, the rho-squared statistic of 0.113 is not particularly high. In sharp contrast, the PLC model yields a much improved rho-squared of 0.253. Second, since the MNL model is nested in the PLC model (i.e., since the MNL is a special case of the PLC) a likelihood-ratio statistic given by *-2[log likelihood at convergence of the PLC model - log likelihood at convergence of the MNL model]* can be used to test the null hypothesis that loyalty is not an important factor in determining the share of automobile makes and models in the market. The likelihood-ratio statistic is computed from Table 2C as *-2 (-893.6 - 1061.9) = 336.6* which is approximately chi-square distributed with 11 degrees of freedom. At any reasonable level of significance, the null hypothesis that loyalty is not an important factor in determining market share is rejected, signifying that loyalty does influence the choice of a consumer in the automobile market. Also, from Table 2A there are substantial differences between the magnitudes of coefficient estimates of the MNL model and the corresponding estimated coefficients of the shopping variables of the PLC model, although we did not test if the differences are significant. In a MNL model, the variance of the error term is inversely related to an unidentifiable scale parameter. In the PLC model, if there is a general increase in the coefficient estimates, this implies an increase in the scale parameter and a corresponding decrease in the variance of the error term[20]. In the model presented in Table 2, twice as many parameters increase in value as decrease or remain the same.

Table 2A - Estimated Coefficients of the Shopping Variables in the PLC Model

Table 2A shows that the estimates of the coefficients of the shopping variables in the PLC model have signs consistent with the coefficients of the MNL model, except for two insignificant variables, *trunk space* and *convertible*, and two other variables, *station wagon* and *dealer experience — (A)*, that were negative and significant in the MNL model and are positive and insignificant in the PLC model. The cost-related coefficients are larger in magnitude in the PLC model but *operating cost* is no longer significant at the 0.05 level. The *length* of the automobile is more significant in the PLC than in the MNL model as shown by the coefficient of the *length* variable, while there is a negative change in the significance of the coefficients for the *height* and *width* variables. There is little change in the effect of carrying capacity on the probability of purchase. *Passive seat belt* is no longer significant in determining choice in the PLC model and the *crash test-young* variable has a smaller effect on purchase probability in the PLC model. *Dealer repair/maintenance services* are equally important determinants of purchase behaviour in the PLC and MNL models. *Dealer experience* for

purchasers of Asian vehicles, which was unexpectedly negative and significant in the MNL model, is now positive and insignificant.

Table 2B - Estimated Coefficients of the Loyalty Variables in the PLC Model

In Table 2B, the estimated coefficients (and the corresponding t-statistics) of the loyalty variables of the PLC model give some evidence that vehicle consumers tailor their search activities to specific submarkets. Weakly consistent with expectations, a larger number of dealer visits has no effect on brand loyalty for the Asian submarket and decreases brand loyalty in the domestic submarket. A stronger result is that the *percent visits - regional submarket* variable has a positive sign and is highly significant, indicating that the more a consumer limits his or her search to a particular submarket, the more likely will that consumer be brand loyal. This is further supported by the coefficient signs and significance of the *size-related submarket — replaced* and *regional submarket — substitute* variables. Replaced and substitute vehicle submarkets that are identical with that of the purchased vehicle increase the probability of brand loyalty. Somewhat surprisingly, the make-up of a household's current fleet has no effect on brand loyalty.

Tables 3A and 3B - Predicted Consumer Reactions and Model Elasticities

We analyze the predictions generated by the MNL and PLC models for changes in automobile price/household income, and operating cost of automobiles based on city mileage. The changes are applied to all individuals in the sample, and the direct and cross elasticities are estimated by sample enumeration. Table 3(a) shows the direct and cross elasticities with respect to *price/household income*, resulting from a uniform 1 percent increase in the variable. The direct elasticities, which are the diagonal entries of 3(A) and 3(B), have negative signs, while the cross elasticities have positive signs. This is consistent with expectations, because cost-related attributes of automobiles have a negative effect on the probability of automobile purchase. We see, from the direct elasticities in Table 3A, that the PLC model predicts that consumer response to changes in the price/income variable for a representative Japanese automobile (Honda Accord) and European automobile (Volkswagen Jetta) is appreciably lower than a corresponding change in the variable for a representative Domestic automobile (Ford Taurus). The effect of a change in the price of one automobile on the probability of choice of another automobile is quite small, as is shown by the cross elasticities in Table 3A. A similar statement can be made about the cross elasticities for the operating cost variable given in Table 3B. Finally, the probability of automobile choice is less sensitive to changes in the price/income ratio than to changes in operating-cost although this conclusion is tentative because, from the estimation results reported in Table 2A, the null hypothesis that operating cost has no effect on vehicle-type choice could only be rejected at the 0.1 level.

Note from Table 3 that the reported elasticities are, in absolute value, quite small in relationship to elasticity measures reported in previous research on vehicle-type choice. This result highlights both the advantage and disadvantage associated with endogenizing brand loyalty. If all consumers are assumed to be Shoppers, when in fact some are brand loyal, then the coefficient estimates from a MNL model will typically overestimate the sensitivity of consumers to changes in vehicle attributes. The assumption that all consumers are Shoppers leads to an upward bias in the elasticity measures. However, the direct and cross elasticities of a vehicle attribute, which enters only the shopping part of the PLC model and is equal to the second term in equations (10) and (11), respectively, are a function of the shopping-choice probability, PC, and the ratio of the choice of vehicle type j conditional on the consumer being a shopper, and the unconditional choice probability P_j. Since $(/P_j)$ is close to unity, the value of the elasticity in the PLC model critically depends upon PC which is inversely related to the number of alternatives to which a consumer can be loyal. Thus, although the probability that a consumer is loyal to any given alternative is quite small, the large number of automobiles available to the consumer implies that the probability of his or her being brand loyal (to some alternative) is very large and, accordingly, the probability that a consumer is a Shopper is reduced. In preliminary runs of the model, which produced few significant determinants of brand loyalty, the probability of being a Shopper was considerably higher and the elasticity measures for the shopping variables were more in line with those obtained from a simple MNL framework.

SOME COMMENTS

We study loyalty and competition in the U.S. automobile market by modelling the loyalty and shopping behaviour of consumers, explicitly modelled as separate functions of several explanatory variables. Our empirical application of the parameterised logit-captivity model, to a sample of consumers from the 1989 J.D. Power data set of buyers of new automobiles in the U.S. automobile market, gives evidence that loyalty of consumers to automobile makes and models is an important factor in determining market shares of automobile brands. Dealer visits and the scope of a consumer's search activities are found to decrease and increase, respectively, loyalty to different automobile brands. The size-related submarket for a replaced vehicle and the regional submarket for a substitute vehicle (if the currently purchased vehicle were not available) were also found to be important determinants of loyalty. The automobile-price-to-household-income ratio, net horsepower, vehicle-size attributes, and dealer maintenance and service are found to be significant explanatory variables of shopping behaviour. Finally, this study shows that modelling loyalty and shopping in a market characterized by fierce competition, such as the U.S. automobile market, using several explanatory variables to explain consumer choice, gives a

significant improvement over other standard modelling methods (e.g., MNL), which do not allow for the effect of loyalty on brand choice.

This analysis focused on two extreme versions of brand loyalty: the MNL model in which no consumers are brand loyal, and the PLC model in which consumers are either shoppers or are loyal to a particular make/model. As noted, the PLC model was found to be superior to the all-Shopper MNL model. However, evidence from this analysis also suggests that, as the number of available alternatives increases, the PLC framework, combined with a well-specified model of brand loyalty, may produce a downward bias on the sensitivity of consumers to changes in those attributes that determine vehicle-type choice. In addition, previous research on brand loyalty in the automobile market modelled brand loyalty by including, as an explanatory variable, previous purchase(s) of the same make and model as the current purchase. Other than to recognize that both approaches found brand loyalty to be a significant determinant of market share, a direct comparison between the results of the PLC model and these earlier studies was beyond the scope of the present analysis. A fruitful area for further research, then, is to use the PLC model as a basis for comparison with alternative approaches to modelling brand loyalty in order to evaluate, theoretically and empirically, the relative benefits of each approach. There is also a need to develop brand-loyalty models in the automobile market that move away from the extreme choice-generating processes considered in this study and towards more realistic processes that allow consumers to be brand loyal to alternative automobile sub-markets.

ACKNOWLEDGMENTS

We are grateful to J.D. Power and Associates for the use of the 1989 automobile data set. In particular, we appreciate the support of Dr. John Hammond and Mr. Mark Rees of J.D. Power and Associates. We would also like to thank Eric Pas and three anonymous reviewers for their encouragement and helpful comments.

REFERENCES

1. Manski, C. F. and L. Sherman, "An Empirical Analysis of Household Choice Among Motor Vehicles," *Transportation Research A*, 1979, 349-366.

2. Hocherman, I., J. N. Prashker, and M. Ben-Akiva, "Estimation and Use of Dynamic Transaction Models of Vehicle Ownership," *Transportation Research Record, 944*, 1983, 134-141.

3. Mannering, F. and C. Winston, "A Dynamic Empirical Analysis of Household Automobile Ownership and Utilization," *Rand Journal of Economics*, 1985, 215-236.

4. Mannering, F. and C. Winston, "Brand Loyalty and the Decline of American Automobile Firms," *Brookings Papers on Economic Activity: Microeconomics*, 1991, 67-114.

5. Swait, J. and M. Ben-Akiva, "Empirical Test of a Constrained Choice Model: Mode Choice In Sao Paolo, Brazil," *Transportation Research B*, 23B, 1987, 2, 103-115.

6. Manski, C. F., "The Structure of Random Utility Models," *Theory and Decisions*, 8, 1977, 229-254.

7. Swait, J. and M. Ben-Akiva, "Constraints on Individual Travel Behavior in a Brazilian City," *Transportation Research Record, 1085*, 1985, 75-85.

8. McCarthy, P. S., P. K. Kannan, R. Chandrasekharan, and G. P. Wright, "Estimating Loyalty and Switching with an Application to the Automobile Market," forthcoming, *Management Science*, 1992.

9. Colombo, R. and D. G. Morrison, "A Brand Switching Model with Implications for Marketing Strategies," *Marketing Science*, 1989, 8, 1, 89-99.

10. Bordley, R. F., "Relaxing the Loyalty Condition in the Colombo/Morrison Model," *Marketing Science*, 1989, 8, 1, 100-105.

11. Gaudry, M. J. I. and M. G. Dagenais, "The Dogit Model," *Transportation Research B*, 1979, 13B, 105-112.

12. Ben-Akiva, M. "Choice Models with Simple Choice Set Generating Processes," Working Paper, Department of Civil Engineering, MIT, Cambridge, MA, 1977

13. Stopher, P. R, "Captivity and Choice in Travel Behavior Models," *Transportation Engineering Journal*, 1984, TE4, 427-35.

14. Ben-Akiva, M. and S. R. Lerman, *Discrete Choice Analysis: Theory and Application to Transportation Demand*, Cambridge: MIT Press, 1985.

15. McFadden, D. "Modeling the Choice of Residential Location," in Karlquist, A., Et. Al., eds., *Spatial Interaction Theory and Residential Location*, North Holland, Amsterdam, 1978.

16. Mannering and Winston, 1991, *op. cit.*

17. McCarthy, et. al., *op. cit.*

18. Manski and Sherman, *op. cit.*

19. Mannering, F. and C. Winston, "U. S. Automobile Market Demand," in Clifford Winston and Associates, *Blind Intersection?: Policy and the Automobile Industry,*

The Brookings Institution, Washington D.C., 1987.

20. Ben-Akiva and Lerman, *op. cit.*, p.105.

22

REGIONALISATION OF CAR-FLEET AND TRAFFIC FORECASTS

Jean-Loup Madre and Alain Pirotte

SUMMARY

Information at the national level is insufficient for long-term traffic forecasting. To integrate new infrastructure at the national level, regional implications must also be considered. This should be done in two stages: a demographic approach to determine how the car fleet will develop and an econometric method to reveal the factors that influence the sale of fuel and characterise car traffic.

Over the next twenty years, the growth of the French household car fleet will differ significantly between regions. The number of potential drivers should increase much faster in the Mediterranean area than in the North or East. Growth will be slower in the Paris area where households became car owners earlier than those in the provinces.

Regions also differ in the way they react to variations in fuel price. Isolated areas in the Massif Central are less sensitive to price than the surrounding transit areas. The significant data enhancement obtained by taking regional aspects into consideration has also made it possible to show that income has little influence on traffic, and that the impact of the price of fuel has been extremely irregular since 1973.

INTRODUCTION

Long-term (in this case the year 2010) forecasts of car-fleet size and traffic have been carried out in a number of countries: Sweden[1], Holland[2], the United Kingdom[3], and France[4,5]. Because forecasts must be differentiated spatially, the planning of infrastructure involves not only determining an overall budget for network development, but also outlining how these networks are extended throughout the country.

It is not easy to define a relevant spatial unit for these projections. The availability of reliable statistics, i.e., based on administrative calculations rather than surveys[6], tends to favour a breakdown in terms of administrative areas (regions, departments, etc.).

However, it is within the areas where employment is concentrated – the regions – that the most significant contrasts with regard to motorisation and car use can be seen[7]. It is also in the regions that many planning and financial implications are to be found (shared national-regional funding). Moreover, these entities are reasonably homogeneous and the demography, geography (extent of urbanisation, etc.), and recent economic history (the effects of the economic downturn, etc.) vary sufficiently from one area to another to make it possible to assess the specifics of the way they evolve in relation to the national average.

As in our previous work, the first area to be studied, using a demographic method, is the car fleet. Fuel consumption is then examined using econometric techniques. Over a vast area, such as metropolitan France, most of the traffic consists of vehicles belonging to those who reside there. The greater the detail used to study the area in question, the less will be the influence of local traffic (i.e., those who live in the area) in relation to inter-zone transit and local journeys made by temporary residents (i.e., tourists). This problem becomes even more apparent when dealing with large-scale infrastructures (motorways, main roads, etc.), because a large proportion of this traffic is interregional. When examining the fuel factor, which applies to total traffic, the predominant factor is local consumption. This chapter deals with this indirect aspect only for traffic as a whole.

A DEMOGRAPHIC METHOD USED FOR CAR FLEET PROJECTIONS

In France, most private cars are owned by households and, if company vehicles made available to these households are included, surveys on households cover more than 98 percent of the fleet. To analyse its long-term development, we use the demographic method developed at the national level. The principle of this method is described in the next section.

Main Stages in Car Distribution

As growth in the car industry started only in the 1950s in Europe, the availability of private cars to subsequent generations was extremely irregular. The demographic method is based on the study of motorisation for each generation (defined as all households where the head of the household was born in the same decade) during twenty or so years of their life cycle. Because the car has become an increasingly personal possession with the development of the second family car, motorisation was measured using the average number of cars per adult, i.e., per person of driving age (currently 18 or over in France). The three main stages of motorisation development are as follows:

- until the mid-1960s, all generations increased the number of cars they owned, this is the LARGE-SCALE DIFFUSION phase;

- between the mid-1960s and the mid-1980s (Figure 1), the paths for the different generations ran practically parallel, and did not seem to have been affected by oil crises: car diffusion reached CRUISING SPEED;

- finally, if the behaviour of the two youngest generations is considered, the deviation between their two paths (due essentially to a second car) is less than the deviation separating the two paths of their elders: a SATURATION stage is reached. Young people are motorised at an increasingly early age, but the way they purchase vehicles is more and more irregular, typified by the purchase and resale of fairly old second-hand vehicles separated by periods without a vehicle.

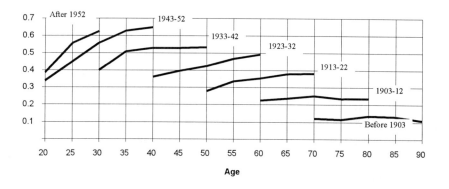

Figure 1

Progression of the Average Number of Cars Per Adult During the Life Cycle for Different Generations

Source: INRETS based on the National Institute for Economic and Statistical Studies (INSEE) Household Conjecture Surveys

Because these curves run relatively parallel, it seemed reasonable to extrapolate. The tendency to saturation was extended by noting an ever-decreasing deviation between new generations. The main objection to this parallel path extrapolation stems from the demotorisation of the elderly. Until now, the average number of cars per adult has not decreased before the age of 80, particularly in better-off families, which are those of

their generation who own the best vehicles. On the other hand, from 55 upwards, people drive less, especially as they no longer have to travel for their work (Figure 2). However, households whose head is now becoming elderly are still under-motorised. The fall in the level of motorisation could be greater, and be seen at an earlier stage, when the generations who have been able to own a second car reach retirement age. Assuming the paths remain parallel and saturation is progressive, the household car fleet should increase by approximately 45 percent over the next twenty years. In the year 2010, 16.5 percent of households will not own a car and 39 percent will own at least two.

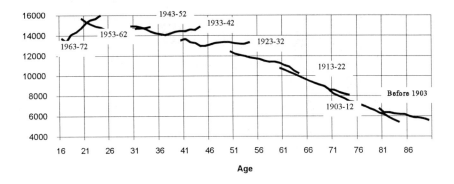

Figure 2

Progression of the Average Number of KM/Car

During the Life Cycle for Different Generations

Source: INRETS based on the INSEE Household Conjecture Surveys

A Significant Disparity in Regional Changes

The sample used for household surveys, the only statistical source likely to differentiate between the behaviour of subsequent generations, is not large enough to be able to draw the curves of Figures 1 and 2 for each region. The only relatively certain indication for these curves is a greater demotorisation of elderly households in the east of France (from Lorraine to Provence). The average for each generation can only be calculated in the largest regions from 1977 to 1988, for which INSEE Household Conjecture survey files are available. It is, therefore, possible to position the difference in curves for each region in relation to the national average.

As in many other countries, households in the capital city became car owners before those in the provinces. Until the mid-1960s, the proportion of households without cars was less in the Paris area than in the rest of France. Now, because of parking and congestion problems caused by a high population density, people living in Paris are less motorized than those living in the provinces. This can be seen from Figure 3, showing the regional differences for households belonging to the same generation. There is less disparity for older people than for younger people. The Greater Paris area is the only region where young people have fewer cars than the regional average.

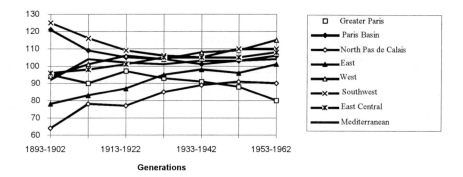

Figure 3
Motorisation According to Generation and Region
(Unit: Car/Adult Compared to the National Average)
Source: French Research Center for the Study and Observation of Living Conditions (CREDOC) based on the INSEE Household Conjecture Surveys

Figure 3 shows two types of differences :

- between densely populated and not very motorised regions (Greater Paris, North Pas de Calais, etc.) and predominantly rural and highly motorized zones (West, Southwest, etc.), and

- between regions that were previously motorised (Paris Basin, Southwest etc.) and those where car ownership is a more recent phenomenon (West, East, East Central, etc.).

This regional background to car history, modified by the rate at which the population ages, explains the progression in expected car ownership over the next twenty years shown in Table 1; Greater Paris (+16 percent), in contrast to the provinces (from +25 percent to +28 percent), where the most significant progression will be in the West. The main factor that differentiates the regions is demographic growth. The number of people of driving age should increase by 26 percent in the Mediterranean zone, as opposed to only 4 percent in the North and in the East and 7 percent in Greater Paris. The combination of demographic factors and increased ownership results in an extremely wide-ranging fleet growth: from 24 percent in Greater Paris to 46 percent in the West, and even as high as 59 percent around the Mediterranean.

Table 1.

Demographic Model: Progression 2010/1990 for Large Regions

	Adults (percent)	Car/Adult (percent)	Fleet (percent)	KM/Car (percent)	Traffic (percent)
Greater Paris	+7	+16	+24	-4.7	+18
Paris Basin	+11	+25	+39	-3.2	+35
North	+4	+25	+29	-2.9	+26
East	+4	+26	+31	-3.3	+27
West	+14	+28	+46	-2.0	+43
Southwest	+9	+27	+39	-2.7	+35
East Central	+13	+26	+41	-2.5	+38
Mediterranean	+26	+27	+59	-3.4	+54
France as a whole	+11	+24	+38	-3.3	+34

Given the extent of these phenomena, the reduction in car use resulting from the aging of the population plays a minor role. This brings the increase in the number of journeys made by those living in Greater Paris to 18 percent, which is considerable given the problems of traffic congestion, and to 54 percent for those living around the Mediterranean. It should be emphasized that this applies to traffic generated by those living in the region and not traffic using the regional infrastructure. In addition, this model takes into consideration only demographic factors; other methods will have to be used to reveal the influence of price and income.

ECONOMETRIC ANALYSIS OF FUEL SALES

In the absence of direct global traffic data (very little is known about traffic on local networks), fuel sales were used to differentiate regional behaviour with regard to car use. The econometric analysis of traffic on motorways and main roads[8,9] covering France as a whole was limited, because it was based on too short (since 1972) and too irregular a series (oil crises and post-crises, economic crises, then subsequent recovery). Because the data are considerably enhanced due to regionalisation (multiplied by a factor of 21), it is possible not only to investigate this spatial dimension, but also to use time-series analysis in order to identify breakdowns and to single out transitory fluctuations in long-term trends. The data have also been improved: fuel-price trends now take into account the effect of an increasing proportion of diesel vehicles in the fleet, and the types of vehicles for which consumption can be measured and the fleet (private cars and light commercial vehicles) have remained practically the same.

The first phase is to define the tested specification, involving the choice of data and the availability of the series. The results obtained by using the ordinary least-squares method were analysed and various stability tests were implemented using the Kalman filter algorithm.

A Standard Consumption Model Adjusted to More Appropriate Data

The specification selected was that of a classical consumption model, where the sale of a good at date t is a function of disposable household income, the price of this commodity, and possible state variables, in this case, the car fleet. This static model is in contrast to a dynamic specification into which a certain number of lags are introduced[10].

The complete equation formulation is:

$$logCARB_{it} = a_{i1} + a_{i2}logVIG_{it} + a_{i3}logRREV_{it} + a_{i4}logPMOY_{it} + U_{it}$$
$$\text{with } u_{it} \sim i.i.d.(0,\sigma_U^2) \tag{1}$$

It is adjusted for the period from 1973 to 1988. Because the influence of income did not prove to be significant, and because this variable was not available for 1989, a reduced form was adjusted for the period from 1973 to 1989 :

$$logCARB_{it} = b_{i1} + b_{i2}logVIG_{it} + b_{i3}logPMOY_{it} + \epsilon_{it} \ with \ \epsilon_{it} \sim i.i.d.(0,\sigma_\epsilon^2) \qquad (2)$$

where:

CARB = fuel sales (source: Comité Professionnel du Pétrole)

VIG = the car fleet; this represents the number of road-tax stickers sold during the renewal period (November-December) for vehicles under 16 tonnes

RREV = disposable real income per head

PMOY = weighted mean of fuel price calculated according to the relative importance of the two main fuel types (petrol and diesel); the estimation is based on the car fleet subject to road tax. This factor seemed more appropriate than the standard fuel-price index which does not take the proportion of diesel vehicles in the fleet into account and, therefore, the substitution of diesel fuel (less expensive for tax purposes) for other fuels. This variable is not regionalised: in fact, the price of petrol was state controlled until 1985, since when only a national index has been available.

Unlike the first section that dealt with private household cars, this section analyses light commercial vehicles, but excludes heavy goods vehicles. In an effort to remain in line with fleet statistics, use was made of the national distribution keys provided by the Comité Professionnel du Pétrole. This information is very well-suited when dealing with ordinary and 4-star petrol, generally used by light vehicles, but, for diesel fuel, it assumes that the growth rate for light vehicles is the same in all areas. As the above are log-log type equations, the coefficients can be interpreted as elasticities.

These equations are first estimated region by region; then the same model is estimated, after having stacked the regional observations (this procedure is represented by the letter *e* as an index in the equations below). It should be noted that, when operating in this way, it is assumed *a priori* that fuel sales are homogeneous in all regions and, therefore, an unique specification can be used. Should this hypothesis prove correct, the coefficient values obtained should be equal to those that are determined when considering France as a whole. The second model is written as follows :

$$logCARB_e = c_1 + c_2logVIG_e + c_3logRREV_e + c_4logPMOY_e + U_e$$
$$\text{with } U_e \sim i.i.d.(0,\sigma^2_{u_e}) \tag{3}$$

$$logCARB_e = d_1 + d_2logVIG_e + d_3logPMOY_e + \epsilon_e \text{ with } \epsilon_e \sim i.i.d.(0,\sigma^2_{\epsilon_e}) \tag{4}$$

It would have been useful to test the influence of other variables such as the fleet-renewal rate or the average age of the fleet (new cars consume less petrol), road infrastructure characterisation, a population concentration index, etc. However, the problem remains that the statistical sources are either non-existent or do not provide an accurate estimate of annual trends at a regional level.

Diversity of Regional Behaviour: the Importance of the Isolation Factor

By using the ordinary least-squares method, first-order autocorrelation was detected for some regions; it was corrected using the maximum-likelihood method (the most efficient at a finite distance). For certain regions, an indicative, although insufficient, improvement was then noted in the Durbin-Watson statistic (the most usual test for first-order autoregressive errors). The main justification for differences in the quality of these results is that, in some departments in the regions, sharp variations in fuel-sales series were noted that could be explained in part by changes in the distribution structure (the start-up of sales at supermarkets, the closing down of small petrol stations). This is the case for the Loire area, Poitou-Charente, Midi-Pyrénées, and Languedoc Roussillon. Other regions for which the adjustments are poor are in frontier zones (Alsace, Provence): the price of petrol, lower in Germany and higher in Italy, can have an effect on local markets. For some regions where the specification does not seem satisfactory (Auvergne, Midi-Pyrénées, Poitou-Charente), the influence of the growth in toll motorways was examined. This test proved negative; it is therefore reasonable to suppose that, contrary to fears expressed in the introduction to this paper, the models are not greatly affected by traffic from outside the region.

In the model given by equation (1), shown in Table 2 and Figure 4, the influence of income was significant for only three regions (Basse-Normandie, Burgundy and, Franche-Comté) with an elasticity of between 0.5 and 0.6; the fleet elasticity is, therefore, relatively low (0.4 to 0.6). Because the infuence of income is rarely significant, the model given by equation (2)and shown in Table 3 and Figure 5 is examined. Fleet elasticity is between 0.7 and 1.1 practically everywhere.

Price-elasticity is approximately -0.2, but differs quite considerably from one region to another.

Using these results, regions with similar behaviour are matched. Thus, Provence, Côte d'Azur, Corsica, Haute Normandie, and Champagne-Ardennes seem to show behaviour similar to the national average; this also applies to Greater Paris, which is more surprising when congestion and parking problems in the Paris area are considered. Among the regions where price-elasticity is close to zero, there are, on the one hand, zones severely affected by economic crises and by industrial reconversion (North Pas de Calais, Lorraine), and on the other hand the Massif Central (Limousin, Auvergne). In contrast, regions where price has a considerable effect (an elasticity of -0.3 to -0.4) are transit zones; Burgundy and Rhône-Alpes on the way to the Southeast, the Centre and Poitou-Charente on the way to the West and Southwest, and Languedoc Roussillon on the way to Spain. It has already been noted in previous studies[11] that the effect of traffic on the price of fuel is greater on link motorways than on the remainder of the national network. If a comparison is made between the Massif Central and the regions surrounding it, it would seem that the more isolated the area, the less the effect of price trends.

For stacked regressions for equations (3) and (4) shown in Tables 2 and 3, the coefficient values are intuitively reasonable in relation to respective evaluations for France as a whole. Fleet elasticity (now greater than 1) and price elasticity become more significant, while at the same time the influence of income totally disappears. This would seem to prove that there is indeed a heterogeneity between regions, always assuming that the specification is valid.

Table 2.
Results of Model (1) and (3)

Regions	INT	log VIG	log RREV	log PMOY	DW	R^2
1	1.515	0.928	-0.004	-0.134	1.903	0.989
Greater Paris	-3.579	-20.231	(-0.032)	(-4.292)		
2	2.521	0.841	0.006	-0.139	1.825	0.983
Champagne-Ard.	-4.809	-12.832	(0.052)	(-3.416)		
3	3.904	0.714	0.134	-0.175	1.895	0.986
Picardy	-11.810	-17.771	-1.122	(-4.363)		
4*	2.437	0.832	0.139	-0.231	2.152	0.996
Hte-Normandie	-13.216	-29.560	-1.963	(-12.070)		
5*	1.075	0.960	0.093	-0.339	1.757	0.995
Centre	-2.596	-17.118	(0.785)	(-10.900)		
6	5.283	0.499	0.514	-0.119	2.168	0.987
Basse-Normandie	-10.398	-7.134	-3.890	(-3.346)		
7	6.735	0.393	0.604	-0.207	1.843	0.963
Burgundy	-7.021	-3.027	-2.547	(-3.744)		
8	5.344	0.568	0.260	-0.030	2.094	0.974
Nord-P.D.Calais	-9.339	-7.298	-1.464	(-0.645)		
9	7.836	0.403	0.137	-0.034	2.174	0.891
Lorraine	-9.123	-3.120	(0.473)	(-0.510)		
10*	2.301	0.980	-1.634	-0.149	1.655	0.975
Alsace	-1.722	-4.396		(-2.087)		
11	3.179	0.654	0.512	-0.202	1.890	0.988
Franche-Comtè	-7.825	-11.242	-3.586	(-5.073)		
12	2.862	0.746	0.320	-0.139	1.794	0.983
Pays de Loire	-2.510	-4.813	-1.041	(-2.450)		
13	3.016	0.753	0.223	-0.093	1.891	0.992
Brittany	-4.546	-8.120	-1.190	(-2.549)		
14*	-0.121	0.969	0.379	-0.320	1.332	0.984
Poitou-Charente	(-1.097)	-5.379	-1.019	(-4.172)		
15	0.9	0.971	0.030	-0.176	1.896	0.991
Aquitaine	-1.443	-12.040	(0.192)	(-4.151)		
16*	5.100	0.567	0.334	-0.134	1.718	0.958
Midi-Pyrènèes	-3.866	-3.632	-1.229	(-1.635)		
17*	3.978	0.684	0.109	-0.138	1.788	0.974
Limousin	-5.100	-7.206	(0.757)	(-2.428)		
18*	-0.820	1.127	-0.061	-0.307	2.198	0.997
Rhône-Alpes	(-3.119)	-30.568	(-0.662)	(-12.770)		
19*	5.843	0.461	0.375	0.048	1.492	0.938
Auvergne	-4.843	-2.891	-1.277	(0.667)		
20*	-0.689	1.122	-0.040	-0.263	1.652	0.992
Languedoc-Rous.	(-1.315)	-15.250	(-0.248)	(-4.795)		
21*	2.912	0.831	0.057	-0.219	1.632	0.995
Provence+Corsica	-6.999	-17.660	(0.587)	(-5.927)		
22	2.758	0.840	0.131	-0.183	1.861	0.995
France as a whole	-6.307	-18.685	-1.260	(-6.985)		
Stacked	1.443	0.964	-0.077	-0.270	1.708	0.999
regressions*	-4.633	-35.428	(-1.597)	(-16.408)		

* First-order autocorrelation corrected

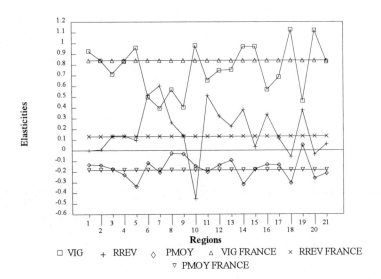

Figure 4
Regional Coefficient Values: Model with Income Variable

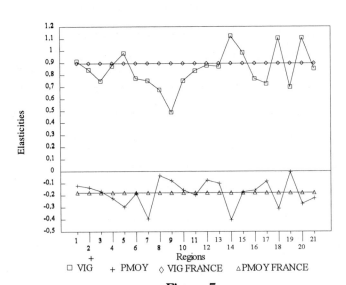

Figure 5
Regional Coefficient Values: Model Without Income

Table 3.
Results of Models (2) and (4)

Regions	Cste	log VIG	log PMOY	DW	R^2
1 Greater Paris	1.712 (4.542)	0.912 (36.491)	-0.121 (-4.395)	1.763	0.989
2 Champagne-Ard.	2.515 (7.044)	0.843 (30.785)	-0.317 (-4.056)	1.830	0.985
3 Picardy	3.892 (12.896)	0.749 (33.051)	-0.169 (-4.783)	1.815	0.987
4 Hte-Normandie	2.356 (12.238)	0.875 (59.978)	0.226 (-11.181)	1.844	0.996
5 Centre	1.074 (3.769)	0.979 (47.087)	-0.297 (-9.386)	1.883	0.993
6* Basse-Normandie	3.606 (5.293)	0.771 (14.786)	-0.185 (-3.389)	1.646	0.984
7* Burgundy	4.387 (3.424)	0.751 (7.768)	-0.396 (-6.091)	1.343	0.973
8 Nord-P.D.Calais	4.752 (11.446)	0.677 (22.512)	-0.035 (-0.834)	1.552	0.973
9 Lorraine	7.222 (12.097)	0.490 (11.020)	-0.078 (-1.279)	1.757	0.896
10* Alsace	3.710 (6.154)	0.751 (16.432)	-0.158 (-2.337)	1.606	0.976
11* Franche Comte	2.652 (4.200)	0.834 (16.897)	-0.199 (-3.477)	1.808	0.980
12** Pays de Loire	2.034 (7.170)	0.879 (42.472)	-0.075 (-2.073)	2.566	0.999
13 Brittany	2.210 (8.041)	0.869 (43.625)	-0.102 (-3.020)	1.837	0.992
14* Poitou-Charente	-2.298 (-1.704)	1.124 (12.276)	-0.403 (-3.927)	0.833	0.978
15 Aquitaine	0.811 (2.671)	0.984 (45.190)	-0.173 (-4.862)	1.978	0.993
16* Midi-Pyrenees	3.547 (4.444)	0.768 (13.250)	-0.160 (-1.952)	1.672	0.960
17 Limousin	3.730 (8.698)	0.727 (21.313)	-0.085 (-1.789)	1.690	0.970
18 Rhone-Alpes	-0.698 (-3.261)	1.104 (74.837)	-0.311 (-13.227)	2.428	0.997
19* Auvergne	4.112 (5.846)	0.699 (13.039)	-0.006 (-0.081)	1.159	0.925
20 Languedoc-Rous.	-0.630 (-1.922)	1.108 (46.145)	-0.272 (-6.040)	1.730	0.993
21* Provence+Corsica	2.827 (8.226)	0.852 (35.286)	-0.225 (-6.616)	1.675	0.996
22 France as a whole	2.313 (8.717)	0.895 (56.259)	-0.180 (-7.690)	1.707	0.995
Stacked regressions*	1.586 (4.804)	0.933 (38.307)	-0.265 (-16.265)	1.696	0.998

* First-order autocorrelation corrected ** Second-order autocorrelation corrected

Does Behaviour Remain Stable Over Time?

Parameter stability plays a particularly important part in making forecasts. Their instability can reflect structural phenomena (poor specification, variables omitted), or specific events over a period of time (oil crisis, political or economic measures, new legislation, etc.). An effective approach to test coefficient stability is to evaluate these coefficients recursively using the Kalman filter[12,13], i. e., by adding observations one by one. It is then possible to assess how the model adapts to data. Brown, Durbin, and Evans[14] have developed stability tests based on this recursive procedure. To be able to apply this type of test, we have reorganised the data base by stacking the observations not by region but by year. The specification of equation (4) is used throughout this section. Recursive coefficient evaluations using the Kalman algorithm are shown in Figures 6 and 7.

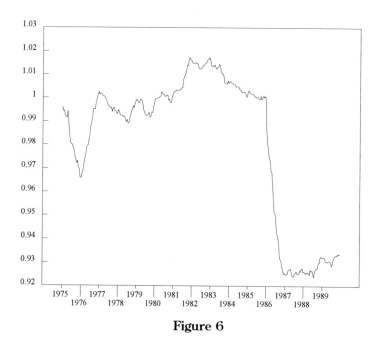

Figure 6

Estimation of Car-Fleet Coefficient Using Kalman Filter Algorithm

Figure 7

Estimates of Average Price-of-Fuel Coefficient Using Kalman Filter Algorithm

These figures illustrate a breakdown which took place in 1986. The impact of this crisis is seen on both the car-fleet variable (Figure 6) and the average-price-of-fuel variable (Figure 7). Interpretation of actual coefficient progression from these graphs is quite difficult because the information in them is conditional on previous information and based on the assumption of homogeneity.

The Cusum test is a graphic test that detects systematic movements in coefficient value, which in fact illustrates the validity of the chosen specification and possible structural modifications in parameters. It can be seen from Figure 8 that the curve does not deviate very much from the interval and that, *a priori* the specification looks correct.

Figure 8

CUSUM Test – 10% Confidence Interval Limits

The Cusum Square test is based on the same principle (graphic test) but has a different objective because it detects movements that can be considered as more random. According to Figure 9, there are three distinct periods (because the curve exceeds the confidence interval limits by 10 percent). These periods are as follows:

- 1973 to 1978: from the first oil crisis,

- 1979 to 1986: the second oil crisis and its after-effects,

- 1987 to 1989: following on from the after-effects.

Figure 9

CUSUM Square Test – 10% Confidence Interval Limits

Over the first and last period, real household income increased continuously; on the other hand, the middle period was subject to fluctuations (falls separated by the 1981-1982 upturn in the economy). The most unexpected breakdown occurred in 1987 following the after-effects of the oil crisis and the economic upturn in 1986; in a later phase of this work, this point could be clarified using a dynamic specification.

The Chow test[15,16] confirms the heterogeneity of these three periods[a]. It illustrates that it is not linked to fleet elasticity, which does not undergo any significant variation throughout the period, as shown in Table 4. During the middle period, however, the influence of price decreased considerably.

[a] The calculation of the Chow statistic results in C=13.5. It is known that it follows a Fisher distribution with (6,348) degrees of freedom. By checking the value of this theoretical Fisher statistic in a table with a significance level of α=5 percent, the result is: $F(6.348) = 2.12$. Thus C > F, the assumption of time stability is rejected.

Table 4.

Chow Test : Results of Regressions for the Different Periods

PERIODS	INT	Log VIG	Log PMOY	DW	SCR	R2
1973-1989	1.586 (4.804)	0.933 (38.307)	-0.265 (-16.265)	1.696	0.187	0.998
1973-1978	0.964 (2.908)	0.997 (39.718)	-0.404 (-21.463)	2.262	0.03	0.999
1979-1986	1.365 (3.406)	0.939 (31.697)	-0.166 (-7.753)	1.662	0.083	0.999
1987-1989	0.916 (1.346)	0.995 (20.769)	-0.358 (-3.268)	1.062	0.039	0.999

The influence test is also graphic, as shown in Figures 10 and 11. It evaluates the information provided by each observation. As a result, the test makes it possible to ascertain whether the breakdowns that occurred at coefficient level are temporary or longer-lasting.

Figure 10

Influence Test Results: Car-Fleet Variable

Figure 11

Influence Test Result: Price Variable

It can be noted, from Figures 10 and 11, that the effects seem to vary from region to region and that they occur intermittently in 1973-1974 and in 1986, the curve of each graph remaining practically flat for the other years. For the two explicative model variables, a similarity can be noted in the curves of Figures 10 and 11. For the fleet variable, in Figure 10 the fluctuations are greater in 1973-1974 than in 1986-1987, whereas the inverse can be seen for the price variable in Figure 11. There appear to be significant changes in coefficient values. Furthermore, the impact of these crises was not felt in the same way in every region. The flat curve for the other years shows that the adaptative phenomena played their part and subsequently made it possible to recover a certain homogeneity between regions. The impact of a crisis is, therefore, felt differently depending on the region in question.

CONCLUSION

Although this work is not yet complete, some factors can be put forward to provide a provisional conclusion. The demographic model shows that in France over the next twenty years, the growth of the car fleet and traffic will vary considerably from region to region. The increase in the number of adults (potential drivers) will contribute most to these differences between regions; zones where car ownership was first apparent (Greater Paris) will develop more slowly than zones where car ownership is the most recent (West). The aging of the population will be a factor in slowing down the increase in traffic rather than the changes in the car fleet.

The regionalisation of the econometric analysis, using more appropriate data, provides a much improved basis and opens up greater perspectives for both our national analysis and for the differentiation of regional behaviour. By studying fuel sales, it could be assumed that household income has no direct effect on traffic, once the influence of the car fleet is taken into account. Furthermore, the influence of fuel price has varied considerably since 1973, being a considerable influence at the beginning and end of the period. It seems to have weakened considerably during the second oil crisis and its after effects. Regional differences are more significant. The influence of price is more noticeable in transit areas than in the isolated regions of the Massif Central (mountains in the central part of France). Because short-term price effects have been shown to be unstable, we will use lagged variables for years with a strong shift (1974 and 1986) in order to isolate the long-term effects that are the essence of this research work.

ACKNOWLEDGMENTS

We are particularly grateful to S.E.T.R.A. (Service d'Etudes Techniques des Routes et Autoroutes) which financed this work and participated in our discussions. We would also like to thank Patrick SEVESTRE, Professor of Economics at the University of Evry and Georges BRESSON, Professor of Economics at the University of Paris II and ERUDITE - University of Paris XII, for their assistance with econometric methodology.

REFERENCES

1. Jansson, J. O., "Car Ownership Entry and Exit Propensities of Different Generations - a Key Factor for the Development of the Total Car Fleet," Oxford Conference on Travel and Transportation, T. S. U. , 1988.

2. Van Den Broecke, A. and G. Van Leusden, "Long-term Forecasting of Car Ownership with the Cohort Processing Model," I. C. T. B. la Baume-lès-Aix, 1987.

3. *National Road Traffic Forecasts*, H. M. S. O., U. K., 1989.

4. Glaude, M. and M. Moutardier, "Projection de la demande d'automobiles pour 1980 et 1985," les Collections de l'INSEE série M, no. 64, 1978.

5. Madre, J. L., "Projection du trafic automobile sur les routes nationales et les autoroutes Françaises," Actes de la Conférence mondiale sur la recherche dans les transports, Yokohama, 1989.

6. Lemenec, D. and J. L. Madre, "Comprendre la cohérence des statistiques sur l'automobile," rapport CREDOC, 1991.

7. *Ibid.*

8. Durbin, J. and G. S. Watson, "Testing for Serial Correlation in Least Squares Regression," *Biometrika*, Vol. 37, 1950, pp. 409-428.

9. Durbin, J. and G. S. Watson, "Testing for Serial Correlation in Least Squares Regression," *Biometrika*, Vol. 38, 1950, pp. 159-177.

10. Houthakker, H. S. and L. D. Taylor, *Consumer Demand in the United States, 1929-1970*, Harvard University Press, 1966.

11. Madre, J. L., *op. cit.*

12. Harvey, A. C., "Time Series Models," Philip Alan, 1981, pp. 101-120.

13. Harvey, A. C., "The Econometric Analysis of Time Series," Philip Alan, 1981, pp. 151-154.

14. Brown, R. L., J. Durbin and J. M. Evans, "Techniques for Testing the Constancy of Regression Relationships Over Time," *Journal of the Royal Statistical Society*, Series B, Vol. 37, no. 2, 1975, pp. 149-192.

15. Orfeuil, J. P., "Prix et consommation de carburant dans les transports routiers de voyageurs," *Revue Transport*, no. 341, 1990.

16. Chow, G. C., "Tests of Equality Between Sets of Coefficients in Two Linear Regressions," *Econometrica*, Vol. 28, 1960.

23

MODELLING TRAVEL BEHAVIOUR TO SUPPORT POLICY MAKING IN STOCKHOLM

Staffan Algers, Andrew Daly, and Staffan Widlert

ABSTRACT

This chapter presents the structure of a system of traffic models that has been developed in Stockholm and describes some of the major results that have been obtained. The system will be used for policy analysis by different regional planning authorities in Stockholm County, where many important planning issues are currently being considered. The model system allows for linkages between different choice levels and takes into account a number of possible choices that have not normally been included in the model systems. It also takes into account different household interactions, for example, concerning the allocation of the car between household members and the selection of household members to do the shopping. The model system also incorporates the effect of various constraints.

The system includes models for work, school, business, shopping, social visits, and other trip purposes. The models are based on a detailed home-interview survey and are estimated using maximum-likelihood methods. The models are being implemented in a forecasting program that runs on microcomputers to produce summary information and trip matrices for assignment.

INTRODUCTION

Transportation models have been used in Stockholm for a long time[1,2] in evaluating transportation projects. Most of these models have been limited to work trips, and deal mainly with mode choice. This has been a severe constraint in the evaluation of projects, because many of the effects may be more important for other trip purposes than work trips. In many cases, effects like changes in trip distribution and trip

frequency may be very important, but cannot be handled with the present models. Politicians also require a more detailed analysis of distributional effects than has been possible hitherto.

The planning authorities in Stockholm had discussed at length the need for a more comprehensive model system. The decisions were finally made and the project started with a travel survey in 1986 and 1987. In this major upgrade of the Stockholm model system, the breadth and complexity of the planning issues and social and spatial developments made it necessary to consider a number of improvements to current modelling practice.

The objective of this chapter is to describe the requirements for the model system, its design, and some of the main results, as well as the application procedures. The focus of the chapter is to give an overview of the results from all models that are available today, rather than presenting detailed estimation results for only some models.

At the time of this writing, the work is at a stage where four models – work, school, business, and shopping – are implemented in the forecasting system. Models for the other purposes, mainly social, recreational, and service trips, have been estimated and will be implemented shortly. When completed, the system will be used by several public transport and road planning authorities within Stockholm County. The project is being carried out by the Development Department at Stockholm Transport and the County Council Public Transport Office with the support of Hague Consulting Group.

REQUIREMENTS

Need for Policy Analysis

Stockholm County comprises 6500 square kilometres and 25 municipalities with a total of 1.5 million inhabitants. Transportation planning in Stockholm County is carried out at the county level as well as at the municipality level. At the county level, the Regional Traffic and Planning Board is responsible for long-range land-use plans that also involve road and public-transport network aspects. The only public-transport operator in the county, Stockholm Transport, is owned by the County and is responsible for public-transport planning throughout the County. Also at the county level, the regional branch of the National Road Administration is responsible for most major roads. At the municipality level, each municipality is responsible for its short term land-use plans and for its road network. Of course, the various planning bodies need to (and do) cooperate extensively.

Many important planning issues are now being considered in Stockholm. Area licensing is suggested for the inner city, the introduction of new trams is under consideration, new ring roads are widely debated, etc. There is, therefore, a great demand for project evaluation. However, transportation in this area (as in most places) is affected not only by changes made at the level of the road network and public-transport system, but also by changes taking place at the level of overall economic development and by land-use changes. Thus, there is a need for a model system that is capable of describing the consequences of transportation projects in a changing environment.

An important issue in the Stockholm debate on transportation is the incidence of different policies, i.e., to what extent distributional effects are caused by these policies. This means that the model system should be capable of predicting not only consequences in terms of the number of trips by mode, and origin and destination but, also, in terms of distributional consequences, that is, who gains, who loses, and how much. Clearly, this calls for a model system that takes the distribution of socioeconomic variables across the population into account.

Need to Represent Behaviour

Transportation projects affect the travel behaviour of individuals through changes in travel time, cost, etc. Individuals respond to these changes by modifications at various choice levels – for example, at the levels of mode and destination choice, or at the level of frequency choice. This has been recognised for a long time[3], and also has been taken into account in, for instance, applications of disaggregate, nested logit models that allow for linkages between the different choice levels[4]. Such models have not, however, been estimated for the Stockholm region before.

There are, however, other possibilities for individuals to adapt to changes in the transportation system than at the choice levels mentioned above. One example is a shift of car use between the different members of a household, that might be the consequence of an area-licensing scheme. Another example might be a shopping trip that can be assigned by the household to other household members as a consequence of a price or trip time change, affecting accessibility for different household members. A third example would be to substitute a second destination on the trip between work and home in place of a home-based trip. A change of times or costs may make it relatively easier to carry out shopping on the way home than as a home-based trip. There are also various constraints that limit adaptation possibilities, such as the availability of the family car and the opening hours of shops.

To be able to consider the different possibilities of adaptation to the effects of various policies, they have to be modelled explicitly. There is a clear need to design the forecasting system to model explicitly the mechanisms of travel behaviour. There is good reason to suppose that these effects are relatively more important in the Stockholm region than in other urban areas, in particular because of the high rate of employment among women. The Stockholm model system has, therefore, been developed explicitly to take account of these interactions and constraints to the extent that this is possible in a practical forecasting system.

DEVELOPMENT OF THE MODEL SYSTEM

The requirements sketched out above for the model system are very challenging. The model must not only allow the testing of a wide range of policy measures, but also take into account a rich description of travel behaviour. This implies that the model is necessarily large and complex, presenting problems for both estimation and implementation. However, once these problems are solved, the planning instrument thus obtained will have an exceptional range of capability.

Scope of Modelled Behaviour

An important component of the policy packages to be considered with the aid of this model is infrastructure planning. The planning of infrastructure implies that a relatively long planning horizon must be used, perhaps 20 years. Medium-to long-term planning in turn implies that the models must be capable of predicting travel behaviour substantially different from what can be observed today. New housing and employment areas will spring up and the links between the existing areas may well change substantially.

These fundamental changes in travel patterns require the model to be capable of constructing a complete synthetic picture of future travel. While information on existing behaviour should be used as intensively as possible, it is necessary to construct a complete picture of travel frequency and trip distribution, as well as, the shorter-term choices such as mode and route choice. Thus, the Stockholm model system necessarily includes all of the components normally found in the classical "four-stage" planning models.

A further aspect of travel behaviour that was also included in the model was car ownership. It is necessary to incorporate car ownership into the modelling of other aspects of travel when travellers make their car-ownership decisions jointly with decisions about other aspects of travel. At least as regards travel to work, this joint decision making is plausible *a priori* and was shown to be important by the empirical

results. For consistent prediction of travel, it is necessary to predict car allocation within the household as well as car ownership.

A key difference between the Stockholm model system and those developed in other areas is the degree of interaction that is allowed for in the system. The interaction between household members in the allocation of the car (or cars) owned has already been mentioned. In addition, interactions are modelled in the choice of destination, taking account of detours on the home-work journey to business, shopping, and other secondary destinations. Interactions are also modelled between household members in the choice of which members are to do the shopping. Of course, other interactions of importance can be postulated within a household's travel patterns that are not usually incorporated in travel-demand models, but it was felt that the interactions listed above were the most important that could reasonably be incorporated in a practical forecasting system.

The household behaviour that is represented in these models is treated as choice under constraint. That is, the household and its individual members are represented as choosing among a number of alternatives that are available for the particular aspect of behaviour covered by each model. Some alternatives are excluded for various reasons: they involve walking too far, they are too expensive compared with the household income, or they are excluded by other choices (such as not buying a car, for instance).

Thus, the model system represents a large number of interdependent choices made by households and their members. A specific feature of the modelling is that the choices are made among discrete alternatives. The structure of the system for different travel purposes varies to take account of the varying aspects of importance in each case.

Form of the Models

The representation on a large scale of complicated sets of behaviour, such as those proposed for the Stockholm model, requires a model form that is capable of representing the full interactions that are required to be studied, while not imposing too great computational requirements either in estimation or in application. To balance these competing requirements, it was decided to use models of the generalized tree-logit form. Models of this form allow the main correlations between different choices to be represented, without requiring the sophistication of full correlation, such as could be offered by a "probit" model. The properties of the tree-logit model and the role of the structural parameters are discussed elsewhere[5].

Estimation Procedure

The tree-logit model form was chosen as the most general that could be estimated reliably with the commercially-available software. Improvements were made, however, to the software being used, to increase its capability, operating speed, and the size of problems that could be handled. Model estimation was based entirely on "revealed-preference" data, collected in the home-interview survey, that used a design fairly typical of transportation planning. However, advantage was taken of the most recent developments in survey design to improve the quality of the data and to maximize the response rate.

The software used, Hague Consulting Group's ALOGIT package, performs a full-information maximum-likelihood estimation of the tree-logit model. A limited extent of further non-linearity in the "utility" functions of the alternatives is also accepted: models can be specified that contain "size" variables measuring the attractiveness of the alternatives[6]. However, the very large model systems defined for this project proved to be too large for simultaneous estimation of the entire system for a single travel purpose. Also, it was necessary to separate the choices made by different decision-making units, such as households and persons. The models were therefore segmented *a priori* and the segments estimated as tree-logit models.

Computer software and hardware issues played an important part in the model estimation. The key packages used were ALOGIT (mentioned above) and EMME/2, that was used for the network analysis to support estimation. Both of these packages were available on Vax mini-computer systems and industry-standard microcomputers. However, as the project continued, the improvement in performance of microcomputers, together with their greater convenience of use, led to their increased use in the later parts of the project.

THE MODELS ESTIMATED

Detailed descriptions are given of the models for work, school, business, and shopping trips. The models for social, service, and recreation purposes are similar to the shopping models and are described more briefly. Space does not allow presentation of detailed model-estimation results. Results for the work model are given in Algers, Daly, and Widlert[7] and for the shopping model in Algers, Daly, and Widlert[8].

Work Tours

Overview

Figure 1

Structure of the work-tour model

The work-travel model, the most important single component of the system, is described in some detail. Many of the issues that are relevant here are also relevant for other travel purposes. In order to incorporate the household interactions and choices discussed earlier, together with the traditional interactions and choices discussed earlier, and also with the traditional choices of generation, distribution and mode choice, the structure shown in Figure 1 was estimated.

In the logit model, the utility of each alternative is described by a utility function. The utility function contains a systematic component, and a stochastic component that represents factors like unobserved attributes, measurement errors, etc. The position of the different choices in the structure depends on the variance of the stochastic component. Choices with a large variance must be placed at low levels in the structure. The structure in Figure 1 was suggested in the planning phase of the project and was confirmed by the empirical results. The whole structure is too large to be estimated at one time. Therefore, the structure has been split into substructures, indicated by the dotted lines. Each of these substructures has been estimated separately. The figure shows the choices for a household with two working members. If a household only has one working member, the complexity reduces considerably. If the household has more than two working members, two "main" workers are

identified. The other working members of the household are then treated individually (as one-person households). The two main workers are denoted A and B; the coding procedures are such that A is usually a man and B a woman.

At the top of the structure is the car-ownership model. The next model in the structure is a destination model for the simultaneous choice of destination (destinations denoted D^1 to D^n) for the two main workers in the household. One variable in the destination model is a logsum from the "lower" models in the structure.

The middle substructure consists of models for trip frequency, car allocation, and mode choice. These three models are estimated simultaneously. A logsum from this substructure is then calculated and passed "up" to the final substructure, car-ownership and destination choice, that are estimated simultaneously. At the mode-choice level, the alternatives are car as driver, car as passenger, public transport, walk, and bicycle. Of course, the car-driver alternative is only available if the household has a car and if the person has a driving license.

At the car-allocation level, the alternatives depend on the number of working people in the household. If only A goes to work, he has the alternatives of using the car (A) (if he has a license) or not using the car (O) in the car-allocation step. If he does not take the car, he can choose between going as a car passenger (in another household's car, or with a non-working driver from his own household), going by public transport, walking, or cycling. If only B goes to work, she has a corresponding choice set.

If both A and B go to work, they have the following alternatives in the car-allocation step:

O: neither uses the car
A: A uses the car
B: B uses the car
AB: both use the same car (shared ride)
A and B: they use different cars (only if the household has more than one car)

In the frequency model, the alternatives are that the household makes no trip (O), that person A makes a trip to work (1(A)), that person B makes a trip (1(B)), or that both persons make a trip that day (2).

The "lowest" model in the work-trip structure is a model for choice of secondary destination during work trips. Secondary destinations are those visited on the way to

or from work, for example, shops, etc. This model must be estimated first in order to calculate the logsums to be passed "up" to the next level.

The estimation results for the work model are briefly described below. The models are described in the order of estimation (i.e., from the bottom up in the structure above).

Secondary destination

The choice of secondary destinations is modelled as two explicit choices: the choice of whether to chain a second trip purpose or not; and if so, to what destination. In this case, the location of home and work is assumed given, as well as the mode for the "primary" work trip. Since the mode is given, separate secondary destination models are defined for each mode.

The modes considered are car and public transport. Slow modes are not considered, because of the fact that they mostly concern short trips within one zone. The mode used to the secondary destination is assumed to be the same as for the primary tour.

The variables found to be important in the model are attraction variables, network variables, socioeconomic variables, and constants. In summary, the models allow us to model the impacts of transport systems on secondary destination choices in a reasonable way.

Mode choice, car allocation, and travel frequency

At the mode-choice level, we found different time and cost variables with higher valuations for out-of-vehicle components. As expected, people who sometimes use their car during work have a higher probability of using the car on all days. A car competition variable reflects competition with non-working members of the household (competition with the working members is explicitly modelled at the allocation level). A dummy variable captures the higher probability for travelling as a car passenger for workers belonging to a car-owning household, reflecting the possibility of travelling as a passenger with a non-working member of the household (car as passenger with a working member is defined as shared ride). When it is freezing weather, the probability of bicycling decreases substantially.

The coefficient of a logsum variable from the secondary destination model is significantly different from zero and one, indicating that the accessibility to different destinations on the way to and from work with different modes affects the choice of main mode, as was hypothesized when specifying the structure.

At the car allocation level, dummy variables show that women — everything else being equal — have a lower probability of getting access to the car in households with two working members. Dummy variables indicate that younger women and women with higher education seem to be more equal to the men when "negotiating" for the car. A logsum variable measures how the accessibility affects the car allocation and was found to be significantly different from zero and one. The parameter shows that the accessibility gained by using the car is an important element when the household decides about car use.

In the frequency model, weekday parameters reflect the lower work-trip rate on Saturdays and Sundays. The part-time dummies show that people who work part-time often work fewer days (not only a shorter time each day). A dummy for households with children (age 7 and under) and two workers show that such households have a higher probability of staying home (normally because a child is sick). Dummies for the alternatives with one trip show the same effect—when there are small children in the household, there is a higher probability that one (working) member stays at home. The coefficient of the logsum variable from the allocation model is small and not significantly different from zero. Accessibility has not been found significantly to affect the number of work trips per day for working households. It might, however, influence the choice of part-time or full-time employment, that is not modelled.

Destination and car-ownership choice

As mentioned above, the destination model deals with the household's choice of *combinations* of workplaces for both working members in the household (if there are two). In the destination model, there is a logsum variable from the lower levels, measuring the accessibility of different destinations, given the possible modes for the household. In this way, it is possible to take account of the effects on the destination choice of the benefits of the two people working so close together that it is possible for them to travel together in one car. There are also variables that take account of the fact that some parts of the Stockholm region are in reality more or less self-contained employment areas. Different distance-related variables capture information effects.

In the car-ownership models there are income variables showing a stronger income effect on the second car than on the first, and different variables connected to the size of the household — also showing a stronger effect on the second car. Parking costs in the living area are shown to affect the car ownership levels significantly. A logsum variable that measures the increased accessibility to all alternative destinations when the household has one or two cars also has a strong effect on car ownership. The parameter of the logsum variable that measures the increased accessibility to all alternative destinations when the household has one or two cars also has a strong

effect on car ownership. The parameter of the logsum variable is not significantly different from one.

School Tours

Overview

The school-trip model deals with trips made by people 12 years and older and with "study" as the main occupation. For these students, choice of trip frequency is not realistic. There are also few household interactions to consider. Therefore, only mode and destination choice were modelled. Empirical results showed that the structure shown in Figure 2 below should be used.

car
driver

car
pass.

walk cycle public
 transp.

D1 D10

Figure 2

Structure of school tour model

There are five mode alternatives in the model. For estimation ten destinations were sampled in a stratified random sampling.

Choice of destination and mode

For younger students the number of pupils in each area is used as the attraction variable. For students at the university level, the number of employed teachers is used. In Sweden, students at the high-school level (or under) do not have a free choice of which school to attend, but are allocated to schools in their own district. Apart from the attraction variable, the destination model, therefore, also includes variables that capture the high probability of young students going to schools in their own residential area and the low probability of going to schools in the inner city.

At the mode-choice level, we found that the traditional level-of-service variables were all estimated with good statistical quality. The results also show that the car-passenger mode is primarily used by students at the high-school level, but not by university students nor by younger children who normally go to school so close that walking is the totally dominant alternative. This reflects the willingness of parents to drive their children at the middle level to school. Students at the university level often live independently and, if they live with their parents, they often have a long distance to travel. The logsum variable from the destination-choice level got a parameter that was found to be significantly different from both zero and one.

Cycling has a much higher probability if the student is at the high school level, for similar reasons to those discussed for car passenger above. Cycling also has a much lower probability during winter when snow is quite common in Stockholm. Car as driver is obviously only an alternative for older students who have a driving license (minimum age 18). The probability of driving a car naturally depends heavily on the car availability in the household.

Business Tours

Overview

The system covers all business trips within the region of Stockholm, except those made by people who are professional drivers (bus and lorry drivers, patrolling policemen, etc.). The business models have employed individuals as their base. The structure is shown in Figure 3.

Different structures with different orders of the models were tested during the estimation work. The structure in Figure 3 was the only one that produced logsum coefficients with acceptable values at all levels.

At the top of the structure is a separately-estimated frequency model with the alternatives to make no trip, one trip, and two or more trips. The chain model covers home-based and work-based trips, and also trip chains: visiting business destinations on the way to or from work. A simplifying assumption is that the mode of the business trip can be modelled independently of the mode for the primary work trip. Three modes are distinguished — car (car as passenger, car as driver, and taxi), public transport and other (walk and bicycle). In the destination-choice model, 17 destinations are sampled for estimation from five different strata related to the distance from the work place. Trip chain, mode, and destination choice are modelled simultaneously in a model with 153 alternatives at the bottom level.

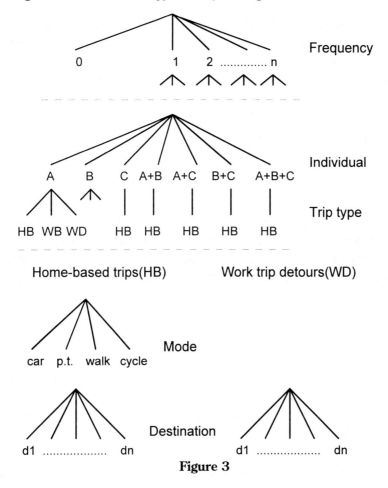

Figure 3

Structure of business tour model

For the chain alternative, we use the extra travel time and cost, compared to the time and cost if travelling directly between work and home. Time and cost are measured for the time periods at which the trips took place.

Choice of destination, mode, and trip chain

In the destination model, the attraction is measured by the total number of employed persons at each destination. The mode-choice part contains standard level-of-service variables, some socioeconomic variables, and a logsum variable from the destination level with a parameter that is significantly different from both zero and one.

The most important variable at the chain level is the logsum variable from the lower levels. The logsum variable shows that accessibility has a significant effect on choice of the type and chain. The parameter is significantly different from zero, but not from one. There are also variables capturing different probabilities for different chain types if the business visit is to be made early in the morning or late in the afternoon, if the visit has a very long duration. There is also a sex dummy reflecting the different business trip patterns of men and women.

Choice of trip frequency

The main variables in the frequency model are connected to the profession of the individual or to the type of work place. Companies and professions with many business trips are, as can be expected, very common in the inner city of Stockholm. When the variables for profession and type of work place are introduced, the business trip frequency in the inner city is therefore over-estimated. Dummy variables for the inner city are included in the model to correct this effect.

In the frequency model, we assume that the destinations are chosen independently if more than one destination is visited during the day. The logsum variable for the 2+ alternative is simply calculated as 2.3 times the logsum for the alternative of making one trip (there is an average of 2.3 business trips in the 2+ alternative). The logsum parameter is significantly different from zero (but not from one) and has a value of 0.9 that indicates a strong accessibility effect on the trip-frequency choice.

Shopping Tours

The model structure used for shopping tours is as shown in Figure 4. At the highest level in the structure is a frequency model, that predicts the number of visits to shops that will be made by the household in a day. At the next two levels below, the allocation of the household trips to individuals and trip type is modelled. Below those levels, mode and destination choice are modelled for home-based trips and destination only for work-based and secondary-destination trips. We also found that it was possible to derive a satisfactory model for time-of-day choice for home-based trips, but because that choice was not modelled for other trip types, it was decided not to include time-of-day choice in the shopping-model system. Connections between levels in the model structure by logsum variables make the model integrated.

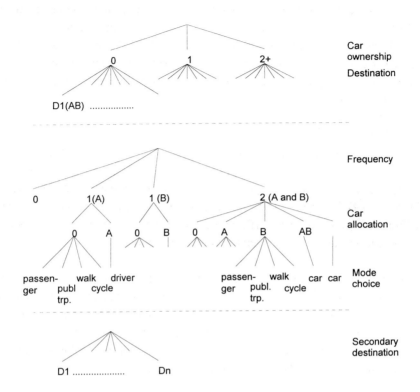

Figure 4

Structure of Shopping Tour Model

Shopping trips are not very homogeneous. Some trips concern daily needs that are standard products bought in small quantities. Other trips may concern daily needs but in large quantities, and yet other trips may concern durables of differing value (such as clothing and TV sets). The more homogeneous the good in question, the smaller the chance that a more distant destination will give an advantage. This effect of product heterogeneity is difficult to model explicitly, because variables related to the advantages of heterogeneity (price level, service, quality, etc.) were not possible to measure for the project.

For this reason, the unexplained variance in the utility of the destination is likely to be higher for shopping concerning less homogeneous goods, resulting in a small scale

factor for these trips and also explaining the greater mean trip length. Therefore, shopping trips were divided into two different trip categories that were assumed to reflect the differences mentioned above. The operational criteria that had to be used for the subdivision were type of shopping (daily needs or other) and duration of the purchasing activity at the destination (shorter or longer than 30 minutes). One category consists of trips for short duration shopping for daily needs, and the other group consists of the remaining trips. The full model structure was estimated for these two types separately, and detailed results are reported in Algers, Daly, and Widlert [9].

Choice of mode and destination for home-based shopping trips

The decision unit in this model is the combination of individuals that make the trip together. It may thus be only one person, two persons, or the whole family travelling together. The level-of-service variables are calculated to reflect the number of people in the party, so that all variables are on a per person basis.

The mode-choice alternatives are the car, public transport, walk, and bicycle alternatives. The car mode was considered available only if one person in the party had a license and the household had a car. The destination alternatives are the 850 zones that make up the zonal subdivision of Stockholm County. To make the estimation of this model feasible, a stratified sample of 9 destinations was used.

The variables for mode choice include costs, in-vehicle time, and out-of-vehicle time components for public transport (walk time and waiting time), walk time for the walk mode and bicycle time. Destination variables include attraction (size variables such as the number of employees in different branches), and dummy variables for supermarkets, regional centres, and city areas. The destination and mode-choice levels are connected by logsum variables, the coefficients of which take values of approximately 0.4 and 0.5 (depending on the shopping trip category) and are significantly different from both 0 and 1.

Choice of destination for work-based and secondary-destination trips

There is not an explicit destination-choice model for work-based trips. These are normally short walk trips that are of limited interest *per se*. To calculate a logsum for the next choice level, a size variable was created for the areas close to and including the work place. The logsum then expresses the accessibility to shops from the workplace (not necessarily on the same scale as the logsum from the home-based model).

The choice of destination for shopping trips that are part of a journey from work to home (or reverse, which is not common), is calculated by means of the secondary-destination model described above. This model was also used to calculate the logsum to the next level, expressing the accessibility to shops in the course of the work trip (again possibly another scale). For persons not choosing car or public transport for their work journey, a similar logsum measure as for work-based travel was calculated. However, this logsum connection was not found to be significant.

Choice of individual and trip type

The middle substructure concerns the allocation of a household trip to one or more household members, and also to one of the trip types described above (home-based tour, work-based tour, or a work-trip detour). The household is divided, where possible, into an A-person (a worker, generally a man), a B-person (a worker, generally a woman) and unspecified C-persons (the other household members of 12 years and above). Combinations of these three person types yield a maximum of 7 alternatives to which a household shopping trip can be allocated: A, B, C, AB, AC, BC and ABC.

The main variables in the trip-type model are those describing the working hours of the household's workers and logsums from the mode and destination-choice models. In the model for choice of individual, the main variables are the logsum variables from the trip-type choice. At the trip-type choice level, the logsum parameters from the home-based trip type and the work-based trip type are significantly different from zero (and from one) for both trip categories. However, the logsum (or accessibility) from the secondary-destination model did not turn out to be significant (that may be due to the fact that trip length is positively correlated with this accessibility, but negatively correlated with time left for shopping).

We might expect that longer working time will make the time constraint more binding for home-based trips and trip chains than for work-based trips. The results support this, although not all work-time variables turned out to be significantly different from zero (and are therefore not included in the models). The results imply that with increased work time for both man and wife, the probability increases that the wife will carry out the shopping. Also, the logsum parameters at the level of choice of individuals are significantly different from zero (although the logsum parameter in the model for "other shopping" is restricted to one, because it otherwise would be — marginally — larger than one). Thus, the new finding from this model is that the accessibility of different trip types has an influence on the choice of trip type, and that the accessibility for different combinations of the household members has an influence on the allocation of the shopping trip in the household. Therefore, it seems that the

estimated model has proved that there is an allocation process in the household, and that accessibility (i.e., the transportation system) has an important role in this process.

From the trip-type and individual(s)-choice substructure, a logsum variable is calculated, to be used at the next level in the choice structure. This logsum variable can be said to express the accessibility of the household to shops — over possible destinations, over possible modes of travel, over possible trip types, and over possible household combinations.

Choice of frequency

Frequency choice is found at the top of the structure. The period for which the frequency is defined is a day. The alternatives are zero, one, two, and more trips, giving an adequate range of alternatives.

The variables in the submodel are socioeconomic variables and the logsum variable from all the choice levels below. The role of income appears to be complicated in that income over a certain level does not seem to increase demand for shopping trips with short duration, whereas income increases the demand for other shopping trips on Fridays. The logsum variable is significantly different from zero (and from one), which means that the whole structure of the shopping-trip model is integrated. Thus, changes in the transportation system will influence all choice levels in the model.

Social and Other Tours

The model system also contains models for social tours and other tours (recreation and personal-business tours). These trip purposes are modelled separately, and with some differences in their structures. For "other" trips, the same structure as for shopping trips has been used. Broadly, the results are similar to those for shopping trips, although differences were found in the values of the estimated coefficients. For this trip purpose also, the whole structure is integrated.

For social trips, the structure is different in that it is not household oriented. In this case, we are dealing with an activity that takes place in the interest of the visitor, and that often is triggered by an invitation of the person(s) to be visited. Therefore, it is not expected that such trips will be allocated to different household members on accessibility grounds (that is our prime interest concerning household interaction). Personal visits are therefore modelled as individual trips. Trip-type choice turns out not to be possible to model, which means that a separate frequency model had to be estimated for trips made in conjunction with the work trip.

Thus, two separate structures are modelled for social trips – one structure related to home-based trips, and one related to work-trip detours. For home-based trips, a structure comprising destination choice, mode choice, and frequency choice is estimated, that is fully integrated in terms of significance of logsum variables. For work-trip detours, a structure comprising detour destination choice and frequency choice is estimated, but the logsum variable from the detour destination choice was not found to be significant.

APPLICATION PROCEDURES

In a large and complex model system like the Stockholm model, application procedures need careful thought to ensure that the policy issues of interest can be investigated quickly and usefully. For the Stockholm model, three types of output are being considered, each with specific advantages for particular types of policy analysis. These are: summary results, network assignments, and screen presentations. First, however, attention is given to the basic structure of the forecasting system.

Forecasting Framework

A range of application procedures may be used for the application of disaggregate models, the choice of the most appropriate method depending on the policy issues to be analysed and the structure of the models to be applied. Additionally, software issues can be vital in ensuring correct and efficient implementation of complicated models.

Level of detail of forecasting

An important component of the policy to be investigated with these models concerns the evaluation of infrastructure investment. Infrastructure can be evaluated effectively when the likely flows on the new links are known, i.e., implying the need to make assignments of traffic. Both highway and public-transport infrastructure are under consideration and both types of assignment are therefore needed.

The assignment package used for most purposes in Stockholm is EMME/2. Like other assignment packages, EMME/2 requires that demand be presented in the form of zonal matrices. This is necessary for the travel-demand forecasting system to be able to produce matrices on a zonal basis. A system of about 850 zones has been developed for the Stockholm agglomeration for other purposes and seems suitable also in this context. A high level of spatial detail is necessary for accurate public-transport assignment.

It is not necessary to meet the needs of accuracy in assignment that non-zero forecasts should be made for every cell in an 850 by 850 matrix. Previous experience has shown

that some degree of sampling is acceptable among the cells of the matrix. The simplest is to sample 100 percent of the origins, but for each origin to sample a fraction of the destinations, say 10 to 30 percent. By choosing the most important (i.e., largest flow) destinations, that are typically nearer the origin and city centre destinations, a large fraction of the flow (90 percent or more) can be covered and by expansion the entire flow can be estimated with high reliability in 10 to 30 percent of the computer time that would be needed to evaluate the full matrix.

The need for the emphasis on spatial detail implied by assignment at the level of 850 zones (even after destination sampling) means that the role of socioeconomic detail in the forecasting system needs to be considered carefully. At present, it is not feasible to evaluate the model for a large sample of households in each zone, when the zonal system is so large. The best procedure seems to be to analyse the models carefully to select the most important socioeconomic distinctions that need to be retained for accuracy. Other socioeconomic distinctions must be approximated.

This approach leads to a system of segmentation in which the key socioeconomic distinctions are preserved. The segmentation is different by purpose: for example, for the education model, students attending different types of school are processed separately; while for the journey-to-work model, these distinctions are of course not relevant.

Detailed structure of the models

The model system as it is applied is treated separately by travel purpose. That is, while there are some limited dependencies (in particular, travel for other purposes depends on decisions made for travel to work) the primary structure that governs the model implementation is that of travel purpose.

Further, the model systems have been based, as indicated above, on behaviour observed in a home-interview survey and the models have been estimated to represent travel generated by households. Thus, it is natural to find that, for each travel purpose, the models are organized by the zone of residence. Each zone is processed separately in turn. The further structure of the models varies by purpose. The forecasting software therefore displays differing structures at lower levels: destination and mode loops are entered as appropriate, as are the purpose-specific structures such as car allocation.

An important aspect of the software structure is the treatment of the various segments in the models that vary by travel purpose. However, in all cases there is a large degree of overlap between the terms included in the utility functions for differing segments.

By appropriate structuring of the program, evaluations are made only of those parts of the utility functions that are different for specific segments. This structuring has the consequence that the loops for different segments are found at a low level in the structure of the implementation programs.

Use of Forecasts Results

Results from a forecasting system of the type described here are typically used in detail for network assignment and in summary to report the main impacts of policy. A structure adopted in some other forecasting systems is to use a system for generating summary results separate from the main forecasting system. While this organization can have advantages, in particular if a very fast summary system can be set up, the need to approximate and, therefore, to generate results that are different in detail from the main results often causes confusion.

For the Stockholm Model, summary results are drawn from the main forecasting system. The summary results are output from the forecasting system in the form of a file containing the information needed with respect to a number of dimensions that are of interest for summary reporting. Numbers of trips, kilometres travelled, etc. are available for the various travel purposes and modes, and can also be broken down by origin and destination and by various specifications of traveller type. While these dimensions are too numerous to use all of them simultaneously, by the use of appropriate software selections, aggregations and permutations can be presented in many different ways suitable to the analysis of different policy issues.

An important part of the evaluation of alternative policy packages is the presentation of the results to people who are less familiar with the analytical approach and the model structure. For this reason, display capabilities ('Stockholm on Screen') have been developed that allow attractive and flexible presentation of the results in many differing ways. These display capabilities are integrated with the tabulation facilities described above and share many common features.

Assignments to both highway and public-transport networks are performed in Stockholm using the EMME/2 system. The demand-forecasting system, therefore, produces files that can be input directly into EMME/2. EMME/2 offers its own sophisticated display features to present the results of assignments.

CONCLUSIONS

The results show that it has been possible to take into account a number of modelling extensions that have been proposed over previous years (at International Travel Behaviour Conferences and elsewhere) in order to improve modelling of travel behaviour. Most important are the interactions within the household, integration of decisions concerning trip chaining and joint choices by separate individuals, and the treatment of constraints on travel behaviour.

The parts of the model system that can be compared with previous Swedish models agree well (weights for components, etc.). The approach with household models has worked well, and it has proved possible to model explicitly a number of additional household interactions. It has also been possible to get good statistical quality in the estimates of the logsum parameters that connect different substructures.

Model development has taken considerably more time and resources than was anticipated at the beginning of the project. The question of whether it has been worth the extra effort in both estimation and implementation is difficult to answer before a number of practical applications of the system have been made. It is now known which interactions are, and which are not, important to include in the models, and that knowledge will grow during the applications. Hardware and software improvements that have taken place during the project will reduce the effort needed for future modelling of this type.

The Stockholm model system is believed to represent the state of the art in portraying detailed behavioural interactions in a model that is practical in application to a major conurbation. The entire forecast system should run in less than one hour on suitable microcomputers, giving forecasts of detailed traffic flows for assignment or summaries of policy effects. An extended series of applications is planned.

REFERENCES

1. Algers, S., A. Hansson G. Tegner and S. Widlert, "Sweden's State of the Art Report to the International Collaborative Study on Factors Affecting Public Transport Patronage," Swedish Council for Building Research, Report D7, 1979.

2. Algers, S. and G. Tegner, "The Role of Quantitative Methods in Urban Transport Planning: A Practitioner's Viewpoint," Working paper 19, Cerum, University of Umeå, 1987.

3. Ben-Akiva, M. E. and S. R. Lerman, *Discrete Choice Analysis*. MIT Press, 1985.

4. Daly, A. J., J. van der Valk, and H. H. P. van Zwam, "Application of Disaggregate Models for a Regional Transportation Study in The Netherlands," World Conference on Transport Research, Hamburg, 1983.

5. Daly, A. J., "Estimating 'Tree' Logit Models," *Transportation Research*, 1987, 21B, pp.251-267.

6. Daly, A. J., "Estimating Choice Models Containing Attraction Variables," *Transportation Research*, 1982, vol. 16B.

7. Algers, S., A. J. Daly, and S. Widlert, "The Stockholm Model System - Travel to Work," Fifth World Conference on Transportation Research, Yokohama, 1989.

8. Algers, S., A. J. Daly, and S. Widlert, "The Stockholm Model System - Shopping Trips," Sixth World Conference on Transport Resarch, Lyon, France, 1992.

9. *Ibid.*

INDEX